"Provides easy-to-read legal analysis of some issues involved in the Palestinian quest for freedom and serves as a valuable historical (and legal) record for those analyzing Palestinian decision-making in the late 1980s and early 1990s."
—*Journal of Palestine Studies*

"This book is a must reading for all those interested in the legal background of the Palestinian-Israeli conflict."
—**Ghada Talhami**
Arab Studies Quarterly

"Boyle's penetrating analyses of Israeli and American roles in the crisis that has destabilized the Middle East for over fifty years are as cogent as his criticisms are fearless and his warnings prescient."
—*Washington Report on Middle East Affairs*

"This book provides important background to how the International Court of Justice reached its conclusions, and some interesting hints about the likely consequences."
—*Middle East International*

"This book provides a comprehensive legal analysis for the Palestinian right to an independent state."
—*Mediterranean Journal of Human Rights*

"Absolutely crucial to the broader understanding of why the Palestinian-Israeli conflict is where it is today"
—**Sam Bahour**
Ramallah Online Book Review

"The advisory opinion of the International Court of Justice on the Israeli Wall published in July could almost stand alone as a review of Professor Francis Boyle's book. The World Court judges comprehensively confirm and validate his work in elaborating the case for the Palestinians in international law."
—*Socialism and Democracy*

Palestine, Palestinians and International Law

Palestine, Palestinians

and

International Law

by

Francis A. Boyle

CLARITY PRESS, INC.

ISBN: 0-932863-37-X

In-house editor: Diana G. Collier

Cover photo: CP/MEMBER SOURCE (Vadim Ghirda)

Also by Francis A. Boyle:

World Politics and International Law (1985)
Defending Civil Resistance under International law (1987)
The Future of International Law and American Foreign Policy (1989)
The Bosnian People Charge Genocide (1996)
Foundations of World Order (1999)
The Criminality of Nuclear Deterrence (2002)

Library of Congress Cataloging-in-Publication Data

Boyle, Francis Anthony, 1950-
 Palestine, Palestinians, and international law / by Francis A. Boyle.
 p. cm.
Includes bibliographical references and index.
 ISBN 0-932863-37-X
 1. Palestine—International status. 2. Arab-Israeli conflict. I.
 Title.
 KZ4282.B69 2003
 341.26—dc21

 2002156476

Support for this publication from Americans for Middle East Understanding (AMEU) is gratefully acknowledged.

CLARITY PRESS, INC.
Ste. 469, 3277 Roswell Rd. NE
Atlanta, GA. 30305

http://www.claritypress.com

Dedication

In the name of God, the Compassionate, the Merciful:

"Say: 'O God, Master of the Kingdom, Thou givest the Kingdom to whom Thou wilt, and seizest the Kingdom from whom Thou wilt. Thou exaltest whom Thou wilt, and Thou abasest whom Thou wilt; in Thy Hand is the good; Thou art powerful over everything." – *Sadaga Allahu Al-Azim.*

This book is dedicated to my client and friend Dr. Haidar Abdul Shaffi, Head of the Palestinian Delegation to the Middle East peace negotiations in Madrid and Washington, D.C. from 1991 to 13 September 1993.

While serving as Legal Advisor to the Palestinian Delegation, I was informed that Dr. Abdul Shaffi wanted me to come to his private suite in order to discuss UN Security Council Resolution 242 (1967). So I grabbed a copy of its text, together with its negotiating history, and all of my private notes on Resolution 242, which I then put into logical order for briefing Dr. Abdul Shaffi on it. I went up to his room, knocked on the door, and sat down. There were just the two of us, alone: "Professor Boyle, I know that we are at these negotiations on the basis of Resolution 242 because that is a condition the Americans imposed upon us. But I want you to figure out a way for us to get back to the borders of Resolution 181." While UN General Assembly Resolution 181(II) of 1947 calls for the partition of the League of Nations Mandate for Palestine into an Arab State and a Jewish State with an International Trusteeship for the City of Jerusalem, Security Council Resolution 242 only calls for Israel to evacuate the West Bank, Gaza, and East Jerusalem (as well as the Golan Heights in Syria). The 1947 UN Partition Plan called for the Palestinian people to have 44% of historic Palestine for their state, a much larger share than the 20% contemplated by UN Security Council Resolutions 242 of 1967 and 338 of 1973. Nevertheless at the very outset of the Middle East peace negotiations in 1991, ignoring the pre-established terms of the negotiations, the Israeli government made it quite clear that it did not intend to obey Security Council Resolution 242 (1967).

Israel still does not.

May God always hold Dr. Haidar in the Palm of His Hand!

Table of Contents

Standing in Solidarity
with the Palestinian People

I am not Arab. I am not Jewish. I am not Palestinian. I am not Israeli. I am Irish American. Our people have no proverbial "horse in this race." The viewpoints expressed here are solely my own. What follows is to the best of my immediate recollection:

The Big Lie

Even though I grew up in the United States during the late 1950s and early 1960s in a family that strongly supported the just struggle of African Americans for civil rights, I was nonetheless brainwashed at school as well as by the mainstream news media and popular culture to be just as pro-Israel as everyone else in America. Then came the 1967 Middle East War. At that time, I recognized that Israel had attacked these Arab countries first, stolen their lands, and then driven out their respective peoples from their homes. I then realized that everything I had been told about Israel was "The Big Lie". Israel was Goliath, not David. I resolved to study the Middle East in more detail in order to figure out where the truth in the Middle East conflict really lay.

By then I had figured out that the pie-in-the-sky "Camelot" peddled by the Kennedy administration after the Bay of Pigs invasion/fiasco and its self-induced Cuban Missile Crisis that was a near-miss for nuclear Armageddon were also part of The Big Lie. The same soon became apparent in relation to U.S. foreign policy toward Latin America after the Johnson administration's gratuitous invasion of the Dominican Republic. Everything I was being told about the Vietnam War was clearly part of The Big Lie. So I just added the Middle East to the list of international subjects that I needed to pay more attention to in my life.

Chicago

I entered the University of Chicago as an undergraduate in September of 1968 after having just attended the tumultuous Chicago Democratic National Convention. Because of the heavy common-core requirements there, I could not take a course on the Middle East until the next academic year. Then I signed up for a course on "Middle East Politics" taught by Professor Leonard Binder.

To his great credit, Professor Binder was most fair and balanced in his presentation of the Palestinian and other Arab claims against Israel during the course of his classroom lectures. In addition, his massive reading list forced me to go through almost everything then written in English that was favorable to the Palestinian people, as well as reading the standard pro-Israel sources. By the end of Professor Binder's course in the Winter of 1970, I had become convinced of three basic propositions: (1) that the world had inflicted a terrible injustice upon

the Palestinian people in 1947-1948; (2) that there would be no peace in the Middle East until this injustice was somehow rectified; and (3) that the Palestinian people were certainly entitled to an independent nation state of their own. I have publicly maintained this position for the past three decades at great personal cost. I have been accused of being everything but a child molester because of my public support for the Palestinian people. I have witnessed the violation of every known principle of academic integrity and freedom that our nation ostensibly cherishes in order that basic fundamental truths in relation to this longstanding conflict in the Middle East might be suppressed. Through my personal experience, as will be evident below, these hallowed rights do not exist in the United States of America– ". . . the land of the free, and the home of the brave. . ." –where it concerns asserting the basic rights of the Palestinian people under international law.

Notwithstanding, the University of Chicago has always had a first-rate Center for Middle Eastern Studies that I have heartily recommended over the years to many prospective students all over the world seeking my advice on where to study that subject. By comparison, Harvard's Center for Middle Eastern Studies could be viewed as effectively operating as a front organization for the C.I.A. and probably the Mossad as well.

Harvard

Nevertheless, I entered Harvard in September of 1971 in order to pursue a J.D. at the Harvard Law School and a Ph.D. in Political Science at the Harvard Graduate School of Arts and Sciences (GSAS), Department of Government–not the Kennedy School of Government. I purposefully chose to enter the same doctoral program that had produced Henry Kissinger, Zbigniew Brzezinski, Samuel Huntington, and numerous other Machiavellian realpolitiquers trained by Harvard to "manage" the U.S. global empire. In other words, I have experienced the kind of training that America offers for its prospective Imperial Managers. "There but for the Grace of God go I!"

For the next seven years at Harvard I was quite vocal in my support for the Palestinian people, including and especially their basic human rights, their right to self-determination, and their right to an independent state of their own. Although I felt like a distinct "minority of one" among the Harvard student body at the time, I did receive the support and encouragement for my pro-Palestinian viewpoints from several of my teachers. At the Harvard Law School were Roger Fisher (The Williston Professor of Law), Louis Sohn (Bemis Professor), Richard Baxter (Hudson Professor), Clyde Ferguson (Stimson Professor), and Harold Berman (Ames Professor). In particular, Louis Sohn was most fair and reasonable in his systematic presentation and examination of the legal rights and claims of the Palestinian people during his course on "United Nations Law" during the 1974-75 academic year.[1]

At the Harvard GSAS Government Department, Stanley Hoffmann was my doctoral dissertation supervisor. For as long as I have known him (*i.e.*, over three decades), Stanley has always been most sympathetic to the tragic plight of the Palestinian people. He is now a University Professor—Harvard's highest accolade, and well deserved.[2] And in credit to Harvard, my frequently-expressed pro-Palestinian views as a student did not forestall my successful passage through its halls—J.D. magna cum laude (1976); A.M. (1978) and Ph.D. (1983) in Political Science; Associate, Harvard Center for International Affairs (1976-78; Executive Committee, 1977-78); Teaching Fellow in the Harvard College (1976-78).

Such tolerance was not in play for Walid Khalid, widely recognized as one of the world's foremost experts on the Middle East, whom I met while in

residence as a Graduate Student Associate at the Harvard Center for International Affairs (CFIA) from 1976 to1978. Shamefully, Harvard never granted a tenured full professorship to Walid Khalidi because he is a Palestinian. I was present for the dramatic off-the-record confrontation between him and Shimon Peres at the standing CFIA Seminar on "American Foreign Policy" then conducted by Stanley Hoffmann at their old headquarters on 6 Divinity Avenue. Peres refused to budge even one inch no matter how flexible Khalidi was. In retrospect, it proved a harbinger for the Middle East Peace Negotiations from 1991 to 1993, where the three of us would be involved.

Entebbe Lecture

Soon after my graduation from Harvard Law School in June of 1976, I gave my very first public lecture at the invitation of the Harvard International Law Society (HLS/ILS). I decided to speak on the subject of "The Israeli Raid at Entebbe," during which I analyzed many of the legal and political problems surrounding this "raid", which had just been so unanimously applauded by the U.S. news media. Roger Fisher was kind and gracious enough to show up at this, my first public lecture. He also offered some words of support when I was attacked by another professor for discussing the political motivations behind the Entebbe hijacking by the Popular Front for the Liberation of Palestine (PFLP).

I had expressed my opinion that the PFLP/PLO political claims can, should and must be negotiated. We even got into a little debate about who were the *real* "terrorists" here. Obviously, mine were not very popular points of view back in the fall of 1976 at Harvard. Clyde Ferguson would later inform me that my well-known pro-Palestinian viewpoints prevented him from reporting my dossier out of the Harvard Law School Appointments Committee (upon which he then sat) despite his best efforts to get me hired at Harvard.[3]

Naively, I decided to take my HLS/ILS "Entebbe Show" on the road and to use it as my standard job interview lecture in order to be hired elsewhere as an Assistant Professor of Law. Not surprisingly, I was rebuffed at the very top law schools. But in December of 1977, I received an offer to become an Assistant Professor of Law at the University of Illinois College of Law in Champaign, which had just been semi-officially ranked the Number Eleven law school in the country by an American Association of Law Schools Report. So I moved back to Illinois on July 14, 1978 (Bastille Day) hoping and expecting that someday I would be able to make a positive contribution to the plight of the Palestinian people, which was desperate even then.

The Middle East and the American Society of International Law

Upon arriving at Illinois, one of the first things I did was to rewrite my Entebbe Lecture as a scholarly article, which I submitted to the *American Journal of International Law*. It was promptly accepted—a real feather in my cap as a beginning Assistant Professor of Law on a three-year tenure track who needed to "publish-or-perish" posthaste. But the then Editor-in-Chief of the *Journal* informed me that I would have to eliminate any "favorable" references to the PLO/PFLP in the article, stating: "We cannot have the *American Journal of International Law* saying that you could negotiate with terrorists!" As a matter of principle and standing in solidarity with the Palestinian people, I could not accept such blatant anti-Palestinian censorship. So of course, they refused to publish my article. It was later published in the Netherlands exactly as it had been originally written.[4]

Around about the same time, Clyde Ferguson was to become the first African American President of the parent organization of the *American Journal of*

International Law—the American Society of International Law. In that capacity, Clyde was to preside over their 75th Anniversary Convocation in 1981, and decided to put me on their Concluding Plenary Panel that he would personally chair: "*I want you to get up there and send those people a message!*," Clyde enjoined me.

And so I did, as indicated by the text of my Speech.[5] In particular, I publicly supported the right of the Palestinian people to self-determination and the fact that the PLO was their sole and legitimate representative as was, after all, recognized by the United Nations Organization. I also severely criticized Israel's grievous mistreatment of the Palestinian people as a violation of international humanitarian law, and soundly condemned Israel's criminal practices in Lebanon. I also presented critical stances on nuclear arms control, the Iraq-Iran War, Cuba, Angola, Namibia, etc., that vigorously dissented from the campaign positions of the then incoming Reagan administration.

After this speech, I was thenceforth treated by the Members of the so-called Society as the proverbial skunk at their yearly garden party. But Clyde was pleased, which was all that really mattered at the time.

At American Society of International Law Conventions over the next decade, I would vigorously speak out in support of, and publicly debate against innumerable pro-Israel supporters, the rights of the Palestinian people under international law. But after ten years of banging my head against this wall, I concluded that I was wasting my time. I have not returned since to the American Society of International Law and Power, in view of its blatant bias towards Israel and flagrant failure to entertain, as it relates to this conflict, the principles of its own academic discipline. Ditto for the American Bar Association, of which I have been a member for over 25 years, and especially its Section on International Law and Power. Both organizations, in my view, are dominated and controlled by die-hard anti-Arab/Muslim bigots and racists.

Israel's 1982 Invasion of Lebanon

A year later, when Israel yet again invaded Lebanon in 1982, I immediately tried to organize what little academic opposition there was among professors of international law. I drafted a *Statement* condemning this invasion in no uncertain terms, and then proceeded to call up about 35 professors of international law here in the United States to see if they would sign it. Not unexpectedly, I could only "round-up the usual suspects": Roger Fisher, Clyde Ferguson, Stanley Hoffmann, Richard Falk, and Tom Mallison. The late George Ball personally contributed $1000 out of his own pocket to help publicize our stand. But after the most strenuous efforts, I could not even get this *Statement* published anywhere in the United States. Tom Mallison eventually got it published in Britain.[6]

It was a very sad and telling commentary that only a handful of American international law professors possessed the fortitude of soul required to soundly condemn Israel's egregious invasion of Lebanon, as well as to support the basic rights of the Palestinian people under international law. This, from a group of professors allegedly committed to promoting the rule of law in international relations, can only be termed intellectual, moral, and professional cowardice and hypocrisy of the worst type! Not much has changed during the past two decades— except that I no longer waste my time trying to line up professors of International Law willing to stand up for the basic rights of the Palestinian people.

Two Bogus Wars on Terrorism

Soon thereafter I found myself speaking, writing, and lecturing all over the country against the Israeli invasion of Lebanon and in support of the basic rights of the Palestinian people under international law. Such viewpoints were later summed up in an essay entitled "Dissensus Over Strategic Consensus", published in my *Future of International Law and American Foreign Policy* (1989), setting forth a comprehensive critique of the Reagan administration's foreign policy toward the Middle East from an international law perspective. In a similar vein and included here was my "Preserving the Rule of Law in the War Against International Terrorism", which provided a detailed critique of the Reagan administration's self-styled "war against international terrorism" from an international law perspective, with a special emphasis on the Middle East. Insofar as not much has changed two decades later under the Bush Jr. administration and its patently bogus "war against international terrorism"[7], the latter article has been substantially updated to respond to the events of September 11th, the Bush Administration war on terrorism, and its plans to imminently invade Iraq.

Yaron and Sharon Redux

Leading the legal charge against the Israeli invasion of Lebanon would ultimately result in my filing a lawsuit in a U.S. federal district court against Israeli General Amos Yaron, who bore personal criminal responsibility for the 1982 massacre of about 2000 completely innocent and unarmed Palestinian women, children and old men at the Sabra and Shatilla refugee camps in Lebanon. To the best of my knowledge, this was the first time ever that any lawyer had attempted to hold an Israeli government official accountable for perpetrating a massacre against the Palestinian people. I lost the lawsuit when the Reagan administration officially entered the case on the side of the war criminal, Yaron. No surprise there since the Reagan administration fully supported the Israeli effort to exterminate the PLO in Lebanon. But for historical purposes— should interested readers of this volume seek to refer to it — the Editors of the *Palestine Yearbook of International Law* published my key court papers.[8]

Not surprisingly, when General Ehud Barak became Israeli Prime Minister, he appointed General Yaron to serve as Director-General of the Israeli "Ministry of Defense." So a major war criminal and genocidaire was serving in this high-level capacity, where he continued to inflict heinous international crimes against the Palestinian people during Israel's repression of the Al Aqsa Intifada, instigated on 28 September 2000 by General Ariel Sharon—who had been the architect of the 1982 Israeli invasion of Lebanon while then serving as Israel's "Minister of Defense" and thus Yaron's Boss during the Sabra/Shatilla massacre.

From this demented perspective, it made perfect sense for the genocidaire Sharon to continue the appointment of the genocidaire Yaron when he became Prime Minister of Israel. Not surprisingly then, under the command of Sharon/Yaron the Israeli army inflicted war crimes, grave breaches of the Fourth Geneva Convention of 1949, and a crime against humanity upon the Palestinian inhabitants of Jenin in April of 2002.[9] The United States government under Reagan/Bush, Clinton, and Bush Jr. fully supported Begin/Sharon/Yaron, Barak/Yaron, and then Sharon/Yaron in perpetrating their serial massacres upon the Palestinian people.

Speaking for the Palestinians at the UN

Two decades after Israel launched the June 1967 Middle East War that first sparked my involvement in the tragic plight of the Palestinian people, the UN Committee on the Exercise of the Inalienable Rights of the Palestinian People

scheduled a 20th Anniversary Commemorative Session at UN Headquarters in New York for June of 1987. The PLO asked former U.S. Attorney General Ramsey Clark and me to speak on their behalf. Seated right next to us at the speaker's podium was Northwestern University Professor Ibrahim Abu-Lighoud, while behind us sat the entire Palestinian Delegation at that time: Ambassador Zuhdi Terzi; his Deputy, now Ambassador Nasser Al-Kidwe; and Counselor Riyad Mansour. The rest of the hall was occupied by Ambassadors from supposedly pro-Palestinian UN member states.

After Ramsey spoke most eloquently on the Palestinian right of self-determination, I proceeded to forthrightly state that pursuant thereto, the time had now come for the Palestinian people to unilaterally proclaim their own independent state under international law and practice. I then proceeded to sketch out precisely why and how this could be done—following the precedent set by the United Nations on Namibia. I argued that the Palestinians must not go to any International Peace Conference to ask the Israelis to give them their State. Rather, the Palestinians must unilaterally proclaim their own independent state now, and then attend an international peace conference where they would simply ask Israel to evacuate from Palestine, etc.

I spoke for about half an hour along these lines. Needless to say, Abu-Lighoud stared at me throughout this period as if I had just descended on a spaceship from Mars. At that point in time, the most the PLO had contemplated was to declare themselves a "government-in-exile."

By contrast, I was explaining to the PLO and to the United Nations Organization both why and how the Palestinians must unilaterally create their own independent state, and then have Palestine become internationally recognized, including and especially by the United Nations itself. There must be a Palestinian State first before there could be a Palestinian government—something I had learned and remembered from Louis Sohn's Final Examination in his "United Nations Law" course at Harvard Law School. Less than eighteen months after my UN Speech, the Palestine National Council would determine that the Executive Committee of the PLO constitutes the Provisional Government of the State of Palestine—not a so-called "government-in-exile". But that is jumping ahead of the story.

Sparring with Jordan

After I had concluded my UN Speech, the Jordanian Deputy Ambassador immediately demanded from the President of the Conference the so-called "right-of-reply". He reprimanded me that as a professor of International Law, I should know better than to publicly propose the dismemberment of a UN member state—Jordan—at UN Headquarters in New York. Of course he was referring to the West Bank and East Jerusalem, which had been illegally occupied and annexed by Jordan after the termination of Britain's Palestine Mandate up until the 1967 war, when the West Bank and East Jerusalem were then illegally occupied and the latter illegally annexed by Israel.

Since I was speaking at the United Nations Headquarters as a guest of the PLO, I had to be most diplomatic in my response to the Jordanian Deputy Ambassador. So I chose my words quite carefully: "Jordan has been as helpful as it can to the Palestinian people—under the circumstances. But the entire world knows these lands are Palestinian." Abu-Lighoud chuckled at my diplomatic circumlocution since he knew full well that I was never one to mince words. There was some more diplomatic sparring back and forth between the Jordanian Deputy

Ambassador and me about the right of the Palestinian people to unilaterally establish their own independent state on the West Bank and Gaza Strip with East Jerusalem as their capital. But eventually he gave up arguing with me—just as King Hussein later would in July of 1988.

The First Intifada

Immediately after my UN Speech, the members of the Palestinian Delegation asked me numerous questions about why and how they could go forward and unilaterally proclaim their own independent state under international law and practice. Zuhdi Terzi then asked me to prepare a *Memorandum of Law* on this entire matter for formal consideration by the Palestine Liberation Organization. Standing in solidarity with the Palestinian people, I readily agreed to do so free of charge.

I spent the entire summer researching and drafting this *Memorandum of Law*, then gave it to my research assistant to research, document, and add the footnotes for the *Memorandum*. He returned the footnoted draft *Memorandum* to me in December of 1987—just in time for the outbreak of the first Palestinian Intifada in Gaza.

This original Intifada was a spontaneous uprising by the Palestinian people who had been living under the boot of Israel's racist, colonial, and genocidal occupation for twenty years. The PLO leadership then headquartered in Tunis were taken completely unaware by the outbreak of the Intifada in occupied Palestine. The PLO did not order the Inifada, the PLO did not direct the Inifada, and the PLO had to constantly scramble in order to try to keep up with it.

Quickly the leaders of the Intifada living in occupied Palestine established their own Unified Leadership of the Intifada. In the Winter of 1988, the Unified Leadership issued a Communiqué in which they demanded that, in recognition of the courage, bravery, and suffering of the Palestinian people living in occupied Palestine during the Intifada, the PLO must create an independent state for all Palestinians living all over the world. It was just about at that time that I transmitted my revised *Memorandum of Law* to the PLO on this precise subject, which I entitled imperatively: *"CREATE THE STATE OF PALESTINE!"*

Then nothing happened in this regard for several months. There was a deafening silence from the PLO. It became clear to me that the creation of a Palestinian State would generate too many internal political problems for the PLO, which at that time operated upon the principle of consensus. Back in those days, the Palestinian independence movement was a genuine democracy. The creation of a Palestinian State would have forced the PLO to make some very difficult political decisions that could have produced a terrible division among the different groups comprising the Palestinian independence movement at the very time when the Palestinian people were being massacred by the Israeli army repressing their Intifada. So I waited in silence.

Creating the Palestinian State

On 31 July 1988, I was teaching Summer School when King Hussein of Jordan announced that he was severing all forms of legal and administrative ties between Jordan and the West Bank. Later that afternoon in class, my students asked me what I thought would happen as a result of this decision: "Honestly speaking, I really do not know." When I returned to my office at the end of teaching that very class, there was a message sitting on my desk from Zuhdi Terzi. He asked me to come to New York immediately in order to discuss my *Memorandum of Law*.

In attendance as this meeting convened at the PLO Mission to the United Nations in New York were Zuhdi Terzi, Nasser Al-Kidwe, and Ramsey Clark, as well as Tom and Sally Mallison. Since I had already drafted a comprehensive *Memorandum of Law* on how to create a Palestinian State, I had to do a good deal of the talking. The Palestinians had a list of questions from PLO Headquarters in Tunis that they wanted us to answer for transmission back to the PLO Leadership. The first question was: "Why should the PLO create an independent Palestinian state?" My answer was succinct: "If you do not create this State, you will forfeit the moral right to lead your People!" So that there was no misunderstanding during the process of transmission, I personally faxed that message over to the highest levels of the PLO in Tunis.

After this meeting, I continued to serve as Legal Advisor to the Palestine Liberation Organization on the creation of the State of Palestine—again free of change, again standing in solidarity with the Palestinian people. *Pro bono publico* in the true sense of that hallowed legal tradition.

My *Memorandum of Law* would serve as the PLO's position paper for their right to create the Palestinian State. Although originally provided to the PLO under attorney-client confidence, Ibrahim Abu-Lighoud arranged to have my *Memorandum* published in *American-Arab Affairs*. [10] It was later included in my book, *The Future of International Law and American Foreign Policy* (1989), together with the Palestinian Declaration of Independence and some additional explanatory background materials, which are now included here in the chapter below entitled "Creating the State of Palestine."

The Palestinian Declaration of Independence

On 15 November 1988, the Palestine National Council meeting in Algiers proclaimed the existence of the new independent state of Palestine. Later that evening, after the close of prayers at Al-Aqsa Mosque in Jerusalem, the worshippers came out of the Mosque into the Great Courtyard in front of the Dome of the Rock, where the Prophet Muhammad (May Peace Be Upon Him!) had made a spiritual ascent into heaven. Then one man got up and read the Palestinian Declaration of Independence right there in front of the assembled multitude.

It had been my advice to the PLO that the Palestinian State must also be proclaimed from the capital of their new State in Jerusalem; that since this State would be declared "In the Name of God..." (which it was), the State must be proclaimed in the Grand Courtyard in front of the Al-Aqsa Mosque—the third holiest site in Islam—at the close of prayers on Independence Day. I told the PLO that although I would very much like to be the person to do this job, it would be inappropriate for me because I was not a Palestinian. I likewise declined their request to write a first draft of the Palestinian Declaration of Independence for similar reasons. But some of my suggestions can be found there and in its attached Political Communiqué. So much for a "government-in-exile." We already had Political Leadership on the ground in Palestine!

Immediately after 15 November 1988, Palestinian President Yasser Arafat sought to travel to the United Nations General Assembly in New York in order to explain these momentous developments to the entire world at its Official Headquarters. But the Reagan administration illegally deprived President Arafat of the requisite visa. Abu-Lighoud called to ask my advice: "If Muhammad can not come to the mountain, then bring the mountain to Muhammad. Have the General Assembly adjourn, and then reconvene at UN Headquarters in Geneva." So it was done!

President Arafat then addressed the UN General Assembly meeting in a Special Session at Geneva. That was the *real* start of the Middle East Peace Process—by the Palestinian people themselves, not by the United States government, and certainly not by Israel. As a direct result thereof, President Ronald Reagan then commenced an official "diplomatic dialogue" between the United States government and the PLO, whose Executive Committee serves as the Provisional Government for the State of Palestine. It amounted to nothing less than de facto diplomatic recognition. This U.S./PLO "diplomatic dialogue" continues until today.

Diplomatic Recognition

As I had predicted to the PLO, the creation of Palestinian State was an instantaneous success. Palestine would eventually achieve de jure diplomatic recognition from about 130 states. The only regional hold-out was Europe and this was because of massive political pressure applied by the United States government. Nevertheless, even the European States would accord the Palestinian State de facto diplomatic recognition. Eventually, the European Union promised to give Palestine de jure diplomatic recognition.

Furthermore, following the strategy I had worked out for the PLO, the Provisional Government of the State of Palestine would repeatedly invoke the UN General Assembly's Uniting for Peace Resolution (1950) in order to overcome U.S. vetoes at the Security Council for the purpose of obtaining for Palestine all the rights of a UN member state except the right to vote.[11] In other words, Palestine eventually became a de facto—though not yet a de jure—UN member state. The votes were and still are there for Palestine's formal admission to UN membership. Only the threat of a veto by the United State government at the Security Council has kept the State of Palestine out of formal de jure UN membership.

Palestine's de jure UN membership is only a matter of time—and unfortunately more bloodshed by the Palestinian people. Witness, for example, Security Council Resolution 1397 of 12 March 2002: "Affirming a vision of a region where two States, Israel and Palestine, live side by side within secure and recognized borders." If the U.S. government were really serious about the Palestinian State and achieving Middle East Peace on the basis of a two-state solution, all it has to do is stand aside in order to permit the other UN member States to formally admit Palestine to UN membership.

The Effort to Accede to the Geneva Conventions and Protocols

After all of these dramatic and extraordinary events had settled down somewhat, Ibrahim Abu-Lighoud called to ask me what our next step should be: "The State of Palestine should become a Party to the Four Geneva Conventions of 1949 and their Two Additional Protocols of 1977." I adduced several reasons for this recommendation: First, it would indicate that the State of Palestine will exercise its international legal right of self-defense in accordance with the laws and customs of warfare as well as international humanitarian law. Second, it would protect innocent civilians on both sides of the conflict—Palestinian and Israeli. Third, it would establish the case for Palestinian soldiers around the world to be treated, not as "terrorists," but as prisoners of war, at all times subject to the laws and customs of warfare.

Abu-Lighoud agreed with my logic and recommendation. So pursuant to his request, I prepared a *Memorandum of Law* for consideration by the Provisional Government of the State of Palestine on why Palestine should become a Party to the Four Geneva Conventions of 1949 and their Two Additional Protocols of 1977.

For good measure, I later faxed a copy of this 22 March 1989 *Memorandum* directly to President Arafat himself.

On 14 June 1989, the Palestinian Ambassador to the United Nations in Geneva deposited the Instrument of Accession to the Four Geneva Conventions of 1949 and their two Additional Protocols of 1977 on behalf of the State of Palestine with the Swiss Federal Council—the Swiss government being the depositary for the Geneva Conventions and Protocols. Nevertheless, the United States government immediately applied enormous diplomatic and political pressure upon the Swiss government to reject Palestine's Instrument of Accession. Speaking only for myself, I could not think of anything more sick and demented. Here was a major diplomatic initiative that I had originally intended to be purely humanitarian by nature—to protect innocent human lives on both sides of this conflict. Yet the United States government went all out to successfully sabotage it.[12]

The Isolation of the Palestinians

These extraordinary, dramatic, and momentous legal, political, and diplomatic developments are summarized in my essay "The International Legal Right of the Palestinian People to Self-Determination and an Independent State of Their Own", which was accepted for publication by the exact same *American-Arab Affairs* during the Summer of 1990—when Iraq invaded Kuwait. The Provisional Government of the State of Palestine refused to join the so-called Coalition put together by President Bush Sr. to attack Iraq, but instead did its level-headed best, working in conjunction with Libya and Jordan, to produce a peaceful resolution of this inter-Arab dispute. For their policy of principle and peace, the Palestinian leadership and people were and still are unjustly but predictably vilified by the United States government and Western news media sources.

While the crisis over Iraq was unfolding in the fall of 1990, I corrected the page-proofs for my essay that was then scheduled to be the lead article in the next issue of *American-Arab Affairs* coming out around the turn of the new year. Then I received a notification from the *American-Arab Affairs* editorial office that the issue was at the printer and would soon be distributed. The next thing I heard was that the executive director of their parent organization had resigned. It was well known that *American-Arab Affairs* and its parent organization were heavily subsidized by Gulf Arab funds. I was subsequently informed that this entire issue of *American-Arab Affairs* with my essay as the lead article had been suppressed, withdrawn, and would never see the light of day. Apparently the Gulf Arab funders of *American-Arab Affairs* and its parent organization did not want to see a lead article arguing that the Palestinian people had a right to self-determination and an independent nation state on the verge of their U.S.-sponsored war against Iraq without the support of the Palestinians. The essay would later be published in Stockholm, Sweden,[13] and is included here.

Over the past 25 years of my public advocacy of the rights of the Palestinian people under international law, I have lost track of the number of times when my lectures, panels, publications, and appearances have been disrupted, interfered with, or killed outright. But this was the first time that my pro-Palestinian viewpoints had been suppressed by an Arab source. It would not be the last such incident. This inexcusable instance of anti-Palestinian censorship by a leading Arab-American organization at the apparent behest of its Gulf Arab funders should make it crystal clear how truly desperate the plight of the Palestinian people really is. They have been repeatedly abandoned and betrayed by most Arab Leaders. The Palestinians are on their own, and they know it full well.

So the reader must interpret all of the current hypocritical statements and diplomatic maneuvering by the "leaders" of Arab governments in light of this undeniable fact. They would be more than happy to sell out the basic rights of Palestine and the Palestinian people in return for more money and weapons provided by the United States. For most of these Arab leaders, Palestine and the Palestinians are nothing more than a domestic public relations problem. But not so for the Arab people, and indeed, Muslim peoples everywhere!

Middle East Peace Negotiations?

In any event, my suppressed essay provided an excellent snapshot of the legal, political, and diplomatic situation that confronted the Palestinian people just before the United States and its so-called Coalition launched their genocidal war against Iraq.[14] In order to get the support of the Arab "leaders" for that slaughter, U.S. Secretary of State James Baker promised them that when the "war" was over the United States government would do something for the Palestinians. Eventually the Middle East Peace Negotiations would open in Madrid in the fall of 1991. At that time I was invited by the PLO to travel to Tunis in order to speak at a Conference being held there in support of and in solidarity with the Palestinian Delegation then going to Madrid. I also conducted consultations with PLO leaders in Tunis who had been illegally barred from the Middle East peace negotiations by the United States acting in conjunction with Israel despite the fact that the United Nations had long before recognized the PLO as the sole and legitimate representative of the Palestinian people.

Upon my return home, I was asked to serve as Legal Advisor to the Palestinian Delegation to the Middle East peace negotiations headed by Dr. Haidar Abdul-Shaffi. Some of the most important work that I did as the lawyer for Dr. Abdul-Shaffi and the Palestinian Delegation can be found in my essay "The Al Aqsa Intifada and International Law", which was based upon a public lecture I gave at Illinois State University (ISU) in Bloomington-Normal on 30 November 2000. A substantially revised and edited version of this essay was later published by the Americans for Middle East Understanding (AMEU).[15] A further revised updated version of this article appears here, now titled "From the Oslo Accords to the Al Aqsa Intifada". Dr. Abdul-Shaffi expressly waived all attorney-client confidences with respect to my work as Legal Advisor to the Palestinian Delegation to the Middle East peace negotiations in the hope and expectation that it might do some good to substantiate the fact that the so-called Oslo Agreement of 13 September 1993 called for the imposition of an apartheid-like bantustan upon the Palestinian people.

The Palestinian Alternative to Oslo

It is a matter of public record that the Oslo Agreement was signed at the White House against the most vigorous objections by Dr. Abdul-Shaffi acting in reliance upon my advice and counsel. Indeed, about a year prior thereto, Dr. Abdul-Shaffi had instructed me to draw up the Palestinian counteroffer to Israel's apartheid Bantustan in order to negotiate a genuine Interim Peace Agreement with Israel. This I did by means of a Memorandum of Law entitled "The Interim Agreement and International Law", which was later published in *Arab Studies Quarterly*.[16] My Memorandum of Law was approved by the Palestinian Delegation to the Middle East Peace Negotiations as well as by the PLO Executive Committee (which constitutes the Provisional Government for the State of Palestine), and served, in effect, as the Palestinian alternative to Oslo.[17] It is included herein.

Nevertheless, as a result of the process described in Chapter One of this book, the Oslo Bantustan was signed on the White House Lawn on 13 September 1993. Again, I bided my time in silence for the next four years.

Suing Israel?

It was only fitting and appropriate that I had the opportunity to return to Palestine in December of 1997 in order to commemorate the 10th Anniversary of the original Intifada. I visited the very street in Gaza where the Intifada had commenced. I then gave a public lecture before a human rights conference convened by the Palestinian Center for Human Rights headquartered in Gaza. The title of my lecture was "Palestine Must Sue Israel for Genocide Before the International Court of Justice!", which was later published in the *Journal of Muslim Minority Affairs*.[18]

I then personally met with President Arafat in his subsequently bombed-out headquarters in Gaza and discussed this proposed World Court lawsuit against Israel for genocide with him, personally placing my written proposal into President Arafat's hands. Since our last meeting in December of 1997, I have repeatedly asked for his authority to file this lawsuit for genocide against Israel on behalf of Palestine and the Palestinian people before the International Court of Justice in The Hague, to no avail.

The Status of Jerusalem

Over the years, one of the most important issues I have dealt with repeatedly for the Palestinian people is Jerusalem. For example, my friend Michael Saba and I launched an initiative to prevent the United States Government from illegally moving the United States Embassy from Tel Aviv to Jerusalem. In order to forestall this abomination, I prepared *Memoranda of Law* on the U.S.-Israel Land-Lease and Purchase Agreement of 1989 that would enable the construction of this U.S. Jerusalem "Embassy," which I sent to Congressman Lee Hamilton, who was then Chairman of the Subcommittee on Europe and the Middle East of the Committee on Foreign Affairs of the U.S. House of Representatives. These *Memoranda* were published in *American-Arab Affairs*.[19] The Israel Lobby and its supporters in Congress are still attempting to pressure the United States government to move the U.S. Embassy from Tel Aviv to Jerusalem.[20] Of course this would be a political, legal, and diplomatic disaster.

To be sure, there would certainly be no problem under international law and practice for the United States government to move its Embassy from Tel Aviv to Jerusalem as part of a comprehensive Middle East peace settlement whereby this Embassy would be simultaneously accredited to Israel and Palestine, with Jerusalem being recognized as the shared Capital of both States. Why and how this can be done is fully explained elsewhere in this book. Years ago the PLO had already approved my proposal set forth herein for this "Final Status of Jerusalem." But Israel wants Jerusalem for itself. And the United States has never been solomonic when it comes to Palestine and the Palestinian people.

Divestment/Disinvestment

During the drafting of the Palestinian Declaration of Independence, the Palestinians carefully studied the American Declaration of Independence as well as the 1916 Proclamation of the Irish Republic. As can be seen from the text of their Declaration set forth below, the Palestinians deliberately patterned their Declaration upon America's Declaration. In other words, the Palestinians purposefully sought to communicate with Americans in terms the Palestinians

thought the Americans could readily comprehend and sympathize with. There are good grounds to believe that their message has finally gotten through and been well received by the American People.

Toward the end of the aforementioned public lecture I gave at Illinois State University in Bloomington-Normal on 30 November 2000, I issued a call for the establishment of a nationwide campaign of divestment/disinvestment against Israel, which I later put on the internet. In response thereto, the Students for Justice in Palestine of the University of California at Berkeley launched a divestment campaign against Israel there. Then the City of Ann Arbor Michigan considered divesting from Israel. Next, the Palestinian Students at the University of Illinois at Urbana-Champaign (whom I am privileged to advise) launched an Israeli divestment campaign here. As of last count, around 50 campuses in the United States have organized divestment/disinvestment campaigns against Israel. This grassroots movement is taking off!.

Concerned citizens and governments all over the world must organize a comprehensive campaign of economic divestment and disinvestment from Israel along the same lines of what they did to the former criminal apartheid regime in South Africa. This original worldwide divestment/disinvestment campaign played a critical role in dismantling the criminal apartheid regime in South Africa.[21] A worldwide divestment/disinvestment campaign against Israel will play a critical role in dismantling its criminal apartheid regime against the Palestinian people living in occupied Palestine as well as in Israel itself.

For much the same reasons, a worldwide divestment/disinvestment campaign against Israel can produce an historic reconciliation between Israelis and Palestinians—just as it successfully did between Whites and Blacks in South Africa. This new worldwide divestment/disinvestment campaign could provide the Palestinians with enough economic and political leverage required to negotiate a just and comprehensive peace settlement with the Israelis— just as it did for the Blacks in South Africa. Today the Republic of South Africa stands as a beacon of hope for peoples and states all over the world. The same could be true for Palestine and Israel.

Prologue

This book has been published at a most critical time in the history of the Israeli-Palestinian conflict and of American foreign policy towards the Middle East. It sets forth essential information on the international legal and human rights principles applicable to the Israeli-Palestinian conflict and their relevance to the production of a comprehensive Middle East peace settlement between Israel and Palestine as well as between Israel and the surrounding Arab States. Indeed, there is no way anyone can even begin to comprehend the Israeli-Palestinian conflict and how to resolve it without developing a basic working knowledge of the principles of international law and human rights related thereto. By the end of this book, the reader should be in an excellent position to go out and work for peace with justice for all peoples and states in the Middle East. I doubt very seriously that history will give any of us a second chance to do so.

ENDNOTES

1. *See Remarks in Honor of Louis Sohn*, in my The Future of International Law and American Foreign Policy xvii-xx (1989).

2. *See Hans Morgenthau on Stanley Hoffmann*, in my Foundations of World Order viii-ix (1999).

3. *See* my *In Memoriam: C. Clyde Ferguson, Jr. — "With Compassion,"* 97 Harv. L. Rev. 1259-

62 (1984).

4. *The Entebbe Hostages Crisis*, 29 Nether. Int'l L. Rev. 32 (1982).

5. *The American Society of International Law: 75 Years and Beyond*, 75 Am. Soc'y Int'l L. Proc. 270 (1981), *reprinted in* my Defending Civil Resistance Under International Law 320-27 (1987).

6. *Violations of International Law*, Middle East International, September 3, 1982, *reprinted in* my *Defending Civil Resistance Under International Law* 335-38 (1989).

7. *See George Bush, Jr., September 11th and the Rule of Law*, in my The Criminality of Nuclear Deterrence 16-39 (2002).

8. *Memorandum on the Yaron Case*, 5 Palestine Y.B. Int'l L. 254, 257 (1989).

9. *See* Human Rights Watch, Jenin: IDF Military Operations, Vol. 14, No. 3(E) (May 2002).

10. *Create the State of Palestine!*, American-Arab Affairs, No. 25, at 86 (Summer 1988).

11. *See* Mary Barrett, *PLO Looks at the Uniting for Peace Plan in UN*, Arab American News, Vol. VI, No. 269, June 30-July 6, 1990.

12. *See Application to Accede to the Geneva Conventions*, 5 Palestine Y.B. Int'l L. 318-24 (1989).

13. *The International Legal Right of the Palestinian People to Self-Determination and an Independent State of Their Own*, 12 Scandinavian J. Development Alternatives, No. 2 & 3, at 29 (June-Sept. 1993).

14. *See* Ramsey Clark, The Fire This Time (1992); *Francis A. Boyle, U.S. War Crimes During the Gulf War*, New Dawn Magazine, No. 15 (Sept.-Oct. 1992) *and on* Counterpunch.org, Sept. 2, 2002; Boyle, *Petition on Behalf of the Children of Iraq Submitted to the United Nations*, 23 Arab Studies Quarterly, No. 4, at 137 (Fall 2001).

15. *Law & Disorder in the Middle East*, The Link, Vol. 35, No. 1 (Jan.-Mar. 2002).

16. *The Interim Agreement and International Law*, 22 Arab Studies Quarterly, No. 3, at 1-44 (Summer 2000).

17. *See* Bilal Al-Hassan, *PLO Annuls All Legal Advice*, Inquiry, Spring 1994, *and in* Arab American News, Vol. X, No. 475, Oct 1-7, 1994, at 4.

18. *Palestine:; Sue Israel for Genocide before the International Court of Justice!*, 20 J. Muslim Min. Aff., No. 1, at 161-66 (2000).

19. *Memoranda of Law on the U.S.-Israel Land-Lease and Purchase Agreement of 1989 (Ex. Comm. 89-57)*, American-Arab Affairs, No. 30, at 125 (Fall 1989).

20. *See* Walid Khalidi, The Ownership of the U.S. Embassy Site in Jerusalem (2000).

21. *See* my Defending Civil Resistance Under International Law 211-81 (1987); John Quigley, Palestine and Israel (1990).

Chapter One

Creating the State of Palestine

On June 22, 1987, I delivered a speech before the United Nations Committee on the Exercise of the Inalienable Rights of the Palestinian People at UN Headquarters in New York City. . . . At the end of that speech, I concluded that under the current political conditions in both Israel and the United States, there was no realistic prospect for the convocation of an international peace conference on the Middle East for the immediate future. Therefore, I suggested that the Palestinian people unilaterally proclaim their own independent state; that the United Nations Organization immediately recognize the independent state of Palestine; and that the United Nations then proceed to apply the same approach to obtaining Israeli withdrawal from the occupied state of Palestine as it has applied to obtaining South African withdrawal from the occupied state of Namibia. In my opinion at the time, the creation of the independent state of Palestine would fulfill the historic right of the Palestinian people to self-determination while also creating a dramatic breakthrough in the prospects for obtaining peace with justice in the Middle East.

Several members of the Palestine Liberation Organization were present at this UN Conference to hear my speech, and were seriously interested in my proposal that the Palestinian people unilaterally create the independent state of Palestine. They requested that I prepare a research paper for them on this subject that would discuss at greater length their legal authority for the unilateral creation of the independent state of Palestine; how this could be done; how the United Nations should recognize the independent state of Palestine; and how the UN could then act to obtain the withdrawal of Israeli occupation troops from Palestine, etc. I agreed to undertake this research project for them on a pro bono basis.

On March 11, 1988, I submitted my research paper to the PLO and to several prominent Palestinian Americans, some of whom are members of the Palestine National Council (PNC). This paper was entitled CREATE THE STATE OF PALESTINE!. There matters stood until July 31, 1988, when King Hussein of Jordan gave his now-famous speech in which he severed all forms of legal and administrative ties between Jordan and what he called the West Bank. Immediately thereafter, I was asked to serve as a consultant to the Legal Committee of the Palestine National Council that was placed in charge of the project to create the independent state of Palestine. On November 15, 1988, the Palestine National Council meeting in Algiers proclaimed the existence of the new independent state of Palestine.

The rest of this chapter contains the actual text of the research paper that I submitted to the Palestine Liberation Organization in March of 1988, which has since become a public document. It is presented here in the hope and expectation that the reader will obtain a better comprehension of the true meaning and precise significance of the monumental events that occurred at the PNC meeting in Algiers. The creation of the state of Palestine has produced a spectacular opportunity for progress by all those who wish to achieve peace with justice in the Middle East.

CREATE THE STATE OF PALESTINE!

The volatile deadlock over prospects for peace in the Middle East and the unwillingness of the United States government to do anything about it raise the general question of whether or not there is anything the rest of the international community can do to create and preserve a legal and political status quo that would be conducive to the conclusion of a final peace settlement between Israel and the Palestinian people on the basis of a two-state solution. This author submits that the answer to this question is in the affirmative. It lies in an examination of the precedent set by the international community in 1946 when a white minority racist regime in South Africa illegally and unsuccessfully attempted to annex and then to continue to maladminister the territory comprising the Mandate for South West Africa (SWA), which is today known as Namibia. The subsequent treatment of the Namibian issue by the United Nations General Assembly, the Security Council and the International Court of Justice provides a useful example of how the entire international community can make it emphatically clear to both Israel and the United States that someday soon Israel must withdraw from these occupied territories so that the Palestinian people are able to exercise their international legal right to self-determination specifically therein.

The League of Nations Mandates for Palestine and South West Africa

No point would be served here by attempting to elaborate a detailed and comprehensive analysis of the respective histories of the Mandate for South West Africa (SWA)[1] that was awarded by the League of Nations in 1920 to Great Britain to be exercised on its behalf by South Africa, or of the Mandate for Palestine[2] that was awarded by the League to Great Britain in 1922. But at this preliminary stage in the analysis it would be useful to say a few words about the origin and purpose of the League Mandate system. With the defeat of the Central Powers in 1918 by means of U.S. military intervention into the war, the question arose as to what to do with their colonial possessions around the world. The traditional practice in international relations had always been for the conquerors to divide up and redistribute among themselves the colonial possessions of the conquered powers. But in the Fourteen Points Address, President Woodrow Wilson made it quite clear that at the end of the Great War, this phenomenon was not to repeat itself. In Wilson's opinion, the denial of the right of national self-determination had been responsible for the eruption of the war in the first place. Hence to preserve the future peace of the world it would be necessary to grant the right of national self-determination to the various peoples living in these newly liberated territories.

The Fourteen Points Address,[3] the Paris Peace Conference,[4] the Treaty of Versailles[5] and the League of Nations Covenant[6] guaranteed that various different ethnic groups in Central and Eastern Europe would quickly attain an independent national state of their own; in contrast, the peoples of Africa, the Middle East, and the Far East would have to wait. Thus, article 22 of the Covenant of the League of Nations established a mandate system to be applied to those former colonial possessions that had been stripped away from Germany and Turkey in the aftermath of the First World War.[7]

Covenant article 22(1) provided that all mandates would be governed by the principle "that the well-being and development of such peoples form a *sacred trust of civilization*.[8] According to Covenant article 22(2) "the tutelage of such peoples should be entrusted to advanced nations who by reason of their resources, their experience or their geographical position can best undertake this

responsibility, and who are willing to accept it, and that this tutelage should be exercised by them as Mandatories on behalf of the League."[9] To be sure, this arrangement was only one step removed from outright colonial annexation of the mandated territories, but it was nevertheless one step removed. Under the League Mandate system, the terms of these mandates did not involve any cession of territory or transfer of sovereignty to the mandatories.[10]

The League Mandates were divided into three categories in accordance with the League's determination of the respective peoples' stages of development concerning their preparations for national independence.[11] Article 22(4) of the League Covenant provided that certain communities formerly belonging to the Turkish Empire "have reached a state of development where their existence as independent nations can be provisionally recognized."[12] These became known as Class A Mandates and were later to include among their number the Mandate for Palestine that was awarded to Great Britain in 1922.[13] By contrast, according to League Covenant article 22(6), South West Africa became a Class C Mandate, which "can be best administered under the laws of the Mandatory as integral portions of its territory."[14] In 1920 the League of Nations had conferred the mandate over South West Africa on Great Britain, to be exercised on its behalf by the Union of South Africa.

Mandatories were subject to the overall jurisdiction of the League of Nations Council, which in turn delegated supervision of the mandatory administration to a Permanent Mandates Commission consisting of ten members of whom the majority were nationals of non-mandatory states.[15] The actual Mandates themselves consisted of international treaties that were concluded between the Council of the League of Nations, on the one hand, and the mandatory power on the other.[16] These Mandates typically included extensive protections for the indigenous peoples of the mandated territory.[17] They also required an annual report to be submitted to the Council of the League that would be satisfactory to the latter.[18] The mandatory also agreed that in the event any dispute arose concerning the interpretation of the Mandate, such disputes shall be submitted to the Permanent Court of International Justice, which was the predecessor to the current International Court of Justice.[19]

There matters stood until the end of the Second World War and the creation of the United Nations Organization with its international trusteeship system that was established by Chapter XII of the UN Charter.[20] Article 77(1)(a) thereof provided that League mandated territories could be placed under the UN trusteeship system by means of a trusteeship agreement that would be concluded between the mandatory power and the UN General Assembly operating with the assistance of the UN Trusteeship Council, except in the case of "strategic areas", which is not relevant here.[21] With respect to the Mandates for South West Africa and for Palestine, these trusteeship agreements were never concluded between the respective mandatory powers and the UN General Assembly. In the case of South West Africa, the South African government refused to do so whereas in the case of Palestine the British government simply decided to turn the entire problem over to the UN General Assembly, which resulted in its adoption of the Partition Resolution in 1947,[22] that was never implemented. It is important to note, however, that all other mandatory powers consented to the conversion of League mandates into the UN trusteeship system.

Nevertheless, in the cases of the Mandates for South West Africa and for Palestine, UN Charter article 80(1) made it clear that the terms of these Mandates remained in effect pending their placement under the UN trusteeship system:

Article 80
1. Except as may be agreed upon in individual trusteeship agreements, made under Articles 77, 79, and 81, placing each territory under the trusteeship system, and until such agreements have been concluded, nothing in this Chapter shall be construed in or of itself to alter in any manner the rights whatsoever of any states or any peoples or the terms of existing international instruments to which Members of the United Nations may respectively be parties.[23]

This "conservatory clause" clearly applied to the League of Nations Mandates for Palestine and for South West Africa because neither one was ever converted into a UN trusteeship.[24] Hence, the terms of the Mandates for Palestine and South West Africa still survived as matters of positive international law and applied to these mandated territories despite the dissolution of the League of Nations and its replacement by the United Nations. Indeed, by virtue of UN Charter article 80(1), League Covenant article 22 likewise still survived as a matter of positive international law.

The History of Namibia at the United Nations
 By means of Resolution 9(I) of 1946, the UN General Assembly invited those states administering territory held under a League Mandate to conclude trusteeship agreements for them with the United Nations.[25] Instead, the government of South Africa informed the UN General Assembly that it wanted to annex the mandated territory of South West Africa into its sovereign domain. The General Assembly rejected this proposal in Resolution 65(I) of 1946, and reiterated its request that South West Africa be placed under a UN trusteeship.[26] Following the adoption of this resolution, South Africa decided not to proceed with the incorporation of the mandated territory but to maintain the status quo. Nevertheless, by 1949 South Africa had informed the United Nations that it would no longer transmit the required information on South West Africa to the General Assembly.[27]
 The General Assembly responded to this defiance by requesting an advisory opinion from the International Court of Justice on the international status of South West Africa, which was rendered on July 11, 1950.[28] The World Court held that the United Nations General Assembly was legally qualified to exercise the supervisory functions previously exercised by the League of Nations with regard to the administration of the SWA mandated territory[29] and that the government of South Africa was under an obligation to submit to the supervision and control of the General Assembly and to render annual reports to it.[30] Hence, South West Africa was held to be a territory still under the Mandate of December 17, 1920.[31]
 According to the World Court, territories held under a Mandate were not automatically placed under the UN trusteeship system by the Charter—the Charter did not impose on South Africa an obligation to place South West Africa under the trusteeship system.[32] Nevertheless, in the absence of the conclusion of such a trusteeship agreement, the SWA Mandate still remained in effect and the Council of the League of Nations' powers of supervision over the Mandate now belonged to the United Nations General Assembly.[33]
 Subsequently, in a related advisory opinion of June 7, 1955, the World Court held unanimously that the General Assembly's adoption of a set of special rules applying as far as possible the procedure followed by the Council of the

League of Nations—including a rule which prescribed a two-thirds vote of the General Assembly on questions relating to reports and petitions concerning the territory of South West Africa—was a correct interpretation of its 1950 advisory opinion.[34] Hence, according to the World Court, the voting system requiring unanimity under the League of Nations Covenant was no longer in effect. A two-thirds vote of the General Assembly was legally sufficient for it to exercise its supervisory powers over League-mandated territories.[35]

After twenty years of obstinate South African refusal to grant independence to the people of South West Africa, the United Nations General Assembly adopted Resolution 2145 in 1966.[36] Therein the General Assembly decided that the Mandate for South West Africa was terminated and that South Africa had no other right to administer the territory.[37] The General Assembly also determined that, henceforth, South West Africa came under the direct responsibility of the United Nations and that the United Nations must discharge its responsibilities with respect to South West Africa; that there be established an Ad Hoc Committee for South West Africa; and called upon South Africa "forthwith to refrain and desist from any action, constitutional, administrative, political or otherwise which will in any manner whatsoever alter or tend to alter the present international status of South West Africa."[38]

In Resolution 2248 of 1967,[39] the General Assembly then decided to establish a UN Council for South West Africa consisting of eleven member states that would administer, promulgate laws, form a constituent assembly, maintain law and order, etc. for the SWA mandated territory;[40] maintaining that the General Assembly had ultimate responsibility over the Council; and establishing a UN Commissioner for South West Africa.[41] It also decided that South West Africa shall become independent on a date fixed in accordance with the wishes of the people and by June 1968.[42] In 1968 South West Africa was officially redesignated as Namibia by UN General Assembly Resolution 2372.[43]

There then occurred a lengthy series of resolutions by the UN General Assembly that were designed to bring about South African withdrawal from Namibia: determining that the South African occupation of Namibia was illegal;[44] that the people of Namibia have a right to independence;[45] and that South Africa should withdraw from Namibia.[46] Most significantly, in Resolution 283 of 1970,[47] the Security Council established a complete legal regime to be applied by all members of the United Nations with respect to Namibia for the purpose of guaranteeing that no member state of the Organization maintains any relations with South Africa implying recognition of the authority of South Africa over Namibia and specifying an entire series of steps to be taken in that regard.[48] This was followed by Security Council Resolution 284 of 1970[49] that requested an advisory opinion from the International Court of Justice on the legal consequences for states of the continued presence of South Africa in Namibia.[50]

This advisory opinion of the World Court was issued on June 21, 1971.[51] The World Court held that the continued presence of South Africa in Namibia was illegal;[52] that South Africa was under an obligation to withdraw its administration from Namibia immediately and thus to put an end to its occupation of the territory;[53] that state members of the United Nations were under an obligation to recognize the illegality of South Africa's presence in Namibia and the invalidity of its acts on behalf of or concerning Namibia and to refrain from any acts and in particular any dealings with the government of South Africa implying recognition of this illegality or lending support or assistance to such administrative presence.[54] The Court also called upon states that were not members of the United Nations to act in accordance with this ruling.[55]

In addition the Court reiterated the holding of its 1950 advisory opinion to the effect that the General Assembly of the United Nations was legally qualified to exercise the supervisory functions previously exercised by the League of Nations with regard to the administration of the mandated territory, and that South Africa was under an obligation to submit to supervision and control of the General Assembly and to render annual reports to it.[56] Most significantly, the Court also held it would not be correct to assume that just because the General Assembly was in principle vested with recommendatory powers, it would be debarred from adopting in specific cases within the framework of its competence resolutions which make determinations or have operative design.[57] In other words, General Assembly resolutions concerning formerly mandated territories that have not yet attained independence could be legally obligatory for all member states of the United Nations. By means of Resolution 301 of 1971,[58] the Security Council took note with appreciation of the World Court's advisory opinion on Namibia.[59]

In 1973 the United Nations General Assembly recognized the South West African Peoples' Organization (SWAPO) as the authentic representative of the Namibian people.[60] In 1976 the UN General Assembly invited SWAPO to participate in its work as an observer and decided that any independence talks on Namibia must occur between representatives of South Africa and SWAPO under United Nations auspices.[61] In 1977 the UN Security Council voted unanimously to impose a mandatory arms embargo against South Africa, the first time in the history of the United Nations that enforcement action was taken against a member state of the United Nations under Chapter 7 of the Charter.[62] Similarly, the Council for Namibia and the UN General Assembly condemned South Africa's purported annexation of Walvis Bay as illegal, null and void.[63]

Finally, on September 29, 1978, the UN Security Council adopted Resolution 435[64] creating machinery for implementing independence for Namibia. It decided to establish under its authority a United Nations Transition Assistance Group (UNTAG) to assist the special representative of the UN Secretary General to ensure the early independence of Namibia through free elections under the supervision and control of the United Nations.[65] Following these elections, authority would be assumed by the government of Namibia.[66]

It is the author's opinion that if Jimmy Carter had been reelected as President in the fall of 1980, Namibia would have been independent today. The South African government had officially endorsed Resolution 435, but in the aftermath of Carter's defeat repudiated it, probably as the result of a meeting between Henry Kissinger and South African Foreign Minister Roelof Botha in Paris.[67] Shortly after the election, President-elect Ronald Reagan apparently dispatched Kissinger with the message that his incoming administration was going to reevaluate the U.S. government's overall foreign policy towards South Africa, a process which would later become known as "constructive engage-ment".[68] Thus, the international conference that was to set into motion the plan outlined in Resolution 435 met in Geneva in January of 1981 but quickly broke down over South Africa's repudiation of its previous acceptance of Resolution 435 despite its clear-cut obligation to comply therewith under UN Charter article 25.[69] This duplicitous act occurred with the tacit acquiescence if not the active encouragement of the Reagan administration, which wanted to "link" Namibian independence to securing the withdrawal of Cuban troops from Angola.[70]

To be sure, Namibia today is not yet independent. Nevertheless, the entire international community agrees, and indeed the official position of the United States government [71] is that some day Namibia must become independent.

Therefore I would like to suggest that a similar procedure could be followed with respect to Palestine in the hope and expectation that the entire international community, including someday the United States if not Israel, would agree to the proposition that the Palestinian people should likewise have the opportunity to exercise their international legal right of self-determination in Palestine. In particular, if the United Nations General Assembly was entitled to act in the aforementioned manner with respect to the people of South West Africa who had been under a Class C Mandate, then a fortiori the General Assembly would certainly be entitled to act in a similar manner with respect to the people of Palestine who had been under a Class A Mandate and, furthermore, had already been provisionally recognized as an independent nation by article 22(4) of the Covenant of the League of Nations, which recognition is still in effect today under UN Charter article 80(1) and is thus binding upon all member states of the United Nations. Based upon the Namibian precedent, therefore, the constructive proposal that I would like to offer here is that the Palestinian people proceed forthwith to create the state of Palestine.

How to Create the State of Palestine

It is generally agreed that an independent state must possess certain characteristics in order to have its existence recognized by the states of the world community: (1) a determinable territory; (2) a fixed population; (3) a functioning government; and (4) the capacity to enter into relations with other states.[72] There should be no problem with having the state of Palestine satisfy these four criteria. Indeed, whether they know it or not, all state parties to the United Nations Charter—including the United States and Israel—have already provisionally recognized the Palestinian people as an independent nation by virtue of UN Charter article 80(1) and League Covenant article 22(4).

Furthermore, article 103 of the United Nations Charter provides that in the event of a conflict between the terms of the Charter and the obligations under any other international agreement, the obligations under the Charter "shall prevail".[73] Hence, the conservatory clause of Charter article 80(1) with respect to guaranteeing the continued validity of League Mandates pending their conversion into UN trusteeships takes precedence over any other subsequent international agreement that might be concluded with respect to League-mandated territories in the event of a conflict between their respective terms. For example, to the extent that the Framework for Peace in the Middle East of the 1978 Camp David Accords[74] conflicts with the terms of the Mandate for Palestine and League Covenant article 22 by directly interfering with the right of the Palestinian people to self-determination, the former is invalid and entitled to absolutely no respect whatsoever as a matter of positive international law.

The same can be said for the commitment the United States gave to Israel in 1975 that it would not negotiate with the PLO until the latter formally accepts Resolution 242 and recognizes Israel. As the successor to the League of Nations with respect to the Mandate for Palestine, the General Assembly had the exclusive legal authority to determine that the PLO is the legitimate representative of the Palestinian people. That determination is binding upon all member states of the United Nations, including the United States and Israel whether they like it or not.

The Palestine National Council (PNC) is the supreme legislative organ of the Palestinian people. Hence, as a first step, the PNC must formally proclaim the existence of the state of Palestine by means of issuing a short but succinct

Proclamation of Independence to that effect. This point is critical because it is up to the Palestinian people themselves, not the United Nations, to proclaim their existence as an independent state. The League of Nations Covenant had already provisionally recognized the Palestinian people as an independent nation, which recognition is still entitled to legal effect under the conservatory clause found in the United Nations Charter. The supreme legislative organ of the Palestinian people has the right to perfect and finalize this outstanding degree of recognition by proclaiming the existence of the independent state of Palestine.

This Proclamation of Independence should also contain the minimum amount of information necessary to establish that the state of Palestine possesses all the characteristics required to constitute a state under the standard recognized criteria of international law. First, the Proclamation would have to address the question of nationality for citizens in the new state of Palestine. Article 7 of the British Mandate for Palestine provided that:

Article 7
The Administration of Palestine shall be responsible for enacting a nationality law. There shall be included in this law provisions framed so as to facilitate the acquisition of Palestinian citizenship by Jews who take up their permanent residence in Palestine.[75]

Pursuant to this requirement, the British enacted the Palestine Citizenship Order in Council of July 24, 1925,[76] which is still entitled to some legal effect today under Mandate article 7, League Covenant article 22, and UN Charter article 80(1). Hence, the Proclamation of Independence could indicate that pending the completion of a comprehensive and updated Palestine Citizenship Act, on a preliminary basis all individuals who were citizens of Palestine within the meaning of the 1925 Palestine Citizenship Order in Council as of a date-certain (*e.g.*, September 1, 1939—the start of the Second World War), together with the children and grandchildren of such individuals, are ipso facto citizens of the new state of Palestine.

That way, most Palestinians would automatically become citizens of the new state of Palestine without any need for further action on their part. Nor would it be necessary for any Palestinian who already possesses citizenship or nationality in another state to disavow the latter in order to obtain Palestinian citizenship. Furthermore, most Palestinians living in the diaspora who had not obtained a foreign nationality would immediately cease to be "stateless" persons. Nevertheless, Palestinian citizens living in occupied Palestine would still remain "protected persons" within the meaning of the Fourth Geneva Convention until the completion of a final peace settlement between Israel and Palestine as required by article 7 thereof.

Under this procedure, many Palestinians living in Israel and Jordan would automatically become dual nationals. Also, some Jewish citizens of Israel would automatically become citizens of Palestine and thus dual nationals. I suspect, however, that most of these Jewish dual nationals would decline to exercise their right to Palestinian citizenship. Yet, it is conceivable that some Jewish dual nationals currently living illegally on the West Bank and Gaza Strip might decide to remain living in the state of Palestine, though that decision would not give them any right to own property taken in violation of international law. A final determination of these complex issues relating to dual nationality would

have to be negotiated over among the Governments of Palestine, Israel and Jordan during the course of any peace conference.

Next, the Proclamation of Independence must create the Government of Palestine (GOP). The Government of Palestine could then issue an official statement that it is prepared to negotiate with the Government of Israel over the delimitation of their respective boundaries on the basis of UN Security Council Resolution 242 (1967) and UN General Assembly Resolution 181(II) (1947). Although an independent state must have a determinable territory, it is not critical that the territory of the state be fixed and permanent. The primary case in support of this proposition is Israel itself, which does not have any type of fixed boundaries that are internationally recognized but only armistice lines that came into existence after the 1948 war. Despite the absence of permanently fixed and internationally recognized borders, Israel is a member of the United Nations Organization and is recognized by many states in the international community. The same would be true for the state of Palestine pending a definitive delimitation of its boundaries.

The Admission of Palestine to the United Nations

Finally, the Proclamation of Independence should direct the Government of Palestine to claim the outstanding right of the Palestinian people and the state of Palestine to membership in the United Nations Organization. Article 4 of the United Nations Charter governs the procedure for states to be admitted to membership:

> Article 4
> 1. Membership in the United Nations is open to all other peace-loving states which accept the obligations contained in the present Charter and, in the judgment of the Organization, are able and willing to carry out these obligations.
> 2. The admission of any such state to membership in the United Nations will be effected by a decision of the General Assembly upon the recommendation of the Security Council.

Thus, admission to membership in the United Nations Organization requires concurrent action by both the Security Council and the General Assembly.

In its 1948 Advisory Opinion on the *Conditions of Admission of a State to Membership in the United Nations*[77] the International Court of Justice interpreted article 4 to enunciate five requisite conditions for UN membership. To be admitted, an applicant must (1) be a state; (2) be peace loving; (3) accept the obligations of the Charter; (4) be able to carry out these obligations; and (5) be willing to do so. The Court held that a member of the United Nations, when voting upon admission of a state to membership in the UN, whether in the Security Council or in the General Assembly, is not juridically entitled to make its consent to the admission dependent on conditions not expressly provided for by paragraph 1 of article 4.

However, the Court clarified this point by stating that article 4 does not prevent the member state from taking into account any factor which it is possible reasonably and in good faith to connect with the conditions laid down in article 4(1). Nevertheless, in regard to the proposed admission of Palestine, it must be remembered that all state parties to the UN Charter—including the United States of America—have already provisionally recognized the Palestinian people as an independent nation. Hence, according to the World Court's *Conditions of*

Admission opinion, the U.S. government would be obliged in good faith to vote for the admission of Palestine in both the Security Council and the General Assembly.

In a related 1950 Advisory Opinion on the *Competence of the General Assembly for the Admission of a State to the United Nations*,[78] the World Court held that the admission of a state to membership in the United Nations pursuant to article 4(2) of the Charter cannot be effectuated by a decision of the General Assembly when the Security Council has made no recommendation for admission by reason of the candidate failing to obtain the requisite majority or the negative vote of a permanent member upon a resolution so to recommend. The Court held that an affirmative and favorable recommendation of admission by the Security Council is required. There were, however, dissenting opinions by Judges Alvarez and Azevedo to the effect that there should be no veto power vested in the permanent members when it came to resolutions on admission.

Hence, it would first be necessary for sympathetic members of the Security Council to introduce a resolution for admission to membership on behalf of Palestine. In general, membership questions are considered to be substantive, not procedural, and are therefore thought to be subject to the veto power exercised by the five permanent members (U.S., UK, USSR, France and China) under Charter article 27(3). At this point the United States government would be presented with three options: (1) vote in favor of the resolution; (2) abstain on the resolution; or (3) veto the resolution. It would be an interesting question whether given the current political circumstances in the Occupied Territories, the United States government might decide at least to abstain in any such vote on the admission of Palestine and therefore, effectively, permit its admission—assuming none of the other four permanent members vetoes the resolution and there is an affirmative majority of Security Council members in favor of it. After all, there has been a history of the United States government abstaining from some UN Security Council resolutions that are critical of Israel and thus permitting their adoption.

Moreover, by virtue of UN Charter article 80(1), the U.S. government is estopped to deny that it too has already provisionally recognized the Palestinian people as an independent nation. Therefore, any United States veto of a Security Council resolution calling for the admission of Palestine to the United Nations would violate Charter article 80(1) and thus be not only illegal but also ultra vires of the United States. The exercise of such a veto by the United States would create a "dispute" between the United States and all other member states of the United Nations, which already have provisionally recognized the Palestinian people as an independent nation. That U.S. veto could then be subject to further Security Council action under Chapter VI of the UN Charter dealing with the Pacific Settlement of Disputes.

Thereunder, UN Charter article 35 provides that any UN member state may bring any "dispute" to the attention of the Security Council or the General Assembly.[79] Charter article 36(1) provides that the Security Council may, at any stage of a dispute, the continuance of which is likely to endanger the maintenance of international peace and security, "recommend appropriate procedures or methods of adjustment."[80] At that point a sympathetic member of the Security Council could introduce another resolution recommending Palestine for admission to the United Nations as a procedure or method of adjustment for the peaceful settlement of this dispute, the continuation of which will undoubtedly endanger the maintenance of international peace and security.

Pursuant to Charter article 27(3),[81] a permanent member of the Security Council such as the United States "shall abstain from voting" when it is "a party to

a dispute" involving Security Council "decisions" under Chapter VI. Under these circumstances, the United States government would be obliged to abstain from voting on a Security Council resolution recommending the admission of Palestine to membership in the United Nations that was submitted for consideration and adoption under Chapter VI of the Charter. Even if the United States tried to vote and actually voted, the President of the Security Council would be entitled to make a procedural ruling to the effect that America's negative vote was invalid under article 27(3), or at least not tantamount to a veto. That ruling could then be challenged by the United States, but would stand unless overruled by an affirmative vote of nine Security Council members as provided for by article 27(2). In this manner, the Security Council could indeed adopt a resolution recommending Palestine for admission to the United Nations over the objections of the United States.

Thus, a Security Council recommendation for Palestine's admission under article 4(2) might be subject to a U.S. veto, but thereafter another Security Council resolution recommending Palestine for admission under article 36(1) would not. Article 36(1) provides an alternative means to article 4(2) for obtaining a Security Council resolution recommending Palestine for admission that could then be turned over to the General Assembly for further action under article 4(2): The General Assembly actually *admits* the candidate state to membership, whereas the Security Council only needs to *recommend* such admission to the General Assembly.

All Charter article 4(2) requires is a "recommendation" by the Security Council. It should be legally immaterial whether the Security Council provides its recommendation to the General Assembly by means of an original vote by reference to article 4(2) or a second vote pursuant to its powers under article 36(1). Of course the success of this latter scenario would require that a majority of nine Security Council members prove to be willing to further challenge an original U.S. veto of Palestine's admission to the United Nations. But perhaps the prior recognition of these potential consequences might at least induce the U.S. government to abstain on any Security Council resolution recommending the admission of Palestine to the United Nations in the first place.

UN General Assembly Sanctions Against Israel

In any event, the rest of this analysis will assume: (1) that the United States government will exercise a veto power over the adoption of such a resolution under article 4(2); and (2) that a majority of nine Security Council members are unwilling to challenge that veto under article 36(1) for political reasons. At that point, the matter could be removed from the agenda of the Security Council and turned over to the United Nations General Assembly for action in accordance with the terms of its Uniting for Peace Resolution of 1950.[82] Since the United States government originally proposed and sponsored the passage of the Uniting for Peace Resolution in the General Assembly for the express purpose of circumventing the repeated exercise of the veto power by the Soviet Union in the Security Council during the Korean War,[83] the United States government would be estopped to deny that such General Assembly action with respect to the state of Palestine was lawful. Furthermore, in its Advisory Opinion on the *Certain Expenses of the United Nations* in 1962,[84] the International Court of Justice gave its stamp of approval to the Uniting for Peace procedure when it was used to create the United Nations Emergency Force (UNEF) for the purpose of facilitating the termination of the 1956 Middle Eastern War.[85]

Since the United States government took the lead role in arguing the *Certain Expenses* case before the International Court of Justice, it would be extremely difficult for the United States government to repudiate the World Court's express approval of the Uniting for Peace procedure when applied to Palestine without running the substantial risk of being accused of rank hypocrisy by the entire world community. Most regrettably, so far the Reagan administration has never been deterred by that prospect during the now seven years of its tenure in office. But if the United States of America willfully continues to obstruct the implementation of the international legal right of the Palestinian people to self-determination at the Security Council, then the other members of the international community must lead the way in the General Assembly.

Of course the implementation of the Uniting for Peace procedure would depend upon a prior determination that at least two-thirds of the membership of the UN General Assembly would be prepared to apply the Namibian precedent to Palestine. This is because UN Charter article 18(2) requires the General Assembly to adopt resolutions with respect to the maintenance of international peace and security by a two-thirds majority of the members present and voting.[86] Notice in this regard that an abstention by a state is treated as if that state were not "present and voting."[87] Likewise, article 18(2) specifically requires a two-thirds majority of members present and voting for the General Assembly to admit a state to UN membership.

Assuming the requisite degree of two-thirds support is present, the General Assembly could adopt a resolution determining that after twenty years of grave breaches of the Fourth Geneva Convention of 1949 and the Hague Regulations of 1907, the continued occupation of the West Bank and Gaza Strip by Israel stands in explicit violation of UN Security Council Resolutions 242 (1967) and 338 (1973),[88] the General Assembly Partition Resolution 181 (II) of 1947,[89] the Mandate for Palestine, League Covenant article 22, and UN Charter article 80(1),[90] inter alia, and is therefore invalid under international law and an obstacle to the implementation of the Palestinian peoples' right to self-determination. Next, relying upon the International Court of Justice's series of advisory opinions with respect to South West Africa, the General Assembly should affirm that it is the legitimate successor to the League of Nations Council with respect to supervising the League-mandated territory of Palestine. Thereafter the General Assembly could then act to formally recognize the existence of the independent state of Palestine that had already been proclaimed by the Palestinian people.[91]

Next, in the same resolution the General Assembly should then enact a complete international legal regime for the state of Palestine that would require all member states of the international community to refrain from providing any form of recognition to Israel's illegal occupation of Palestine, or its illegal supervision of Palestinian citizens therein, along the lines of what the United Nations has done for Namibia. Furthermore, under the powers granted by the terms of the Uniting for Peace Resolution together with its powers to administer League-mandated territory, the General Assembly should recommend, if not require, that all UN members impose on their own accord the specific set of sanctions described in Charter article 41 against the Israeli government.[92] These measures would include the complete or partial interruption of economic relations and of rail, sea, air, postal, telegraphic, radio and other means of communication, and the severance of diplomatic relations.[93] The General Assembly's adoption of such sanctions would provide the legal basis for any state that has the will to carry them out to do so without being held legally responsible for violating any rules of

customary international law or treaty law to the contrary, let alone any terms of the United Nations Charter. In this way the Israeli government's illegal occupation policies in Palestine could be effectively opposed by all members of the world community in a manner consistent with the requirements of international law.

In the meantime, the General Assembly should direct the UN Committee on the Exercise of the Inalienable Rights of the Palestinian People to cooperate with the Government of Palestine in order to achieve Israeli withdrawal from the state of Palestine. The General Assembly would also direct UNRWA to continue its humanitarian operations in cooperation with the Government of Palestine, etc. In other words, the General Assembly should order or recommend, as the case may be, that the entire bureaucratic infrastructure erected by the United Nations Organization, its specialized agencies and affiliated organizations to deal with the various aspects of the Palestinian question must henceforth work in full cooperation with the Government of Palestine.

Finally, very careful political consideration must be given to the question of whether the General Assembly should accord the Government of Palestine (GOP) the right to participate and vote in the activities of the General Assembly as well as in those of the United Nations specialized agencies and affiliated organizations as if the GOP represented a member state. Since all UN member states and the United Nations Organization itself have already provisionally recognized the Palestinian people as an independent "nation", the General Assembly certainly has the authority to treat Palestine as an independent "state" whose Charter right to UN membership has been illegally denied by an ultra vires veto by the United States at the Security Council. In other words, UN Charter article 80(1) and League Covenant article 22(4) have already mandated that the UN General Assembly must permit the Palestinian people to participate in the activities of the United Nations Organization as a member state from the very moment they have proclaimed the existence of an independent state of their own.

For example, in 1972 the Credentials Committee of the UN General Assembly refused to accept the credentials of the government of South Africa because of its reprehensible policies. This decision was ultimately upheld by the entire General Assembly[94] against a United States procedural challenge, thus effectively suspending South Africa from participation in the activities of the General Assembly, which suspension remains in effect to this date. Conversely, the General Assembly should certainly be willing to accept the credentials of the Government of Palestine and thus allow the GOP to participate in the activities of the General Assembly as if it represented a member state.

The General Assembly could also order or recommend, as the case may be, that a similar procedure be followed by the General Assembly's subsidiary bodies as well as by the United Nation's specialized agencies and affiliated organizations, etc. This approach to the problem would not run afoul of U.S. domestic legislation providing that the U.S. government must suspend its participation in and financial contributions to the United Nations should the South African credentials rejection precedent be applied to Israel.[95] Instead of effectively suspending Israel's participation in the United Nations to any extent, the General Assembly should effectively admit Palestine to membership throughout the Organization to whatever extent functionally possible. In any event, if for political reasons the General Assembly decides not to do this, then at a minimum it should at least bestow Observer Status upon the state of Palestine along the lines of that accorded to states which are not members of the United Nations such as Switzerland.

Palestine Versus Namibia

The only minor technical legal difference between implementing these procedures for Palestine and what had occurred with respect to Namibia is that in the latter case there occurred joint cooperation between the United Nations General Assembly and the United Nations Security Council. Under the worst case scenario postulated here, the United States government would actively oppose all such measures concerning UN recognition of the independent state of Palestine and securing Israeli withdrawal from occupied Palestine, which would include the repeated exercise of its veto power at the UN Security Council if necessary. Hence, such proposed General Assembly actions with respect to Palestine would not have the benefits of Charter article 25 specifically requiring all member states to adhere to the terms of the General Assembly's recognition of, regime for, and sanctions on behalf of Palestine.[96] Yet even without such explicit authorization by the Security Council for these measures, I would submit that based upon the Namibia precedent and all the legal authorities discussed above, the General Assembly would certainly have both the legal competence as well as the political and economic power to recognize the independent state of Palestine and to so act in order to effectuate Israeli withdrawal from the territory of Palestine.

In addition, since the Mandate for Palestine still survives as a matter of positive international law under UN Charter article 80(1), several articles of the Mandate would bolster the legality of the General Assembly's power to recognize the state of Palestine and then to take whatever measures are necessary to secure Israeli withdrawal from occupied Palestine. For example, Mandate article 2 states that the mandatory shall be responsible for safeguarding the civil and religious rights of all of the inhabitants of Palestine, irrespective of race and religion.[97] Article 3 states that the mandatory "shall, so far as circumstances permit, encourage local autonomy." Article 5 provides that the mandatory shall be responsible for seeing that no Palestinian territory shall be ceded or leased to, or in any way placed under the control of the government of any foreign power.[98]

Article 9 requires the mandatory to provide that the judicial system in Palestine shall assure to the native inhabitants "a complete guarantee of their rights" as well as respect "for the personal status of the various peoples and communities and for their religious interests." According to article 12, the mandatory shall be entrusted with the control of the foreign relations of Palestine and the power to afford diplomatic and consular protection to citizens of Palestine when outside its territorial limits.[99] According to article 15, the mandatory shall ensure to all inhabitants of Palestine "complete freedom of conscience and the free exercise of all forms of worship," and shall prohibit any form of discrimination "between the inhabitants of Palestine on the ground of race, religion or language."

Mandate article 17 provides that the "Administration of Palestine may organize on a voluntary basis the forces necessary for the preservation of peace and order, and also for the defense of the country." Finally, Mandate article 28 specifically refers to the obligations incumbent upon "the Government of Palestine" after the proper termination of the Palestine Mandate by the consent of the League of Nations Council as required by article 27. In other words, the Mandate clearly contemplated the creation of both the *State* and the *Government* of Palestine, as well as the right of Palestinian citizens to live freely and independently within the state of Palestine.

As a matter of positive international law, all of these powers, among others, to administer the territory comprising the Mandate for Palestine now reside

in the United Nations General Assembly as the legitimate successor to the League of Nations Council. In turn, the General Assembly can certainly decide that the most expeditious and effective manner for it to exercise these powers would be to recognize the independent state of Palestine and thus perfect and render permanent the provisional recognition of the Palestinian people as an independent nation that had already been accorded by the League of Nations and is still in effect today under UN Charter article 80(1). A similar argument would further support the right of the General Assembly to adopt the aforementioned sanctions against Israel under its Uniting for Peace Resolution in order to secure Israeli withdrawal from occupied Palestine.

Palestine: One Nation, Two States

The right of the Palestinian people to self-determination, including therein UN membership and representation, cannot be defeated by drawing an incredibly artificial and completely disingenuous technical legal distinction between an independent "nation" (which they already are) and an independent "state" (which they have an immediate and unconditional right to become of their own accord). In both the theory and practice of international law and politics, the terms "state" and "nation" are used interchangeably. The provisional recognition of the Palestinian people as an independent "nation" by League Covenant article 22(4) and UN Charter article 80(1) is tantamount to the provisional recognition of the Palestinian people as an independent "state." Once the Palestinian people have created the state of Palestine, they will have perfected their right to participate in the activities of the United Nations Organization as a member state.

To be sure, the Government of the Federal Republic of Germany takes the official position that although there might exist two German "states", there is only one German "nation".[100] Similarly, the Government of Palestine could take the position that although there might exist two "states" in the former Palestine Mandate, nevertheless there exists only one "nation" of Palestine. For example, the Palestine National Council could decide to affirm the unity of the nation of Palestine in a formal Constitution for the state of Palestine, while at the same time it could authorize the Government of Palestine to conclude a peace treaty with Israel. Such an approach to cutting this Gordian Knot would permit the Palestine National Council and the Government of Palestine to adopt the good-faith position before the entire Palestinian people that they have not abandoned the goal of the Palestine Liberation Organization to create one, secular and democratic state in all of Palestine.[101] Nevertheless, the peace treaty would indicate that henceforth this goal can only be achieved by peaceful means and in cooperation with and by the express agreement of the Government of Israel.

That is the current situation in the territory that comprised the former German Reich which, except for Berlin, was ultimately divided into two states, each of which was separately admitted to the United Nations in 1973, in accordance with their mutual agreement.[102] A two-state solution to Europe's "German problem" has proved to be quite successful at defusing this monumental threat to international peace and security in relations between the United States and the Soviet Union after the Second World War, thus effectively forestalling a further series of crises over the status of the completely surrounded city of Berlin. A two-state solution with a special status for the city of Jerusalem could do the same for the supercharged political problems of the Middle East that were created by Britain's irresponsible, illegal and void ab initio attempt to terminate the Mandate for Palestine unilaterally.

From a long-term perspective, although German "reunification" is difficult to imagine under the current political conditions of international relations, perhaps someday a peaceful and voluntary unification of the state of Israel and the state of Palestine into the form of a confederal or federal state might be feasible, if not desirable, because of economic considerations. Professor Gidon Gottlieb at the University of Chicago Law School has already drafted a proposal along these lines involving Jordan as well.[103] Although I am not in complete agreement with all the elements of Professor Gottlieb's plan, his study indicates that there are thoughtful people on both sides of the issue who are giving serious consideration to developing longer-range solutions to the problems of obtaining peace with justice in the Middle East. Nevertheless, it is my personal opinion that a two-state solution to the Israeli-Palestinian conflict (with a special status for Jerusalem) is the essential precondition for the establishment of any degree of peace or justice in the Middle East for the immediate and indefinite future.

Of course, the creation of the independent state of Palestine along the lines described above would certainly not automatically result in the withdrawal of Israeli occupation forces from the territory of Palestine. But it could have the advantage of freezing the legal status quo in a manner that would make it difficult for the Israeli government to annex these occupied territories either de jure or de facto with or without the implicit encouragement of the United States government. Applying the Namibian precedent to Palestine could get the entire international community, including someday the United States and perhaps Israel, around to the point of view that Israel must leave these occupied territories and that the Palestinian people must be able to implement their international legal right of self-determination specifically therein.

To be sure, Namibia is not yet free, but the almost universal consensus of international opinion is that some day it shall be set free. All that is required with respect to Namibia is for the United States government to put enough pressure on the government of South Africa. Undoubtedly this will not occur during the tenure of the Reagan administration operating under its reprehensible policies of "constructive engagement" and "linking" the independence of Namibia to the withdrawal of Cuban troops from Angola. But a new government in the United States of America could certainly obtain the independence of Namibia whenever it genuinely wanted to—just as the Carter administration did for Rhodesia/Zimbabwe in 1979/80[104] and planned to do for Namibia in 1980/81.[105]

I believe it would be beneficial for the rest of the international community to place the Palestinian people in precisely the same situation. The actual creation of the state of Palestine could develop a universal consensus among all states of the international community that the Palestinian people are entitled to implement their international legal right of self-determination in the occupied territories and that Israeli occupation forces must withdraw. The clear-cut establishment of this legal situation could then be used to eat away at the opposition to such an eventuality within the United States and Israel.

In particular, the creation of the state of Palestine could be employed quite effectively in the internal domestic debate within the United States of America and especially in the U.S. Congress and to the American people and news media by explaining to them the solid legal and political basis for the U.S. government to demand Israeli withdrawal from the occupied state of Palestine. As we have seen in the case of South African apartheid, a similar strategy proved to be quite effective, eventually resulting in the imposition of economic sanctions against the South African government by the United States Congress in 1986 despite the

publicly declared opposition to such sanctions by President Reagan himself.[106] To be sure, it will be a much more difficult job to accomplish similar results with respect to Israel because of the awesome power of the pro-Israeli lobby over the United States Congress and news media. But at least the application of the Namibian precedent to Palestine provides a non-violent alternative for all individuals interested in working for peace and justice in the Middle East rather than facing the prospect of another round of regional war with potentially globally catastrophic consequences. I submit we owe it to the Palestinian people, as well as to the peoples of Israel and of the Arab states throughout the Middle East, to give this constructive proposal a try: *CREATE THE STATE OF PALESTINE!*

The Palestinian Declaration of Independence

On November 15, 1988 the Palestine National Council (PNC) meeting in Algiers proclaimed the Palestinian Declaration of Independence in Arabic, the language of the desert and of the holy Quran. Thereby the Palestine National Council created the independent state of Palestine, and in addition, determined that the Executive Committee of the Palestine Liberation Organization (PLO) shall serve as the Provisional Government of the state of Palestine, which it still does today.

The Palestinian Declaration of Independence created a remarkable opportunity for peace because therein the PNC also explicitly accepted the UN General Assembly's Partition Resolution 181(II) of 1947—which called for the creation of a Jewish state and an Arab state in the former Mandate for Palestine, together with an international trusteeship for the City of Jerusalem—in order to resolve the basic conflict with Israel. The significance of the PNC's acceptance of partition in the Palestinian Declaration of Independence itself cannot be overemphasized. Prior thereto, from the perspective of the Palestinian people, the Partition Resolution had been deemed to be a criminal act that was perpetrated upon them by the United Nations. The acceptance of the Partition Resolution in their actual Declaration of Independence signaled the genuine desire by the Palestinian people to transcend the past century of bitter conflict with Jewish people living in their midst in order to reach an historic accommodation with them on the basis of a two-state solution. The Declaration of Independence is the foundational document for the State of Palestine. It is determinative, definitive, and irreversible.

Arabic is the sole, exclusive, official, and only authentic language for the Palestinian Declaration of Independence. But immediately after the Declaration had been proclaimed, the PLO gave the Arabic language text of the Declaration to the United Nations Organization in order for it to be translated into the five official languages of the United Nations (English, Chinese, French, Russian and Spanish), and then distributed as such to all UN member states. It soon became obvious that the United Nations bureaucracy had deliberately sabotaged their English-language translation of the Declaration in order to grossly misrepresent and distort its true meaning and ultimate significance. The late Professor Ibrahim Abu-Lighoud urgently sought my advice on how to retrieve and rectify this situation that seriously threatened the related Palestinian peace initiative.

During the course of our lengthy conversation on this crucial matter, it became clear that the parameters for a solution must be as follows:

First, the PLO would have to immediately prepare its own English-language translation of the Declaration.

Second, the PLO would have to make it clear that its English-language translation of the Declaration was the only authorized English-language translation of the Declaration, thus implicitly repudiating, negating, superseding and nullifying the misleading English-language translation of the Declaration provided by the UN bureaucracy.

Third, for diplomatic reasons, this repudiation had to be done in such a way so as not to attack or criticize the United Nations Organization, or even explain why the PLO was putting out its own authorized English-language translation of the Declaration. At this critical moment in time, the PLO could not afford to antagonize the UN Secretariat and the UN Secretary General.

Fourth, this all had to be done in a manner that would not undercut the original Arabic language of the Declaration as proclaimed by the Palestine National Council. Only the Palestine National Council has the legal authority to represent the interests of all the Palestinian people living around the world. The PLO has no legal authority to do anything that would contradict, undermine, or even call into question any decision by the Palestine National Council. But as the Provisional Government of the State of Palestine, the PLO Executive Committee had the legal authority to commission the production of an English-language translation of the Declaration.

Given these requirements, it was my recommendation that the PLO prepare their own English-language translation of the Declaration, then simply put it onto official PLO letterhead as is without any explanation whatsoever as to its status, and then circulate this document to the member states of the United Nations Organization as well as to the world's news media. So it was done. The authorized English-language version of the Palestinian Declaration of Independence commissioned by the PLO appears below. But in the meantime, the mistranslated English-language translation provided by the UN bureaucracy had already inflicted terrible harm upon the just cause of the Palestinian people. Questions remain as to why the English-language translation was sabotaged, under whose authority, and in whose interests.

One must bear in mind that it had been the United Nations Organization in the first place that had illegally carved up the Mandate for Palestine in gross violation of the right of the Palestinian people to self-determination. The Palestinians must never rely upon the United Nations Organization to be operating with total objectivity, free from the influence of powerful states. After all, while Israel officially accepted the UN Partition Resolution as a condition for its admission to membership in the United Nations Organization (as well as accepting it in its own Declaration of Independence), today Israel is a UN member state, whereas Palestine is not.

Furthermore, the 1947 UN Partition Plan called for the Palestinian people to have a much larger section of historic Palestine for their state than do the 1967 boundaries contemplated by UN Security Council Resolutions 242 (1967) and 338 (1973). By comparison, today the Palestinian people would be prepared to accept the 1967 boundaries for the state of Palestine, which would consist essentially of the West Bank, Gaza Strip and East Jerusalem. The PNC's contemporaneous acceptance of Resolutions 242 and 338 represented a significant concession by the Palestinian people for the benefit of the Israeli people. What is needed now from the Israeli government and people is the same will for peace that was demonstrated by the Palestinians fourteen years ago.

Organisation de Libération de la Palestine
CONSEIL NATIONAL PALESTINIEN
18 SESSION EXTRAORDINAIRE
Session de L'INTIFADA
Alger du 12 au 18 novembre 1988

PALESTINIAN DECLARATION OF INDEPENDENCE

In the name of God, the Compassionate, the Merciful

Palestine, the land of the three monotheistic faiths, is where the Palestinian Arab people was born, on which it grew, developed and excelled. The Palestinian people was never separated from or diminished in its integral bonds with Palestine. Thus the Palestinian Arab people ensured for itself an everlasting union between itself, its land and its history. .

Resolute throughout that history, the Palestinian Arab people forged its national identity, rising even to unimagined levels in its defense as invasion, the design of others, and the appeal special to Palestine's ancient and luminous place on that eminence where powers and civilizations are joined All this intervened thereby to deprive the people of its political independence. Yet the undying connection between Palestine and its people secured for the land its character, and for the people its national genius.

Nourished by an unfolding series of civilizations and cultures, Inspired by a heritage rich in variety and kind, the Palestinian Arab people added to its statute by consolidating a union between itself and its patrimonial land. The call went out from temple, church, and mosque to praise the Creator; to celebrate compassion and peace was indeed the message of Palestine. And in generation after generation, the Palestinian Arab people gave of itself unsparingly in the valiant battle for liberation and homeland. For what has been the unbroken chain of our people's rebellions but the heroic embodiment of our will for national independence? And so the people were sustained in the struggle to stay and to prevail.

When in the course of modern times a new order of values was declared with norms and values fair for all, it was the Palestinian Arab people that had been excluded from the destiny of all other peoples by a hostile array of local and foreign powers. Yet again had unaided justice been revealed as insufficient to drive the world's history along its preferred course.

And it was the Palestinian people, already wounded in its body, that was submitted to yet another type of occupation over which floated the falsehood that "Palestine was a land without people". This notion was foisted upon some in the world, whereas in Article 22 of the Covenant of the League of Nations (1919) and in the Treaty of Lausanne (1923), the community of nations had recognized that all the Arab territories, including Palestine, of the formerly Ottoman provinces were to have granted to them their freedom as provisionally independent nations.

Despite the historical injustice inflicted on the Palestinian Arab people resulting in their dispersion and depriving them of their right to self-determination following upon UN General Assembly Resolution 181 (1947), which partitioned Palestine into two states, one Arab, one Jewish, yet it is this Resolution that still provides those conditions of international legitimacy that ensure the right of the Palestinian Arab people to sovereignty and national independence.

By stages, the occupation of Palestine and parts of other Arab territories by Israeli forces, the willed dispossession and expulsion from their ancestral homes of the majority of Palestine's civilian inhabitants, was achieved by organized terror; those Palestinians who remained, as a vestige subjugated in its homeland, were persecuted and forced to endure the destruction of their national life.

Thus were principles of international legitimacy violated. Thus were the Charter of the United Nations and its Resolutions disfigured, for they had recognized the Palestinian Arab people's national rights, including the Right of Return, the Right to Independence, the Right to Sovereignty over territory and homeland.

In Palestine and on its perimeters, in exile distant and near, the Palestinian Arab people never faltered and never abandoned its conviction in its rights of Return and Independence. Occupation, massacres and dispersion achieved no gain in the unabated Palestinian consciousness of self and political identity, as Palestinians went forward with their destiny, undeterred and unbowed. And from out of long years of trial in ever mounting struggle, the Palestinian political identity emerged further consolidated and confirmed. And the collective Palestinian national will forged itself in a political embodiment, the Palestine Liberation Organization, its sole, legitimate representative, recognized by the world community as a whole, as well as by related regional and international institutions. Standing on the very rock of conviction in the Palestinian people's inalienable rights, and on the ground of Arab national consensus, and of international legitimacy, the PLO led the campaigns of its great people, molded into unity and powerful resolve, one and indivisible in the triumphs, even as it suffered massacres and confinement within and without its home. And so Palestinian resistance was clarified and raised into the forefront of Arab and world awareness, as the struggle of the Palestinian Arab people achieved unique prominence among the world's liberation movements in the modern era.

The massive national Uprising, the Intifada, now intensifying in cumulative scope and power on occupied Palestinian territories, as well as the unflinching resistance of the refugee camps outside the homeland, have elevated consciousness of the Palestinian truth and right into still higher realms of comprehension and actuality. Now at last the curtain has been dropped around a whole epoch of prevarication and negation. The Intifada has set siege to the mind of official Israel, which has for too long relied exclusively upon myth and terror to deny Palestinian existence altogether. Because of the Intifada and its revolutionary irreversible impulse, the history of Palestine has therefore arrived at a decisive juncture.

Whereas the Palestinian people reaffirms most definitely its inalienable rights in the land of its patrimony:

Now by virtue of natural right, and the exercise of those rights historical and legal and the sacrifices of successive generations who gave of themselves in defense of the freedom and independence of their homeland;

In pursuance of Resolutions adopted by the Arab Summit Conference and relying on the authority bestowed by international legitimacy as embodied in the Resolutions of the United Nations Organization since 1947;

And in exercise by the Palestinian Arab people of its rights to self-determination, political independence, and sovereignty over its territory:

The Palestine National Council, in the name of God, and in the name of the Palestinian Arab people, hereby proclaims the establishment of the State of Palestine on our Palestinian territory with its capital Jerusalem (Al-Quds Ash Sharif).

The State of Palestine is the state of Palestinians wherever they may be. The state is for them to enjoy in it their collective national and cultural identity, theirs to pursue in it a complete equality of rights. In it will be safeguarded their political and religious convictions and their human dignity by means of a parliamentary democratic system of governance, itself based on freedom of expression and the freedom to form parties. The rights of minorities will duly be respected by the majority, as minorities must abide by decisions of the majority. Governance will be based on principles of social justice, equality and nondiscrimination in public rights men or women, on grounds of race, religion, color or sex under the aegis of a constitution which ensures the role of law and on independent judiciary. Thus shall these principles allow no departure from Palestine's age-old spiritual and civilizational heritage of tolerance and religious co-existence.

The State of Palestine is an Arab state, an integral and indivisible part of the Arab nation, at one with that nation in heritage and civilization, with it also in its aspiration for liberation, progress, democracy and unity. The State of Palestine affirms its obligation to abide by the Charter of the League of Arab States, whereby the coordination of the Arab states with each other shall be strengthened. It calls upon Arab compatriots to consolidate and enhance the emergence in reality of our State, to mobilize potential, and to intensify efforts whose goal is to end Israeli occupation.

The State of Palestine proclaims its commitment to the principles and purposes of the United Nations, and to the Universal Declaration of Human Rights. It proclaims its commitment as well to the principles and policies of the Non-Aligned Movement.

It further announces itself to be a peace-loving state, in adherence to the principles of peaceful co-existence. It will join with all states and peoples in order to assure a permanent peace based upon justice and the respect of rights so that humanity's potential for well-being may be assured, an earnest competition for excellence be maintained, and in which confidence in the future will eliminate fear for those who are just and for whom justice is the only recourse.

In the context of its struggle for peace in the land of love and peace, the State of Palestine calls upon the United Nations to bear special responsibility for the Palestinian Arab people and its homeland. It calls upon all peace- and freedom-loving peoples and states to assist it in the

attainment of its objectives, to provide it with security, to alleviate the tragedy of its people, and to help to terminate Israel's occupation of the Palestinian territories.

The State of Palestine herewith declares that it believes in the settlement of regional and international disputes by peaceful means, in accordance with the UN Charter and resolutions. Without prejudice to its natural right to defend its territorial integrity and independence, it therefore rejects the threat or use of force, violence and terrorism against its territorial integrity, or political independence, as it also rejects their use against the territorial integrity of other states.

Therefore, on this day unlike all others, November 15, 1988, as we stand at the threshold of a new dawn, in all honor and modesty we humbly bow to the sacred spirits of our fallen ones, Palestinian and Arab, by the purity of whose sacrifice for the homeland our sky has been illuminated and our land given life. Our hearts are lifted up and irradiated by the light emanating from the much blessed Intifada, from those who have endured and have fought the fight of the camps, of dispersion, of exile, from those who have borne the standard of freedom, our children, our aged, our youth, our prisoners, detainees and wounded, all those whose ties to our sacred soil are confirmed in camp, village and town. We render special tribute to that brave Palestinian woman, guardian of sustenance and life, keeper of our people's perennial flame. To the souls of our sainted martyrs, to the whole of our Palestinian Arab people, to all free and honorable peoples everywhere, we pledge that our struggle shall be continued until the occupation ends, and the foundation of our sovereignty and independence shall be fortified accordingly.

Therefore, we call upon our great people to rally to the banner of Palestine, to cherish and defend it, so that it may forever be the symbol of our freedom and dignity in that homeland, which is a homeland for the free, now and always.

In the name of God, the Compassionate, the Merciful.

"Say: 'O God, Master of the Kingdom, Thou givest the Kingdom to whom Thou wilt, and seizest the Kingdom from whom Thou wilt. Thou exaltest whom Thou wilt, and Thou abasest whom Thou wilt; in Thy hand is the good; Thou art powerful over everything."

Sadaga Allahu Al-Azim

* *

Statehood Declaration is Part of PLO's Carefully Researched Plan

Sada Alwatan, Vol. IV, No. 189
November 26-December 2, 1988

By M. Kay Siblani

Editor, Sada Alwatan

DEARBORN—Two weeks after the Palestine Liberation Organization declared an independent Palestinian state and issued its political program for negotiating peace in the Arab-Israeli conflict, there has been little to generate hope that the U.S. and Israel will respond positively to the PNC's moves. In Israel, a Likud government in coalition with the far right and the religious parties appears ever closer, not only boding ill for any movement toward peace, but heralding the onset of intensifying repression against Palestinians in occupied Palestine, possibly to the point of genocide. The American Administration, meanwhile, has responded to the PLO concessions it expressly demanded with tepid statements that the moves were promising, but did not go far enough. There is some optimism being expressed that when the Bush Administration assumes control a more pragmatic approach to the Middle East will prove more forthcoming to Arab evidences of moderation, but that is admittedly mere speculation at this point.

The PLO, however, has embarked upon a carefully planned course of action designed to create on-the-ground statehood for Palestine however the U.S. and Israel decide to proceed. Their plan is firmly grounded in legal precedent at the United Nations whereby statehood can be achieved without the support or acquiescence of the U.S., should that become necessary.

Whether or not the United States supports the creation of an independent Palestinian state, and whether or not Israel likes it, that state will come into existence, if ultimately necessary in much the same manner that Namibian independence moved a step closer to reality this week, despite long South African denial of its right to do so, and long U.S. support of that South African intransigence. That is the opinion of Dr. Francis Boyle, Professor of International Law at the University of Illinois at Champaign, who has meticulously researched the legalities of the Namibian precedent at the United Nations and subsequently recommended that the Palestinians proceed similarly.

A long-time supporter of Palestinian rights who once initiated a lawsuit on behalf of Palestinians against Gen. Amos Yaron for his part in the Sabra and Shatila massacres, Dr. Boyle began his research into the legalities of the Namibian precedent in mid-1987 at the request of the PLO Observer Mission to the United Nations. By the time it was completed in manuscript form on March 11, 1988, the intifadeh was three months old and consuming most of the PLO's attention. But when King Hussein delivered his disengagement speech on July 31, it became clear that the PLO had to make a move to assume formal control. Declaring an independent state was a clear demand from those in the occupied Palestine too. Boyle's painstaking research became immediately relevant to those guiding the PLO's plan of action, a fact which is reflected in comparing the Declaration of Independence of Palestine with his findings.

Boyle's evaluation of the Namibian precedent and its applicability to the Palestinian issue is contained in a lengthy and complex legal brief/manuscript, published in the Summer edition of *American Arab Affairs*, the quarterly scholarly journal patterned after *Foreign Affairs*. Faced with continuing deadlock over the Mideast and continued unwillingness on the part of the U.S. do to anything constructive about it, Boyle asks rhetorically if the international community can bypass the intransigence and "create and preserve a legal and political status quo that would be conducive to the conclusion of a final peace settlement between Israel and the Palestinian people on the basis of a two state solution." He proceeds to prove the answer to that question is affirmative.

In a telephone interview this week with *Sada Alwatan*, Dr. Boyle explained how statehood for Palestine could be effected by this process, even in the event that Security Council cooperation is absented by U.S. veto on behalf of Israel. Cautioning against excessive optimism, Boyle nevertheless says that with the Bush-Baker team in Washington, anything might happen, including a more pragmatic approach to the Mideast which might result in earlier, easier resolution of the conflict. But it's not for Palestinians to sit around and wait for someone else to act, he says. Assuming the offensive and taking charge of their own destiny requires that they proceed on sound legal and historical bases, whatever anyone else does:

Q: Can you briefly outline the procedure whereby Palestinian statehood can be effected through the United Nations using the precedent established by Namibia?

A: Palestine and Namibia were at one point in time Mandates awarded by the League of Nations to Great Britain. Palestine Britain kept for itself, South West Africa it gave to South Africa. South Africa continued to govern South West Africa and is still there illegally today. In Palestine the British just unilaterally decided to leave, (precipitating) the 1948 war and the rest is history. In South West Africa, South Africa continued to stay despite the fact that they were ordered to leave by the United Nations. Eventually the United Nations got so disgusted at the fact that South Africa refused to leave that they revoked the Mandate that had been awarded to them, proclaimed the existence of a new state called Namibia, and then proceeded to impose a whole regimen of sanctions against South Africa with respect to Namibia. They ordered the entire world that they must not deal with South Africa with respect to Namibia but must deal only with the United Nations and a UN committee on Namibia, with respect to anything concerning Namibia. It was that series of events that led to the position we see today, where the South African government has apparently made the decision to leave Namibia, despite the fact that they have been in illegal occupation of that country for some time now. So, my argument is that we must put the Palestinian people in the same position that the UN put the Namibian people in which is that, everyone agrees, including the United States, that South Africa must leave Namibia. You'll note that even the Reagan Administration has finally agreed on that one. The same thing can be done for the Palestinian people and must be done in order to break through the barriers in the United States to our government adopting a fair,

reasonable, balanced policy that recognizes the Palestinian peoples' right to self-determination and to a state of their own. For many years in this country people viewed South Africa as a bastion against communism and we worked hand-in-glove with the South African government. That attitude has changed and we have the adoption of the comprehensive Anti-Apartheid Act of 1986. It seemed to me that the same type of perceptual transformation had to occur with respect to the Palestinian people.

In the case of South Africa, they just decided that it's too expensive, too much of a burden for them to keep occupying Namibia. There's just too much international opprobrium attached to it. And my theory is that the same type of strategy can be pursued with respect to Palestine. Especially here in the United States with an independent state of Palestine, with a forthcoming program of peaceful settlement which the PNC adopted in Algiers, we should be able to work in convincing the American people, Congress and the Executive branch that there is no alternative but for Israel to leave.

Q: The legal basis for this plan of action is the original League of Nations Mandate?

A: Well, let me put it this way: In my opinion, the right of the Palestinian people to a state of their own is based upon the inalienable right of self-determination of peoples. That can be found in the United Nations Charter. It's really not necessary to do anything more. However, to develop a legal argument on their behalf, I traced it back to the League of Nations Mandate for Palestine in which Palestine had already been recognized as an independent nation. And if you look at the Declaration of Independence for the State of Palestine, you will see that it states that quite clearly: "And it was the Palestinian people, already wounded in their body, that was submitted to yet another type of occupation over which floated the falsehood that 'Palestine was a land without people.' This notion was foisted upon some in the world, whereas in Article 22 of the Covenant of the League of Nations (1919) and in the Treaty of Lausanne (1923), the community of nations had recognized that all the Arab territories, including Palestine, of the formerly Ottoman provinces were to have granted to them their freedom as provisionally independent nations."

What they are saying is 'Look, we were already recognized as an independent nation and a right to statehood was already guaranteed way back in 1921, so no one today has a right to deprive us of that.'

Next came the United Nations Charter which again guaranteed the fundamental principle of self-determination of peoples, including the Palestinian people. As I point out in my article, the League of Nations Mandate continued and a provision of the UN Charter expressly protected the continuation of that Mandate, and the rights of all the peoples under the terms of that Mandate and the right of the Palestinian people to a state of their own. So as I saw it, there was more than enough authority there under the Covenant and the Mandate and the UN Charter to affirm that the Palestinian people are already an independent nation and have been recognized as such for quite some time and now simply need to proclaim their state, like any other nation in the world.

Then of course came the Partition Resolution. I think a good argument can be made that from the Palestinian perspective it was inflicted upon

them ultra vires . . . and was void and invalid. Nevertheless, the Declaration of Independence clearly says: "Despite the historical injustice inflicted on the Palestinian Arab people resulting in their dispersion and depriving them of their right to self-determination, following upon UN General Assembly Resolution 181 (1947) which partitioned Palestine into two states, one Arab, one Jewish, yet it is this Resolution that still provides those conditions of international legitimacy that ensure the right of the Palestinian Arab people to sovereignty." And as I pointed out, the right of the Palestinian people to the state of Palestine stands on even better legal footing, to be sure, than the right of the Jewish people to found the state of Israel. And that is not trying to prejudice the question one way or the other as to whether or not the Jewish people had a right to found the state of Israel under international law at the time, but rather it was the argument that I made that if you read the Jewish State's Declaration of Independence, it states quite clearly that their right to found their state goes back to the Palestine Mandate, the portion of it called the Balfour Declaration, and the Partition Resolution. If those are the two sources that you're citing—the Mandate and the Partition Resolution—then nothing could be clearer than that the Palestinians have an even greater right to establish a state of their own.

Q: Subsequent activity, like four wars, twenty years of occupation and the Camp David Accords, how do they impact on this?

A: Legally not at all, because when Israel was admitted to the United Nations after the events of 1948, one of the conditions for its admission was that it accepted the Partition Resolution which it voluntarily agreed to do. It also voluntarily accepted the General Assembly resolution providing that the Palestinian people had the right of return or else compensation for those who do not return, so subsequent events have no role to play in that, at least as a matter of law. The Camp David Accords you have to separate into two parts—the peace treaty between Egypt and Israel and then the portion dealing with the Palestinians. The portion of the Camp David Accords that purported to deal with the Palestinians had no validity whatsoever as a matter of international law. If Egypt and Israel want to make peace, that of course is their right to do so; under international law they can make peace if they want to, but neither Israel nor Egypt have any right to speak on behalf of the Palestinian people and an agreement that attempted to do that and to deprive the Palestinian people of the right to self-determination, which had already been determined by the United Nations Charter, was a meaningless act. Now I'm saying this in terms of law, I'm not saying it doesn't have policy implications. You still hear Shamir saying "the Camp David process." Why does he support the Camp David process? Quite simply the second part of it, what was called the Framework for Peace in the Middle East, if carried out, would have resulted in the Palestinian people being denied their right to their own state, to self-determination. So my opinion was legally that portion meant nothing though again the peace treaty between Israel and Egypt is a valid peace treaty and in my opinion should be obeyed by both parties.

Q: Now that the Declaration of Independence has been issued, what is the next step?

A: Well the next step is the political program that was attached to the

Declaration. As I understand it, it contains an acceptance of the two state solution, that there will be a state of Israel and there will be a state of Palestine, that the governments of both states will sit down and negotiate a peace agreement on the basis of sovereign equality, that no borders have been yet claimed for the new state of Palestine. Israel's never claimed borders officially, they don't have any internationally recognized borders except with Egypt, so Palestine does not need them either. The borders will be negotiated between the two governments when they sit down and negotiate peace. The Declaration of Independence has indicated that they are prepared to negotiate peace on the basis of a two state solution and on the basis of UN Security Council Resolutions 242 and 338 that call for the right of all states in the region, and that would include both Israel and Palestine, to exist within secure and recognized borders. As the result of the process, hopefully there'll be an international peace negotiation and the two governments will sit down and probably Jordan will join the process, but as an independent actor now, not speaking on behalf of the Palestinians. Jordan obviously does have some say in this whole thing and is in conflict with Israel and would need to sit and negotiate with Israel but as a partner separate from and independent of the government of Palestine. In theory there are at least three parties. The Syrians might decide to join, but at least these three parties would sit down and negotiate a peace settlement. Probably the borders of the two states would be set along the lines of the borders of the cease fire lines of '67 after the end of the '67 war, but of course that would be subject to negotiation by the governments involved as well as all the other conditions that are related to negotiating peace, just as any two governments that have had a war or history of conflict will finally sit down and negotiate a peace agreement.

Q: Negotiations would be under the aegis of the United Nations?

A: Yes. The program calls clearly for an international peace conference under the aegis of the Security Council, especially the five permanent members, the U.S., the U.S.S.R., Great Britain, France and China, and of course the theory there is that the U.S. would, if necessary, have whatever influence necessary to protect the interests of Israel and the other members hopefully would be there to protect the interests of the state of Palestine. As you know now the Soviets and China have recognized the state (of Palestine) so that I think is the hope and of course that is the only realistic way to go because any type of agreement or final peace settlement will have to be guaranteed by the UN Security Council. There will probably have to be some type of UN peacekeeping force in the region, there will have to be some type of special status for Jerusalem, so any type of peace agreement that comes out the UN Security Council will have to be involved. And that shows I think the foolishness of U.S. policy going back to Henry Kissinger, that somehow the U.S. government by itself will be able to broker this type of settlement and freeze the Russians out of it. There's no way that's going to happen, the Russians will have to be involved at least under the auspices of the Security Council and this settlement will have to have their backing too. So here it's a call for abandonment of the Kissinger approach . . . return to a multilateral approach at the UN and that's where it should be.

Q: With respect to the Namibian process in the UN, there was cooperation between the UN General Assembly and the Security Council. Is it your belief that even in the absence of this cooperation, in other words if the U.S. were to repeatedly veto Security Council resolutions, there is another procedure that can be followed to accomplish the same goal?

A: Sure. It appears very likely that Yasser Arafat will be coming to the United Nations to address the General Assembly and ask the General Assembly to recognize the state of Palestine. As far as I'm concerned that's the end of the process, the General Assembly, whatever the Reagan Administration thinks of it, most of the rest of the world sees the General Assembly as the supreme legislative organ for the entire world and I feel confident that the votes are there in the General Assembly to recognize the state of Palestine and when the state of Palestine is recognized by the General Assembly, that will be all the recognition it needs. Then the General Assembly can proceed for the time being to designate Palestine as an observer state . . . with diplomatic privileges and immunity, although this would have to be done without prejudice to the outstanding rights the Palestine Liberation Organization already has at the UN. The General Assembly probably will take that step within the next two weeks. Now at that point the PLO will have many things to do besides worrying right away about admission to the UN and things of that nature. As you know there are a lot of Palestinians being killed on a daily basis there and they're spending a lot of their time first concentrating on that and second, just proclaiming this state. So to be sure, even after that speech most of the PLO's time is going to be spent trying to protect the Palestinian people and keeping the intifadeh going. In the meantime, however, I think the hope will be that, say within the next year, you'll see most of the world recognize the state of Palestine, following the General Assembly. We'll probably see most of the Third World-Latin America, Africa, Asia recognize it. I'm sure if the General Assembly acts to recognize the state eventually most of the European states will recognize it as well. They're being subjected right now to enormous pressure by the U.S. government to hold the line but I think that after Reagan is out of there and Bush is in there and the General Assembly has acted eventually they'll come around. At some point in time then, we'll see the state of Palestine petition for membership to the UN and it's not quite clear what will happen at that stage but if that is vetoed by the U.S. government, I've pointed out that there are steps that can be taken by the General Assembly acting unilaterally without the cooperation of the Security Council to assure the rights of Palestine to participate in the General Assembly and in the activities of the organization. And also then, if necessary, to adopt economic sanctions against Israel in the event it continues to occupy illegally the state of Palestine rather than engaging in good faith negotiations leading to a withdrawal. So I have also, in my article, explained how these other steps can be taken in the event the U.S. government pursues an obstructionist role in the Security Council.

Q: In the case of Namibia, even with General Assembly and Security Council cooperation, the Reagan Administration was able to delay Namibian independence by tying it to another foreign policy objective. Might

it not be even better for the state of Palestine if the alternate path were taken?

A: My best guess at the time I wrote this was that the U.S. government would play an obstructionist role and (so) I proceeded to describe a policy that can be undertaken by the PLO in the event of U.S. obstructionism. My feeling at the time that I first addressed this was that the Palestinian people needed to define themselves rather than allow the U.S. and the Israelis to define them to the world. Proclaiming their own state is a unilateral act that they could take that was not dependent on Israel or the U.S. and that would transform the entire situation legally, politically and otherwise in the perception of the entire world. And that was something that they should pursue rather than just sitting around and waiting for this Middle East peace conference. I would say the same thing should be done now—sure pursue the program for a Middle East peace conference and try to work for cooperation on the part of the U.S. government, but in the meantime not to give up the struggle, whether in occupied Palestine—the use of the initfadeh—or whether it is at the United Nations. There is an approach that can be pursued diplomatically that could lead to the UN deciding to sanction Israel, that is to cut off all forms of economic, diplomatic and communications-type arrangements with it by the entire international community, if Israel does not withdraw from occupied Palestine. That can be done independently of U.S. policy assuming that the states in the General Assembly are willing to stand up to the United States and say on this issue (they) don't care if (the U.S.) is going to apply pressure, (they) will proceed to sanction Israel. Now of course you'll need a two-thirds vote in the General Assembly. Obviously there'll be some states that are more than willing to do it in principle but are not willing to risk the wrath of the U.S. government. But I would hope again over time, if the U.S. continues to obstruct the will of the international community when it comes to the right of the Palestinian people to self-determination, that the General Assembly would come to that point of view. And that is what happened on Namibia. Again it's taken ten years to get from Resolution 435 in 1978 until now when it looks like the whole thing is going to happen on Namibia, and we might be talking about the same thing on Palestine. I certainly hope not, but I think you've got to start the process now and start moving in that direction and the Palestinian people need to indicate to Israel and to the U.S. government that there is an independent option here and they are now taking the initiative. They are defining themselves, they are defining the situation, and the Israelis will be the ones scrambling to keep up. Indeed that is what we've seen ever since the state was proclaimed. The Israelis have been scrambling for once and not the Palestinians. The Israelis are in disarray and now they're all fighting over the Law of Return, they can't even get their own act together.

ENDNOTES

1. *See* Mandate Agreement Regarding German South West Africa of December 17, 1920, art. 2, *reprinted in* I. Dore, The International Mandate System and Namibia 177 (1985). *See also* Crawford, *South West Africa: Mandate Termination in Historical Perspective*, 6 Col. J. of Transnt'l L. 91 (1967).

2. *See* British Mandate for Palestine, August, 1922, 8 League of Nations O.J. 1007 (1922). *See generally* Cunningham, *Palestine — The Last Days of the Mandate*, 24 Int'l Affairs 481 (1948); Hamilton, *Partition of Palestine*, 23 Foreign Pol'y Rep. 286 (1948).

3. *See* President Wilson's State Papers and Addresses 464-72 (A. Shaw ed. 1918).

4. Department of State, *Papers Relating to the Foreign Relations of the United States, 1919, The Paris Peace Conference* (13 vols., Washington: United States Gov't. Printing Office, 1942-47). *See generally* H. Nicolson, Peacemaking 1919 (1933).

5. Treaty of Versailles, Germany, June 28, 1919, 2 Bevans 43, 11 Martens (3rd) 323.

6. League of Nations Covenant, June 28, 1919, 225 C.T.S. 195, 13 Am. J. Int'l. L. Supp. 128, *reprinted in* Basic Documents of the United Nations 295 (L. Sohn ed. 1968).

7. League of Nations Covenant art. 22.

8. *Id.* at art. 22, para. 1 (emphasis added).

9. *Id.* at art. 22, para. 2.

10. *See* League of Nations Covenant art. 22.

11. *Id.* at art. 22, paras. 3-6.

12. League of Nations Covenant art. 22, para. 4.

13. *See* I. Dore, The International Mandate System and Namibia 6-7 (1985) (describing the Class A Mandates).

14. League of Nations Covenant art. 22, para. 6.

15. *See* League of Nations Covenant art. 22, paras. 7-9.

16. *See* Terms of the League of Nations Mandates, U.N. Doc. A/70, October 1946, republished by the United Nations.

17. *See* League of Nations Covenant art. 22, para. 3.

18. *See* League of Nations Covenant art. 22, para. 7.

19. *See generally* League of Nations, The Mandates System 33-67 (L.N. Publ. 1945 VI.A.1), *reprinted in* L. Sohn & T. Buergenthal, International Protection of Human Rights 337-373 (1974).

20. U.N. Charter, *reprinted in* Basic Documents of the United Nations 1-25 (L. Sohn ed. 1968). For specific provisions of the trusteeship system established under Ch. XII, *see* U.N. Charter arts. 75-85.

21. U.N. Charter art. 77, para. 1(a) provides: "The trusteeship system shall apply to such territories in the following categories as may be placed thereunder by means of trusteeship agreements: a. territories now held under mandate. . . ."

22. U.N. GAOR (128th plen. mtg. V.R.) at 1424-25 (1947). For a brief view of the plan's recommendations and its discussion in the United Nations, *see* R. Chowdhuri, International Mandates and Trusteeship Systems 106-111 (1955). *See also* Hales, Some Legal Aspects of the Mandate System: Sovereignty, Nationality—Termination & Transfer, 23 Transactions of the Grotius Society 85-126 (1937).

23. U.N. Charter art. 80, para. 1. *See also* Dean, *The San Francisco Conference*, 21 Foreign Pol'y Rep. 110, 122 (1945); Gilchrist, *Colonial Questions at the San Francisco Conference*, 39 Am. Pol. Sci. Rev. 982, 991 (1945); McKay, *The Arab League in World Politics*, 22 Foreign Pol'y Rep. 206 (1946); Pact of the Arab League (Cairo Pact), *reprinted in* 39 Am. J. of Int'l L. 266 (Supp.-Oct. 1945).

24. A review of the debates on art. 80(1) supports this stance:

 > The Committee then returned to paragraph B, 5, to which the Delegate for Egypt had submitted an amendment at the previous meeting (see Summary Report of Ninth Meeting, Doc. 552, II/4/23, p. 3).
 >
 > The Delegate for the United States stated that paragraph B, 5, was intended as a conservatory or safeguarding clause. He was willing and desirous that the minutes of this Committee show that it is intended to mean that all rights whatever they may be, remain exactly the same as they exist—that they are neither increased nor diminished by the adoption of this Charter. Any change is left as a matter for subsequent agreements. The clause should neither add nor detract, but safeguard all existing rights, whatever they may be.
 >
 > Doc. 580 (English) II/4/24, 10 U.N.C.I.O. 485, 486 (1945).
 >
 > The delegate for the United States moved that the paragraph be amended, stating
 >
 > . . . that at the appropriate time he would make a statement to be included in the official Commission records to the effect that among the

"rights whatsoever of any states or any peoples," mentioned in the pro-
posed amendment, there were included any rights set forth in paragraph 4
of Article 22 of the Covenant of the League of Nations.
Doc. 877 (English), II/4/35, 10 U.N.C.I.O. 513, 515 (1945).
As noted in a Draft of the Rapporteur of Committee II/4:
The Delegate for the United States emphasized the fact that paragraph
5 neither increased nor diminished the rights of any states or any peoples
with respect to any territories and that any change in such rights would
remain a matter for subsequent agreement.
In the discussion of paragraph 5, it was suggested, with reference to
mandated territories, that the paragraph should include a specific reference
to paragraph 4 of Article 22 of the Covenant of the League of Nations.
Objections to this suggestion were raised on the grounds that it would be
inadvisable to refer, specifically, to any one international instrument to
which all the United Nations were not parties. It was stated that the phrase
"existing international instruments" was preferable.
The Committee accepted the interpretation that among the "rights what-
soever of any states or any peoples," mentioned in the proposed amend-
ment, there are included any rights set forth in paragraph 4 of Article 22 of
the Covenant of the League of Nations.
Doc. 1091 (English), II/4/44, 10 U.N.C.I.O. 574, 578 (1945).
The *identical* language also appeared in the actual *Report of the Rapporteur of Committee II/4*,
see Doc. 1115 (English), II/4/44(1)(a), 10 U.N.C.I.O. 607, 611 (1945). *See also* Summary
Report of Ninth Meeting of Committee II/4, Doc. 552 (English), II/4/23, 10 U.N.C.I.O. 475-77
(1945).

25. G.A. Res. 9(I), 1 U.N. GAOR Supp. (No. 5), U.N. Doc. A/64 at 13 (1946). The General
Assembly:
Invites the States administering territories now held under mandate to
undertake practical steps, in concert with other States directly concerned,
for the implementation of Article 79 of the Charter. . . .

26. The General Assembly rejected the proposal in G.A. Res. 65(I), 1 U.N. GAOR Supp. (No. 5),
U.N. Doc. A/64/Add 1, at 123 (1946), by stating:
[The General Assembly] is unable to accede to the incorporation of the
territory of South West Africa in the Union of South Africa; and recom-
mends that the mandated territory of South West Africa be placed under
the international trusteeship system and invites the Government of the
Union of South Africa to propose for the consideration of the General
Assembly a trusteeship agreement for the aforesaid territory.

27. South Africa, though refusing to conclude a Trusteeship Agreement, did declare that it would
continue to honor its obligations under the Mandate. *See* Crawford, *South West Africa:
Mandate Termination in Historical Perspective*, 6 Col. J. of Transnt'l L. 91, 124-25 (1967).

28. International Status of South-West Africa, 1950 I.C.J. 128 (Advisory Opinion of July 11,
1950).

29. *Id.* at 136-37.

30. *Id.*

31. *Id.* at 138.

32. *Id.* at 138-40.

33. *Id.* at 143.

34. *See* Voting Procedure on Questions Relating to Reports and Petitions Concerning the Territory
of South-West Africa, 1955 I.C.J. 67, 77-78 (Advisory Opinion of June 7, 1955).

35. *Id.*

36. G.A. Res. 2145, 21 U.N. GAOR Supp. (No. 16) at 2, U.N. Doc. A/6316 (1966).

37. *Id.*

38. *Id.* at 3.

39. G.A. Res. 2248, 22 U.N. GAOR 5th Special Session, U.N. Doc. A/6657/Supp. 1 (1967).

40. *Id.* at art. II, para. 1(a)-(e).

41. *Id.* at para. 3.

42. *Id.* at art. VI.

43. G.A. Res. 2372, 22 U.N. GAOR Supp. (No. 16A) at 1, U.N. Doc. A/6717/Add. 1 (1968).

44. *See,* G.A. Res. 2403, 23 U.N. GAOR Supp. (No. 18) at 3, U.N. Doc. A/7218 (1968) (declaring
South African occupation of Namibia illegal, condemning the refusal to withdraw, and recom-
mending Security Council action to ensure a withdrawal).

45. *See* G.A. Res. 2498, 24 U.N. GAOR Supp. (No. 30) at 65, U.N. Doc. A/7630 (1969) (declaring
right of Namibian people to self-determination and independence, and condemning South
African refusal to withdraw); G.A. Res. 2678, 25 U.N. GAOR Supp. (No. 28) at 90, U.N. Doc.
A/8028 (1970) (calling upon South Africa to treat Namibian people captured during their struggle

for freedom as prisoners of war under Fourth Geneva Convention of 1949).

46. *See* G.A. Res. 2517, 24 U.N. GAOR Supp. (No. 30) at 68, U.N. Doc. A/7630 (1969) (reiterating the illegality of South African occupation, calling upon South Africa to withdraw, reaffirming Namibian right to independence, and once again drawing attention of Security Council, United Nations Council for Namibia, Secretary-General and member States to the need for appropriate measures); G.A. Res. 2679, 25 U.N. GAOR at 91, U.N. Doc. A/8028 (1970) (establishing a United Nations fund for Namibia).

47. S.C. Res. 283, 25 U.N. SCOR at 2, U.N. Doc. S/INF/25 (1970).

48. *Id.*

49. S.C. Res. 284, 25 U.N. SCOR para. 1, U.N. Doc. S/INF/25 (1970).

50. *Id.*

51. Legal Consequences for States of the Continued Presence of South Africa in Namibia (South West Africa) Notwithstanding Security Council Resolution 276 (1970), 1971 I.C.J. 16 (Advisory Opinion of June 21, 1971).

52. *Id.* at 58.

53. *Id.*

54. *Id.*

55. *Id.*

56. *Id.* at 37-38.

57. *Id.* at 53-54.

58. S.C. Res. 301, 26 U.N. SCOR at 7, U.N. Doc. S/INF/27 (1971).

59. *Id.*

60. *See* G.A. Res. 3111, 28 U.N. GAOR Supp. (No. 30) at 93, U.N. Doc. A/9030 (1973) (formally recognizing SWAPO as the "authentic representative of the Namibian people").

61. U.N. Gen. Res. 31/152, 31 U.N. GAOR Supp. (No. 39) at 136, U.N. Doc. A/31/437 (1976).

62. S.C. Res. 418, 32 U.N. SCOR at 5, U.N. Doc. S/INF/33 (1977).

63. *See* G.A. Res. S-9/2, 33 U.N. GAOR 9th Spec. Sess. Supp. (No. 1) para. 11, U.N. Doc. A/S-9/4 (1978); G.A. Res. 34/92, 34 U.N. GAOR Supp. (No. 46) para. 2(c), U.N. Doc. A/34/46 (1979); G.A. Res. 35/227, 35 U.N. GAOR Supp. (No. 48) paras. 11-12.

64. S.C. Res. 435, 33 U.N. SCOR at 13, U.N. Doc. S/INF/34 (1978).

65. *Id.* At para. 3.

66. *Id.*

67. *See* N.Y. Times, Nov. 14, 1980, at 3, col. 1 (Kissinger declares he will meet with South African Foreign Minister Roelef Botha); N.Y. Times, Nov. 15, 1980, at 6, col. 3 (Western officials concerned about Kissinger meeting with Botha and South African stance on SWA independence); N.Y. Times, Jan 8, 1981, at 10, col. 1 (U.N. Conference on Namibian independence convenes in Geneva); and N.Y. Times, Jan. 30, 1981, at 2, col. 6 (Botha declares conference failed because of U.N. link to SWAPO).

68. *See, e.g.,* "Constructive Engagement and Linkage," U.S. Dept. of State, 1986 Am. Foreign Pol'y Current Docs. 1984 Ch. 14, Doc. 415, at 822 (interview transcript with Assistant Secretary of State for African Affairs Chester Crocker 5/16/84). *But see* Boyle, Destructive Engagement in Southern Africa, American Branch, International Law Association, International Practitioner's Notebook, No. 29 (Jan. 1985), *reprinted in* F. Boyle, Defending Civil Resistance Under International Law 211 (1987).

69. U.N. Charter art. 25. This article provides that United Nations members "agree to accept and carry out the decisions of the Security Council in accordance with the [U.N.] Charter."

70. Shultz, "Southern Africa: Toward An American Consensus," 85 Dep't St. Bull. 22 (June 1985) (Secretary of State George Shultz's Address to the National Press Club—P.R. #73).

71. *Id.* at 25: "Let there be no mistake about it: U.N. Security Council Resolution 435 remains the only internationally acceptable basis for a solution."

72. *See* M. Akehurst, A Modern Introduction to International Law 53 (4th ed. 1982).

73. U.N. Charter art. 103.

74. *See* Camp David Accords, Sept. 17, 1978, *reprinted in* Dept. State Bull., Oct. 1978, at 7. The Camp David Accords consisted of (1) a Framework for Peace in the Middle East, *reprinted in id.* at 7-9, and (2) a Framework for the Conclusion of a Peace Treaty Between Egypt and Israel, *reprinted in id.* at 9-10. *See also* Treaty of Peace, Mar. 26, 1979, Egypt-Israel, *reprinted in* 18 I.L.M. 362 (1979).

75. British Mandate for Palestine, at art. 7.

76. Palestine Citizenship Order in Council, S.R. & O., 1925, No. 777, p. 474.

77. Conditions of Admission of a State to Membership in the United Nations, 1948 I.C.J. 57 (Advisory Opinion of May 28, 1948).

78. Competence of the General Assembly for the Admission of a State to the United Nations, 1950 I.C.J. 4 (Advisory Opinion of March 3, 1950).

79. U.N. Charter art. 35.

80. U.N. Charter art. 36(1).

81. U.N. Charter art. 27(3).

82. Uniting for Peace Resolution, Nov. 3, 1950, G.A. Res. 377A(V), 5 U.N. GAOR Supp. (No. 20)

at 10, U.N. Doc. A/1775 (1951).

83. *See generally*, L. Sohn, Cases on United Nations Law 491-507 (1967).

84. Certain Expenses of the United Nations, 1962 I.C.J. Reports 151 (Advisory Opinion of July 20, 1962), *reprinted in* 56 Am. J. Int'l L. 1053 (1962).

85. *Id.*

86. U.N. Charter art. 18(2).

87. *See* Rules of Procedure of the General Assembly, Rule 88, approved by Resolution 173(II), 17 November 1947 A/520; GAOR II, Res. (A/519), p. 104; *reprinted in* Basic Documents of the United Nations 41, 54 (L. Sohn ed. 1968). The rule states:

> For the purpose of these rules, the phrase "members present and voting" means Members casting an affirmative or negative vote. Members which abstain from voting are considered as not voting.

88. S.C. Res. 242, 22 U.N. SCOR (1382d mtg.) at 8-9, U.N. Doc. S/8247 (1967); S.C. Res. 338, 28 U.N. SCOR 10, U.N. Doc. S/RES/338 (1973).

89. Concerning the Future Government of Palestine, Nov. 29, 1947, G.A. Res. 181(II), 2 U.N. GAOR Res. at 131-150, U.N. Doc. A/519 (1947), *reprinted in* L. Sohn, The United Nations in Action 23 (1968).

90. U.N. Charter art. 80(1).

91. G.A. Res. 3376, 30 U.N. GAOR Supp. (No. 34), U.N. Doc. A/10034 (1975), *reprinted in* 15 D. Djonovich, United Nations Resolutions: Series I General Assembly 1972-74 at 443 (1984).

92. U.N. Charter art. 41.

93. *Id.*

94. G.A. Res. 2948, 27 U.N. GAOR Supp. (No. 30) (2104th plen. mtg.), U.N. Doc. A/8730 (1972), *reprinted in* D. Djonovich, XIV United Nations Resolutions: Series I General Assembly 1972-74 at 242 (1984).

95. *See* Department of State Authorization, Pub. L. No. 98-164, §115, 97 Stat. 1021 (1983), as amended by Pub. L. No. 99-93, §142, 99 Stat. 424 (1985).

96. *See* U.N. Charter art. 25, which provides "the Members of the United Nations accept and carry out the decisions of the Security Council in accordance with the present Charter."

97. British Mandate for Palestine art. 2.

98. *Id.* at art. 5.

99. *Id.* at art. 12.

100. *See The Basic Law of the Federal Republic of Germany*, *reprinted in* Constitutions of the Countries of the World 43 (ed. Blaustein & Flanz 1985).

101. *See The Palestinian National Charter*, *reprinted in* 3 The Arab-Israeli Conflict: Documents 706-11 (J.N. Moore ed. 1975). *See also* C. Rubenberg, The Palestinian Liberation Organization — Its Institutional Infrastructure (1983), C. Rubenberg, Israel and the American National Interest (1986).

102. G.A. Res. 3050, 28 U.N. GAOR Supp. (No. 30A) (2117th plen. mtg.), U.N. Doc. A/9030/Add. 1 (1973), *reprinted in* 14 D. Djonovich, United Nations Resolutions: Series I General Assembly 1972-74 at 370 (1984).

103. Gottlieb, *From Autonomy to a Framework State*, Contemporary Issues in International Law 493-514 (T. Buergenthal ed. 1984).

104. *See* U.S. Dept. of State, 1984 Am. Foreign Pol'y Current Docs. 1981 Ch. 1, Doc. 40, at 20 (annual message to the Congress by President Carter 1/16/81).

105. *Id.* President Carter further addressed his administration's intentions by stating:

> The focus of our efforts . . . has now turned to Namibia. Negotiations are proceeding among concerned parties . . . [which] should lead to implementation of the U.N. plan for self-determination and independence for Namibia during 1981.

106. *See* Comprehensive Anti-Apartheid Act of 1986, Pub. L. 99-440, 100 Stat. 1086 (Oct. 2, 1986). Congress overrode President Reagan's veto of this Act with a 2/3 majority vote in both Houses. *Id.* at 1116.

The International Legal Right of the Palestinian People to Self-determination and an Independent State of Their Own

The Intifadah

The December 1987 beginning of the massive uprising or intifadah by Palestinian youths on what heretofore had been called the Gaza Strip, West Bank and Jerusalem as well as in Israel itself, was a natural reaction to what they perceived as the tragic plight of hopelessness, oppression, desperation and injustice that has been inflicted upon the Palestinian people since at least 1947. It is the generation of the sons who had been born and grown up during Israeli occupation that decided to discard the seemingly collaborationist policies of their fathers by rising up to cast off Israeli oppression. The entire world has now witnessed the awesome manifestation of their justifiable rage.

The intifadah has been a time of terrible tragedy and great suffering for the Palestinian people. According to the Chicago-based Palestine Human Rights Information Center (PHRIC), from December 9, 1987 through May 31, 1990 there have occurred 838 deaths directly attributable to Israeli occupation forces, 208 of whom were children. Of these victims, 689 were shot to death and 88 deaths were produced by tear gas. During that same period, the PHRIC estimated the infliction of 93,500 personal injuries upon Palestinians; 9,550 people subjected to administrative detention; 3,770 days of curfew on the West Bank and 3,771 days on the Gaza Strip; and 1,467 homes and other structures demolished or sealed. In a veritable war against nature, the Israeli army has also uprooted approximately 87,473 olive and fruit trees.

And yet, paradoxically, despite this enormous amount of human suffering, the intifadah has also proved to be the time of the greatest glory of the Palestinians, an affirmation of their essential dignity as an independent people. As a result of these elemental processes, the Unified Leadership of the Intifadah requested the Palestine Liberation Organization (PLO) to proclaim the existence of a new state of Palestine in recognition of the courage, suffering, and bravery of the Palestinian people living under Israeli occupation. On July 31, 1988, the creation of the Palestinian state became an inevitability when King Hussein of Jordan announced that he was terminating all forms of administrative and legal ties with what he called the West Bank. If the PLO had not acceded to the intifadah's request for statehood, then the PLO would have forfeited the moral right to lead the Palestinian people as their sole and legitimate representative.

So on November 15, 1988, the independent state of Palestine was proclaimed by the Palestine National Council (PNC), meeting in Algiers, by a vote of 253 to 46, as well as in front of Al-Aqsa Mosque in Jerusalem, the capital of the new state, after the close of prayers. I will not bother here to discuss at great length the legal basis for the Palestinian people to proclaim their own state. This matter has already been analyzed in detail by me in a research paper that was requested by the PLO in June 1987 and later published in the Summer 1988 issue of *American-Arab Affairs* entitled *"CREATE THE STATE OF PALESTINE!"* Generally put, however, there are four elements constituent of a state: territory, population, government, and the capacity to enter into relations with other states. All four characteristics have been satisfied by the newly proclaimed independent state of Palestine.

The Elements of Palestinian Statehood

Indeed, as long ago as 1919, the Palestinian people were provisionally recognized as an independent nation by the League of Nations in League Covenant article 22(4) as well as by the 1922 Mandate for Palestine that was awarded to Great Britain. This provisional recognition continues into effect until today because of the conservatory clause found in article 80(1) of the United Nations Charter. Pursuant to the basic right of self-determination of peoples as recognized by UN Charter article 1(2) as well as by the International Court of Justice in the *Namibia* and *Western Sahara* Advisory Opinions, the Palestinian people have proceeded to proclaim their own independent state in the land they have continuously inhabited for thousands of years.

1. *Territory.* The territory of a state does not have to be fixed and determinate. For example, Israel does not have fixed and permanent borders (except most recently with respect to Egypt) and yet it is generally considered to be a state. Thus, the state of Palestine also does not have to have declared borders either. Rather, borders will be negotiated between the government of Israel and the government of Palestine. This is the same way peace negotiations would occur between any other two states/governments in dispute over the existence of their respective borders. To be sure, however, it is quite clear from reading the Palestinian Declaration of Independence and the attached Political Communiqué that the PLO believes that the new state of Palestine consists essentially of what has been called the West Bank and Gaza Strip, together with its capital being East Jerusalem.

2. *Population.* In occupied Palestine, there lives the population of the Palestinian people; they have lived there forever, since time immemorial. They are the original inhabitants and occupants of this territory. They are fixed and determinate, and so they definitely constitute a distinguishable population. They have always been in possession of their land and are therefore entitled to create a state therein.

3. *Government.* During the course of his various public pronouncements in Europe during December of 1988, Yasser Arafat stated that currently the PLO is serving as the Provisional Government of the state of Palestine. Acting in conjunction with the Unified Leadership of the Intifadah, this Provisional Government already controls substantial sections of Palestine as well as the entire populace of Palestine. It is thus already exercising effective control over large amounts of territory and people, and is providing basic administrative functions and social services to the Palestinian people living in Palestine and abroad. This is all that is required for there to be a fulfillment of this criterion for statehood under international law.

4. *The capacity to enter into international relations.* Over ll4 states have already recognized the newly proclaimed state of Palestine, which is more than the 93 that maintain some form of diplomatic relations with Israel. Furthermore, on December 15, 1988, the United Nations General Assembly adopted Resolution 43/177, essentially recognizing the new state of Palestine and according it observer-state status throughout the United Nations Organization. That resolution was adopted by a vote of 104 in favor, the United States and Israel opposed, and 44 states abstaining. For reasons fully explained in my 1988 research paper for the PLO, such General Assembly recognition of the new state of Palestine is constitutive, definitive, and universally determinative.

Who Controls Palestine?

Some governments have so far failed to recognize the independent state of Palestine on the alleged grounds that its government supposedly does not exercise effective "control" over Palestine. Perhaps the best definition of this concept of political control or power has been provided by my former international relations teacher at the University of Chicago, the late Hans Morgenthau, in his classic book *Politics Among Nations*.[1]

> Political power is a psychological relation between those who exercise it and those over whom it is exercised. It gives the former control over certain actions of the latter through the influence which the former exert over the latter's minds. That influence derives from three sources: the expectation of benefits, the fear of disadvantages, the respect or love for men or institutions. It may be exerted through orders, threats, persuasion, the authority or charisma of a man or of an office, or a combination of any of these.

According to Morgenthau's criteria, clearly it is the PLO acting in conjunction with the Unified Leadership of the Intifadah that exercises effective control over Palestine.

Moreover, it is obvious from the public record that Israel is certainly not in control of Palestine. At best, the Israeli army makes periodic forays into inhabited areas of Palestine usually during the daytime for primarily demonstrative purposes. There it kills Palestinian civilians, especially children. But the killing of Palestinian civilians by the Israeli army is not "control," but only murder. Murder is murder, not control.

It is a basic principle of public international law as well as of all civilized legal systems in the world today that *ex iniuria non oritur ius*: Right does not arise from injury! No legal consequences whatsoever can enure to the benefit of Israel from its murder of Palestinian civilians in violation of international humanitarian law. All of the above-mentioned atrocities inflicted by the Israeli army against the Palestinian people and land in its vain attempt to suppress the intifadah violate both the customary and conventional international laws of belligerent occupation, including but not limited to the Fourth Geneva Convention of 1949 and the 1907 Hague Regulations on Land Warfare.

These grievous violations of international humanitarian law constitute "war crimes" that create personal criminal responsibility for the perpetrators. Thus, those Israeli soldiers and political leaders who have committed, ordered, condoned, or aided and abetted these war crimes against the Palestinian people can be criminally prosecuted by any state in the world community that obtains

control over them. Like unto pirates, these Israeli war criminals are *hostes humani generis*—the enemies of all humankind.

Today, the murder and extermination of the Palestinian people by Israeli occupation forces demonstrates precisely why they require an independent state of their own in order to better protect their physical existence and to preserve their cultural heritage. In the aftermath of the Second World War, identical sentiments motivated the international community to support the creation of the state of Israel for the protection of the Jewish people against a repetition of the Nazi holocaust. Despite dramatic improvements in the utility of international human rights law in direct reaction to the genocidal horrors of World War II, an independent state still remains the only effective means that the international community has so far devised to defend one national group from physical and cultural annihilation by another national group. There will be no peace in the Middle East until the Palestinian people are likewise given the opportunity to exercise their international legal right of self-determination in an independent state of their own.

Palestinian Steps Toward Peace

So the intifadah will continue until the Israeli government is willing to sit down and negotiate an overall peace settlement with the PLO. In this regard the Palestine National Council has taken several steps in the Palestinian Declaration of Independence and in the Political Communiqué attached thereto in order to establish the framework necessary for negotiating a comprehensive peace settlement with Israel. In addition, Yasser Arafat has made several public pronouncements in his official capacity as Chairman of the Executive Committee of the PLO, which is functioning as the Provisional Government of the state of Palestine. As such, Arafat's statements constitute Unilateral Declarations of Intention that are binding upon the PLO and the state of Palestine as a matter of customary international law. Indeed, Arafat has recently become the first President of the state of Palestine.

First and foremost, the Palestinian Declaration of Independence explicitly accepted the UN General Assembly's Partition Resolution 181(II) of 1947. The significance of this acceptance of partition by the Palestinian Declaration of Independence itself cannot be overemphasized. Prior thereto, from the perspective of the Palestinian people, the Partition Resolution had been deemed to be a criminal act that was perpetrated upon them by the United Nations. Today, the acceptance of the Partition Resolution in their actual Declaration of Independence signals a genuine desire by the Palestinian people to transcend the past forty years of history and now reach an historic accommodation with Israel on the basis of a two-state solution.

The very fact that this acceptance was found in the Declaration of Independence indicates the degree of sincerity with which the Palestinian people have now accepted partition. The Declaration of Independence is the foundational document for the state of Palestine. It is determinative, definitive, and irreversible. A Declaration of Independence is not something that can be amended or bargained away.

Second, in the Declaration of Independence, the Palestine National Council declared its commitment to the purposes and principles of the United Nations Charter, to the Universal Declaration of Human Rights, and to the policy and principles of nonalignment. This last commitment indicated quite clearly that the state of Palestine would be prepared to forswear any type of security treaty arrangement with the Soviet Union along the lines of the one currently in

existence between Syria and the USSR. That would eliminate any threat of a Soviet presence in the state of Palestine, a boogeyman constantly trotted out by the United States and Israel to justify their mutual hostility to an independent Palestinian state. This promise is clearly intended to be another confidence building measure for the benefit of Israel.

Third, in the Declaration of Independence, the Palestine National Council declared that without prejudice to its natural right to defend the state of Palestine, the PNC rejected "the threat or use of force, violence and intimidation against its territorial integrity and political independence or those of any other state." This latter commitment clearly applies to Israel, and was specifically intended to be yet another form of confidence building measure for its benefit.

Fourth, in the Political Communiqué attached to the Declaration of Independence, the Palestine National Council indicated its willingness to accept United Nations supervision over Palestine on an interim basis in order to terminate Israeli occupation. For example, the Palestinian plan for UN supervision could be implemented by means of a UN trusteeship imposed upon Palestine in accordance with Chapter XII of the United Nations Charter. The PNC's expressed willingness to accept temporary UN supervision (or even temporary supervision by U.S. troops) over their state is clearly intended to serve as yet another confidence building measure for the benefit of Israel.

Fifth, in the Political Communiqué, the Palestine National Council has called for the convocation of an International Peace Conference on the Middle East on the basis of UN Security Council Resolutions 242 (1967) and 338 (1973), that shall guarantee the legitimate national rights of the Palestinian people, first and foremost among which is their right to self-determination. In other words, the Palestine National Council has now explicitly accepted Resolutions 242 and 338. The PNC's solemn acceptance of Resolutions 242 and 338 represented yet another significant concession by the Palestinians for the benefit of Israel: The 1947 UN Partition Plan called for the Palestinian people to have a much larger section of historic Palestine for their state than do the 1967 boundaries set forth in Resolutions 242/338. In this regard, I should point out that Israel officially accepted the Partition Resolution in its own Declaration of Independence and as a condition for its admission to membership in the United Nations Organization. By comparison, today the PLO would be prepared to accept declared boundaries for the state of Palestine that consist essentially of the West Bank, Gaza Strip and East Jerusalem.

Sixth, in the Political Communiqué the PNC called for "Israel's withdrawal from all the Palestinian and Arab territories which it has occupied since 1967, including Arab Jerusalem." Here the PNC reiterated its willingness to accept the existence of a Palestinian state that consists of far less territory than that which had originally been allocated to the Palestinian people by the UN Partition Resolution, let alone by the League Mandate for Palestine, which would have included today's Jordan as well. Once again, the PNC officially indicated that it would be prepared to accept declared boundaries for the state of Palestine that consist essentially of the West Bank, Gaza Strip and East Jerusalem.

Seventh, in the Political Communiqué the PNC indicated its willingness to enter into a voluntary confederation between the states of Jordan and Palestine if necessary in order to produce an overall peace settlement. This clearly represents an attempt by the PNC to accommodate the wishes of both the United States and Israel that Palestine somehow be linked to Jordan, going all the way back to the Allon Plan of 1976, the Camp David Accords of 1978, and more

recently the so-called Reagan Peace Plan of 1982. Despite their strident opposition to the latter two approaches when initiated by the United States government, the Palestinian people are now prepared to accommodate the objective of establishing some type of confederal link between Jordan and Palestine. The PNC's acceptance of confederation with Jordan is intended to be yet another form of confidence building measure for the benefit of Israel.

Eighth, in the Political Communiqué, the PNC "once again states its rejection of terrorism in all its forms, including state terrorism. . ." Furthermore, on December 6, 1988, Yasser Arafat, speaking in his official capacity as Chairman of the Executive Committee of the Palestine Liberation Organization, stated that he renounced all forms of terrorism and was ready to start negotiations that would eventually lead to peace in the Middle East. Moreover, at his Geneva press conference on December 14, 1988, Arafat accepted Resolutions 242 and 338 without directly coupling them with demands for Palestinian independence; specifically named the state of Israel as having the right to exist in peace and security; and declared: "We totally and absolutely renounce all forms of terrorism including individual, group and state terrorism." With that statement, Arafat had technically fulfilled all the conditions set forth by the United States government in order for it to commence negotiations with the PLO. Apparently, the magical words the United States government wanted to hear were "renounce terrorism"; "242 and 338 as the only basis"; and "existence of Israel accepted".

Therefore, on December 14, 1988, President Ronald Reagan authorized the start of a diplomatic dialogue between the United States and the PLO. In his *Statement* on American relations with the PLO of that date, President Reagan called for "the beginning of direct negotiations between the parties, which alone can lead to such a peace." Since Reagan had just authorized direct negotiations between the United States and the PLO, the implication was quite clear that the "parties" to which Reagan was referring meant the PLO and Israel.

To the same effect were several later statements by President George Bush's Secretary of State James Baker that the Israeli government will probably have to begin negotiating a peace settlement directly with the PLO because all the Palestinian people living in Palestine and abroad recognize the PLO as their sole and legitimate representative. The long-standing hope of the United States and Israel that quislings could be found among the Palestinian people living in Palestine who would negotiate a self-styled peace settlement with Israel that would allow for the outright return of this territory to Jordanian rule has now apparently been abandoned by America. Indeed, on April 3, 1989 President George Bush bluntly stated that Israel should end its occupation of Arab lands and that the Palestinians must be given their political rights by means of an international peace conference.

Self-defense Is Not Terrorism!

Nevertheless, despite these promising statements, in June of 1990 the Bush administration invoked a pretext for suspending the dialogue between the PLO and the United States on the alleged grounds that the PLO had violated its pledge against terrorism. But the PLO has repeatedly condemned, repudiated and renounced all forms of terrorism. And self-defense is not terrorism! [See "Preserving the Rule of Law in the War Against International Terrorism" herein.]

As is true for any other state in the world today, the newly-proclaimed state of Palestine possesses the inherent right of individual and collective self-defense recognized by customary international law and article 51 of the United

Nations Charter. As the Provisional Government of the state of Palestine, the PLO has the absolute right to use force in self-defense in order to terminate Israel's illegal occupation of Palestinian territory and to protect all Palestinian people around the world from Israeli aggression. Moreover, the Palestinian people actually living under this criminal occupation have the perfect right under international law to resist the Israeli army by the use of force, just as the French Resistance did against the Nazi forces occupying France during the Second World War.

In recognition of this fundamental right of organized civilian resistance movements to use force against an army of occupation, article 4 of the Third Geneva Convention of 1949 provided that its members must be treated as prisoners of war, not criminals or terrorists, in the event such individuals fall into the hands of the occupying army. In other words, the intifadah resisters are privileged to engage in armed combat under the customary and conventional laws of war and are therefore entitled to all the rights, privileges and immunities afforded to soldiers fighting in an international armed conflict, which this certainly is. The same principles hold true for PLO fighters living abroad who engage in armed combat against Israeli military targets located anywhere.

As would be true for any other state in the world community, however, the government of Palestine must exercise its right of self-defense in accordance with the laws and customs of warfare and international humanitarian law. These standards for the legitimate conduct of armed hostilities can be found, essentially, in the Four Geneva Conventions of 1949 and the Hague Regulations on Land Warfare of 1907, among others. So, in recognition of these basic international legal obligations, the PLO ratified the Four Geneva Conventions of 1949 on behalf of the state of Palestine during the summer of 1989. The PLO transmitted its instrument of ratification to the government of Switzerland, which is the official depositary for the Geneva Conventions. Yet, because of massive overt pressure mounted by the United States government, the Swiss government did not formally accept the PLO's instrument of ratification. This nefarious episode was a severe setback to the sacred cause of promoting international humanitarian law as well as to the safety and well-being of innocent civilians living in Palestine, Jerusalem, and Israel.

Despite this technical problem, the PLO has provided every indication that it will adhere to the laws and customs of warfare and international humanitarian law in its legitimate defense of the Palestinian people and land from Israeli aggression and criminal occupation practices. Thus, in the event that any Palestinian fighters subject to the control of the PLO have been found to have violated these rules, the PLO must discipline them. Under the international laws of armed conflict, however, the PLO is not responsible for the behavior of any fighters who are not subject to its direct supervision. Nevertheless, should such fighters have committed grave violations of the laws and customs of warfare and subsequently come under its control, the PLO must discipline them as well. These are precisely the same obligations that would apply to the government of any other state in the world engaged in a war of self-defense.

By contrast, the Israeli government has absolutely refused to apply the Four Geneva Conventions of 1949 and the 1907 Hague Regulations, inter alia, to its occupation of Palestine and to its conduct of hostilities against the Palestinian people. According to common article 1 of the Four Geneva Conventions of 1949, every state of the world community is obliged to bring to bear whatever pressure it can upon the Israeli government to terminate its violation of these sacred Conventions: "The High Contracting Parties undertake to respect and to ensure

respect for the present Convention in all circumstances." Indeed, after twenty-three years of an incredibly inhumane, callous and brutal military occupation, the only really effective manner for all 166 states that are parties to the Geneva Conventions to discharge their solemn obligation to ensure respect for the terms of the Fourth Convention by Israel would be for them to compel Israeli military forces to withdrawal immediately from Palestine and Jerusalem, and then to turn these lands over to a United Nations peacekeeping force for temporary supervision pending the conclusion of a comprehensive peace settlement.

In particular, the government of the United States is obliged to demand that Israel adhere to the terms of the Four Geneva Conventions of 1949 and the 1907 Hague Regulations during the course of its war against the Palestinian people and land, which America has rarely and only superficially done. The American government, Congress, and people have a special obligation to demand Israeli adherence to the laws and customs of warfare and international humanitarian law because it is only by means of weapons, equipment, supplies, loans, grants, and tax deductions provided by the United States that Israel is enabled to wage aggressive war against the Palestinian people and land, as well as to commit these grievous violations of international humanitarian law. The American people must not allow their government to continue acting to aid and abet Israel's commission of war crimes against the Palestinian people. For these reasons, then, there was an overwhelming degree of hypocrisy manifest in the Bush administration's decision to suspend its dialogue with the PLO while it continues to finance Israeli atrocities against the Palestinian people and land.

The Framework for Negotiating a Comprehensive Middle East Peace Settlement

On the same day the UN General Assembly essentially recognized the state of Palestine and accorded it observer-state status, it had also adopted Resolution 43/176 calling for the convocation of an international peace conference on the Middle East under the auspices of the United Nations with the participation of all parties to the conflict including the Palestine Liberation Organization, on an equal footing, and the five permanent members of the UN Security Council, based on Security Council Resolutions 242 (1967) and 338 (1973) and the legitimate national rights of the Palestinian people, "primarily the right to self-determination." This resolution was adopted by a vote of 138 in favor, the United States and Israel opposed, with Canada and Costa Rica abstaining.

Therein the General Assembly identified the following principles for the achievement of a comprehensive Middle East peace settlement:

3. *Affirms* the following principles for the achievement of comprehensive peace:

(a) The withdrawal of Israel from the Palestinian territory occupied since 1967, including Jerusalem, and from the other occupied Arab territories;

(b) Guaranteeing arrangements for security of all States in the region, including those named in resolution 181 (II) of 29 November 1947, within secure and internationally recognized boundaries;

(c) Resolving the problem of the Palestine refugees in conformity with General Assembly resolution 194 (III) of 11 December 1948, and subsequent relevant resolutions;

(d) Dismantling the Israeli settlements in the territories occupied since 1967;

4. *Notes* the expressed desire and endeavours to place the Palestinian territory occupied since 1967, including Jerusalem, under the supervision of the United Nations for a limited period, as part of the peace process;

5. *Requests* the Security Council to consider measures needed to convene the International Peace Conference on the Middle East, including the establishment of a preparatory committee, and to consider guarantees for security measures agreed upon by the Conference for all States in the region; . . .

In the professional opinion of this author, this General Assembly resolution—that was drafted with the full knowledge, cooperation, and approval of the PLO—contains the basic elements for achieving a comprehensive peace settlement between Israel, on the one hand, and Palestine, Jordan, Syria, Lebanon, and the other Arab states, on the other.

Finally, in another major breakthrough toward peace, on March 22, 1989 a PLO official who had just met that day with the U.S. Ambassador to Tunisia designated for conducting official American talks with the PLO, indicated that the PLO would be willing to engage in bilateral negotiations directly with Israel as a complement to an international peace conference that would lead to the liberation of the Palestinian state from Israeli occupation. If such direct negotiations between Israel and the PLO should occur, then a separate set of negotiations directly between Israel and Syria could deal with the permanent demilitarization of the Golan Heights and their return to Syria. Both sets of direct negotiations could occur within the overall framework of an international peace conference held under the auspices of the UN Security Council, which ultimately will have to approve and guarantee whatever peace settlements are finally reached between the parties directly concerned.

Any troop withdrawals, territorial rearrangements and demilitarization regimes will have to be supervised by a semi-permanent UN Middle East peacekeeping force organized under Chapter VII of the UN Charter and reporting directly to the Security Council through the medium of the UN Secretary General. This force could not be removed without the Security Council's approval, including all five permanent members, each of which would retain indefinitely a veto power over the removal of the force. In that manner, the U.S. government alone could prevent the hasty departure of the force in the face of threatened hostilities.

This would solve the problem that occurred in 1967 when UN Secretary General U Thant withdrew UNEF (I) from the Sinai. The UN General Assembly had organized UNEF (I) in 1956 as a peacekeeping force under Chapter VI of the

UN Charter. But the General Assembly has never had the ability to enforce its will against recalcitrant states. By contrast, the members of the Security Council can legally, politically, and if necessary, militarily impose their will upon aggressive states by virtue of Charter article 25 and their enforcement powers under Chapter VII.

Finally, the U.S. government should be prepared to provide bilateral guarantees of an overall peace settlement to Israel, Palestine, Jordan, Lebanon, and Syria, if so requested. The Carter administration essentially did this in order to procure the 1979 Israeli-Egyptian Peace Treaty that was based upon the 1978 Camp David accords. If Israel so desires, the U.S. government should also be prepared to enter into a mutual defense treaty with Israel modeled along the lines of article 5 of the 1949 North Atlantic Treaty to the effect that "an armed attack against" Israel "shall be considered an attack against" the United States.

A U.S. guarantee once kept the completely surrounded and beleaguered City of Berlin free and open for 45 years. It should be able to do the same for the heavily militarized state of Israel. Indeed, the effectual truth of the matter is, however, that as part of a comprehensive Middle East peace settlement, it shall prove to be the Palestinian state and people who will really require effective international security guarantees against a renewal of Israeli aggression and expansion. Witness General Ariel Sharon's savage attack against Beirut, Lebanon during the Summer of 1982 in violation of explicit promises given by Israel to the United States that culminated in the wholesale massacre of several hundred innocent Palestinian and Lebanese civilians at the Sabra and Shatilla refugee camps by Phalange militia units working in cooperation with the Israeli army.

A Solution for Jerusalem

In this regard, various individuals and organizations have given an ominous interpretation to the fact that the Palestinian people proclaimed Jerusalem to be their capital. Although I am not authorized to speak for the PLO, I know that they are certainly prepared to be flexible with respect to negotiating over the ultimate status of Jerusalem. In all fairness, however, I should point out that neither Israel nor Palestine nor both together have the basic right under international law to dispose of Jerusalem. Rather, the 1947 UN Partition Resolution called for the creation of an international trusteeship for the City of Jerusalem that would be administered as a *corpus separatum* apart from both the Jewish state and the Arab state contemplated therein. [This issue is discussed in further length in "The Future Peace of Jerusalem," herein.]

Human Impediments to Peace

Quite obviously, a remarkable opportunity for peace with justice for all peoples in the Middle East has been created by the Palestinian Declaration of Independence, its attached Political Communiqué, and subsequent public statements made by Yasser Arafat acting in his official capacity. Historically, it is now possible for there to occur a comprehensive Middle East peace settlement on the fundamental basis of the two-state solution that was originally envisioned and mandated by the United Nations in its 1947 Partition Resolution, and as supplemented by Security Council Resolutions 242 (1967) and 338 (1973). All the elements for peace are now in place. What is needed today from the Bush administration is the same type of dynamic leadership and will for peace that was demonstrated by the Carter administration over a decade ago.

Unfortunately, despite these monumental steps toward peace taken by the Palestinian people, it is clear from the public record that the Israeli govern-

ment requested the Bush administration to divert the flow of Soviet Jewish immigrants from the United States to Israel expressly for the purpose of moving these people into Palestine and Jerusalem, and the U.S. government readily acquiesced. As Israeli Prime Minister Yitzhak Shamir publicly admitted, a "great aliyah" requires a "greater Israel." Of course, technically speaking, the vast majority of these Soviet Jewish citizens did not have a right to settle in the United States under international law or United States domestic law because most of them were economic migrants. Yet, they had been allowed into the United States because of domestic political pressures mounted by the Israel lobby and its supporters in Congress and the Executive Branch of the federal government.

The strongest argument that can be made against allowing the immigration of people from the Soviet Union to Palestine and Jerusalem can be based upon the Fourth Geneva Convention of 1949. In particular, article 49 thereof provides as follows: "The Occupying Power shall not deport or transfer parts of its own civilian population into the territory it occupies." Furthermore, common article 1 provides that all state parties to the Four Geneva Conventions undertake to respect and to ensure respect for the Geneva Conventions by all other state parties "in all circumstances."

Therefore, the Soviet Union is under an absolute obligation to prevent Israel from transferring Soviet Jewish citizens from Israel into Palestine and Jerusalem, for any reason. Furthermore, the Soviet Union has an absolute obligation under the Fourth Geneva Convention to prevent its Jewish citizens from traveling directly or indirectly to Israel so long as the Soviet government knows that any of them are settling in the West Bank, Jerusalem, Gaza Strip, Golan Heights, etc. Similarly, those European states that are parties to the Fourth Geneva Convention such as Poland, Hungary, Finland, Austria, etc. are also under an absolute obligation to prevent Soviet Jewish citizens from transiting through their territories to Israel for the purpose of settling in Palestine and Jerusalem.

As far as can be told, approximately ten percent of these recent Soviet Jewish citizens immigrating to Israel eventually settle in East Jerusalem, the West Bank, or Gaza Strip. Moreover, that estimate of ten percent does not include West Jerusalem, which itself is deemed to be occupied territory subject to the international laws of belligerent occupation that prohibit such activities as well. In other words, the true extent of illegal settlement activity by Soviet Jewish citizens in Palestine and Jerusalem is undoubtedly much higher than ten percent.

Recent reports in the *Wall Street Journal* and the *New York Times* indicate that over one million Soviet Jews have requested exit visas. Also, there is currently a campaign underway by the Israeli government working in conjunction with American Zionist groups to systematically scare almost the entire Jewish population out of the Soviet Union and into Israel and Palestine by manipulating charges of anti-Semitism and fears of anti-Jewish pogroms.

The implications of this strategy are quite clear:

According to the calculations of the Israeli government, if it can obtain the mass migration of over one million Soviet Jews to Israel, and then convince at least ten percent of these individuals (i.e., over one hundred thousand people or so) to live in Palestine and Jerusalem, then it will have successfully created yet another *fait accompli* that, in its opinion, would make peace negotiations with the PLO or the Palestinian people unnecessary. Moreover, with the flow of Soviet Jewish citizens to Israel and Palestine now at the rate of approximately 12,000 people per month, there is no incentive for any government in Israel to negotiate in good faith with the PLO or even non-PLO Palestinians for any reason. So long

as this massive flow of Soviet Jewish immigrants to Israel, Palestine and Jerusalem continues unabated, even renewed talks between the U.S. government and the PLO in Tunis or elsewhere will probably go nowhere and, indeed, could easily become counterproductive in the sense of providing a thin veneer of pseudo-legitimacy to this entire process of creeping annexation of Palestine.

Soviet Immigration to Palestine Violates International Law

To be sure, according to article 13(2) of the Universal Declaration of Human Rights, Soviet Jews have the basic right under international law to leave the Soviet Union. But according to the terms of the Fourth Geneva Convention, they cannot live in Palestine and Jerusalem. And the Soviet government cannot permit large numbers of its own citizens to leave the country knowing full well that ten percent or more of them will live in Palestine and Jerusalem in violation of the Fourth Geneva Convention of 1949. It is this fundamental distinction that must be brought home in no uncertain terms to the Soviet Union as well as to those other European states that are currently serving as transhipment points for the immigration of Soviet Jewish citizens to Israel, Palestine, and Jerusalem.

Of course, the Soviet Union has never accepted the Universal Declaration of Human Rights as binding upon it as a matter of positive international law. So it does not seem likely that the Soviet government has permitted the current mass emigration of its Jewish citizens for primarily humanitarian reasons. Rather, the better explanation is Soviet President Mikhail Gorbachev's desire to secure a Most-Favored-Nation (MFN) Agreement on trade with the United States of America. That MFN Agreement between the two countries was just signed by Presidents Bush and Gorbachev at their recently concluded Washington Summit at the end of May 1990. Nevertheless, under article 1, section 8, clause 3 of the United States Constitution, that MFN Agreement must still be approved by both Houses of the U.S. Congress since it relates to foreign trade.

The Israel lobby has always made it quite clear that the Soviet Union would be unable to obtain an MFN Agreement from the United States Congress unless it was willing to permit almost all of its Jewish citizens to emigrate. Therefore, in order to get the MFN Agreement, the Soviet Union has apparently decided to permit almost all of its Jewish citizens to leave for Israel, Palestine, and Jerusalem. Nevertheless, despite the importance of an MFN Agreement to the Soviet Union, it still might be possible to convince the Soviet government to take effective measures to terminate its aiding and abetting these Israeli violations of the Fourth Geneva Convention.

Moreover, in this regard it should also be pointed out to the Soviet Union that as yet another express condition for its admission to the United Nations Organization, the government of Israel officially endorsed and agreed to carry out the aforementioned UN General Assembly Resolution 194(III) of 1948, which determined that Palestinian refugees have the right to return to their homes, or that compensation should be paid to those who choose not to. Furthermore, that same article 13(2) of the Universal Declaration of Human Rights which Soviet Jews rely upon to justify their emigration from the Soviet Union provides that: "Everyone has the right . . . to return to his country." That absolute right of return clearly applies to Palestinian refugees living in their diaspora who want to return to their homes in Israel, Palestine, and Jerusalem.

The state of Israel owes a prior legal obligation to resettle Palestinian refugees who want to return home before it undertakes the massive resettlement of Soviet Jewish citizens from the Soviet Union. *A fortiori*, since Israel has stated

that it is now prepared to resettle over one million Soviet Jewish citizens, it certainly has both the capability and the obligation to fulfill its outstanding commitment to resettle at least one million Palestinian refugees to their homeland. If Israel were to express its willingness to resettle one million Palestinian refugees at this time, that gesture would go a long way toward the facilitation of an overall peace settlement between Israel, on the one hand, and the Palestinian people, on the other.

Conclusion

Due to the gravity and immediacy of this Soviet immigration crisis, Arab and Islamic states must launch vigorous efforts to have the entire international community demand that the Soviet Union live up to its obligations under the Fourth Geneva Convention in regard to Palestine and Jerusalem. According to article 1 thereof, any state party to this Convention has both the right and the duty to protest to the Soviet Union that its policies with respect to the immigration of Soviet Jewish citizens to Palestine violate article 49. Likewise, all 166 state parties to the Geneva Conventions have both the right and the duty to lodge similar protests with those other countries in Europe that are willingly serving as transhipment points for Soviet Jewish immigrants to Israel, Palestine, and Jerusalem.

Arab and Islamic states should be able to mobilize international public opinion around this basic proposition, and then bring this pressure to bear upon the governments of the Soviet Union, Poland, Hungary, Finland, Austria and any other country that contemplates playing a role in the movement of Soviet Jewish citizens to Israel, Palestine, and Jerusalem. In this endeavor, they could also request the assistance of the International Committee of the Red Cross (ICRC). The UN General Assembly should request an Advisory Opinion from the International Court of Justice condemning all of these practices as a violation of the Fourth Geneva Convention and therefore a "war crime" that creates personal criminal responsibility for the perpetrators under international law. Finally, the UN General Assembly must give serious consideration to invoking its Uniting for Peace Resolution of 1950 against Israel in order to redress the deteriorating human rights situation in Palestine and Jerusalem.

In any event, the time for the international community to organize and act is now before it becomes too late for the Palestinian people. The goal of obtaining peace with justice for all peoples in the Middle East can only be achieved on the basis of a two-state solution for the Palestinian people and the Jewish people, respectively. Failure by the governments of Israel, the United States, and the Soviet Union to seize this historic moment for peace will only make another general war in the Middle East an inevitability.

ENDNOTES

1. Hans Morgenthau, Politics Among Nations 27 (4th ed. 1967).

The Future Peace of Jerusalem

Many categorical statements have emanated from the Israeli government about the yet-to-be-negotiated final status of Jerusalem. Indeed, Jerusalem was said to have been the stumbling block that led to the breakdown of the Camp David II negotiations in the summer of 2000, though the negotiating situation was far more complicated than that. A brief review of the historical record can shed some light upon Jerusalem's legal status, and thus point the way towards an ultimate solution for this most Holy City in the estimation of the three monotheistic faiths: Islam, Judaism, Christianity.

The Legal Status of Jerusalem

On September 25, 1971, then-Ambassador George H.W. Bush, speaking as U.S. Representative to the United Nations, delivered a formal *Statement on Jerusalem* before the UN Security Council explaining the official position of the United States government with respect to the City of Jerusalem.[1] Therein, Ambassador Bush expressly repeated and endorsed a December 1969 Statement by U.S. Secretary of State William Rogers: "We have made clear repeatedly in the past two and one-half years that we cannot accept unilateral actions by any party to decide the final status of the city."

Ambassador Bush then specifically repeated and endorsed a 1969 statement made before the Security Council by his predecessor, Charles Yost, criticizing Israeli occupation policies in East Jerusalem in the following terms: "The expropriation or confiscation of land, the construction of housing on such land, the demolition or confiscation of buildings, including those having historic or religious significance, and the application of Israeli law to occupied portions of the city are detrimental to our common interests in the city." Ambassador Bush then reaffirmed Yost's prior statement that the United States government considers East Jerusalem to be "occupied territory and hence subject to the provisions of international law governing the rights and obligations of an occupying Power." Succinctly put, these latter obligations can be found in the Fourth Geneva Convention of 1949, which expanded upon and improved—but did not displace— the 1907 Hague Regulations on Land Warfare. The United States government is a party to both the Fourth Geneva Convention and The Hague Regulations, and Israel is bound by the terms of both treaties as well.

Previously, Ambassador Yost had continued his 1969 statement in the following language:[2]

> ...Among the provisions of international law which bind Israel, as they would bind any occupier, are the provisions that the occupier has no right to make changes in laws or in administration other than those which are temporarily necessitated by his security interests, and that an occupier may not confiscate

or destroy private property. The pattern of behavior authorized under the Geneva Convention of 12 August 1949 and international law is clear: the occupier must maintain the occupied area as intact and unaltered as possible, without interfering with the customary life of the area, and any changes must be necessitated by the immediate needs of the occupation. I regret to say that the actions of Israel in the occupied portion of Jerusalem present a different picture, one which gives rise to understandable concern that the eventual disposition of East Jerusalem may be prejudiced and that the private rights and activities of the population are already being affected and altered.

My Government regrets and deplores this pattern of activity, and it has so informed the Government of Israel on numerous occasions since June 1967. We have consistently refused to recognize those measures as having anything but a provisional character and do not accept them as affecting the ultimate status of Jerusalem.

Then, Ambassador Bush continued his 1971 Statement as follows:

We regret Israel's failure to acknowledge its obligations under the fourth Geneva Convention as well as its actions which are contrary to the letter and spirit of this Convention. We are distressed that the actions of Israel in the occupied portion of Jerusalem give rise to understandable concern that the eventual disposition of the occupied section of Jerusalem may be prejudiced. The Report of the Secretary General on the Work of the Organization, 1970-71, reflects the concern of many Governments over changes in the face of that City. We have on a number of occasions discussed this matter with the Government of Israel, stressing the need to take more fully into account the sensitivities and concerns of others. Unfortunately, the response of the Government of Israel has been disappointing.

All of us understand...that Jerusalem has a very special place in the Judaic tradition, one which has great meaning for Jews throughout the world. At the same time Jerusalem holds a special place in the hearts of many millions of Christians and Moslems throughout the world. In this regard, I want to state clearly that we believe Israel's respect for the Holy Places has indeed been exemplary. But an Israeli occupation policy made up of unilaterally determined practices cannot help promote a just and lasting peace any more than that cause was served by the status quo in Jerusalem prior to June 1967 which, I want to make clear, we did not like and we do not advocate re-establishing.

Ambassador Bush then concluded his 1971 statement on Jerusalem by supporting what would later that day become Security Council Resolution 298 (1971), which provided in its most significant parts as follows:

. . ..

Reaffirming the principle that acquisition of territory by military conquest is inadmissible,

....

2. *Deplores* the failure of Israel to respect the previous resolutions adopted by the United Nations concerning measures and actions by Israel purporting to affect the status of the City of Jerusalem;

3. *Confirms* in the clearest possible terms that all legislative and administrative actions taken by Israel to change the status of the City of Jerusalem, including expropriation of land and properties, transfer of populations and legislation aimed at the incorporation of the occupied section, are totally invalid and cannot change that status;

4. *Urgently* calls upon Israel to rescind all previous measures and actions and to take no further steps in the occupied section of Jerusalem which may purport to change the status of the City or which would prejudice the rights of the inhabitants and the interests of the international community, or a just and lasting peace;

....

Security Council Resolution 298 (1971) became yet another violated resolution in "a long Train of Abuses and Usurpations" by Israel that were never enforced by the Security Council.[3]

In any event, the Statements made by Bush and Yost have always represented the United States government's official position on the numerous illegalities surrounding Israel's conquest, occupation and illegal annexation of East Jerusalem since 1967. The comments on East Jerusalem that Bush made later in 1990 as U.S. President were to the same effect:[4]

The President. Well, I'm not sure there was equivocation. My position is that the foreign policy of the United States says we do not believe there should be new settlements in the West Bank or in East Jerusalem. And I will conduct that policy as if it's firm, which it is, and I will be shaped in whatever decisions we make to see whether people can comply with that policy. And that's our strongly held view. We think it's constructive to peace— the peace process—if Israel will follow that view. And so, there's divisions in Israel on this question, incidentally. Parties are divided on it. But this is the position of the United States and I'm not going to change that position.

Yost's 1969 Statement, Bush's 1971 Statement, and his 1990 comments are fully consistent with and indeed required by Article 1 of the Fourth Geneva Convention, which requires the United States government not only to respect but also to ensure respect for the terms of this Convention by other parties such as Israel "in all circumstances". As treaties, both the Fourth Geneva Convention and the Hague Regulations are deemed to be the "supreme Law of the Land" by Article VI of the United States Constitution. Contrary to the public

suggestions made in the United States by the Israel Lobby and its supporters, the United States government is under legal obligation to support the vigorous application of the international laws of belligerent occupation to produce the termination of all illegal Israeli practices in Jerusalem as well as in the West Bank and Gaza Strip, together with the Golan Heights—including and especially illegal Israeli settlers and settlements.

The Political Problem of Jerusalem

For similar reasons, the United States government has never recognized Israel's conquest and annexation of West Jerusalem as valid or lawful, either. That is why the U.S. Embassy to Israel still remains in Tel Aviv, not Jerusalem. Nevertheless, the pro-Israel lobby in the United States and its beneficiaries in the U.S. Congress have systematically attempted to pressure successive U.S. Presidents into recognizing Jerusalem as the capital of Israel, even though such an act would enflame public opinion throughout the Muslim world—over 57 states and 1 billion people, a sixth of all humanity—against the United States. Such an act of formal diplomatic recognition would be a legal, political and diplomatic disaster that would prevent a peace agreement between Israel and Palestine and thus preclude a comprehensive Middle East peace settlement between Israel and the surrounding Arab states. Perhaps that is the Israel Lobby's intention.

Undaunted, the U.S. Israel Lobby has continued apace bribing, threatening, and intimidating members of the U.S. Congress and the President to move incrementally towards an awesome "clash of civilizations" between the United States and the Muslim world over Jerusalem as forecast by Harvard's Samuel Huntington.[5] No point would be served here by reviewing the sordid history of the U.S. Israel Lobby's efforts to move the U.S. Embassy from Tel Aviv to Jerusalem since that saga has recently been recounted elsewhere.[6] Suffice it to say that the U.S. Israel Lobby procured passage by Congress of the so-called Jerusalem Embassy Act in 1995.[7] Among other outrages too numerous to analyze here, section 3 of this statute provided in relevant part as follows:

> STATEMENT OF THE POLICY OF THE UNITED STATES
>
> (2) Jerusalem should be recognized as the capital of the State of Israel; and
> (3) The United States Embassy in Israel should be established in Jerusalem no later than May 31, 1999.

Article 1, Section 10, Clause 1 of the United States Constitution has historically been interpreted to mean that such acts of diplomatic recognition are to be performed by the President. In deference thereto, Congress employed the word "should" instead of "shall" in the statute.

Nevertheless, in section 3(b) thereof Congress did wield its well-recognized constitutional "power of the purse" to cut State Department funding for "Acquisition and Maintenance of Buildings Abroad" unless and until "the United States Embassy in Jerusalem has officially opened." But section 7 of the Statute permits the President to waive this fiscal sanction every six months on the grounds that "such suspension is necessary to protect the national security interests of the United States." So far that is what President Clinton and President Bush Jr. have consistently done.

Dissatisfied with Congressional support which, while submissive to Zionist demands, had not yielded changes in actual U.S. policy, the Israel lobby proceeded to procure the passage of an even more strictly tailored piece of legislation that in a nutshell requires the U.S. President to recognize Jerusalem as the capital of Israel on official U.S. government documents, once again upon pain of fiscal sanctions—so-called "paper recognition".[8] While President Bush Jr. stated that he will ignore this requirement on the grounds that it is unconstitutional—infringing upon the President's constitutional power to perform such acts of diplomatic recognition—there was such an uproar throughout the Muslim world over this "paper recognition" of Jerusalem as being the capital of Israel by the United States Congress that the Arab TV Network Al Jazeera invited this author to appear live by satellite on their evening news program for Thursday, 17 October 2002 in order to critique this statute under U.S. constitutional law and under international law, as well as to explain how this statute fits within the overall conduct of U.S. foreign policy toward the Middle East and the Muslim world. In further reinforcement of the deleterious effects that changes in U.S. policy on Jerusalem have on U.S. interests—as opposed to those of Israel—on 29 October 2002 CNN reported that a U.S. diplomat had been murdered the previous day in Amman, Jordan because of this statute's recognition of Jerusalem as the capital of Israel.

Clearly, it is doubtful that the Israel Lobby will be satisfied with Bush Jr.'s statement that he will ignore Congress's "paper recognition" of Jerusalem as the capital of Israel. But it is not clear that President Bush Jr. will really honor his pubic commitment to ignore this legislation. The battle for Jerusalem will continue in Washington, DC as well as in the streets of Palestine, Israel, and elsewhere.

A Solution for Jerusalem

The 1947 United Nations Partition Plan for the Mandate of Palestine called for the creation of an international trusteeship for the City of Jerusalem that would be administered as a *corpus separatum* apart from both the Jewish state and the Arab state contemplated therein. Today, however, it would not be necessary to go so far as to establish a separate United Nations trusteeship for the City of Jerusalem alone under Chapter XII of the UN Charter. Rather, all that would be necessary would be the withdrawal of the Israeli army from the City of Jerusalem, with a United Nations peacekeeping force to be substituted in its place. This UN force would maintain security within the City of Jerusalem while the provision of basic services to all the inhabitants could be enhanced, especially for the Palestinians.

The simple substitution of a UN peacekeeping force for the Israeli army would have the virtue of allowing both Israel and Palestine to continue making whatever claims to sovereignty they want with respect to the City of Jerusalem. Thus, Israel could continue to maintain that Jerusalem is the sovereign territory of Israel, its united capital, and shall remain so, one and undivided, forever. The Israeli Knesset could remain where it is, in territory designated as a capital district, and the Israeli flag could be flown anywhere throughout the City of Jerusalem.

Likewise, the State of Palestine could maintain that Jerusalem is its sovereign territory and capital and shall remain so, one and undivided, forever. Palestine would be entitled to construct a parliament building and capital district within East Jerusalem. The Palestinian flag could also be flown anywhere within the territorial confines of the City of Jerusalem. Both Israel and Palestine would be entitled to maintain ceremonial honor guards, perhaps armed with revolvers, at their respective capital districts. But no armed troops from either Israel or

Palestine would be permitted within Jerusalem.

The residents of Jerusalem would be citizens of either Israel, or Palestine, or both, depending upon the respective nationality laws of the two states involved. Residents of Jerusalem would be issued a United Nations identity card to that effect, which would give them and only them the right to reside within the City of Jerusalem. Nevertheless, all citizens of the State of Palestine would be entitled to enter Jerusalem through UN checkpoints at the eastern limits of the city. Likewise, all citizens of the State of Israel would be entitled to enter Jerusalem at UN checkpoints located at the western limits of the city. Yet, mutual rights of access for their respective citizens to the two States through Jerusalem would be subject to whatever arrangements could be negotiated between the government of Israel and the government of Palestine as part of an overall peace settlement. The myriad of other complex issues related to Jerusalem and its inhabitants would be progressively negotiated in good faith between the governments of Palestine and Israel under the auspices of the United Nations Organization.

In addition, both Israel and Palestine would have to provide assurances to the United Nations Security Council that religious pilgrims (Muslims, Christians, and Jews) would be allowed access through their respective territories in order to visit and worship at the holy sites in the City of Jerusalem. Some type of UN transit visa issued by the UN peacekeeping force should be deemed to be sufficient for this purpose by both governments. Of course this right of transit could not be exercised in a manner deleterious to the security interests of the two States.

Thus, Jerusalem would become a free, open, and undivided city for pilgrimage and worship by people of the three monotheistic faiths from around the world. Neither Israel nor Palestine would have to surrender whatever rights, claims, or titles they might assert to the city. Security would be maintained by the United Nations peacekeeping force. The city of Jerusalem would remain subject to this UN regime for the indefinite future.

If a comprehensive Middle East peace settlement were to be negotiated along these lines, then it would be perfectly appropriate under international law for the United States government to move its Israeli Embassy from Tel Aviv to Jerusalem. There the U.S. Embassy could be simultaneously accredited to the State of Palestine as well as to the State of Israel. The same could be done by all other states in the international community. The presence of these embassies in Jerusalem under such circumstances would permit both Israel and Palestine to claim that the entire international community has now recognized Jerusalem as its capital.

Conclusion

There are many other historical precedents that could be drawn upon to produce a mutually acceptable arrangement for Jerusalem: *e.g.,* the Free City of Danzig, the Vatican City State, the District of Columbia, United Nations Headquarters in New York City, etc. So determining the final status of the city of Jerusalem is not and has never been an insuperable obstacle to obtaining a comprehensive Middle East peace settlement—despite Israeli rhetoric and propaganda to the contrary. If the will for peace were there on the part of the Israeli government, then creative lawyers on each side can devise an artful arrangement for the city of Jerusalem that would allow both peoples to claim victory while achieving peace. In fact, several years ago I drafted a formal proposal similar to the above-described

solution for consideration by the PLO. A high-level PLO official informed me that this proposal was acceptable to the PLO. So far, it has proved to be unacceptable to Israel, which continues to stubbornly insist that Jerusalem shall remain its "sole", "undivided" and "eternal" capital despite all the rules of international law to the contrary and the fact that in the Oslo Agreement of 13 September 1993, Israel expressly agreed in writing to negotiate over the final status of Jerusalem with the PLO. You do not expressly agree to negotiate with your adversary over "your", "sole", "undivided", "eternal" "capital" if it is really *yours*! The time has long past for Israel to put aside its relentless rhetoric and propaganda about Jerusalem, and negotiate in good faith with the Provisional Government of the state of Palestine over the ultimate disposition of Jerusalem. The Palestinians have repeatedly demonstrated their will for peace. So far, the Israeli government has only demonstrated its will to power. But when it comes to Jerusalem—Jews, Muslims, and Christians: "Can't we all get along?" I sincerely believe we can.

ENDNOTES

1. U.N. SCOR, 26th Sess., 1582nd mtg. at 33, U.N. Doc. S/Agenda/1582 (1971).
2. U.N. SCOR 24th Sess., 1483nd mtg. at 11, U.N. Doc. S/Agenda/1783 (1969).
3. For a list of Security Council Resolutions against Israel as of 1995, see Paul Findley, Deliberate Deceptions 187-94 (1995). See also Paul Findley, They Dare To Speak Out (1989).
4. 26 Weekly Comp. Pres. Doc. 357 (Mar. 3 1990).
5. Samuel P. Huntington, The Clash of Civilizations and the Remaking of World Order (1996).
6. See Walid Khalidi, The Ownership of the U.S. Embassy Site in Jerusalem (2000).
7. Jerusalem Embassy Act of 1995, Pub. L. No. 104-45, 109 Stat. 398 (1995).
8. Foreign Relations Authorization Act, Pub.L. No. 107-228, §214, 116 Stat 1350 (2002).

The Palestinian Alternative to Oslo

Editor's Note from *Arab Studies Quarterly*, Vol. 22, No. 3, p. 1, (Summer 2000):

"With the Final Status negotiations between the Israelis and the Palestine National Authority apparently near, the background concerning them becomes critical. The editors of Arab Studies Quarterly felt that its readership would benefit from the confidential arguments presented in the following memorandum which was presented to the Palestinian Delegates to the Middle East Peace Negotiations on 1 December 1992. The memorandum was written by Francis A. Boyle, a well-known and respected University of Illinois Professor of International Law. The editors became aware of the Boyle document through an article in Inquiry by Bilal al-Hasan, member of the PLO's National Council and a noted journalist, published in the Spring of 1994. Al-Hasan makes clear reference to the turning down of Boyle's expert legal advice. Boyle, in his memorandum, went to great lengths in advising the Palestinian delegation regarding the multiple legal traps which the American administration has set for it. Had Boyle's expert advice been followed, perhaps the Palestinian National Authority would have extracted a much stronger settlement for their people in the negotiations. Having obtained Boyle's document, Arab Studies Quarterly *is publishing the entire document, which begins on Page 2, without comment."*

<div align="center">

MEMORANDUM OF LAW

</div>

DECEMBER 1, 1992

FROM: PROFESSOR FRANCIS A. BOYLE

TO: THE PALESTINIAN DELEGATES TO THE MIDDLE EAST PEACE
 NEGOTIATIONS

SUBJECT: *THE INTERIM AGREEMENT AND INTERNATIONAL LAW*

DEAR FRIENDS:

I. INTRODUCTION.

The Assignment.

1. About five weeks ago the Head of the Palestinian Delegates, Dr. Haidar Abdul Shaffi, invited me to come out to Washington, D.C. in order to consult

with you on numerous legal issues related to the so-called Interim Agreement. I spent two weekends in a row meeting with many of you, including Dr. Shaffi, and answering your many questions on various issues related to the Interim Agreement and international law. Dr. Shaffi has kindly requested me to provide a formal Legal Opinion that would attempt to develop a unified position on these issues for the members of the Delegation to consider and adopt. In addition, I have been told that this Legal Opinion would also be forwarded to the Political Leadership of the Palestinian people in Tunis for their consideration as well. This Memorandum of Law is intended to discharge the request that has been made to me by Dr. Shaffi as well as by many other members of the Delegation.

The Qualifications.

2. I have prepared this Memorandum on the basis of the questions that you have all posed to me during those two weekends. I will attempt to pull together all the advice that I have given to each of you in this one Memorandum. Please understand, however, that these are only my tentative thoughts on the Interim Agreement. Due to your time deadline and my teaching constraints, I have not had the opportunity to engage in scholarly research upon any of these points. Therefore, if you agree with me, all of the points that I make here will need to be fleshed out by you during the course of your further research and deliberations.

3. In addition, all of you have had numerous private conversations with the members of the Israeli negotiating team during the course of the formal negotiations themselves as well as informally. I have not had the benefit of any of these personal conversations. Also, you have had many conversations with official representatives of the United States government that I have not had the benefit of cither. Rather, all I can do here is to comment upon the documents which you have given to me for examination and to give you my expert opinion as a Professor of International Law, a practicing international lawyer, and also as a licensed American attorney-at-law for the past fifteen years.

You Must Distrust Israeli and American Oral Assurances.

4. What the Americans and the Israelis have told you orally is one thing. What the documents say is quite another thing. There is an enormous gap between the two. And it has been my experience as a practicing lawyer in international law for the past fifteen years, that any oral assurances not put in writing are worthless and will never be honored. Indeed, as we all saw at the outset of these negotiations, the Israelis did not honor the commitments made in the Letters of Invitation and Assurances to "direct bilateral negotiations" with the Palestinian people. And the Americans did not insist that the Israelis live up to and honor the commitments that they had made in writing to the Americans to "direct bilateral negotiations" with the Palestinians.

American Deception and Racism.

5. Since this is undeniably the case, we will have a very difficult time getting the Israelis and the Americans to live up to any commitments that they make in writing about an Interim Agreement, let alone a Final Settlement. For this reason, I would caution you to be very skeptical about anything the Israelis or the

Americans are telling you orally that they are unprepared to put in writing. Indeed, most of the Americans involved in this so-called peace process . . . are undoubtedly seeing this process from the Israeli perspective, not the Palestinian perspective. They are not and could never be "honest brokers" for peace.

. . . .

II. A STRATEGIC VISION FOR THE INTERIM AGREEMENT.

You Must Reject the Israeli and American Camp David Approach to These Negotiations.

7. It seems clear to me from all the documentation that I have read so far that both the Israelis and the Americans view these so-called peace negotiations as a continuation of the Camp David Accords and Framework but under another name. For example, I have carefully reviewed the document entitled *Minutes of Meeting at U.S. Department of State, Wednesday, October 21, 1992*. It is obvious from this document that all of the American participants . . . view the peace process and this Interim Agreement as a working out of the Camp David Accords and Framework. In other words, the Americans fully agree with and support the basic "strategic vision" and approach that the Israelis have to these negotiations.

8. Therefore, the Americans are inviting you to walk down the garden path of Camp David, which will result in "autonomy for the people" and maybe, at best, "autonomy for the land." As you well know, Prime Minister Begin stated that the Camp David Accords called for "autonomy for the people" but not "autonomy for the land." This interpretation of Camp David was emphatically rejected by President Carter. Nevertheless, it is clear from reading these *Minutes* that the . . . officials involved in these negotiations perceive this Interim Agreement as consisting of "autonomy for the people" and perhaps "autonomy for the land" in the Final Settlement. But nothing more.

9. Indeed, some of these . . . seem to interpret the Camp David Accords in the way Begin did, not Carter. They make it sound as if they are doing you a favor by suggesting that you might have "autonomy for the people" now and maybe "autonomy for the land" later. Of course, such a suggestion is ridiculous, unacceptable, and insulting. You were not parties to the Camp David Accords or the Linowitz negotiations thereafter. Hence, you are not bound by them to any extent.

You Must Not Count Upon Some Written "Interconnection" Between an Interim Agreement and a Final Settlement to Protect Your People and Land.

10. Indeed, if the Camp David Accords is any precedent, then I doubt very seriously that you will ever get to a Final Settlement at all. The Camp David Accords called for an "interconnection" between the Israeli-Egyptian Peace Treaty and a "Framework for Autonomy" for the Palestinians. The Egyptians bargained quite assiduously for this "interconnection" so as to avoid the appearance of concluding a separate peace between Israel and Egypt at the expense of the Palestinians. Nevertheless, after the implementation of the Israeli-Egyptian Peace Treaty, the Israelis paid no attention whatsoever to this so-called "interconnection"

despite express language to that effect. The so-called Linowitz negotiations got nowhere because of Israeli stalling. Eventually the Linowitz negotiations died a quiet death after Carter lost the 1980 presidential election. That was twelve years ago.

11. Today, the United States government has finally gotten around to reviving the so-called Camp David peace process. But because of Israeli stalling and because of American presidential election politics, there could be a twelve-year, sixteen-year, or even twenty-year interval between the Interim Agreement and the so-called Final Settlement no matter what the documents might say about some "interconnection." Indeed, if the Israelis have their way with their supporters in the Democratic and Republican parties and in the United States Congress, you will **never** see that Final Settlement. The Israelis, with American help, will simply stall, drag out, and indefinitely postpone and delay a Final Settlement while they continue to kill your people, steal your land, and drive the rest of you out of your Homes.

You Must Negotiate the Interim Agreement As If It Were the Final Settlement.

12. For that reason, it is my conclusion that you *must* negotiate and draft the so-called Interim Agreement as if it were the Final Settlement. That is, you must draft the Interim Agreement in the full knowledge and expectation that your people might have to live with it for quite a long time no matter what the document says about some "interconnection" with the so-called Final Settlement. This requires, then, that under any Interim Agreement you *must* protect your claims under the terms of Resolutions 242 and 338 as well as your rights under the Fourth Geneva Convention of 1949, inter alia. In addition, you must build into the Interim Agreement a mechanism whereby the Palestinian Interim Self-Government Authority (PISGA) can ripen into internationally recognized legal sovereignty over a period of time irrespective of whatever Israel does.

You Must Be Able to Build Your State Up From the Land and the People Under the Interim Agreement.

13. In other words, under the terms of the Interim Agreement, you must be able to build your State up from the land and the people. And the only way this can be done is to make sure that PISGA has independent legislative authority and powers. *If* PISGA has independent legislative authority and powers, then over a period of time PISGA will be able to gradually ripen into internationally recognized legal sovereignty for the Palestinian people and land. But without independent legislative authority and powers, PISGA will be nothing more than the civilian administrative arm of the Israeli occupation army in Palestinian lands designed for the purpose of doing the Israeli army's dirty work for it by repressing the Palestinian people. Without independent legislative authority and powers, PISGA will be in the position of having to repress those Palestinian people who will undoubtedly oppose such a defective and fatally flawed Interim Agreement.

III. YOU MUST PRESERVE YOUR CLAIMS UNDER RESOLUTION 242 AS PART OF AN INTERIM AGREEMENT.

The American Strategy Is to Conclude a Separate Peace Among Israel, Jordan, Syria, and Lebanon at the Expense of the Palestinians.

14. Under any Interim Agreement, you must make it very clear that the Interim Agreement does not satisfy the terms of Resolution 242. Otherwise, the Israelis will argue that the Interim Agreement itself, when coupled with peace treaties with Jordan, Syria and Lebanon, collectively satisfy the terms of Resolution 242. I shall assume for the purpose of this analysis that the United States government will broker some type of agreement between Israel and Syria, which seems to be in the works. And as we know, the Lebanese will do whatever the Syrians tell them to do. So the rest of this Memorandum will not deal with the Syrians and the Lebanese. But Jordan is a serious problem.

15. It is also very clear that the United States government is brokering an agreement between Israel and Jordan on concluding a peace treaty between the two of them. It is my opinion that certainly the Israelis and probably the Americans view an Israeli-Jordanian peace treaty very much as they viewed the Israeli-Egyptian peace treaty: That is, as a separate peace between Israel and Jordan at the expense of the Palestinian people.

16. The Israeli approach and the American approach seem to be that they will strike a deal with Jordan and then the three states together will present it to the Palestinians as the best that can be done under the circumstances on a take-it-or-leave-it basis. In this regard, remember that King Abdullah and the Jewish Authorities secretly agreed to carve up Palestinian lands between them back in 1948. It seems to me that a similar arrangement between Israel and Jordan, with the full support of the United States government, is currently underway now. For this reason, you must be very careful to draft the Interim Agreement in such a way as to make it clear that an Israeli-Jordanian peace treaty together with an Interim Agreement will not satisfy the terms of Resolution 242—once again, putting aside the Syrians and the Lebanese for the purpose of this analysis. These conclusions become quite clear from an analysis of the text of Resolution 242 itself.

The Interim Agreement Must Deal With the Deceptive Language of Resolution 242.

17. There would be absolutely no point served here by going through the sorry history of UN Security Council Resolution 242 (1967), of which I am sure you are painfully aware. Rather, I plan to discuss the implications of an Interim Agreement under Resolution 242. For this purpose, I intend to focus this analysis upon paragraph 1 of Resolution 242, which reads as follows:

1. Affirms that the fulfillment of Charter principles requires the establishment of a just and lasting peace in the Middle East which should include the application of both the following principles:

(i) Withdrawal of Israeli armed forces from territories occupied in the recent conflict;

(ii) Termination of all claims or states of belligerency and respect for and acknowledgement of the sovereignty, territorial integrity and political independence of every State in the area and their right to live in peace within secure and recognized boundaries free from threats or acts of force; ...

18. You will note that paragraph 1, subparagraph (i) calls for the withdrawal of Israeli armed forces "from territories occupied in the recent conflict..." It does not call for Israeli withdrawal from "*the*" territories occupied in the recent conflict. The omission of the definite article "the" before the words "territories occupied" was a deliberate deception of the Arab states by the United States government.

19. The story of this deception has recently been told by Mr. George Ball, former Under-Secretary of State in the Johnson administration, in his latest book, *The Passionate Attachment*:

> Second—and a cause for endless problems in the future— America failed to insist on the British and Soviet demand to include the definite article "the" in the clause calling for the return of "territories occupied in the recent conflict." *By deleting the definitive article before "territories occupied," the American delegation secured Arab approval by an ambiguity that amounted to deception*. As noted above, Hussein and other Arab leaders had been given to understand that they would be able either to recover all their territory or be compensated for any minor border rectifications on which Israel insisted.

> Practically everyone else, including the British government speaking through Lord Caradon, thought that even without a definite article in the English text (it *was* included in the French and Spanish versions), the resolution would require the Israelis to evacuate all, or practically all, of the territories, with only minor adjustments.

20. Everyone knows that the omission of the word "the" was a deliberate deception of the Arabs perpetrated by the United States government at the behest of Israel. Nevertheless, it created an ambiguity in the terms of Resolution 242. And your Delegation is charged with knowledge of this ambiguity under international law. Therefore, it is incumbent upon you to protect yourself from this ambiguity in any Interim Agreement. If you do not protect yourself from this ambiguity, then this ambiguity will be construed against the Palestinian people to your great detriment.

21. In other words, Israel will be able to further exploit this deception by claiming that an Interim Agreement calling for only a partial withdrawal of Israeli troops from Palestinian lands, when coupled with peace treaties with Jordan, Syria, and Lebanon, will constitute a fulfillment of the literal terms of Resolution 242. Indeed, such an arrangement would arguably fulfill the requirement for the "Withdrawal of Israeli armed forces from territories occupied in the recent conflict..." At least, that is what the Israelis will claim unless you make it clear that you are preserving your claims under Resolution 242 as part of an Interim Agreement.

22. Indeed, such an Israeli position would be consistent with their current interpretation of Resolution 242 to the effect that it does not apply on all fronts. So far, Israel has had the sheer audacity to argue that their withdrawal from the Sinai has fulfilled the terms of Resolution 242. You can bet your bottom

dollar that if they conclude a peace treaty with Jordan, and an Interim Agreement with the Palestinians, Israel will then argue that this arrangement has fulfilled the literal terms of Resolution 242 and therefore that there is no reason for any further withdrawals.

23. The Israelis will then proceed to stall and delay on the negotiation of any Final Settlement irrespective of whatever language on some "interconnection" might be found in the Interim Agreement—just as they did with Linowitz on the Camp David Accords. Meanwhile, the Israelis will continue to steal your land, kill your people, and drive them out of their Homes. The only way to prevent this from happening is to make it expressly clear in one way or the other that the Interim Agreement does not satisfy the requirements of Resolution 242, which must still be binding as a matter of public international law into the indefinite future.

The Interim Agreement Must Consider the Actual Text of Resolution 242.

24. These conclusions are strengthened by an analysis of sub-paragraph (ii) of paragraph 1 of Resolution 242 quoted above. Subparagraph (ii) calls for: "Termination of all claims *or* states of belligerency..." Notice the use of the disjunctive word "or" as opposed to the conjunctive word "and."

25. In the event you sign an Interim Agreement with the Israelis without preserving your claims under Resolution 242, the Israelis will argue that the Interim Agreement with the Palestinians together with peace treaties with Jordan, Syria and Lebanon, have terminated "all...states of belligerency" and thus that they have fulfilled the literal and actual terms of subparagraph (ii) of paragraph 1 of Resolution 242.

26. The Israelis will also argue that the outstanding Palestinian "claim" to your own land becomes irrelevant because subparagraph (ii) calls for the termination of either "all claims" *or* "all...states of belligerency"; but not both. So if Israel can fulfill either one of these two requirements, then Israel will have fulfilled the literal language of subparagraph (ii) of paragraph 1 of Resolution 242. The Israelis will argue that any outstanding "claims" the Palestinians have to your own land after the conclusion of the Interim Agreement will be deemed irrelevant to the fulfillment of Resolution 242. Hence, the conclusion is inexorable that you *must* preserve your claims under Resolution 242 as part of any Interim Agreement.

The Palestinian People Are Not Per Sese Protected by the Literal Text of Resolution 242.

27. This conclusion is even strengthened by the rest of the language found in subparagraph (ii) of paragraph 1 of Resolution 242. It calls for: "...and respect for and acknowledgement of the sovereignty, territorial integrity, and political independence of every State in the area and their right to live in peace within secure and recognized boundaries free from threats or acts of force..." This language clearly protects Jordan, Syria, and Lebanon. It does not protect the Palestinians per sese because it only applies to "every State in the area."

28. The State of Palestine did not exist in 1967. Hence, the Palestinian people are technically unable to claim the literal protection of this language found

in Resolution 242 in their own right. In other words, Resolution 242 gave Jordan the international legal right and standing to insist upon Israeli withdrawal from occupied Palestinian lands after 1967. But today, Jordan could easily sell out the Palestinian people and your lands if you are not very careful in drafting this Interim Agreement.

29. If Israel concludes peace treaties with Jordan, Syria, and Lebanon, together with an Interim Agreement with the Palestinians that calls for only a partial withdrawal of Israeli troops from Palestinian lands, then the Israelis will be able to claim that they have satisfied the literal requirements of subparagraph (ii) of paragraph 1 of Resolution 242. In other words, such a settlement would have terminated "all...states of belligerency" and have obtained "respect for and acknowledgement of the sovereignty, territorial integrity, and political independence of every *State* in the area..." The Palestinian peoples' "claim" to your own land arguably becomes irrelevant because of the use of the disjunctive word "or" as explained above. Once again, therefore, you must preserve your claims to Israeli withdrawal from Palestinian lands as required by Resolution 242 under any Interim Agreement. Otherwise, you will lose them.

How to Preserve Your Claims Under Resolution 242 in an Interim Agreement.

30. I realize of course that Israel might not be prepared to sign an Interim Agreement that expressly incorporates a reference to Resolution 242. In the event this should prove to be an insuperable obstacle during the course of the negotiations, then I do have one fallback position for you to take: Namely, you must demand that the two Co-sponsors, the United States and the Russian Federation, secure the passage of a new United Nations Security Council Resolution that expressly recognizes that Resolution 242 is still valid and binding as a matter of international law even after the conclusion, signature, and approval of the Interim Agreement and any other peace treaties related thereto between Israel, Jordan and Syria. In this fashion, Israel would not have to expressly consent to the continued applicability of Resolution 242. But the Security Council itself would and must do so.

31. Of course you would have to draft the language of this Security Council Resolution quite carefully to make it clear that the entire text of Resolutions 242 and 338 continue into existence. But the adoption of such a new Resolution by the Security Council would bind Israel under article 25 of the United Nations Charter whether Israel likes it or not: "The Members of the United Nations agree to accept and carry out the *decisions* of the Security Council in accordance with the present Charter." [Emphasis added.]

32. To be sure, the Israelis have also attempted to deny the applicability of Security Council resolutions unless they expressly consent to them. The way around that would be to make sure that when it comes to the approval of the Interim Agreement and any related peace treaties by the United Nations Security Council, that the Security Council indicates quite clearly in the text of the new Resolution that it is acting under its powers found in Chapter VII of the United Nations Charter. In addition, in this new resolution the Security Council should also formally determine the existence of a "threat to the peace" under article 39 of the Charter, and then "decide" (not recommend) that Resolutions 242 and 338

continue into full force and legal effect irrespective of the terms of the Interim Agreement and any related peace treaties. There must be a formal "Decision" by the Security Council that Resolutions 242 and 338 are still binding as a matter of public international law after the Interim Agreement and any related peace treaties. At a minimum, this Security Council Resolution must use the word "decides" in the operative paragraphs to obtain the benefits of Charter article 25 against Israel.

33. Of course it would be preferable to have Israel expressly agree to the continuation of Resolutions 242 and 338 in the text of the Interim Agreement itself. But if that should prove to be impossible, and if the Co-sponsors are acting in good faith, then the United States government and the Russian government should be prepared to give you another Security Council Resolution as outlined above. After all, Resolution 242 is the creature of the Security Council, not of the Israeli government. Under the United Nations Charter the Security Council has the legal authority to do whatever it wants to do with its own resolutions.

34. This Security Council approach to the problem would provide you with one way out of this dilemma that in turn would not compromise your claims under Resolution 242. But the Resolution itself would have to be very carefully drafted and approved beforehand as part of the documentary "package" surrounding an Interim Agreement. Conversely, if the Americans are not prepared to promise you this new Security Council Resolution guarantee on Resolution 242, then you *know* that they are not acting in good faith as so-called honest brokers. The same rule-of-thumb would apply to the Russians.

You Cannot Rely Upon the Letters of Invitation and Letters of Assurances to Protect You After the Interim Agreement Is Approved.

35. In this regard, you cannot rely upon the Letters of Invitation and Letters of Assurances to get you from an Interim Agreement to a Final Settlement. The promises given in the Letters of Invitation and Letters of Assurances do not mean very much as a matter of public international law. The Israelis will argue that they never assumed the status of an international treaty or treaties within the meaning of the Vienna Convention on the Law of Treaties. The Israelis will also argue that they do not have a direct agreement with the Palestinians under the terms of the Letters of Invitation and Assurances anyway. Therefore, they are not bound by these documents as a matter of public international law, etc.

36. Moreover, the United States government will argue that these are not international treaties or agreements within the meaning of United States constitutional law. Indeed, these documents have never been formally registered under the terms of the U.S. Case Act that requires the formal registration of all international agreements to which the United States government is a party with Congress. Without such registration, they are not binding under American law and are not obliged to be respected by subsequent administrations, let alone by Congress.

37. In other words, once you have signed an Interim Agreement, you simply cannot rely upon any of these Letters in order to get you to the Final Settlement as a matter of Public International Law and American Constitutional Law. Once the Interim Agreement is signed and registered with the United Nations

Organization—as is clearly contemplated by the Letters of Invitation and Assurances—then it will be treated as if it were an international convention within the meaning of the Vienna Convention on the Law of Treaties. The normal rule of interpretation for such conventions is to look at the actual text of the language itself. The secret negotiating history of any international agreement is generally disregarded by the International Court of Justice.

38. Thus, the standard international practice will be to rely upon the text of the Interim Agreement itself. And in this case, the text of Resolution 242 is clearly deceptive and ambiguous. So it is up to you to make it crystal clear that Resolution 242 will not be fulfilled by signing any Interim Agreement. Otherwise, you could very well lose your "claims" under Resolution 242 to complete Israeli withdrawal from Palestinian lands.

IV. THE PALESTINIAN DELEGATES MUST SIGN AND APPROVE THE INTERIM AGREEMENT WITH ISRAEL BY THEMSELVES.

39. I have been asked to express my Legal Opinion as to how the Palestinians should sign and approve the Interim Agreement. From the above analysis it should now become clear why you must insist upon your independent legal right to conclude the Interim Agreement with Israel and without Jordan. If Jordan signs the Interim Agreement with you, then Israel will claim that this Interim Agreement has terminated "all...states of belligerency" and obtained "respect for and acknowledgement of the sovereignty, territorial integrity and political independence of every *State* in the area...," etc.

40. Since Israel refuses to recognize the existence of the independent State of Palestine, the Israelis will claim that neither Palestine nor the Palestinian people have any rights or claims under Resolution 242. Jordan was the belligerent occupant of Palestinian lands as of 1967. Hence, Israel will argue that its obligations towards Jordan with respect to the Palestinian lands under Resolution 242 will have been fulfilled by the Interim Agreement together with a peace treaty with Jordan.

41. Furthermore, if you sign the Interim Agreement with Jordan, Israel will claim that the Interim Agreement is really an international convention between the two sovereign states of Israel and Jordan dealing with and disposing of the Palestinian people and the Palestinian lands. The Israelis will claim that the Palestinian Delegates signed the Interim Agreement as a matter of courtesy; but that this does not mean that Israel recognizes that the Palestinians have any sovereign capacity or rights or claims whatsoever. If you sign the Interim Agreement with Jordan, the Israelis will argue that the Palestinian people are nothing more than wards, subjects, or dependents of the Jordanians for the purpose of public international law. This is very similar to the way the British Empire used to sign international treaties on behalf of its dependencies around the world during the colonial era of history. Once again, the only way to protect yourself from these traps is to make sure that there only two "parties" to the Interim Agreement itself: the Israelis and the Palestinians; but not the Jordanians.

The Letters of Invitation and Assurances Give the Palestinian Delegates the Right to Conclude the Interim Agreement with Israel by Yourselves.

42. Indeed, the Letters of Invitation and Assurances make it quite clear that the United States government promised that there will be an Interim Agreement between Israel and the Palestinians that will be registered with the United Nations Organization and therefore constitute an international convention or treaty. And of course Israel has agreed to attend these so-called peace negotiations and to negotiate on this basis. Hence, the Palestinian Delegates have been empowered to sign an international convention or treaty with Israel by yourselves. Thus, the Palestinian Delegates have been given an independent and international legal personality for the purpose of these negotiations and agreements. You must insist upon it when it comes time to sign and approve the Interim Agreement. Otherwise, you will lose it and the Palestinian people and land will become nothing more than "wards" or "dependents" of the Jordanians and the Israelis after the Interim Agreement.

43. I have already analyzed these matters at greater length in two Memorandums of Law I wrote for use by the Palestinian Delegates during the first round of negotiations in Washington, D.C. in December of 1991, entitled *Analysis of U.S. Invitation and Letters of Assurances for the Mideast Negotiations* (Nov. 21, 1991) and *The Right of the Palestinian People to Direct Bilateral Negotiations With the Israeli Delegation* (Dec. 8, 1991). I will not bother to repeat all that analysis here since you have already seen these two memoranda and currently possess copies of them in your Delegation's Archives. However, due to the requirements of space and time, I will simply incorporate by reference here the conclusions found in paragraphs 14, 18, 19 and 20 of the December 8, 1991 Memorandum:

The Right of the Palestinian People to Direct
Bilateral Negotiations With the Israeli Delegation

by

Francis A. Boyle
Professor of International Law

December 8, 1991

....

14. We now must turn to the U.S./Soviet Letter of Assurances to the Palestinians dated October 18, 1991. Once again, paragraph 1 refers to "direct negotiations" between Israel and the Palestinians. It calls for "Palestinian participation" in the context of "direct negotiations with Israel."

....

18. Paragraph 6 repeats the call for "direct bilateral negoti-ations" between "the parties," which would mean "direct bilateral negotiations" between Israel and the Palestinians since the Palestinians have been recognized as one of the "parties" to these negotiations.

19. Paragraph 7 repeats the call found in the Invitation for two tracks of direct bilateral negotiations, one of which will be between Israel and the Palestinians, that will be separate and apart from the direct bilateral negotiations between Israel and the respective Arab states (i.e., Jordan, Syria, and Lebanon).

20. According to paragraph 10, agreements reached between the "parties," apparently including any agreement between Israel and the Palestinians, will be registered with the UN Secretariat, thus giving such an agreement the standing of an international "treaty". Thus, the co-sponsors have apparently given the Palestinian people here the degree of international legal personality and recognition necessary and sufficient to negotiate and conclude an international agreement

....

44. It is clear from the above analysis that the Palestinian Delegates have been given the international legal right and standing to sign the Interim Agreement with Israel alone. You must insist upon that right. Otherwise, if you sign the Interim Agreement with Jordan, Israel will claim that the Interim Agreement is really a treaty between the two sovereign states of Israel and Jordan and that the Palestinians were nothing more than "wards," "subjects" or "dependents" of the Jordanians at the time of signature. Therefore, the Israelis will argue that an Interim Agreement signed by Israel, on the one side, and Jordan and the Palestinians, on the other, will create nothing more than a shared condominium type of arrangement between Israel and Jordan to treat the Palestinian people and lands as their joint "wards," "subjects," and "dependencies."

45. In order to avoid this result, you must insist upon your independent right to sign the Interim Agreement with Israel by yourselves and without Jordan. Even then, the Interim Agreement must be carefully drafted in full awareness of whatever the peace treaty between Israel and Jordan will say. Otherwise, you risk the same result: The Israelis and the Jordanians could simply agree between themselves to set up a condominium arrangement over the people and land of Palestine. Based upon what happened in 1948, that is probably what the Americans, the Israelis and the Jordanians are planning to do to you now.

How the Palestinians Can Approve the Interim Agreement.

46. Let us assume that you successfully produce an Interim Agreement that fulfills the requirements set forth in this Memorandum. What would be the technical procedures required for approval by the Palestinian people? Upon the completion of the text, the Interim Agreement could be initialed by the Heads of the three sets of delegates: Israeli; Jordanian; and Palestinian. The Israelis will probably insist upon this since you are part of a Joint Delegation and technically the Joint Delegation would have negotiated the Interim Agreement.

47. But although the Jordanian Head might initial the Interim Agreement, he must not sign it. Nor must the Interim Agreement have been pre-approved by the Jordanian Parliament; nor must the Interim Agreement be

subsequently submitted for approval to the Jordanian Parliament. Here more research must be done on the Jordanian constitutional law concerning the approval or ratification of treaties. We will need a Memorandum on this subject from an expert on Jordanian constitutional law and international law with respect to treaties in order to be careful. So let us put aside the Jordanians for the time being pending the submission of that memorandum.

48. Hence, the text of the Interim Agreement must be initialed *ad referendum* by the Head of the Palestinian Delegates but not *ad referendum* by the Head of the Jordanian Delegates. Then the Interim Agreement should be submitted to the Palestine National Council for its debate and approval. At that point, the Palestine National Council could authorize the Palestinian Delegates to sign the Interim Agreement with Israel in the name of the PNC

49. This does not mean that the Palestinian Delegates must sign the Interim Agreement in the name of the Palestine National Council as indicated on the document itself. But rather, that the Palestinian Delegates could sign in their own names after having been duly authorized to do so by the Palestine National Council. The Israelis could do the same with their Knesset.

50. The instruments of approval or ratification for the Interim Agreement would then have to be exchanged between the Israeli Delegates and the Palestinian Delegates. Here you must be careful to follow the absolute letter of the Vienna Convention on the Law of Treaties concerning these technical and procedural matters. *You must act as if you represent the sovereign State of Palestine because you do!*

51. Thereafter, the Interim Agreement would be transmitted to the United Nations for registration as a treaty or international convention. The Interim Agreement would then be treated as any other treaty that could be raised within the context of any of the organs of the United Nations Organization, including the International Court of Justice. The Interim Agreement would be subject to the Vienna Convention on the Law of Treaties, which is the customary international law in this area. Once again, therefore, the Interim Agreement must be carefully drafted in accordance with the requirements of the Vienna Convention on the Law of Treaties.

52. Thus, it is critically important that you hold out for your established right to sign the Interim Agreement with Israel and without Jordan. It would also be important to closely examine the text of the Peace Treaty between Israel and Jordan to make sure that there is nothing in there that would indicate that somehow the Palestinians are being treated as wards, dependents, or subjects of the State of Jordan. Otherwise, the Palestinians could lose the degree of international legal personality and capacity that has already been conferred upon you by the Letters of Invitation and Assurances as explained above.

53. Even more importantly, if these technical matters are not handled properly, you could lose the formal diplomatic recognition of the State of Palestine by the 125 states that have already recognized Palestine as a sovereign state, as well as by the United Nations Organization itself. In other words, you would undo and reverse the Palestinian gains since 1988. You do not want to jeopardize that high degree of international consensus and recognition in any way. So a good

deal of attention must be paid to these technical and procedural matters. Otherwise, the net result here could then mean some type of condominium arrangement between Israel and Jordan over the people and lands of Palestine. It seems clear to me that this is the trap that the Israelis, the Americans, and perhaps the Jordanians are currently setting for you and the Palestinian people.

V. YOU MUST PRESERVE YOUR RIGHTS UNDER THE FOURTH GENEVA CONVENTION UNDER ANY INTERIM AGREEMENT.

The Interconnection Between Resolution 242 and the Fourth Geneva Convention.

54. The above analysis of Resolution 242 in light of an Interim Agreement should also make it crystal clear why you will need to preserve your rights under the Fourth Geneva Convention as part of any Interim Agreement. This is because Israel will claim that the conclusion of the peace treaty between Israel and Jordan together with an Interim Agreement between Israel and the Palestinians will represent a termination of the "state of belligerency" between Israel and Jordan. Therefore, the Israelis will argue that the literal requirements of Resolution 242 will have been fulfilled and also that the Fourth Geneva Convention will no longer apply.

55. In other words, the Interim Agreement could be construed as a termination of the "state of belligerency" between Israel, on the one hand, and Jordan and the Palestinians, on the other. This would certainly be the case if an Interim Agreement expressly calls for peaceful relations and cooperation between Israel and the Palestinian people. This is a requirement that the Israelis will undoubtedly insist upon in any Interim Agreement.

56. Public international law does not require a formal peace treaty in order to terminate a state of belligerency. So if the state of belligerency between Israel, on the one hand, and Jordan and the Palestinians, on the other, has arguably been terminated by a peace treaty between Israel and Jordan and an Interim Agreement between Israel and the Palestinians, then the Fourth Geneva Convention might arguably no longer apply to protect the people and lands of Palestine. At least, that is what the Israelis will argue. And the Americans might back them up.

57. Israel will argue that the Interim Agreement with the Palestinians and a peace treaty with Jordan will terminate the state of belligerency among all of you and therefore that the Fourth Geneva Convention no longer applies thereafter to protect the people and land of Palestine. Hence, the Israelis will argue that after the conclusion of such an Interim Agreement, any remaining Israeli settlers and settlements are no longer illegal because the Fourth Geneva Convention no longer applies. And since Resolution 242 would no longer apply, the settlers and settlements can stay there forever. So the only way to prevent this from happening is to preserve your rights under the Fourth Geneva Convention as well as your claims under Resolution 242 in any Interim Agreement.

The Dangers of Article 6(3) of the Fourth Geneva Convention.

58. The need to protect your rights under the Fourth Geneva Convention is also made quite clear by paragraph 3 of article 6 thereof: "In the case of

occupied territory, the application of the present Convention shall cease one year after the general close of military operations..." The Israelis will argue that the conclusion of an Interim Agreement with the Palestinians together with a peace treaty with Jordan would trigger article 6, paragraph 3 with respect to any remaining occupied Palestinian lands. Therefore, the Fourth Geneva Convention arguably no longer applies in accordance with its own terms one year after the approval of the Interim Agreement.

59. Finally, and most importantly, the Israelis will also argue that failure to preserve your rights under the Fourth Geneva Convention in any Interim Agreement that recognizes the continued existence of Israeli settlers and settlements in occupied Palestinian lands constitutes the "regularization" or *de facto* "legalization" of the presence of the settlers and settlements in Palestinian lands. Of course, you do not want to do that. But the Israelis are trying to get you to sign an Interim Agreement that will effectively "regularize" or "legalize" some of the settlers and the settlements pending a Final Settlement, which in turn you will not see for ten, fifteen, or twenty years, if ever.

60. Once again, the only way to make it clear that the settlers and the settlements are illegal and ultimately must be withdrawn and dismantled, is to preserve your rights under the Fourth Geneva Convention, as well as your claims under Resolutions 242 and 338, with respect to any Interim Agreement. Failure to preserve your rights under the Fourth Geneva Convention in one fashion or another will mean that you will lose your current ability to object to the settlers and to the settlements under international law and in essence will have tacitly acquiesced to their *de facto* presence indefinitely.

The International Consensus in Support of the Application of the Fourth Geneva Convention Must Not Be Jeopardized.

61. I realize of course that some of you will say that the Fourth Geneva Convention has not done your people and land much good. But imagine how terrible the situation might be today after twenty-five years of occupation if there were no Fourth Geneva Convention? The Israelis would probably have stolen all of your land and expelled all of your people by now.

62. Today the entire international community (except for Israel) agrees that the Fourth Geneva Convention applies to protect the Palestinian people and the Palestinian lands. That is an overwhelming degree of international consensus that you do not want to lose or jeopardize in any way. The Fourth Geneva Convention provides some degree of protection for your people and your land from further Israeli expulsions, murders, and confiscation. It would be an extremely dangerous thing for you to do to fail to preserve your rights under the Fourth Geneva Convention as part of some Interim Agreement.

The State of Palestine Has Already Ratified the Four Geneva Conventions.

63. Indeed, the Palestine National Council has already ratified the Four Geneva Conventions of 1949 on behalf of the State of Palestine. I will not go through the sorry history of what happened after that in this Memorandum. But this ratification is binding as a matter of public international law.

64. Thus, all 125 states that recognize the State of Palestine are also obliged to recognize that Palestine is a state party to the Fourth Geneva Convention. This would include the Co-sponsor, the Russian Federation, which is the successor-in-law to the former Soviet Union, which recognized the State of Palestine. Jordan is also obliged to recognize that Palestine is a party to the Four Geneva Conventions.

65. Thus, you do not want to sign an Interim Agreement that will jeopardize the PNC's international legal ratification of the Fourth Geneva Convention. Indeed, as a delegation you are bound to recognize and observe this PNC ratification. Moreover, as Palestinians living in occupied territory, you do not currently have the legal power to negotiate, sign, or approve an Interim Agreement that gives up Palestinian rights under the Fourth Geneva Convention. This conclusion is made crystal clear by article 8 of the Fourth Geneva Convention: "Protected persons may in no circumstances renounce in part or in entirety the rights secured to them by the present Convention, and by the special agreements referred to in the foregoing Article, if such there be."

66. Al Haq has already sent you a Memorandum on this subject about one year ago before the negotiations began in Washington. I will not bother to repeat any of that analysis here. But I fully agree with their conclusions.

How to Preserve Your Rights Under the Fourth Geneva Convention.

67. Once again, it would be preferable to have the Israelis expressly acknowledge in the Interim Agreement that the Fourth Geneva Convention does indeed apply to occupied Palestinian lands, including Jerusalem. But in the event this should prove to be impossible, then in the aforementioned United Nations Security Council Resolution, you should have the Security Council affirm that it is acting under its powers found in Chapter VII of the United Nations Charter; make a formal determination that there exists a "threat to the peace" under article 39; and then "decide" that the Fourth Geneva Convention continues to apply to occupied Palestinian lands, including Jerusalem, irrespective of the terms of the Interim Agreement. Such a new Security Council resolution would give you all the legal protection you need. Conversely, if the Americans are not prepared to promise you such a Security Council Resolution now, then you *know* that they are not acting in good faith, let alone as self-styled "honest brokers." The same rule-of-thumb would apply to the Russians.

VI. HOW TO HANDLE JURISDICTION, LAWS, AND ISRAELI MILITARY REGULATIONS UNDER THE INTERIM AGREEMENT.

Rejecting the Israeli Approach.

68. The Israelis have submitted a proposal on how to treat the 2,000 or so military regulations that they have enacted in occupied Palestinian lands since 1967. I will not bother to provide a detailed critique of their proposal in this Memorandum because of limitations of time and space. Rather, I will put forward a position for the Palestinian people to consider and adopt that will fully protect your rights under international law.

69. Briefly put, however, you must not sign any Interim Agreement that

effectively "regularizes" or "legalizes" any of these Israeli military regulations. Undoubtedly, 99% of all these Israeli military regulations are clearly illegal under the terms of the Hague Regulations of 1907 and the Fourth Geneva Convention of 1949. Thus, you do not want to sign an Interim Agreement that effectively gives your consent to *any* of them. Otherwise, if you so consent to any of these Israeli military regulations, then you will effectively be consenting to the continued Israeli belligerent occupation of Palestinian lands and people for the indefinite future.

70. The critical point is this: Right now it is undeniable that Israel is the belligerent occupant of the Palestinian people and lands. But at least you have never consented to their belligerent occupation. You do not want to sign an Interim Agreement that formally recognizes, consents to, assents to, or acquiesces in, Israeli belligerent occupation in any way, shape, or form, Otherwise, you will never get rid of them. How do you do this?

Applying U.S. Army Field Manual 27-10 (1956).

71. As I have already explained to the lawyers on the Delegation, the better approach to this problem can be found in the customary and conventional international laws of belligerent occupation. Succinctly put, these laws can be found in one publication that is entitled *Department of the Army Field Manual FM27-10, The Law of Land Warfare* (July 1956), which has been adopted by the United States Department of the Army. This Field Manual was published by the United States government and is still applied by the U.S. Army to its troops in the field as required by the Hague Conventions and the Geneva Conventions. This Field Manual constitutes an official statement by the United States government of what it believes to be the customary and conventional international laws applicable to land warfare, belligerent occupation, and humanitarian law, etc. Both the British government and the Israeli government have issued similar Field Manuals to their troops as required by the Hague Conventions and the Geneva Conventions.

72. Moreover, this Field Manual is not simply a statement of narrow self-interest by the United States government. Rather, the Pentagon had this Field Manual written by the late Professor Richard R. Baxter of the Harvard Law School, who at the time was generally recognized to be the world's leading expert on the laws of war. Professor Baxter later became a Judge on the International Court of Justice, but died soon thereafter. So the Field Manual is also a scholarly statement of the rules of international law concerning armed conflict and belligerent occupation that was produced by the world's leading expert on these subjects. Many years ago, I was Professor Baxter's top student on the laws of war at the Harvard Law School.

You Must Terminate the "Effectiveness" of Israeli Military Occupation Under an Interim Agreement.

73. We must begin this analysis with an examination of Paragraph 360 of Field Manual 27-10:

360. Maintenance of Occupation

Occupation, to be effective, must be maintained. In case the occupant evacuates the district or is driven out by the enemy, the

occupation ceases. It does not cease, however, if the occupant, after establishing its authority, moves forward against the enemy, leaving a smaller force to administer the affairs of the district. Nor does the existence of a rebellion or the activity of guerrilla or para-military units of itself cause the occupation to cease, provided the occupant could at any time it desired assume physical control of any part of the territory. If, however, the power of the occupant is effectively displaced for any length of time, its position towards the inhabitants is the same as before occupation. [Emphasis added.]

This Paragraph 360 provides the key that will unlock the door to many of our dilemmas, problems, and traps surrounding the Interim Agreement. It is based upon the customary international laws of belligerent occupation, including the Hague Regulations. We will have to do a detailed analysis of its text in order to understand its implications for the Interim Agreement.

74. First, notice the affirmative statement: "Occupation, to be effective, must be maintained." What this means precisely can be found in Paragraph 356 of the Field Manual, which I will discuss later on. Right now, I simply want you to focus upon the second sentence of Paragraph 360: "In case the occupant evacuates the district..., the occupation ceases."

75. What this language means is quite clear: Namely, to the extent that Israeli occupation forces withdraw from Palestinian lands—subject to certain qualifications discussed below—then its belligerent occupation of those lands under the Hague Regulations ceases. In other words, belligerent occupation under the Hague Regulations can terminate on a district-by-district basis throughout Palestinian lands upon the withdrawal of Israeli troops and their redeployment to specified military bases. This would be the normal way in which this should occur pursuant to the international laws of belligerent occupation.

76. Hence, for this reason, you must not sign an Interim Agreement that effectively recognizes Israel as the belligerent occupant of any Palestinian lands after a troop withdrawal to certain military bases to any extent. This is what the Israelis want you to do. Rather, what you must do is as follows:

77. You must have the Israelis sign an Interim Agreement that calls for their military forces to withdraw to military bases in Palestinian lands subject to severe restrictions upon the ability of Israeli military forces to leave those military bases. In other words, those military forces must be "effectively" confined to those military bases. The Israelis must not have the right to leave those military bases as organized military forces at their discretion.

78. These requirements are made quite clear by the third sentence of Paragraph 360: "Nor does the existence of a rebellion or the activity of guerrilla or para-military units of itself cause the occupation to cease, *provided the occupant could at any time it desired assume physical control of any part of the territory.*" (Emphasis added.) In other words, it must be your objective in the negotiating process to guarantee that Israeli military forces confined to these military bases absolutely cannot "at any time it desired assume physical control of any part of the territory."

79. To the contrary, if you sign an Interim Agreement whereby Israeli military forces can do this, then you will have effectively consented to Israel continuing to be the belligerent occupant of all Palestinian lands indefinitely. Furthermore, you would have regularized and legalized their belligerent occupation status in your own lands by means of your own consent. This would be reprehensible. At least up until now, the Israelis do not have your consent to occupy your people and lands. You certainly do not want to give them this consent in an Interim Agreement.

80. Hence, you must make sure that when Israeli military forces withdraw to Israeli military bases in occupied Palestinian lands that they cannot "at any time it desired assume physical control of any part of the territory." Thus, as part of an Interim Agreement, you must cut off the ability of Israeli military forces confined to military bases to re-enter upon Palestinian lands as they so desire. In the event that you can accomplish this objective, then the Israeli military occupation of Palestinian lands terminates over all Palestinian lands on a district-by-district basis, except for those remaining Israeli military bases.

81. This latter conclusion is made quite clear by the last sentence of Paragraph 360: "If, however, the power of the occupant is effectively displaced *for any length of time*, its position towards the inhabitants is the same as before occupation." (Emphasis added.) So in any Interim Agreement you must obtain the "effective displacement" of Israeli occupation forces from Palestinian lands to these military bases "for any length of time." And you must ensure that these military forces cannot leave these military bases "at any time it desired" as an organized military force.

82. In other words, Israeli military forces must be stringently and severely constricted to any military bases remaining in Palestinian lands as part of an Interim Agreement. In the event that you can accomplish this objective, then Israel's position towards the Palestinian people "is the same as before occupation." Thus, Israeli military occupation would completely terminate in all Palestinian lands that they withdraw from, provided that they cannot return at will to those lands. Henceforth, I will refer to these Palestinian lands from which Israeli troops withdraw as "liberated" Palestinian lands in comparison to the remaining Israeli military bases which will still remain "occupied" Palestinian lands.

83. Let us now examine the awesome implications of the last sentence of Paragraph 360: "If, however, the power of the occupant is effectively displaced for any length of time, *its position towards the inhabitants is the same as before occupation.*" (Emphasis added.) In other words, assuming that you can effectively confine Israeli military forces to Israeli military bases remaining in Palestinian lands as part of an Interim Agreement, then Israeli occupation ceases in all Palestinian lands from which they withdraw. **What this means, then, is that the entire legal, political, and governmental situation as it existed in Palestinian lands before the 1967 war revives fully as a matter of public international law.**

84. Let me repeat that: The governmental, legal, and administrative arrangements that existed prior to the 1967 war in Palestinian lands revives fully and completely as a matter of public international law. Thus, all of the 1967 laws,

administrative bodies, municipal councils, courts, etc. would come back into legal existence upon the withdrawal of Israeli military forces to these military bases, provided that the latter's right to resume control is effectively cut off in the Interim Agreement. **In other words, the Palestinian people would be effectively governing themselves as a matter of public international law!**

How to Cut-off Israeli Control.

85. Therefore, it becomes critical for you to cut-off any right to resume control by Israeli military forces in the Interim Agreement itself. This is made quite clear by the aforementioned Paragraph 356 of the Field Manual:

356. Effectiveness of Occupation

It follows from the definition that belligerent occupation must be both actual and effective, that is, the organized resistance must have been overcome and the force in possession must have taken measures to establish its authority. It is sufficient that the occupying force can, within a reasonable time, send detachments of troops to make its authority felt within the occupied district. It is immaterial whether the authority of the occupant is maintained by fixed garrisons or flying columns, whether by small or large forces, so long as the occupation is effective. The number of troops necessary to maintain effective occupation will depend on various considerations such as the disposition of the inhabitants, the number and density of the population, the nature of the terrain, and similar factors. The mere existence of a fort or defended area within the occupied district, provided the fort or defended area is under attack, does not render the occupation of the remainder of the district ineffective. Similarly, the mere existence of local resistance groups does not render the occupation ineffective.

86. Notice the second sentence of Paragraph 356: "It is sufficient that the occupying force can, within a reasonable time, send detachments of troops to make its authority felt within the occupied district." Hence, in any Interim Agreement, you must have absolute guarantees that Israeli military forces confined to their bases *cannot* "within a reasonable time, send detachments of troops to make its authority felt within the occupied district." The Israelis will try to achieve that objective in an Interim Agreement. But if you permit them to do this, then Palestinian lands will remain under Israeli belligerent occupation. And worse yet, the Israelis will have gotten you to consent to your own belligerent military occupation in this Interim Agreement. In other words, as a matter of international law, you will have given up and surrendered your well-established international legal right to resist them. Of course you must not do that!

87. The third sentence of Paragraph 356 makes this conclusion quite clear: "It is immaterial whether the authority of the occupant is maintained by fixed garrisons or flying columns, whether by small or large forces, so long as the occupation is effective." Once again, you *must* cut-off any right or ability of Israeli military forces confined to military bases in occupied Palestinian lands to leave those bases as organized military forces per se. You must get them strictly

confined to those military bases. Of course, they will have a right to defend themselves in the event that they are attacked. But they must have no right to go into Palestinian lands at will. Otherwise, under international law, Israel will remain the belligerent occupant of Palestine and you will have consented to your own occupation in the Interim Agreement.

88. Once again, the need to strictly confine Israeli military forces to their military bases is made quite clear by the rest of Paragraph 356 and, in particular, the next-to-last sentence: "The mere existence of a fort or defended area within the occupied district, provided the fort or defended area is under attack, does not render the occupation of the remainder of the district ineffective." The Israelis will argue that an Interim Agreement that calls for their troops' withdrawal to military bases in Palestinian lands does not terminate their belligerent occupation. The only way to counter this is for you to make sure that those military forces are effectively and securely confined to those military bases.

The Maintenance of Law and Order in Liberated Palestinian Lands.

89. In the event that you can accomplish this objective, then the Israeli military occupation of all the rest of the Palestinian lands will terminate on a district-by-district basis as a matter of international law. At that point, then, all of the pre-1967 laws, institutions, governments, courts, etc. immediately come back to life and the Palestinian people will be in the process of effectively governing themselves by means of their pre-1967 institutions and laws, as well as by means of the Palestinian Interim Self-Government Authority (PISGA) set up by the Interim Agreement. That is the objective you want to accomplish. That will solve most of your problems with respect to jurisdiction, laws, and, as we shall see, settlers and settlements. But, once again, all this depends upon you confining those Israeli military forces to those military bases effectively, securely, and strictly.

90. The Israelis will argue that "law and order" must be maintained in liberated Palestinian lands. Of course, that is a correct conclusion. The Palestinian police force will have to maintain law and order in the liberated Palestinian lands. But the source of their authority to maintain law and order will be based upon the pre-1967 legal system that was in existence before the Israeli military occupation. You must not expressly agree in an Interim Agreement that the basis of authority for the Palestinian police force is Israel's alleged authority to maintain law and order as a belligerent occupant. Under my scenario outlined above, Israel will no longer be the belligerent occupant in liberated Palestinian lands. Your authority to maintain law and order by means of a Palestinian police force must come from the pre-1967 laws and the PISGA, and not to any extent from the Israelis. Therefore, you must not agree to any extent that the authority of the Palestinian police force, let alone of the PISGA, is subject to that of the Israeli army or government.

You Must Make Sure That PISGA Is Not a Puppet Government Under International Law.

91. What the Israelis are trying to do here is to set up the PISGA as the civilian arm of the Israeli military occupation forces. They call it the Palestine Administrative Council (PAC). But it is clear from an examination of the documents that they contemplate the PAC to become the civilian administrative arm of their

military occupation forces in Palestinian lands. Of course, you must prevent this from happening in the Interim Agreement. Otherwise, the Israelis can appropriately claim that the PAC or PISGA is nothing more a "puppet government" under international law. This is made quite clear by Paragraph 368 of the Field Manual:

368. Nature of Government

It is immaterial whether the government over an enemy's territory consists in a military or civil or mixed administration. Its character is the same and the source of its authority the same. It is a government imposed by force, and the legality of its acts is determined by the law of war.

92. This is exactly what the Israelis want you to consent to in the Interim Agreement. They want to set up a PAC or a PISGA that will be the civilian administrative arm of their military occupation authorities. Its name will be irrelevant to them.

93. From the Israeli perspective, then, they want to set up a local government in Palestinian lands (whether PISGA or PAC) that is effectively a "puppet government" of the Israeli military occupation forces. This they can do under international law provided they adhere to the laws of war, which they will not do in any event. This conclusion is made quite clear by Paragraph 366 of the Field Manual:

366. Local Governments Under Duress and Puppet Governments

The restrictions placed upon the authority of a belligerent government cannot be avoided by a system of using a puppet government, central or local, to carry out acts which would be unlawful if performed directly by the occupant. Acts induced or compelled by the occupant are nonetheless its acts.

94. Nevertheless, this is precisely what the Israelis want to do. They want to establish a Palestinian "puppet government" that will repress the Palestinian people in order to uphold the Interim Agreement. The Israelis will then claim that since the Palestinian people have consented to this puppet government established by the Interim Agreement, that such repression does not violate the laws of war or the Fourth Geneva Convention because the Palestinians are doing it to themselves.

95. This is the same way the Nazis ruled by means of puppet governments throughout the European countries they took over before the Second World War (*e.g.*, Austria and Czechoslovakia) as well as during the war (*e.g.*, Quisling in Norway). Here, the Israelis are trying to set up PISGA/PAC to become the "quislings" of the Palestinian people. And so far the Americans seem to be backing them up.

96. But under international law, it is your personal responsibility to make sure that this does not happen: After the war, Quisling was convicted of high treason and shot. Thus, it is your obligation to make sure that the Interim

Agreement does not recognize PISGA as the civilian administrative arm of the Israeli occupation forces. Otherwise, PISGA will be nothing more than a "puppet government" under international law. You will be agreeing to enslave your own people and then to police this enslavement with your own police force. There is no point in signing such an Interim Agreement.

VII. YOU MUST AVOID AN INTERIM AGREEMENT THAT WILL SET OFF A CIVIL WAR AMONG THE PALESTINIAN PEOPLE.

7. Indeed, if you were to agree to such an Interim Agreement, then it would probably set off a civil war among the Palestinian people between those for PISGA/PAC enslavement versus those against PISGA/PAC enslavement. More Palestinians will kill Palestinians than Israelis. But if Palestinians are to die, then it should be at the hands of the Israelis, not Palestinians. Let the Israelis do their own dirty work. Palestinians should not be doing Israel's dirty work for it.

8. On these points I speak from the experience of my own people— the Irish. We have been fighting the British Empire for the past 800 years. We have been subjected to colonialism, occupation, genocide, apartheid, extermination, racism, settlers, etc. for over 800 years. And now, after 800 years of struggle, we have finally come to the verge of success in expelling the British Empire from our Homeland.

9. Nevertheless, back in 1921 one segment of our National Liberation Movement—the Irish Republican Army (IRA)—decided to sign a Treaty of Partition with the British Empire that would allow the British Empire to remain as the belligerent occupant of six of our northeast counties. This terrible decision set off a civil war among the pro-treaty and anti-treaty forces of the Irish Republican Army, and among the pro-treaty and anti-treaty portions of the Irish people. More Irish killed Irish than British. Effectively, the British Empire got a portion of our people to do their dirty work for them.

10. The Palestinian people must not fall into the same trap that is being set for you . . . You must not sign an Interim Agreement that will set off a civil war among your own people between pro-treaty and anti-treaty forces. Palestinians will be slaughtering each other with abandon while the Israelis stand back and watch. And after you have all killed each other off, then the Israelis will move in and steal the rest of your land irrespective of whatever this so-called Interim Agreement says.

11. A Palestinian civil war and self-extermination is precisely what the Israelis have in mind for you. This is the Israeli "final solution" to the Palestinian people, which is almost identical to the "final solution" that Hitler had in mind for the Jewish people. Hence, you must not fall into this trap that is being set for you by the Israelis with the support of these . . . Americans. From an historical perspective, it is far more important to maintain the unity, cohesion, and integrity of the Palestinian people in order to resist Israeli occupation and repression.

VIII. THERE MUST BE SOME UNDERSTANDING ON A FINAL SETTLEMENT AS PART OF AN INTERIM AGREEMENT.

12. Let us return to the scenario I outlined above: Namely, Israeli military forces withdraw to military bases in Palestinian lands where they are strictly confined to their bases. And we must also make sure that any Interim Agreement you sign does not expressly recognize in any way the "right" of Israel to remain a belligerent occupant in Palestinian lands; or that the authority of PISGA or the Palestinian police force come from the Israeli belligerent occupation to any extent. Assuming those conditions, then how might you go about dealing with the questions of jurisdiction, laws, settlers, and settlements? The rest of this Memorandum will attempt to deal with those difficult subjects from a Palestinian perspective. But you must understand that there is absolutely no precedent that is favorable to the Palestinian people in the modern history of international law and politics for the success of such an Interim Agreement. Rather, most of the precedents we know of have been failures for the occupied peoples and lands. Indeed, this is even the conclusion of an official Department of State Study on the history of so-called autonomy and international law.

13. After the Camp David Accords were signed, and in explicit reference thereto, the Department of State entered into a contract with two professors of law to examine the history of autonomy under international law. This study was later published by the Procedural Aspects of International Law Institute in 1980 by Professors Hannum and Lillich under the title *The Theory and Practice of Governmental Autonomy.* The findings of this official State Department Study were summarized in an article by Professors Hannum and Lillich that was published soon thereafter in *The American Journal of International Law,* entitled "The Concept of Autonomy in International Law". I will not bother to go through this entire Department of State Report here. Rather, I simply wish to quote at this time the following conclusion of the authors: "...the present survey offers *no* examples of the successful implementation of a transitional regime without prior agreement on the general nature of the permanent regime to follow."[2] *And yet, this is exactly what the Americans and the Israelis are asking you to do!*

14. Both the Americans and the Israelis *know* on the basis of the State Department's own study that historically there has *never* been a successful transitional arrangement unless there is a prior agreement upon the ultimate outcome of the process. Nevertheless, both the Americans and the Israelis want you to go forward with this transitional agreement without any understanding on the final outcome. The reason why is quite obvious: Both the Americans and the Israelis know full well that if you go along the path of this transitional agreement without any assurances on the final outcome, that the transitional agreement will fail and the Israelis will remain in full control of your people and your land indefinitely.

15. The Israelis and the Americans are not dumb. They know exactly what they are doing—based upon their own Study. They are trying to get you to agree to an Interim Agreement without any understanding on the final outcome in the hope and expectation that this transitional agreement will fail and nevertheless that thereafter you will have consented to your own enslavement by means of the transitional agreement.

16. You must point this out to the Americans: How can they expect you to enter into a transitional agreement without any understanding on the final settlement when their own Study says quite definitively that under those

circumstances, the transitional agreement will fail? The Americans are not acting in good faith here. You must not trust their word. They are trying to entice you down the garden path of autonomy set forth in Camp David whereby your people will be enslaved for the rest of time. You must make it clear to both the Americans and the Israelis that you know exactly what is going on here and that you will not stand for it. Indeed, even the Americans' own Study makes this quite clear. You must use this State Department Study to your own advantage.

IX. PISGA MUST HAVE INDEPENDENT LEGISLATIVE AUTHORITY AND POWERS.

17. Assuming that you can accomplish the aforementioned objectives, this analysis then gets to the legal and administrative situation in Palestinian lands after Israeli forces have withdrawn to military bases to which they have been effectively and securely confined. What happens then? First, the Israeli military occupation dissolves as a matter of international law because it is no longer effective, except in the remaining military bases. Hence, the Israeli military regulations mean nothing in liberated Palestinian lands. They become null and void, and die and dissolve of their own accord under the laws of war. This result would not be so, however, for the remaining Israeli military bases which remain under the international laws of belligerent occupation.

18. So under the scenario outlined above, all of the pre-1967 Palestinian laws, institutions, councils, administrative bodies, courts, etc. revive upon the withdrawal of Israeli military forces to their military bases, except for those bases. And law and order is maintained in these liberated Palestinian lands by means of a Palestinian police force that is not subject to the control of the Israeli Army, but rather to the control of the pre-1967 laws and the PISGA, which in turn must not be the civilian administrative arm of the Israeli occupation forces. Hence, all of the Israeli military regulations will no longer apply in liberated Palestinian lands and you will be effectively governing yourselves under your own pre-1967 laws and institutions, together with the PISGA.

19. Admittedly, these pre-1967 laws are 25 years old and some of them will need to be amended, revised, abolished, altered, updated, etc. That, then, will become the function of the PISGA, which must have independent legislative authority and powers to do this as part of any Interim Agreement and during this transitional phase that will probably become the Final Settlement in any event. Until PISGA enacts this new legislation, however, the pre-1967 laws, institutions, and courts will remain in existence and function as best as possible under the circumstances. There is an important point of principle here that you must insist upon: Namely, that your people are governed by the pre-1967 laws and institutions and not to any extent by Israeli laws and institutions—at least until PISGA can get organized and functioning.

20. Hence, during this transitional phase, and until PISGA gets operating, all of your pre-1967 laws and courts will determine civil and criminal matters for all people living in liberated Palestinian lands. Nevertheless, clearly these laws will have to be brought into harmony with the current situation on the ground in liberated Palestinian lands. That is precisely why PISGA must have independent legislative authority and powers.

21. The Israelis have already conceded that there was "legislation" in effect prior to 1967. Therefore, PISGA must have independent legislative authority and powers to enact new laws so as to amend, alter, abolish, revise, and update, the preexisting legislation in light of 25 years of history and occupation. Therefore, you *must* insist that PISGA have independent legislative authority and powers. Otherwise, the Israeli military regulations will remain in effect either de facto or de jure, and PISGA will become nothing more than the civilian administrative arm of the Israeli occupation forces and therefore constitute a puppet government under international law.

22. Hence it is critical that PISGA have independent legislative authority and powers to enact laws. You cannot allow the Israelis to perform these tasks to any extent. Indeed, on this point even the State Department's own Study that I mentioned above agrees with me! It concludes as follows as to one basic requirement for "a fully autonomous territory": "There should exist a locally-elected body with some *independent legislative power*, although the extent of the body's competence will be limited by a constituent document. ..." (Emphasis added.)

23. Therefore, in your discussions with the Americans and with the Israelis, you must insist that PISGA have "independent legislative power". Even their own State Department Study says this! How can the Americans offer you anything less? How can the Americans ask you to accept anything less?

24. And yet that is exactly what the Israelis and the Americans are asking you to accept. They are asking you to accept a PAC or a PISGA that has no independent legislative powers whatsoever. This is precisely what the Begin government sought in the Camp David Accords and during the course of the Linowitz negotiations, to which you were not a party and are therefore not bound. Once again, you must emphatically reject the Camp David approach to these negotiations, whether as interpreted by Begin or Carter.

X. THE AMERICANS ARE TRYING TO DECEIVE YOU ON THE PISGA.

25. It is also clear to me that the Americans are trying to deceive you on the question of independent legislative authority and powers for PISGA. The proof of this American deceit can be found in the statements made by Assistant Secretary of State Ed Djerejian in the aforementioned document entitled *Minutes of Meeting at U.S. Department of State, Wednesday, October 21, 1992,* at page 4. Here I will have to analyze this paragraph on a line-by-line basis to show you how deceptive Djerejian is being and why he is really following the Israeli Camp David approach to these negotiations.

26. The critical language starts with the following comment by Djerejian: "...We have heard that elected authority, and we understand the elected authority would be called an executive council, rather than an administrative council." From the perspective of a licensed and practicing American lawyer and a law professor, this language constitutes a lot of double-talk and baloney.

27. In the Anglo-American common law system of government, there is no basic distinction between executive powers and administrative powers. They are both essentially the same thing. To be sure, executive powers are at the

next higher governmental level than administrative powers. Executive powers determine administrative powers; and thus administrative powers are subordinate to executive powers. But executive powers, let alone administrative powers, are not legislative powers. Indeed, legislative powers determine both executive powers and administrative powers. Thus, both executive powers and administrative powers are subordinate to legislative powers.

28. Let me give you one example drawn from the laws and institutions of the United States of America. Many years ago, I was a practicing tax lawyer, and am still licensed to practice tax law before the United States Tax Court and the United States Court of Claims. So my analogy will be drawn from the U.S. taxation system in order to illustrate the Americans' deception here on PISGA.

29. The Internal Revenue Service is an administrative agency within the Department of Treasury, which in turn is part of the Executive Branch of federal government of the United States of America. Hence, the Internal Revenue Service is the administrative authority with administrative powers. It is part of the Department of Treasury, which is the executive authority with executive powers that controls the I.R.S. But the Department of Treasury and the Internal Revenue Service have no independent legislative authority or powers to enact legislation or laws for the purpose of collecting taxes from the American people.

30. Under the terms of the United States Constitution, that power to enact the tax laws resides exclusively in both Houses of the United States Congress together. The Department of Treasury and the Internal Revenue Service are supposed to do what Congress tells them to do when it comes to collecting taxes. They have no independent legal authority or powers in their own right. Rather, when it comes to the collection of taxes, their powers and authority are delegated powers alone—delegated by the United States Congress.

31. Hence, it is no concession that Djerejian has made here. By offering to transform the PISGA/PAC from an administrative council into an executive council, all he has offered to do is to increase your stature from the I.R.S. to the Department of Treasury. PISGA will still not have any independent legislative authority or powers whatsoever.

32. According to Djerejian's "strategic vision," then, as a matter of administrative law, PISGA will become nothing more than the executive arm or the administrative arm of the Israeli military occupation forces. In other words, PISGA will become the civil administration or "puppet government" for the Israeli army in charge of occupying your own people. Of course, you do not want this to happen. But unless the PISGA has independent legislative powers, that is exactly what it will become. And the Israelis and the Americans know it.

33. The Americans are trying to deceive you here by drawing some false distinction between administrative powers and executive powers. There is no basic, fundamental, constitutional distinction between administrative powers and executive powers. In the United States of America, administrative bodies are set up under the control of and are subordinate to executive bodies. That is all. But the authority and powers of American executive bodies comes from the legislative body, which in the United States is Congress or the Constitution itself.

34. Thus, PISGA's authority must come from somewhere: either from the Israeli military occupation forces; or from the Palestinian people and land. Therefore, you must make sure that in the Interim Agreement, the source of authority for PISGA comes (1) from general elections by the Palestinian people living on their land and (2) with independent legislative authority and power for PISGA over Palestinian lands and the people living therein. If not, then PISGA's authority comes from the Israeli military occupation forces, which in turn means that PISGA would be nothing more than an administrative branch or an executive branch of the Israeli occupying forces. The conclusion is inexorable that without independent legislative authority and powers, PISGA will be nothing more than a "puppet government" under international law.

35. Let me continue with the Djerejian statement and show you how knowingly deceptive and misleading he really is: "It could have the power to enact decrees and regulations and edicts which carry the force of law, and we think..." Once again, this carefully chosen language is purposely deceptive and misleading. Of course, the Internal Revenue Service has the "power to enact decrees and regulations and edicts which carry the force of law..." But that does not mean that the Internal Revenue Service has any independent legislative authority or powers whatsoever to actually enact the laws themselves. The I.R.S. does not. Rather, the ability of the I.R.S. to enact decrees, regulations and edicts "which carry the force of law" is based upon the authority and powers that have been delegated to it by the United States Congress. Only the U.S. Congress can actually enact the tax laws themselves.

36. Likewise, the Department of Treasury has "the power to enact decrees, and regulations and edicts which carry the force of law..." But it has no independent legislative authority or powers to enact the laws themselves. Rather, the laws are enacted by Congress, which in turn gives the Department of Treasury the executive authority to "enact decrees and regulations and edicts" to carry out the tax laws that Congress has enacted. On the basis of this Congressional authority and laws, the Department of the Treasury then directs the I.R.S. to actually collect the taxes themselves. The I.R.S., then, is the administrative agency for the collection of taxes, which is a part of and subordinate to the Department of Treasury, which is the executive agency for this and other purposes. Ultimate authority and power over U.S. tax policy still remain in the hands of Congress under the terms of the U.S. Constitution.

37. It is clear to me as an American lawyer that Djerejian is trying to deceive you, trick you, and confuse you. Djerejian gives away his outright fraud and deception in the next part of this sentence when he says: "...and we think that you should not confuse the legislative function and the issue of legislative authority, and therefore throw out a good idea." This is total nonsense! This is a deceptive distinction without a difference. Djerejian is lying to you and deceiving you.

38. Under the American practice, without legislative authority, there is no such thing as a legislative function. Without legislative authority, then all you have is administrative function or executive function. Enacting decrees, regulations and edicts is an administrative and executive function. It is not a legislative function. Legislative bodies enact laws—not decrees, regulations or edicts. Only administrative and executive agencies enact decrees, regulations and edicts. And that is all which they are empowered to enact.

39. These are well-known distinctions here in the United States that I am sure Djerejian and his legal advisers fully comprehend. Once again, they are lying to you and trying to deceive you in order to get you to accept the Israeli/Camp David approach to these negotiations. You must not fall into their trap. You cannot trust these Americans. They do not have your best interests at heart, no matter what they tell you to your face. They are acting here hand-in-glove with the Israelis, and promoting the Israeli agenda and the Camp David approach to these negotiations.

40. Once again, you must insist that PISGA have independent legislative authority and power to enact laws. Even the State Department's own Study on "autonomy" says this, as indicated above. Otherwise, PISGA will be nothing more than an executive/administrative arm of the Israeli Army and therefore a puppet government.

41. Let me continue with the Djerejian statement and show you how purposefully deceptive he really is: "We understand it is reasonable that Palestinians insist they must have authority to enact decrees which carry the force of law." Once again, this statement is nonsense and he knows it. The Palestinians must insist that they have independent legislative authority to enact *laws* which carry the force of law, not decrees. You must insist that the PISGA have independent legislative authority and powers to enact laws. Otherwise, the PISGA will remain an adjunct of the Israeli Army and military occupation forces and thus a puppet government.

42. Using this language, Djerejian is trying to get you to agree that PISGA will have authority "to enact decrees which carry the force of law," but which are not laws in their own right. Thus, he clearly wants you to agree to have PISGA become nothing more than an administrative arm or executive branch of the Israeli occupation forces. Because if PISGA has no independent legislative authority or powers, then its authority and power must come from somewhere: The Israeli Ministry of Defense and Army. If so, then PISGA will be nothing more than its administrative branch or executive organ—in other words, a puppet government.

43. The final sentence by Djerejian I wish to analyze here is as follows: "It is not reasonable for Palestinians to insist on independent legislative rights to overturn agreements yet to be negotiated, or to legislate issues that could change the agreements unilaterally." Of course that is not what you want to do. And Djerejian is purposely misrepresenting what you want to do!

The Need for a Basic Law.

44. You must insist that PISGA have independent legislative authority and powers to enact laws. But of course you can also agree that the independent legislative powers of PISGA would be subject to a Basic Law that would prohibit PISGA from doing certain things. For example, in this Basic Law, you could agree that PISGA would not declare an independent Palestinian State. Of course that is fine because the PNC has already declared an independent Palestinian State in 1988; so PISGA does not have to declare the State a second time. Likewise, you could also agree that in the Basic Law, PISGA would have no authority to "overturn" or "change" the Interim Agreement itself.

45. Moreover, even the State Department's own Study on this matter has reached the exact same conclusion that I am recommending: "There should exist a locally-elected body with some independent legislative power, although the extent of the body's competence will be limited by a *constituent document.*" (Emphasis added.) That constituent document would be a Basic Law. It should not be a formal Constitution until the Palestinian people are able to exercise full sovereign powers within their own lands.

46. But as I understand it, you are fully willing to limit the powers of PISGA by a Basic Law that contains some basic restrictions on its independent legislative powers. This is a fully reasonable position to take. Indeed, this position is fully supported by the State Department's own Study. And Djerejian and his lawyers and advisers know it!

47. Hence, these Americans are trying to get you to agree to less than what their own State Department Report recommended. In other words, they are trying to get you to agree to the Israeli position on a PISGA that is nothing more than a PAC, which is nothing more than an administrative agency or executive council under the control of the Israeli Ministry of Defense or Army, which in turn is nothing more than a puppet government. Thus, it is clear to me that both the Americans and the Israelis want PISGA/PAC to be nothing more than the civilian administration of the Israeli occupation forces.

48. But you must not agree to occupy your own people. Once again, let the Israelis do their own dirty work for themselves. You must maintain the unity, cohesion, and integrity of the Palestinian people in order to resist Israeli occupation and oppression at all costs. If the Israelis do not want peace with justice at this time, then so be it.

You Must Take Your Case Directly to Clinton.

49. Indeed, in reading through the transcript of the *Minutes* of this meeting of October 21, 1992, it seems clear to me that all of the Americans there are operating within the framework of the Camp David Accords, though they do not use the name of Camp David. I see no point in this Memorandum in going through the *Minutes* on a line-by-line basis pointing this out. But it is all very clear to me that each and every American in there views this so-called peace process in terms of the Camp David Accords. In other words, they are working hand-in-glove with the Israelis to get you to agree to the Camp David Accords by calling it something else. But we all know where the Camp David Accords lead for the Palestinian people: The "final solution" envisioned by Begin, Shamir, Sharon, Eytan, Kahane and now Rabin.

50. Moreover, most of the Americans at this meeting are Jewish. For this reason, they see this entire process through Israeli eyes. They are psychologically incapable of seeing this process through the eyes of the Palestinian people. They are not honest brokers.

. . . .

PISGA's Independent Legislative Authority and Powers Will Become the Progenitor of Palestinian Sovereignty.

146. There is one definitive reason why you must insist upon independent legislative authority and powers for PISGA even subject to a Basic Law. Both the Israelis and the Americans are trying to put your people and land into the straitjacket of Camp David forever. There is only one way around this. Namely, you must build into any Interim Agreement a mechanism whereby PISGA can ripen into internationally recognized legal and political sovereignty over the people and land of Palestine. In other words, you must build your State from the bottom up. The essence of sovereignty is a people living on their land and exercising control over Themselves and their land. But this can only be done if PISGA has independent legislative authority and powers to enact laws over your people and their lands.

147. In the event that PISGA has independent legislative authority and powers to enact laws during the "life" of the Interim Agreement, then PISGA will have de facto international legal sovereignty over the Palestinian people and lands. It will act as if it were the sovereign legislative body even if it is not actually so as of yet. By enacting laws, PISGA will be engaging in sovereign functions. It will mean that the Palestinian people control their own land and their own people. By doing this, PISGA will be able, then, to build up the Palestinian State from the bottom up—that is, from the land and the people.

148. As a matter of international law and politics, international legal sovereignty will only come from the Palestinian people and the Palestinian land. So the Palestinian State must be built from the bottom up. The Israelis want to do the reverse: They want to set up a PISGA/PAC whose authority and powers come from the Israeli Army and thus to prevent the establishment of any independent Palestinian legal sovereignty in Palestinian lands. So the only way to avoid that result is to demand that PISGA must have independent legislative authority and powers to enact laws. And of course, there must be a system of general national elections by the Palestinian people to choose the members of PISGA.

149. If you can accomplish these objectives, then you will have the essence of sovereignty in your own hands. A Palestinian State will become an inevitability no matter how long the Interim Agreement might last and even if you never get to that so-called Final Settlement. Once again, for reasons previously explained, I do not believe you will ever see that so-called Final Settlement.

150. For this reason, then, you must build into the Interim Agreement the mechanism by which Palestinian sovereignty will ripen with time no matter what happens. And the only way this can be done is to insist upon a PISGA with independent legislative authority and powers to enact laws applicable to all people and lands under its jurisdiction. This would require PISGA control over all liberated Palestinian lands and the people living there, but excluding any remaining Israeli military bases established pursuant to the Interim Agreement. These latter comments, then, bring us directly to the difficult question of the treatment of Israeli settlers and Israeli settlements under any Interim Agreement. I will now address those complicated issues.

XI. THERE MUST BE NO ISRAELI "SETTLERS" PER SESE UNDER THE INTERIM AGREEMENT!

151. The Israelis would like the Palestinians to sign an Interim

Agreement that would "regularize" or "legalize" the presence of Israeli settlers and settlements in Palestinian lands on a *de facto* basis. Of course, you must not do that. Indeed, you do not even have the legal power to do that under articles 7 and 8 of the Fourth Geneva Convention as indicated above.

152. Nevertheless, what the Israelis want to do here is to get you to sign an Interim Agreement that effectively will "regularize" or "legalize" the continued presence of Israeli settlers and settlements in Palestinian lands. The Israelis will then claim that the conclusion of the Interim Agreement, together with a peace treaty with Jordan, has terminated the applicability of the Fourth Geneva Convention. Therefore, the Israelis will argue, any settlers and settlements remaining in Palestinian lands after the Interim Agreement are valid and duly recognized by the Palestinian people themselves. Once again, however, you do not want to do this in an Interim Agreement or otherwise. *So how do you square the circle here?* We must go back to the scenario that I outlined above:

153. Following that scenario, all of the pre-1967 laws and institutions would revive in full force and effect in the liberated Palestinian lands. As I understand it, there are provisions within these pre-1967 laws that regulate the presence of foreigners as such within Palestinian lands. Hence, any Israelis who continue to insist to live in liberated Palestinian lands after the conclusion of the Interim Agreement must be subject to the pre-1967 laws for the regulation of foreigners.

154. In other words, the Interim Agreement can be drafted in such a way as to make it clear that the settlers will not be thrown out. On the other hand, the Interim Agreement must not expressly permit settlers to remain because this would violate the Fourth Geneva Convention. Hence, once again, the absolute need to preserve your rights under the Fourth Geneva Convention as indicated above.

155. Thus, with regard to Israeli settlers, there are three basic requirements of any Interim Agreement: (1) The Interim Agreement cannot expressly permit by name the continued presence of Israeli settlers in liberated Palestinian lands; (2) nevertheless, the Interim Agreement can be drafted in a neutral way to make it clear that non-Palestinians (*i.e.*, foreigners) currently living in Palestinian lands can continue to live there as residents; (3) but that any foreigners choosing to live in liberated Palestinian lands must be subject to the pre-1967 laws and the PISGA. The net result here would be that Israelis currently living in settlements would be able to continue to live in the liberated Palestinian lands provided they are willing to obey the pre-1967 laws and whatever laws are enacted by PISGA, subject to any protections for them set forth in a Basic Law.

156. On this matter, of course, the Israeli government would want an assurance that Israeli citizens living in liberated Palestinian lands would not be discriminated against. That would be fine. In the Palestinian Declaration of Independence of 1988 and the Political Communiqué attached thereto, the Palestine National Council made it quite clear that it did not want to discriminate against anyone for any reason.

157. Therefore, one way this matter could be handled would be to have the aforementioned Basic Law include within itself the Universal Declaration

of Human Rights of 1948. In other words, PISGA would have independent legislative authority and powers to enact laws, but it could not enact any law that contravened the Universal Declaration of Human Rights. The incorporation of the Universal Declaration into the Basic Law would protect both Palestinians and Israelis living in the liberated Palestinian lands. But it would not protect Israelis per se or by that name. It would be a piece of neutral legislation that would protect everyone as human beings and irrespective of nationality. In this manner, the Israelis would not be able to argue that you have somehow regularized or legalized the presence of Israeli settlers in liberated Palestinian lands under an Interim Agreement.

158. Of course, I am not an expert on the laws that existed in Palestinian lands prior to 1967. But I have been told by a Palestinian lawyer that these laws do not permit foreigners to become permanent residents. If that is the case, then in order to make it possible for Israelis to live in liberated Palestinian lands for a period of time, the PISGA could enact legislation that would provide that non-Palestinians living in land subject to its jurisdiction would have the right to continue to live there for a guaranteed five years (*i.e.,* the proposed term of the Interim Agreement), provided that they obey Palestinian laws like everyone else, but subject to the protections established by the Universal Declaration of Human Rights as incorporated into the Basic Law. A five-year deadline in this PISGA legislation would make it quite clear that in the event the Israeli government stalled on the so-called Final Settlement, then all foreigners (*i.e.,* Israelis) living in liberated Palestinian lands would have to go home.

There Must Be No Israeli "Settlers" Per Sese Under a Final Settlement!

159. In regard to these settlers, you could also indicate to the Israelis at this time that as part of the Final Settlement, PISGA would be prepared to enact legislation that would give foreigners currently living in occupied Palestinian lands the right of permanent resident alien status. In the United States, this means a foreigner who has a so-called "green card". Indeed, this PISGA "green card" legislation could be modeled upon the American system for permanent resident alien status.

160. Under that body of U.S. law, permanent resident aliens have almost all the rights of American citizens except, principally, the rights to vote and to hold public office. There are some other incidental restrictions that are not relevant here—*e.g.,* some states prevent aliens from becoming public school teachers. But the bottom line is that permanent resident aliens in the United States are treated almost like citizens for all practical purposes.

161. Furthermore, you could even indicate now that as part of a Final Settlement, the PISGA would be prepared to enact legislation that would offer Palestinian citizenship to foreigners living in liberated Palestinian lands, and without a requirement that such foreigners renounce whatever other citizenship they might already have. Thus, Israelis living within liberated Palestinian lands could become dual nationals and, in that event, would have all the rights of Palestinian citizens living in the Palestinian State.

162. Quite obviously, I do not have the time here to go through all of the possible implications and ramifications of this proposal. But I simply wish to

indicate that it is premised upon the assumption that PISGA must have independent legislative authority and powers in the first place. I must also assume that both the Israelis and the Americans are prepared to negotiate in good faith for a solution on the settlers. This is not apparent right now.

163. Finally, let me repeat that when it comes to the actual drafting of the Interim Agreement itself, the language must be carefully written in such a way so that you do not expressly regularize or legalize the presence of Israeli settlers *per sese* in liberated Palestinian lands. Rather, the language of the Interim Agreement must be neutral and you must preserve your rights in one fashion or another under the Fourth Geneva Convention as indicated above. Otherwise, once again, the Israelis will claim that the Interim Agreement has regularized or legalized the presence of Israeli settlers and settlements in liberated Palestinian lands. Let us now turn to the question of how an Interim Agreement might deal with Israeli settlements in a manner consistent with international law.

XII. THERE MUST BE NO ISRAELI "SETTLEMENTS" PER SESE UNDER THE INTERIM AGREEMENT!

164. According to the above scenario, we will have a certain number of Israeli citizens living in liberated Palestinian lands but subject to Palestinian laws under the Interim Agreement. I doubt very seriously that this number will be too many people. But it could be some. You will need to reach some type of tacit understanding as to the maximum number permissible.

165. Likewise, a similar tacit understanding on the maximum number in a Final Settlement would have to be agreed upon, though not expressly recognized in the documents themselves. And in any event, all of these foreigners living in liberated Palestinian lands would be subject to Palestinian laws just like everyone else. Indeed, this is the way it is with foreigners legally living in any other state in the world community today. The same should be true for Israelis living in liberated Palestinian lands, whether during the Interim Agreement or after the Final Settlement.

166. This brings the analysis to the question of where these Israeli nationals can live. Well, of course they should be able to live anywhere within liberated Palestinian lands that is subject to the jurisdiction and laws of the PISGA without discrimination. In other words, as part of an Interim Agreement these Israeli nationals would not be forced to move from where they are currently living today. Undoubtedly, a large number of these Israeli nationals will choose to return to Israel. On the other hand, undoubtedly, some will probably decide to stay where they are, especially the religious fanatics.

167. But under the arrangements sketched out above, there will be no such thing recognized as an Israeli "settlement" in liberated Palestinian lands in the Interim Agreement itself. All liberated Palestinian lands and all people living therein must be subject to the legislative authority and powers of the PISGA and the Basic Law. The only land and people that would not be subject to the authority of the PISGA would remain the land and the people still under the control of the Israeli Army as the belligerent occupant of the military bases to which they have withdrawn their military forces as part of an Interim Agreement. This brings the

analysis to the international legal regime that must apply to those military bases and their personnel under the international laws of belligerent occupation.

XIII. ISRAELI MILITARY BASES IN LIBERATED PALESTINIAN LANDS.

168. Under the scenario described above, I have called for the withdrawal of Israeli military forces to military bases that are located in Palestinian lands. These Israeli military forces will remain under the international laws of belligerent occupation. On the other hand, the Interim Agreement must not expressly consent to their presence *in haec verba*. And you must preserve your claims under Resolutions 242 and 338 as indicated above. Otherwise, those Israeli military forces will stay in those military bases forever. You must make it clear in some fashion or another that the Interim Agreement does not regularize or legalize the continued presence of Israeli military forces in these military bases at all, and that eventually they are required to leave even if a Final Settlement is not concluded.

169. I now wish to deal with the question of the legal regime that applies to the Israelis living on those military bases. The black-letter rule on this subject can be found in Paragraph 374 of the aforementioned U.S. Army Field Manual 27-10 (1956):

374. Immunity of Occupation Personnel From Local Law

Military and civilian personnel of the occupying forces and occupation administration and persons accompanying them are not subject to the local law or to the jurisdiction of the local courts of the occupied territory unless expressly made subject thereto by a competent officer of the occupying forces or occupation administration. The occupant should see to it that an appropriate system of substantive law applies to such persons and that tribunals are in existence to deal with civil litigation to which they are parties and with offenses committed by them.

170. Thus, all Israelis living on these military bases are subject to Israeli military control and jurisdiction. Under no circumstances must you recognize in an Interim Agreement the "right" of the Israeli government to apply any of its civilian laws to civilians living on these military bases. On the other hand, an Interim Agreement does not necessarily have to forbid the Israelis from applying their civilian laws to civilians living on these military bases. Under the laws of war, these laws will be presumed to be part of the military occupation regime no matter what the Israelis call them. The critical point is that you must not *consent* to the application of Israeli civilian laws to any civilians living on these military bases.

171. As you can see clearly from the first sentence of Paragraph 374, the laws of war would permit "civilian personnel of the occupying forces and occupation administration and persons accompanying them" to live on these Israeli military bases. In other words, it would be permissible for Israeli civilians to live on these military bases provided that they are part of or attached to the Israeli military forces or "occupation administration". Hence, the Israelis would be entitled to maintain not only military forces in these military bases, but also an

"occupation administration" consisting in part of civilian personnel, together with their families.

172. To be sure, under no circumstances can you agree that this "occupation administration" on these Israeli military bases has any jurisdiction over any liberated Palestinian lands or people living therein. But under the rubric of "occupation administration" as carefully defined, it would be permissible for you to accept the presence of a certain number of Israeli civilians living on these military bases provided that they are "civilian personnel of the occupying forces [or] occupation administration." In addition, the first sentence of Paragraph 374 also seems to contemplate that such "civilian personnel" would be entitled to have on these military bases "persons accompanying them"—in other words, their families.

173. Thus, it would be possible to set up an arrangement whereby you could accept the presence of a certain number of Israeli civilians and their family dependents on these Israeli military bases as part of the Interim Agreement. And of course, you would need to reach some type of tacit understanding as to the maximum number of "civilian personnel" and "persons accompanying them" that would remain in these Israeli military bases. You should not agree in writing to a certain number of civilians. But various mechanisms can be worked out to settle upon a mutually satisfactory number.

174. The soldiers and civilians living on these military bases would be subject to the military laws of Israel. The next question then becomes: What laws apply to these Israelis—whether military or civilian—as they transit from Israel to and from these military bases located in liberated Palestinian lands. No point would be served here by going through all the permutations and combinations of overlapping jurisdictions between PISGA and the Israeli army concerning the Israeli military and civilian personnel and their dependents living on these military bases when they travel to and from Israel. This matter will have to be thought through very carefully.

175. I do not have the time in this brief Memorandum to explore this matter in detail. Rather, what needs to be done is for one of your experts to look into the transit agreements that were set up for Allied Forces in the City of Berlin before the reunification of that city as part of the overall Treaty for the reunification of Germany. Up until the time of that treaty, the City of Berlin was occupied territory subject to the exclusive sovereignty and control as belligerent occupants of the United States, Great Britain, France, and the Soviet Union.

176. Hence, the Berlin situation would not be precisely analogous because under international law, the four Great Powers actually exercised legal sovereignty over Berlin on a shared basis. By comparison, you must not accept any implication whatsoever that Israel has any sovereign rights or claims to these military bases. Though to be sure, Israel would be subject to the international laws of belligerent occupation in those military bases. Hence, the international legal precedent concerning the City of Berlin before reunification should be thoroughly researched in regard to transit rights for the United States, Great Britain, and France into and out of Berlin. But, once again, whoever does this research must keep in mind that the four Great Powers actually had international legal sovereignty over the City of Berlin jointly, whereas Israel does not have any legal sovereignty or claims to sovereignty over these military bases.

177. In addition, you should also examine the so-called Status-of-Forces Agreement concluded by the United States with the Federal Republic of Germany dealing with the stationing of U.S. military forces, civilian personnel, and their dependents in the Federal Republic of Germany. Once again, this situation is not precisely analogous because, technically, U.S. military bases in Germany are not arguably there pursuant to the international laws of belligerent occupation, but rather pursuant to the terms of a treaty concluded between two sovereign states. Thus, you could consider offering to conclude something like a Status-of-Forces Agreement with Israel somewhat along the lines of the agreement between the Federal Republic of Germany and the United States for the stationing of U.S. military forces and their dependents in Germany. But this matter would require more detailed research by your experts before I could express a formal Legal Opinion one way or another on its advisability under international law. For, once again, you do not want to regularize or legalize the Israeli presence in your lands as part of an Interim Agreement or otherwise.

XIV. SHOULD ISRAELI MILITARY FORCES BE PERMITTED TO WITHDRAW TO CURRENT ISRAELI "SETTLEMENTS" AS PART OF AN INTERIM AGREEMENT?

178. These latter observations then bring us to the crux of the problem: Could an Interim Agreement permit Israeli military forces to withdraw to some currently existing Israeli settlements and thus establish their military bases there? In theory, it might be possible to do this; but it would have to be done very carefully. Otherwise, you risk losing sovereign control over those military bases/settlements forever.

179. First, an Interim Agreement would have to be drafted in a neutral fashion so as to indicate that you are not in any way sanctioning, legalizing, or regularizing Israeli settlements currently located in occupied Palestinian lands. For example, the Interim Agreement might contain a precise geographical delineation of where these Israeli military bases could be located in terms of latitude and longitude without mentioning the names of towns, cities, villages or anything like that.

180. Second, it would have to be clear that any civilians remaining in those military bases are "civilian personnel" attached to the Israeli occupying forces or the occupation administration, together with their families. You cannot consent to the presence of any other civilians in those military bases without violating the Fourth Geneva Convention and thus providing a *de facto* legitimization, regularization, or legalization of the settlers and the settlements. You do not want to do this in any event.

181. Third, you must understand that there will be a serious and grave risk of Israel making a claim to legal sovereignty over these military bases in the event that they are located in land where Israeli settlements are located today. If you agree to this arrangement without preserving your rights and claims under the Fourth Geneva Convention and Resolution 242 as indicated above, the Israelis will claim that an Interim Agreement that allows them to establish military bases in areas where civilian settlements are located today would constitute a *de facto* if not *de jure* recognition, regularization, and legalization of their claims to those settlements.

182. The Israelis will argue that they had long ago put forward a "claim" to these settlements as a matter of international law and practice under the Yehuda Bloom *Missing Reversioner* argument, and that you were on notice as to their claims. The Israelis will then argue that your failure to refute their claims is tantamount to a *de facto* acceptance of their claims. The Israelis will conclude their argument by pointing out that you have effectively countenanced their claims by permitting them to establish military bases in these currently existing settlements.

183. So if you are not very careful, an Interim Agreement that permits the withdrawal of Israeli military forces to military bases on illegal Israeli civilian settlements could arguably legitimize the settlements and you might permanently lose control over this land. In addition to these claims, the Israelis will also argue the doctrines of adverse possession and prescription in order to justify their claims to sovereignty over these military bases/settlements as part of a Final Settlement or otherwise. Once again, the only way to prevent this from happening is to preserve your rights and claims under the Fourth Geneva Convention and Resolution 242 as part of any Interim Agreement in the manner indicated above.

184. Even then, that might not be sufficient to protect your sovereign rights to these military bases/settlements. It would certainly be better to have the Israeli military forces withdraw to military bases that are separate and apart from current Israeli settlements. That arrangement would provide you with much better protection.

185. In this regard, you must be very concerned about the unfortunate precedent of the situation in Cyprus. As part of the agreements that produced the independence of Cyprus, the Cypriots themselves had to agree that Britain would be able to maintain military bases in Cyprus and that these military bases were subject to British sovereign control. In other words, the British military bases in Cyprus are British territory, not Cypriot territory, under international law. You do not want the same thing to happen to Israeli military bases in Palestine, whether as part of a Final Settlement or otherwise.

186. Indeed, the status of the British military bases in Cyprus is even worse than the status of U.S. military forces in the old Panama Canal Zone. Under the terms of the old Panama Canal Treaty, the United States government had rights to the Panama Canal Zone "as if it were the sovereign." That language was very carefully drafted to make it clear that the United States government was not in fact or in law "the sovereign" in the old Panama Canal Zone. That important distinction paved the way for the 1977 Panama Canal Zone Treaties that call for the United States government to evacuate Panama at the end of this century. Of course, it is an open question whether or not the United States government will actually withdraw from Panama. But at least the treaties are clear that the United States government must withdraw by the year 2000.

187. By comparison, the British military bases in Cyprus are sovereign British territory—just like London. You do not want that to happen with Israeli military bases/settlements in Palestine—just like Tel Aviv.

188. In this regard, remember that at one point in time the Labor

government of Rabin had adhered to the so-called Allon Plan. You do not want to sign an Interim Agreement that will result in the Allon Plan as the Final Settlement. But the Allon Plan could very well be Rabin's bottom line. Once again, in order to prevent this from happening, you must preserve your rights under the Fourth Geneva Convention as well as your claims under Resolutions 242 and 338 as part of any Interim Agreement.

XV. JERUSALEM AND THE INTERIM AGREEMENT.

189. Both the Israelis and the Americans are encouraging you to put aside the status of Jerusalem until the so-called Final Settlement. But this is a trap that they are trying to set for you. You must not fall into it. The reason why this suggestion is a trap is because of the U.S.-Israel Land-Lease and Purchase Agreement of 1989, which calls for the transfer of the U.S. Embassy from Tel Aviv to Jerusalem by July of 1996.

190. This Embassy Agreement was based upon the so-called Helms Amendment, which served as the U.S. domestic authorizing legislation for the negotiation of this Agreement between the Reagan administration and Israel. I have already analyzed the illegalities surrounding this Agreement and the Helms Amendment in two Memorandums I wrote for Congressman Lee Hamilton, Chairman of the House Subcommittee on Europe and the Middle East, which have been published in *American-Arab Affairs*.[3] I will not bother to repeat any of that analysis here because you have already seen these memoranda and have them in your archives.

191. Suffice it to say, however, this Embassy Agreement and the Helms Amendment call for the U.S. Embassy to be transferred from Tel Aviv to Jerusalem by July of 1996. The Helms Amendment was enacted into law by Senator Jesse Helms at the behest of the American-Israel Public Affairs Committee (AIPAC). It was designed expressly for the purpose of making sure that the U.S. Embassy would be transferred from Tel Aviv to Jerusalem during 1996, which will be a presidential election year.

192. Notice that the timing here was no coincidence: July of 1996. This will be right at the time of the Republican Convention and immediately before the Democratic Convention during that election year and thus just before the presidential elections take place in November of 1996. It is very clear that in order to get renominated as President and to obtain the political and economic support of AIPAC and Jewish-Americans, President Clinton will have to transfer the U.S. Embassy from Tel Aviv to Jerusalem by July of 1996. By then, the pressure upon him to do this will be overwhelming.

193. Indeed, as you know, AIPAC has enormous influence over Clinton in any event. And the 1992 platform of the Democratic Party upon which Clinton was elected calls for this result as well. It would be imprudent for you to ignore these domestic political realities concerning Jerusalem in the Interim Agreement. Otherwise, your people could lose all of Jerusalem forever.

194. Therefore, it is my conclusion that you *must* deal with the Helms Amendment and this Embassy Agreement *now*. You cannot wait to the so-called

Final Settlement because you will probably not even begin negotiating the Final Settlement until after July of 1996, if ever. At best, you might be in the process of negotiating the so-called Final Settlement in July of 1996, when President Clinton moves the U.S. Embassy from Tel Aviv to Jerusalem as required by the Helms Amendment and this Agreement in order to get re-elected and thus preempts your claims to Jerusalem. Thus, you must try to head off the Helms Amendment and this Embassy Agreement now before the political momentum becomes overwhelming.

195. So far, the Department of State has given oral assurances at a very low level that there is nothing to worry about in the Helms Amendment and this Agreement. Of course, that is total nonsense and a lie. There must be an absolute iron-clad guarantee that the United States government will not transfer its Embassy from Tel Aviv to Jerusalem unless and until the so-called "Final Settlement" has been negotiated, approved, ratified, and implemented in a manner that is acceptable to both the Palestinians and the Israelis. There are a variety of ways in which such a guarantee can be given to you concerning this Agreement and the Helms Amendment. I will not bother to get into them here.

196. The bottom line is that if the United States government is not prepared to give you an absolute, iron-clad guarantee that it will not transfer the U.S. Embassy from Tel Aviv to Jerusalem until after the implementation of the so-called Final Settlement, then you know that the United States government is not negotiating in good faith with you now. That is the very least the Americans can do for you in order to facilitate an Interim Agreement. And if the United States government is not prepared to give you this guarantee on Jerusalem, then you know that the Americans are preparing to sell you out to the Israelis on Jerusalem, and everything else for that matter.

197. In this regard, it would be important to provide both the Americans and the Israelis with some idea of what you think a Final Settlement on Jerusalem might look like. Again, going back to the aforementioned State Department Study, there is no historical example of a successful transitional arrangement unless the parties have an understanding as to the Final Settlement. The same principle would apply to Jerusalem.

198. In this regard, I have written an article entitled "The Future Peace of Jerusalem" in which I outlined a proposal for the City of Jerusalem that fulfills the publicly-stated requirements of Israel, the United States, the Palestine National Council, and the Vatican. I will not bother to repeat that analysis here since I have made this article available to Members of the Delegation. But if you have any questions about it, please feel free to contact me.

199. Once again, I strongly recommend that you put forward some idea of what you believe would be an overall Final Settlement on the City of Jerusalem. As the State Department Study indicates quite clearly, there has *never* been a successful transitional arrangement unless the parties have an understanding as to the ultimate Final Settlement.

200. The Americans at the State Department know this. And the Israelis know this. That is exactly why they want you to sign an Interim Agreement without

any understanding on a Final Settlement, including Jerusalem. They do not want the Interim Agreement to succeed. Rather, they want the Interim Agreement to become the "final solution" to the Palestinian people. It is up to you to make sure that this does not happen.

XVI. CONCLUSION.

201. This Memorandum of Law has been written in order to provide you with some guidance as to how an Interim Agreement can be negotiated and drafted to guarantee that an independent State of Palestine will some day come into existence on Palestinian lands no matter what the Israelis or the Americans do. You cannot trust their oral assurances. You must study very carefully every jot and tittle of every written document that they give you. You must also parse very carefully every word that the Americans and the Israelis tell you on the basis of their so-called Talking Points.

202. These people are not dumb. They know exactly what they are doing. They have had some of the best lawyers in the world sit down to try to devise a very elegant and clever series of legal chains by which to enslave your people for the rest of history. It is up to you to reject those chains while at the same time offering them the hand of peace and friendship, which you have already been doing for at least the past four years. Of course, you cannot continue to extend that hand of peace and friendship forever. But under no circumstances must you put that hand into their trap and legal chains. For once your hand is in their trap, you will never be able to get your people and land out.

203. I realize that these are difficult decisions that only you can make. I have done the best that I can within a limited period of time and without any extensive research to provide you with the best guidance that I can on the negotiation of this Interim Agreement under international law. If you have any further questions, I would be more than happy to meet with you personally in Washington, Amman, Jerusalem or Ramallah, or with the Political Leadership of the Palestinian people in Tunis to discuss these matters. I am at your disposal. I await your further instructions.

May God be with you and your People at this critical time in your nation's history.

Yours very truly,

Francis A. Boyle
Professor of International Law

ENDNOTES

1. George W. Ball & Douglas B. Ball, The Passionate Attachment 63 (1992).
2. 74 American Journal of International Law 858-89, at 865 (1980).
3. American-Arab Affairs, No. 30, at 125-38 (Fall 1989).

From the Oslo Accords to the Al Aqsa Intifada

Introduction

It was my great honor and pleasure to have served as the Legal Adviser to the Palestinian Delegation to the Middle East peace negotiations from 1991 to 1993, including and especially to the Head of the Delegation, Dr. Haidar Abdul Shaffi, a man of great courage, integrity, and principle. The following reflections are to the best of my immediate recollection and the viewpoints expressed here are solely my own.

Palestinian Good Faith

The Palestinian Delegation entered the Middle East peace negotiations in good faith in order to negotiate an Interim Peace Agreement with Israel that would create a Palestinian Interim Self-Government for a transitional five-year period. Indeed, immediately after the ceremonial opening at Madrid on 30 October 1991, I was instructed to draft several Position Papers on numerous issues that were expected to come up during the first round of negotiations scheduled to begin a month later in Washington, DC. But when we got to our Headquarters at the Grand Hotel in Washington, nothing happened. There were no reasonable good-faith negotiations conducted by the Israeli Team for dealing with the Palestinians at U.S. State Department Headquarters, which was the venue for all Tracks of the Middle East peace negotiations.

Shamir's Stall-job

At that time the Israeli Government was headed by the Likud Party under Prime Minister Yitzhak Shamir. And later on, Shamir admitted that his so-called strategy at the peace negotiations was to drag them out for the next decade. Having been personally subjected to this process, I can assure you that Prime Minister Shamir accomplished this objective for as long as he was in power.

But what was most distressing was that the United States State Department went along with Shamir's strategy of stalling. It became quite obvious that the U.S. State Department officials involved with the negotiations had no intention whatsoever to pressure Israel to negotiate in good faith. Indeed, it was usually the case that U.S. State Department officials sided with the Israeli Delegation against the Palestinian Delegation in a manner which supported Shamir's strategy to stall the negotiations. Furthermore, having done some work at the request of the Syrian Delegation to the Middle East peace negotiations (who were also headquartered in the Grand Hotel) during the First Round in Washington, DC, I can certify that the same strategy was applied to the Israeli-Syrian Track.

Labor vs. Likud?

But Likud lost the elections in June of 1992, and the Labor Party came to power under Prime Minister Yitzhak Rabin. One of the first changes Rabin made with respect to the Middle East peace negotiations was to fire the Israeli Syrian Team of negotiators, and bring in new and dynamic leadership under Professor Itimar Rabinowitz, generally considered to be Israel's top expert on Syria. With the new Israeli Syrian Team in place, substantial progress was made during the course of the Israeli-Syrian Track to such an extent that if Labor had won the next round of Israeli elections, it was clear there would have been an Israeli-Syrian peace agreement along the lines of the Israeli-Egyptian Peace Treaty. This remains a possibility—if Israel ever becomes willing to implement UN Security Council Resolution 242 (1967), which Israel is obligated to do in any event.

To compare, Prime Minister Rabin kept the existing Likud Team for negotiating with the Palestinian Delegation. This was a most inauspicious sign. Soon thereafter, in late summer of 1992, the Israeli Team tendered a proposal for an Interim Peace Agreement that included a draft of their proposal for Palestinian interim self-government to the Palestinian Delegation in Washington.

Israel's Bantustan Proposal

Because of its importance, Dr. Abdul Shaffi asked me to fly out personally to Washington, DC in order to analyze this proposal for the entire Palestinian Delegation *in situ*. One of my responsibilities had been to analyze all preceding peace proposals put forward by Israel with respect to the Palestinians going all the way back to the original Camp David Accords, including the ensuing "Linowitz negotiations" that took place thereafter under the Carter Administration. Upon my arrival at the Ritz-Carlton Hotel in Pentagon City where the Palestinian Delegation was then headquartered, I was ushered into a suite where the Delegation Leaders had assembled, and then instructed by one of its accredited negotiators: "Tell us what is the closest historical analogue to what they are offering us here!"

I then went back to my hotel room and spent an entire day reading through and analyzing the Israeli proposal. When my analysis was finished, I returned to the same suite and reported to the Delegation: "A *bantustan*. They are offering you a bantustan. As you know, the Israelis have very close relations with the Afrikaner apartheid regime in South Africa. It appears that they have studied the bantustan system quite closely. And so it is a bantustan that they are offering you."

I then proceeded to go through the entire Israeli Proposal in detail in order to substantiate my bantustan conclusion.[1] It was akin to the legal chicanery that the Afrikaners had unsuccessfully attempted to impose upon the Black People in the Republic of South Africa.[2] Or the "Indian reservations" that the United States has so far successfully imposed upon its Indigenous peoples.[3] I also pointed out to the Palestinian Delegation that this proposal basically carried out Prime Minister Menachim Begin's disingenuous misinterpretation of the Camp David Accords—which was rejected by U.S. President Jimmy Carter—that all they called for was autonomy for the Palestinian people and not for the Palestinian land as well. Even worse yet, Israel's proposed Palestinian interim self-government would be legally set up to function as the Civilian Arm of the Israeli military occupation forces! Not surprisingly, after consultations among themselves, and under the Chairmanship of Dr. Haidar Abdul Shaffi, the Palestinian Delegation rejected Israel's bantustan proposal.

The Palestinian Anti-Bantustan Proposal

Shortly thereafter, Dr. Abdul Shaffi personally requested that I return to Washington, DC in order to consult with the entire Palestinian Delegation for a second time on this matter. I had a series of sequential meetings with the different members of the Delegation in order to hear them out and understand their basic concerns about negotiating an Interim Peace Agreement with Israel. I was then ushered into Dr. Abdul Shaffi's private suite. The two of us were alone.

Dr. Abdul Shaffi then quite solemnly instructed me: "Professor Boyle, we have decided to ask you to draft this Interim Peace Agreement for us. *Do whatever you want! But do not sell out our right to our State!*" The emphasis was that of Dr. Abdul Shaffi.

I responded to him quite simply: "Do not worry, Dr. Abdul Shaffi. As you know, I was the one who first called for the creation of the Palestinian State back at United Nations Headquarters in June of 1987, and then served as the Legal Adviser to the PLO on its creation. I will do nothing to harm it!" I then went back to my hotel room in order to research, conceptualize, and develop the Palestinian approach to negotiating an Interim Peace Agreement with Israel that was designed to get the Palestinians from where they were then, eventually to a free, viable, democratic independent state on the West Bank and Gaza Strip with their capital in Jerusalem, and by the required intermediate means of establishing a genuine Palestinian interim self-government, which was not a bantustan.

I spent an entire day sketching out what I shall call here my "anti-bantustan" proposal for the Palestinian Delegation to consider. I then met again with Dr. Abdul Shaffi in order to brief him on it. Then at the instructions of Dr. Abdul Shaffi, the entire Palestinian Delegation assembled for me to brief them on my anti-bantustan proposal.

During the course of this briefing, an extremely high-level and powerful PLO official began to yell at me at the top of his lungs: "Professor Boyle, what good has the Fourth Geneva Convention ever done for my people!" My reply was blunt: "Without the Fourth Geneva Convention the Israelis would have stolen all your land and expelled most of your people years ago." From my other sources I already knew that the PLO had been putting enormous pressure upon Dr. Abdul Shaffi and the rest of the Palestinian Delegation to accept Israel's bantustan proposal right then and there in Washington, DC. This, Dr. Abdul Shaffi adamantly refused to do!

I then left the room in order to confer once again with Dr. Abdul Shaffi. Right before this meeting, I commented to a very prominent and now powerful Palestinian Lawyer from Gaza, who had heard my briefing: "My instructions from Dr. Abdul Shaffi were to figure out how to square the circle. I believe I have accomplished this objective." He replied laconically: "Yes, you have."

I then went to meet once again with Dr. Abdul Shaffi. I reported to him about the vociferous opposition to my anti-bantustan proposal by this top PLO official. After a brief conversation about handling this dilemma, Dr. Abdul Shaffi then instructed me to write up my anti-bantustan proposal as a Memorandum for consideration and formal approval by the Palestinian Delegation in Washington as well as by the PLO Leadership then headquartered in Tunis. Having rejected the Israeli bantustan proposal, it was up to Dr. Abdul Shaffi to come up with an anti-bantustan proposal not only for the purpose of negotiating in good faith with the Israelis, but also to convince the PLO Leadership in Tunis that there did indeed exist a viable interim peace agreement that would not sell-out the right of the Palestinian people to an independent nation state of their own, and also by

the required intermediate means of establishing a genuine Palestinian interim self-government, which was not a bantustan. Dr. Abdul Shaffi was now counting upon me to square this circle to the satisfaction of the political leadership of the Palestinian people then headquartered in Tunis.

At that precise moment in time, it felt as if the weight of the entire world had just descended upon my shoulders. For the next five weeks I once again bore responsibility for five million Palestinians, their children, and their children's children, as well as indirect responsibility for three million Israelis, their children, and their children's children. My Memorandum was entitled "The Interim Agreement and International Law," and was completed on December 1, 1992. Then I shipped it off by couriers to Dr. Abdul Shaffi and the Palestinian Delegation in Washington, DC, as well as to the political leadership of the Palestinian people then headquartered in Tunis and living elsewhere in their diaspora.

This lengthy Memorandum was then translated into Arabic for review, consideration, and approval by the PLO Executive Committee, which serves as the Provisional Government of the State of Palestine, whose President was at the time and still is Yasser Arafat. My Palestinian anti-bantustan model was approved by the Palestinian Delegation to the Middle East peace negotiations as well as by the PLO leadership in Tunis. In other words, there was an officially approved Palestinian alternative to Oslo. So there did indeed exist a "choice".[4]

Because of its historical significance, the Board of Editors of the distinguished *Arab Studies Quarterly* decided to publish this Memorandum in full in their Volume 22, No. 3, Summer 2000 Issue, together with a brief Editorial Note, which are set forth in the preceding chapter. Dr. Abdul Shaffi, expressly waived attorney-client confidences on these matters. The reader is free to decide for himself or herself whether or not I successfully discharged the weighty responsibilities given to me by Dr. Abdul Shaffi and the Palestinian Delegation to the Middle East peace negotiations. While reviewing this Memorandum, the reader should understand that the Israeli bantustan proposal severely criticized therein later became the Oslo Agreement of 13 September 1993. In other words, this 1 December 1992 Memorandum provided the PLO leadership with a detailed roadmap of precisely what was wrong with Oslo, what would be the negative consequences of Oslo, and why Oslo would inevitably fail.

The entirety of this analysis was well-known to President Arafat, Dr. Abdul Shaffi, the Palestinian Delegation to the Middle East peace negotiations, and the PLO Executive Committee well before 13 September 1993. Hence, contrary to some news media accounts and academic speculation, President Arafat knew exactly what he was signing on 13 September 1993. He had been fully informed and properly advised. But he signed on to the Oslo bantustan anyway.

Secret Negotiations in Norway

While peace negotiations were being pursued in Washington, unbeknownst to both Dr. Abdul Shaffi and myself, the Israeli Government proceeded to open up a secret channel of communications in Norway with PLO emissaries who reported personally and in private to President Yasser Arafat. Eventually, during the course of these Norwegian negotiations, the Israeli Team re-tendered their original bantustan proposal that had already been rejected by the Palestinian Delegation to the Middle East peace negotiations in Washington, DC. It was this original bantustan proposal, re-tendered in Norway, that later became known as the so-called Oslo Agreement, which was signed on the White House lawn on September 13, 1993.

Dr. Abdul Shaffi and I had known all along that we were engaged in a most desperate struggle against the Israelis—working hand-in-glove with the Americans—in order to prevent the Palestinian political leadership in Tunis from accepting Israel's bantustan proposal. Of course we lost. In the summer of 1993, the wire services reported that a secret agreement between Israel and PLO emissaries had been reached in Norway. Soon thereafter, Dr. Abdul Shaffi called me up from Washington and asked if I could analyze this Norwegian document for him immediately. I readily agreed. He later faxed the Norwegian document into my office.

After a very detailed study of this Norwegian document, I called back with my report: "This is the exact same document we have already rejected in Washington!" Dr. Abdul Shaffi responded in his customarily low-key manner: "Yes, that was my impression too."

At the end of a very lengthy interchange, Dr. Abdul Shaffi exclaimed: "I will call Abu Ammar and *demand* that he get a written opinion from you on this document before he signs it! Can you give me that opinion right away?"

"Yes, of course, you can count on me!" I replied.

"I will call Abu Ammar immediately!" said a determined Dr. Abdul Shaffi.

Abu Ammar is the nom-de-guerre of Yasser Arafat. He and Dr. Abdul Shaffi go all the way back to the very founding of the PLO—so that must have been one incredibly tumultuous conversation.

But President Arafat had already made up his mind to sign the Israeli bantustan proposal now emanating from Norway instead of Washington. There was nothing Dr. Abdul Shaffi could do to change his mind or to stop him. It was for this reason that Dr. Abdul Shaffi never attended the signing ceremony on the White House lawn on September 13, 1993. He knew Oslo merely offered a bantustan and wanted nothing at all to do with it.

As for me, on that day I had to be in the International Court of Justice in The Hague in order to personally accept the second World Court Order I would win for the Republic of Bosnia and Herzegovina ordering the rump Yugoslavia to cease and desist from committing all acts of genocide against the Bosnian people. I had to watch the signing ceremony on television that evening in my Amsterdam hotel room. "This will never work", I said to myself with a heavy heart, "but perhaps President Arafat knows something that I do not."

Why Did President Arafat Accept What Was Offered in Oslo?

Now you might ask yourself: Why would President Arafat accept and sign an Israeli proposal that he knew would constitute nothing more than a bantustan for the Palestinian people? I really do not know the answer to that question. President Arafat did not discuss this matter with me, though he did discuss it with Dr. Abdul Shaffi. But I was not privy to that conversation, and I never asked Dr. Abdul Shaffi about it.

In fairness to President Arafat, I believe he felt that he must take what little was offered to the Palestinian people by Israel and the United States, even if he knew it was nothing more than a bantustan, and then prove his good faith and that of the Palestinian people to the satisfaction of both Israel and the United States: prove that the Palestinians were willing to live in peace and harmony with Israel and the Israeli people throughout a trial test-period of five years—even under *their* bantustan model. Possibly then, he hoped, at the end of the five years, there would then be a legitimate, free, viable, and independent Palestinian State on the West Bank and Gaza Strip, with its capital in Jerusalem.

Also, in fairness to President Arafat, the Oslo Agreement made it quite clear that all issues—including Jerusalem—would be open for negotiations in the so-called final status negotiations—despite the massive Israeli rhetoric and propaganda that Jerusalem was "their", "eternal", "undivided", "capital." You do not expressly agree in writing to negotiate over "your," "eternal," "undivided," "capital" if it is really *yours*!

Finally, in fairness to President Arafat, there was already a Resolution on the books that had been adopted by the Palestine National Council authorizing the PLO to take control of any portion of occupied Palestine that was offered to them by Israel. This is precisely what President Arafat and the PLO then headquartered in Tunis proceeded to do. But it is important to note for the record that the Palestinian Delegation to the Middle East peace negotiations—all of whom lived in occupied Palestine, not in Tunis—had explicitly rejected this Israeli bantustan proposal during the course of the formal negotiations in Washington, DC. For that very reason, other Palestinian accredited negotiators in addition to Dr. Abdul Shaffi refused to attend the signing ceremony on the White House lawn on 13 September 1993, including my friend, the Palestinian negotiator referred to earlier who had personally instructed me to analyze the Israeli bantustan proposal for the Delegation. Just like Dr. Abdul Shaffi, they knew full well that Oslo was a bantustan, and wanted nothing at all to do with it.

Post-Oslo Agreements

President Arafat had assumed a modicum of good faith on the part of Israel and the United States. My 1 December 1992 Memorandum had not, but had rather assumed the contrary. Unfortunately, Israel and the United States then proceeded to stall and delay the implementation of Israel's bantustan model throughout the entire course of the Oslo process, and indeed even after the expiration of Oslo itself, all the time providing no realistic hope or expectation that at the end of the road the Palestinians would have a free, viable and genuine independent state of their own on the West Bank and Gaza with its capital in Jerusalem.

I am not going to waste my time here analyzing the numerous post-Oslo Agreements between Israel and the PLO that were "brokered" by the United States, for they all constitute nothing more than implementation and refinements of Israel's original bantustan proposal that the Palestinian Delegation to the Middle East peace negotiations had already rejected in Washington, DC. From the perspective of public international law, however, numerous provisions of all these agreements were void *ab initio* under articles 7, 8, and 47 of the Fourth Geneva Convention of 1949, inter alia.

Camp David II

This then brings the story up to the summer of 2000—the so-called Camp David II negotiations. This proposed conclusion to the final status negotiations was not the idea of the Palestinian political leadership. Rather, these negotiations were the "brainchild" of Israeli Prime Minister General Ehud Barak with the full support of President Clinton who had depended heavily on the Israel Lobby for financing at the very start of his run for the U.S. presidency.

In a curious twist of fate, Bill Clinton had spent a night at the Grand Hotel in Washington, DC while the Palestinian Delegation was in residence. Our personal paths would cross in the lobby of the Grand Hotel as I went out for my usual early morning walk before the negotiations began, while he assembled there with his political handlers just prior to holding a press conference as

presidential candidate over at the State Department later that morning. Knowing what Clinton et al. were up to, I walked by him in silence out into the cold and refreshing morning air.

By comparison, late one December 1991 afternoon the Reverend Jesse Jackson showed up unannounced and unaccompanied in the same lobby of the Grand Hotel, obviously seeking to help the Palestinian Delegates at this critical moment in their nation's history. I went up to him, introduced myself, and then gave him a quick briefing on the deplorable situations in occupied Palestine as well as right there in the Washington, DC "negotiations" being held over in the U.S. State Department Headquarters. The terrible accounts in the news media concerning both locations had motivated his selfless humanitarian gesture. I then arranged for him to go upstairs in order to meet with Dr. Abdul Shaffi. The Reverend Jackson proved to be a true Good Samaritan.

Almost nine years later at Camp David, President Clinton fully intended to pressure President Arafat and the political leadership of the Palestinian people into accepting the supposedly interim Oslo bantustan arrangement permanently for the West Bank, Gaza Strip, and Jerusalem as in fact the final, permanent outcome of the so-called final status negotiations—the "final solution" for the Palestinian people, marking "paid" to the notion of a Palestinian state without having permitted one in the slightest. This is exactly what the criminal apartheid regime in South Africa had attempted to impose upon the Blacks of that country, which was successfully opposed by Nelson Mandela and the ANC. To his great and everlasting credit, President Arafat refused to accept the Oslo bantustan as a permanent model for the Palestinian people and their land. But it was a near-death experience.

True to his pro-Israeli stance, President Clinton then proceeded to blame President Arafat and the political leadership of the Palestinian people publicly for their alleged intransigence. Clinton also publicly threatened to illegally move the United States Embassy from Tel Aviv to Jerusalem unless President Arafat succumbed to permanently accepting Israel's original bantustan model in its original format as offered in 1992. This President Arafat still refused to do.

The Israeli Origins of the Al Aqsa Intifada

When it became crystal clear to the Israeli Government that they could not impose Oslo's bantustan arrangement permanently upon the Palestinian people by means of negotiations—and even when conjoined with the customary bullying, threats, harassment, intimidation and bribery by the U.S. government— then General Barak and Likud Leader General Ariel Sharon decided to revert to inflicting raw, naked, brutal, military force upon the Palestinian people in order to get their way.

On 28 September 2000, General Ariel Sharon—the Butcher of Beirut, the architect of the Israeli invasion of Lebanon that had exterminated about 20,000 Arabs, the man personally responsible for the massacre of about 2,000 innocent Palestinian civilians at the refugee camps in Sabra and Shatilla, a man who had even been cashiered by his own government for these very acts—appeared at Haram Al-Sharif in Jerusalem—the third holiest site in Islam, where stand the Al Aqsa Mosque on the one hand, and the magnificent Dome of the Rock on the other, where Muhammad (PBUH) had ascended into Heaven—surrounded by about 1,000 armed Israeli forces. But this should not be mistaken as the act of a rogue general run amok; rather, it was undertaken with the full approval of Prime Minister Barak. Hence the Israeli origins of what came to be known as the Al Aqsa

Intifada. General Barak and General Sharon knew *exactly* what they were doing! They knew *exactly* what the reaction of the Palestinian people would be to Sharon's deliberate desecration of, and provocation at, their holiest religious site. And if there had been any lingering doubt about the matter, Israeli armed forces returned *the next day* and shot dead several unarmed Palestinians on Haram Al-Sharif, thus setting off what has come to be known as the Al Aqsa Intifada—the uprising in support of the Al Aqsa Mosque.

Security Council Resolution 1322

On 7 October 2000, the United Nations Security Council adopted Resolution 1322 (2000), which is critical for all subsequent analysis. The vote was fourteen to zero, with the United States government abstaining. The United States government could have vetoed this Resolution, but did not. And so this Resolution became a matter of binding international law. I will not go through the entire Resolution here, but I do want to spend just a few moments commenting on its most important provisions.

In paragraph 1, the Security Council: "Deplores the provocation carried out at Al-Haram al-Sharif in Jerusalem on 28 September 2000 and the subsequent violence there...." Notice, the Security Council by a vote of 14 to 0 made it crystal clear that it was Sharon's desecration of the Haram Al-Sharif with the support of Prime Minister Barak that was responsible for the start of the current round of warfare and bloodshed perpetrated by Israel against the Palestinian people living in occupied Palestine. Nothing could be further from dispute than this factual finding adopted 14 to 0 by the Security Council itself. A matter of binding international law.

Even the United States did not vote against that determination, and thus deliberately let it pass permanently into international law as a determination of responsibility. Hence, there is no factual dispute about who and what started the Al Aqsa Intifada: It was the "provocation" deliberately inflicted by General Ariel Sharon, now the Prime Minister of Israel, with the full support and approval of General Barak, who was at the time the Prime Minister of Israel.

Israel's Belligerent Occupation of Palestine

In paragraph 3 of Resolution 1322 (2000), the Security Council, again 14 to 0: "Calls upon Israel, the occupying Power...." "Occupying power" has a definite meaning in public international law. Israel only "occupies" the West Bank, the Gaza Strip, and the entire City of Jerusalem. Israel is what international lawyers call a "belligerent occupant." As such, Israel has *no* sovereignty over the West Bank, or the Gaza Strip, or the entire City of Jerusalem.

Israel is not and has never been the sovereign there. Israel only belligerently occupies this Palestinian land. So what is going on there now is a war being waged by a belligerent occupant, Israel, against a people living on their own land, the Palestinians. Under international law and practice, a people living on their own land is the essence of sovereignty. It is the Palestinian people who are sovereign in occupied Palestine.

So Israel has no sovereignty over the West Bank, or the Gaza Strip, or the City of Jerusalem. This is not sovereign Israeli land as far as the Security Council is concerned, as far as international law is concerned, as far as the entire international community is concerned, and even as far as the United States of America is *officially* concerned. And that has been the case for the West Bank and Gaza Strip since the war of 1967. That has been the case for East Jerusalem since the war of 1967.

As for West Jerusalem, the world has never recognized Israel's annexation of West Jerusalem as valid either. That is why the United States' Embassy and the embassies of almost every country in the world that has diplomatic relations with Israel—except for a few banana republics that have been bought and paid for—have their embassies in Tel Aviv and not Jerusalem. That is also why Clinton's public threat to move the U.S. Embassy to Jerusalem was clearly illegal insofar as it threatened to recognize Israel's bogus claim to sovereignty over Jerusalem.

The International Laws of Belligerent Occupation

Belligerent occupation is governed by the Hague Regulations of 1907, as well as by the Fourth Geneva Convention of 1949, and the customary laws of belligerent occupation. Security Council Resolution 1322 (2000), paragraph 3 continued: "Calls upon Israel, the occupying Power, to abide scrupulously by its legal obligations and its responsibilities under the Fourth Geneva Convention relative to the Protection of Civilian Persons in a Time of War of 12 August 1949;..." Again, the Security Council vote was 14 to 0, becoming obligatory international law.

The Fourth Geneva Convention applies to the West Bank, to the Gaza Strip, and to the entire City of Jerusalem in order to protect the Palestinians living there. The Palestinian people living in occupied Palestine are "protected persons" within the meaning of the Fourth Geneva Convention. All of their rights are sacred under international law. That top PLO official mentioned earlier had absolutely no comprehension of the vital importance of the Fourth Geneva Convention to his own people. Maybe he does today, because it is this Convention which has enabled the Security Council to make determinations on the Palestinians' behalf— with all the advantages that that entails for Palestinian diplomacy, enabling it in turn to assert the rectitude of its cause under international law.

There are 149 substantive articles of the Fourth Geneva Convention that protect the rights of almost every one of these Palestinians living in occupied Palestine. The Israeli Government is currently violating and has since 1967 been violating almost each and every one of these sacred rights of the Palestinian people recognized by the Fourth Geneva Convention. Indeed, violations of the Fourth Geneva Convention are war crimes.

So this is not a symmetrical situation where there is some right and some wrong on both sides. As matters of fact and of law, the gross and repeated violations of Palestinian human rights by the Israeli army and by Israeli settlers living illegally in occupied Palestine constitute war crimes. Conversely, the Palestinian people are defending themselves and their land and their homes against Israeli war crimes and Israeli war criminals, both military personnel and armed settlers. Nevertheless, innocent civilians can never be legitimate targets for direct military attack (e.g., F-16 and Apache helicopter missile strikes, suicide bombings, etc.). In an international armed conflict such as this, the direct military targeting of innocent civilians as such is a serious war crime.

The UN Human Rights Commission Specifies Israeli Actions As War Crimes and Crimes Against Humanity

Indeed, the human rights situation is far more serious than that. On 19 October 2000 a Special Session of the UN Commission on Human Rights adopted a Resolution set forth in UN Document E/CN.4/S-5/L.2/Rev. 1, "Condemning the provocative visit to Al-Haram Al-Sharif on 28 September 2000 by Ariel Sharon, the

Likud party leader, which triggered the tragic events that followed in occupied East Jerusalem and the other occupied Palestinian territories, resulting in a high number of deaths and injuries among Palestinian civilians." The UN Human Rights Commission then said it was "[g]ravely concerned" about several different types of atrocities inflicted by Israel upon the Palestinian people, which it denominated "war crimes, flagrant violations of international humanitarian law and crimes against humanity."

In operative paragraph 1 of its 19 October 2000 Resolution, the UN Human Rights Commission then: "Strongly condemns the disproportionate and indiscriminate use of force in violation of international humanitarian law by the Israeli occupying Power against innocent and unarmed Palestinian civilians... including many children, in the occupied territories, which constitutes a war crime and a crime against humanity;..." And in paragraph 5 of its 19 October 2000 Resolution, the UN Human Rights Commission: "Also affirms that the deliberate and systematic killing of civilians and children by the Israeli occupying authorities constitutes a flagrant and grave violation of the right to life and also constitutes a crime against humanity;..." Article 68 of the United Nations Charter had expressly required the UN's Economic and Social Council to "set up" this UN Commission "for the promotion of human rights". This is its UN-Charter-mandated job.

Israel's War Crimes against Palestinians

The reader has a general idea of what a war crime is, so I am not going to elaborate upon that term here. But there are different degrees of heinousness for war crimes. In particular are the more serious war crimes denominated "grave breaches" of the Fourth Geneva Convention. Since the start of the Al Aqsa Intifada, the world has seen those heinous war crimes inflicted every day by Israel against the Palestinian people living in occupied Palestine: *e.g.*, willful killing of Palestinian civilians by the Israeli army and by Israel's illegal paramilitary settlers. These Israeli "grave breaches" of the Fourth Geneva Convention mandate universal prosecution for their perpetrators, whether military or settlers, as well as universal prosecution for their commanders, whether military or civilian, including and especially Israel's political leaders.

Israel's Crimes Against Humanity against Palestinians

I want to focus for a moment on Israel's "crime against humanity" against the Palestinian people—as determined by the UN Human Rights Commission itself, set up pursuant to the requirements of the United Nations Charter. What is a "crime against humanity"? This concept goes all the way back to the Nuremberg Charter of 1945 for the trial of the major Nazi war criminals in Europe. In the Nuremberg Charter of 1945, drafted by the United States Government, there was created and inserted a new type of international crime specifically intended to deal with the Nazi persecution of the Jewish people.

The paradigmatic example of a "crime against humanity" is what Hitler and the Nazis did to the Jewish people. This is where the concept of a "crime against humanity" came from. And this is what the UN Human Rights Commission determined that Israel is currently doing to the Palestinian people: crimes against humanity. Expressed in *legal terms*, this is just like what Hitler and the Nazis did to the Jews. That is the significance of the formal determination by the U.N. Human Rights Commission that Israel has inflicted crimes against humanity upon the Palestinian people. The Commission chose this well-known legal term of art quite carefully and deliberately based upon the evidence that it had compiled.

The Precursor to Genocide

Moreover, a crime against humanity is the direct historical and legal precursor to the international crime of genocide as defined by the 1948 Convention on the Prevention and Punishment of the Crime of Genocide. The theory here was that what Hitler and the Nazis did to the Jewish people required a special international treaty that would codify and universalize the Nuremberg concept of a "crime against humanity." And that treaty ultimately became the 1948 Genocide Convention.

I submit that if something is not done quite soon by the American people and the international community to stop Israeli war crimes and crimes against humanity being perpetrated against the Palestinian people on an ongoing basis, it could very well degenerate into genocide, if the situation has not deteriorated to that point already. As it stands in this regard, Israeli Prime Minister Ariel Sharon is already what international lawyers call a *genocidaire*—one who has committed genocide in the past. Sharon is ready, willing, and able to inflict genocide yet again upon the Palestinians unless the world stops him!

In further evidence of the extent of Israeli crimes against the Palestinian people, the reader is referred to the extensive *Bibliography of Genocidal/Apartheid Acts Inflicted by Israel on the Palestinians During the Al Aqsa Intifada*, herein.

U.S. Complicity

Historically, Israel's criminal conduct against Palestine and the Palestinians has been financed, armed, equipped, supplied, and politically supported by the United States government despite the fact that the United States is a founding sponsor of, and a contracting party to, both the Nuremberg Charter and the Genocide Convention, as well as the United Nations Charter and the Four Geneva Conventions of 1949. These legal facts have never made any difference to the United States government when it comes to either its criminal mistreatment of the Palestinian people or its support for the Israelis.

So far during the course of the Al Aqsa Intifada, the world has not yet heard even one word uttered by the United States government and its NATO allies in favor of "humanitarian intervention" against Israel in order to protect the Palestinian people from Israeli war crimes, crimes against humanity, and genocide. The United States, its NATO allies and the Great Powers on the UN Security Council would not even dispatch a UN Charter Chapter VI "monitoring force" to help protect the Palestinians, let alone even contemplate any type of UN Charter Chapter VII "enforcement action" against Israel—shudder the thought! The doctrine of "humanitarian intervention" so readily espoused elsewhere when U.S. foreign policy goals were allegedly at stake clearly proves itself to be a joke and a fraud when it comes to stopping the ongoing Israeli campaign of genocide against the Palestinian people.

As a matter of fact, in the case of Israel, genocide has proved quite an irrelevant consideration when it comes to Israeli financial support from the U.S. government—which is paid to the tune of several billions[5] year after year by the United States government and Congress—without whose munificence this instance of genocide—and indeed conceivably the State of Israel itself—would not be possible. On the contrary, what we have here is dishumanitarian intervention by the United States government against Palestine and the Palestinians.

Oslo is Dead

Just before the 13 September 1993 Oslo Agreement signing ceremony on the White House lawn, I advised another high-level official of the Palestine Liberation Organization: "This document is like a straight-jacket. It will be very difficult to negotiate your way out of it!" This PLO official readily agreed with my assessment, and responded: "Yes, you are right. It will depend upon our negotiating skill." Of course I have great respect for Palestinian negotiators. They have done the very best they can by negotiating in good faith. But no matter how skilled a negotiator you are, nothing can be achieved at the negotiating table if the corresponding party has not come to the table in good faith, and has no intention whatsoever of allowing the negotiation to proceed in the direction and for the purpose for which negotiations were set up in the first place. Even if Oslo and Camp David II had succeeded, they would have resulted in the permanent imposition of a bantustan upon the Palestinian people. But Oslo is dead.

Generals Barak and Sharon deliberately killed off Oslo on 28 September 2000 when they knowingly instigated the Al Aqsa Intifada by desecrating the Haram-Al-Sharif. When Barak could not compel President Arafat into permanently accepting the Oslo bantustan arrangement as the "final solution" for the Palestinian people at the Camp David II negotiations in July, he and Sharon decided to revert to inflicting raw, naked, brutal force that would culminate in the planned reimposition of Israel's outright military occupation upon the West Bank. All of the subsequent violence between Israelis and Palestinians is directly attributable to this malicious decision undertaken jointly by Barak ("Labor") and Sharon ("Likud") with the full acquiescence of the United States government (under both Clinton and Bush Jr.) every step of the way.

The Israeli/American destruction of Oslo was only a matter of time. There was never any good faith on the part of the Israeli government and the United States government when it came to negotiating a just Middle East peace settlement with the Palestinians going all the way back to the preparatory work for the convocation of the 1991 Madrid Conference by the Bush Sr. administration.

In our conversations before Oslo was signed and afterwards, the greatest fear and concern shared by Dr. Abdul-Shaffi and me was that Oslo would set off a Palestinian civil war. This would not have bothered the Israelis and the Americans one bit. But to his great credit, so far President Arafat has refused to ignite a Palestinian civil war in the name of enforcing the Oslo bantustan. Precisely because President Arafat would not do their dirty work for them, the Israelis and the Americans then turned upon him. Both the Israelis and the Americans decided to jettison President Arafat in preference to installing some Palestinian quisling willing to become the "chief" of a Palestinian bantustan where he would then employ its "reservation police force" in order to suppress the Al Aqsa Intifada.

So on 24 June 2002, President Bush Jr. delivered his much touted and highly anticipated Middle East Peace "vision" – not a Plan, just that old "vision thing", calling for greater democracy in relation to a man, President Arafat, who at least had been democratically elected by the vast majority of his own people—unlike Bush Jr. The time-frames seem deliberately designed by the Bush Jr. administration to punt on all critical issues beyond the 2004 U.S. presidential elections, likely in an attempt to pander to the Israel Lobby and their Christian fundamentalist supporters in the United States prior to the November 2002 elections. While Israel publicly repudiated Oslo, resumed its brutal occupation of the West Bank, and assaulted Gaza, Bush Jr. proferred the Palestinians nothing but vague promises of good intentions by the United States government that have

never materialized during the past 35 years of Israeli occupation of Palestinian lands with U.S. support. Bush Jr. has given Sharon the proverbial "green light" to dump Arafat.

It is doubtful that the Israelis and the Americans will succeed at imposing their nefarious objectives upon Palestine and the Palestinians without producing violent resistance. What the ultimate consequences might be remain unpredictable. Nonetheless, it is clear that the longer the United States government facilitates Israeli torment of the Palestinians and the indefinite denial of their UN-mandated right to an independent state of Palestine, the progressively less likely a comprehensive Middle East peace settlement becomes.

ENDNOTES

1. My extensive reasons for this Bantustan conclusion were soon thereafter committed to writing in a Memorandum of Law that I prepared at the instruction of Dr. Haidar Abdul Shaffi for the Palestinian Delegation to the Middle East Peace Negotiations in Washington and for the Political Leadership of the Palestinian People then headquartered in Tunis. That Memorandum is set forth in the chapter of this book entitled *The Palestinian Alternative to Oslo*.
2. See Francis A. Boyle, Defending Civil Resistance Under International Law 211-81 (1987).
3. See USA on Trial: The International Tribunal on Indigenous Peoples' and Oppressed Nations in the United States (1996).
4. *See* Bilal Al-Hassan, PLO Annuls All Legal Advice, Inquiry, Spring 1994, *and in* Arab American News, Vol. X, No. 475, Oct 1-7, 1994, at 4.
5. According to the Washington Report on Middle East Affairs, U.S. financial aid to Israel since 1949 amounted to $84,854,827,200 as at November 1, 1997. An extensive discussion of U.S. aid to Israel can be found on the Washington Report on Middle East Affairs website at http:// www.wrmea.com/html/us_aid_to_israel.htm.

Preserving the Rule of Law in the War Against International Terrorism

State Terrorism

Despite the tragic events of 11 September 2001, the world must never forget that the overwhelming majority of "terrorist" acts—whether in number or in terms of sheer human and material destructiveness—have always been committed by strong states against weak states, as well as by all governments against their own people. In particular, as far as a good deal of the Third World is concerned, the United States of America has progressively become one of the world's leading "terrorist" states—a dubious distinction it shares with Israel. In order to underscore these points, this author agreed to serve as Rapporteur for what has come to be known as the *Geneva Declaration on Terrorism*, which was issued by the International Progress Organization's 1987 Conference on International Terrorism. If American citizens are sincerely interested in learning why so many people around the world "hate" the government of the United States of America, then they can start by studying this unrequited and unanswered Bill of Particulars that was set forth fifteen years ago in response to the state terrorism perpetrated by the Reagan/Bush Sr. administration upon the rest of the world.

THE GENEVA DECLARATION ON TERRORISM

Preamble

The peoples of the world are engaged in a fundamental series of struggles for a just and peaceful world based on fundamental rights now acknowledged as sacred in a series of widely endorsed international legal conventions.

These struggles are opposed in a variety of cruel and brutal ways by the political, economic and ideological forces associated with the main structures of domination present in the world that spread terrorism in a manner unknown in prior international experience. Although these struggles are global in scale there are certain areas that require particular attention and urgent action at this time. We mention in this regard the central struggle in southern Africa against the apartheid system, the criminal regime and policies that sustain this system, and engage in military interventions throughout the region spreading terrorism beyond the immediate battleground of South Africa and Namibia; we mention the ongoing struggle of the Palestinian people for their homeland in the face of Israeli and

United States military and paramilitary policies throughout the entire eastern Mediterranean region bringing special hardships and anguish to the various peoples of Lebanon; and we mention the struggles in Central America against reactionary forces in and out of governmental control that are being organized and orchestrated by the United States through the special instrumentality of the CIA.

Against this background of torment and struggle, the debate about international terrorism is waged, being manipulated in the media and elsewhere by forces of domination; the public is encouraged to associate terrorism exclusively with those victims of this system. We seek to make clear that terrorism is overwhelmingly an expression of these structures of domination and only very derivatively with the struggles that arise in legitimate resistance.

Let us understand that the distinguishing feature of terrorism is fear and that this fear is stimulated by threats of indiscriminate and horrifying forms of violence directed against ordinary people everywhere. The most flagrant type of international terrorism consist of preparations to wage nuclear war, especially to extend nuclearism to outer space and to work feverishly for the presence of first-strike weaponry. Terrorism involves the prospects of holocausts unleashed by state power against the peoples of the world.

The terrorism of modern state power and its high technology weaponry exceed qualitatively by many orders of magnitude the political violence relied upon by groups aspiring to undo oppression and achieve liberation.

Let us also be clear, we favor nonviolent resistance wherever possible and we praise those long efforts by the liberation movement in South Africa and elsewhere to avoid violence in their pursuit of justice. We condemn all those tactics and methods of struggle that inflict violence directly upon innocent civilians as such. We want no part of any form of terrorism but we must insist that terrorism originates with nuclearism, criminal regimes, crimes of state, high-technology attacks on Third World peoples, and systematic denials of human rights. It is a cruel extension of the terrorist scourge to taunt the struggles against terrorism with the label "terrorism." We support these struggles and call for the liberation of political language along with the liberation of peoples.

1. State Terrorism

Terrorism originates from the statist system of structural violence and domination that denies the right of self-determination to peoples (e.g., in Namibia, Palestine, South Africa, the Western Sahara); that inflicts a gross and consistent pattern of violations of fundamental human rights upon its own citizens (*e.g.*, in Chile, El Salvador, Guatemala, South Africa); or that perpetrates military aggression and overt or covert intervention directed against the territorial integrity or political independence

of other states (*e.g.*, Afghanistan, Angola, Grenada, Lebanon, Libya, Mozambique, Nicaragua). In particular, state terrorism manifests itself in:

1) police state practices against its own people to dominate through fear by surveillance, disruption of group meetings, control of the news media, beatings, torture, false and mass arrests, false charges and rumors, show trials, killings, summary executions and capital punishment;

2) the introduction or transportation of nuclear weapons by a state into or through the territory or territorial waters of other states or into international waters;

3) military exercise maneuvers or war games conducted by one state in the vicinity of another state for the purpose of threatening the political independence or territorial integrity of that other state (e.g., in Honduras, in Korea, in the Gulf of Sirte/Sidra);

4) the armed attack by the military forces of a state on targets that put at risk the civilian population residing in another state (*e.g.*, the bombings of Benghazi, Tripoli and Tunis, Druze villages in Lebanon and Kurdish villages);

5) the creation and support of armed mercenary forces by a state for the purpose of subverting the sovereignty of another state (*e.g.*, against Nicaragua);

6) assassinations, assassination attempts, and plots directed by a state towards the officials of other states, or national liberation movements, whether carried out by military strike, special forces units or covert operations by "intelligence forces" or their third party agents (*e.g.*, the CIA in Nicaragua, the Qadhafi family, Yasser Arafat);

7) covert operations by the "intelligence" or other forces of a state which are intended to destabilize or subvert another state, national liberation movements, or the international peace movement (*e.g.*, the bombing of the *Rainbow Warrior*);

8) disinformation campaigns by a state, whether intended to destabilize another state or to build public support for economic, political or military force or intimidation directed against another state;

9) arms sales which support the continuation of regional wars and retard the search for political solutions to international disputes;

10) the abrogation of civil rights, civil liberties, constitutional protections and the rule of law under the pretext of alleged counter terrorism; and

11) the development, testing and deployment of nuclear and space-weapons systems that in all circumstances increase the probability of genocide and ecocide, while condemning the poor to continued misery and all humanity to a state of perennial fear. It follows that the most dangerous and detrimental form of state terrorism in the world today is that practiced by the nuclear weapons states against the rest of the international community, which is euphemistically called nuclear deterrence. This system of nuclear terrorism actually constitutes ongoing international criminal activity—namely, the planning, preparation and conspiracy to commit crimes against peace, crimes against humanity, war crimes, genocide and grave breaches of the Four Geneva Conventions of 1949. Hence those government decision-makers in the nuclear weapons states with command responsibility for their nuclear weapons establishments are today subject to personal criminal responsibility and punishment under the Nuremberg Principles for the nuclear terrorism they daily inflict upon all states and peoples of the world community. That being said, we nevertheless welcome the constructive proposals put forth by the Soviet government to achieve genuine nuclear arms control and reduction agreements with respect to space weapons, strategic nuclear weapons and intermediate nuclear forces. We regret that the United States government has failed to respond to these promising initiatives, but has instead exacerbated the nuclear arms race by pursuing its so-called Strategic Defense Initiative.

2. National Liberation Movements

As repeatedly recognized by the United Nations General Assembly, peoples who are fighting against colonial domination and alien occupation and against racist regimes in the exercise of their right of self-determination have the right to use force to accomplish their objectives within the framework of international humanitarian law. Such lawful uses of force must not be confused with acts of international terrorism. Thus, it would be legally impermissible to treat members of national liberation movements in the Caribbean Basin, Central America, Namibia, Northern Ireland, the Pacific Islands, Palestine, and South Africa, among others, as if they were common criminals. Rather, national liberation fighters should be treated as combatants subject to the laws of humanitarian armed conflict as evidenced, for example, by the 1907 Hague Regulations, the Four Geneva Conventions of 1949, and their Additional Protocol I of 1977.

Hence, national liberation fighters would be held to the same standards of belligerent conduct that are applicable to soldiers fighting in an international armed conflict. Thus, when a liberation fighter is captured by a belligerent state, he should not be tried as a criminal, but would be treated as a prisoner of war. He could be interned for the duration of the conflict, or released upon condition of a pledge to refrain from further participation in hostilities, or traded in a prisoner of war exchange. In the event such a national liberation fighter is found in a neutral state, he should not be subjected to extradition to the belligerent state.

In the spirit of Geneva Protocol I, just as is true for soldiers in regular armed forces, when a national liberation fighter is captured after directly attacking innocent civilians as such, he would still be treated as a prisoner of war, but would be subject to prosecution for the commission of war crimes before an impartial international tribunal, preferably in a neutral state or by an international court. And, to the extent that the concerned belligerent states refuse to treat national liberation fighters analogously to soldiers for political reasons or propaganda purposes, they must assume a considerable amount of direct responsibility for whatever violence that is inflicted upon their civilian populations by national liberation fighters.

Nevertheless, we wish to emphasize that the over-whelming majority of violations of the laws and customs of warfare have been and are still being committed by the regular, irregular, para-military and covert forces of states, but not national liberation fighters. The Western news media have purposely distorted and perverted this numerical relationship in order to perpetuate the cult of counter terrorism for their governments' own militaristic and terroristic purposes.

3. Non-international Armed Conflicts

With respect to those situations where sub-national groups or organizations use force against the apparatus of the state but nevertheless do not represent national liberation movements, we affirm the applicability of common article 3 to the Four Geneva Conventions of 1949 and their Additional Protocol II of 1977 to these non-international armed conflicts. In particular, the fundamental distinction between combatants and noncombatants must be maintained at all times and under all circumstances.

4. The Role of the International Media

The international media also play a direct role in interna-tional terrorism when they uncritically disseminate disinforma-tion from "official sources" that creates public support for the use of deadly force or other forms of economic and political violence against another state. The international media also play an indirect role in terrorism through a pattern of selective definition and coverage. The media specifically ignore or

understate institutional forms of terrorism, preserving the term instead for national liberation movements and their supporters. In such ways the media become agents of ideological control, advancing an inverted standard of terrorism.

5. Conclusion

The principles of the United Nations Charter—if applied in all of their ramifications—constitute an effective instrument for reshaping the actual policies of power and hegemony among sovereign states into those of mutual respect. Conversely, the real international terrorism is founded in the imposition of the will of the powerful states upon the weak by means of economic, political, cultural and military domination. We declare that the key to ending all forms of terrorism is the development of new relations among nations and peoples based on unfailing respect for the right to self-determination of peoples, and on a greater measure of economic, political and social equality on a world scale.

<div style="text-align:right">

Rajab BOUDABBOUS (Libya)
Francis A. BOYLE, Rapporteur (USA)
Robert CHARVIN (France)
Ramsey CLARK (USA)
Richard FALK (USA)
Hans KOECHLER (Austria)
Sean MACBRIDE (Ireland)
William D. PERDUE (USA)
Themba SONO (South Africa)

</div>

Geneva, Switzerland
21 March 1987

Defining Terrorism

Upon its ascent to power in January of 1981, the Reagan/Bush Sr. administration forthrightly proclaimed its intention to replace President Carter's emphasis on human rights with a war against international terrorism as the keystone of its foreign policy.[1] The Reagan/Bush Sr. administration's specious argument was that terrorism constituted the ultimate denial of human rights and therefore, in a classic nonsequitur, somehow justified the renewal of military and economic assistance for the then repressive regimes in Argentina, Guatemala, Chile, and the Philippines,[2] as well as somehow warranting the destabilization of Colonel Qadhafi in Libya, among other such nefarious projects.[3] This inversion of priorities for the future conduct of American foreign policy was perversely misguided and should have been immediately repudiated by the American people.

"Terrorism" is a vacuous and amorphous concept entirely devoid of an accepted international legal meaning, let alone an objective political referent.[4] The standard cliché that "one man's terrorist is another man's freedom fighter" is not just a clever obfuscation of values. It indicates that the international community has yet to agree upon a legal or political meaning for the term "terrorism". Even the UN Ad Hoc Committee on International Terrorism could not agree upon a definition for the word "terrorism".[5] Yet due to the transnational character of "terrorist" violence, the establishment of multinational consensus and international

cooperation is the only way that wanton attacks directed against innocent civilians around the world can be adequately combatted.[6]

The pejorative and highly inflammatory term "terrorism" has been used by the governments of the United States, Great Britain, the former Soviet Union and now Russia, apartheid South Africa, India, and Israel, among others, to characterize acts of violence ranging the spectrum of human and material destructiveness from common crimes to wars of national liberation. One state's invocation of a holy war against international "terrorism" may constitute effective governmental propaganda designed to manipulate public opinion into supporting a foreign policy premised on Machiavellian power politics. But it cannot serve as the basis for conducting a coherent and consistent global foreign policy in a manner that protects and advances a state's legitimate national security interests in accordance with the requirements of international law.[7]

The Reagan/Bush Sr. administration was elected in part on the claim that the Carter administration's general "softness" had been responsible for an alleged increase in international terrorist attacks during the latter's tenure. Thus, shortly after entering office, Director of Central Intelligence William Casey ordered the CIA to conduct a study on international terrorism designed to document their unsubstantiated campaign rhetoric. But when finally produced, the CIA study did not come up with enough terrorist incidents to support the administration's assertions. Not being content with the truth, Casey ordered the CIA to change its definition of "terrorism" in a manner that would substantiate the Reagan/Bush Sr. administration's irresponsible claims. Whereupon the CIA broadened its definition of "terrorism" and dutifully complied with Casey's ukase by issuing a new report that doubled the number of terrorist attacks documented in the previously rejected report.[8]

The truth of the matter was that starting in the mid-1970's there had occurred a significant decline in the number of so-called "terrorist attacks" against the United States by the various Palestinian groups operating out of the Middle East. This was because the United States government had worked very hard at the United Nations, the International Civil Aviation Organization (ICAO), the International Committee of the Red Cross (ICRC) negotiations at Geneva, and in all other available forums to convince the PLO as well as Arab states that "terrorism" was counterproductive in the sense that it would not help advance their cause but rather would retard it in the estimation of U.S. and European public opinion. By the end of the decade, that message had gotten through.[9]

Despite these serious reservations about the practical utility of employing the term "terrorism" and its numerous derivatives, I will do so here even though that term obscures more than it clarifies. For analytical purposes, I would prefer to talk about "transnational violence perpetrated by non-state actors against members of the civilian population for political reasons." Nevertheless, for want of a better term, I will use the words "terrorism" and "terrorists," but only because they have become popularly accepted, and always subject to the above reservations and qualifications.

The Israeli Origins of the Reagan/Bush Sr. Administration's War Against International Terrorism

With the advent of the Reagan/Bush Sr. administration in 1981, the overall foreign policy of the United States government toward the Middle East dramatically changed. The Reagan/Bush Sr. administration became the most vigorously pro-Israeli government that has ever been experienced in the United States of America.

Large numbers of the foreign affairs and "defense" appointees brought in by the Reagan administration were themselves ardent supporters of the state of Israel. Operating under the mistaken assumption that what was good for Israel was by definition good for the United States, they put the interests of Israel first and those of the United States second when it came to the formulation of American Middle East foreign policy.

The Israelis had always been arguing a very tough line against international terrorism. The Reagan/Bush Sr. administration became so enamored of the tough Israeli rhetoric that they proceeded to pattern American Middle East foreign policy on what the Israelis said was their approach to fighting the war against international terrorism. So the Reagan/Bush Sr. administration proceeded to adopt the same types of philosophy, rhetoric, tactics and at times illegal and reprehensible behavior that the Begin/Sharon government was then practicing against Arab states and peoples throughout the region. Under the aegis of the Reagan/Bush Sr. administration, America and the world witnessed the progressive Israelization of U.S. foreign policy toward the Middle East.

For example, from the time of the signing of the United Nations Charter in 1945, the United States government had always taken the position that retaliation and reprisal were not legitimate measures of self-defense under article 51.[10] To the contrary, this provision of the Charter made it quite clear that self-defense could only be exercised in the event of an actual or perhaps at least threatened and imminent "armed attack" against the state itself. By definition, this would not include retaliation and reprisal since they occur after the fact. Hence, under the regime of the United Nations Charter as historically interpreted by the U.S. government, retaliation and reprisal were clearly illegal and thus prohibited.

The U.S. government took this position of a restrictive interpretation of the right of self-defense found in Charter article 51 because of its belief that it was in the best interest of America to minimize the scope for the threat or use of force by other states in the world community to the least extent possible. An expansive reading of the doctrine of self-defense to include retaliation and reprisal would gratuitously provide ample grounds for many other states to come up with all sorts of justifications and pretexts for engaging in the threat and use of force that could significantly undermine international peace and security, thus threatening the vital national security interests of the United States and its allies in the peaceful maintenance of a favorable postwar status quo. Until the advent of the Reagan/ Bush Sr. administration, the United States government had generally preferred the stability produced by the peaceful settlement of international disputes to the instability generated by the unilateral threat and use of military force.

Even during the dark days of the Vietnam War, the U.S. government never formally abandoned its attachment to the legal proposition that retaliation and reprisal were prohibited by international law. At the time, this policy position had been repeatedly reaffirmed by the United States government with respect to Israeli retaliatory attacks into surrounding Arab states. The Israeli government maintained that its actions were in retaliation and reprisal for attacks on civilian targets in Israel or occupied Palestine and therefore could be justified under the doctrine of self-defense as recognized by article 51 of the United Nations Charter. The United States government strongly disagreed, and refused to accept the Israeli interpretation of the article 51 right of self-defense so as to include the latter's retaliatory and later preemptive strikes.

The disagreement over this point was politically and legally important because the United States and Israel had and still have an arms supply agreement

which provides that American weapons, equipment and supplies can only be used in legitimate self-defense as determined by article 51 of the UN Charter or as part of an enforcement action authorized by the United Nations Security Council.[11] In addition, there was and still is a similar requirement of the United States domestic law known as the Arms Export Control Act.[12] Therefore, an attempt had to be made by Israel's American supporters to get the Department of State to change its formal position on the illegality of retaliation and reprisal.

In 1973-74, Eugene V. Rostow—who had been Undersecretary of State in the Johnson administration, was later to serve as the Director of the Arms Control and Disarmament Agency (ACDA) in the Reagan/Bush Sr. administration, and was a passionate supporter of the state of Israel—requested that the Department of State change its policy on retaliation and reprisal. Pursuant to Rostow's request, the State Department did look into the matter. Yet the State Department concluded that there were no good grounds for the United States government to change its longstanding policy that retaliation and reprisal were not legitimate exercises of the right of self-defense and, therefore, were prohibited by international law.[13] Essentially, what happened was that the Reagan/Bush Sr. administration unofficially adopted the Israeli disinterpretation of article 51 of the United Nations Charter to include retaliation and reprisal despite the fact that the State Department specifically refused to do so over ten years beforehand.

Terrorism as a Response to the Israeli Invasion of Lebanon

The above considerations put into context the reason why there occurred a resurgence of terrorist actions against U.S. citizens, and against airplanes, facilities, programs, etc. affiliated with the United States government located abroad during the tenure of the Reagan/Bush Sr. administration. In particular, as a direct result of the 1982 Israeli invasion of Lebanon, more than 20,000 people were killed. The vast majority of the victims were Palestinians and Lebanese Muslims who were quite wantonly destroyed by means of weapons, equipment, supplies, money and diplomatic and political support provided by the United States government to Israel and to the Phalange militia during the course of the invasion and its aftermath. The Arab peoples of the Middle East held the United States government fully responsible for all atrocities against the civilian population of Lebanon that were undeniably perpetrated by the Israeli army and the Phalange militia. Under basic principles of international law, they certainly had a perfect right to do so.

Common article 1 to the Four Geneva Conventions of 1949 required that a party to the Conventions such as the United States must not only "respect" the Conventions itself but also "ensure respect" for the terms of the Conventions by other contracting parties such as Israel "in all circumstances".[14] The United States government maliciously failed to perform its obligations under the Geneva Conventions to make sure that the Israelis obeyed the laws and customs of warfare during the course of their invasion of Lebanon by means of U.S. weapons, equipment, and supplies. Indeed, from all the indications in the public record, it appeared that the United States government connived and consented in advance to this illegal invasion.[15]

As a result of the 1982 Lebanon invasion, the entire PLO infrastructure was destroyed and with it the ability of Arafat and his particular organization, Al Fatah, to control the other Palestinian groups was significantly diminished. These anti-Arafat Palestinian groups proceeded to undertake a series of terrorist attacks against U.S. interests around the Mediterranean that were launched from their

respective headquarters in the Syrian-controlled Bekaa valley or in Damascus itself. In addition, the Shiites in Lebanon also proceeded to undertake terrorist attacks against Americans by means of hijacking airplanes, kidnapping U.S. citizens, assassinations, bombings and atrocities of this nature. Whereas prior to Israel's 1982 invasion, the Shiite population of Lebanon had been basically quiescent, thereafter U.S. support for both the Israeli invasion and the latter's continued occupation of southern Lebanon provided the immediate reason why these devoutly religious people decided to fight back against the interests of the United States and Israel in whatever primitive manner they could. Hence the origins of Hezbollah in Lebanon, which is presently on the U.S. list of terrorist organizations.

The Reagan/Bush Sr. administration's "wholesale terrorism" inflicted upon Arab and Muslim states and peoples simply encouraged the latter to respond by sponsoring or engaging in acts of "retail terrorism" against American airplanes, facilities and citizens around the world.[16] It is not surprising, therefore, that American embassies in the region had to transform themselves into armed bunkers in order to provide some degree of protection from retaliatory terrorist attacks, while at home, America became even more of a garrison state like Israel after 11 September 2001.

The American people cannot even begin to comprehend how to deal with the problem of international terrorism in the Middle East unless they first come to grips with the fact that the Reagan/Bush Sr. administration was directly responsible for the perpetration of one of the great international crimes in the post World War II era against the Palestinians and Muslim people in Lebanon. Only if America were willing to face up to its collective responsibility under international law for this crime against humanity could it then proceed to make some progress on the problem of international terrorism. Until that time, Americans will continue to become targets of attack by these frustrated and aggrieved individuals throughout the Middle East and the Mediterranean. And now in their "homeland" —shades of the Reich.

The Reagan/Bush Sr. Administration's War Against International Law

The Reagan/Bush Sr. administration pursued a unilateralist anti-terrorism policy that was essentially predicated upon the illegal threat and use of U.S. military force in explicit and knowing violation of article 2(4) of the United Nations Charter.[17] Their preferred measures included military retaliation and reprisal, "preemptive" and "preventive" attacks, kidnapping suspected terrorists, hijacking aircraft in international airspace, destabilization of governments, fomenting military coups, assassinations, and indiscriminate bombings of civilian population centers, etc. Predictably, the results proved to be quite negligible in terms of accomplishing their purported objectives and most counterproductive for the purpose of maintaining international peace and security. Witness the needless deaths of over 300 U.S. marines and diplomats in Lebanon as a direct result of the Reagan/Bush Sr. administration's illegal military intervention into that country's civil war in order to prop-up a supposedly pro-Western regime that was imposed by the Israeli army. Both of the latter were guilty of inflicting barbarous outrages upon the Palestinians and Muslim people in Lebanon.

The foremost proponents of such reprehensible anti-terrorism policies were Secretary of State George Shultz and his second Legal Adviser, former federal district judge Abraham Sofaer, another passionate Israel supporter. One of the great ironies of the Reagan/Bush Sr. administration proved to be the fact that its Secretary of State was consistently far more bellicose than its Secretary of

Defense, Caspar Weinberger. Indeed, what little restraint that was demonstrated by the Reagan/Bush Sr. administration when it came to the illegal threat and use of military force generally originated from the Pentagon, not the State Department. Whenever Shultz failed to obtain his foreign policy objectives by means of diplomacy, his standard fallback position was to call for the threat and use of U.S. military force—whether in Lebanon, the Persian Gulf, Central America and the Caribbean, Libya, or to combat international terrorism.[18] If the U.S. government and American citizens became special targets for attack by international terrorist groups, this phenomenon was directly attributable in substantial part to the Reagan/Bush Sr. administration's primary reliance upon the illegal threat and use of military force as an ultimately self-defeating substitute for its bankrupt foreign policies—especially toward the Middle East.

The Perversity Behind the Shultz Doctrine

The operational premise behind the so-called Shultz Doctrine was that the Reagan/Bush Sr. administration should fight international terrorism by means of American sponsored counter-terrorism. This rationale constituted a most pernicious assault upon the U.S. government's historical commitment to upholding the rules of international law and promoting the integrity of the international legal order. Just because some of the adversaries of the United States might pursue patently illegal policies in their conduct of belligerent hostilities provides absolutely no good reason why America's government should automatically do the exact same thing. The United States of America has to analyze the equation of international relations in light of both its own vital national security interests and its own cherished national values.

In particular, America cannot abandon or pervert its national values simply because its adversaries might not share them. Likewise, America cannot ignore its vital national interest in preserving the rules of international law and upholding the integrity of the international legal order simply because our adversaries might not share that exact same interest. If America mimics international terrorists, then America gradually becomes like them and eventually becomes indistinguishable from them in the eyes of its allies, friends, neutrals, and, most tragically of all, its own citizens. During the tenure of the Reagan/Bush Sr. administrations, the United States government became just as terroristic and Machiavellian in its conduct of foreign affairs as many of America's international adversaries undoubtedly were. In particular, the progressive Israelization of American foreign policy during the past twenty years has disserved both the values and the interests of the United States and the American people.[19]

The Sofaer Corollary

The paradigmatic example of the Reagan/Bush Sr. administration's mirror-image reasoning process with respect to international terrorism was provided by the aforementioned Legal Adviser to the United States Department of State in a speech he gave before a plenary session of the American Society of International Law Convention devoted to the World Court on April 10, 1986, shortly after President Reagan had decided to bomb the Libyan cities of Tripoli and Benghazi.[20] There former Judge Abraham Sofaer did his best to justify a perverse innovation in the theory of international law and the practice of international relations: Namely, that the United States government possesses some god-given right to resort to the use of military force in alleged self-defense as unilaterally determined by itself alone.

In light of the fact that earlier that same day the so-called "Society" had commemorated the Fortieth Anniversary of the Nuremberg Tribunal, it was striking and indeed saddening that the U.S. Legal Adviser was making an argument similar to that put forth in defense of the Nazi war criminals before the Nuremberg Tribunal in 1945 with respect to the non-applicability of the Kellogg-Briand Pact of 1928.[21] This "Paris Peace Pact" had formally renounced war as an instrument of national policy. However, when signing the Pact, Germany entered a reservation to the effect that it reserved the right to go to war in self-defense as determined by itself. So when in 1945 the Nazi war criminals were indicted for crimes against peace on the basis of the Kellogg-Briand Pact, they argued that the Second World War was a war of self-defense as determined by the German government, and therefore that the Nuremberg Tribunal had no competence to determine otherwise because of Germany's self-judging reservation. Needless to say, the Tribunal summarily rejected this preposterous argument and later convicted and sentenced to death several Nazi war criminals for the commission of crimes against peace, inter alia.

International Law on the Threat and Use of Force

Over a half-century after Nuremberg, the critical question becomes how America can proceed to grapple with the foreign and domestic problems created by the phenomenon of international terrorism while at the same time preserving its fundamental commitment to the rule of law both at home and abroad. In this regard, consider what the contemporary international legal order has to say about the threat and use of force by governments in the name of combating international terrorism. Of course there is not enough space here to discuss all the institutions, procedures, and rules of the international legal regime concerning the transnational threat and use of force that was set up by the United States government, inter alia, as of 1945. Its essential component was the United Nations Organization and its Charter. Then came the so-called regional organizations that were brought into affiliation with the United Nations by means of Chapter VIII of the United Nations Charter: *i.e.*, the Organization of American States (OAS), the League of Arab States, the Organization of African Unity (OAU)--now replaced by the African Union, recently the Organization for Security and Cooperation in Europe (OSCE), and perhaps someday the Organization of Southeast Asian Nations (ASEAN). These institutions were joined by the so-called collective self-defense agreements concluded under Article 51 of the United Nations Charter, the foremost exemplar of which is NATO.

In 1945, under U.S. hegemonic direction, the only legitimate justifications and procedures for the perpetration of violence and coercion by one state against another state became those set forth in the UN Charter. The Charter alone contains those rules which have been consented to by the virtual unanimity of the international community that has voluntarily joined the United Nations Organization. Succinctly put, these rules include the UN Charter's Article 2(3) and Article 33(1) obligations for the peaceful settlement of international disputes; the Article 2(4) prohibition on the threat or use of force; and the Article 51 right of individual or collective self-defense to repel an actual "armed attack" or "*aggression armée*," according to the French-language version of the UN Charter, which is equally authentic with the English.

Related to this right of self-defense are its two fundamental requirements for the "necessity" and the "proportionality" of a state's forceful response to the foreign armed attack or armed aggression. In regard to this first requirement of

"necessity", as definitively stated by U.S. Secretary of State Daniel Webster in the famous 1837 case of *The Caroline*, self-defense can only be justified when the "necessity of self-defence is instant, overwhelming, and leaving no choice of means, and no moment for deliberation."[22] The Nuremberg Tribunal later endorsed and ratified this *Caroline* test for self-defense, thus enshrining it as a basic principle of the contemporary international legal order. So much for the alleged legality of "pre-emptive" attacks as perpetrated by Israel in its 1981 bombing of the Iraqi nuclear reactor, and as currently threatened by George Bush, Jr. against the government of Iraq.

The Illegality of Intervention, Protection and Self-Help

In the historical era prior to the conclusion of the United Nations Charter, some Western imperialist powers of the North asserted that there existed supposed principles of customary international law that permitted them to engage in the unilateral threat and use of military force against other states, peoples, and regions of the world. In particular, these "principles" included the so-called doctrines of intervention, protection, and self-help. Yet, these three alleged doctrines were *unanimously* rejected by the International Court of Justice in the seminal *Corfu Channel Case* (United Kingdom v. Albania) of 1949 as being totally incompatible with the proper conduct of international relations in the post World War II era. Rebutting the British arguments in support of these three atavistic doctrines in order to justify its military intervention into Albanian territorial waters, the World Court ruled:[23]

> The Court cannot accept such a line of defence. The Court can only regard the alleged right of intervention as the manifestation of a policy of force, such as has, in the past, given rise to most serious abuses and such as cannot, whatever be the present defects in international organization, find a place in international law. Intervention is perhaps still less admissible in the particular form it would take here; for, from the nature of things, it would be reserved for the most powerful States, and might easily lead to perverting the administration of international justice itself.
>
> The United Kingdom Agent, ..., has further classified "Operation Retail" among methods of self-protection or self-help. The Court cannot accept this defence either. Between independent States, respect for territorial sovereignty is an essential foundation of international relations. The Court recognizes that the Albanian Government's complete failure to carry out its duties after the explosions, and the dilatory nature of its diplomatic notes, are extenuating circumstances for the action of the United Kingdom Government. But to ensure respect for international law, of which it is the organ, the Court must declare that the action of the British Navy constituted a violation of Albanian sovereignty.

Even more significantly, the World Court unanimously repudiated these three so-called doctrines—including and especially intervention—without explicitly relying upon the UN Charter because Albania was not yet a contracting party thereto while Great Britain was. Hence, the World Court's decision rejecting

these three doctrines—including and especially intervention—constituted an authoritative declaration of the requirements of customary international law binding upon all members of the international community irrespective of the requirements of the UN Charter. *A fortiori*, when all states parties to an international dispute are members of the United Nations, Charter articles 2(3), 2(4), and 33 absolutely prohibit any unilateral or multilateral threat or use of force that is not specifically justified by the article 51 right of individual or collective self-defense, or else authorized by the United Nations Security Council. Furthermore, in regard to the extent of the authority of the Security Council itself, on 27 February 1998 the International Court of Justice issued two Judgments rejecting Preliminary Objections raised by the United States and the United Kingdom as Respondents (i.e., defendants) in the *Lockerbie* bombing cases filed against them by Libya with the assistance of this author, making it crystal clear that the UN Security Council is definitely not the Judge, the Jury, and the Lord-High Executioner of International Law.[24]

Next, three seminal UN General Assembly Resolutions have a distinct bearing on the so-called doctrine and practice of military intervention: the Declaration on the Inadmissibility of Intervention in the Domestic Affairs of States and the Protection of Their Independence and Sovereignty (1965); the Declaration on Principles of International Law Concerning Friendly Relations and Cooperation among States in Accordance with the Charter of the United Nations (1970); and the Definition of Aggression (1974). Considered together, these three resolutions stand for the general proposition that, in the emphatic opinion of the member states of the UN General Assembly, non-consensual military intervention by one state into the territorial domain of another state is absolutely prohibited for any reason whatsoever.

Just to quote only one paragraph from this 1970 Declaration on Principles of International Law Concerning Friendly Relations and Cooperation among States in Accordance with the Charter of the United Nations (1970):[25]

> No State or group of States has the right to intervene, directly or indirectly, for any reason whatever, in the internal or external affairs of any other State. Consequently, armed intervention and all other forms of interference or attempted threats against the personality of the State or against its political, economic and cultural elements, are in violation of international law.

A specific instance of so-called military intervention would probably be most properly classified as a "breach of the peace" and an "act of aggression" within the meaning and purpose of UN Charter article 39 as interpreted by reference to these three UN General Assembly resolutions. So much for the alleged legality of "regime change" in Iraq by the U.S. itself or by an American-organized multinational force!

In the seminal decision of *Nicaragua v. United States of America* (1986), the International Court of Justice found that this aforementioned 1970 Declaration on Principles of International Law concerning Friendly Relations and Cooperation among States etc. sets forth rules of customary international law establishing an absolute prohibition against military intervention by one state against another state except in cases of legitimate self-defense, or collective self-defense at the express request of the victim state itself. The Reagan/Bush Sr. administration had publicly attempted to justify its contra-terrorist war against Nicaragua in substantial part on humanitarian grounds. Consequently, this author spent one

week in Nicaragua during the contra-terrorist war from November 16-23, 1985 as part of a Lawyer's Delegation in order to investigate the human rights situation there. This Delegation consisted of former U.S. Attorney General Ramsey Clark, the noted American Civil Rights Attorney Leonard Weinglass, and two French Canadian human rights lawyers from Montreal, Robert Saint-Louis and Denis Racicot. At the request of my colleagues, this author drafted our final Report that was endorsed by the entire Delegation.

To quote only one sentence from this Report that is the most directly relevant here: "...Contrary to press reports in the United States, [we] found that the counterrevolutionary army created by the U.S. Central Intelligence Agency in Honduras constitutes nothing more than a mercenary band of cowards, terrorists and criminals who attack innocent Nicaraguan civilians—old men, women, children, invalids and religious people...."[26] If anything, it was the People and the State of Nicaragua who desperately needed "protection" and "intervention" against the United States and its contra-terrorist surrogates.

The Reagan/Bush Sr. administration's contra-terrorist war against Nicaragua was soundly condemned by the International Court of Justice in this seminal decision of 1986. Moreover, for technical procedural reasons not relevant here, like unto the *Corfu Channel* case, in the *Nicaragua* case the International Court of Justice had to condemn this U.S. military aggression as a matter of customary international law instead of by directly applying the prohibitions found in the United Nations Charter *per se*. Furthermore, in the *Nicaragua* case the World Court explicitly reaffirmed the above-quoted rulings from the *Corfu Channel* case, and also held: "The Court concludes that acts constituting a breach of the customary principle of non-intervention will also, if they directly or indirectly involve the use of force, constitute a breach of the principle of non-use of force in international relations."[27]

Finally, in the *Nicaragua* case the World Court expressly rejected the assertion by the United States that it had some putative right of military intervention against Nicaragua on the grounds of alleged human rights violations:[28]

> 268. In any event, while the United States might form its own
> appraisal of the situation as to respect for human rights in
> Nicaragua, the use of force could not be the appropriate
> method to monitor or ensure such respect....The Court
> concludes that the argument derived from the preservation of
> human rights in Nicaragua cannot afford a legal justification
> for the conduct of the United States....

The *Corfu Channel* case and the *Nicaragua* case are the two leading and most conclusive authorities under international law that soundly condemn in no uncertain terms the so-called doctrine of "intervention" for any reason.

Traveling all over the world, one will find that the only significant source of opposition to the World Court's decision in the *Nicaragua* case has always come from international lawyers and law professors in the United States—for obvious reasons. Nevertheless, today the transnational threat or use of military force and military intervention by one state against another state is only permissible in cases of individual or else collective self-defense where the victim state of an armed attack has expressly requested such assistance from another state or states. Or as lawfully authorized by the UN Security Council acting within the proper scope of the powers delegated to it by the UN member states under the terms of the United Nations Charter.

International Legal Means for Responding to the Threat and Use of Force

That being said, what does the world do about acts of terrorism that undeniably do occur around the world today? Certainly, the world must not accord the great military powers such as the United States, Britain, Russia, China, France, Israel, and India, inter alia, some fictitious "rights" of "intervention," or "protection," or "self-help," or "retaliation," or "reprisal" or "pre-emption" – let alone "regime change" – that these powerful states will only abuse and manipulate in order to justify military intervention against less powerful states and peoples for their own selfish interests. There are more than enough international laws and international organizations to deal with the phenomenon of international terrorism. Indeed, behind most of the major "terrorist" atrocities going on around the world today, the international community has seen in operation the dirty and bloody hands of the Great Powers.

There exist several institutions and procedures that function as integral parts of this international law regime to prevent, regulate and reduce the transnational threat and use of force. To mention only the most well-known: (1) "enforcement action" by the UN Security Council as specified in Chapter VII of the Charter; (2) "enforcement action" by the appropriate regional organizations acting with the authorization of the Security Council as required by Article 53 and specified in Chapter VIII of the Charter; (3) the so-called peacekeeping operations and monitoring forces organized under the jurisdiction of the Security Council pursuant to Chapter VI of the Charter; (4) peacekeeping operations under the auspices of the UN General Assembly acting in accordance with its Uniting for Peace Resolution (1950); and (5) peacekeeping operations and monitoring forces deployed by the relevant regional organizations acting in conformity with their proper constitutional procedures. To this list should also be added the "good offices" of the UN Secretary General; the International Court of Justice; the Permanent Court of Arbitration; and numerous other techniques and institutions for international arbitration, mediation, and conciliation, and so on.

The Bush Jr. Administration

When George Bush Jr. came to power in January of 2001, he proceeded to implement foreign affairs and so-called "defense" policies that were every bit as radical, extreme and excessive as had the Reagan/Bush Sr. administrations starting in January of 1981. Upon his installation, Bush Jr.'s "compassionate conservatism" quickly revealed itself to be nothing more than reactionary Machiavellianism—as if there had been any real doubt about this during the presidential election campaign. Even the Bush Jr. cast of realpolitickers were pretty much the same as the original Reagan/Bush Sr. foreign affairs and "defense" experts, many of whom were called back into service and given promotions In implicit condonation of the international crimes they had already committed anywhere from ten to twenty years beforehand.

In quick succession, the world saw these Bush Jr. Leaguers repudiate the Kyoto Protocol on global warming, the International Criminal Court, the Comprehensive Test Ban Treaty (CTBT), an international convention to regulate the trade in small arms, a verification Protocol for the Biological Weapons Convention, an international convention to regulate and reduce smoking, the World Conference Against Racism, the Third Geneva Convention of 1949, the Vienna Convention on Consular Relations, the Anti-Ballistic Missile Systems Treaty, etc. To date, the Bush Jr. Administration has not found an international convention that they like.

For twelve years the Constitution and the Rule of Law—whether domestic or international—did not deter the Reagan/Bush Sr. administrations from pursuing their internationally lawless and criminal policies around the world—although Bush Sr. did argue that his UN mandate did prevent him from proceeding into Baghdad in his Gulf War. The same was true for the Clinton administration as well–invading Haiti; bombing Iraq, Sudan, Afghanistan, and Serbia, etc. The Bush Jr. administration has behaved no differently from its lineal predecessors. Bush Jr.'s bellicose handling of the 11 September 2001 tragedy was no exception to this general rule.[29]

In order to better prosecute his bogus "war on international terrorism," under the pernicious influence of Federalist Society Lawyers, President Bush Jr. personally resurrected a long-defunct World War II era legal category of dubious provenance denominated "enemy combatant",[30] which was soon thereafter superseded by the Four Geneva Conventions of 1949. Bush Jr. has used this quasi-category to create an anti-matter universe of legal nihilism where human beings (including U.S. citizens) can be disappeared, detained incommunicado, denied access to attorneys and regular courts, tried by kangaroo courts, executed, tortured, assassinated and subjected to numerous other manifestations of State Terrorism. This Bush Jr. category of "enemy combatants" negates almost the entirety of the post World War II regime for the International Protection of Human Rights established by the U.N. Charter in 1945 and most of the major international human rights treaties derived therefrom, which are too numerous to list here. Bush Jr.'s gross mistreatment of "enemy combatants" also violates several basic protections of the United States Constitution and in particular the Bill of Rights, again too numerous to list here. At a minimum, those responsible Bush Jr. administration officials, including the President himself, run the risk of international and U.S. domestic criminal prosecution for violating the Third and Fourth Geneva Conventions of 1949. No wonder that the Bush Jr. administration has done everything humanly possible to sabotage the International Criminal Court.

Bush Jr. Embraces Weapons of Mass Extermination

Then came the monumentally insane, horrendous, and tragic announcement on 13 December 2001 by the Bush Jr. administration to withdraw from the ABM Treaty, effective within six months. Of course it was sheer coincidence that the Pentagon released their self-styled Bin Laden Video just as Bush Jr. himself publicly announced his indefensible decision to withdraw from the ABM Treaty in order to pursue his phantasmagorical National Missile Defense (NMD) Program, the lineal successor to the Reagan/Bush Sr. dream of "Star Wars." The terrible national tragedy of 11 September was thus shamelessly exploited in order to justify a reckless decision that had already been made for Machiavellian reasons long before. Then on 25 January 2002, the Pentagon promptly conducted a sea-based NMD test in gross violation of Article 5(I) of the ABM Treaty without waiting for the required six months to expire, thus driving a proverbial nail into the coffin of the ABM Treaty before its body was even legally dead.

The Bush Jr. withdrawal from the ABM Treaty, which was originally negotiated by those well-known realpolitickers Richard Nixon and Henry Kissinger, threatens the very existence of other seminal arms control treaties and regimes such as the Nuclear Non-Proliferation Treaty (NPT) and the Biological Weapons Convention, which have similar withdrawal clauses. The prospect of yet another round of the multilateral and destabilizing arms race now stares humanity directly in the face, even as the Bush Jr. administration today prepares for the quick

resumption of nuclear testing at the Nevada test site in outright defiance of the CTBT regime and NPT Article VI. The entire edifice of international agreements regulating, reducing, and eliminating weapons of mass extermination (WME) has been shaken to its very core. And now the Pentagon and the CIA are back into the dirty business of researching, developing and testing biological weapons and biological agents that are clearly prohibited by the Biological Weapons Convention and its U.S. domestic implementing legislation, the Biological Weapons Anti-Terrorism Act of 1989.[31]

Bush Jr.'s First-Use Nuclear Terrorism

Next, writing in the March 10, 2002 edition of the *Los Angeles Times*, defense analyst William Arkin revealed the leaked contents of the Bush Jr. administration's Nuclear Posture Review (NPR) that it had just transmitted to Congress on January 8. The Bush Jr. administration ordered the Pentagon to draw up war plans for the first-use of nuclear weapons against seven states: the so-called "axis of evil" — Iraq, Iran, and North Korea—-plus Libya, Syria, Russia and China, the latter two of which are nuclear armed. This component of the Bush Jr. NPR incorporated the Clinton administration's 1997 nuclear war-fighting plans against so-called "rogue states" set forth in Presidential Decision Directive 60. These warmed-over nuclear war plans targeting these five non-nuclear states expressly violate the so-called "negative security assurances" given by the United States as an express condition for the renewal and indefinite extension of the Nuclear Non-Proliferation Treaty (NPT) by all of its non-nuclear weapons states parties in 1995.[32]

Equally reprehensible from a legal perspective is the NPR's call for the Pentagon to draft nuclear war-fighting plans for first nuclear strikes (1) against alleged nuclear/chemical/biological "materials" or "facilities"; (2) "against targets able to withstand non-nuclear attack"; and (3) "in the event of surprising military developments," whatever that means. According to Bush Jr.'s NPR, the Pentagon must also draw up nuclear war-fighting plans to intervene with nuclear weapons in wars (1) between China and Taiwan; (2) between Israel and the Arab states; (3) between North Korea and South Korea; and (4) between Israel and Iraq. It is obvious upon whose side the United States will actually plan to intervene with the first-use nuclear weapons. Most ominously of all, today the Bush Jr. administration accelerates its plans for launching an apocalyptic military aggression against Iraq, deliberately raising the spectre of a U.S. first-strike nuclear attack upon that long-suffering country and its people. The Bush Jr. administration has made it crystal clear to all its chosen adversaries around the world that it is fully prepared to cross the threshold of actually using nuclear weapons that has prevailed to date since the U.S. criminal bombings of Hiroshima and Nagasaki in 1945.[33]

In this regard, Article 6 of the 1945 Nuremberg Charter provides in relevant part as follows:

....

> The following acts, or any of them, are crimes coming within the jurisdiction of the Tribunal for which there shall be individual responsibility:
>
> (a) *Crimes against peace:* namely, planning, preparation, initiation or waging of a war of aggression, or a war in violation of international treaties, agreements or assurances, or participation in a common plan or conspiracy for the accomplishment

of any of the foregoing;

...

Leaders, organizers, instigators and accomplices participating in the formulation or execution of a common plan or conspiracy to commit any of the foregoing crimes are responsible for all acts performed by any persons in execution of such plan.

To the same effect is the Sixth Principle of the Principles of International Law Recognized in the Charter of the Nuremberg Tribunal and in the Judgment of the Tribunal, which were adopted by the International Law Commission of the United Nations in 1950:

PRINCIPLE VI

The crimes hereinafter set out are punishable as crimes under international law:

(a) Crimes against peace:

(i) Planning, preparation, initiation or waging of a war of aggression or a war in violation of international treaties, agreements or assurances;

(ii) Participation in a common plan or conspiracy for the accomplishment of any of the acts mentioned under (i).

...

It now becomes crystal clear why the Bush Jr. administration has been doing everything humanly possible to sabotage the International Criminal Court (ICC). What lawyers call "consciousness of guilt."

The Rogue Elephant

The Bush Jr. administration has obviously become a "threat to the peace" within the meaning of UN Charter article 39. It must be countermanded by the UN Security Council acting under Chapter VII of the UN Charter. In the event of a U.S. veto of such "enforcement action" by the Security Council, then the UN General Assembly must deal with the Bush Jr. administration by means of invoking its Uniting for Peace Resolution of 1950.

There very well could be some itty-bitty "rogue states" lurking out there somewhere in the Third World. But today, under the aegis of the Bush Jr. administration, the United States government has become the sole "rogue elephant" of international law and politics. For the good of all humanity, the Bush Jr. administration must be restrained. Time is of the essence!

ENDNOTES

1.	At a Jan. 27, 1981 press conference, Secretary of State Alexander Haig declared: "International terrorism will take the place of human rights . . . The greatest problem to me in the human-rights

area today is the area of rampant international terrorism." B. Woodward, Veil 93 (1987).

2. *See, e.g.*, Jacobs, *The Reagan Turnaround on Human Rights*, 64 Foreign Aff. 1066, 1069 (1986).

3. *See* Hersh, *Target Qaddafi*, N.Y. Times Mag., Feb. 22, 1987, at 17.

4. For a short history of the search for a definition, *see* F. Boyle, World Politics and International Law 136-39 (1985).

5. *See Report of the Ad Hoc Committee on International Terrorism*, 34 UN GAOR Supp. (No. 37) at 11, UN. Doc. A/34/37 (1979).

6. For a look at past efforts at combatting international terrorism, *see* League of Nations 1937 Convention for the Prevention and Punishment of Terrorism, *opened for signature* Nov. 16, 1937, League of Nations Doc. C.546(I).M.383(I) (1937), *reprinted in* 7 Hudson, International Legislation 862 (1941); 1972 United States Draft Convention for the Prevention and Punishment of Certain Acts of International Terrorism, *reprinted in* 67 Dept. State Bull. 431 (1972).

7. It has been pointed out that "terrorism has come to replace Communism as a way of legitimizing U.S. military action." *See Introduction* to Mad Dogs: the U.S. Raids on Libya 3 (M. Kaldor ed. 1986).

8. *See Terrorism: Dubious Evidence*, Economist, May 9, 1981, at 28 (CIA's fatuous redefinition of "terrorism"); *C.I.A.*, Economist, July 4, 1981, at 26.

9. *See* World Politics and International Law, *supra* at 136-54.

10. *See generally*, J. Sweeney, C. Oliver & N. Leech, The International Legal System 774-75 (1988) (reprinting excerpt from Starke, Introduction to International Law 499 (1984)).

11. In a Mutual Defense Assistance Agreement of July 23, 1952, Israel agreed that American-supplied weapons "will be used solely to maintain its internal security, its legitimate self-defense or to permit it to participate in the defense of the area of which it is a part, or in United Nations collective security arrangements and measures, and that it will not undertake any act of aggression against any other state." *Israeli Use of U.S. Arms An Old Dispute*, 1981 Cong. Q. Weekly Rep. 1036 (June 13, 1981).

12. 22 U.S.C. § 2754 (1982).

13. *See* U.S. Dept. of State, File No. P74 0071-1935, *reprinted in* 1974 Digest of U.S. Practice in International Law 700 (response to Rostow). *See also* Dept. of State File No. P79 0058-1597, *reprinted in* 1979 Digest of U.S. Practice in International Law 1749-52 (review of U.S. position on reprisals and self-defense).

14. Geneva Conventions of 1949, 6 U.S.T. 3114, T.I.A.S. No. 3362, 75 UNT.S. 31 (wounded and sick in field armed forces); 6 U.S.T. 3217, T.I.A.S. No. 3363, 75 UNT.S. 85 (wounded and sick in forces at sea); 6 U.S.T. 3316, T.I.A.S. No. 3364, 75 UNT.S. 135 (prisoner of war treatment); 6 U.S.T. 3516, T.I.A.S. No. 3365, 75 UNT.S. 287 (protection of civilians in wartime). *See also* International Convention on the Prevention and the Punishment of the Crime of Genocide, Dec. 9, 1948, 78 UNT.S. 277 (1951). Israel is a party to the Genocide Convention. The Ratification of International Human Rights Treaties 10 (1976).

15. *See* World Politics and International Law, *supra* at 230-49.

16. *See* Noam Chomsky, Pirates & Emperors: International Terrorism in the Real World (1986).

17. United Nations Charter, art. 2, para. 4 provides:
 All Members shall refrain in their international relations from the threat
 or use of force against the territorial integrity or political independence
 of any state, or in any other manner inconsistent with the purposes of
 the United Nations.

18. For an example of Shultz urging that the U.S. take action to "raise the cost" of terrorism, *see* N.Y. Times, Jan. 13, 1986, at A8, col. 3.

19. *See* George W. Ball & Douglas B. Ball, The Passionate Attachment (1992); Cheryl A. Rubenberg, Israel and the American National Interest (1986).

20. *See* 80 Am. Soc'y Int'l L. Proc. 204 (1986). *But see* Schachter, *Introduction: Self-Judging Self-Defense*, 19 Case W. Res. J. Int'l L. 121 (1987). The decision to bomb Libya was made on April 5. *See* Hersh, *supra* at 74.

21. Kellogg-Briand Pact, Aug. 27, 1928, 46 Stat. 2343, T.S. No. 796, 94 L.N.T.S. 57. Article 1 provided: "The High Contracting Parties solemnly declare in the names of their respective peoples that they condemn recourse to war for the solution of international controversies, and renounce it as an instrument of national policy in their relations with one another."

22. *See* Bartram S. Brown, *Humanitarian Intervention at a Crossroads*, 41 William & Mary Law Rev. 1683, 1714 (2000).

23. 1949 International Court of Justice Reports 35.

24. American Society of International Law, 37 International Legal Materials 587 (1998).

25. American Society of International Law, 9 International Legal Materials 1292 (1970).

26. Francis A. Boyle, Defending Civil Resistance under International Law 198 (1987).

27. 1986 International Court of Justice Reports 106-112, at par. 209.

28. *Id.* at 134-135.

29. *See* Francis A. Boyle, *George Bush, Jr., September 11 and the Rule of Law*, in The Criminality

of Nuclear Deterrence 16-40 (2002).

30. *See* Francis A. Boyle, *Bush's Banana Republic, CounterPunch.org,* Oct 11, 2002; Jordan J. Paust, *There Is No Need to Revise the Laws of War in Light of September 11th,* American Society of International Law Task Force on Terrorism (ASIL Webpage: Nov. 2002); Jordan J. Paust, *Antiterrorism Military Commissions: Courting Illegality,* 23 Michigan J. Int'l L. 1 (Fall 2001).

31. *See* Judith Miller, Stephen Engelberg & William Broad, Germs (2001); Boyle, *Biowarfare, Terror Weapons and the U.S.,* CounterPunch.org, April 25, 2002.

32. *See* Boyle, The Criminality of Nuclear Deterrence, *supra* at 210

33. *Id.* at 55-91.

Chapter Seven

What Is To Be Done?

It is my purpose here to sketch out some new directions to support Palestinian self-determination for the Palestinian people and their friends around the world to consider:

1. UN Suspension of the State of Israel

We must immediately move for the *de facto* suspension of Israel throughout the entirety of the United Nations System, including the General Assembly and all UN subsidiary organs and bodies. We must do to Israel what the UN General Assembly has done to the genocidal rump Yugoslavia and to the former criminal apartheid regime in South Africa! The legal basis for the *de facto* suspension of Israel at the UN is quite simple:

A condition for Israel's admission to the United Nations Organization was its acceptance of General Assembly Resolution 181(II) (1947) (on partition and Jerusalem trusteeship) and General Assembly Resolution 194 (III) (1948) (Palestinian right of return), *inter alia*. Nevertheless, the government of Israel has expressly repudiated both Resolution 181(II) and Resolution 194(III). Therefore, insofar as Israel has violated its conditions for admission to UN membership, it must accordingly be suspended on a *de facto* basis from any participation throughout the entire United Nations system.

During the 1948 Security Council debates on Israel's Application for UN Membership,[1] U.S. Ambassador Jessup stated: " ... it is the view of my Government that Israel is a peace-loving nation. The Jewish community in Palestine, which created the State of Israel, expressed its willingness and readiness, a year ago, to accept the General Assembly resolution of 29 November 1947 and to co-operate loyally in carrying it out."[2] Quite obviously, Israel is not and has never been a "peace-loving" state within the meaning of UN Charter article 4(1), which condition is required for UN Membership. Consequently, Israel deserves to be expelled from the United Nations Organization pursuant to the procedure set forth in UN Charter article 6 precisely because from its very foundation Israel "has persistently violated the Principles contained in the present Charter," which are set forth in article 2.

But since the United States would undoubtedly exercise its veto power to prevent the formal expulsion of Israel from the United Nations Organization, the UN General Assembly can and must exercise its UN Charter powers under Chapter IV to suspend Israel's participation throughout the entire UN Organization on a de facto basis. United Kingdom Ambassador Cadogan eloquently framed this relentless American support during the 1948 Security Council debates on Israel's admission to the UN as follows:[3]

. . . .

As a proof that they were ready to comply with the demands and resolutions of the General Assembly, the

representative of the United States mentioned the fact that, when the resolution of 29 November 1947 was announced to them, they accepted it. Certainly they accepted it. It is like the case of a father who, in referring to his bad son, would say: "You see, he is very obedient; I tell him to eat this plate of apricots and he does it right away; I tell him to take this sugar, and he eats it." Certainly he does; he is obedient to his father because he likes the sweets that are given to him. But that is not enough; is he obedient when his father orders him to work, or to set aside his evil ways? If he does not do that, he is not obedient at all. Is the fact that the Jews accepted the resolution on the partitioning of Palestine any proof? It is not; the partition of Palestine was an offer, it was a present given to them gratuitously, and certainly they accepted it. But can that be called obedience?

When the Jews were told to withdraw from positions which they had no right to occupy, when they were told not to commit breaches of the truce, when they were told not to increase their munitions or to change their political and military positions, they did not obey at all. It is well known that they have been violating those requests all the time. Is that compliance with the resolutions of the General Assembly or the Security Council? I do not know how the representative of the United States can allow himself to make such a statement.

He said that they have conformed to the definition of a State according to international law. He said that they have territory – but that territory has no boundaries. He said that they have population – where are the people? Half the people of the territory which they occupy have been expelled and dispersed throughout the country. They are now homeless, starving and dying. These are the people of the territory which they are occupying; does the representative of the United States mean that he is coming here to represent them? How can he represent people who have been dispersed in such a way? How can he say that his people are peace-loving and are complying with the requirements of Article 4 of the Charter? That is not a way of discussing matters here which is in keeping with our prestige and dignity. He said that their admission will serve the cause of peace, that they were here to serve the maintenance of peace and security, but it is known to him and to everybody else that the admission of the so-called State of Israel to the United Nations would not serve peace but would, on the contrary, disturb peace.

We are here to create friendly relations between States and nations, but this will not create any friendship. There are seven Arab States and there are many States of the Moslem world in Asia and other places who are against this. There are many people against it in China, in India, in France, in the United Kingdom, and in the USSR. In the USSR there are twenty-five or thirty million Moslems who are against this idea and who protest against it. In the French colonies and possessions in North Africa there are twenty-five million Moslems and Arabs and

perhaps other Moslems who are not Arabs and who are yet against it. These people would be upset by such a decision by the United Nations, and yet the representative of the United States considers that it is urgent! Why is it urgent, now that they have obtained their votes and certain advantages in New York and Washington and other places in the United States? Yet it has become urgent for those very reasons in spite of the feelings and sentiments of four hundred million Moslems, Arabs and Christians throughout the world.

What are the Jews doing with the Holy Places in the Holy Land? I will submit to the Security Council a long list of the atrocities which they have committed; yet it is considered to be urgent and helpful to serve the Jews. The Jews were persecuted in Europe, but the Arabs in Palestine did not persecute them. Nevertheless they are now retaliating against the Arabs of Palestine and are now submitting them to worse and more cruel treatment than they themselves received in Germany and in Eastern Europe.

Is that the way in which the United Nations or the Security Council should deal with such international questions and humanitarian problems? Now is not the time to enlarge upon this subject. The matter will return to us later and we shall have ample time to discuss it fully.

In regard to Israel's absolute dependence upon the UN General Assembly's Partition Resolution 181(II) for its very existence as a State under international law, let alone for its UN Membership, USSR Ambassador Malik forthrightly stated during those Security Council debates:

. . . .

The problem of Palestine is probably one of those to which the United Nations has been and still is devoting more attention than to many others. The State of Israel has been created and exists in accordance with a resolution passed in the General Assembly on 29 November 1947. It is therefore incorrect to assert that its territory is not defined. Its territory is clearly defined by an international decision of the United Nations, namely by the resolution adopted on 29 November 1947 by the General Assembly.[4]

. . . .

The delegation of the Soviet Union would give the same attention in the Security Council to an application for admission to the United Nations submitted by an Arab State set up on the territory of Palestine as provided in the resolution of 29 November 1947.[5]

Israel's absolute dependence upon Partition Resolution 181(II) for its very existence as a State under international law, as well as for its admission to UN Membership, is definitively confirmed by a Letter dated 29 November 1948

from Moshe Shertok, Minister for Foreign Affairs of the Provisional Government of Israel, to the UN Secretary General "concerning Israel's application for membership in the United Nations and declaration accepting the obligations contained in the Charter," which provides in relevant part as follows:

> On 14 May 1948, the independence of the State of Israel was proclaimed by the National Council of the Jewish people in Palestine by virtue of the natural and historic right of the Jewish people to independence in its own sovereign State and in pursuance of the General Assembly resolution of 29 November 1947.[6] . . .

During the course of the Security Council debates on Israel's admission to the United Nations, Soviet Ambassador Malik stated:[7]

> In conclusion, the delegation of the USSR also thinks it necessary to draw the Security Council's attention to the resolution of 29 November 1947, paragraph (f), which provides for the admission of membership of both the Jewish and Arab States to be created in Palestine under that resolution. The Jewish State has been created; it exists, and the Security Council has every reason to consider the question of its admission to membership favourably. When, under the same resolution, an Arab State has been created in Palestine, the Security Council will take appropriate action in accordance with the provisions of that resolution.

Even Israeli Prime Minister Ariel Sharon has recently publicly conceded that the existence of the Palestinian State is now a matter of fact—de facto diplomatic recognition of Palestine by Israel.[8] The time has long passed for Palestine to be admitted to the United Nations Organization as a Member State in accordance with UN Charter article 4, and as interpreted by the International Court of Justice in its Advisory Opinion on the *Competence of the General Assembly for the Admission of a State to the United Nations* (1950). The United States government is impeding Palestine's formal admission to the United Nations Organization as a Member State at the behest of Israel. Consequently, an appropriate act on the part of the UN General Assembly would be to indicate its intention to de facto suspend Israel from UN participation until such time as recommendation of the admission of the State of Palestine has been received from the Security Council.

2. International Law as the Basis for Peace

Any further negotiations between Palestine and Israel must be conducted on the basis of Resolution 181(II) and its borders; Resolution 194(III);[9] subsequent General Assembly resolutions and Security Council resolutions; the Third and Fourth Geneva Conventions of 1949; the 1907 Hague Regulations; and other relevant principles of public international law, etc.

In regard to Palestinian refugees living in their Diaspora around the world, UN General Assembly Resolution 194(III) of 1948 determined that Palestinian refugees have a right to return to their homes, or that compensation should be paid to those who choose not to return. Furthermore, that same article 13(2) of the 1948 Universal Declaration of Human Rights which Soviet Jews

relied upon to justify their emigration from the former Soviet Union provides that: "Everyone has the right...to return to his country." That absolute right of return clearly applies to Palestinian refugees living in their Diaspora who want to return to their homes in Israel and Palestine. The state of Israel owes a prior legal obligation to resettle Palestinian refugees who want to return home before it undertakes the further massive settlement of Jews and non-Jews from around the world.

Pursuant to UN Charter article 4(2), admission of a State to UN Membership "will be effected by a decision of the General Assembly upon the recommendation of the Security Council." Thus, admission to UN Membership is a decision jointly shared between the Security Council and the General Assembly, but it is the General Assembly that ultimately admits a State to UN Membership. During the debates on Israel's admission to the United Nations held by the Ad Hoc Political Committee of the UN General Assembly, the Representative of the Provisional Government of Israel Abba Eban gave the following commitment on General Assembly Resolution 194 of 11 December 1948 concerning the repatriation of Palestinian refugees, in order to obtain Israel's admission to the United Nation's Organization by the UN General Assembly:[10]

> Mr. Casatro (El Salvador):
>
>
>
> In the light of those statements and remembering always that no effect has as yet been given to the General Assembly resolution, I wish to ask the representative of Israel whether he is authorized by his Government to assure the Committee that the State of Israel will do everything in its power to co-operate with the United Nations in order to put into effect (a) the General Assembly resolution of 29 November 1947 on the internationalization of the City of Jerusalem and the surrounding area and (b) the General Assembly resolution of 11 December 1948 on the repatriation of refugees.
>
> Mr. Eban (Israel):
>
>
> I can give unqualified affirmative answer to the second question as to whether we will co-operate with the organs of the United Nations with all the means at our disposal in the fulfillment of the resolution concerning refugees.

Pursuant thereto, the UN General Assembly formally admitted Israel to UN Membership by means of Resolution 273(III) of 11 May 1949, which provided in relevant part as follows:

> *Recalling* its resolutions of 29 November 1947 and 11 December 1948 and taking note of the declarations and explanations made by the representative of the Government of Israel 5/ before the *ad hoc* Political Committee in respect of the implementation of the said resolutions, . . .
> 5/ See documents *A/AC.24/SR.*45-48, 50 and 51.

Israel's repudiation of Resolution 194(III) provides yet another reason for the UN General Assembly to suspend Israel from participation throughout the entire UN system on a de facto basis—just as the UN General Assembly did to the former criminal apartheid regime in South Africa and later to the genocidal rump Yugoslavia. The criminal apartheid regime in Israel has become the new pariah of international law and must be at last be treated as such by the entire world.

3. Dump the Dishonest Broker

All who support Palestinian self-determination must abandon the fiction and the fraud that the United States government is an "honest broker" in the Middle East, let alone elsewhere. The United States government has never been an "honest broker" since from well before the very outset of the Middle East peace negotiations in 1991. Rather, it has invariably sided with Israel against the Palestinians as well as against the other Arab States. As I can attest from personal experience, the Palestinian negotiators have always been subjected to continual bullying, threats, harassment, intimidation, bribery, lies, and outright deceptions perpetrated by the United States working in conjunction with Israel.

It cannot be emphasized too strongly: just as President Clinton ordered Indonesia out of East Timor, President Bush Jr. can order Israel out of Palestine tomorrow. Anything less than that is just a diplomatic dog-and-pony show maliciously orchestrated by the United States government on behalf of Israel—unless the U.S. seriously wishes to concede that its hands are tied in foreign policy in the Middle East by the illegal and aggressive interests of another state. We must settle for nothing less than that U.S. presidential order to Israel!

4. Sanctions

We must move to have the UN General Assembly adopt comprehensive economic, diplomatic, and travel sanctions against Israel according to the terms of the Uniting for Peace Resolution (1950). Pursuant thereto, the General Assembly's Emergency Special Session on Palestine is now in recess just waiting to be recalled. The General Assembly repeatedly sanctioned the former criminal apartheid regime in South Africa. It has the power to do the same to the genocidal apartheid regime in Israel.

5. International Criminal Tribunal for Palestine

We must pressure the Member States of the UN General Assembly to found an International Criminal Tribunal for Palestine (ICTP) in order to prosecute Israeli war criminals, both military and civilian, including and especially Israeli political leaders. The UN General Assembly can set up this ICTP by a majority vote pursuant to its powers to establish "subsidiary organs" under UN Charter article 22. This International Criminal Tribunal for Palestine should be organized by the UN General Assembly along the same lines as the International Criminal Tribunal for the Former Yugoslavia (ICTY) that has already been established by the UN Security Council. In contrast to the International Criminal Tribunal for Rwanda (ICTR), which deals with an "internal armed conflict," the ICTY applies the rules of international criminal law applicable to an "international armed conflict," which legal categorization has always characterized the military hostilities inflicted by Israel upon the Palestinians.

For political reasons, I doubt very seriously that the International Criminal Court (ICC) will have the courage, integrity, and principles required to prosecute

Israeli—let alone American—war criminals. Indeed, the Bush Jr. administration is doing everything humanly possible to sabotage the ICC in order to avoid such prosecutions—reflecting what criminal lawyers would call "consciousness of guilt." Hence the need for the International Criminal Tribunal for Palestine to be established under the auspices of the UN General Assembly.

6. World Court Lawsuit for Genocide

The Provisional Government of the State of Palestine must sue Israel before the International Court of Justice in The Hague for inflicting acts of genocide against the Palestinian people in violation of the 1948 Genocide Convention.[11] Article II of the 1948 Genocide Convention defines the international crime of genocide as follows:

> In the present Convention, genocide means any of the following acts committed with intent to destroy, in whole or in part, a national, ethnical, racial or religious group as such:
>
> (a) Killing members of the group;
> (b) Causing serious bodily or mental harm to members of the group;
> (c) Deliberately inflicting on the group conditions of life calculated to bring about its physical destruction in whole or in part;
> (d) Imposing measures intended to prevent births within a group;
> (e) Forcibly transferring children of the group to another group.

Certainly, Palestine has a valid claim that Israel and its predecessors-in-law—numerous Zionist agencies, forces, and terrorist gangs—have committed genocide against the Palestinian people that actively started on or about 1948 and has continued apace until today in violation of Genocide Convention Article II(a), (b), and (c), inter alia. [12]

For at least the past five decades the Israeli government and its predecessors-in-law—numerous Zionist agencies, forces, and terrorist gangs— have ruthlessly implemented a systematic and comprehensive military, political, and economic campaign with the intent to destroy in substantial part the national, ethnic, racial and different religious (Muslim and Christian) group constituting the Palestinian people. This Zionist/Israeli campaign has consisted of killing members of the Palestinian people in violation of Genocide Convention Article II(a). This Zionist/Israeli campaign has also caused serious bodily and mental harm to the Palestinian people in violation of Genocide Convention Article II(b). This Zionist/Israeli campaign has also deliberately inflicted on the Palestinian people conditions of life calculated to bring about their physical destruction in substantial part in violation of Article II(c) of the Genocide Convention.

To be sure, the Palestinians can expect that the United States government will do everything possible to line up the votes of certain World Court Judges against Palestine. But it is no longer the case that the United States government controls the International Court of Justice. In this regard, recall the high degree of independence and objectivity the World Court demonstrated by condemning the United States government throughout the proceedings of *Nicaragua v. United*

States of America (1986). Of course, if necessary, Palestine could also sue the United States before the International Court of Justice for aiding and abetting Israeli genocide against the Palestinian people in violation of Article III(e) of the 1948 Genocide Convention that expressly criminalizes such "complicity" in genocide.

The mere filing of this genocide lawsuit against Israel at the World Court would constitute a severe defeat for Israel in the court of world public opinion. Furthermore, any contracting party to the Genocide Convention can sue Israel at the International Court of Justice in The Hague for inflicting acts of genocide against the Palestinian people in violation of the 1948 Genocide Convention, and request provisional measures of protection for them on an emergency basis. Today, over 132 States are contracting parties to the Genocide Convention. We must pressure all of them to have the courage, integrity and principles to sue Israel at the World Court in order to stop its ongoing and longstanding campaign of genocide against the Palestinians. If one willing state can be found, I will offer it my services to file that genocide lawsuit against Israel, and request provisional measures of protection on behalf of the Palestinians, just as I successfully did twice for the Republic of Bosnia and Herzegovina against the genocidal rump Yugoslavia in 1993.[13]

7. Divestment/Disinvestment Campaign

Concerned citizens and governments all over the world must organize a comprehensive campaign of economic divestment and disinvestment from Israel along the same lines of what they did to the former criminal apartheid regime in South Africa. This original worldwide divestment/disinvestment campaign played a critical role in dismantling the criminal apartheid regime in South Africa. For much the same reasons, a worldwide divestment/disinvestment campaign against Israel will play a critical role in dismantling its genocidal apartheid regime against the Palestinian people living in occupied Palestine as well as in Israel itself. Simply put, divestment calls for the sell-off of all investments in corporate entities that do business with Israel, whereas disinvestment calls for all to eliminate any investments in Israel.

The above seven steps taken in conjunction with each other should provide the Palestinian people with enough political, diplomatic, and economic leverage needed to negotiate a just and comprehensive peace settlement with Israel. By contrast, if the defunct Oslo process is somehow resuscitated and resumed by the United States government, it will inevitably result in the permanent imposition of a bantustan upon the Palestinian people living in occupied Palestine, as well as the final dispossession and disenfranchisement of all Palestinian people living in their Diaspora.[14] Consequently, I call upon all Palestinian people living everywhere, as well as their friends around the world, to consider these new directions in support of Palestinian self-determination.

How To Support the Israeli Divestment/Disinvestment Campaign

I have been asked to provide some advice and guidance for the burgeoning international grassroots Campaign for Israeli Divestment/Disinvestment. These thoughts have been inspired by my involvement in the original Divestment/ Disinvestment Campaign against the former criminal apartheid regime in South Africa.[15] In particular, I owe a great debt of gratitude to my late teacher, mentor, and friend, C. Clyde Ferguson Jr., the Stimson Professor at Harvard Law School (HLS) and the first tenured African American Professor on its Faculty. I was privileged to have taken the first course he ever taught at HLS on The International Protection

of Human Rights, using the Sohn and Buergenthal Casebook (1973) published under that title. Based upon his extensive first-hand experience at having handled these matters for the Nixon administration, Professor Ferguson was the first teacher I ever had who fully exposed me to the true horrors of the former criminal apartheid regimes in South Africa, Southwest Africa (today Namibia), and Rhodesia (today Zimbabwe), as well as their aggressions against Mozambique and Angola, inter alia, in order to preserve apartheid. Even at that time, the legal, political, and human rights similarities to the genocidal apartheid regime imposed by Israel in occupied Palestine and against Israel's own Palestinian third-class "citizens," as well as Israeli aggressions against the surrounding Arab states in order to preserve apartheid both at home and abroad, were uncanny.

The Israeli Divestment/Disinvestment Campaign is a completely spontaneous, international grassroots movement. That is the beauty and the power of it. There is no central organizing committee or headquarters. If I were struck down by lightening tomorrow, the Campaign would go on without me. What follows are some general comments and analysis that grassroots organizers and participants might want to consider for the future of our Campaign. Needless to say, everyone must do what his or her conscience tells them to do.

APPLYING THE 1973 APARTHEID CONVENTION TO DISMANTLE ISRAEL'S GENOCIDAL APARTHEID REGIME

Opponents of the Israeli Divestment/Disinvestment Campaign have argued that the former criminal apartheid regime in South Africa is not similar to the genocidal apartheid regime in Israel. Fortunately, there are objective criteria that can be applied in order to resolve this dispute: they are articulated in the 1973 International Convention on the Suppression and Punishment of the Crime of Apartheid[16] At least 101 states currently are parties to the Apartheid Convention. Israel and the United States are not—for obvious reasons. In any event, the absolute prohibition on apartheid is a requirement both of customary international law and of *jus cogens*—a peremptory norm of international law—that binds all states in the world community, including Israel and the United States. During the course of a 25 September 2002 debate on WBUR Radio Station, the National Public Radio (NPR) affiliate in Boston, that I had with Alan Dershowitz over the Israeli Divestment/Disinvestment Campaign, I made most effective use of this 1973 Apartheid Convention.

Apartheid Convention Article I

Article I of the 1973 International Convention on the Suppression and Punishment of the Crime of Apartheid determines that apartheid is a "crime against humanity" and that those who commit the crime of apartheid are international criminals, by means of the following language:

Article I

1. The States Parties to the present Convention declare that *apartheid* is a crime against humanity and that inhuman acts resulting from the policies and practices of *apartheid* and similar policies and practices of racial segregation and discrimination, as defined in Article II of the Convention, are crimes violating the principles of international law, in particular the purposes and principles of the Charter of

the United Nations, and constituting a serious threat to international peace and security.

2. The States Parties to the present Convention declare criminal those organizations, institutions and individuals committing the crime of *apartheid*.

I have already pointed out above in this book that the paradigmatic example of a "crime against humanity" is what Hitler and the Nazis did to the Jewish People. Today, Israel is doing the same thing to the Palestinians in the name of the Jewish People. To be sure, large numbers of Jewish People in Israel, America, Britain, South Africa and all over the world vigorously oppose what Israel is doing to the Palestinians. These latter Jewish People know from tragic first-hand experience what a crime against humanity is all about.

Apartheid Convention article 1(2) specifically determines that all Israeli organizations, institutions, and individuals committing the crime of apartheid are "criminal." The same conclusion would apply to those pro-Israeli "organizations, institutions, and individuals" abroad in the United States and elsewhere around the world who aid and abet Israeli apartheid against the Palestinians. They are all "criminal." A very powerful argument to be made in support of the Israeli Divestment/Disinvestment Campaign.

Apartheid Convention Article II

Article II of the Apartheid Convention defines the term "the crime of apartheid" as follows:

Article II

For the purpose of the present Convention, the term 'the crime of *apartheid*', which shall include similar policies and practices of racial segregation and discrimination as practiced in southern Africa, shall apply to the following inhuman acts committed for the purpose of establishing and maintaining domination by one racial group of persons over any other racial group of persons and systematically oppressing them:

(a) Denial to a member or members of a racial group or groups of the right to life and liberty of person:

 (i) By murder of members of a racial group or groups;

 (ii) By the infliction upon the members of a racial group or groups of serious bodily or metal harm by the infringement of their freedom or dignity, or by subjecting them to torture or to cruel, inhuman or degrading treatment or punishment;

 (iii) By arbitrary arrest and illegal imprisonment of the members of a racial group or groups;

(b) Deliberate imposition on a racial group or groups of living conditions calculated to cause its or their physical destruction in whole or in part;

(c) Any legislative measures and other measures calculated to prevent a racial group or groups from participation in the political, social, economic and cultural life of the country and the deliberate creation of conditions preventing the full development of such a group or groups, in particular by denying to members of a racial group or groups basic human rights and freedoms, including the right to work, the right to form recognized trade unions, the right to education, the right to leave and to return to their country, the right to a nationality, the right to freedom of movement and residence, the right to freedom of opinion and expression, and the right to freedom of peaceful assembly and association;

(d) Any measures, including legislative measures, designed to divide the population along racial lines by the creation of separate reserves and ghettos for the members of a racial group or groups, the prohibition of mixed marriages among members of various racial groups, the expropriation of landed property belonging to a racial group or groups or to members thereof;

(e) Exploitation of the labour of the members of a racial group or groups, in particular by submitting them to forced labour;

(f) Persecution of organizations and persons, by depriving them of fundamental rights and freedoms, because they oppose *apartheid*.

Israel has inflicted and currently inflicts almost each and every one of these "inhuman acts" of apartheid upon the Palestinian, excepting "the prohibition of mixed marriages. . . ."

Of course, there is no way I could even begin to document in the Conclusion to this book the "inhuman acts" constituting "the crime of apartheid" that Israel has inflicted upon the Palestinian people. In fact, such documentation has been the subject of several other books.[17] For analytical purposes here, it is important to note that the Preamble to the 1973 Apartheid Convention makes it clear that there is an overlap between criminal acts of apartheid and criminal acts of genocide within the meaning of the 1948 Genocide Convention: "*Observing that*, in the Convention on the Prevention and Punishment of the Crime of Genocide, certain acts which may also be qualified as acts of *apartheid* constitute a crime under international law. . . ." The reader is referred to the *Bibliography of Genocidal/Apartheid Acts Inflicted by Israel Upon the Palestinians During the Al Aqsa Intifada,* set forth below, for the most recent factual documentation of Israeli apartheid and genocide against the Palestinians.[18] Israeli Divestment/

Disinvestment Campaigners can simply apply the texts of the 1948 Genocide Convention and the 1973 Apartheid Convention (referenced therein) to the human rights violations set forth in these bibliographical materials in order to substantiate their arguments, positions, recommendations, and conclusions, etc.

Apartheid Convention Article III

Article III of the 1973 Apartheid Convention provides for "international criminal responsibility" for apartheid for "individuals, members of organizations and institutions and representatives of the State," and "irrespective of the motive involved," in the following language:

> *Article III*
>
> International criminal responsibility shall apply, irrespective of the motive involved, to individuals, members of organizations and institutions and representatives of the State, whether residing in the territory of the State in which the acts are perpetrated or in some other State, whenever they:
>
> (a) Commit, participate in, directly incite or conspire in the commission of the acts mentioned in Article II of the present Convention;
>
> (b) Directly abet, encourage or co-operate in the commission of the crime of *apartheid*.

Pursuant to article III, therefore, all Israeli "individuals, members of organizations and institutions and representatives of the State [*e.g.*, government officials and Knesset members]" who commit, participate in, directly incite, or conspire in the commission of the above-listed apartheid acts are international criminals. The same conclusion holds true for those Israeli "individuals, members of organizations and institutions and representatives of the State" who directly abet, encourage or cooperate in the commission of the crime of apartheid. They are all international criminals.

Furthermore, Apartheid Convention article III creates international criminal responsibility for all non-Israeli "individuals, members of organizations and institutions and representatives of the State" who "directly incite or conspire" in the commission of, or who "[d]irectly abet, encourage or co-operate" in Israeli apartheid against the Palestinians. Certainly that criminalization would apply to all non-Israelis around the world who actively support Israel's genocidal apartheid regime against the Palestinians. They are all international criminals. This represents a very powerful condemnation of the pro-Israel Lobbies in the United States, Canada, Britain, Australia, France, Germany, etc.—and a very powerful argument in support of the Israeli Divestment/Disinvestment Campaign.

Apartheid Convention Article IV

Article IV of the Apartheid Convention provides direct legal authority in support of the Israeli Divestment/Disinvestment Campaign in the following language:

Article IV

The States Parties to the present Convention undertake:

(a) To adopt any legislative or other measures necessary to suppress as well as to prevent any encouragement of the crime of *apartheid* and similar segregationist policies or their manifestations and to punish persons guilty of that crime;

(b) To adopt legislative, judicial and administrative measures to prosecute, bring to trial and punish in accordance with their jurisdiction persons responsible for, or accused of, the acts defined in Article II of the present Convention, whether or not such persons reside in the territory of the State in which the acts are committed or are nationals of that State or of some other State or are stateless persons.

Obviously Apartheid Convention article IV(a) mandates Divestment/Disinvestment from Israel in order "to suppress as well as to prevent any encouragement of the crime of *apartheid*" against the Palestinians. Furthermore Apartheid Convention article IV(b) requires the establishment of universality of criminal jurisdiction by governments to prosecute all Israeli and non-Israeli individuals who participate in or actively support Israel's genocidal apartheid regime against the Palestinians. Yet another very powerful argument in support of the Israeli Divestment/Disinvestment Campaign.

Apartheid Convention Article V

Next with respect to the Israeli Divestment/Disinvestment Campaign, article V of the Apartheid Convention provides:

Article V

Persons charged with the acts enumerated in Article II of the present convention may be tried by a competent tribunal of any State Party to the Convention which may acquire jurisdiction over the person of the accused or by an international penal tribunal jurisdiction with respect to those States Parties which shall have accepted its jurisdiction.

In other words, there currently exists universality of criminal jurisdiction for governments to prosecute all those Israeli and non-Israeli international criminals who participate in or actively support Israel's genocidal apartheid regime against the Palestinians. In particular, both Israelis and non-Israelis who participate in or actively support Israel's genocidal apartheid regime can and must be prosecuted by any one of the 101+ States that are currently contracting parties to the Apartheid Convention. The Israeli Divestment/Disinvestment Campaign must insist upon the prosecution of these Israeli and non-Israeli international criminals by any government in the world that has them within its jurisdiction for any reason. In this regard, legally they are just like pirates—*hostis humani generis*—the enemy of all humankind.

The Rome Statute for the International Criminal Court[19]

Concerning the "international penal tribunal" mentioned above in Apartheid Convention article V, article 7 of the 1998 Rome Statute for the International Criminal Court (ICC) that is now in force determines that the "crime of apartheid" is a "crime against humanity" by means of the following language:

ARTICLE 7

Crimes against humanity

1. For the purpose of this Statute, "crime against humanity" means any of the following acts when committed as part of a widespread or systematic attack directed against any civilian population, with knowledge of the attack:

.

(j) The crime of apartheid;

. . . .

2. For the purpose of paragraph 1:

. . . .

(h) "The crime of apartheid" means inhumane acts of a character similar to those referred to in paragraph 1, committed in the context of an institutionalized regime of systematic oppression and domination by one racial group over any other racial group or groups and committed with the intention of maintaining that regime; . . .

Certainly, the government of Israel constitutes "an institutionalized regime of systematic oppression and domination by one racial group [Jews] over any other racial group [Palestinian Arabs]. . . and committed with the intention of maintaining that regime." Hence, under the Rome Statute those Israeli and non-Israeli individuals who participate in or actively support Israel's genocidal apartheid regime against the Palestinians run a risk of criminal prosecution by the International Criminal Court. Yet another very powerful argument in support of the Israeli Divestment/Disinvestment Campaign.

Apartheid Convention Article VI

According to article VI of the Apartheid Convention:

The States Parties to the present Convention undertake to accept and carry out in accordance with the Charter of the United Nations the decisions taken by the Security Council aimed at the prevention, suppression and punishment of the crime of *apartheid*, and to co-operate in the implementation of decisions adopted by other competent organs of the United Nations with a view to achieving the purposes of the Convention.

There were large numbers of resolutions and decisions adopted by all the competent organs of the United Nations Organization designed to dismantle the former criminal apartheid regime in South Africa. Many of them could and should be revived and applied directly to dismantle the genocidal apartheid regime in Israel.

Local Obligations and Options Under the Apartheid Convention

During the original struggle against the former criminal apartheid regime in South Africa, large numbers of state and local governments, universities, pension funds, and corporations all over the United States of America officially adopted numerous statutes, ordinances, and resolutions that sanctioned the former criminal apartheid regime in South Africa and those who did business with it. Many of these state, local, university, pension fund, and corporate statutes, ordinances, and resolutions were never repealed and are thus still officially on the books. It might be possible to apply these statutes, ordinances, and resolutions *proprio vigore* directly to the genocidal apartheid regime in Israel; or else to amend those statutes, ordinances and resolutions already on the books so as to apply them. If necessary, attorneys licensed to practice law in the respective local jurisdictions could redraft such statutes, ordinances and resolutions to make them directly applicable to the genocidal apartheid regime in Israel for adoption by state and local governments, universities, pension funds and corporations, etc.[20] Fortunately, the anti-apartheid "wheel" does not need to be "re-invented." It is already there just waiting to be put into operation against the genocidal apartheid regime in Israel by the Israeli Divestment/Disinvestment Campaign.

Apartheid Convention Article X

According to X of the Apartheid Convention:

1. The States Parties to the present Convention empower the Commission on Human Rights;

(b) To prepare, on the basis of reports from competent organs of the United Nations and periodic reports from States Parties to the present Convention, a list of individuals, organizations, institutions and representatives of States which are alleged to be responsible for the crimes enumerated in Article II of the Convention, as well as those against whom legal proceedings have been undertaken by States Parties to the Convention; . . .

The Israeli Divestment/Disinvestment Campaign must demand that the UN Human Rights Commission prepare "a list of individuals, organizations, institutions and representatives of States which are alleged to be responsible"

for the genocidal apartheid regime in Israel as well as those non-Israelis who aid and abet it from abroad. The compilation and public dissemination of such a list of international criminals and criminal entities by the UN Human Rights Commission will provide a most powerful incentive in support of the Israeli Divestment/Disinvestment Campaign all over the world.

Apartheid Convention Article XI

Finally, Article XI of the 1973 Apartheid Convention provides:

> 1. Acts enumerated in Article II of the present Convention shall not be considered political crimes for the purpose of extradition.

> 2. The States Parties to the present Convention undertake in such cases to grant extradition in accordance with their legislation and with the treaties in force.

So those individuals who are directly responsible for Israel's genocidal apartheid regime are extraditable for prosecution, as well as those non-Israelis who directly aid and abet Israel's genocidal apartheid regime against the Palestinians.

The Israeli Divestment/Disinvestment Campaign must demand either the prosecution, or else the extradition of these international criminals to a state willing to prosecute them. It is a well known principle of customary and conventional international law applicable to international criminals: *aut dedere, aut judicare*— either extradite or prosecute. The time has long passed for all governments in the world community to apply this hallowed principle of international law to these Israeli criminals and to those non-Israeli criminals who aid and abet them.

Under the Apartheid Convention, the Genocide Convention, and the ICC Rome Statute, both the government and the Knesset of Israel constitute an ongoing International Criminal Conspiracy. The Israeli Divestment/Disinvestment Campaign must start treating them all as such in recognition of this fact, and to promote awareness of it.

Precedents from Dismantling the Former Criminal Apartheid Regime in South Africa

Obviously, there is no way in the Conclusion to this book that I can deal comprehensively with all the legal ramifications of dismantling the genocidal apartheid regime in Israel. Fortunately, I have analyzed at great length many of the legal ramifications for dismantling the former criminal apartheid regime in South Africa in Chapter 6 of my book Defending Civil Resistance Under International Law (Transnational Publishers: 1989). The reader can obtain a "Special Paperback Edition" of this book expressly written "For Pro Se Protestors" at Amazon.com for $10. The extensive materials set forth in this book have already been successfully used all over the United States of America to dismantle the former criminal apartheid regime in South Africa. Almost identical arguments *par passu* can be used to dismantle the genocidal apartheid regime in Israel.

In particular, with respect to the Israeli Divestment/Disinvestment Campaign, I will reprint here revised and edited testimony I gave in court under oath and subject to cross-examination in Champaign County, Illinois on behalf of University of Illinois students who were prosecuted/persecuted by University of Illinois Administrators for a peaceful, non-violent protest in support of divestment

from the criminal apartheid regime in South Africa that was held at the Ilinois Student Union on the occasion of a University of Illinois Board of Trustees Meeting. This direct examination of me is conducted by Mr. Bryan Savage, Esq., formerly of Urbana, Illinois, who was the top student in the very first course I ever taught on Public International Law at the University of Illinois College of Law during the 1978-1979 academic year. Its direct applicability to the genocidal apartheid regime in Israel is obvious.

<center>"Constructive Engagement"[21]</center>

Q. Now, you've stated in your testimony today that the various conventions we have discussed prohibit inchoate crimes, such as complicity in the international law violations, by aiding and abetting, by making the crime your own and so on. Are you familiar with the various cases brought before international criminal courts after the Second World War, regarding German industrialists?

A. Yes.

Q. Can you explain to the Court what concepts of complicity were used by the courts in these cases?

A. Well, again, generally recognized principles of complicity. As I said, complicity is a doctrine, one of those general principles of law recognized by all civilized states. And, here you had German industrialists who were knowingly using slave labor or manufacturing poison gas for the extermination of Jews and others. And, it was found that because of this knowledge, they themselves could be appropriately found guilty of war crimes. And, in addition, after the war, some of these German industries paid compensation to the victims. Even today, there was a recent case just coming up this year, where a German corporation has paid compensation to survivors of the slave labor that had been perpetrated.

Q. In your opinion, under international common law principles of complicity, is the United States government, through its policy of constructive engagement, aiding and abetting the South African government in its violations of international law?

A. Well, that depends on the knowledge and purpose of officials of the United States government. Complicity would depend on whether or not U.S. government officials intended to facilitate, encourage, make their own, profit from the policies of the South African government. And, certainly the doctrine that had been pursued by the Reagan administration, known as constructive engagement, I think, creates very serious problems of complicity under well recognized principles of international law.

Under the Carter administration, the U.S. position had been quite clear, that what was going on in South Africa, internally and externally, was essentially organized criminal activity and that the United States government had to oppose it in whatever manner possible. Under the Reagan administration, under the influence of Chester Crocker, who is Assistant Secretary of State for African Affairs, that policy changed to one known as "constructive engagement." One of the other areas I teach at the University of Illinois is criminal law. And, I guess if you're talking about an individual constructively engaging in an organized criminal enterprise, that would certainly make you complicit as an aider and abetter, in that organized criminal enterprise. And, certainly, in my opinion, the South African government itself is an organized criminal enterprise, very similar to the Nazi government and its organs, as was determined by the Nuremberg Tribunal.

Corporate Complicity[22]

Q. In your opinion, would corporations such as GM, Ford, Caterpillar, and other labor-intensive industries, which profit by their businesses in South Africa, be complicity in the violations you have described, under both common law rules of complicity and the concepts of complicity discussed by the international tribunals after the Second World War?

A. Well, what I would says is this: To the extent they have knowledge of the South African international criminal law violations that are going on, and to the extent that they knowingly participate in this system and derive profit from it, it could certainly be the case that complicity would be established. Or, from another perspective, it would certainly be reasonable for the defendants to believe that there might be complicity present.

University Complicity

Q. In your opinion now, under principles of complicity as developed in international law and in common law, and depending on the same factors, that is knowledge, could the Trustees of the University of Illinois be complicit in those violations by continuing to invest funds in corporations doing business in South Africa, thus aiding and abetting the South African government in its violations of international law?

A. Well, again, as I said, that would depend on the extent of their knowledge and their intentions. If they intended, by actively participating in an investment program for the purpose of facilitating, furthering, promoting, benefiting from or profiting from apartheid, or any of the other international crimes that I mentioned to you, again the answer would be, yes—as aider and abetters. I do not express any opinion at all on the

knowledge, intention or purpose of various members of the Board of Trustees of the University. But, simply, that it could be reasonable for the defendant to believe, certainly, that complicity is a possibility.

The equivalent here would be to the University of Illinois investing in I.G. Farben knowing full well that it was using slave labor or manufacturing poison gas for the purpose of killing and exterminating German Jews and other individuals. And that would turn on the question of intent, as is the case with respect to any charge on aiding and abetting. Namely, does the University know or should it know that conduct that it is engaging in will be further facilitating, assisting, helping, or profiting from the commission of international crimes. That is the relevant test. And I take it the students involved here concluded that the answer to that question was yes. And hence, this motivated their conduct.

Q. In your opinion then, if the defendants in this case had believed, when they were arrested, that the government of South Africa was engaged in gross violations of human rights law, would their belief be reasonable?

A. I would certainly say that, yes, their belief would be reasonable, as an international law professor. Of course, that would be an issue to be determined by the jury, not by me. But, clearly, there would be reasonable grounds for that belief and the reasonable grounds would be what I have been testifying here for the past hour now. Certainly on the basis of the facts presented, it seems that a good faith belief can be developed.

Q. And, is it your testimony that reasonable grounds could also be found for a belief that the United States government is complicit, depending upon these factors?

A. Under the doctrine of constructive engagement, yes, there are reasonable grounds for that belief. It could be a mistaken belief, but it would be a good faith belief, which is all that is required. Indeed, other governments have pointed this out to the United States government, that the doctrine of constructive engagement creates serious legal complicity problems. And, indeed, as best as I can tell, in the past six months or so, in absolute disgust at some of the practices of the South African government, even now the Reagan administration has not explicitly but certainly implicitly, disavowed the doctrine of constructive engagement.

Q. With the same kinds of limitations and qualifications, do you think there are reasonable grounds for a belief that U.S. corporations doing business in South Africa, especially the corporations which are labor intensive, are complicit under the doctrines we have been talking about?

A. Certainly if you look at the definition of aiding and abetting, that is facilitating, furthering, promoting, making it your own, investing in and making a profit from an organized criminal enterprise, this is certainly enough to make you a criminal yourself, under an aiding and abetting theory.

Q. And, with the same limitations and understanding that you cannot testify as to someone's intent, could there be reasonable grounds, on the part of the defendants, to believe that the Trustees were complicit by continuing their policy of investment in corporations doing business in South Africa?

A. Well, once again, it would be subject to the same types of qualifications. It would depend upon their knowledge, their intention, their purpose, their action. But, if any of these Trustees believed that by pursuing these particular policies they were furthering, promoting, making their own, making a profit from, the organized criminal activities going on in South Africa, that very well could create accomplice liability. And of course I take it the reason these stocks were purchased by the University was to make a profit.

Civil Resistance

Q. In your studies, especially in your studies of political science, did you have occasion to study social movements, such as the civil rights movement, in the United States?

A. Yes.

Q. And, the tactics used by civil rights advocates, such as Martin Luther King?

A. Yes. What was then popularly called civil disobedience, which I think is different from what we have in this case.

Q. Now, in your opinion, was that an effective tactic to effect changes in the civil rights laws in the United States?

A. I believe it was. Just as a matter of fact, yes.

Q. Do you have personal knowledge of the tactics used by the defendants in this case?

A. Well, as I understand it, they did engage in what is popularly called civil resistance, which is different from civil disobedience in that these defendants were attempting to prevent what they believed to be ongoing criminal activity under international law.

Q. And, you understand it was not violent civil resistance?

A. As I understand it, yes.

Q. In your opinion, could they have a reasonable belief that that was an effective tactic to effect a change either in the policies of the South African government, the complicity of the United States, complicity of the corporations or complicity of the Trustees?

A. Certainly. In my opinion, as someone who has written on this subject and has taught about it, the one thing I think that will bring the South African government along to a change is economic sanctions. And, pursued as part of a policy of getting the United States government to adopt economic sanctions against South Africa, this type of activity could clearly be very effective.

Indeed, this type of activity that has gone on, not simply here but in other places, eventually did result in the Reagan administration adopting limited economic sanctions against the South African government. And, as I see it, the ultimate objective of all of these activities, is to get the United States government to exercise its authority at the United Nations Security Council, to impose a mandatory economic embargo against South Africa. This would be very similar to what happened in 1977, when the Carter administration went to the United Nations Security Council and imposed a mandatory arms embargo against the South African government because of the policies it was pursuing internally against its Black population, because of the aggressive policies it was pursuing against its neighboring states and also because of its illegal occupation of Namibia.

Necessity

Q. In your opinion, were any of the defendants with blame in occasioning or developing the violations of international law we have discussed?

A. Not that I know of. I don't believe any of the students have been responsible for any of the policies that have been undertaken by the South African government or the United States government. Indeed, as I understand it, they have attempted to change these policies in a peaceful, not violent, manner.

Q. Are you familiar with Chapter 38, Section 7-13 of the Illinois Revised Statutes, dealing with the necessity defense?

A. Yes. I am quite extensively familiar with that statute.

I was involved in both the *Jarka* and *Streeter* cases that you mentioned as their expert on international law.

Q. And under that section of the statute, would a student's actions which otherwise might constitute, for example, a violation of a criminal trespass statute, be justified, by reason of necessity, if that student was without blame in occasioning or developing the breaches of international law by the South African government, or the complicity of the United States government or the University of Illinois in said violations; and that student's actions were reasonably calculated and necessary to effect a change in the policies of the South African government, the United States and the University of Illinois; and the harm caused by that student was less than the harm caused by the South African government, the United States government and the University of Illinois; and there was no other reasonable alternative open to that student in order to effect those changes?

A. The answer is yes, certainly. When you have trespass on the one hand, and on the other hand you have crimes against peace, crimes against humanity, war crimes, genocide, apartheid, and torture, at a minimum, certainly. We could be here for the next five hours discussing the violations of international law committed by South Africa. If you look at the statute, it talks about avoiding a greater public or private harm or injury. And, clearly these crimes that the South African government is committing are certainly a greater public and private injury than a simple trespass. And this defense has been made successfully by other students in similar criminal cases. For example, on two separate occasions the Evanston city attorney has dismissed criminal charges against students at Northwestern University protesting in favor of divestment after we have filed international law necessity motions on their behalf.

Mr. Savage: Your Honor, I'm done with my examination. We'll tender the witness.

Shortly after our most vigorous defense of these original Divestment/Disinvestment Campaigners, the University of Illinois Board of Trustees voted to divest itself of stock from corporations doing business with the former criminal apartheid regime in South Africa.

CONCLUSION

Since the inception of the Israeli Divestment/Disinvestment Campaign, I have advised those students who have sought my opinion on the matter of tactics, to go back into the archives for their respective student newspapers in order to research and then replicate the tactics that had been employed by their predecessors to dismantle the former criminal apartheid regime in South Africa. Needless to say, these tactics varied from campus to campus all over the country. It is not my purpose here to recommend or advise that anyone engage in any particular types of tactics in order to dismantle the genocidal apartheid regime in Israel.

Indeed, Israeli Divestment/Disinvestment Campaigners must expect that pro-Israel University Administrators will inflict punitive, repressive, vindictive and retaliatory tactics against them, including criminal prosecutions and student disciplinary proceedings. That is exactly what University Administrators did to students peacefully campaigning against the former criminal apartheid regime in South Africa all over the United States. For example, here at the University of Illinois, we got all of our South African Divestment/Disinvestment Campaigners dismissed from criminal charges but three, who were convicted despite our best efforts on their behalf. Other students were subjected to so-called University disciplinary proceedings, which are really kangaroo courts where "the fix is in" by the University Administration right from the very outset.

The pro-Israel University of California at Berkeley Administrators (especially my former of University of Illinois "colleague" Berkeley Chancellor Robert Berdahl) have already persecuted the Students for Justice in Palestine because of their peaceful Israeli Divestment/Disinvestment Campaign activities on campus. Needless to say, Berkeley's Students for Justice in Palestine set up the world's first chapter of the Israeli Divestment/Disinvestment Campaign in February of 2001. Students must be aware of and seriously consider the risks that they run from vindictive pro-Israeli Campus Administrators and Boards of Trustees for participation in the Israeli Divestment/Disinvestment Campaign. As stated at the very beginning of this book, remember that there are and have never been academic freedom, academic tenure, academic rights, and academic due process of law when it comes to dismantling Israel's genocidal apartheid regime. Consequently, once again, everyone must do what his or her conscience tells them to do. Good luck. **Free Palestine!**

ENDNOTES

1. *See Israel's application for admission to membership in the United Nations,* UN SCOR, 3d Sess., 383rd mtg. at 7 (1948).
2. *Id.* at 11.
3. *Id.* at 19-20.
4. *Id.* at 22.
5. *Id.* at 23.
6. *See* S/1093, UN SCOR, 3rd Sess., Supp., Dec. 1948, at 118 (1948).
7. *See* UN SCOR, 3d Sess., 386th mtg., at 32-33 (1948).
8. Gil Hoffman, *Sharon Admits a Palestinian State Is Already an Established Fact,* Jerusalem Post, Nov. 14, 2002.
9. *See also* John McHugo, *Resolution 242: A Legal Reappraisal of the Right-Wing Israeli Interpretation of the Withdrawal Phrase with Reference to the Conflict Between Israel and the Palestinians,* 51 Int'l & Comp. L. Q. 851 (2002).
10. *See* UN GAOR Ad Hoc Political Comm., 3d Sess., 45th mtg., at 4, at 7, UN Doc. AC/AC 24/SR 47 (1949).
11. *See* Francis A. Boyle, *Palestine: Sue Israel for Genocide before the International Court of Justice!,* 20 J. Muslim Minority Affairs, No. 1, at 161-66 (2000).
12. *See* Issa Nakleh, I & II Encyclopedia of the Palestine Problem (1991). *See also* Bibliography of Genocidal/Apartheid Acts Inflicted by Israel upon the Palestinians During the Al Aqsa Intifada, *infra.*
13. Francis A. Boyle, The Bosnian People Charge Genocide (Aletheia Press: 1996).
14. *See, e.g.,* Jeff Halper, A Most UnGenerous Offer, The Link, Vol. 35, No. 4 (Sept. – Oct. 2002).
15. See Francis A. Boyle, Defending Civil Resistance Under International Law 211-83 (1987).
16. *See* International Convention on the Suppression and Punishment of the Crime of Apartheid, Nov. 30, 1973, 1015 UNTS. 243, 296. *See also* International Convention Against Apartheid in Sports, Dec. 10, 1985, 1500 UNTS. 161, 244, which must also be applied to Israel immediately.
17. *See, e.g.,* Issa Nakhleh, I & II. Encyclopedia of the Palestine Problem (1991); John Quigley, Palestine and Israel (1990); Raja Shehadeh, Occupier's Law (rev. ed. 1988); Raja Shehadeh,

From Occupation to Interim Accords: Israel and the Palestinian Territories (1997).

18. *See also* The New Intifada: Resisting Israel's Apartheid (Roane Carey ed.: 2001).

19. Rome Statute for the International Criminal Court, July 17, 1998, UN Doc. A/Conf. 183/9 (July 17, 1998).

20. *But cf.* Crosby v. National Foreign Trade Council, 530 U.S. 363 (2000).

21. *See U.S. Financial Aid to Israel: Figures, Facts and Impact*, Washington Report on Middle East Affairs, Nov. 26, 2002; David R. Francis, *Economist Tallies Swelling Cost of Israel to U.S.*, Christian Science Monitor, Dec. 9, 2002.

22. *See* Nicole Itano, *Should IBM and Others Pay Apartheid Bill?*, Christian Science Monitor, Nov. 26, 2002 (damages lawsuit filed by South African apartheid victims against multinationals). *See generally* Jordan J. Paust, *Human Rights Responsibilities of Private Corporations*, 35 Vanderbilt J. Transnational L. 801 (2002); Andrew Clapham & Scott Jerbi, *Categories of Corporate Complicity in Human Rights Abuses*, 24 Hastings Int'l & Comp. L. Rev. 339 (2001). *See, e.g.*, Bigio v. Coca-Cola, 239 F.3d 440 (2d Cir. 2001). *See also* Symposium, *Holocaust Restitution: Reconciling Moral Imperatives with Legal Initiatives and Diplomacy*, 25 Fordham Int'l L. J. S-vii-S-494 (2001).

Postscript

Having served as Legal Advisor to the Palestinian Delegation to the Middle East Peace Negotiations from 1991 to 1993, and in a similar capacity to the Syrian Delegation to the Middle East Negotiations during their First Round held in Washington, DC during 1991, I can state unequivocally that if there had been good faith on the part of the governments of Israel and the United States back in 1991, a comprehensive Middle East peace settlement between Israel on the one hand, and Palestine, Syria, Lebanon and Jordan, respectively, on the other, could have been negotiated by no later than the end of 1993. As became obvious at the time and is even more evident at present, the governments of Israel and the United States were never seriously interested in obtaining a comprehensive and just Middle East peace settlement in the first place, right from the very commencement of preparatory work for the Middle East peace negotiations by the Bush Sr. administration in the aftermath of its criminal war against Iraq for oil. Rather, Israel's perpetration and prolongation of its longstanding campaign of ethnic cleansing against the Palestinians as well as its "low intensity conflict" against Lebanon, the Lebanese, and Palestinian refugees living involuntarily in Lebanon, suit the political and economic interests of the interpenetrated security-military-industrial-complexes that really control the governments of the United States and Israel.

At this writing, the government of Israel and Pro-Zionist forces in the U.S. can be numbered among the major proponents for a war of catastrophic aggression to be launched by the U.S.–alone, if need be—against Iraq. Israeli Prime Minister General Ariel Sharon may very well be seeking such a second Bush Family anti-Iraqi oil crusade to provide suitable cover for a military resolution to the indefatigable Palestinian intifada which is wreaking demoralization and economic havoc in Israel—yet another Israeli round of ethnic cleansing against the Palestinian people, driving their West Bank residents into Jordan, and their Gaza inhabitants into the Sinai desert, together with Israel's Palestinian third-class "citizens". A second Al Nakba for the Palestinians.

There are also indications that Sharon would very much like to launch a major new aggression and land-grab against Lebanon and Syria just as he did in 1982 when as Israel's so-called Minister of Defense, he obtained the proverbial "green light" from the Reagan administration to do so and exterminated about 20,000 Arabs in the process. Meanwhile, President Bush Jr. has dispatched Secretary of State Colin Powell around the world to tamp down international discontent over Israel's serial massacres of the Palestinians in order to better enable the United States to reap the whirlwind of Iraq. This incredibly volatile situation could readily degenerate into a war for the entire Middle East with the world's sole Superpower orchestrating the carnage, in relentless pursuit of an open-ended global agenda.

Could World War III be far behind?

Bibliography of Genocidal/ Apartheid Acts Inflicted by Israel on the Palestinians During the Al Aqsa Intifada

INTRODUCTION

United Nations http://www.un.org/

International Court of Justice http://www.icj-cij.org/

Universal Declaration of Human Rights
http://www.unhchr.ch/html/menu6/2/fs2.htm#universal

United Nations Information System on the Question of Palestine
http://domino.un.org/unispal.nsf

Human Rights Watch
http://www.hrw.org

Amnesty International – working to protect human rights worldwide
http://www.amnesty.org/

Center for Economic and Social Rights
http://www.cesr.org/

TREATIES

Charter of the United Nations
http://www.unhchr.ch/html/menu3/b/ch-cont.htm

Statute of the International Court of Justice
http://www.icj-cij.org/icjwww/ibasicdocuments/ibasictext/ibasicstatute.htm#CHAPTER_II

Rome Statute of the International Criminal Court
http://www.un.org/law/icc/statute/romefra.htm

Convention on the Prevention and Punishment of the Crime of Genocide
http://www.hrweb.org/legal/genocide.html

International Convention on the Suppression and Punishment of the Crime of Apartheid
http://www.unhchr.ch/html/menu3/b/11.htm

International Covenant on Civil and Political Rights
http://www.unhchr.ch/html/menu3/b/a_ccpr.htm

Convention against Torture and Other Cruel, Inhuman or Degrading Treatment or Punishment
http://www.hrweb.org/legal/cat.html

International Convention on the Elimination of All Forms of Racial Discrimination, New York, 7 March 1966
http://untreaty.un.org/English/TreatyEvent2001/6.htm

Geneva Convention (III) relative to the Treatment of Prisoners of War
Adopted on 12 August 1949 by the Diplomatic Conference for the Establishment of International Conventions for the Protection of Victims of War, held in Geneva from 21 April to 12 August, 1949
http://www.unhchr.ch/html/menu3/b/91.htm

Geneva Convention (IV) relative to the Protection of Civilian Persons in Time of War
Adopted on 12 August 1949 by the Diplomatic Conference for the Establishment of International Conventions for the Protection of Victims of War, held in Geneva from 21 April to 12 August, 1949
http://www.unhchr.ch/html/menu3/b/92.htm

Protocol Additional to the Geneva Conventions of 12 August 1949, and relating to the Protection of Victims of International Armed Conflicts (Protocol 1)
http://www.unhchr.ch/html/menu3/b/93.htm

The Convention on the Rights of the Child
http://www.unicef.org/crc/crc.htm

Optional Protocol to the Convention on the Rights of the Child on the Involvement of Children in Armed Conflict
http://untreaty.un.org/English/TreatyEvent2001/index.htm

SECURITY COUNCIL RESOLUTIONS

Security Council Resolution 1322 of October 7, 2000
On the situation in the Middle East, including the Palestinian question
http://domino.un.org/UNISPAL.NSF/db942872b9eae454852560f6005a76fb/
22f8a95e5c0579af052569720007921e!OpenDocument

Security Council Resolution 1325 of October 31, 2000
On Women and peace and security
http://domino.un.org/UNISPAL.NSF/d744b47860e5c97e85256c40005d01d6/
f88d17eda6fedeef85256a230074c84e!OpenDocument

Security Council Resolution 1397 of March 12, 2002
The situation in the Middle East, including the Palestinian question
http://domino.un.org/UNISPAL.NSF/d744b47860e5c97e85256c40005d01d6/
4721362dd7ba3dea85256b7b00536c7f!OpenDocument

Security Council Resolution 1402 of March 30, 2002
The situation in the Middle East, including the Palestinian question
http://domino.un.org/UNISPAL.NSF/d744b47860e5c97e85256c40005d01d6/
a6205d0f6a75f92c85256b8e00542b01!OpenDocument

Security Council Resolution 1403 of April 4, 2002
The situation in the Middle East, including the Palestinian question
http://domino.un.org/UNISPAL.NSF/d744b47860e5c97e85256c40005d01d6/
4cebf3aed5fca54885256b920053bb30!OpenDocument

Security Council Resolution 1405 of April 19, 2002
The situation in the Middle East, including the Palestinian question
http://domino.un.org/UNISPAL.NSF/d744b47860e5c97e85256c40005d01d6/
9d8245ad174f11d785256ba3004c8663!OpenDocument

Security Council Resolution 1435 of September 24, 2002
The situation in the Middle East, including the Palestinian question
http://domino.un.org/UNISPAL.NSF/d744b47860e5c97e85256c40005d01d6/
2557b4ed9525563485256c3f004bbf4e!OpenDocument

GENERAL ASSEMBLY RESOLUTIONS

General Assembly Resolution 10/7
Illegal Israeli actions in Occupied East Jerusalem and the Rest of the Occupied Palestinian
Territory
October 10, 2000
http://domino.un.org/UNISPAL.NSF/a06f2943c226015c85256c40005d359c/
08596718a4f2273685256998004d3993!OpenDocument

General Assembly Resolution 183/L.2/Add.21
Resolution and Decision Of The General Assembly And The Security Council Relating To
The Question of Palestine
November 6, 2000
http://domino.un.org/UNISPAL.NSF/a06f2943c226015c85256c40005d359c/
4cf688743859aeed852569880057d9c2!OpenDocument

General Assembly Resolution 55/18
Bethlehem
November 7, 2000
http://domino.un.org/UNISPAL.NSF/a06f2943c226015c85256c40005d359c/
49c7bd1294cd4890852569d7004acd1e!OpenDocument

General Assembly Resolution 55/50
Jerusalem
December 1, 2000
http://domino.un.org/UNISPAL.NSF/a06f2943c226015c85256c40005d359c/
93c27908e093d385852569ee004df14f!OpenDocument

General Assembly Resolution 55/52
Committee on the Exercise of the Inalienable Rights of the Palestinian People
December 1, 2000
http://domino.un.org/UNISPAL.NSF/a06f2943c226015c85256c40005d359c/
6c384b66e8c89f8b852569f2004fd79d!OpenDocument

General Assembly Resolution 55/53
Division for Palestinian Rights of the Secretariat
December 1, 2000
http://domino.un.org/UNISPAL.NSF/a06f2943c226015c85256c40005d359c/
55a5b0118627eccc852569ee00505ae9!OpenDocument

General Assembly Resolution 55/54
Special information program on the question of Palestine of the Department of Public
Information of the Secretariat
December 1, 2000
http://domino.un.org/UNISPAL.NSF/a06f2943c226015c85256c40005d359c/
ffa3d86448c9f5a6852569f4004ff610!OpenDocument

General Assembly Resolution 55/55
Peaceful settlement of the question of Palestine
December 1, 2000
http://domino.un.org/UNISPAL.NSF/a06f2943c226015c85256c40005d359c/
a9d5de890aa9b1b3852569f500513f81!OpenDocument

General Assembly Resolution 55/87
The right of the Palestinian people to self-determination
December 4, 2000
http://domino.un.org/UNISPAL.NSF/a06f2943c226015c85256c40005d359c/
850739a21fcf5cd685256a14004dce8a!OpenDocument

General Assembly Resolution 55/123
Assistance to Palestine refugees
December 8, 2000
http://domino.un.org/UNISPAL.NSF/a06f2943c226015c85256c40005d359c/
a054fe7a454eb73c85256a10004e34ff!OpenDocument

General Assembly Resolution 55/124
Working Group on the Financing of the United Nations Relief and Works Agency for
Palestine Refugees in the Near East
December 8, 2000
http://domino.un.org/UNISPAL.NSF/a06f2943c226015c85256c40005d359c/
7d7438bbdd84aa4785256ab5004bf766!OpenDocument

General Assembly Resolution 55/126
Offers by Member States of grants and scholarships for higher education, including
vocational training, for Palestine refugees
December 8, 2000
http://domino.un.org/UNISPAL.NSF/a06f2943c226015c85256c40005d359c/
d1c1dab315ed028185256a10004effd7!OpenDocument

General Assembly Resolution 55/127
Operations of the United Nations Relief and Works Agency for Palestine Refugees in the
Near East
December 8, 2000
http://domino.un.org/UNISPAL.NSF/a06f2943c226015c85256c40005d359c/
a7cef288008ca9c685256a150050ea41!OpenDocument

General Assembly Resolution 55/128
Palestine refugees' properties and their revenues
December 8, 2000
http://domino.un.org/UNISPAL.NSF/a06f2943c226015c85256c40005d359c/
711ae3531b7d133d85256a0e004e3b39!OpenDocument

General Assembly Resolution 55/129
University of Jerusalem "Al-Quds" for Palestine refugees
December 8, 2000
http://domino.un.org/UNISPAL.NSF/a06f2943c226015c85256c40005d359c/
5c5653065995df6a85256a16004fc4fc!OpenDocument

General Assembly Resolution 55/130
Work of the Special Committee to Investigate Israeli Practices Affecting the Human Rights
of the Palestinian People and Other Arabs of the Occupied Territories
December 8, 2000
http://domino.un.org/UNISPAL.NSF/a06f2943c226015c85256c40005d359c/
f2a3eb2fd15503cb85256a1000502ed7!OpenDocument

General Assembly Resolution 55/131
Applicability of the Geneva Convention relative to the Protection of Civilian Persons in Time
of War, of 12 August 1949, to the Occupied Palestinian Territory, including Jerusalem, and
the other occupied Arab territories

December 8, 2000
http://domino.un.org/UNISPAL.NSF/a06f2943c226015c85256c40005d359c/
52388b99e216c66c85256a0f00537139!OpenDocument

General Assembly Resolution 55/132.
Israeli settlements in the Occupied Palestinian Territory, including Jerusalem, and the
occupied Syrian Golan
December 8, 2000
http://domino.un.org/UNISPAL.NSF/a06f2943c226015c85256c40005d359c/
43b9bd55802e5c9085256a0f005572c2!OpenDocument

General Assembly Resolution 55/133.
Israeli practices affecting the human rights of the Palestinian people in the Occupied
Palestinian Territory,
including Jerusalem
December 8, 2000
http://domino.un.org/UNISPAL.NSF/a06f2943c226015c85256c40005d359c/
0cd6262153b8053d85256a0f00565760!OpenDocument

General Assembly Resolution 55/173
Assistance to the Palestinian people
December 14, 2000
http://domino.un.org/UNISPAL.NSF/a06f2943c226015c85256c40005d359c/
16627a19d141890385256a0f0057baa7!OpenDocument

General Assembly Resolution 55/209
Permanent sovereignty of the Palestinian people in the Occupied Palestinian Territory,
including Jerusalem, and of the Arab population in the occupied Syrian Golan over their
natural resources
December 20, 2000
http://domino.un.org/UNISPAL.NSF/a06f2943c226015c85256c40005d359c/
021e075dcce0a03f85256a08004f41e3!OpenDocument

General Assembly Resolution 56/33
Committee on the Exercise of the Inalienable Rights of the Palestinian People
December 3, 2001
http://ods-dds-ny.un.org/doc/UNDOC/GEN/N01/478/45/PDF/N0147845.pdf?OpenElement

General Assembly Resolution 56/111
Assistance to the Palestinian people
October 14, 2001
http://domino.un.org/UNISPAL.NSF/a06f2943c226015c85256c40005d359c/
c190885378b6f15285256b7200575306!OpenDocument

General Assembly Resolution 56/31
Jerusalem
December 3, 2001
http://domino.un.org/UNISPAL.NSF/a06f2943c226015c85256c40005d359c/
2973f7625341869185256b2f0054e2ed!OpenDocument

General Assembly Resolution 56/33
Committee on the Exercise of the Inalienable Rights of the Palestinian People
December 3, 2001
http://domino.un.org/UNISPAL.NSF/a06f2943c226015c85256c40005d359c/
01289ef273e46d9585256b2f00564b66!OpenDocument

General Assembly Resolution 56/34
Division for Palestinian Rights of the Secretariat
December 3, 2001
http://domino.un.org/UNISPAL.NSF/a06f2943c226015c85256c40005d359c/
745aeca273a9492985256b2f0056bfea!OpenDocument

General Assembly Resolution 56/35
Special information programme on the question of Palestine of the Department of Public
Information of the Secretariat
December 3, 2001
http://domino.un.org/UNISPAL.NSF/a06f2943c226015c85256c40005d359c/
f1f816564b5a95b885256bdf006a21ee!OpenDocument

General Assembly Resolution 56/36
Peaceful settlement of the question of Palestine
December 3, 2001
http://domino.un.org/UNISPAL.NSF/a06f2943c226015c85256c40005d359c/
c303b9a601cbbb9785256b3b006b4e16!OpenDocument

General Assembly Resolution 56/52
Assistance to Palestine refugees
December 10, 2001
http://domino.un.org/UNISPAL.NSF/a06f2943c226015c85256c40005d359c/
f76b77503671888485256b6f00540d17!OpenDocument

General Assembly Resolution 56/56
Operations of the United Nations Relief and Works Agency for Palestine Refugees in the
Near East
December 10, 2001
http://domino.un.org/UNISPAL.NSF/a06f2943c226015c85256c40005d359c/
7a4709905f554c6b85256b6f00577ae5!OpenDocument

General Assembly Resolution 56/57
Palestine refugees' properties and their revenues
December 10, 2001
http://domino.un.org/UNISPAL.NSF/a06f2943c226015c85256c40005d359c/
c956b0ebeeedc10885256b7200545652!OpenDocument

General Assembly Resolution 56/58
University of Jerusalem "Al-Quds" for Palestine refugees
December 10, 2001
http://domino.un.org/UNISPAL.NSF/a06f2943c226015c85256c40005d359c/
64934053feff64b885256b720054fbb3!OpenDocument

General Assembly Resolution 56/59
Work of the Special Committee to Investigate Israeli Practices Affecting the Human Rights
of the Palestinian People and Other Arabs of the Occupied Territories
December 10, 2001
http://domino.un.org/UNISPAL.NSF/a06f2943c226015c85256c40005d359c/
8ab57842da3d443b85256b760050ee7d!OpenDocument

General Assembly Resolution 56/60
Applicability of the Geneva Convention relative to the Protection of Civilian Persons in
Time of War, of 12 August 1949, to the Occupied Palestinian Territory, including Jerusa-
lem, and the other occupied Arab territories
December 10, 2001

http://domino.un.org/UNISPAL.NSF/a06f2943c226015c85256c40005d359c/
765529ce2510abc685256b7200556efa!OpenDocument

General Assembly Resolution 56/61
Israeli settlements in the Occupied Palestinian Territory, including Jerusalem, and the
occupied Syrian Golan
December 10, 2001
http://domino.un.org/UNISPAL.NSF/a06f2943c226015c85256c40005d359c/
d70ec31005f32be985256b72005642e6!OpenDocument

General Assembly Resolution 56/62
Israeli practices affecting the human rights of the Palestinian people in the Occupied
Palestinian Territory, including Jerusalem
December 10, 2001
http://domino.un.org/UNISPAL.NSF/a06f2943c226015c85256c40005d359c/
e6b96c310a060c8b85256b7500512493!OpenDocument

General Assembly Resolution 56/142
The right of the Palestinian people to self-determination
December 19, 2001
http://domino.un.org/UNISPAL.NSF/a06f2943c226015c85256c40005d359c/
4ba587b815ee2e9d85256b82005533d0!OpenDocument

General Assembly Resolution E/S-10/8
Illegal Israeli actions in Occupied East Jerusalem and the rest of the Occupied Palestinian
Territory
December 20, 2001
http://domino.un.org/UNISPAL.NSF/a06f2943c226015c85256c40005d359c/
3d705272cfb3f0de85256b30004e138a!OpenDocument

General Assembly Resolution E/S-10/9
Illegal Israeli actions in Occupied East Jerusalem and the rest of the Occupied Palestinian
Territory
December 20, 2001
http://domino.un.org/UNISPAL.NSF/a06f2943c226015c85256c40005d359c/
d3ee72d2fe9be00c85256b30004f28e4!OpenDocument

General Assembly Resolution 56/55
Offers by Member States of grants and scholarships for higher education, including
vocational training, for Palestine refugees
December 20, 2001
http://domino.un.org/UNISPAL.NSF/a06f2943c226015c85256c40005d359c/
e4292b0b0f9579a385256b7200539dc1!OpenDocument

General Assembly Resolution 56/204
Permanent sovereignty of the Palestinian people in the Occupied Palestinian Territory,
including Jerusalem, and of the Arab population in the occupied Syrian Golan over their
natural resources
December 21, 2001
http://domino.un.org/UNISPAL.NSF/a06f2943c226015c85256c40005d359c/
8345dd0eec2ee0ae85256b7a00522a82!OpenDocument

General Assembly Resolution E/S-10/10
Illegal Israeli actions in Occupied East Jerusalem and the rest of the Occupied Palestinian
Territory
May 7, 2002

http://domino.un.org/UNISPAL.NSF/a06f2943c226015c85256c40005d359c/
72da83ff10657c9985256bc2005b8d23!OpenDocument

General Assembly Resolution E/S-10/11
Illegal Israeli actions in Occupied East Jerusalem and the rest of the Occupied Palestinian
Territory
September 10, 2002
http://domino.un.org/UNISPAL.NSF/a06f2943c226015c85256c40005d359c/
035daf0c2adaba8085256c3a004969ed!OpenDocument

UN HUMAN RIGHTS COMMISSION

Resolution adopted by the Commission at its fifth special session
Grave and massive violations of the human rights of the Palestinian people by Israel
October 19, 2000
http://domino.un.org/UNISPAL.NSF/de3c5500ad87043b85256c40005d636f/
16ec5d0cfab45921852569ae00502c5e!OpenDocument

Commission on Human Rights resolution 2001/2
Situation in occupied Palestine
April 6, 2001
http://domino.un.org/UNISPAL.NSF/de3c5500ad87043b85256c40005d636f/
08f7a94456e1f46685256ab1006f1569!OpenDocument

Commission on Human Rights resolution 2001/7 on the question of the violation of human
rights in the occupied Arab territories, including Palestine
April 18, 2001
http://domino.un.org/UNISPAL.NSF/db942872b9eae454852560f6005a76fb/
e72420b9df69a7bd85256ab200527d86!OpenDocument

Commission on Human Rights resolution 2001/8 on Israeli settlements in the occupied
Arab territories
April 18, 2001
http://domino.un.org/UNISPAL.NSF/db942872b9eae454852560f6005a76fb/
8f8d06ff7644b07285256ab20053e96f!OpenDocument

Commission on Human Rights resolution 2001/2 on the situation of and assistance to
Palestinian women
July 24, 2001
http://domino.un.org/UNISPAL.NSF/de3c5500ad87043b85256c40005d636f/
6a73b65132aa14f885256b6c005bf4b7!OpenDocument

Commission on Human Rights resolution 2001/23 on economic and social repercussions
of the Israeli occupation on the living conditions of the Palestinian people in the occupied
Palestinian territory, including Jerusalem, and the Arab population in the occupied Syrian
Golan
July 25, 2001
http://domino.un.org/UNISPAL.NSF/e525829c08b4932c85256c40005dde2f/
62d80f8d3c153879852569b90051c78e!OpenDocument

Commission on Human Rights resolution 2002/1 on Situation of human rights in the
occupied Palestinian territory
April 5, 2002
http://domino.un.org/UNISPAL.NSF/de3c5500ad87043b85256c40005d636f/
f9a0f66f6883325f85256b9c006b96cb!OpenDocument

Commission on Human Rights resolution 2002/3 on Situation in occupied Palestine
April 12, 2002
http://domino.un.org/UNISPAL.NSF/de3c5500ad87043b85256c40005d636f/
b73f716aa4a30ad585256bab0064b510!OpenDocument

Commission on Human Rights resolution 2002/7 on Israeli settlements in the occupied
Arab territories
April 12, 2002
http://domino.un.org/UNISPAL.NSF/de3c5500ad87043b85256c40005d636f/
bb1c33db634f47ed85256bab0065b7ec!OpenDocument

Commission on Human Rights resolution 2002/8 on question of the violation of human
rights in the occupied Arab territories, including Palestine
April 15, 2002
http://domino.un.org/UNISPAL.NSF/de3c5500ad87043b85256c40005d636f/
df9caa26e9beb10485256bab00666603!OpenDocument

Commission on Human Rights resolution 2002/9 on the situation of human rights in the
occupied Palestinian territory
April 26, 2002
http://domino.un.org/UNISPAL.NSF/de3c5500ad87043b85256c40005d636f/
c350221dc32e541385256bb4006a2718!OpenDocument

Commission on Human Rights resolution 2002/31 on economic and social repercussions of the
Israeli occupation on the living conditions of the Palestinian people in the Occupied Palestinian
territory, including Jerusalem, and the Arab population in the occupied Syrian Golan
August 23, 2002
http://domino.un.org/UNISPAL.NSF/de3c5500ad87043b85256c40005d636f/
444cac3af2d61adf85256c5b0069e175!OpenDocument

Civil and political rights including the question of torture and detention, Report of the Special
Rapporteur, Sir Nigel Rodley, submitted pursuant to Commission on Human Rights resolution
2000/43*
January 25, 2001
http://domino.un.org/UNISPAL.NSF/db942872b9eae454852560f6005a76fb/
36d254c40ba11cfe85256a5b004b61df!OpenDocument

Report of the human rights inquiry commission established pursuant to Commission resolu-
tion S-5/1 of 19 October 2000
March 16, 2001
http://domino.un.org/UNISPAL.NSF/db942872b9eae454852560f6005a76fb/
4a5fcb3241d55a7885256a1e006e75ad!OpenDocument

U.N. COMMISSION ON THE STATUS OF WOMEN

Resolution 2001/2
The situation of and assistance to Palestinian women
July 24, 2001
http://domino.un.org/UNISPAL.NSF/e525829c08b4932c85256c40005dde2f/
6a73b65132aa14f885256b6c005bf4b7!OpenDocument

Resolution 2002/25
The situation of and assistance to Palestinian women
August 13, 2002
http://domino.un.org/UNISPAL.NSF/e525829c08b4932c85256c40005dde2f/
608fdb93a60b2bb885256c5b0068c85b!OpenDocument

STATEMENTS BY UN SECRETARY-GENERAL

In message of Latin American meeting on Palestine, Secretary-General Says "There can be no military solution to this conflict"
13 June, 2001
http://www.un.org/News/Press/docs/2001/sgsm7844.doc.htm

Question of the violation of human rights in the occupied Arab territories, including Palestine (Note by the Secretary-General)
October 4, 2001
http://domino.un.org/unispal.nsf/9a798adbf322aff38525617b006d88d7/
b3e2ad721cf5a16485256af5006a79cc!OpenDocument&Highlight=0,dugard

Secretary-General's opening comments at press conference following Quartet meeting on the situation in the Middle East and the Question of Palestine
September 17, 2002
http://www.un.org/apps/sg/sgstats.asp?nid=66

Secretary-General's statement to Security Council meeting on the situation in the Middle East, including the Question of Palestine
September 23, 2002
http://www.un.org/apps/sg/sgstats.asp?nid=76

Statement attributable to the Spokesman for the Secretary-General on the situation in the Middle East, including the question of Palestine
September 26, 2002
http://www.un.org/apps/sg/sgstats.asp?nid=81

Statement attributable to the Spokesman for the Secretary-General on the situation in the Middle East, including the question of Palestine
October 7, 2002
http://www.un.org/apps/sg/sgstats.asp?nid=99

Statement attributable to the Spokesman for the Secretary-General on the situation in the Middle East, including the question of Palestine
October 17, 2002
http://www.un.org/apps/sg/sgstats.asp?nid=116

Secretary-General Kofi Annan's Anwar Sadat Memorial Lecture at the University of Maryland
November 13, 2002
http://domino.un.org/unispal.nsf/ed773cbec245eb6d85256b82005b029b/
7e4ffed4e6b0dd5085256c71005051a6!OpenDocument

Following West Bank Killings, Secretary-General again stresses that political settlement is only viable solution to MidEast conflict
November 20, 2002
http://domino.un.org/unispal.nsf/ed773cbec245eb6d85256b82005b029b/
beb7a356f373ac8085256c770068e1e6!OpenDocument

Secretary-General Reaffirms Validity of Two-State Solution in Message
November 27, 2002
http://www.un.org/News/Press/docs/2002/sgsm8529.doc.htm

Day of Palestinian Solidarity 'a day of mourning and a day of grief', says Secretary-General
November 29, 2002
http://domino.un.org/unispal.nsf/ed773cbec245eb6d85256b82005b029b/
ace40be3efc07aa185256c80007018e6!OpenDocument

STATEMENTS BY UN HIGH COMMISSIONER FOR HUMAN RIGHTS

Report of the United Nations High Commissioner for Human Rights and Follow-up to the World Conference on Human Rights
Question of the Violation of Human Rights in the occupied Arab Territories, Including Palestine
November 29, 2000
http://domino.un.org/UNISPAL.NSF/db942872b9eae454852560f6005a76fb/
43b5ee16eeba0d5d852569ac005a1f17!OpenDocument

Statement by the High Commissioner for Human Rights to the 58th session
of the Commission on Human Rights
Geneva, 2 April 2002
http://www.unhchr.ch/huricane/huricane.nsf/424e6fc8b8e55fa6802566b0004083d9/
1dba9880cdbe8d22c1256b9700285dc0?OpenDocument

HUMAN RIGHTS WATCH

Human Rights Watch
http://www.hrw.org

Israel's Interrogation of Palestinians from the Occupied Territories
http://www.hrw.org/reports/1994/israel/

Israel: the occupied west Bank and Gaza Strip, and the Palestinian Authority territories.
Investigation into unlawful use of force in the West Bank, Gaza Strip, and Northern Israel
Volume 12, Number 3(E) October, 2000
http://www.hrw.org/reports/2000/israel/

UN Should Monitor Rights in West Bank, Gaza
International Observer Mission Needed to Protect Civilians
New York, November 14, 2000
http://hrw.org/press/2000/11/un-ltr1114.htm

Israel/Palestinian Authority:
Letter to Security Council
December 5, 2000
http://www.hrw.org/press/2000/12/isrpa1206-ltr.htm

Human Rights Watch Urges Attention to Future of Palestinian Refugees
Letter to Israeli Prime Minister Barak
New York, December 22, 2000
http://www.hrw.org/press/2000/12/isrpab1222.htm

Israel: End "Liquidations" of Palestinian Suspects
New York, January 29, 2001
http://www.hrw.org/press/2001/01/ispr012901.htm

Letter to Ehud Barak: Halt "Liquidations"
January 29, 2001
http://www.hrw.org/press/2001/01/isrlet012901.htm

Israel/Palestine: Armed Attacks on Civilians Condemned
New York, February 21, 2001
http://www.hrw.org/press/2001/02/isr-pa-0221.htm

Israel: Palestinian Drivers Routinely Abused
New York, February 27, 2001
http://www.hrw.org/press/2001/02/isr-0227.htm

Item 8 - Question of the violation of human rights in the occupied Arab territories, including
Palestine Human Rights Watch Oral Intervention at the 57th Session of the UN Commission
on Human Rights
Geneva, March 28, 2001
http://www.hrw.org/press/2001/04/un_oral8_0405.htm

Israel: Sharon Investigation Urged
New York, June 23, 2001
http://www.hrw.org/press/2001/06/isr0622.htm

Israel: Palestinian Academic Rights Violated
Delayed Graduation Today from Bir Zeit University
New York, July 14, 2001
http://www.hrw.org/press/2001/07/academic-israel.htm

Letter to Israeli Prime Minister Ariel Sharon
Brussels, July 19, 2001
http://www.hrw.org/press/2001/07/sharon-0719-ltr.htm

Discrimination Against Palestinian Arab Children in Israel's Schools
September 2001
http://www.hrw.org/reports/2001/israel2/ISRAEL0901.pdf

Justice Undermined:
Balancing Security and Human Rights in the Palestinian Justice System
Vol.13, No.4 (E), November, 2001
http://www.hrw.org/reports/2001/pa/

Israeli Schools Separate, Not Equal
Palestinian Arab Citizens Face Discrimination in Access to Education
Jerusalem, December 5, 2001
http://www.hrw.org/press/2001/12/SecondClass1205.htm

Israel: Opportunistic Law Condemned
New York, March 7, 2002
http://www.hrw.org/press/2002/03/israel0307.htm

Israel, the occupied West Bank and Gaza Strip, and the Palestinian Authority territories in
a dark Hour: The use of civilians during IDF arrest operation.
Vol. 14, No. 2 (E), April 2002
http://www.hrw.org/reports/2002/israel2/

Item: 8 Question of the violation of human rights in the occupied Arab
territories, including Palestine
Oral Statement by Human Rights Watch at the fifty-eighth session of the Commission on
Human Rights
April 2, 2002
http://hrw.org/un/unchr_item8.pdf

Joint Statement Given in Jerusalem: April 7, 2002
with Amnesty International and the International Commission of Jurists
http://hrw.org/press/2002/04/isrstmnt040702.htm

Israel: Allow Access to Jenin Camp
Jerusalem, April 15, 2002
http://hrw.org/press/2002/04/jenin0415.htm

Israel: Don't Coerce Civilians to Do Army's Work
Jerusalem, April 18, 2002
http://hrw.org/press/2002/04/israel041802.htm

Israel: Decision to Block U.N. Inquiry Condemned
Geneva, April 24, 2002
http://hrw.org/press/2002/04/un-inquiry0424.htm

Live from Jenin
With Peter Bouckaert
Human Rights Watch investigator
Friday, April 26, 2002; 2:30 p.m. EDT
http://www.washingtonpost.com/wp-srv/liveonline/02/world/world_bouckaert0426.htm

Live from Jenin (Online Chat on Washington Post)
With Peter Bouckaert
Human Rights Watch investigator
Friday, April 26, 2002 ; 2:30 p.m. EDT
http://hrw.org/campaigns/israel/jenin-chat.htm

Israel/Occupied Territories: Jenin War Crimes Investigation Needed
Human Rights Watch Report Finds Laws of War Violations
Jenin, May 3, 2002
http://hrw.org/press/2002/05/jenin0503.htm

Photos from Jenin
http://hrw.org/photos/2002/jenin/

Israel, the occupied West Bank and Gaza Strip, and the Palestinian Authority territories
Jenin: IDF Military operations
Vol. 14, No. 3 (E) May, 2002
http://hrw.org/reports/2002/israel3/israel0502.pdf

Israel Seeks to Legalize War Crimes
New York, June 22, 2000
http://www.hrw.org/press/2000/06/isr0622.htm

Israel: Cuts in Child Allowance Discriminate Against Palestinian Arab Children
New York, June 7, 2002
http://hrw.org/press/2002/06/israel0706.htm

Israeli Airstrike on Crowded Civilian Area Condemned
New York, July 23, 2002
http://hrw.org/press/2002/07/gaza072302.htm

Gaza: IDF House Demolition Injures Refugees
Gaza, October 24, 2002
http://hrw.org/press/2002/10/gaza1024.htm

AMNESTY INTERNATIONAL

Amnesty International
http://www.amnesty.org/

The Right to Return: The Case of the Palestinians, Policy Statement
March 30, 2001
http://web.amnesty.org/ai.nsf/Index/MDE150132001?OpenDocument&of=COUNTRIES/
PALESTINIAN+AUTHORITY

Palestinian Authority: Justice must not be discarded
November 8, 2001
http://web.amnesty.org/802568F7005C4453/0/
5CDB7DD808F684FA80256AFF0042B0FD?Open&Highlight=2,palestine

Broken lives – a year of intifada
November 11, 2001
http://web.amnesty.org/802568F7005C4453/0/
64F59DC0B44C5FEF80256AFF0058B1B8?Open

Killings by Israelis
http://web.amnesty.org/ai.nsf/468d0bd6ba5d2b6280256af600687342/
64f59dc0b44c5fef80256aff0058b1b8/$FILE/ch2.pdf

Arrest, torture and unfair trials by Israelis
http://web.amnesty.org/ai.nsf/468d0bd6ba5d2b6280256af600687342/
64f59dc0b44c5fef80256aff0058b1b8/$FILE/ch4.pdf

Israel/Occupied Territories: Detention and beatings underline degradation of respect for
human rights
January 3, 2002
http://web.amnesty.org/ai.nsf/Index/
MDE150012002?OpenDocument&of=THEMES\HUMAN+RIGHTS+DEFENDERS

US efforts to obtain impunity for genocide, crimes against humanity and war crimes
February 9, 2002
http://web.amnesty.org/802568F7005C4453/0/
4C453D02446864BD80256C25003D3289?Open

Israel and the Occupied Territories
Shielded from scrutiny: IDF violations in Jenin and Nablus
April 11, 2002
http://web.amnesty.org/ai.nsf/recent/MDE151432002!Open

AI Index MDE 15/058/2002 - News Service Nr. 71
Preliminary findings of Amnesty International delegates' visit to Jenin
22 April 2002
http://web.amnesty.org/802568F7005C4453/0/
42AFE4733B0613F080256BA400452633?Open

Israel / Occupied Territories: Killing Palestinian civilians will not bring security or peace
July 23, 2002
http://www.web.amnesty.org/ai.nsf/Index/MDE151222002?OpenDocument&of=
COUNTRIES\PALESTINIAN+AUTHORITY

Israel / Occupied Territories / Palestinian Authority:
UN Secretary-General's report on Jenin underscores the need for a full inquiry
August 1, 2002
http://www.web.amnesty.org/ai.nsf/Index/
MDE151262002?OpenDocument&of=COUNTRIES\PALESTINIAN+AUTHORITY

Israel/OT: High Court decision gives green light for collective punishment
August 6, 2002
http://www.web.amnesty.org/ai.nsf/Index/
MDE151272002?OpenDocument&of=COUNTRIES\PALESTINIAN+AUTHORITY

Israel/Occupied Territories: Israeli Defense Force war crimes must be investigated
November 4, 2002
http://www.web.amnesty.org/ai.nsf/Index/
MDE151542002?OpenDocument&of=COUNTRIES\PALESTINIAN+AUTHORITY

B'TSELEM—THE ISRAELI INFORMATION CENTER FOR HUMAN RIGHTS IN THE OCCUPIED TERRITORIES

B'tselem
www.btselem.org

Human Rights Violations During the Events in the Occupied Territories
29 September – 2 December 2000
http://www.btselem.org/Download/Illusions_of_Restraint_Eng.doc

Border Police Officers Beat Izlikha and Ahmad al-Muhtaseb, Hebron,
25 October, 2002
http://www.btselem.org/English/Testimonies/
021025_Beating_of_Ahmad_and_Izlikha_al_Muhtasab_Hebron.asp

IDF Soldiers Harass the Abu 'Ubeid Family and Forces the Brothers Naji and Tawfiq Abu
'Obeid to Break the Ramadan Fast, Jenin,
9 November, 2002
http://www.btselem.org/English/Testimonies/
021109_Harrassment_of_Abu_Ubeid_Brothers_Jenin.asp

IDF Soldiers Seize Samah Suqiya's Water Tanker and Hold it for Three Days, Jenin,
15 November, 2002
http://www.btselem.org/English/Testimonies/0211115_Water_Tanker_Confiscation.asp

Death of Samar Shar'ab, a 21 Year-Old Woman, by a Tank Shell Fired by the IDF Allegedly
to Enforce Curfew in Nablus,
16 November, 2002
http://www.btselem.org/English/Testimonies/021116_Death_of_Samar_Sharab.asp

IDF Takes Over the Abu al-Hija Family Home in the Jenin Refugee Camp for Two Weeks,
October-November, 2002
http://www.btselem.org/English/Testimonies/
021025_Soldiers_Take_Over_al_Hija_Home_Jenin.asp

Foreseen but not Prevented: The Performance of Law Enforcement Authorities in
Responding to Settler Attacks on Olive Harvesters
December 2, 2002
http://www.btselem.org.il/English/Press_Releases/2002/021202.asp

PALESTINIAN CENTER FOR HUMAN RIGHTS

Palestinian Center for Human Rights
http://www.pchrgaza.org/

Arab Commission for Human Rights
Letter to the High Commissioner for Human Rights
October 2, 2000
http://www.pchrgaza.org/Library/2-10.htm

CDFJ is gravely concerned over Israeli violence against Palestinianjournalists
October 3, 2000
http://www.pchrgaza.org/Library/3-10-1.htm

FAILURE OF ISRAEL TO HONOUR ITS INTERNATIONAL OBLIGATIONS
October, 2000
http://www.pchrgaza.org/Library/Emhrn.htm

AMNESTY INTERNATIONAL PRESS RELEASE
October 9, 2000
http://www.pchrgaza.org/Library/9-10-1.htm

Israel/Occupied Territories: Findings of Amnesty International's delegation
October 19, 2000
http://www.pchrgaza.org/Library/19-10.htm

Israel/Occupied Territories: Findings of Amnesty International's delegation
December, 2000
http://www.pchrgaza.org/Library/19-10.htm

The Al Aqsa Intifada and Israel's Apartheid: The U.S. Military and Economic Role in the
Violation of Palestinian Human Rights
January, 2001
http://www.pchrgaza.org/Library/NLG_MidEastReport.pdf

Broken Lives – A Year of Infitida
October, 2001
http://www.pchrgaza.org/Library/Broken%20Lives.pdf

Israeli occupation forces have committed many war crimes...
March 2002
http://www.pchrgaza.org/images/2002/moh_e.htm

Theme Packages
http://www.pchrgaza.org/Themes/Frontpage_themes.htm

Including

Closures
http://www.pchrgaza.org/Themes/intro.closure.htm

Destruction of Land and Property
http://www.pchrgaza.org/Themes/intro.destruction.htm

Violation of Children's' Rights
http://www.pchrgaza.org/Themes/intro.children.htm

Violations against Journalists and Media Institutions
http://www.pchrgaza.org/Themes/intro.journalists.htm

Arbitrary Detention, Ill-treatment and Torture
http://www.pchrgaza.org/Themes/intro.torture.htm

Gazan Children's Daily Life
http://www.pchrgaza.org/images/2002/Children/children.htm

Images from Jenin
http://www.pchrgaza.org/images/2002/jenen/jenen.htm

Obstruction of Relief Work
http://www.pchrgaza.org/images/2002/others/other.htm

House Demolitions by Israeli occupation forces in Khan Yunis Refugee Camp, 11 April 2001
http://www.pchrgaza.org/images/khanyounes/khan.htm

Destruction of Agricultural Land by Israeli occupying forces
http://www.pchrgaza.org/images/sweeping/sweeping.htm

Mass House Demolitions in Rafah Refugee Camp, 10-11 January 2002
http://www.pchrgaza.org/images/rafah/rafah.htm

Weekly Report on Israeli Human Rights Violations in the Occupied Palestinian Territories.
November 21-27, 2002
http://www.pchrgaza.org/files/W_report/English/2002/28-11-2002.htm

Killings by Israeli Occupying Forces and Settlers in the OPT
September 28, 2000 – October 31, 2002
http://www.pchrgaza.org/special/killings_chart.htm

On Israeli Human Rights Violations in the Occupied Palestinian Territories
November 28 – December 3, 2002
http://www.pchrgaza.org/files/W_report/English/2002/04-12-2002.htm

Israeli forces kill two Palestinian civilians and demolish three houses in Beit Lahia
December 1, 2002
http://www.pchrgaza.org/files/PressR/English/2002/108-2002.htm

Stop Israeli violations against handicapped Palestinians in the Occupied Palestinian
Territories
December 3, 2002
http://www.pchrgaza.org/files/PressR/English/2002/109-2002.htm

PCHR condemns the Attack on al-Jeel Press Office
December 7, 2002
http://www.pchrgaza.org/files/PressR/English/2002/110-2002.htm

Weekly Report On Israeli Human Rights Violations in the Occupied Palestinian Territories
December 4-11, 2002
http://www.pchrgaza.org/files/W_report/English/2002/12-12-2002.htm

In a new Israeli attack on Palestinian civilian property,
Israeli occupying forces demolished 16 houses and destroyed 8 greenhouses in Rafah
December 16, 2002
http://www.pchrgaza.org/files/PressR/English/2002/111-2002.htm

STATISTICS WITH REFERENCE TO INTERNATIONAL HUMANITARIAN LAW

o General Statistics on the Occupied Palestinian Territories (OPT)
 http://www.pchrgaza.org/Intifada/General_Stat.htm
o Settlements
 http://www.pchrgaza.org/Intifada/Settlements_stat.htm
o Killings and Injuries
 http://www.pchrgaza.org/Intifada/Killings_stat.htm
o Closures, unemployment and poverty
 http://www.pchrgaza.org/Intifada/Closures_stat.htm
o Attacks and restrictions on medical personnel and the right to health care
 http://www.pchrgaza.org/Intifada/Medical_care_stat.htm
o Destruction of Land and Property
 http://www.pchrgaza.org/Intifada/House_demolitions_stat.htm
o Arrests, imprisonment and torture
 http://www.pchrgaza.org/Intifada/Arrests_torture_stat.htm

THE PALESTINIAN SOCIETY FOR THE PROTECTION OF HUMAN RIGHTS AND ENVIRONMENT

The Palestinian Society For the Protection of Human Rights and Environment
http://www.lawsociety.org

The Impact on the Palestinian Economy of Confrontations,
Mobility Restrictions and Border Closures
28 September—26 November 2000
http://www.lawsociety.org/Intifada2000/UN/impact.html

UNHRC urges international action against violence in Palestine
http://www.lawsociety.org/Intifada2000/articles/UNHRC.htm

UN's Robinson Supports Monitors in Mideast
http://www.lawsociety.org/Intifada2000/articles/robinson.htm

Intifada updates - Related Articles
http://www.lawsociety.org/Intifada2000/articles.htm

LAW Submission to the Special Session of the UN Commission on Human Rights
Israel's Use of Military Force Against Palestinian Demonstrators
October 2000
http://www.lawsociety.org/Reports/reports/2000/UNHCHR.htm

LAW Submissions to UN Human Rights High Commissioner Mary Robinson
12 November 2000
http://www.lawsociety.org/Reports/reports/2000/unhr.htm

UN Human Rights Commissioner Mary Robinson calls for international protection for
Palestinians
November 29, 2000
http://www.lawsociety.org/Intifada2000/UN/mary.htm

UN Assembly, opening debate on question of Palestine, hears call for enhanced involve-
ment in current Middle East situation
November 29, 2000
http://www.lawsociety.org/Intifada2000/articles/UN29-11.htm

UN General Assembly, opening Middle East debate, Receives texts on Golan Heights,
Administration of Jerusalem
November 30, 2000
http://www.lawsociety.org/Intifada2000/UN/GA9837.htm

UN General Assembly adopts 6 resolutions on Palestine
December 1, 2000
http://www.lawsociety.org/Intifada2000/UN/unresolutions.htm

The Israeli Media and the Intifada
December 4, 2000
http://www.lawsociety.org/Reports/reports/2000/media1.html

Indiscriminate use of force
Serious Israeli breaches of duties as occupier
25 January 2001
http://www.lawsociety.org/Reports/reports/2001/breaches.html

The Palestinian Preparatory Group for the World Conference Against Racism
September 2001
http://www.lawsociety.org/Apartheid/palngo.htm

Israel's brand of Apartheid:
The Nakba Continues
August 2001
http://www.lawsociety.org/Apartheid/dibook.html

Israel's brand of apartheid: The Palestinian Preparatory Group for the World Conference
Against Racism
August - September, 2001
http://www.lawsociety.org/Apartheid/palngo.htm

LAW Press Releases 2002
http://www.lawsociety.org/Press/Index.html

LAW Weekly Roundup
31 October – 6 November 2002
http://www.lawsociety.org/Press/Preleases/2002/nov/novw1.html

LAW Weekly Roundup
7 November - 13 November 2002
http://www.lawsociety.org/Press/Preleases/2002/nov/novw2.html

LAW Weekly Roundup
14 November - 20 November 2002
http://www.lawsociety.org/Press/Preleases/2002/nov/nov26.html

Israel's Apartheid Wall: we are here and they are there
November 26, 2002
http://www.lawsociety.org/wall/wall.html

Visitor to al-Ramle prison physically abuses female prisoner
November 27, 2002
http://www.lawsociety.org/Press/Preleases/2002/nov/nov27.html

LAW Weekly Roundup

28 November - 3 December 2002
http://www.lawsociety.org/Press/Preleases/2002/dec/decw1.html

OTHER LINKS

Israeli Practices in occupied Palestinian territories, form of Apartheid. Fourth Committee
told, as debate continues
November 12, 2002
http://www.un.org/News/Press/docs/2002/GASPD254.doc.htm

Mission report on Israel's violations of human rights in the Palestinian territories occupied
since 1967, submitted by Mr. Giorgio Giacomelli, Special Rapporteur
http://domino.un.org/UNISPAL.NSF/f39e4d190ca752160525672e00736dab/
20c39f227e664d02852569af00530859!OpenDocument

Adalah – The Legal Center For Arab Minority Rights in Israel
http://www.adalah.org/

Aspects of Intifada you do not hear about…list of Palestinians killed, Stories and images
http://infitidaonline.com/

Genocide in Palestine
http://www.po.org.ar/english/751art3.htm

Genocide in Palestine
http://www.middleeast.org/forum/fb-public/1/175.shtml

Question of Palestine
http://domino.un.org/UNISPAL.NSF?OpenDatabase

Palestinian Red Cross Society
http://www.palestinercs.org

Total daily numbers of deaths & injuries - West Bank & Gaza
Figures inclusive during the period September 29, 2000 – December 1, 2002
http://www.palestinercs.org/crisistables/table_of_figures.htm

Muslim Feast in Gaza Turns to Massacre
http://palestinechronicle.com/article.php?story=20021206054247330

Israeli soldiers near Ramallah murder 95-year-old woman; oldest known victim of the
Intifada
3 December 2002
http://www.palestinemonitor.org/updates/update_cover.htm

World Condemns Israeli "Shameful Aggression" on Gaza
December 7, 2002
http://www.islam-online.net/english/news/2002-12/07/article11.shtml

Details of Al-Bureij Refugee Camp Massacre
December 8, 2002
http://www.yourmailinglistprovider.com/pubarchive.php?iapinfo+684

Israelis Kill Palestinian Mother
December 9, 2002
http://www.arabia.com/newsfeed/article/english/0,14183,347638,00.html

Israel kills mentally-handicapped Palestinian; PA says Arafat should attend Christmas celebrations in Bethlehem
December 9, 2002
http://www.albawaba.com/news/index.php3?sid=235983&lang=e&dir=news

UN Relief Agency Seeks $94 Million to Help West Bank and Gaza
December 10, 2002
http://palestinechronicle.com/article.php?story=20021210175327474

Free Palestine
http://www.freepalestine.com/index.htm
Israel Silent on Food Warehouse Razing

Israeli Government, Military Silent on Army Destruction of U.N. Food Warehouse in Gaza
December 10, 2002
http://abcnews.go.com/wire/World/ap20021210_233.html

Israeli army murders second Palestinian mother in 24 hours
December 10, 2002
http://www.yourmailinglistprovider.com/pubarchive.php?iapinfo+689

Invisible killings: Israel's daily toll of Palestinian children
Ali Abunimah, The Electronic Intifada,
December 10, 2002
http://electronicintifada.net/v2/printer957.shtml

Hunger in Palestine By Peter Hansen
December 11, 2002
http://www.miftah.org/Display.cfm?DocId=1562&CategoryId=5

Israel Wins the World's Worst Housing Rights Violators Award
December 11, 2002
http://www.miftah.org/Display.cfm?DocId=1571&CategoryId=2

Israel Kills Five Unarmed Palestinians in Gaza
December 12, 2002
http://reuters.com/newsArticle.jhtml?type=topNews&storyID=1895909

Hansen Accuses Israel of Hindering UNRWA's Work
December 12, 2002
http://www.palestine-pmc.com/details.asp?cat=1&id=368

WORLD SOCIALIST WEB SITE

World Socialist Web Site
Published by the international Committee of the Fourth International
http://www.wsws.org/

Israeli provocation against Palestinians ignites a social powder keg
4 October 2000
http://www.wsws.org/articles/2000/oct2000/isra-o04.shtml

Israel's war measures and the legacy of Zionism
16 October 2000
http://www.wsws.org/articles/2000/oct2000/mide-o16.shtml

After the Arab summit: Israel escalates attack on Palestinians
24 October 2000
http://www.wsws.org/articles/2000/oct2000/mid-o24.shtml

Israel steps up military and economic warfare against Palestinians
23 November 2000
http://www.wsws.org/articles/2000/nov2000/isr-n23.shtml

Washington think tank report calls for the use of "excessive force" and torture against Palestinians
5 December 2000
http://www.wsws.org/articles/2000/dec2000/cord-d05.shtml

Zionism's legacy of ethnic cleansing
Part 1—Israel and the Palestinian right of return
22 January 2001
http://www.wsws.org/articles/2001/jan2001/pal1-j22.shtml

Zionism's legacy of ethnic cleansing
Part 2—Israeli expansion creates more Palestinian refugees
http://www.wsws.org/articles/2001/jan2001/pal2-j23.shtml

Human rights groups condemn Israel for assassinations and indiscriminate killing
23 January 2001
http://www.wsws.org/articles/2001/feb2001/idf-f23.shtml

International condemnation of Israeli settlements dominates events in Middle East
19 May 2001
http://www.wsws.org/articles/2001/may2001/isr-m19.shtml

Sharon calls ceasefire but says Israeli settlements will continue
23 May 2001
http://www.wsws.org/articles/2001/may2001/shar-m23.shtml

Israeli army reservists refuse to serve in occupied territories
31 January 2002
http://www.wsws.org/articles/2002/jan2002/isra-j31.shtml

Protest by Israeli reservists opens new chapter in the struggle against Zionism
9 February 2002
http://www.wsws.org/articles/2002/feb2002/isra-f09.shtml

Sharon's war crimes in Lebanon: the record
22 February 2002
http://www.wsws.org/articles/2002/feb2002/sab-f22.shtml

Sharon's war crimes in Lebanon: the record
February 25, 2002
http://www.wsws.org/articles/2002/feb2002/sab3-f25.shtml

Correspondence on the Israeli-Palestinian conflict
March 23, 2002
http://www.wsws.org/articles/2002/mar2002/corr-m23.shtml

International protests against assault on Palestinian Authority
5 April 2002

Palestine, Palestinians and International Law / Francis A. Boyle

http://www.wsws.org/articles/2002/apr2002/isin-a05.shtml

With Washington's tacit support, Sharon steps up West Bank assault
9 April 2002
http://www.wsws.org/articles/2002/apr2002/isra-a09.shtml

Israeli protestors speak out against Sharon's war
10 April 2002
http://www.wsws.org/articles/2002/apr2002/isra-a10.shtml

Israeli devastation of West Bank paves way for mass expulsions
12 April 2002
http://www.wsws.org/articles/2002/apr2002/isra-a12.shtml

Powell ends Mideast trip: a US cover for Israeli war crimes
18 April 2002
http://www.wsws.org/articles/2002/apr2002/powe-a18.shtml

Australian protests against Israeli invasion of the West Bank
April 23, 2002
http://www.wsws.org/articles/2002/apr2002/demo-a23.shtml

Milosevic and Sharon: when is a war criminal not a war criminal?
2 May 2002
http://www.wsws.org/articles/2002/may2002/isra-m02.shtml

UN pronounces on Jenin: Forget about it
3 May 2002
http://www.wsws.org/articles/2002/may2002/jeni-m03.shtml

US Congress backs Israeli assault on Palestinians
7 May 2002
http://www.wsws.org/articles/2002/may2002/cong-m07.shtml

Human Rights Watch report into Jenin accuses Israel of war crimes
10 May 2002
http://www.wsws.org/articles/2002/may2002/hrwa-m10.shtml

Israel to expand Jewish settlements in Hebron
November 26, 2002
http://www.wsws.org/articles/2002/nov2002/hebr-n26.shtml

Israel: Ethnic cleansing is now official government policy
December 3, 2002
http://www.wsws.org/articles/2002/dec2002/isra-d03.shtml

Israel: An attempt to resuscitate the Labour Party
December 9, 2002
http://www.wsws.org/articles/2002/dec2002/mitz-d09.shtml

Israel targets civilians and UN personnel with impunity
December 12, 2002
http://www.wsws.org/articles/2002/dec2002/isra-d12.shtml

Bibliography on the Middle East and International Law

During the past two decades, I have written many publications dealing with Palestine, Palestinians, and International Law. For obvious reasons, I do not have the space to reprint them all here. But in order to facilitate research into these heavily censored subjects as well as on others which have been suppressed outright, I have included an incomplete *Bibliography* on these and some of my other writings on the Middle East and International Law in general. These other topics include, inter alia, Iran, Iraq, Lebanon, Libya, Syria, and "terrorism" in the Middle East. For reasons that should be clear, it is almost impossible for works to be published on these subjects in the United States of America. It has been a real struggle simply to get these meager offerings into print.

It can be fairly said, in a nutshell, that U.S. Mideast foreign policy has not shown one iota of respect for international law. Of course the same can be said for American imperial policy elsewhere around the world. But in order to substantiate that latter proposition, the reader will have to consult, inter alia, the rest of my opera that are not listed here.

World Politics and International Law (Duke University Press: 1985; 2d prtg. 1987; 3d prtg. 1995).

The Future of International Law and American Foreign Policy (Transnational Publishers: 1989). The Islamic World Studies Center in Malta published an Arabic language edition in 1993.

International Law in Time of Crisis, 75 Nw. U.L. Rev. 769 (1980), *republished in* 2 Nat'l. L. Rev. Rep. 537 (1981).

International Law as a Basis for Conducting American Foreign Policy, 8 Yale J. World Pub. Ord. 103 (1981), *republished as* U.S. Department of Defense, Current News: Special Edition, No. 979 (Mar. 23, 1983). *See also* 75 Am. Soc'y Int'l L. Proc. 270 (1981).

The Entebbe Hostages Crisis, 29 Nether. Int'l L. Rev. 32 (1982); 22 Indian J. Int'l L. 199 (1982); *and in Terrorism, Political Violence and World Order* 559 (H. Han ed. 1984; 2d rev. ed. 1993).

International Law and Organizations as an Approach to Conflict Resolution in the Middle East, in *Contemporary Issues in International Law: Essays in Honor of Louis B. Sohn* 515 (T. Buergenthal ed. 1984). *See also* Middle East International, Sept. 3, 1982, at 11; 4 Arab Stud. Q. 336 (1982); *Terrorism, Political Violence and World Order* 511 (H. Han ed. 1984); 77 Am. Soc'y Int'l L. Proc. 223 (1983); 79 Am. Soc'y Int'l L. Proc. 217 (1985); Mideast Monitor, July, 1985.

Conclusions and Judgment of Brussels Tribunal, N.Y. Times, Oct. 7, 1984, at 77; *and in* IPO, *The Reagan Administration's Foreign Policy* 459 (H. Kochler ed. 1985).

The Iranian Hostages Crisis, 63 Revue De Droit International 1 (Geneva: 1985).

Preserving the Rule of Law in the War Against International Terrorism, 8 Whittier L. Rev. 735 (1986).

Military Responses to Terrorism, 81 Am. Soc'y Int'l L. Proc. 288 (1987).

The Geneva Declaration on Terrorism, Am. Branch, Int'l L. Ass., Int'l Prac. Notebook, July 1987.

International Crisis and Neutrality: U.S. Foreign Policy Toward the Iraq-Iran War, in *Neutrality: Changing Concepts and Practices* 59 (A. Leonhard ed. 1988); *and in* 43 Mercer L. Rev. 523 (1992).

Create the State of Palestine!, American-Arab Affairs, No. 25, at 86 (Summer 1988); 7 Scandinavian J. Development Alternatives, No. 2 & 3, at 25 (June-Sept. 1988); 4 Palestine Y.B. Int'l L. 15 (1987-88).

Memoranda of Law on the U.S.-Israel Land-Lease and Purchase Agreement of 1989 (Ex. Comm. 89-57), American-Arab Affairs, No. 30, at 125 (Fall 1989).

Memorandum on the Yaron Case, 5 Palestine Y.B. Int'l L. 254, 257 (1989).

The Creation of the State of Palestine, 1 European J. Int'l L. 301 (1990); *and in* 1991 Australian Int'l L. News 46. *See also International Law and Solutions to the Arab-Israeli Conflict*, 83 Am. Soc'y Int'l L. Proc. 122 (1989); 84 Am. J. Int'l L. 879 (1990); *Soviet Immigration to Palestine Violates International Law*, 7 Mideast Monitor, No. 2, (Summer 1990); *George Bush on Jerusalem*, American-Arab Affairs, No. 32, at 121 (Spring 1990).

Memorandum of Law on the Dispute Between Libya and the United States and the United Kingdom over the Lockerbie Bombing Allegations, in Nord-Sud XXI, No. 1, at 55 (Geneva: 1992).

United States War Crimes During the Persian Gulf War, in Nord-Sud XXI, No. 1, at 97 (Geneva: 1992).

The Definitional Context of the Iranian Hostages Crisis, 6 Journal of Foreign Policy, Nos. 2 & 3 (1992), Institute for Political and International Studies (IPIS), Tehran, Iran (Farsi translation of Chapters 13 & 14 of *World Politics and International Law*).

The International Legal Right of the Palestinian People to Self-Determination and an Independent State of Their Own, 12 Scandinavian J. Development Alternatives, No. 2 & 3, at 29 (June-Sept. 1993*). See also Transcript of a Mock Arbitration of Israeli-Palestinian Disputes Before the American Bar Association Annual Meeting in Chicago (Aug. 7, 1990)*, in 6 A.B.A. International Litigation Quarterly, No. 4, at 101, 112 (Dec. 1990); *and in* 2 Arbitration Materials 5 (Dec. 1990).

Palestine: Sue Israel for Genocide before the International Court of Justice!, 20 J. Muslim Min. Aff., No. 1, at 161-66 (2000).

The Interim Agreement and International Law, 22 Arab Studies Quarterly, No. 3, at 1-44 (Summer 2000).

Petition on Behalf of the Children of Iraq Submitted to the United Nations,23 Arab Studies Quarterly, No. 4, at 137 (Fall 2001).

Law & Disorder in the Middle East, The Link, Vol. 35, No. 1 (Jan.-Mar. 2002).

Humanitarian Intervention under International Law, 1 Rev. Int'l Aff., No. 4, at 45-56 (London: Summer 2002).

See also AAUG Newsletter, Jan.-Feb.-Mar. 1985 (Sharon); PHRC Newsletter, Jan.-Mar. 1987 (L.A. 8 case), Oct.-Nov. 1987 (PLO); Palestine Perspectives, Mar./Apr. 1988, at 4 (Landau Report); Am. Branch, Int'l L. Ass., Int'l Prac. Notebook, Dec. 1986 (Libya); 11 COPRED Peace Chron., No. 5 (1986) (George Ball).

Index

Homunculus Saga

Blacl

Homunculus Saga

Table of Dimensions

Dedication

The Journey to Black Shonen was one that took five years and if it wasn't for the team who helped me create this book and tell the stories that go in my head it would have taken a lot longer. First, my mother, Bridget Harris, who was a constant inspiration these five years. Next is my Best friend, Bro, and character designer Kweli Wilson, and his beautiful fiancé who is the cover designer Jasmine Zecchini. Their Instagrams are Kweli Wilson and Frolynn Almighty, check them out for some good art and they do commissions! My Editor, Marketer, good friend, and business partner Peter Angelo is another person who has helped me reach my dreams by leap and bounds and last but not least our newest recruit for Team Shonen is Wendy Louise Nog, who created the beautiful website www.blackshonen.com. Well, now that all that important stuff is out the way, read the book, meet some good and cool characters, and escape into the Zeroverse!

The Realm of Treasure

Prologue:

The Waste Bar on Planet Kaka was known for its dangerous residents. The planet was filled with criminals such as thieves, rapists, murderers, and many forms of villainy. To most sane space travelers this was a planet that wasn't even marked on their map, because it was far too hazardous. However, to the more adventurous half, the intergalactic bar served as a hub for adventurers and fortune.

Today, the bar had a silence running through it. The various aliens that inhabited the place kept to themselves as they sipped or snorted their spirits, lost in their thoughts of debauchery. The lost criminals didn't expect the bar's double ebony doors to bash open, revealing a human walking into the land of the wicked. The milk chocolate woman went by the name Juliet Valentine, and she had made a name for herself in the darkest of regions. The various species all turned their queer faces to the human girl, their many eyes scanned her brown skin and long curly jet black hair, their odd noses took in the scent of battle, sweat, and grime coming from her skintight yet strong black armor, they turned their misshaped heads as Juliet's intense blonde eyes looked them over. Some even left the bar as her tattered black cloak floated by their table. Fortunately, for the criminals, Juliet wanted nothing to do with them. She had a far more profitable venture in mind.

Juliet made her way to the bartender, "Gimme Space Poison on the rocks!"

The Bartender's five crimson eyes peered down at the battle tested girl, and the alien almost jumped at seeing a human this deep in the unknown. "Space Poison?" the bartender scratched his moist head, "You think you can handle that?"

Juliet's golden eyes looked up at the moist, blubbery, multi-eyed bartender, and she gave one of her beautiful sneers, as her right hand reached behind her shawl. The bartender watched the hand, noticing the pommel of a large blade, just hidden behind her dark cloak.

"Ok, Ok." The bartender didn't want to test the human. This was the first one he had seen up close in his life, and he heard from his ancestors that even though they look weak some of them are very strong in mind and body.

Juliet rested her hands on the counter, "Make it quick." The girl coughed up a lugie, and spat it on the floor, "I got shit to do."

The bartender almost feeling silly to be scared of such a small creature began to rush making her drink, "What brings a human here? Why do you have my customers scared to suck on their mom's tits?"

Juliet gave a ghastly smile, as the alien bartender set down her fizzy purple drink, "I've been around." The girl raised her filthy mug and let half of the drink slide down her throat, as she made loud sucking noises, "Ahhh, hit the spot. So, they told me you might be able to tell me some important information for my next venture?"

The bartender eye's filled with suspicion, "A human venturing to the Mutated Planet. A fool's journey, I hardly got out myself."

"You old alien bums ain't got nothing on us new generation." Juliet retorted, "I already got a plan to infiltrate that planet and get the fortune." Juliet took another swig of her purple spirits, "I got a team. I know a few other crazy bastards that decided to leave Terra Firma and venture into the darkness."

The bartender grabbed his oversized stomach and let out a hearty laugh, "Looks like stupidity is common in all species."

Juliet licked the remnants of her drink from her plush lips, "Give me the coordinates to the planet so I can put it in my mech and get the fuck outta here."

"And what if I don't foolish human?"

Juliet pulled out several rusted coins and put them on the table, "Looks like I'll have to kill the answer out of you." The young girl grabbed her blade with her right hand and had the weapon to the alien's neck before he could think. "Tell me the coordinates, or I'll decorate this room with your multicolored blood." Juliet's eyes glanced around the room, "I'm sure some of the customers here wouldn't mind."

The bartender weighed his options. How could a human be this strong? This confident? Humans, they were a race of chaos. "It's 3.332, 5.444, 7.9999, 8.33333, in the Vile Placid Sector.

Juliet smiled, and just for a second the alien could see a radiance of beauty emit from the young girl, but her negative aura quickly cloaked it, "Great doing business." Juliet sheathed her blade on her back, "If you gave me the wrong coordinates, I'm killing you and everyone in this bar." The young woman's eyes tapped into the alien's fears, and the bartender could feel coldness travel down his many

spines. Juliet gave one last devilish of a smile and headed for the doorway.

The aliens who had been peeping on the conversation quickly turned their heads down as Juliet passed, pretending to continue paying attention to their drinks.

When Juliet reached the door, she turned around back to the alien drunkards, "Just to grind it in that disgusting obese head of yours, if you lie my beloved bartender, I will kill you and everyone here. Don't think I can't find you." With another turn the girl kicked open the doors and left the bar.

Chapter 1: Meet the Bastards

Isaiah the Space Mercenary pushed through the smooth blue doors of Club Shallow. The smoke in the air smelled like strawberries, aliens of all species were happily grinding on one another, lost in some false sense of bliss, the DJ had irritating music playing, as his six hands repeatedly scratched discs and everyone seemed to be having a real good time. Isaiah saw it as lustful fools wasting space.

"Look at'em, Chaos." The Space Mercenary said to his partner, "Grinding, lost in the pseudo world of drugs and sprits. Why did she have to pick this abysmal building?"

Isaiah's partner was robot formed in female shape. The robot had brown skin like her master, The robot's moon colored hair was short and trimmed into a stylish bob cut, the upper half of her body was covered in light silver armor, and the lower half was covered in fitted black baggy pants and black combat boots.

Chaos processed her master's question, "Juliet seems to be prone to highly sexual habitats. Master."

"Of course." Isaiah said, rolling his eyes.

Chaos pointed at a solo black round table, "I think that's the designated spot she wanted to meet us." Chaos ran the coordinates in her head again, "Correction....Master that is the spot."

Isaiah nodded and the two headed to the round table ahead. When they went to sit down, Isaiah noticed the couch was in a sphere form.

"I guess we're not the only ones to join this farce." Isaiah said, as he and Chaos sat down, "That warlord title must have really gotten to that woman's

ego, if she thinks we can pull this mission off."
Isaiah had traveled with Juliet on missions countless
times in his life. It wasn't because he liked her looks,
but because she was a good damn warrior. She had
saved his life multiple times and vice versa. Isaiah
told himself he was paying a debt, but by Chaos's
calculations the robot knew it was deeper than that.

　　　　"She would pick such an immoral place."
Said, Shiro Mitsurugi.
　　　　"Everything's Immoral to you," said Asuka
Nakamura, "We're in space, let loose."
　　　　Shiro sighed, "Asuka, were heading for the
table."
　　　　"Aww, Shiro your such a buzz kill"
　　　　The two walked into the crowd of drunken
dancing aliens, finding a black table and familiar
faces.
　　　　"It's that damn merc." Shiro said, observing
Isaiah, "Does he really need to be here?"
　　　　"Stop pretending to be upset." Teased Asuka,
"You know he's your best friend in the whole damn
galaxy."
　　　　Shiro rolled his eyes, "Yes, me, friends with
the guy who built a robot based on a girl who teased
and tortured him through high school."
　　　　"And you're the lonely samurai who
everyone is scared of." Asuka added.
　　　　Shiro ignored Asuka, and made his way to
Isaiah, "Looks like you and the sexbot aren't
enough."
　　　　Chaos immediately jumped on the table, a
white foot long blade came from out her right
forearm, and she pointed it at the neck of Shiro,
"Sexbot is a trigger word…Correct Master?"

Shiro already had his left hand on the handle of his katana. He would be damned if something that wasn't even alive could kill him in battle.

Isaiah waved his right hand, "We'll let it pass."

The white blade retracted back into Chaos's arm, and the robot returned to its seat as if nothing ever conspired.

"I could have destroyed your toy doll." Shiro stated, "Why don't you be a man and come fight me yourself, Mad Inventor?"

Isaiah quickly grabbed his dual plasma pistols from their holsters and pointed them straight at Shiro, "Let's see how fast you are Mitsurugi!"

"It's cute." Asuka smiled to the boys.

"What's cute?!" Isaiah and Shiro questioned.

"Your bromance." Asuka answered.

Isaiah and Shiro exchanged glances and sheathed their weapons.

"Asuka you're a thorn in my brain." Shiro said, taking a seat, "Can you get the waiter, so we can eat?"

"I hope this rock we're on has decent food." Said Isaiah to Chaos, "I already have to deal with shitty service."

"What was that?" Shiro overheard.

Ultra Girl a.k.a Caroline White was ecstatic to enter the confines of Club Shallow. This was the eighteen-year-old's first time outside of her own Galaxy. She didn't know what to expect or what beings to see. She was excited to be invited by the one and only Juliet Valentine, a role model in the world of heroines. Caroline could only aspire to

reach such heights as her idol. The dazzling lights of the club were the first thing that caught her eye, the people were of all shapes, sizes, skin colors, eyes, mouths, and everything you could see, there was a smell similar to strawberries stuck to the air, a wave of tension and sexuality emitted from people's vibrations, and Caroline wanted to be part of it all.

However, the young red-haired heroine knew she had more serious business to attend to. Caroline quickly scanned over the residents inside the building; it only took her half a second to find the correct table. She knew it was the one with the black round table and matching couch. There already seemed to be a good amount of people over there. How would she introduce herself? What would she say? The closer she got to the table, the more she could feel sweat perspire out her body, her fingers twitched, and her thoughts became muddled.

"Hey, I'm Caroline…. Oops," the super-heroine quickly covered her mouth, the nervousness was getting to her, "I mean…oh…. Ultra Girl! Protector of Planet Terra Firma."

Isaiah looked up at the girl, "Are you the waiter for our food?"

"No..Uh…" Now Caroline was really embarrassed, "I'm here for the mission."

"Another girl!" Asuka screamed, "Yes!"

With Asuka's excitement Caroline began to feel a little better, "Yes, I'm here to help with the Mutated Planet Expedition."

"So it's an expedition now?" Shiro said, sarcastically.

Caroline's confidence began to wane, "Well, That's how Juliet explained it."

"Cause it is an expedition you bitches and bastards!" The group knew whom the voiced belong to before even seeing her voice, no one's vocabulary could be more vulgar than Juliet Valentine, "Now, that I'm here let's go over the perks attached to this fucked up mission!"

Chapter 2: Juliet's Party

Juliet Valentine, The Warlord of Space walked into the confines of Club Shallow. The Warlord was immediately hit with a heavy smell of strawberries and sexual musk. It took her eyes a second to adjust to the multicolored lights, that danced around her. As she walked to her a favorite table, a female alien passed her by. The alien had smooth orange skin, long purple hair, giant baby green eyes, and a body that held more curves than any earth woman. Juliet gave a confident smile, the alien smiled back.

When Juliet made it closer to the table, she began to see the comrades she had ordered. The first person her eyes saw was one of her most trusted companions, she saw the form of a Mad Inventor. Isaiah was a young man, with long black hair braided into a ponytail, Kevlar armor protected his chest, and lastly he wore fitted black baggy pants and black combat boots. Next to the Mad Inventor was one of his greatest creations, an assistant fighter named Chaos. Chaos was Isaiah's right hand and always had his back in a pinch, even though to most she just seemed like a low-tech android.

The next group of comrades-in-arms Juliet spotted was Shiro Mitsurugi and Asuka Nakamura. Shiro Mitsurugi was known on Terra Firma and to aliens alike as The Hunter. Shiro's job, passed on from his ancestors was to guard Terra Firma against any extraterrestrial threat. Asuka Nakumara was to serve as a helper to Shiro, much like Isaiah and Chaos. Shiro and Asuka were dressed in similar outfits that resembled police uniforms from the Mejia era of Japan. Juliet always noticed

Shiro's face looked upset, his short black hair contoured to his head, and his eyes always seemed like they were in deep concentration. However, Asuka was completely the opposite. Asuka had long brunette hair spilling from her police cap, always with a smile planted on her face, and to Juliet's admiration, Asuka always wore a black schoolgirl skirt that showed off her shapely legs and thighs.

Last, was the newest in Juliet's talent roster, the up and coming super heroine Ultra Girl. Juliet had ran into her on Terra Firma about several months ago, and The Warlord could automatically tell the naïve heroine was smitten. Juliet used that leverage to add the eighteen-year-old to the intergalactic adventure. The young red headed hero had shoulder length hair, big blue eyes, and freckles decorated her fair skin. The young woman's urban outfit consisted of a black shirt with a capital U on the chest, a short black cape, blue acid stained jeans, and worn low top black shoes. Juliet did find the young hero attractive, but The Warlord didn't know how she felt about Celebrity Heroes.

"I'm glad all you fools could make it." Juliet said to her team, "Are you guys ready to be the richest motherfucker's in the galaxy?"

"Ol' great warlord." Isaiah sarcastically responded, "But we don't know if we even have a chance of surviving?"

"Last I heard," Shiro intervened, "the most recent group who went to the Mutated Planet recorded their adventure for everyone to see. They claimed they were going to find the Royal Treasure of the War." Shiro made a smirk, "After the ninth day a flash of some creature came upon the screen, then it went black. No one's

heard anything from the group. It's obvious what happened."

"What happened?" Caroline said, enthralled with the story.

"Isn't it obvious?" Isaiah hissed, "They died."

"No!" Caroline gasped, putting her hands on her mouth.

"You can't be serious?" Isaiah said, highly stupefied, "What do you think happened?"

"Hey, lay off." Asuka giggled, "Don't scare the newbie away."

"Don't worry." Juliet reassured Ultra Girl, "No one's going to die."

Caroline obediently nodded.

"She hopes." Isaiah whispered.

"I just want to know," Shiro said, "What makes you think we have a chance on The Mutated Planet? Asuka, Ultra Girl, and I are newbies to space. Wouldn't we just be holding you and the mercenary back?"

Juliet smiled and shook her head, "No we need fresh meat. Adventurers untouched by the wonders of space. You aren't jaded like me and Isaiah, your coming into this adventure new and full of excitement. The reason people keep dying," Juliet jumped onto the table, "is because they go to the planet expecting to die. So many stories and lies flying around that sickening orb. No, we, the newest adventurers, we'll get the treasure and make the galaxy our bitch."

If Juliet knew anything, it was how to raise morale. The group couldn't help but let a twinge of a smile from their mouths, as they thought about the riches and what it could bring them.

"Um, Excuse me." Juliet turned around to see a tentacled waitress, balancing several dishes on her suction cups, "The food is ready."

The Warlord smiled, "Let's eat and party our asses off. Twenty four Terra hours from now we're setting off," Juliet pointed to the ceiling, where lights forming stars and moons danced on the wall, "To the Mutated Planet!"

Chapter 3: Journey to The Mutated Planet

26 Terra Hours later…….

"I knew that wild woman wouldn't keep her word." Shiro said, with a roll of his eyes.

"Do you think she's hurt?" Caroline asked, "Maybe we should go look for her?"

"That would be easy if we knew which room she stayed in." Asuka said, with her hands behind her head," This Club Shallow has so many bedrooms, I doubt we could find her within a day."

"Juliet wouldn't let money pass her by." Isaiah stated, "She might not be the best about proficiency, but trust me, she will show."

"Hmmmm, will she show, Inventor?" Shiro questioned, "She's probably drunk somewhere between a whore's legs!"

Isaiah's pistol was in his right hand before he even realized he had taken action, "I would restrain you from talking about The Warlord."

A white blade shot out from each of Chaos's forearms.

"Did I touch a nerve, Inventor?" Shiro smiled, "I'd say you have a crush on the wench."

Isaiah pulled down the hammer and his index finger hovered above the trigger, "Do you want to test me Hunter?"

"There she is!" Caroline nearly screamed.

"Uuuuh, why did I drink and smoke so much?" Juliet mumbled to herself, "Heh, at least I got a taste of that orange waitress."

"Juliet!" Said Caroline, flying up to The Warlord, "Are you Okay? Are you hurt?"

The Super Heroine's high pitch voice cause Juliet to hold her head, wishing someone shut the girl up, "I'm fine. Let's just head to the ship, eh, doll face."

Caroline blushed, and quickly turned around, "As long as you're okay."

She's cute, Juliet thought.

The Warlord struggled through the tube pathway and into the space station, where the rest of her crew was waiting for her. Juliet could tell by the two boys enraged faces they were just in an altercation.

"You two fighting again?" Juliet said, "Why don't you two fuckers kill each other already?"

"That Hunter is nothing but talk." Isaiah said, crossing his arms, "Plus, I'm a mercenary, he wouldn't put up a good bounty anyway."

"No one's hunting for a two bit Inventor." Shiro stated.

The two young men exchanged glances with seething eyes.

Juliet's head vibrated with pain, "I can't deal with your two's shit. Let's saddle up and get this fucking money."

"You guys are truly silly." Asuka teased the boys, "Ultra Girly, let's promise not to be all dumb and testosteroney."

Caroline nervously nodded, "Okay."

To a traveler of the great darkness their spaceship is everything. A spaceship represents a person's spirit, pride, image, and heart. Most space pirates base the perceived strength of a crew by their vessel alone. Each member of Juliet's team had their

own ship, equipped to do battle with anyone and anything lying out in the sea of blackness and stars.

Isaiah's space ship was a Fighter DX Delta. To the average person of Terra Firma, it look like a giant black jet with four wings; Two of the wings were positioned pointing upwards, two were positioned downwards under the craft, and with a cannon attached to each wing. Isaiah, Chaos, and Ultra Girl would occupy the ship, named Pain.

Shiro and Asuka's ship took the form of a giant black ball, with thrusters all around it to guide its direction. It was named The Seeker. Juliet's mech, however, was the most spectacluar of all. The giant robot reached sixty feet in height, it was created from the strongest metals within Terra Firma. The robot was fairly worn with scratches decorating its black metallic armor, a dark cloak was wrapped around its body, hiding it's gigantic jagged blade. The mech went by the name Romeo.

Juliet rose her right gauntlet and spoke, "O, Romeo, Romeo! Wherefore are thou Romeo? Deny they father and refuse they name; or, it thou will not, be but sworn my love, and I'll no longer be a Capulet."

The mech answered The Warlord's call, with the loud moaning of rusted steel and screws opening its chest cavity, and releasing a rope ladder. Juliet climbed upwards into the cockpit, which took the form of a comfy leather chair, a joystick on each chair arm, and a lever for each foot. She quickly sat down and let out a deep sigh. It was good to be back in the seat of her robot, one of the last things to connect her to her late father. Juliet quickly reached in the back of her chair, pulled out two migraine pills, swallowed them, then pushed a button on each

joystick. A holographic screen appeared, showing Juliet the outside world of the space station. The girl pushed the buttons again and a screen appeared on the left and right sides of the main screen, showing her comrades.

"Are you finally ready?" Isaiah asked, his face sketched with irritation as Caroline kept trying to nudge herself into the screen.

"Hey, Juliet!" Caroline smiled, "These spaceships are really amazing, I've never been in one before."

"Please refrain from getting closer than twenty feet to me!" Isaiah snarled at Caroline.

Caroline's face sagged, becoming that of a saddened puppy.

"Be nice." Hacked Juliet.

Isaiah sighed, "Ms. Hero is going in that mech of yours on the way home."

"Are we ready to shove off?" Shiro questioned, "Or are we waiting another two hours before launch?"

"Shut the fuck up!" Juliet snapped, "The mission starts when the Top Bitch is ready!"

"Yeah." Asuka repeated, "When the Top Bitch is ready."

How I wish I could throw you in a black hole Asuka. Shiro thought.

Asuka flipped several buttons on the mainframe controls of the ship, "Starting thrusters."

"Starting thrusters." Isaiah repeated.

"Starting the thrusters and Auto Pilot, I'm taking a nap." Juliet reported.

One after the other, energy in the form of red fire began to pour from out the two spaceships and from under the mech's cloak. The

roof of the space station rapidly opened, letting the vehicles enter into the abyss of the galaxy to start their mission for riches and reputation.

Chapter 4: Rough Landing!

Juliet Valentine was thirteen again, trapped in her uncle's house. The room she occupied was damp and filled with mold. The covers smelled of must, and her windows were painted with grime. The only piece of clothing she owned was a ratty dress, that she used to wipe her tears. The young teen glanced at the giant robot outside of her bedroom. The robot her uncle tried to break into it day after day, to gain it's immense power, but to no avail. The young girl through her darkest moments liked to look upon the robot, imagining it as her savior. It was the only real connection to her late father, and her only reminder to keep on living.

Juliet crept to her window, where the giant hand of the machine was only an arm length away. She reached out and touched it, feeling its cool broken metal. The touch reassured her she could live another day, it assured her everything be alright, and there would be freedom from the tyranny of her uncle. A thunderbolt crashed into the ground, causing Juliet to look toward the dark distance. The glowing silhouette of a giant monstrosity could be seen, standing on all fours, with tentacles waving on its back. Juliet screamed.

<p style="text-align:center">***</p>

Juliet awoke to blazing red alarms. The young woman's main screen was filled with blue clouds and purple lightning, on her right screen Isaiah was screaming hysterical blabber, and on the left Shiro was pretty much doing the same.

"Shut up! You bitches!" Juliet screamed, "I need to focus!"

"You need to lower your thrusters." The Mad Inventor protested. "Before you crash the mech straight into the ground!"

"Leave it to the drunkard to almost kill herself." Shiro added.

Juliet grabbed the joysticks, settled her feet on her pedals, and smoothly pushed each forward. The disruptive speed of swirling blue clouds and dashes of violet lightning stabilized into a form of normalcy. The sixty-foot robotic knight calmly landed on the sickening blue dirt of the Mutated Planet, between Pain and The Seeker.

"We're here!" Juliet announced, jumping from her rope ladder, "I can already see the asses of all the strippers my money will be going to."

Isaiah scanned the area as he stepped off his ship. The ground was a mixture of black and blue, most likely cause by the mutation from several nuclear wars ago. They had landed in front of a forest, with the entrance in the form of bent trees, which looked dead, but had blue glowing veins. The sky took the form of dark blue with purple strikes of lightning, followed by the booming of thunder.

"This place looks tragic." Caroline said.

"I hope you know what you're doing, Warlord?" Shiro questioned, looking over the pathetic planet, "This sure would be an unpleasant place to die."

"Chaos scan for life forms." Isaiah demanded, "We don't need anything getting the drop on us."

"No trace of dangerous life forms." Chaos stated.

"You heard the robot!" Juliet screamed, "Let's get rich!"

Chapter 5: Powerless

When Isaiah nearly brushed the age of becoming a teenager his mother died. The young man's father became a drunkard soon after, causing Isaiah to depend on himself. High school didn't fare well for the young inventor, whom was obsessed with robots. The other kids thought his hobby weird and taunted him. In the beginning, Isaiah thought nothing of his bullies, thinking of them as inferior. However, as time passed, and Isaiah's harassers saw the young man ill affected, they decided to one-up their horseplay. One day, the young Isaiah decided to stay after class and work on his newest robotic project, in the middle of his work several kids came in the room. They immediately attacked the young inventor, destroying his project of three months and threw him in the school's garbage bin.

The evening Isaiah took the plunge from the bridge. The day he hit the salty waves of the ocean only for a second, only to be abducted by the ancient aliens known as The Greys. The young inventor was broken down, manipulated, and molded to fit the Grey's image of a mercenary. Within the next month the entire galaxy knew the name of Isaiah The Mad Inventor.

"Isaiah, Isaiah!" Juliet snarled, "Did you tell the robot to check for life forms!"

Isaiah broke from the daydreams of his past, "Sorry, Warlord. Chaos check for nearby life forms."

"Are we getting lost in thought, Inventor?" Shiro teased, "Is being close to The Warlord too much?"

Isaiah waved Shiro away, "Focus on the mission."

"No life forms master."

"Ahhhhh, I'm getting a little bored." Asuka whined, "I wish there were life forms."

"So is all the life on this planet mutated?" Caroline asked.

"Pretty much." Isaiah answered, "From my research all the life here has been drastically changed from the war in one way or the other."

"Yeah," Juliet chimed in, "The castle were heading to is supposed to have all types of fucked up creatures inside."

"Really?" Caroline asked, feeling fear creep within her.

"What are you worried for?" Isaiah said, "You have every fighting ability in the book."

"Fuck?" Juliet held her fist in the air, signaling her group to stop, "Shit, something's coming."

A yellow light began to shine in the near distance.

"Chaos, I thought you said there were no life forms." Isaiah whispered.

"Mas…." Chaos sounded hesitant, "The Creature must have been able to hide its life signature." The robot released the blades from her forearms, "I'll take care of the threat."

Chapter 6: First Blood

Drops of sweat slid down Isaiah's face, his hands lightly shook, and his anxiety grew as he turned the knobs. A sigh left the Mad Inventor's mouth as he connected the last of the wires. He quickly closed the area he was working on and backed away as the robot awakened. It was like seeing a baby experience the world for the first time. The moon hair robot slowly raised its body, its eyes scanned the laboratory it was created in, and a white blade shot out from its forearms.

Isaiah felt a tinge of excitement arise within, "Those are your main weapons."

The robot nodded.

"Your name is Chaos."

The robot took a glance at the mirror, across from where she sat. The android quickly found out it's skin was a chocolate brown, black stiches laid scattered on its body, and it's eyes held only empty darkness, "Yes, I am Chaos."

Chaos spun, slicing through three, slimy, gray, electric filled tentacles. A fourth tentacle attached to the robot's forehead. Chaos immediately began to convulse with electricity, shutting down her systems. The space creature had no time to celebrate its victory as bullets of plasma collided into its leathery skin. The monster let out a cry that sounded like the voice of a dying woman, and swooped down toward Isaiah. The Inventor jumped to the left, firing his plasma pistols. When the creature passed by, The Inventor was able to get a good look at his

opponent. The upper half of the creature looked almost human, its skin was gray and leathery, the beast had no eyes, its mouth was filled with black rotten fangs, and eighteen tentacles filled with paralyzing electricity flowed under its body. The nightmare looking creature dove for Isaiah again, but it was crushed under the metal of Juliet's mighty blade.

"How do you like my sword taking a bite out of your ass!" Juliet roared, as she yanked her jagged sword from the creature's back, "Maybe you need another bite." Juliet rose her large blade above her head and with both hands swung it down on the back of the creature once again, causing blue blood to splatter onto her face, "Bitch ass Alien!"

Caroline eyes widened, as she noticed a tentacle rise behind Juliet.

Before Caroline could yell her name, Juliet felt a tentacle attach to her neck.

The Warlord rolled her eyes, and said, "Got dammit."

Juliet felt the sensation of fire being injected into her veins. The scream that came out was not one of a vicious warlord that people had learn to fear, but one of a woman on the edge of adulthood scared and in pain. When the shock was over Juliet eyes drooped, her sword fell from out her hand, and she fell face first into the dirt.

The monster, badly injured, but still able to fight, took to the skies with a flap of its limbs. Shiro met the monster with an effortless jump, cutting into the monster's abdomen with one fluid strike. Navy blue blood spilled into Shiro's hair. The monster let out another scream and tumbled onto the ground. Shiro landed on his legs as softly as

a cat and sprinted towards the monster for the final kill. The remaining tentacles shot out towards Shiro like whips, but with a swish of his sword, Shiro cut each appendage down. When he rapidly made it to the body, he aimed for the chest, but the creature grabbed Shiro's blade with great accuracy. Shiro watched as golden bolts materialized from the hands of the creature, danced on his sword, and shot into his body, sending him vaulting into the ground.

A punch to the face sent the creature sprawling. Caroline followed her first attack with an uppercut, sending the creature tumbling into the air, she followed up with a right knee, bashing the monster back into the ground. When the monster tried to raise itself back into the air, Asuka Nakamura held it down with her Cat String, which emitted from the gloves of her outfit. With one hard tug, Asuka caused the monster to crash back into the ground.

"I got it Ultra!" Asuka screamed, "Do your superhero thing!"

Caroline took a deep breath and let out a freezing gust of wind. The wind spiraled and focused onto the creature, freezing it solid.

"Is Juliet alright?" Caroline said, swooping down to her idol.

"She has survived worse." Isaiah said, inspecting Chaos.

Caroline quickly put her ear to Juliet's chest, "Good, she's still breathing."

"Looks like The Warlord couldn't handle the challenge." Shiro stated.

"Could you say that to her face?" Isaiah questioned.

Shiro frowned, "I'll remind The Warlord of her recent fall."

"Gosh, you two love to bicker." Caroline said.

Isaiah and Shiro turned to Ultra Girl, "Shut Up!"

"Why? It's the truth?" Asuka said, "Two meteors in an asteroid belt."

"Doesn't even make sense." Shiro muttered.

"We should probably get out of here." Isaiah said, holding Chaos in his arms like a lover, "We don't know how much time we have before that thing breaks free."

Caroline gave one of her naïve smiles, "Oh my ice breath is super thick nothing can break through it."

The rock of ice that held the creature shattered into cold mist. The nightmarish creature, with its rotten teeth, and long black claws rose into the air, with a shrill scream. Its tentacles, completely restored, it lashed out at the group. The creature caught Shiro and Asuka off guard, paralyzing their bodies. Isaiah blasted the three tentacles that came for himself and Juliet. Meanwhile Caroline released tunnels of fire from her eyes, burning four appendages to a crisp.

The monster rose, taking Juliet, Shiro, and Asuka with it, wrapped in its tentacles. The creature held out his hands to the remainder of the team, focusing a ball of golden lightning in the center.

Isaiah held his left gun toward the creature, a smile creeping on his face, "Do you dare to face The Mad Inventor?"

Caroline braced herself to take off and tackle the creature. The monster smiled a hideous smile and the blast of lightning left its hands aimed for Isaiah and Caroline.

Chapter 7: Escape

Shiro Mitsurugi bowed onto his knees and looked up at his Grandfather. The elderly man was lean, yet filled with muscle, he had a gray beard, and long flowing gray hair. He sat crossed legged, in a white robe, printed with Japanese symbols. The man's eyes seem like they were closed, but Shiro knew his grandfather used other avenues for his senses.

The elderly man took in the sweet smell of the temple and spoke, "Shiro, you have surpassed me." The old mentor lightly massaged his neck with his left hand, "I remember being your age and being taught the ancient practices. I remember being told of how our planet was surrounded by beings from afar, at first I was scared, but you were different Shiro." The old man sat and thought for a moment, "You didn't fear this new information. Shiro, you embraced it. You let it stir the innards of your soul." At the old man's lap was a katana wrapped in a black sheath, imprinted with a golden dragon. The man put his hand over the katana, "This weapon has been part of the Mitsurugi family for ages." Shiro's Grandfather began to shed a tear, "With your inept father, I thought our bloodline was done, but you were born. Born to save the Mitsurugi bloodline and continue to protect Terra Firma from outside forces."

When Shiro returned to the waking world, his entire body felt heavy. The young Samurai tried to move, but he was stuck to something. He slowly looked around, noticing rotting walls, a sour smell, and the floor was crumbling apart, covered in centuries of dust. Shiro looked up, realizing what

was keeping him secure. The appendage beast known by the planet as a Light-Walker, had trapped Juliet, Asuka, and himself in a large black spider-web. Shiro struggled again, only to feel useless. The young Samurai quickly glanced around for the creature that had trapped them. It was nowhere to be seen. The young man began to pace his breathing. Shiro let all external forces disappear from his mind, as he concentrated on his internal forces. With a tug and a yell, Shiro broke from his sticky shackles and fell onto the ground, with a soft thud from his shoes.

Shiro felt like he had been trapped in the web for hours and rolled his neck and arms, as he glanced over the nearby ruins. The building obviously resembled a cathedral with its high walls, cement floors, and pillars. When Shiro turned to the windows, he saw the bluish gray sky and its purple thunderbolts crashing upon the land. He turned to the giant spider web and swiftly released his blade.

"The Inventor will be highly upset once he finds out I saved his woman." Shiro gloated.

It would give the samurai much pleasure to see Isaiah's small angry face. Shiro bent his knees, ready to jump and destroy the web in several slices, then he heard a noise. It sounded like hard footsteps coming toward him. Shiro swiftly spun around, facing the desecrated entryway.

When the creature hit the queer gray moonlight, Shiro legs became slightly weak. The bipedal creature had creamy skin, covered in bulging muscles, and red veins. The head of the monstrosity was only a large yellow eye, accompanied with a fanged mouth, filled with

saliva. The right arm of the creature was a large thick steel blade. When the creature walked it was slightly sideways, as if its center of gravity was off.

The creature caused Shiro's stomach to waver, *How could such an abomination want to exist? He thought.*

The monster's large yellow eye settled on the visage of Shiro. Shiro readied his feet to make a dash for the creature. The troublesome creature let out a scream that sounded like a thousand dying men and awkwardly ran towards the samurai. Shiro, fluid and graceful, sprinted towards his opponent, and carved a horizontal slash into the creature's abdomen. The Light-Walker reacted with a downward slash with his sword arm, Shiro spun out of the way, laying a cut on the ribs of the creature. The monster's left arm was of massive size and made a powerful jab for Shiro's head. Shiro ducked, and came up with one clean cut, separating the attacking arm from the rest of the body.

The Light-Walker let out another wail as green and yellow blood splashed upon the ground. Shiro spun, slicing into the chest and letting the cool blood splash into his face and hair. The monster abruptly jumped back and went for a stab for Shiro's chest, but the samurai created parried the attack. The parry created orange sparks from the mighty blades, and caused Shiro to stagger back. The monster swung his sword again and Shiro tried to duck but fell on his butt. The monster swung downwards and Shiro rolled out of the way. The impact of the blade caused vibrations in the ground.

Shiro got to his feet to only feel the cold, wet feel of gray tentacles wrapping around his body. The young samurai looked up at the behemoth and saw the giant eye hold a look of resentment. Shiro looked higher to see the tentacled beast from earlier grinning, stuck to the roof as its limbs dangled. The samurai knew he had lost, as much as he hated to admit it. Shiro screamed as he felt the fires of electricity and fell back into the darkness.

Chapter 8: The Madman to the Rescue

Caroline White was once a sickly girl. A girl who was no more than sixteen, and she couldn't even survive a full day of school without fainting or vomiting. The doctors never truly knew what was wrong with poor Caroline. Some days she would have a fever, other days it would be asthma, and other's stomach pains. One day, the young girl grew tired of it. One afternoon, she took more pills than prescribed. She would be fine with the results, She was fine with death, but death didn't want her that day. Caroline awoke from her overdose and was gifted with super strength, durability, speed, agility, and most of all a healthy body.

"Isaiah! Isaiah! Isaiah! Oh Writer!" Caroline cried to herself, "He's dead!" Caroline quickly put her head to his chest, "Wait, there's a heartbeat. Maybe he's still alive. Maybe I'm not alone in the middle of space!" Caroline quickly wiped the tears from her bruised face and began to shake the inventor, "Wake up! I know you are alive!"

However, no matter how hard the super heroine shook the inventor, his eyes stayed closed.

"Maybe he's in a coma?" Caroline asked herself, "Maybe he has to sleep before he heals?" The young heroine stood up, "I wonder if he's just plain ignoring me?" Caroline stomped her foot onto the ground, "Are you ignoring me you jerk?

The inventor still gave no answer.

Caroline sighed, leaning on the wall of the blue glowing tunnel. Where did the others get taken? How was she going to find them? Was Isaiah permanently like this? All of these were questions

she truly had no clue on how to resolve and answer. When she was on Terra Firma the police would handle all the complicated stuff. Now, she had to handle all the problems. The current dilemma caused the girl to sit on the ground, holding her blood red hair. What was Caroline going to do?

However, one question solved itself as The Inventor let out a painful groan. Caroline immediately rushed to the inventor's side, "Are you okay? Can you move? Breathe? Does everything feel fine?"

Isaiah made several large grunts and rolled onto his stomach, pushing himself slowly up with his arms, "I have parasites within me you ignorant child, they serve as automatic healers. I don't even know if I can truly die?"

"Well, I didn't know." Caroline stated.

"No need." Isaiah hissed, trying to stand on his legs, "We must retrieve The Warlord. I can already hear her yelling for me to come rescue her, she's such a nuisance to my existence."

"Then why do you adventure with her?"

"Because she's a good adventurer." Isaiah said, "She may be brash but she's loyal, she may be loud but she's strong. It's no one else in this disease filled galaxy I could trust but her."

Isaiah struggled to the wall of the tunnel, where he rested his back and legs, "Just give me a few minutes." A worn smile appeared on the inventor's face, "One of my many creations is coming to assist its master." Isaiah gave a slight glance at his android, "It can also repair Chaos."

Caroline nodded, "You are always two steps ahead."

The inventor frowned, "Don't give me that cliché nonsense."

Caroline rolled her eyes, "You are hard to get along with."

"No matter, as long as we can accomplish the mission."

Caroline crossed her arms, "That's a shallow way to think."

Isaiah waved the comment away, "My invention is almost here."

Caroline could hear the rushing of metallic joints. When the invention became visible it resembled a metallic two-foot spider. The core of the creation was made from an indestructible silver alloy, from the Planet Demise. The arachnid fangs were a reflective white, and its blood red eyes cause Caroline skin to lightly tingle. Isaiah turned his back to it and the creature latched on with a jump. Its middle legs pierced into The Inventor's back, causing Isaiah to crunch into his tongue, and for tears to make rivers on his face. The lower legs wrapped around Isaiah's waist, and the higher ones wrapped over his shoulders.

Fully equipped, The Mad Inventor felt revitalized and gave Caroline a wild sneer, "leave the rescuing to me."

Chapter 9: Superheroes, Inventors, and Androids Oh My!

Caroline White and Chaos pushed open the worn stone doors, to the desecrated cathedral. Isaiah was the first one to catch the figure at the end of the hallway. The purple lightning revealed flashes of the wild creature, as it sprinted on two long needle like legs. Its face was a hideous sight of old, failing skin, its arms just like it legs were sharp and needle like, and the body of the creature resembled that of a bony human chest. When the monster let loose its voice, it sounded like that of a wounded child.

Caroline was the first one to attack, bursting into the air, with a right punch to the monster's face. The creature stumbled back, leaving green saliva in its trail. Another purple lightning bolt flashed upon the scene, lighting up the inside of the castle. Isaiah pointed his plasma pistols at the horrific creature, and released four bullets. The projectiles collided into the beast, filling the hallway with the smell of roasted meat and disturbing cries. Chaos rushed forward, summoning her blade, and aiming for the left leg, but was quickly parried by the creature's right leg. The android held her place and stabbed again with her free arm. However, the creature's right leg proved stronger, breaking Chao's blade. The left leg struck again, the creature was countered by another forceful punch from Caroline's, sending it crashing into the wall.

"Insolent girl!" Isaiah screamed, "I told you to stay behind and watch the back! I will be the one to save The Warlord!" The Inventor pointed his plasma gun at the floating hero, "You are a nuisance and should stay out of my way!"

Caroline calmly floated down towards The Inventor, with her arms crossed, "You Know Isaiah? I'm getting a little upset at your attitude."

"Don't talk to me like some school teacher!" The Inventor screeched back, aiming his pistol at Caroline's face, "I've been in space far longer than you! The Dangers! Distractions! If I let you handle the rescue, The Warlord will die before she even notices up from down!"

Caroline smirked, as she stayed several feet above Isaiah, "You like her."

Isaiah gave a frown of disgust, "I have more important business than worrying about human reproduction. I owe her a debt."

Caroline lightly giggled, "You're like a fourth grader on the playground. What do you think you're not allowed to feel? You're not human?"

"I refuse to be human!" The Inventor claimed, "Being human is weak! Being human leaves you open to all kinds of nonsense!" Isaiah began to put pressure on his trigger finger, "Being human leaves you mortal!"

Caroline locked eyes with Isaiah and said, "Shoot."

The Inventor took no hesitation and let concentrated energy flame from the barrel of his gun. Caroline easily slapped it away, sending the stray bullet into the ground.

The Inventor and Heroine stared at one another in silence.

The Mad Inventor sheathed his pistol, put his hands in his pockets, shrugged, and walked past Caroline with Chaos at his heels, heading towards the second floor.

Caroline rolled her eyes and sighed, "Why am I always stuck with the assholes?"

Chapter 10: Juliet's Escape

Juliet Valentine woke up to the floor on the roof and the roof on the floor. The Warlord's memory felt clouded and her tongue felt salty. When she tried to move, she felt she was being restrained. However, that didn't stop the young woman from struggling and reaching her mythical blade. With a swift yank, the jagged sword was released, and freed Juliet from her web imprisonment. The girl hit the ground with a thump, and the weapon fell with a clash. Juliet tried to stand on two feet, only to fall back down, with her legs feeling brittle. Juliet, like a baby crawled to her blade. When her hand reached the pommel, it gave her strength and she used the blade like a cane.

Juliet wasn't sure where to go, but, she inched forward, toward the spiraling stairwell. When she got there she took a glance back, seeing two more bodies stuck in a black web. She couldn't think of their names or who they were so she continued her journey. The girl glanced down the stairwell, then up. She sighed, and chose up. For Juliet each step felt like infinity, the echoes lingered forever, and her body seemed on the brink of an endless sleep, but she persisted anyway.

Juliet reached the top of the stairs with her legs tingling with life again. The Warlord glanced around the area and saw the remainders of pews, lined along the dusty ground. She looked up to see half of a throne, it looked like it could have been magnificent, but now it was brown and rotted. Juliet didn't know why she was here, but her memory was clearing. She came here with friends, she lied to

them about the outcome, but this place was important. She was helping someone.

"Juliet Valentine, The Warlord of Space."

Juliet gasped at the source of the voice.

The statement belong to a man in a white military outfit, he looked like a general.

Juliet's mind and body recovered at once, "The Enlightenment!" Juliet screeched, hefting her giant blade with one hand onto her shoulder, "Give me the plans! Fuck Face!"

The man gave a ghastly smile, "Cookie, can you come here my Marionette."

Juliet eyes tracked a petite female entering the scene. She looked like a crazed court jester from medieval times. She wore a ragged green dress, with black army boots smothered in multi colored blood, her hands were covered in fingerless cotton gloves, in her right she held three knives, and in her left she held one dagger. The wild girl fell into a hysteria, it caused her pigtails to jiggle; one was green and neat, the other messy and orange. Juliet could only see half of the pale girl's insane looks; a mask, in the form of a happy skull, covered the right side of her face.

"Cookie, my faithful Marionette, will you kill her?" The General asked.

Cookie laughed so hard saliva ran down her mouth, and like a rabid creature she sprinted towards Juliet. With no fear and all her fury, Juliet hefted her mighty blade in a horizontal swing. Cookie easily flipped over it, slashing The Warlord's back, and tearing through her worn armor. Juliet wildly spun, but Cookie ducked, letting the weapon fly over her. Cookie performed an uppercut with her three knives, but the attack was halted by Juliet's chest plate. The two ferocious women clashed their weapons, causing

each other to tumble back. Cookie cackled like a banshee and Juliet smiled.

The General had found the plans in a ragged notebook behind the throne. The elderly man laughed, that old scientist Johnnie thought he was so smart. Split his plans, use the portal to scatter them among the universe, and hire mercenaries to protect it. It was all so basic, so amateur. The General put the notebook in his pocket, sat on the throne, while watching the battle between the two young women, and proceeded to masturbate.

Chapter 11: The Deformed Blade

The second floor of the ruined castle took the shape of a rotting kitchen. The ground was covered in spoiled fruit, lubricating the floor, a sour smell danced in the air, and the ceiling leaked with sewage filled raindrops.

"This is awful!" Caroline whined, "Why are we inspecting this?"

"Cause you-!" The Inventor held his tongue, "They most likely took The Warlord to the top. If these are intelligent creatures, which they seem to be, they want to wear us down."

Caroline nodded, but Isaiah could clearly see the girl didn't understand a good chunk of the situation.

Isaiah rolled his eyes, "Just attack when I attack, dodge when I dodge, and listen to what I speak, and you'll be fine."

"I'm not Chaos!" Caroline retorted.

Isaiah lightly chuckled, "Not very much."

Before Caroline could process what he meant, she felt the floor give out from under her. Super heroine, Android, and Inventor began to fall. Caroline using the ability of flight, stopped herself from her descent; Isaiah's four metallic spider legs came to life and embedded themselves into the ceiling. Chaos was the only one to not have a safety measure. As The Android fell back to the first floor, she saw the source of the destruction. Chaos was hurtling toward a disfigured creature; the monster's body was large and bulky, its skin pale, it had one yellow eye, a mouth filled with clear slime, and its right arm was a thick steel blade. Chaos spun her body horizontally, summoning her remaining blade

at the same instant. The creature swung his massive sword arm at the android, causing a parry of orange sparks.

The Mad Inventor didn't leave his robot alone to fight and rained his plasma bullets upon the deformed creature. Caroline vaulted herself toward the monster, landing a powerful right punch into the monster's head. The creature swayed and Chaos performed a right slice into the creature's abdomen. While their opponent sprayed bright green blood, and Isaiah ejected his legs from the ceiling, landing on the pathetic creature. Isaiah's four bladed legs stretched out and pierced themselves into the shoulders of the monster. The bladed creature raised it's weapon, but not before Isaiah landed a bullet into it's singular eye. Chaos stabbed her left blade straight into its abdomen and Caroline gave a sound breaking punch into its chest. The monster's back broke, expelling bones, lime green blood, and intestines. Isaiah's spider legs yanked themselves from the creature, and the Inventor landed safely on the ground.

"Looks like I was right." Isaiah said, sheathing his guns, "The bastards are trying to wear us down."

"Meaning Juliet and the others are on the higher floors?" Caroline questioned.

The Inventor chuckled, he liked a challenge, especially from flesh eating monstrosities, "Meaning these beasts are trying to present us with a trial, and oh, how Inventors love a test to show their skills."

The tentacle monster lazily flew around the spider web, that held Shiro and Asuka. The creature

noticed the third capture was gone, but it didn't mind, the other mutants would handle it. The creature's blackened claws lightly touch the fair skin of Shiro. Oh, how the mutant wanted to feed, but it wanted to wait for its sword wielding partner. The creature knew it should be coming any second, the tentacled creature had heard the battle from below. It was sure its companion had won the match. The monster heard a growl come from its innards and rubbed its face against the sleeping Shiro. Maybe, if it only took a little bit of the young samurai's nutrients, its friend wouldn't mind. The tentacles of the monsters began to surround Shiro, the beast of a creature began to take hold, and then an arrow of Ice pierced through its stomach. The arrow froze the creature from the inside out and the mutant fell to the ground, shattering into several pieces.

An Archer walked upon the shattered ice. She wore a white hood that spilled with golden and black cornrows, her pants were of white cloth, and she wore a white leather cuirass, she walked in with white combat boots. On The Archer's naked arms were tribal tattoos that fueled her power. Lastly, her bow was made of a unique white wood, that took the form of angel wings.

The Archer gave a confident smile at the destruction of the tentacle creature and turned toward the entryway, waiting for Caroline, Isaiah, and Chaos.

Chapter 12: The Arrows of Tiana Forest

Tiana Forest, The Archer in White, stood in front of the crumbling doorway to the third floor. The Archer's fingers rapidly tapped on her bow, as she heard the steps of her enemies. If the data The Enlightenment gave her was right, she would be facing The Inventor, Android, and Ultra Girl at the same time. Tiana shrugged at the thought. She had been raised by The Enlightenment her whole life, and was skilled in alchemy. A three on one battle would only hone her skills.

"A little girl dressed in white." The Mad Inventor teased, making his entrance, "I don't care who you are or why you're here?" The inventor pointed his guns at The Archer, "Do you have something with Juliet's disappearance?"

Tiana let a smile escape her lips, "Men, always letting their small head lead them. Juliet is hiding more than she let's on. You've followed her to a grave planet." Tiana lined her arrow with the string of the bow and pulled back, " The only treasure waiting for you is the peacefulness you gain from death."

Isaiah gave one of his ugly sneers, "Let's see what's faster Archer? Your arrows or my bullets?"

Caroline took a deep breath and stepped between the two, "Isaiah, go save Juliet. I can handle this."

The Inventor first felt offended, but soon realized Caroline had something to prove and sheathed his guns, "Sure, your just getting in my way anyway."

The Inventor and Android receded back into the entryway, to gain the fourth floor.

Caroline cracked her knuckles and gave a smile, focusing her attention on Tiana "Now, I've heard of you back on my planet. The Archer of Alchemy."

Tiana nodded, "Yes, my missions for The Enlightenment have given me a reputation of sorts."

"Back on my home planet Terra Firma you are a top tier villainess." Caroline said, feeling nervousness wrack her body, "If I defeat you that's saying something."

"You want to impress her." Tiana revealed, "Impress, ooooh, Juliet Valentine! Just like the Inventor. Think taking on me she'll give you a kiss with them thick lips." Tiana closed her left eye, "What a dunce."

The Archer let her wooden arrow fly and Caroline caught it with her left hand. However, the element of the arrow shifted to ice and rapidly trapped the young girl.

Tiana let out a mocking laugh, "Stupid bit-"

The block of ice shattered and Caroline zoomed toward The Archer. Tiana rapidly rolled to the left, grabbed an arrow from her quiver, and let it fly. The projectile became the element of fire and was slapped away by Caroline's mighty strength. A third arrow flew towards The Heroine's heart, but Caroline caught it. However, the arrow shifted its element to Lightning, shocking the girl to her knees.

"Goodbye, Ultra Bitch. Looks like I hit my target."

Tiana stood up, and with an arrow already equipped let it fly. Caroline was hit straight in the shoulder and another jolt of electricity rang through her body. The super heroine hit the floor, with blood

trailing from her mouth, and smoke rising from her body.

Tiana walked towards the defeated hero, "Do you know why you pathetic heroes could never deal with me?" Tiana took another arrow from her quiver and pointed it at Caroline, "You heroes could never finish the deal." The Archer smiled as she lined the bow with the arrow, "How I can't wait to ruin The City on the Bridge while you are gone."

A katana pierced through the chest of Tiana Forest. The Young Archer looked down at the bloody blade in surprise and blood gushed from her mouth.

The villainess last words were, "Aw shit."

Shiro Mitsurugi kicked the dead Archer from off his sword and held out his hand toward Caroline, "I doubt that Inventor has the skill to save The Warlord." He said.

Chapter 13: The Truth

The Mad Inventor and Android ran onto the scene of the fourth floor. Juliet Valentine was covered in blood, her eyes wide with adrenaline and fear, sweat watered her skin, and The Warlord could barely hold her sword. Chaos spotted The Wild Marionette springing towards Juliet. The Android dashed forward. A clang went through the air as metal clashed with metal. Cookie parried Chaos's attack with her knives, and stuck her single dagger into the chest of The Android. A mad giggle left from Cookie's mouth, as she kicked The Android into a wall.

Cookie turned her half smiling face back towards Juliet and stalked forward.

The Mad Inventor would not have such nonsense and turned his pistols toward The Marionette, "Oh, Warlord how I grow tired of saving you."

Isaiah released his plasma bullets toward Cookie, and The Marionette fought the bullets with her knives, bouncing the projectiles around the battlegrounds. When Cookie saw a break in the bullets she dashed forward, much to The Mad Inventor's surprise. Isaiah saw the knives go for his face, before he felt their stinging pain. The Mad Inventor bit his tongue as he felt a searing tremor run across his visage. Next, The Mad Inventor lost the vision in his right eye, and could feel blood running down his face. A wild laugh was initiated with a slicing pain in Isaiah's hands and the loss of his guns. The Mad Inventors last available weapons went on the offensive, his spider blades attacked.

Cookie's knives knocked the bladed legs back, proving her weapons equally strong.

The Marionette rapidly planted her bloody knives on Isaiah's neck and asked, "Do you want to feel the pleasures of death?"

"Do you know why you were actually brought here?" said The General in White from the rotting throne, "It wasn't for some treasure guarded by monsters. It was a woman's greed."

Shut up!" Juliet screamed, "Isaiah don't listen or I swear my sword will have a taste of you."

The General took his left hand from out his pants and wiped it on the throne, "You were here to retrieve an item that Juliet was going to turn in for cash."

"And I would've shared it too!" Juliet yelled.

The Mad Inventor's wounds felt minor to his pride, "What Item?"

The General held a notebook in his right hand, "This notebook contains the Information to make an Homunculus, an artificial human with special abilities. This notebook accompanied with four others can give me and my organization an endless supply of indomitable soldiers." The General gave a smile upon the scene, "Juliet was sent to retrieve it and knew she couldn't do it alone. So she tricked a crew and got you fools together to help her out"

Cookie felt a punch crunch into her jaw, shattering her mask, and sending her crashing into the dusty ground.

Caroline White landed next to Isaiah, "Are you ok?"

"I could have done it." The Mad Inventor sneered.

"The Inventor should have cleared this already." Shiro said, walking onto the fourth floor.

"Oh Shiro" Asuka yawned, "Give it a break."

Cookie, fully pale faced, rapidly crawled back to the throne of The General and steadied herself to her feet.

The General stood from his throne, and the gloves on his hands began to glow lavender, "Now it's time to finish this little mission."

Final Chapter: The White General

The White General checked out the sight of his enemies; Juliet Valentine was trying her best to stand up, her armor was filled with dents and scratches, her skin leaked crimson, and her breath ragged. Isaiah, The Mad Inventor had a brooding face as blood trailed from a lifeless eye, with no guns and half of his sight remaining he was as useless as a baby. Shiro Mitsurugi and Asuka Nakamura had just appeared on the scene, but The White General thought of the two as fodder. The most dangerous one of the bunch was Caroline White A.K.A Ultra Girl. The Super Heroine stood up, her ocean colored eyes filled with determination, and her body pumping with adrenaline.

The Super Heroine lunged towards The General, pulling back her right fist, and letting out a scream of fury. The White General simply raised his right hand, which caused a purple aura to flow around Caroline, freezing her in the air.

The Super Heroine struggled as The General lightly chuckled two feet in front of her, "You really thought I could be beaten?" The General's laugh became louder, "How foolish you must feel, woman" The General's left hand began to run through Cookie's hair, " Women, you're all so naive."

The General flipped his hand and Caroline went spiraling into the ceiling, the impact forming a crater around her body.

"I've had enough of this shit!" Juliet screamed, "Fuck with me!"

The Warlord sprinted towards the throne, but received a flying knee in the face from Cookie, this caused Juliet to drop her blade and fall on her back.

Cookie landed onto Juliet and began to convulse with laughter. Juliet tried to struggle from the The Marionette's grip, but without her enchanted weapon, she felt weak under the pressure.

The Mad Inventor began to make his way to The White General, his bladed legs rapidly scraping the ground, supplementing for his lost eye. The White General focused on Isaiah and closed his right hand. The Mad Inventor let out a horrified scream and fell limp.

"What did you do to him?" Shiro demanded.

The White General answered, "I killed him using his worst fears."

"And I will become your worst fear." Shiro said, releasing his blade.

The White General pushed his right hand forward and Shiro and Asuka were hit with a traumatic force. The two Japanese warriors slammed into a wall and their necks snapped, with a whirl of The General's hand.

The White General pleased with the effects of his Pseudo Telekinesis took another glance at Juliet and Ultra girl, "One Marionette is so boring." The General's dark eyes settled on Juliet, "I never had such a feisty girl"

"What did you do to my fucking team?!" Juliet snarled.

"I killed about half of them." The White General answered gleefully, "But you and Ultra Girl, I'd rather keep."

An infuriating scream hailed from Juliet's mouth and tears came from Caroline's eyes. The White General swirled his hand again and Caroline was pulled from the ceiling, floating towards her opponent. Cookie jumped off of Juliet, while The

Warlord was levitated towards Caroline, cussing the entire way. Cookie walked up back to her master, who petted her like an animal.

"Let's go home with your new sisters, shall we Cookie?" The General in White said, "We got what we came for."

"What in the hell are you talking about?" Juliet protested, as she and Caroline were linked back to back.

The General spun both his hands and a six-foot dark portal materialized,
"I'm adding to the family."

Caroline breathing became heavier and her tears began to flow rapidly.

"You think you can handle The Warlord." Juliet debated, "Fuck right."

The General rolled his shoulders, "Oh, that's what Cookie thought and look how obedient she is."

Caroline began to wail.

"Shut up!" Juliet was beginning to worry herself, and Ultra Girl was making the situation worse, "Torture my ass all you want, but I'll be stomping on your balls the entire way."

The General smiled, "That's what I like to hear."

The White General turned towards Juliet, smiled, and stepped through the portal, Cookie followed. Juliet could feel something pulling her and Caroline towards the vortex. Juliet quickly tried to dig her feet in the ground and Caroline through her hysteria tried too, but it was to no avail. Both the girl's shoes dragged easily along the floor. Juliet could see the bodies of Isaiah, Shiro, and Asuka and The Warlord began to burn with anger, but without her blade she was useless.

Caroline's wails became gargles as Juliet felt the wet substance of the portal, it was like being pulled into thick water. The Warlord felt an overwhelming fear. She had run a fool's errand and finally lost.

<div align="center">***</div>

When The White General returned back to his lab, he was pleased to know the screams of young girls would fill his halls once more. He was exceptionally pleased with Juliet, who took six months to put under his control. Caroline took a week. Juliet was such a feisty girl; at first she was strong and brash, cussing and threatening the whole time. However, as the months wore on she began to have less flair. As he starved her she didn't seem so strong anymore, as he experimented on her she became more complacent. When the six months was over she sat in her own shit and piss completely naked, her eyes empty of any true life, mumbling under her own breath, her body malnourished and weak. When The White General stepped into her room, she crawled to him, wrapping her arms around his leg for safety, knowing he would take care of her, as long as she listened. The White General looked down at Juliet Valentine and put his left hand in his pants and proceeded to masturbate.

The End???????

The Valkyrie Garden
Prologue

Ronald Donald tapped his anxious fingers unto his steel desk. He knew she would come in soon. She would demand orders past her title of command and cause hell until she got what she wanted. That's how Juliet Valentine worked, demand, demand, demand, and demand some more. Ronald didn't know how he would stop her, but the mission at hand was too much for three teenage girls. Ronald knew once she stepped into the office, he would have to stop her before she started talking.

The gray stainless doors swung open, disturbing Ronald from his thoughts. With an upside down smile on her face and her eyes wide open for an argument, Juliet Valentine walked in.

"What the hell Ron?" Juliet screamed, slamming her hand on Ronald's pristine desk, "You trying to play me? I wanted that mission."

Ronald sighed and looked up at the enraged girl, "It wasn't in my jurisdiction. The Society of the Unknown thinks collecting a Homunculus Notebook is too much for your team."

"Too Much?" Juliet questioned, "Was it too much crossing dimensions and destroying that demon two months ago, or what about two weeks ago when we attacked that tower that sucked up all the electricity in the city, or what about two fucking days ago when me and the girls killed that yeti thing?" Juliet crossed her arms, sat in the chair beside her, and put her combat boots onto Ronald's desk, much to his dismay, "Bullshit, my team is better than half those agents."

Ronald rubbed the bridge of his nose, "Juliet, it's more serious than raw power, there's papers, files, and we already have a team on the move to the Valkyrie Garden."

Juliet smiled; Ronald knew she had a curve ball, "Lies." She simply said, "I checked with all the other team field operatives and no one is scheduled for the Garden City, most are scared to even set foot on the planet."

Ronald leaned back in his chair, trying to put together a coherent argument, "Juliet- its jus-"

"Just what Ron?" She said, "Just you too scared if any of us die it will fall back on you? My team and I have been working on missions since we were thirteen, I ain't scared of no fucking scientist trying to take over the world, and the girls feel the same way! This is a real mission! A mission to show those higher up bastards we mean business!" Juliet put her feet on the floor and locked her deadly blonde eyes with Ronald, "I need this."

What Could Ronald say? He had been working with Juliet and her team for three solid years, and he had gained a fatherly love for the trio. He didn't want them to get hurt or not come back.

"Fine," Ronald spouted, "but take the new recruit."

Juliet was taken back, "Who?"

"The new recruit, Ginger Snap." Ronald repeated, "She may look naïve and sweet at first, but I'm sure she will be of help, for this mission a foursome might be what's needed."

Juliet knew this was as far as Ronald was going to let things go, "Thanks *dad*, don't worry I'll make sure to not put any dents in the Bentley," Juliet

smiled, getting up and leaving the room, "You're the best *dad* any badass daughter could ask for."

When Juliet closed the door, Ronald sat back feeling totally manipulated, *She's just like her father. He thought*

Chapter 1: The Crows

Four teenage girls emerged from a shining vortex; the first girl had skin of chocolate and long, curly, black hair, tied into a ponytail. She wore gray Kevlar armor, with black cargo pants, and black combat boots, and on her back was a giant jagged blade. She went by the name Juliet Valentine.

The second girl had skin of caramel and she wore a black bodysuit made from cotton; her main armor was a leather medieval battle dress, followed by a gray ragged hooded cloak, which spilled with golden dreadlocks. This girl's weapon was a golden double bladed pole that went by the name of Harbinger. She went by the name Tasia Snow.

The third girl had skin of butterscotch and elongated thick black and gold cornrows. She sported a black and brown leather cuirass, with black leggings, brown leather hunting boots, and a wooden bow in the form of wings lay on her back, accompanied with quiver and arrows. She went by the name Tiana Forest.

The fourth girl had skin of honey and midnight black hair, tied into a ponytail, by a red cat eared shaped bow. She was very traditional in her uniform with red and black Kevlar armor, black jeans, black combat boots, two pistols secured on her hips, and a loose bandolier around her waist. She went by the name Ginger Snap.

Juliet immediately took in the scenery of the foreign planet; the sky was blue with white clouds, similar to Terra Firma. The grass was extremely moist, even the slightest of pressure would produce water, in the near distance was the girl's target location.

"You see that girls." Juliet pointed, "That's the Valkyrie Gardens, The Homunculus Notebook should be somewhere in that joint."

From the foursome's location, the Garden looked more like a Kingdom crafted from a brilliant white stone.

"Preciosa" Ginger accidentally said in Spanish.

Juliet glanced back at the newcomer, "Don't let the sights fool ya, some of the most beautiful places have the most dangerous creatures." Juliet turned back to the garden, "Stay on alert, sightseeing can get you killed."

Ginger quickly nodded, "Si…I mean yes."

"Tasia," Juliet commanded, "What's the wildlife we should worry about?"

Tasia swiftly took out her Zphone and looked over her notes, "Reptilians are the worst of it, but I heard they stay away from the gardens."

"Boring." Tiana said.

"Yeah, it is!" Added Juliet, "Hopefully, well get some action."

Ginger observed how the three got along, talking tactics about the mission. Tiana pulled up a holographic map of the garden with her Zphone, and the three began to go in deep conversation. Ginger twiddled her thumbs, not knowing how to help the three experienced field agents.

"Can I help with anything?" Ginger asked.

Juliet waved her right hand, "Don't worry, and once we get settled I'll tell you where to go. Just stay there and look cute, we'll be done in a second."

Ginger put her hands behind her head and sighed, she hoped she wouldn't be useless.

Chapter 2: Separate Paths

The gates to the Valkyrie Garden looked virtually untouched, they still sparkled in the sun, they still stood tall, and they still took a good amount of strength to move. The foursome of teenage girls put all their strength into pushing the large gates open, revealing the abandon orchard. The grounds of the exotic garden took the form of an element similar to marble, the square twenty foot buildings were carved from white stone, in the middle of the garden Juliet saw a statue of a Valkyrie with all six of her wings spread out, and in the back of the garden there seemed to be a building similar to a cathedral, with a long giant silver rose as a spire.

"Alright bitches," Juliet said, glancing over the scenery, "If we go by the plans I'll take the cathedral, Tasia you go east, Tiana west, Ginger you stay by the statue."

Ginger immediately felt deflated, "I...thought I could help one of you guys."

Juliet turned to Ginger and put her left hand on the newbie's shoulder, "I get it. You want to help, come in with a fucking bang, get your pistols wet, but it's not all about that honey. Sometimes its about staying watch."

Ginger turned to Tasia and Tiana, who nodded in agreement.

"It is my first serious mission," Ginger sighed and faced Juliet, "I understand."

Juliet was happy the girl was taking everything so lightly, Juliet remembered being far more rebellious in her day, "Good, you wait in the middle and if anything happens hit us on the Zphone."

Ginger knew if she did run into an enemy, she would use the chance to prove herself to Juliet, "Sure, Ms. Valentine."

Juliet shook her head, "Call me Juliet."

"And call me let's get going." Tiana said, walking ahead into the gardens.

<p style="text-align:center">***</p>

The Inside of the Valkyrie Gardens housed many queer fauna; Ginger noticed some plants were as red as lava, some resembled Venus Fly Traps and walked by on the roots, other plants held weird pink bulbs that pulsated water, some plants seemed to spill onto the grounds of the garden, fusing with the architecture.

"Alright," Juliet said, slapping the ass of the statue, "Ginger this is your post." Juliet turned to Tasia and Tiana, "Girl's, you have your destinations, now we need to check every inch of this place if we want to find that notebook." Juliet checked her Zphone, "We meet three hours before sundown."

"See ya in three." Tiana said, heading west.

Tasia simply nodded and sprinted east.

"Now, this is your first mission." Juliet warned Ginger, "Listen to me and everything will be fine."

Ginger nodded, crossing her fingers behind her back, "I'll sit here and keep post, any danger call you."

Juliet, feeling confident about her leadership role smiled and made her way to the cathedral, "I think I got this responsible shit down."

Ginger watched as her superiors separated, hoping some action would come her way.

Chapter 3: The Dangers of Tiana Forest

Tiana Forest walked down the western aisle of the Valkyrie Garden, popping a fresh wad of grape bubblegum in her mouth. The young archer eyes explored the ruins as she traveled, and the vines are what caught her attention. The vines of the garden seem to come in multiple colors, some were blue, others purple, some orange, Tiana wondered if they were poisonous, maybe the Valkyrie used plants as a weapon.

Tiana let the thought run several more seconds in her head then simply forgot about it.

"I wonder if I will get to the fight Reptilians?" another thought echoed in Tiana's head, "Ron said they can be pretty stubborn?" Tiana pulled out her Zphone, "It's only been an hour, Oh Writer."

Tiana in her abysmal disappointment turned a left corner to only have her mood suddenly change. Almost running right into a creature, Tiana hid back behind the corner, pulled out a wooden arrow from her quiver, lined it up with the bow string, and held it in place, while peeking back around the corner. In Tiana's eyesight made out a bipedal, man size lizard like creature, holding a small jagged knife.

"A Reptilian." Tiana smiled, "Oh, Writer, you must have heard my prayers!"

Tiana watched as the creatures sniffed the air, flaring its small nostrils, and letting it's pink tongue flicker in the wind. It seemed to flinch, as if it noticed something and turned its sight to the archer.

"Well," Tiana said, gleefully, "looks like it's time to fuck shit up."

Tiana revealed herself to the Reptilian, rapidly pulling back and releasing her arrow. The

projectile immediately shifted from wood to fire and crashed into the creature's face. The monster hissed and swirled, falling onto the ground trying to pat the fire out. Tiana knew the creatures could be dangerous and didn't hesitate in shooting another fiery arrow into its chest. The creature hissed in pain, its limbs moved wildly, and then it went limp, letting the fire turn its body into ashes.

Before Tiana had time to congratulate herself, she felt something hard hit her in the back of her head. The young archer rolled forward and spun around, holding another arrow in her hand. There was a second reptilian, this one seemed more aggressive than the first, it held two sharp knives, and had several scars on its emerald scales.

"Good shit." Tiana said, releasing an arrow that changed its element into ice.

The reptilian, with a quick swipe of his right knife took the ice arrow down. Tiana shot an arrow of fire and the reptilian dodged with a spin, and sprinted towards her. The young archer caught off guard loaded an arrow, and shot it at the face of the monster. The reptilian lunged to the left, letting the arrow fly by, kicked off a building, using its leathery feet, and dove towards Tiana. Tiana purposely fell backwards, grabbed an arrow, pulled back, and shot it. The arrow pierced the Reptilian's stomach and became fierce lightning. The lightning traveled through the creature's stomach, burning it's entrails, cracking its bones into dust, and shot out of its back into the form of a thick white beam. The carcass flew over her head, crashing a couple of feet away. The young archer quickly got up looking at the remains of the monster.

"Whelp, I guess the book isn't here." Tiana said, sheathing her bow and arrows, "I wonder if the other girls have found anything?"

Chapter 4:The Harbinger of Snow

Tasia Snow walked into the confines of what she hoped was the Valkyrie Library. Tasia from an early age loved to read books. The girl would literally pick up anything she could find and devour the material. At first, she got into fiction books focusing on adventure, but as her training began she started to study martial art books. When Tasia got around thirteen, she began to focus on the art of Ninjitsu. The Ninja was a very inspiring warrior to Tasia Snow; stealth, secrecy, fight for the kill, all these things agreed with Tasia. Ninjutsu was her calling, her sanctuary.

Tasia walked into the supposed library with admiration. The building was made in a sphere with shelves circling the wall filled with books. The ceiling of the library was made with vines that sprouted white roses. Tasia knew she had to find the Homunculus Notebook, but her hands couldn't resist picking up a random book and looking at it's words. Unfortunately, for Tasia the words were unreadable. She made a slight curse under the scarf that covered her mouth and closed the book. It wouldn't make sense if the notebook was in this room, The Society of the Unknown said it had fallen from another dimension. What was the luck it would fall in a library of all places? Tasia dashed her chances of reading extraterrestrial literature and headed back to the entryway, but as she turned around a figure made her grab her double bladed pole, Harbinger.

In the entry way stood a seven foot reptilian. The creature had dark green skin, and held a large jagged blade in it's left hand. The reptilian sensed Tasia's surprise and held its sword up with a horrible

hiss from its mouth. Tasia felt no fear as her hands reached for her weapon. The monster saw that as a challenge and charged forward. Tasia held her stance, spinning her white double bladed pole with both hands. The reptilian swung his sword toward the rotating spear, only get knocked back and showered with orange sparks. Tasia followed through with a vertical slash into the beast's chest. Green blood splashed upon the ground, and Tasia spun her pole and quickly produced another cut into the beast's rib. The monster in anger swung his rusted blade with the flickers of his life left, only to get parried, then Tasia ended the battle with a clean swing, separating the head from the body. The Reptilian neck sprouted green blood like a broken faucet, as the carcass fell on it's back.

The ninja walked back to the outside, maybe it was time to report back, there was nothing here? Tasia looked up at the sky, the blue seemed to be turning into a pink, and the wind was beginning to pick up. The air had a nice dew-refreshing breeze, like a forest in the spring. Tasia didn't need to look at her Zphone to know two hours had passed, maybe it was time to report back to Juliet? She was sure the book wasn't in her vicinity. Maybe the reptilians were looking for the same thing, maybe they felt that something unnatural had fallen into their world. The reptilians were not known for entering the garden, naturally they feared the Valkyrie. Even if the all female aliens species had abandoned the garden their scent should have kept the creatures at bay, but it didn't. The reptilians were desperate, they were searching for something.

Chapter 5: Juliet's Overconfidence

The Inside of the Cathedral wafted an a uplifting breeze, the walls were littered with vines, the roof was made of large leaves, and the back of the cathedral had no barrier, leading to a marsh forest. Juliet Valentine was slightly disappointed there were no enemies waiting for her. So far, the mission had been a bust in the fighting department and Juliet had no clue as to where to actually find the Homunculus Notebook.

"Uh, I don't understand." Juliet said to herself, "Where's this notebook? Writer damn this is hard."

Juliet stopped at the entrance to the forest, giving a last check around of the inside of the cathedral. Through the young girls missions, Juliet learned that walls, floors, and even statues unlocked hidden rooms where important things were held, but in this cathedral she saw nothing of the like.

Juliet frowned with impatience, "Then, I guess I go hunting in the damn forest."

Before the young girl could take a step back into the wetlands, she heard a hiss. The sound caused Juliet to grab the pommel of her blade with her right hand and swirl around. She wasn't disappointed this time. Juliet smiled on seeing a seven foot peach colored reptilian, it held a staff in it's right hand made from bark, built into the rod was a crystal ball the size of a man's head. Juliet could see crude shoulder pads made from bark and plants, and even a loincloth made from larger leaves.

"Finally," Juliet said, unsheathing her blade and grabbing it with both hands, "some blood to spill."

The reptilian answered with a hiss and lifted his rod of bark. Juliet sprinted forward, her blade dragging along the ground, slicing the vines in its way. The reptilian raised his cane and the crystal ball began to glow a violet. Juliet's body immediately felt ten times heavier and she found herself falling to the ground.

However, she was quick enough to stop her fall with her hands, "What in the Fucking Bastard is going on!" Juliet, only a few feet from her target struggled to look up at her opponent, "What in the hell are you?"

The reptilian seem to smile at the young girl and raise his staff higher. Juliet could feel her hands being pushed into the floor, her body felt like it had a one hundred pound weight on her back. The young warrior's arms couldn't keep her up and she hit the ground hard, blacking out.

Chapter 6:Ginger's Opportunity

Ginger Snap leaned on the Valkyrie Statue, staring at the white clouds floating through the pink sky. A part of her was happy to finally get accepted on a serious mission, however, she currently felt she was in the way. She was slightly offended no one asked her to join when searching for the Homunculus Notebook, but why would they? She was a newbie. She had no experience on outer dimension missions; she had never truly left a non-earth world. She was out of her element and the others saw her as weak for it. Ginger shrugged, what use was there to pout about it, nothing would change.

Ginger idly looked at the silhouette of the statue; the female figure was tall and curvaceous, her wings were spread out to make her look more intimidating, in each hand was a blade, and when Ginger looked at her own silhouette she felt inadequate. Ginger kept her eyes on the silhouette's and noticed something out of place, the girl rolled, feeling the tip of a blade nimbly run through her hair. Ginger swirled to her feet and automatically pulled out her right pistol, without even thinking she pulled the trigger. The lead bullet hit a blade, shattering it into pieces.

Ginger frowned at the visage of her opponent, "Tu eres mas feo que el culo de un mono."

The creature in front of Ginger was a six-foot navy blue reptilian, its belly was white, and in its left hand was a remaining silver blade. The creature's feet were able to stick to the statue, and with a leap it landed in front of Ginger.

"You surprised me." Ginger said, as her hand quickly swiped for her left pistol, "Let's see if you can dodge my Pistola de Sonic!"

Ginger shot with both pistols and the bullets screeched through the air. One bullet impacted the right arm of the creature, exploding it to fleshy shreds. The second bullet hit its right leg, decimating it on contact. The reptilian went down hissing.

"Guess what puta?" Ginger said, walking up on the creature and aiming her right pistol at the reptilian's head, "You messed with the wrong nina."

Ginger hit the trigger and bits of brain splashed onto her armor, "Reptilians, highly skilled at combat, but stupid in everything else."

As Ginger felt the feelings of victory, she felt something sharp cut into her shoulder blade. Ginger quickly spun around to feel a leathery foot bash into her stomach, the girl fell back first, dropping her pistols, as a second blue reptilian raised his blades in the air, letting out it's own victory screech. Ginger reached for the closest gun, but the creature's foot fell on her hand, pushing it into the cement.

"Got dammit puta, let it go." Ginger screamed, "I'll kill you."

The reptilian knowing it had the upper hand smiled, and let its blade fall upon the girl. Ginger watched as the creature performed its final blow, she knew all was lost. In the end she would prove nothing to Juliet, to nobody. Ginger watched the last bits of her life be torn away from her, and then a beam of magenta fire and lightning flew over Ginger's head and tore through the stomach of the reptilian.

Chapter 7: Meeting Isaac True

With a purple smoking hole in it's chest, Ginger watched the carcass of the reptilian hit the ground. The young girl quickly snatched the closest pistol, spun around, and faced her savior. The boy looked around her age, he had a brown skin, with black cornrows that went down his neck, he wore a black hooded Kevlar jacket, with black pants, and combat boots.

"Who are you?" Ginger demanded.

The young boy raised his hands and took several steps back, "Hey…Hey the name's Isaac True. I'm on your side."

"My side?" Ginger questioned, "I don't even know you?" A thought came to the newbies mind, as she pulled down the barrel of her pistol, "Are you part of The Enlightenment?"

The boy quickly shook his head, "No, never, I'm fighting The Enlightenment, just like you guys. Think of me like an independent agent."

Ginger didn't take it, "Who do you know? How come The Society never told us about you?"

Isaac True held a mischievous smile, "Cause, they don't know about us."

Even with her right hand aching, Ginger raised her gun to Isaac's face; "You're not writing a good tale for yourself Niño."

"My name's Isaac?"

"Shut up!" Ginger demanded "It means boy!"

"Oh!" Isaac said, a little confused, "Then why didn't you just call me boy?"

"Shut up!" Ginger could see that her mysterious savior was trying to think of a question.

Who in the hell was this kid?

"So, do you know Juliet Valentine?" Isaac asked, "I know her team is looking for The Homunculus Notebook. Can you take me to her, so she can check my story?"

"How do you know Juliet?"

"She works with my father."

Ginger didn't know what to truly do in this situation. The boy had saved her, but that could be a ploy. In the training she was warned, The Enlightenment was full of trickery. How did she know this Isaac wasn't a trick or a spy?

"Walk ahead of me," Ginger said, "and put your hands on your head, we're going to The Cathedral."

Chapter 8:
Ginger and Isaac Vs. The Enlightenment

"You know, I met a Valkyrie once," Isaac said, walking towards the cathedral, "She was very motherly, we even had the same abilities."

"You, met a Valkyrie?" Ginger scuffed, keeping her gun pointed at Isaac's head, "They haven't been seen for over a hundred years, how could you meet one, estupido?"

"It's Isaac and I really did meet one." Isaac stopped at the entrance of the cathedral; the large white building was covered in vines, as if they were veins. The entrance looked like it had been once covered in vegetation, but recently cut by a large blade, "That looks like Julie's handiwork."

"Inside." Ginger grunted, "Don't say a word either."

"Ok, Gunlady."

The inside of the cathedral had a nice breeze, the floor and walls were lined with fauna, and in the back of the cathedral Isaac and Ginger spotted a figure. The figure stood at six-foot-three, it wore a long, white, sleeveless hooded trench coat, baggy cotton pants, and white combat boots.

"Hey, Julie!" Isaac screamed.

The figure turned around, showing the face of a blonde man, "So, you defeated my homemade chimera's? How exciting!"

Homemade?" Ginger said, grabbing her second gun and retargeting the man instead, "You were the one who sent those blue monstrosities to kill me?"

"And thought they would." The man put his right fist into his left palm and cracked his knuckles,

"It looks like I will have to do the deed, and I am Paul Savaar of The Enlightenment. Come and become one with death."

"I got this." Isaac said, as a blade of magenta fire and lightning materialized in his right hand, "You go find Julie and the others."

Ginger shook her head, "This Gringo tried to kill me," she gritted her teeth, "I wanted to do this alone, but who cares, let's take care of him now."

Isaac outstretched his left hand and pointed it at Paul, unleashing a beam of impressive magenta energy. The blast hit the man, creating a violent explosion that tore into the ground of the cathedral, and caused the massive building to wobble. However, in the smoke of the explosion Isaac and Ginger could see Paul running towards them, his jovial face revealing fangs. Ginger's training kicked in and she released a cascade of bullets, but Paul kept charging. Isaac met Paul with a downward slash.

"What the fudge?" Isaac questioned, realizing his blade couldn't cut through his skin.

Paul tackled Isaac, causing the boy to collide into a back wall.

Bullets rained upon Paul once more, and he turned his attention to Ginger, "Time to die."

Paul moved swiftly through the remainder of the smoke, appearing in front of Ginger before she could reload. A hardened foot crashed into Ginger's stomach, knocking the wind from her lungs and the guns from her hands. Ginger fell onto her back with defeat in her eyes, this man was far to strong. How could they win?

"Magenta Clasher!"

Ginger's eyes filled with a bright light and an explosion slammed into the back of Paul.

Surprisingly, the man stumbled several feet, turning around and sprinting for Isaac True. Paul swiped a right claw for the boy's head, but Isaac ducked and performed an upper slash to Paul's midsection. Once again, Isaac's attack did nothing and he absorbed a right punch, that sent him spinning to the ground.

"Young boy," Paul said, walking up to Isaac, "sorry to be rude, but you ain't shit."

As Paul walked upon Isaac and the dust cleared, the young boy could see blue scales covered the man's skin, that's why none of his attacks or Ginger's was working.

Paul reached out his clawed hand, "I'll kill you first."

An arrow of lightning crossed the cathedral, clashing into Paul's face, and causing the man to let out an annoyed reptilian hiss.

"So, this is where all the action is." Tiana Forest said, "Ginger was over here hogging all the fun Tasia.

Tasia stepped beside Tiana, grabbing her double bladed spear, and ready for battle.

Chapter 9: 4 V.S. 1

Paul Savaar ducked Tasia Snow's spear, and uppercut punched the young girl in the jaw. The Reptilian Hybrid turned to the left, turning away a fiery arrow of Tiana's. Isaac's purple blade carved into Paul's ribs, with little to no effect and Paul head-butted the boy off balance. A lubricated blue tail ripped from Paul's pants, slapping the incoming Tasia in the face, sending her sprawling to the floor. One arrow of fire and one of lighting collided into the monster's skull, causing a hiss to release from his mouth. Tired of Tiana, Paul sprinted towards the young archer. Tiana grabbed an arrow from her quiver, but by the time she lined it up, Paul's scaly claws were already around her neck. The half man smiled at the young girl, as he bashed her headfirst into the ground.

"Damn Gringo!" Ginger screamed, relentlessly releasing bullets from her pistols.

The bullets on impact let out a force that could crush a car, but to Paul, it was like a bunny slapping his knees.

"Little girl." Paul said, walking towards Ginger with open hands, "Did you really think I could be outmaneuvered by children!"

"adolescente, puta." Ginger said, releasing another bullet.

Paul caught the bullet, letting it explode in his right hand, "I do like your spunk. It's quite satisfying, especially once I put you into the ground with your friends."

Tasia Snow used Ginger bullets as a distraction, to stealthily get behind Paul, and swing her bladed pole into his ribs. The weapon bounced

back from the scales, and Paul's tail wrapped around Tasia's right leg, taking her off her feet, where she hung upside down. Tasia still had her bladed pole and bashed the weapon into the reptilian's face. Paul roared from annoyance and let his right fist slam into Tasia's stomach. The girl bit her tongue, refusing to scream, but that didn't stop pinkish vomit from seething through her teeth. Paul let out a chuckle and another punch slammed into Tasia Snow. The Ninja Girl was beginning to see black splotches cover her vision.

With a smirk, Paul threw Tasia's body and she twirled through the air like a ragdoll, to only be caught by the battered Isaac True.

"I'm tired." The young man spoke, putting Tasia softly onto the ground, "This fight is over, and I'm going to defeat you here and now!"

Isaac outstretched his right hand and aimed it at Paul; with his left hand, he wrapped it around his right wrist, "Be prepared." Isaac spread his feet apart and began to concentrate, causing peculiar flames and lightning into the palm of his open hand, "Your scales won't be able to defend you from this attack."

The girls looked from their beaten bodies as Isaac's queer magenta powers began to spark wildly from his frame.

Paul Savaar was extremely interested. The member of The Enlightenment held out his hands and let out a deep mocking chuckle, "Do it boy. It won't work, my scales can't be touched, burned, or broken, do your worst you fucking nigger."

Chapter 10: Johnnie

Several Hours Ago…………

"The Valkyrie Garden, Jezzers." Johnnie True Jr. overheard his father say on the phone, "Who in the hell are you guys sending up there? You don't know? Just don't send those young girls up there; it's too much for them at this age. Huh? You want me to come? Ok…I understand that jackass from an alternate reality made it, but do you really need me? Bridge is going to ask all kind of questions?" Johnnie Jr. heard his father say several cusswords then say, "Give me a couple of days and I'll head over."

Johnnie Jr. quickly left from the basement doors and sprinted up the stairs to the iron door, entering the living room. He jumped onto his father's old couch, causing dust to scatter. Through several large sneezes, he grabbed his hundred pound dumbbell and began to lift with his right hand. The iron door creaked open, and Johnnie Senior walked into the room. Johnnie Jr., no matter which dimension it was, always felt a tense air when his father walked onto the scene. Johnnie Senior was only 5'10, compared to his son who was 6'1. The wizened scientist wore a white lab coat, with black goggles around his neck, he sported a simple white shirt, blue sweats, and lastly black sandals with white socks.

Johnnie Sr. pulled out a joint and lighter from his lab coat, put the joint to his mouth, and lit it with the lighter. Johnnie Jr. watched as his alternate dimension father took a long inhale and let the smoke leave his nostrils.

"Boy," Johnnie Sr.'s voice was rough, "I got some things to take care of, shit." The old man looked at his alternate son and sighed, "Do anything out of line and I'm beating that ass. I ain't soft like yo momma, you know that."

Johnnie Jr. switched arms with the dumbbell, "I hear you old man." The teenage boy made eye contact, "I'm just waiting for Isaac, were going to the mall."

The old man gave a light chuckle, "Trying to pop your cherry boy?"

Johnnie Jr. lightly smiled and nodded.

"Good, get your mind off The Enlightenment, be teenage boys and chase pussy." Johnnie Sr. puffed his joint three times, gave two mighty coughs, and turned to his son, "If you and Isaac go in my lab, yaw getting yaw assess whupped by me." And with the last threatening quote the old man left the house.

Johnnie Jr. was aware of what his father was talking about in the basement. It was The Homunculus Notebook, the book that changed Johnnie Jr's. life.

The teenage boy had slipped into this alternate universe due to The Enlightenment and The Homunculus Notebook. A universe where his father and mother was still alive, a universe where he had siblings, a universe where he had another version of himself, in the form of a boy name Isaac True. However, Johnnie Jr's. Original mission was to find and hide The Five Homunculus Notebooks from The Enlightenment, who wanted to make an army for their own nefarious plans. So far Johnnie only had one notebook, but luckily due to his strong hearing, he had heard where the second one lay. Now all he needed was Isaac.

Chapter 11: Johnnie and Isaac True

One of the more curious things Johnnie Jr. thought about this world, was his other self. The him of this world, a fifteen-year-old boy named Isaac True. Basically, Isaac and Johnnie were identical but there were slight differences. One difference was where Johnnie had black and brown locks falling onto his shoulder, Isaac had cornrows going down his neck. The second variant involved height; Johnnie was 6'1 and strapping, and Isaac was 6'0 and slender. The third contrast was their hobbies; Johnnie was into Boxing and becoming a better fighter, Isaac was into kendo, videogames, and anime. Originally, Johnnie didn't like Isaac too much, but as circumstances and The Enlightenment brought them together, Isaac became tolerable.

"Hey Johnnie!" Isaac happily screamed, opening the door.

"You know I have canine hearing." Johnnie said.

"Sorry," Isaac apologized, "I forget you're a wolf man."

Johnnie put down his dumbbell and turned to his other self, "So, I got something planned today for us." Johnnie sighed, knowing this was the only way to get Isaac on board, "It's True Twins stuff."

Isaac's smile grew ten times wider, "Are we going on an Adventure?" Sparks of flaming magenta and sizzling lightning began to emit from Isaac's body, "Johnnie! we haven't been on an adventure for like a month! I need this, where are we going?!"

If Isaac wasn't so damn powerful, Johnnie probably wouldn't bring him along, he got way too excited, "Calm down, I found another notebook,

were using dad's Warp-Sphere to go to the Valkyrie Gardens."

"Valkyrie?" Isaac said, scratching between his cornrows, "Didn't I meet one of those before?"

Johnnie nodded, "Yeah, it's located on one of their home planets." Johnnie began to recall what he heard from his father, "It also houses reptilians, but what from that old man says they don't mess to much with the garden, we should be fine."

"Aw, but Johnnie," Isaac whined, "I have new special attacks to try."

Johnnie shook his head, "Always ready for battle, life isn't a videogame Isaac."

"Yeah, but I can pretend it is." Isaac pouted.

"Sometimes, I doubt we are the same person." Johnnie rolled his eyes, "I Copied dad's key at the BVS, let's get the Kevlar armor."

Chapter 12: The Adventure Begins

"Reptilians! Valkyrie! Adventures!" Isaac True chanted, pulling the strap on his Kevlar hooded jacket, "And proper armor to go with it."

Johnnie sighed, pulling the strap on his sleeveless Kevlar hooded vest, "Just shut up."

"Adventures Johnnie!"

The young dreadlocked boy ignored Isaac and walked his way toward the ten-foot metallic sphere. The contraption was made from a mixture of metal, wires, and plastic. On the left side of the device was a black switch that started the process and on the right side was a keypad to type the destination. Johnnie quickly checked the location, hoping the gardens were already put in by the old man. Johnnie smiled, he saw the words Valkyrie Gardens 22X-56Y in the coordinate panel.

"The old man forgot to erase the coordinates!"

"Yeah," Isaac said, giving himself one more look in the mirror, "Dad's pretty forgetful."

Johnnie pushed the black button and the Warp-Sphere began to stir; the lights on the machine flashed golden, the wires began to buzz, and what looked like black liquid began to materialize in the sphere.

"Stuffmuffins." Isaac walked up to the portal; "I've never seen it in usc before."

"I have." Johnnie reminisced about his world, "Plenty of times."

The black liquid filled the inner rim of the Warp-Sphere, switching into a clear liquid that showed Johnnie and Isaac a world with a pink sky and forest.

"Do we just go in?" Isaac asked.

Johnnie nodded and walked towards the portal, slowly putting his hand within the liquid, "The water is going to be thick, cold, it's going to feel like floating slowly through the sky, watch out where you land."

Johnnie gave a last glance at Isaac and walked inside. Isaac immediately felt nervous about the whole situation, what if he got warped somewhere else? How would he find Johnnie? What if he ran into a boss monster? Isaac took a deep breath, banishing the negative thoughts from his mind and ran straight into the portal.

The young boys reappeared into existence amongst a forest marsh. The sky of the marshy land was a hot pink, the air smelled like morning dew, and Johnnie could hear noises amongst the forest.

"Ha, Isaac we are already in the depths." Johnnie said, balling up his fist.

Isaac summoned magenta fire and lightning from his right hand, twisting it into the form of a blade, "looks like I get to try my special attacks after all."

Johnnie emitted a deep howl from his diaphragm, causing the hidden to come into the light. The twins were ambushed by twenty, emerald, scaly, reptilians. The creatures surrounded the boys in a circle, hissing with their pink tongues, brandishing their rudimentary weapons, and swishing their tails as they inched closer.

"Isaac, I want you to escape out of here and head for the gardens." Johnnie ordered.

"Wha?" Isaac questioned, "I wouldn't leave you behind, I don't even know where the gardens are?"

Johnnie turned to his other half, his eyes completely yellow, "Go now Isaac!"

Much to his dismay, Isaac evaporated his blade and called his magenta energy to cover his body.

"You better survive this Johnnie or mom is going to be pissed!"

With one leap, Isaac rocketed over the ambush and into the forest.

Johnnie looked over the reptilians, cracking his knuckles, "Now that I'm alone," a smile full of fangs appeared on the young man's face, "I can really fuck shit up."

Chapter 13: Johnnie Vs. The Reptilians

Johnnie's right fist clashed upon the jaw of a reptilian, and his left fist bashed into a second reptilian's face. Johnnie sent his right elbow into the stomach of another scaly creature, and an uppercut caused a lizard man to spiral in the air and land face first in the wet grass. However, the more Johnnie knocked out the vile creatures the more they erupted from the bushes, hissing and raising their weapons in the air. Johnnie sidestepped to the left, a spear made from bark lightly scratched his face. The young man responded with a sprint and an uppercut into the creature's abdomen.

In the heat of battle, the young man barely noticed the monsters making an enclosing circle around him. One of the reptilians tackled the dreadlocked boy. Johnnie and the scaly creature went down, clashing into the wet grass. This action caused the other split-tongued monsters to follow and jump on top of Johnnie, like a dog pile in a football game. Fortunately, in the darkness, Johnnie could see clearly. The determined young man kept up his punches, fist after fist clashed into the body of the lizard men. The creatures hissed in pain but forced themselves on top of Johnnie, until all went quiet.

The silence didn't last long, with a howl coming from the depths of the reptilian pile. A claw covered in lime blood ripped from the pile of scales. The reptilians tried to scatter as Johnnie emerged, tearing through the creatures with his black claws. Johnnie had let his inner beast take over; the young man's eyes were yellow and feral, his fingernails were blood ridden blades, and a bushy black and brown wolf tail hung from his pants.

With another dreadful howl, Johnnie pursued the fleeing reptilians, tearing through their thick armor with his canine fist. One punch in his bestial form sent several of the creatures smashing into their comrades. A brave emerald creature came behind Johnnie, with his sword held high. Johnnie, sensing the danger, spun around and bit into the creature's neck, tearing it out.

Johnnie stood among dead reptilian bodies, greenish blood got tangled in the hairs of his chest, his eyes were gold and wild, his hands twitched with muscles spams, and his tail was stiff with rage. In his beastly state, Johnnie caught a scent, he sniffed the air several times to confirm it, and it was someone strong. Johnnie turned his vision to the left and spotted a figure walking his way. This figure had a sleeveless white trench coat, white pants, and white boots. A hood covered his head only letting blond strands of hair be seen, and Johnnie in his feral mode could see a deadly crimson aura around the newcomer's body.

Paul Savaar looked out from his hood, "Young Cerberus." Paul smiled as his pale skin became blue and covered in scales, "You thought you could skip worlds and get rid of me?"

Chapter 14: Johnnie True vs. Paul Savaar

In his feral state, Johnnie's right jab connected to Paul's chin. The member of The Enlightenment smiled as the fist hit him, it was like a bunny slapping a lion. Paul's right arm flashed out, hitting Johnnie straight in the face. Johnnie's vision burst into bright colors, he spun, and caught himself with his right foot. Johnnie quickly sidestepped, feeling the air from a left punch, and a right punch crunched into his beastly ribs. Johnnie hunched over from the pain, to only receive a knee to the face.

The canine boy fell onto his back, and Paul's silhouette coveted him.

"The Great Johnnie True, Half man, half myth." Paul smiled, showing his reptilian fangs, "Now I get to tell everyone I'm the one who caught the offspring of The Gatekeeper."

Johnnie rose, his body bleeding, the wolf inside pushing him forward. The dreadlocked boy gave a right uppercut to Paul's chin; a left jab into the stomach, and another right straight to the face. Paul took every hit, feeling minimal pain. The reptilian man shot out his left fist, catching Johnnie in the jaw. A loud popping sound filled the air and Johnnie fell on his back. The young boy's mythical abilities began to recede; the yellow in his eyes became white, his claws reverted to human fingernails, and his bushy tail withered away.

Paul crunched his fingers, "Take him to the nest." Several reptilians emerged from the depths of the marsh forest, "I'm hunting for his partner next." Paul snickered, "That explosive nigger might be a bit more of a challenge."

Chapter 15: Isaac True vs. Paul Savaar

Current Time……

Isaac True looked upon Paul Savaar; The Reptilian man held out his arms, with a grin of fangs. Isaac knew this would be his last attack, if it didn't work the young boy was done. The cornrowed teenager concentrated as magenta flames and lightning focused into his palm, his right arm shook from the abundance of energy, but his left hand held his wrist, keeping the arm in place.

"Do it Nigger!" Paul mocked, "Try and kill me. I'm impenetrable!"

The energy focusing into Isaac's right palm began to feel overwhelming, the boy could feel his ability tear at his flesh. Isaac sunk his feet into the ground and handled the pain.

"C'mon boy, show me that nigger pride."

Isaac could hear the crackle of his lightning and the screams of his flames, "Paul," the boy spoke, "Take my Magenta Crusher!!!!!!"

The young man released a powerful beam of energy that tore through the grounds of the cathedral, ate through the vines of the building, and hit Paul Savaar with a tremendous explosion. The blast sent Isaac True vaulting into a wall, where he stared at the destruction of his attack. Isaac stared through the magenta haze, and falling of debris, he squinted when he saw a silhouette in the midst of the chaos, the silhouette of the durable Paul Savaar. Isaac fell onto his knees, with his right hand steaming of magenta smoke, and his pride of his abilities crushed.

"You thought magenta smoke would crush me?" Paul said, walking upon the teenage boy, "You

really thought I would die?" Paul's blue claw grabbed Isaac by the collar, "Oh, I'm going to torture you boy, I'm going to torture that nice caramel ass of yours."

Isaac hacked a loggie and spat on Paul's face, "Take my Magenta Loogie."

Paul backhanded the boy and Isaac hit the ground, too tired to get back up.

"I hope you like explosive spit. " The boy said weakly.

The spit made a small explosion on Paul's face but caused no damage.

"You Trues don't like to give up." Paul raised his right foot and slammed it onto Isaac's stomach, "How about I crush your insides, would they taste like fried chicken and watermelon?"

Isaac smiled under the pain, "Does yours taste like unseasoned chicken."

Paul's tail reared up and slapped Isaac in the face, causing a stream of blood to come from the boy's mouth, "You're quite wittier than your father."

A sonic bullet bashed into the back of Paul's head, a arrow of ice froze his left leg unto the ground, and Tasia rammed her bladed pole into his stomach. Unfortunately, for Tasia Snow, her weapon broke on contact. Paul's tail moved rapidly, slapping Tasia in the face and sending her sprawling into the ground. Paul broke through the ice trapping his leg and sprinted towards Ginger, who he punched straight in the gut, sending her into the land of the unconscious. Paul changed his direction towards Tiana Forest, punched her in the face, and rushed back to Isaac True.

"I think I have a plan for you intruders." Paul said to Isaac, "The reptilians in this world have a god, how about you meet him?"

Chapter 16:Regroup

Juliet Valentine woke up to bright shades of green, and a dimming pink sky. She heard hisses and the sound of sharp feet, someone seemed to be carrying her, she could feel herself hit something hard every so often. A few minutes later, at least what she conceived as minutes, she felt sharp nails touch her skin, she could feel something wet flicker, and then she hit something!

Isaac heard sounds, wispy sounds, cackles, he felt long black nails touch him, he heard laughter, human laughter, then the nails touched his body, explored his body, then he hit something hard!

"How in the hell did they catch you?"

"Isaac?"

Isaac True opened his eyes to see a ceiling made from a combination of bark and vines. Turning his head to the right, the boy could see bars, signifying he was in some type of cage.

"Get your ass up."

Isaac turned his head to the left to see Juliet Valentine and Johnnie Jr. staring right at him.

"Johnnie!" Isaac said, getting to his feet, "Juliet?"

Johnnie Jr. rolled his eyes, "Yeah, it's us. How in the hell did you get captured?"

"Oh, Johnnie, there's this guy!"

"Is he half reptilian?" Johnnie asked.

Isaac quickly nodded, "Said his name was-"

"Paul Savaar." Johnnie finished.

"Writer," Juliet interrupted, " that twin sentence thing is creepy."

"Did he beat you guys too?" Isaac asked.

"I didn't run into a damn Paul." Juliet snickered, "I got beat by some lizard with a magic wand."

"Like the one guarding the cage?" Isaac noticed.

"Yeah," Juliet said, "I think he's the reason your brother can't access his abilities."

"Paul got me." Johnnie Jr. admitted, "But I'll get his ass back."

"Don't worry." Isaac said, stretching his arms, "I'll just explode us out of here."

Isaac aimed his right hand at the entrance of the cage, expecting his ability to burst forth, but nothing happened.

"Hello, dum, dum." Juliet reminded, "The lizard with the wand is blocking our abilities."

"Oh, yeah." Isaac said, sitting back onto the ground, "Guess I'm out of ideas, maybe I should take a nap?"

"Maybe you should die." Johnnie mumbled.

The loud creak to the entrance of the cage rang though, and three girls were thrown inside.

"My bitches." Juliet said happily.

"Juliet." Tiana said, rubbing her ass from the fall.

Tasia stood up and dusted her cloak.

"I tried my best." Ginger said, tears forming in her eyes, "But I got captured. I'm a perdedora."

"Shut the fuck up." Juliet ordered, "I'm your leader and I'm going fuck up this Paul guy and get our asses out of here."

As if Juliet statement summoned him, the six adventures saw a naked, leathery skinned, human figure walk up to them, and his name was Paul Savaar.

Chapter 17: The Coming of a God

"So, I defeated all six teenage agents," said the naked, scaly, blue Paul Savaar. "What was the Society of the Unknown thinking, sending a bunch of kids to take me down?"

"Uh, I wasn't defeated by you." Interrupted Juliet Valentine, "I was beat by the wizard lizard."

"Can you put some pants on?" Tiana added, disgusted at the naked sight of Paul, "No one wants to see your scaly dong."

"Wizard lizard." Isaac True giggled, "That rhymes."

"I'm glad you guys are still up for some humor." Paul said, "You know what's going to be funny to me?"

"What?" Isaac asked, clearly interested.

An emerald reptilian walked up to Paul, handing him an old notebook. Paul grabbed the book and showed the young agents.

"Were you all looking for this?" Paul teased, with a fanged smile.

"Hey," Isaac noticed, "That's the Homunculus Book!"

"No shit Sherlock." Juliet snapped.

"I'm not amazed at how fast things excite you, Isaac True." Johnnie Jr. said.

"Oh my Writer! I'm a True!" Isaac realized.

Johnnie palmed his face.

Paul scanned the groups surprised and defeated faces, "I have the book. Once I take it back we'll have two out of five of the notebooks."

"So you only have two?" Johnnie shrugged his shoulders, "No biggie."

Paul turned his attention to Johnnie, "I'm glad you're so confident young Cerberus. I'm also glad my ass whupping didn't knock all that beastly confidence from you."

Johnnie growled.

"You niggers really are animals." Paul said, "A cage fits you all."

"Oooooooh," Isaac chanted, "You said a derogatory term."

"I'm Mexican." Ginger defiantly added.

"Race doesn't matter, You're all niggers to me." Paul answered, "Now I have to go and wrap a couple of things up. Adult things. Remember when I said these creatures here have a god, or what they think is a god. For moments like these, they like to feed him intruders. You all look like you fit the bill." Paul's eyes locked on to Isaac and Johnnie, "No abilities." The eyes moved on to Tiana, "No alchemy" then they scanned Juliet, Ginger, and Tasia "And no weapons." Paul stood up straight and took in a deep breath of air, "You should all be an easy picking for the scaly god."

"I bet it's a bluff." Juliet said, "Show me the god right now!"

"Oh, a bluff." Paul said, "You'll see who will be lying and who won't little girl."

Paul gave the group one last look and gave a quick laugh, before walking away and heading into the depths of the marsh forest.

The remainder of the reptilians that chose to stay at the cage began to circle it. The creatures began to bang their weapons, hiss their pink tongues, and gnash their sharp teeth. The peach colored reptilian that held the wand lifted his weapon and let out a piercing cry.

"Um, Juliet." Tiana said, "Maybe you shouldn't have talked all that shit."

Juliet crossed her arms, "Fuck these reptiles and their shitty god."

As if the great creature heard Juliet, the group began to feel a small rumble under the cage, the reptilians grew quiet and faced the depths of the forest, bending down on one knee, and hissing prayers. The rumbles began to grow and the trees of the forest shook violently.

Johnnie, the most attuned to nature began to feel group-wide anxiety take over, "The god, the god is coming!"

Chapter 18: The Old Man

Johnnie Senior got home around 10P.M. The old scientist expected to see his twin boys playing videogames on the big screen, but when he got home the living room was dark with no one inside. The old man thought nothing of it as he made his way to the boy's bedroom, once again nothing.

"Ah, Fuck." Johnnie senior said, knowing what had conspired, "Bridge is going to kill me."

The old scientist rushed to his basement to see the door had been unlocked. He quickly entered his lab and made his way to the Warp-Sphere. The old man activated the machine, the black liquid appeared and disappeared, showing the world of the Valkyrie Gardens.

Johnnie Sr. made his way to the armory. The old man noticed a Kevlar jacket and vest was missing, "Damn those motherfuckers."

The scientist quickly found a long sleeve Kevlar shirt and equipped it, replaced his sandals with combat boots, his sweats with blue jeans, and completed the outfit with his special white lab coat. With a sigh, and a rub of his head, the old scientist walked into the portal to save his soon to be ass-whupped sons.

Chapter 19: God of the Reptilians

The pink sky and orange sun were invaded with purple rainclouds, the wet trees were swayed by an aggressive wind, the lizard men gyrated, raising their swords in the air, and letting their tongues soak in the violet rain drops. The creatures circled around the sturdy cage, created from the environment around them. The monsters had to perform to let their god know, sacrifices had been caught.

Within the depths of the marsh forest, there was a swamp. Inside the swamp an ancient creature slept. When he heard the clicks of the beings who praised and fed him, the monster opened its eyes and swam to the surface. It's long black talons drug themselves upon onto the ground, its long leathery snout sniffed the air, something new had come to its land. The creature pushed its sixty-foot long body across the ground, wondering if this new smell was because of its new meal.

"Hey, you fucking leathery bitches." Juliet screamed through the cage, "You bastards better be listening to me, or I'm tearing this cage down."

"Not without your blade." Johnnie sighed, "We still got magic lizard watching us."

"How about this?" Isaac asked, walking to the bars of the cage, "If you reptilians let us out you can have my whole manga collection!"

Johnnie put his hands behind his head and laid down, "Why did I bring you along?"

"He's doing more than you dog breath!" Juliet snapped.

"It's all futile until we can fight again." Johnnie said.

"Todos iban a morir." Ginger said to herself.

Tiana observed the lizard men,"It's like they're in a trance."

"It's prolly how they summon their god." Isaac excitedly added.

"It's just going to be some fucking overweight lizard." Juliet said, staring out of the cage.

Even though Johnnie's abilities were mostly blocked, he couldn't help but feel some creeping feeling within him.

Suddenly, the reptilians stopped their dancing ritual and began to part, as if they were forming a large pathway for something.

The bashful Juliet Valentine was the first one to see the incoming creature. Its skin was black as midnight, it's eyes were a lime green, its four legs were as big as tree trunks, and it closely resembled a crocodile.

"Wow!" Isaac said, "That thing is huge!"

Johnnie looked at the creature with disbelief, "That's what I was sensing?"

"Shit." Juliet said.

"Juliet," Tiana said, understanding the fuck up that had been made, "I think we took on more than we needed."

Tasia nodded in agreement.

As the large black crocodile crept closer, the six agents began to feel a fear take over. The fighters knew that without their abilities and weapons they would be the ancient beast's dinner.

Chapter 20: Attack on Crocodile

Surprisingly, the black menace tore through its reptilian's servants. The monster's rotten teeth ripped through emerald reptiles, unleashing green and black blood upon the scene. With a wave of its head, the crocodile scooped up the remainder of the reptilians, crushing them in one solid movement.

In the sudden turn of events, Juliet Valentine had noticed something, "Isaac, the Wizard Lizard is gone! Shoot a beam!"

Isaac aimed his right hand at the crocodile creature, the veins in his arm began to glow magenta, "Alright, back online!"

Isaac released a wave of magenta madness, which tore through the gate, and clashed into the large creature's eye, exploding on contact. The monster flinched as black steaming blood gushed from it's wound, eating through the plants it landed on. The large crocodile lashed out its tail in retaliation, taking out the roof of the cage.

"Girls!" Juliet screamed, "Find our weapons, they have to be somewhere close!"

Tiana, Tasia, and Ginger nodded, and they rapidly escaped the clutches of their prison. With the Lizard who stopped their abilities eaten, Juliet was sure she could summon her second weapon.

Isaac shot another magenta wave, however this beam proved to be rather weak, exploding upon the creature's rough skin, but leaving no damage.

"What's wrong?" Johnnie demeaned.

"That Paul guy." Isaac answered, "He took a lot out of me and I haven't eaten anything, so my powers are super we-."

Isaac felt a push from Johnnie and the twins hit the floor. The crocodile's large tail swung over the two, destroying the remnants of the cage. Juliet Valentine had rolled out the cage, dodged the attack, and lifted her left arm in the air. Juliet's left arm held a silver bracelet that she could use to summon her second weapon.

"O Romeo, Romeo," Juliet screamed, "Wherefore art thou Romeo? Deny thy father and refuse thy name. Or if thou wilt not, be but sworn my love And I'll no longer be a Capulet. 'Tis but thy name that is my enemy: Thou art thyself, though not a Montague."

Juliet through the chaos and the lightning kept her eyes toward the violet rain clouds, knowing her weapon was coming. The rain began to get a bit heavier; the pellets began to feel like small pieces of hail. Juliet could hear the screams of Isaac and Johnnie as they tried their best to fight the monster, she could see the frustration in her female comrades as they searched for their weapons, she could see a flash of orange in the sky and the sixty foot mech falling to the ground, and it's gray cloak billowing in the wind.

Chapter 21: Johnnie Sr. VS. Paul Savaar

"Got damn those boys." Johnnie Sr. said, through the purple rains of the marsh forest, "I guess an old nigga like me can't be to upset? I was just like them doing this at their age, probably worse." As the old man talked to himself, he pulled four seeds the size of baseballs from his pocket and threw them on the ground, "I'll just track them and beat their ass, Bridge don't need to find out or my wrinkly ass will be on the line." The seeds burst open on impact and small vines shot out, burying themselves within the dirt, "Those little knuckle heads better be in one piece." A creature emerged from the grounds of the forest, it was in the shape of a Rottweiler, made from, bark, dirt, and plants, "Looks like this soil birthed a strong one" Johnnie glanced over his flora canine and pulled Johnnie Jr.'s leather glove from his lab coat pocket, putting it near the dog's nose, "Go find the boys." The dog took several sniffs and sprinted into the depths of the forest.

Johnnie Sr. sighed, and wiped the rain from his goggles, "Jeezers, and it's raining too."

As the old man traveled farther within, he began to wonder what he would actually say to the boys? He knew he had to be intimidating, but he also had to let them know that this situation was dangerous. Johnnie True Jr. was the real one he had to get through to, Isaac just followed in his place, but what could the old man say to a young boy who had already lost everything? Johnnie Jr. was just trying to get revenge for his world. Johnnie Sr. couldn't count how many revenge missions he had done in his life. Would it be wrong to punish Johnnie Jr.? He was his

parent, even if he wasn't from the same dimension. Right?

A canine's cry disturbed the old man and he looked up to see a figure. A very tall man had his creation by the throat. The dog tried to fight back, but from a distance, the old man saw the creature go limp and fall unto the ground.

"The Enlightenment, Fuck." Johnnie Sr. said under his breath, "Now, I got to deal with these motherfuckers."

The old man reached into his pockets, taking out several more large seeds, and crushed them. Long, thick, green vines erupted from within the seeds and swirled around the old scientist arms, forming into spears.

Paul could see Johnnie Sr. from afar and smiled as he saw the man get ready for battle, "Johnnie Sr." Paul delightfully said, "I heard about you old man, The Mad Botanist."

Johnnie Sr. walked closer to Paul and could tell he was younger, which meant he was probably faster, and stronger. Johnnie knew he would have to initiate the first attack and sprinted towards Paul. Paul saw the old man coming and stood in place, he didn't think the old scientist could take him on directly. Johnnie Sr. stabbed with his left spear and with a wave of Paul's scaly left arm he parried it. The old man shot his right spear and Paul cranked his neck to the left, dodging the blow. Paul performed a swift roundhouse kick into the old man's ribs, and the wizened scientist staggered back. Johnnie quickly ducked a second kick for the face and implanted his spears straight into the ground. Vines erupted from under Paul, binding his limbs. A long thick vine slithered from the ground and viciously entered the

villains' mouth. Paul choked as saliva formed around the ridges of his lips, his body tried to break free, but the vines kept growing tighter around him, lifting him into the sky as he struggled for air. The vine that forced its way into his mouth began to pulsate, releasing a green smoke directly into his lungs. Paul's eyes became red, his body became floppy, and the vine left his mouth, with a plop sound and slithered back into the ground. Johnnie Sr. noticed something hanging from his opponent's pocket and took a better look at it.

"Jezzers." The old man said, taking the Homunculus Notebook from the man's pocket, "Dem little niggas better be happy I found this shit."

The sound of an explosion disturbed the old man's thoughts. He quickly turned to the right to see magenta lightning and fire evaporate in the air. The very next second a sixty-foot robot covered in a ragged cloak fell from the purple sky.

"Shit." Johnnie Sr. said, dashing towards his children.

Chapter 22: Romeo Vs. The Black Croc

Juliet Valentine's second weapon took the form of a sixty-foot bipedal mech. The giant robot was crafted from black steel, foreign technologies made the A.I., A black ragged cloak covered its body, and a giant jagged sword laid on it's back. To Juliet it looked like a knight, to her enemies it was the devil itself. Its name was Romeo.

Romeo's landing shook the ground, distracting the black monster from Isaac and Johnnie. Before the beast had a chance to attack, Romeo unleashed his large blade and swung it downwards, impaling the incoming croc to the grass. The chest of the mech opened, releasing a rope ladder for Juliet. The young girl sprinted to her robot, she hadn't used Romeo in about a month, and Juliet was dying to unleash today's frustrations. When she made it to the ladder, she could see the croc wiggling under Romeo's sword. The black monster foamed at the mouth, as green and black blood oozed from it's back, and it's rotten teeth gnashed with fury.

Juliet gave a quick middle finger to the scaly beast and rushed up the ladder, jumping into the cockpit. The ladder automatically wound up and the chest cavity of the robot closed, leaving Juliet in darkness. Three holographic screens appeared in front of Juliet, the middle screen was to see what's in front of her, the screens on the left and right were to see on the sides of Romeo.

Juliet smiled with pleasure as her hands wrapped around the joysticks and her feet pushed on the pedals of Romeo, "Come here you little scaly bitch."

Romeo yanked the blade from the crocodile, showering the forest in multicolored blood. In reaction, the croc opened its wide and foul mouth clamping down on Romeo's right arm. Romeo dropped his blade with his left and sent a hook into the creature's head. The monster's mouth opened and Romeo regained his blade, slamming it back down towards the croc, but this time the god rolled. The blade hit the ground sending plants and dirt flying every direction. The creature lunged for a leg, and Romeo swung its blade like a golf club, cutting into the poor creature's side. With a yank, Romeo tore his blade from the monster's ribcage, causing blood and reptilians roars to gush forth.

"So cool!" Isaac screamed, watching the battle with Johnnie from afar, "Giant robots fights are always awesome! Especially with monsters."

Johnnie was also impressed by the spectacle, but he would never let Isaac know, "You are amazed by anything aren't you?"

"Johnnie." Isaac said in disbelief, "How are you not amazed by giant robot battles! Oh stuffmuffins, I forgot my Zphone! I got to put this on immediategram!"

"I will never let you hold my phone."

"Here's Juliet's blade." Ginger said, finding it under a pile of grass.

"Too late now." Tiana said, equipping her bow and arrows, "I think she has this."

"With Romeo, she's unstoppable." Tasia said.

Ginger sighed and smiled, sitting on the ground, "I guess the stories about her are true."

In desperation, the Black Crocodile reared now itself up on two legs, going for a bear hug, but the Robot proved more swift as it took a couple of steps back and pierced it's giant blade through the chest of the monster. The creature screamed, spewing blood, its limbs wiggling as Romeo brought the blade up, so the giant beast could slowly slide down. When the creature got near the pommel, Romeo brought down the blade in a horizontal position, and kicked the croc off. The creature landed onto the marsh with another groundbreaking clatter, and gave one last blood gurgling roar before dying.

Final Chapter: Ownership

"We fucking did it!" Juliet screamed, from the edge of her open cockpit.

"Lo hicimos." Ginger yelled, running to Romeo and Juliet.

"Once again another mission done." Tiana said.

"Didn't you think we were going to fail?" Tasia questioned.

Tiana shook her head, "Let's not tell Juliet about that simple detail."

"That rocked!" Isaac said, running up to the group, "Juliet was like POW then BOOM, then BAM, then alligator death."

"It was a crocodile." Tasia corrected.

"Isaac and I could have handled it." Johnnie said, walking up.

"Yeah right, dog breath." Juliet screamed from the cockpit.

Johnnie shrugged it off.

"Now all we need to do is get the notebook." Isaac said.

"I got the notebook you knucklehead niggas."

Hearing the voice of their father, Isaac and Johnnie True immediately turned around.

"I told you boys." Came the rough voice of Johnnie Sr., "I told you to forget about this notebook stuff and be normal." The old man stopped in front of Isaac, who began to sweat and shake at the knees, "Now, Isaac, what did I tell you nigga?"

"Ummm." Isaac looked at Johnnie who looked away, "It was Johnnie's fault."

"What? You're going to snitch on me with the old geezer."

Johnnie Sr., right hand popped Johnnie in the back of his head, "What you call me boy?"

Johnnie Jr. growled, "I'm sorry father."

Johnnie Sr.'s left hand popped Isaac in the side of the head.

"What was that for?" Isaac whined, "For being a sidekick to Johnnie's nonsense?"

The old scientist grabbed his twin boys by their collar and threw the Homunculus Notebook to Tasia, "Get that to the Society. Good going girls."

"Good going? Isaac protested, "We helped too."

"Probably more than them." Johnnie added.

"You probably caused a bunch of fucking mess." The old man rubbed his baldhead, "Jezzers."

An orange portal appeared behind the old man and his sons. Johnnie looked at his twin sons, shook his head, and pulled them into the portal. The girls watched it close and when the portal was gone they began laughing.

"Did you see that shit?" Juliet cried, "They old ass daddy beat they ass."

"Johnnie." Tiana madly giggled, "Big bad wolf was put in check."

"Lo siento padre." Ginger fell onto her back, "Johnnie was so scared."

"It was quite humorous." Tasia said, wiping a tear from her eye, "We should get going and make the report."

"Yeah," Juliet said, gaining her composure, "Let's get the fuck outta here."

<center>***</center>

Paul Savaar woke up onto a marble floor. The member of The Enlightenment felt tired, stiff, and his head felt muggy. The man got to his feet and looked

around to see bronze walls and a large circular table in front of him. Several people sat around the table, all-important members of The Enlightenment.

"Paul." Said one of the members at the table, "You seemed to have failed us."

Paul produced a low growl, "It…. I ran into Johnnie Sr., he's a crafty old bastard."

"You were supposed to take the book and kill the agents." Said the member, "Why did you fail?"

Paul looked down at the floor, he was of flesh once again, his toes covered in dirt and blood, "I…I wanted to make it dramatic."

The member sat down and another rose, "What should we do."

The members began to chatter, however, their voices were so low Paul couldn't hear.

The chatter stopped abruptly and one of the members left the table and stepped towards Paul. Paul made her out as an elderly woman, wearing a long white dress and pearl necklace, her hair was blonde, and her eyes seem to be as cold as her voice.

"We'll make the necessary changes to your DNA, then the next mission you will surely pass."

At the end of her sentence, Paul felt large hands grab his body, "What…what do you mean?"

The old crone smiled.

Paul tried to struggle but he was still short on energy. All he could do was laugh in hysteria as he was lifted up and taken from the Bronze room.

THE END???????????????????????

The Mad Conquest
Prologue:

Johnnie Sr. crept his way through the dim halls of The Society of the Unknown. The wizened scientist was called by the higher-ups, for what reason he did not know. Johnnie was annoyed by this meeting, he would rather be in his lab. The top faculty were all a bunch of youngins, bunch of breast milk fed kids who didn't know what the fuck they were doing. When the old man got to the door of Ronald Donald, he reached in his lab coat pocket, pulled out a joint, a lighter, and swiftly put the joint to his mouth and lit it. The old man took in the healing smoke, letting it run through his body, and then released it through his nose. Johnnie took another puff, turned the black knob, and entered the room.

The hippy scientist entered a place with blackwood floors, two black leather couches, a black steel desk, and a forty-year-old man. Johnnie Sr. scoffed at the young man who sat nervously at the desk, he reminded the scientist of a teenage boy who was waiting for his date.

"Why am I here Ronald?" Came the rough voice of Johnnie Sr.

Ronald shuffled through several papers, his eyes darting to Johnnie's rugged face, then back to his desk and files, "We've…we've been pr- pretty light on manpower." Ronald's voice was rushed, he stumbled on words, "We need everyone we ca- we can on missions to pre-prepare for the Enlightenment. They only have one book, but we shouldn't give them an inch." Ronald's eyes locked

on to Johnnie, "Meaning," Ronald gulped, "meaning were going to need to send you out on a mission."

"I don't do missions." The old scientist responded, "That was back in my younger days, you know I only do the lab."

"Yes." Said Ron nervously, "However, people higher than me want you out in the field." Ronald put three papers on his desk, "There's nothing I can do. Please look at your teammates that will be coming along. "

Johnnie Sr. uttered several cusswords under his breath and glanced at the sheets, "They're all a bunch of damn kids." Johnnie Sr.'s hard dark eyes focused on Ron's sweaty expression, "You motherfucka! I'm not going into hell with a bunch of babies."

Ronald knew this would happen, "They might be young but….but they each hold the title "Mad" in their own field."

"Fuck if I care." Said the old scientist.

"Johnnie," said Ron, "You know you can't get out of this, it's directly from the top"

"Fuck that motherfucka."

Ronald shook his head, "You know what will happen if you disobey."

"I should have gotten out of this shit a long time ago." Johnnie said, rubbing his gray beard, "Fuck."

"So?" Ron said, trying to change conversation, "How are your b-b-boys doing?"

Johnnie gave the man an irritated look, "Don't give me how's the boys you fucking snake." The old man turned towards the door, "Brief me on the mission when your ready, I'm going to my lab. Goddamn you motherfucka."

Johnnie slammed the door with the strength of a man in his early twenties. Ronald nearly hid under his desk. When he knew Johnnie Sr. was gone he sank in his chair and said, "Why do I always get the angry people?"

Chapter 1: We are the Mads!

A ninety-sixty seven, black Camaro Chevy, drove on alien pathways. The car carried two crude guns attached on the hood composed of steel, wires, and plastic. White fire spewed from the barrels of the engine, whenever the car picked up speed. However, the vehicle was not alone, as a beast began to stalk it, jumping from abandoned spire to abandoned spire.

The creature had never seen anything so fast, so queerly made, so foreign. The animal wanted to test it, to see what capabilities the machine had. The creature nine feet in height, with the body of an earthly gorilla with green fur, landed in front of the odd contraption. The car came to a halt, with squealing wheels, and black smoke. Its hand-patched cannons focused on the monsters chest cavity and released bullets in the form of white energy. The green gorilla staggered back with lime green blood in it's mouth, its arms flailed, its mouth then released a deep holler, but none of that mattered to the strange vehicle.

The car decided to drive backwards, away from the gorilla. Its speed caught the creature off guard, but even in its worn state the beast gave chase. It ran on all fours, racing toward the warrior car. The cannons resumed firing bullets, aiming for the monster's face. The creature took the attack head on; white bullets tore into its lips, popped its eyes, and broke through its teeth. The car came to a halt, and then sped forward, its cannons starting to charge. The black automobile crashed into the gorillas chest, releasing its energy. A white blast shot out from the gorillas' back, tearing through green fur, intestines, and bones. The gorilla creature let out one final deep

roar, falling into a pile of its own insides. The black car covered in green blood made its way towards the tallest spire.

The battle scarred car came to a halt within the middle of the spire, releasing its passengers. The first one to come out was an seasoned ebony scientist, with a bald head, black goggles around his neck, a white lab coat, a black Kevlar shirt with matching pants, and lastly dark combat boots. The second passenger was a short, brown skin boy, he had long hair wrapped into a braided ponytail, a white and black Kevlar jacket, with black jeans and combat boots. The third passenger was an eighteen-year-old fair skinned woman, she wore an outfit crafted from kevlar and resembled a blue racecar driver. The girl's face had rings decorating her nose and ears, half her head was shaved, while the other half had pink long hair. The fourth chocolate skinned, teenage girl, wore a droopy witch hat, spilling with black dreadlocks decorated with silver rings, a long black trench coat hid her black long sleeve Kevlar shirt, gray tight pants, and black boots.

"Did you track those two following us?" asked the old man, known as Johnnie Sr. aka The Mad Botanist

The young teenage boy turned to his superior, "I saw them." the boy turned his back on the entrance and reached for his plasma pistols on his hips, "I'd like to try my new invention." The boy was known as The Mad Inventor.

"I thought I shot those bastard's earlier?" Said the pink haired girl, Natalia Espada aka The Mad Racer.

"If you saw them why didn't you shoot them?" said the fourth member, Trina Valentine aka The Mad Alchemist.

"Because I'm going to take them right here." Announced the Mad Inventor, "You three get in the car, I got this."

"Are you sure?" asked Johnnie Sr. "I don't need a dead nigga on my conscience."

"Your language is past its time old man." The Mad Inventor let his hands feel on the trigger of his pistols, "I got this."

The old man nodded, "Don't call me old Nigga, girls get back in the car, were going to the higher floors."

The three remaining scientists hopped back in the car, and made their way to the elevator. The Mad Inventor smiled a vile smile and turned toward the entrance of the spire, where he saw two figures come forth.

Chapter 2: All Hail The Mad Inventor

The Mad Inventor stood at the entrance of the spire, his hands stroking the trigger of his pistols. The young man was keenly aware two members of The Enlightenment had been following him and his comrades. The Inventor was pleased by those facts, cause it meant he could try his new weapon. The young man let violent thoughts fill him with glee. How could he defeat these two opponents? Decapitation? Torture? Fear? So many different and unique ways on how to attack his foes ran through his mind.

"I'll show that Juliet Valentine." The Inventor spoke to himself, "I can't believe this wild debauchery is for her anyway." The Inventor rolled his eyes, "They put too much trust in her."

"Is the little boy Jealous?"

The Mad Inventor left his thoughts and noticed two opponents coming forward. He focused on the taller girl first, her hair was fire red, and her skin fair with a little tan. She wore red Kevlar body armor, black jeans and red boots. The second girl seemed a foot shorter; she was pale in complexion, with silver hair, and a matching silver Kevlar outfit.

The Mad Inventor smiled, while taking out both his pistols, "Jealousy, such an emotion is for weak minded simpletons."

The girl in red made a right fist, which became surrounded in an orange orb. The girl in silver balled both her fist, which became orbs encircled in a silver light.

"You ready." Said the girl in red to her sister.

The silver girl nodded, "Let's rush him and show the power of the Pepper Twins."

The girls exchanged glances and sprinted into the air. The Inventor was surprised to see the girls had the ability of flight. He immediately became trigger happy, releasing beams of red plasma from his pistols. The girl in red easily spiraled between the bullets, but her sister had her problems as several bullets hit, which this caused her to crash into the ground. The Inventor quickly stepped to the left, dodging a flying punch from the redhead girl.

He put his right pistol to the crimson girl's abdomen, and shot it at point blank range. The scarlet girl felt the pain of fireworks exploding in her body, she flew through the air, and crashed back first into a wall. The silver girl got back on her feet and rocketed into the air towards The Inventor. The young man quickly bent his body back, letting the girl fly over him, and sent two plasma bullets into her stomach. The silver girl was blasted several feet into the air, and fell face first into the light blue stone of the spire.

The Inventor smiled as he put his left pistol to the silver girls head, "Check." A metallic sword like leg shot out from The Inventor's back, and stopped inches away from the incoming red girls neck, "Mate."

Chapter 3: The Reason

"So what are we searching for?" Asked Trina Valentine, "The Onion heart?"

"The Oni Heart." Johnnie Sr. grumbled.

"Yeah," Trina said, "and it's all to help my cousin's robot?"

"It's more than just that." Johnnie Sr. said, inhaling and exhaling his joint, "Juliet's mecha Romeo is an relic of the Original Roswell Wars. It has capabilities she is hardly aware of." The old man took another puff, "If only her father was alive to properly train her."

"Sucks, Poor Julie." Trina said, leaning into the comfy leather seat of the car.

"Well, let's be happy we didn't get that Valkyrie Garden job." Said Natalia, "I heard it was rough, eh, old man?"

Johnnie Sr.'s intimidating glance turned towards Natalia, "Call me Johnnie, nothing less, nothing more, you got that young woman."

Natalia nodded, "Si, Johnnie." He obviously wasn't the joking type, the young woman thought.

"So was the Rossie Wars scary?" Trina said, breaking the awkward moment, "You fought with Juliet's dad right? I never got to meet my Uncle, was he cool?"

"He was a nigga that did his job." Answered the wizened scientist, "That's all we could ask of him those days."

"But was he cool?" Trina asked, still pining for an answer.

The old scientist shook his head, "You kids don't know nothing. Little girls shouldn't be out here

doing dangerous missions and that motherfucka inventor boy has a couple of screws loose."

The elevator came to a stop on the top floor of the predestined spire. The vehicle crawled out into the middle of the dome area, releasing its irritated passengers.

"Do you really believe that?" asked Natalia, "That girls shouldn't be agents?"

"Don't matter what an old nigga like me believe." Johnnie Sr. looked over the area. The ice blue floor was made in intricate and elaborate designs, the roof was a glass dome, and defying all laws there seemed to be a corridor connected to the back wall, somehow leading deeper within, "You youngins controlling the world now. Who cares in what I believe in."

"I think he's a cranky old man." Whispered Trina to Natalia.

"Doesn't mean he has to be a pendejo." Natalia whispered back.

Johnnie Sr. walked to the entrance of the corridor. The old scientist noticed the majority of the hallway was pitch black, besides the faint red glow in the far back.

"It must be where the jewel is." The scientist whispered, "Got damn, shit can never be easy."

"You girls stay here." The hippy scientist ordered, "I'll get the jewel and were going to help the boy."

"You might need our help?" Natalia said with a smile.

"Fuck off." Johnnie Sr. said, taking another puff and heading into the depths of the corridor.

Trina nodded and nervously smiled, "Looks like things are starting off nice. He might be old, mean, and grumpy but at least he's caring."

Chapter 4: The Pepper Twins

Sol and Luna Pepper originally had loving parents, but because of the girl's abilities, The Enlightenment abducted them. The girls were put under rigorous training for the next six years. While Luna became quickly obedient to the hand of the Enlightenment, Sol was a different type. She was constantly captured and beat by various members of the Enlightenment, for trying to escape. One time, Sol was knocked so hard in her temple she slept for three days. Sol still remembers the wet loving kisses of her father, the warm hug of her mother, and sometimes she swears they even had a pet dog or cat. She knew one day her and Luna would escape the Enlightenment and find their parents. One day they were going to be free. Sol just had to wait.

"Are you going to shoot me?" Luna said, staring into the barrel of The Mad Inventor's gun.

The Mad Inventor loved to see people grovel to him, it was highly arousing for a man of his intellect, "Maybe I will?" The Inventor turned his multicolored eyes to Sol, who was frozen, due to The Inventor's blade like appendage nimbly scraping her neck, "Or maybe I'll cut your sister's pretty pink neck?" a goblin of a giggle left The Inventor's mouth, "Oh, why do I feel so villainous?"

"I doubt it sis." Said Sol, "I bet he's to much of a chic-"

A light cut across the neck stopped Sol's sentence.

"wouldn't be much of a villain if I didn't keep my word?" Said The Inventor, "I do what I want when I want."

"How about we join you?!" spouted Sol.

Luna gave a quick look of confusion towards to her sister.

"Join?" but why? Thought The Inventor. What were they trying to get at?

"We might be part of the Enlightenment, but I never liked them." Admitted Sol, "Neither has Luna."

"Sister?!"

"Shut up Luna!" Screamed Sol, "Look, Crazy man, you got us beat. You either kill us or send us back to the Enlightenment and they will kill us for you. I've been trying to leave that backward organization for a long time now. You look like just thew ticket."

"So you can just betray us?" The Inventor said, "So I can be a Judas to the Society?"

"No." Responded Sol, "We will be a big help. We know some secrets of The Enlightenment. We even know the location of their Warp Sphere."

"Sister, what are you doing?" Tears began to form in Luna's eyes, "If we betray the Enlightenment they will do to us what they did to Paul."

"Fuck Paul." Said Sol, "He got what was coming to him."

The Inventor ignored the squabbling of the sisters and weighed the pros and cons to Sol Invitation. He knew the Old Man wouldn't like it, but if they knew the location of the Warp Sphere, The Inventor could easily get ahold of all that Enlightenment technology.

"Fine." Acknowledged The Inventor, sheathing his pistol and retracting his bladed leg. "Just to let you guys know," The Inventor pointed to his back, "this contraption that resembles a spider on

my back, releases four bladed legs that act on their own. You try to double cross me and your pathetic heads will be in the air before you know it." Another demonic giggle left from The Inventor's mouth, "Lets go see the old man. He's going to get a good ol' surprise from this one."

Chapter 5: The Demon in the Gem

Johnnie Sr. walked within the dark depths of the alien spire. To combat the void of light the old man took out a joint, lit it with the lighter, put it to his lips, and inhaled. The wizened scientist was immediately granted with the ability to see in the void. Now, with no fear of anything coming out to attack him, the old man let his thoughts wander. The Society said they were low on people, so they use an old man and a couple of kids to get some kind of mystical gem? Things didn't add up to the old ebony man. The Society of the Unknown was always a sketchy group, Johnnie Sr. had only stayed with them so long because they funded him and helped take care of his family. Thinking of his family made the old man rub his head, his most recent children were a handful to handle. Isaac and Johnnie Jr. had got themselves tangled within The Society. Bridge wouldn't like that, The Society had their eyes on them now. Shit, the boys didn't care. One boy was from a whole another dimension and on a crusade for revenge and Isaac had a burning need for adventure and would follow Johnnie Jr. to the depths of the fiery pits.

The old man chuckled, "My life is a fucking mess, Jezzers."

Johnnie's thoughts were disturbed as he noticed the glow of the gem. The crimson color began to overtake the darkness, showing the true form of the halls. The hallway continued to be decorated with intricate design's of the spire. Johnnie also noticed pictures scratched in to the floor. One picture showed a gem and a monster devouring it.

"Shit." Johnnie Sr., said to himself.

The old man continued, the light got brighter; the old man puffed his joint so he could see through the light. When he got close to the gem, he could literally feel heat waves come from the crystal.

"Come out you fucking beast!" Yelled Johnnie Sr., "I got shit to do!"

The Gem reacted with an otherworldly scream, shaking the very insides of the spire. Johnnie Sr. put his hands in his pocket, inhaled some more of his joint, and grimaced.

<div align="center">***</div>

"Did you feel that?" Said Trina Valentine, "I think he needs help?"

Natalia Espada rolled her eyes and shrugged, "That anciano said he could take care of himself." She began to walk toward the corridor, "but I'm bored with nothing to do, might as well see what he's doing?

Trina excitedly nodded and followed.

Chapter 6: The Mad Inventor's Intervention

"Let me explain the details to the old man."
The Mad Inventor said to the Pepper Twins, "With
his archaic thinking he'll probably think you two
seduced me or something."

"Seriously? You? Yeah right!" Said Sol,
staring as the walls passed by outside the elevator.

"Do you really think this is a good idea?"
asked Luna, "We can't just switch teams like this?
The Enlightenment won't have it."

"The Enlightenment can lick my fiery
asshole." Responded Sol, "What about all the things
they have done to us sis?"

"It made us stronger, didn't it?" Questioned
Luna.

Sol shook her head, "They got in you deep."

Luna sighed, "Maybe you just didn't take
what they were offering?"

"Could you two quit your non-"?

Before The Inventor could finish his
complaint, the elevator came to a halting stop. The
outside wall creased vertically, forming a door that
opened into a corridor of darkness. In the very back
of the pathway, The Inventor could spot a faint
crimson glow. With a malicious smile, The Mad
Inventor grabbed his pistols and ventured into the
blackness.

"Come on Luna," said Sol, "were following
him."

Luna didn't understand why her sister was so
intent on breaking from The Enlightenment. Sol and
Luna were two of their most faithful warriors. Luna
was sure one mess up wouldn't end their careers, but
Sol was always the more aggressive one. The one

who constantly challenged the Enlightenment. Luna regretfully followed her sister.

The hallway was dark, but The Inventor had experimented on himself in the past, gaining the ability to see in the blackness. Sol created an orange ball of light in her right hand, to serve as a torch. The light let the girls see the art painted on the walls. The art of a giant beast, that seem to swallow the people who fed it. It gave Luna the slight case of the chills, but Sol hardly paid attention. The Inventor's mind was focused on the crimson light. What did the light mean? Did he find the crystal? Were there secrets waiting to be discovered? The closer The Inventor got to the crystal, the more he wanted to know about it. Touch it. Feel it. It was like he was in a trance. Soon, the red light took over the darkness, filling the hallways and exposing everything to the Trio.

The three were in the center of a large dome area; carvings filled the wall of a beast in a man like figure tearing through humans. The gem which lead them was in the center of a nine foot suit of armor. The armor itself resembled that of a samurai, on it's back was a long red sword, it's helmet took the shape of a beast with large white fangs, and it's arm reached out, grabbing The Inventor.

Chapter 7: Johnnie Sr. Vs. The Red Demon

Long, thick, vines shot out from the sleeves of the old scientist, wrapping around the neck of a four-legged, red-fur, winged, lion faced beast. However, even in the midst of choking, the beast was still able to produce several spheres of fire that aimed for Johnnie Sr. The wizened scientist stomped onto the ground, summoning several vines to erupt from the earth, and act as a shield. The fire hit, eating through the majority of the shield, but keeping the scientist safe. The remainder of Johnnie's vines burst with thorns, implanting their serum into the bloodstream of the gem beast.

The monster of the crystal felt no drowsiness from the plants. They only enraged him as his fangs tore the vegetation from his neck, and his hot breath caused them to wilt, leaving the old man vulnerable. The monster reared his head, gathering fire in its mouth, and aimed downwards toward the old scientist, letting out a deadly stream of flame. Johnnie Sr. was stuck, he had nowhere to go as the blaze spread out before him, blocking him from retreating. The old man was close to giving up, but someone rushed past him, she bashed her specialized blue gauntlets together, forming an invisible shield around the old man, Trina, and herself.

"I don't need no help from a bunch of girls!" exclaimed Johnnie Sr.

Natalia shook her head and smirked, "You be a roasted Abuelo if it wasn't for us."

"You, young women are to soft for this type of deal." Johnnie Sr. snapped, "You'll just be in the way."

"Whelp, We're in the way now so just let us help." Trina smiled, "Pwease."

Johnnie rubbed his baldhead; "Fucking bi-" the old man caught himself, "Fucking women, go ahead."

"Yassssssss!" Trina screamed, slamming her hands unto the ground.

Trina called upon five twelve foot spears, created from the material she stood upon. The weapons arced through the air, piercing the beast in his body and eyes. The monster screamed in pain, fire brewed from his nostrils, and his claws raked against the ground. Johnnie aimed his right arm to the creature's face and took another puff. A singular thick vine came form the man's sleeve and shot into the mouth of the creature, the thorns on the vines extended, and pierced into the roof of the beast. Johnnie Sr. smiled as his plant pumped its juice into the creature, the monster became wobbly on the legs, it's head bobbed back and forth, and several more of Trina's spears appeared under the creature and pierced into its stomach.

Natalia pointed her blue gauntlets toward the beast, flexed her fist, shooting several white bolts, opening wounds, and irritating the creature all together.

The beast, filled with rage, flapped its massive wings, lifting itself into the air, tearing its intestine as it escaped the spears in its stomach. The creature closed its fangs, tearing the vine from its mouth, and began to build its fiery blast once again.

The trio looked up at the beast, a feel of failure began to build in their soul.

Chapter 8:The Armored Demon

The Mad Inventor grabbed his pistols, aimed the weapons at the chest of the armored being, and pulled the triggers. The Plasma bullets collided into the armor, but dealt out no severe damage. The suit of armor looked down at The Inventor and grabbed the pummel of its blade. The Inventor held his stance. The armor rapidly unsheathed its weapon, and went for a horizontal slash for The Inventor's neck. Luckily, one of The Inventor's bladed legs emitted from the metallic spider, parrying the attack.

"Oh," The Inventor said, proud of his creation, "I bet you thought you had me?"

The armored opponent raised its sword again, to only be countered by Sol, who threw an orange glowing fist into the chest cavity of the armor. The red armor crashed into the back of the wall, falling lifeless unto the floor.

"What was that Mighty Inventor?" Sol asked. *What was that Mighty Inventor?*

"This place seems to have a lot of queer life forms." The Inventor admitted.

"We should get done with whatever you people were doing and go." Suggested Luna, "The Enlightenment said this planet has some very nasty level five creatures."

The Inventor was intrigued, "Level five?" The Mad Inventor questioned, "Is that the Enlightenment's rating system? What am I?"

"Doesn't matter." Said Luna.

"You're a four." Answered Sol.

The Inventor nodded, quite pleased with his rating, "Hmmm, sounds about right. I should make a five in my early twenties."

"Happy you feel relieved." Said Luna, sarcastically.

The Inventor turned towards Luna, "I feel like Sol might be the only one who is brave enough?" The Inventor gave one of his ghastly smiles, "Luna, you are faithful to the Enlightenment, are you not?

Luna gave a glance to her sister, Sol had a look on her face that read prove your worth, Luna turned back to The Inventor and her eyes grew wide.

"It's still alive!"

The Mad Inventor had no need to turn around. The metallic spider on his back activated on it's own accord. The legs pierced straight through the crimson armor. The soldier grabbed its blade, and The Inventor pointed his right pistol behind himself, shooting the sword from the armor opponent's hand. The spider legs began to tear themselves from the armor to only pierce it again, and again, and again. The girls watched as the legs began to dissect the living armor, tearing through it's fantastic designs, scratching it's crimson shine, blood began to gush forth from its mouth, squeals of anguish began to be heard, and the whole time The Inventor watched with multicolored eyes of awe, as he stripped the armor, revealing the true opponent.

Chapter 9: The Hell of Failure

Johnnie Sr. ran in a zigzag formation, his head feeling the heat of the monster's flames, his lab coat burned and tarnished, and his body tired. Natalia released a barrage of her white energy diskettes, spraying them upon the open wounds of the beast. Trina shifted the grounds of the spires into spike lances, sending them flying into the bleeding flesh of the creature. The combo attacked cause the monster to stagger and Johnnie Sr. went on the offensive. The old scientist grabbed several seeds from his pocket and smashed them upon the field. The ground under the old man rapidly began to shake, giving birth to several large Venus Flytraps. The plants rapidly slithered from the ground like snakes and gnashed their fangs at the beast. The fiery monster roared, bits of flame escaping from its mouth. The flytraps bared white fangs of bone and attacked, sinking in their bladed teeth and feeding on the blood of their opponent.

The monster summoned another fireball in its mouth and swallowed it, causing fire to escape from every open wound. The flytraps feel back, screeching in pain as the fire burned them alive. The intensity of the heat caused Natalia to summon another invisible shield, to protect her and her allies.

"When the fire goes down we got to hit that motherfucka with everything we got." Johnnie Sr. said, through the rumbling of the flames.

Trina and Natalia nodded in agreement.

The flames of the beast dissipated as fast as they appeared, and Natalia let down her shield. Trina quickly crafted several more spiked spears, sending them into the open mouth of the creature. Natalia

smacked her fist together and released a white beam of concentrated light at the creature's head. Johnnie Sr. pointed his right arm at the monster, rocketing another spear of vines at the creature's face. alchemy, light, and flora collided into the creature. A moaning roar came from the monster as it spiraled into the back wall, leaving a trail of blood as it slid down.

"That was lit!" screamed Natalia. "We wrecked that puto!"

"Shut the fuck up." grumbled Johnnie Sr.

Natalia crossed her hands with a frown, "Admit it, we saved you."

Johnnie Sr. walked up to the creature, rubbing his baldhead, "Shut the fuck up, little girl."

"I think that means thank you." Trina said.

"It means he's an old man stuck in his ways." Natalia added.

The Old scientist bent down eye level with the creature, observing it's body, searching to where the gem laid, but as the old man focused on the creature's eyes he noticed something, there was still a breath of life in them, their beastly opponent wasn't dead.

"Ah, shit." Said the old man getting to his feet, "This nigga still alive."

The lion creature began to moan, the faces of Trina and Natalia went from victorious to scared, the wings of the beast began to beat, the mouth began to move, the muscles began to flex, half dead the creature got to his feet and let out another menacing roar.

Chapter 10: The Flame of Sol

The Mad Inventor was near the point of orgasm, as his sword appendages tore through the creature in the armor. The Inventor was pleased as blood spilled, as the creature flailed, as it screamed unknown words, this was what The Inventor needed, but then it suddenly stopped. The Mad Inventor, with saliva running down his mouth, looked down to see the creature's wrinkly red claw grab all four of his spider blades. The monster stood from out of his broken armor, scaling nine-feet in height. The creature's face looked like a snout, its body was slender, its legs were hooves, and its four arms had three rotten yellow claws. It lifted The Inventor easily off the floor, which in reaction, The Inventor blasted both his plasma pistols into the creature's face. The monster, growing frustrated with The Mad Inventor threw him into the back wall.

Sol and Luna exchanged glances and charged at the demonic beast. Sol was the first one to make it to the creature, throwing a left hook to the monster's face. The creature took a step back, dodging her punch, and blasted all four of its fist into Sol's stomach, sending her flying like a ragdoll. It quickly caught the icy kick of Luna and slammed her into the cold and hard ground. However, Sol was not so easily defeated, as she rushed the creature, and gave a right jab to the monster's stomach. The monster grabbed Sol's right hand, applying the pressure of several strongmen. Sol tried to yank free, but the creature had a good grasp on her wrist. Due to the pain, Sol quickly fell onto her knees, with tears in her eyes, and fear in her heart.

Sol looked towards Luna who was still out cold, she looked towards The Inventor who was still sleeping in the wall, and realized this might be her death. Dread began to cripple the young girl as her thoughts began to turn negative. How would she get out of this? Would she get out of this? Maybe she should have stayed with the Enlightenment? Sol began to give up hope, but her ability chose for her otherwise. Bright orange flames escaped from Sol's right hand, causing the beast to lose grip and stagger back. With her flaming right hand, Sol gave a fiery jab into the creature's abdomen. The monster caught flame as it hit the wall. Unfortunately, for Sol, the flames died quickly.

"Did I?" Sol said to herself, "My powers never done that before?"

The girl tried to summon her flame again, but all she got was black smoke emitting from her palm. An unearthly roar disturbed her, causing her to look up at the wrinkly nine-foot creature. She knew without her newfound flames she be a good as dead in seconds. For the first time in Sol's life, she didn't know what to do. The creature's queer figure covered her as several rays of plasma collided into the monster's body.

"You thought," The Inventor hacked a luge of blood, "You could take me out so simply." The Inventor with hands of blood held on tight to his pistols, as he pointed them toward the beast, "I'll tell you many people have tried to take me out vile creature." The Inventor laughed with a face streaming of crimson, "But you my ugly little friend. You are something else entirely!"

The Inventor became lost in his own madness, going into a trigger-happy state again.

Plasma reigned from metal barrels, charging into the body of the creature at a rapid pace. The monster let out an ear-busting scream, causing The Inventor to flinch. The creature opened its mouth, creating a crimson blast of light that struck The Inventor, trapping him in his own hell.

Chapter 11:The Soul of the Jewel

Johnnie Sr., Trina Valentine, and Natalia Espada looked up at the dying winged lion, as it opened its mouth, releasing a human figure in crimson saliva. The beast immediately crashed lifeless on the ground and the naked lubricated figure stood up. The human was six foot and seven inches; his skin was bronze, his long hair blood red, his body was slender and muscular, and his eyes were black voids. The peculiar man laid his eyes on Johnnie Sr. first. Before the scientist could reach in his pocket, the newly formed man raised his right hand to the wizened scientist and bent his fingers. Johnnie Sr.'s muscles became cold and stiff. The queer man began to walk towards the elderly scientist.

"Correr!" Natalia screamed, "Get out of there old man!"

"This Motherfucker froze me!" warned Johnnie Sr.

Natalia banged her gauntlets together producing another beam of white energy. The red haired man held out his left hand and absorbed the beam with ease.

"Por que?" Said Natalia.

Trina spiraled her hands around each other, and the materials that created the floor became as fluid as water and swirled around her. Trina threw her hands forward and the liquid switched into snakes of cement, brandishing their granite fangs. The bronze skin man held out his left arm and the snakes became sand on impact.

Trina fell onto her knees, deflated, "That was my best trick."

The intimidating figure made his way to Johnnie Sr. and when he reached the old man he said, "Many have came to this foreign building and tried to take the gem." The bronze man looked down at the shorter ebony man, locking eyes with the human, "I am the soul of this gem. The body lies elsewhere in battle. I have the strength of a millennia. What do you have?"

Johnnie Sr. smiled, "Marijuana."

The red haired man shook his head and held out his hand in Johnnie Sr.'s face, "I'm going to obliterate you all and go back to sleep. Goo-"

A red light appeared above the scene, causing everyone to look up and hear the laughter of a mad man.

Chapter 12:The Sins of The Inventor

The Mad Inventor was once a fourteen-year-old girl, who went by the name Jewlee Jubilee. Jewlee lived in a not so nice town, with her not so nice father, in a not so nice apartment. The girl persevered by delving into the world of robotics. Jewlee constantly made small robots that did simple things like sharpening a pencil or cleaning a piece of trash. The girl had no true friends so her small bots were the only thing to give her pleasure. However, over time Jewlee wanted more. The young inventor was always sick, so sick she was bound to a wheelchair and hardly able to go to school. When she was able to go to school the girl could tell people looked at her queerly. They saw she was weak and stayed away. Why would someone want to be friends with someone who was constantly coughing and looked like she was about to die? Jewlee understood.

One day, after months of research and gathering materials, the girl created a serum. The serum shined blue and looked like a glowing ocean. First Jewlee tested it on her pet gerbil. The results were instant. The small creature's eyes became a multicolor of green, orange, and red. The rodent let out several screeches as it grew twice in size, its small teeth became fangs, and it's personality shifted into that of a beast that was trying to chew down his cage. The young inventor was proud of the results, strength, agility, augmented personality, this was everything The Inventor wanted and more. She quickly grabbed the second syringe put the needle to her own flesh and injected the serum.

The Mad Inventor watched as his female self fell from her wheel chair, screaming in agony. He

watched as his muscles grew, as his hair became full, as the sickness temporarily burned away and The Mad Inventor stood on his own two legs.

The Mad Inventor threw back his head and gave a chaotic laugh, "Was this suppose to make me think of better things? I know you did this vile beast. Making me see my past." Tears streamed down The Inventor's face, "Am I supposed to wish I were that sick fool again? Was I pure or something back then? If you're trying to make me regret something all I see is the greatest day of my life! The day she invented the Hyde Serum and I was born!"

The Mad Inventor realized he was back in the depths of the spire. The queer red skin creature had Sol in one of his hands and Luna in the other. The Mad Inventor found his Plasma pistols in their holsters. He pointed his guns towards the head of the red creature and shot them simultaneously. The bullets of red energy arced through the air, shot through the head of the creature, and killed it on impact. Sol and Luna immediately fell to the ground with the monster, quickly getting on their feet and rubbing their necks. All The Mad Inventor could do is laugh, and that's what he did.

Chapter 13: The Inventor comes to Play

A crimson light materialized between the old man and queer superhuman. The light brought forth a malicious mocking laughter, that vibrated through the air. However, the laughter became somewhat familiar to the old man and his companions, as if they heard it before.

"This spire is a room of tricks!" yelled The Inventor, " And I've broken the code!"

The Mad Inventor came into view with the light, appearing between Johnnie Sr. and the superhuman. The Inventor turned his plasma blasters towards the red haired opponent and pulled the triggers. The red hair human smiled as he put out his right hand and absorbed the plasma into his palm.

"So, you seem to be a little bit more difficult than the other one." Smiled The Inventor.

The super human held his palm at The Inventor, building up a red energy in the center of his hand, but a fiery punch from Sol crammed into his face. Their human staggered, changing his aim at Sol and releasing a thick red beam of plasma. Sol was hit with the energy, crashing into the ground. Trina used the distraction to summon her stone spears once again, and sent them hurtling toward her opponent. The red haired man waved his hand and the spears turned into dust. Natalia performed a uppercut into the opponent's jaw with her gauntlet, and fired her white energy on impact. The queer human flipped through the air landing on his stomach. Johnnie Sr. felt his joints become loose and instantly reached in his pockets, summoning his vine spears unto his arms.

"You think you have me?" said the soul of the gem, getting onto his hands and knees, "You think I let something so inconvice-"

The Mad Inventor's spider blades dug into the back of the red haired human, "Yes, I think your cornered. Since I'm here it's no point to thinking you would ever have the ability to win."

The soul of the gem could do nothing but laugh, as blood poured from out his mouth. The Inventor put a plasma pistol to the soul's head, put his finger around the trigger, and fired. Thick, crimson, blood spurted from the soul's temple and it's body fell onto the blue stone like an abandoned toy.

"I'd say the old man is out of his time." The Inventor said, turning to Johnnie Sr.

"What took you so long, little nigga?" Johnnie Sr. said.

"I got caught up and picked up two stragglers." Said The Inventor, "I think they can help us get inside the base of the Enlightenment."

Johnnie Sr. looked over the two girls, they were white, young, female, and trained by the Enlightenment. Could they easily be retrained? Who said they wouldn't just run back to The Enlightenment?

"Why should we trust you two little white girls?" Johnnie Sr. said, walking over to the twin girls, "Who said I shouldn't kill you two now. I already got enough of a fucking headache with the kids I gotta deal with."

"Killing them we would lose precious info," argued The Inventor.

"I think it's pretty stupid." Said Natalia, "For all we know this could be the Enlightenment's plan.

We should just leave them on this planet when were done."

"Hey," Sol intervened, "I've been trying to escape from The Enlightenment for years and just got my chance. If I can take The Enlightenment down the better, and Luna agrees."

Luna, the silver haired twin, could feel everyone's eye's tear into her. She wasn't as excited as breaking from the Enlightenment as Sol, but what could she do?

Luna nodded.

"Well we are low on staff." Trina said.

Johnnie Sr. Grumbled. This mission was supposed to be simple, now it was getting to become a headache. The old man let the vines wither off his arms, grabbed his joint from his pocket, lit it with the lighter, inhaled, and took a deep exhale, "We'll let the Society handle the girls. Let's just get this gem."

The Mad Inventor was already dissecting the body of the red haired fiend with his metallic legs. The mad scientist caught a glow in the chest of the creature and thought it the gem, but the light quickly grew, devouring the six fighters, and bringing them into another existence.

The six found themselves on a reflective floor, with snow white pillars, the afternoon pink sun just starting to settle, and a figure with the head of many eyes and mouths sat before them, in a crystal throne.

"You have come to the resting place of warriors." The figure said, "I'm the mind of the gem. All decisions in battle are invalid your souls will fuel me."

Chapter 14: The Mind of a Gem

Johnnie Sr., The Mad Inventor, Natalia Espada, Trina Valentine, and Sol and Luna pepper found themselves on the true top floor of the mysterious spire. The top of the tower took the form of a cathedral with reflective floors, pillars of crystal, and holes in the walls to let the afternoon pink sky fall in. In the center of the sky cathedral sat a strange being in a throne. The being wore a white robe, it's arms withered and black, and it's head a sphere of searching irises and gaping teeth. The eyes settled on the six fighters and the being stood up.

"Few have made it thus far." it's voice sounded soft and elegant, "Must I stretch my power to show true sorrow?"

"True sorrow?" The Mad Inventor said, grabbing his pistols, "I'll dissect this thing before it's over."

"Don't go rushing in." said The Mad Botanist, "We don't know what this fucking thing can do?"

"It seems every time we win we get in deeper." Said Natalia.

"Most Gems have multiple stages." Sol said, "It's common for the strongest to have three."

"We already defeated one." Luna said.

"And we defeated the second one a couple of minutes ago." Said Trina.

"So this is the third!" Said The Inventor.

The Mad Inventor pulled out his plasma pistols and began to shoot one plasma bullet after another. The mind of the gem raised its withered hands, dissipating the projectiles from existence.

"What!" The Inventor gasped.

"Maybe we got to get close up!" Sol yelled.

Sol and Luna rushed the monster, unleashing a barrage of punches towards the creature. However, the resourceful monster easily made a force field that protected him from the sister's attacks and with a flip of his index finger the girls were tossed back. Trina raised her hands, causing small glass spheres, sprinkled with crystal thorns to erupt from the floor and pillars. She pointed her hands toward the monster and the spheres circled the creature like a tornado, clustering together for full effect. Natalia aided Trina by blasting her diskettes into the tornado and Johnnie Sr., released a green aroma from one of his seeds, to discombobulate the creature. The combined attack swirled around the monster, hisses and coughs could be heard, but it didn't matter. The attack died before the fighters and the creature gave the laugh of a young man.

"You thought plants and technology could defeat such a being as me." said the many eyed monster.

The fighters began to feel themselves levitate from the floor.

"I'm going to torture you all and feed on your sanity.

The Mad Inventor was the first one to scream as black bolts of lighting tore into his body. Soon, everyone began to scream as the pain of a thousands fire wrecked their insides. The creature of the mind smiled with his eyes as his fingers danced along, dousing out pain to everyone. In the midst of his pleasure a loud crackling was heard and a burst of lightning erupted from its body.

Final Chapter: Enter Tiana Forest

An orange portal appeared behind Johnnie Sr. and the others as they were being tortured. A girl exited from the bright vortex. She had skin of milk chocolate, her hair was constrained into thick cornrows that spiraled down her back, and her outfit was composed of black-strapped boots, green cargo jeans, a green tanktop, all supplemented with orange Kevlar elbow and knee pads. In her hands she had a bow, crafted from wood, gears, and wire, on her back was a quiver, and it held several dozen silver arrows.

The girl eyes focused on the grotesque creature that held her comrades. Tiana had never seen anything so cruel looking in all her paranormal journeys. She quickly lined up an arrow with the wire of her bow, and began to pull back. The creature saw the newcomer before she had arrived, with a snap of its fingers Johnnie Sr. and the others fell to the floor in painful groans. Tiana let go of her arrow and watched as the projectile shifted into a streak of blue lightning. The Gem beast quickly summoned and invisible shield, but Tiana's alchemy knew no bounds and broke through the protection, penetrating the heart of the magical creature.

Tiana watched as the lightning sizzled the creature's insides, it's eyes flashed with pain, its mouth's gurgled with blackened foam. Tiana thought it strange as the monster tried to rise, emitting several dozen rotten legs from its robe, and producing clawed feet. The monster let out the scream of a frightened child and rushed towards the Archer of Alchemy. Tiana grabbed another arrow, sending it toward the monster. The arrow transmuted into a

blazing orange fire, to only be smacked down by the creature's magic. Tiana grabbed her third arrow seeing the monster to rise above her, stretching its ragged skin, and blistering Tiana's eardrums with its screams. The monster lunged on top of her, she could feel it's leathery hands upon her face, it's wretched sweet moldy breath danced on her tongue, with no time to line the arrow with the bow she stabbed it deep into the creature's chest, transmuting it into a deadly crimson fire. The queer monster lunged back as it screams became mixed with the loud impact of Tiana's alchemy.

Tiana watched, as the monster flesh became ash. When all was done she looked back to see the swirling orange vortex had returned. Her comrades were badly injured but still alive, its nothing the Healing Pools couldn't fix. A glow caught her eye and Tiana looked down to see a crimson jewel lay by her feet.

She quickly scooped it up and said, "Juliet owes me a soda."

The End??????????????

The Sky Cathedral
Prologue:

"So," said Ronald Donald, "we'll be sending some of our agents over to collect the book."

"I'll send the cargo ship to collect them." said the gaunt king, sitting in his throne, "How many will there be?"

"Oh, no worries." Ronald quickly said, "The Society actually will think it'll be great for them to trek on a 2-3 day pilgrimage." Ronald smiled, while straightening his crooked black tie, " It seems to be a great team building exercise."

"Exercise?" the king said, with a raise of his non existent brow.

"Not to be rude to your traditions," Ronald said, "but our leader thinks it will be a good idea for this specific team to take the pilgrimage. Get to know one another a little bit more." Ronald grabbed a cup of water and quickly threw it back down his throat, "The success rate of this team is fairly low. Hopefully, this is something more their pace."

"A simple delivery mission?" questioned the king.

Ronald nodded, "Yes."

The king gave a light chuckle, "On to other things, what about when you take the book and my kingdom is left unprotected? How do you expect to survive against the savages?"

"We can spare a couple of our agents in the coming of weeks."

"But I will need them immediately."

"When's the last time your kingdom has been attacked?" Ron began to shuffle through several

papers on his desk, "From my knowledge, not in the last hundred years."

"Because people feared my father," the king said, "but me, heh, I'm losing more of the confidence of the people every year. These homunculus your books hold many amazing creatures. However, I don't have enough to secure the kingdom. I need more time. How about in five Terra years?"

Ronald's shook his head, within the floating flat screen, "The Society is in a state of emergency. We need the book back immediately." Ronald gave a smirk, "You don't want our power to reign over you."

The king gulped, he had heard much of The Society due to his father. The king knew alone he could do nothing under the mysteries of The Society of the Unknown.

"Fine." the king said, with a hint of aggression, "Take your book, I will make do."

"Happy we could make this sweet and short." Ronald said, wiping his baldhead of sweat, "Don't worry in a couple of months we can send more agents."

"I thought you said weeks!" screamed the king.

The vision of Ronald turned black and the floating screen levitated away.

A hand covered in a white glove squeezed the shoulders of the king, "I told you The Society look out only for their own."

The king nodded, "Good thing we connected first. For the book and the agents I get the chimeras."

The hand in white was connected to a large man covered in white robes, "You give us the book and you will receive the chimeras for protection. You

can even test the abilities of our beast on the incoming agents."

The king smiled, "That would be fair."

Chapter 1: The Scrub-Dogs

"We are not going to screw this shit up." Sol Pepper said, biting into a blue piece of meat.

Sol Pepper is the leader of the teenage society group named the Scrub-dogs. Once a member of the Enlightenment, the feisty redhead switched sides and joined the Society of the Unknown, to improve her life and her sister's.

"It's a simple pick up." Said Sol's sister Luna, "Everything should go okay if we stick to the basics."

Luna Pepper is the Sister of Sol Pepper. Luna Joined Sol into The Society of the Unknown fearing the backlash of trading upon The Enlightenment. The pale white haired girl was always far less aggressive than her sister.

"I thought we stuck to the basics when we lost King Neptune's trident!" came the voice of an elf eared child, "We made battle with evil fishmen for hours, I was quite hungry after!"

The smiling, brown, elf eared child was known as Shadow Black. The young warlock came from an alternate dimension where fantasy was real and breathing. The boy had slipped into this world and been with The Society of the Unknown ever since.

"It's cause you let that evil guy trick you and steal it." A young woman with half black and half white shoulder length hair said, with a roll of her eyes.

The girl with white and black hair was known as Star Field. Star was a special type of vampire called a "Mimic". The Society had found her when she was young and raised her as an agent.

"Alas, our little Shadow always leads us to the grandest of battles." said a black tailed, doe eyed, and lightly tan elf warrior known as Shawn Bolt.

Shawn had come from the same world as Shadow. Shawn in his original world was a member of a royal prestige of knights. During a mission, Shawn had accidentally slipped into this realm and now is a warrior serving The Society of the Unknown.

"Shawn, Shadow." Sol said, pointing an alien chicken bone at the boys, "I don't care about grand battles and shit, you two bet not." The young girl began to shake her head, "I promise if you two fuck this up and make us look like fools in front of Juliet and her gang I swear!"

"Don't worry, fiery mistress," Shawn said, waving a hand, "We elves will serve you like always."

"Yeah and I promise to keep my eyes on the important items." said Shadow, putting a hand on his heart.

Sol took a gulp of the green bubbly drink and belched, "Check please."

Chapter 2: The Scrub-Dogs Resolve

Sol and her companions mission brought them to a Kingdom within an alien world, that floated through the sky. On this planet, the floating mecca was known for it's freedom of religion. Beings from all over the planet came to pray and worship the deities the kingdom housed. However, there are a few that go against the kingdom, few who can feel it's power waning, few who want it to fall, and those few are powerful.

Sol had no time to admire the statues of various gods, or the silver cobblestone path that led to the larger cathedral and garden, or the various misshaped aliens that looked upon the humans with a devil of curiosity. No, the red haired girl dressed in a black and red Kevlar jacket, black camo pants, and black boots, she had only one focus, make it to the cathedral and complete the mission.

Luna followed her sister and admired the architecture of the planet. The buildings took the shape of small stone cottages; She noticed gas lamps hanging on the some of the houses and some of the aliens looked like they were wearing trench coats, monocles, and even corsets. She had heard other worlds and planets can have similarities, but this was just strange. The young girl dressed in a silver and blue Kevlar trench coat, slim silver pants, and silver boots with blue shoestrings, followed her sister, cataloguing the sights.

The happy go lucky Shadow Black skipped along, waving to all the aliens, his wavy black Mohawk bouncing with his step, his smile as bright as the silver sun itself. To any fantasy fan, the boy was dressed like a wizard. Shadow wore a black and

green ragged hooded robe, mixed with black leather under armor, accompanied with black silk pants, and black boots that looked too big for his feet. Shadow had a feeling this mission was going to be fun.

Star Field popped pink gum in her mouth; She didn't want to be here. She never wanted to really go anywhere. She kinda just wanted to stay in her room and listen to depressing music about death. The sun was out, it was slightly annoying. The pale girl wore black and white leather armor, with black camo pants, and black boots. Star hoped they would just fail soon so they could go back home.

Shawn Bolt tied his wild black hair into a ponytail. It was time to get serious. The mission was starting. Shawn's trained hands touched the pommel of his navy blue daggers, then his hands switched to feel the secure warmth of his bow and arrows. The elf warrior had a good feeling everything was going to be fine. He wore the royal armor of his land; A red pauldron that covered his right arm, with black straps crossing over his chest, khaki baggy cloth pants, and black leather boots. Shawn knew this would be an adventure to remember.

As Sol began to see the silver gates of the Garden Court leading to the cathedral, a sense of battle anxiety began to fill her. She noticed a silver guard clothed in metal armor standing at the front; He was a large man, eight feet tall at least. The guard held a large axe and was stooped over, and his eyes; Sol couldn't see them, she just saw two bright lights come out from the helmet. She clutched her fist.

"You guys wait here." said Sol, "I'm going to make sure the guard knows who we are."

The others nodded, but Sol could see the concern in Luna's eyes. The fiery warrior stopped at

the stairs, looking up at the gate and warrior. The sense of anxiety grew greater, Sol began to sweat, bits of orange flames emitted from her finger tips, and her throat felt dry. She walked up the steps, the knight turned her way, and she could hear the screeching of metal as it moved to look at her.

"My name is Sol Pepper!" the young girl yelled, "Were here to collect the Homunculus book from your pastor or whatever!"

The knight looked down at Sol with spheres of light in his helm, raised his axe, and with a moaning battle cry swung it down upon Sol.

Chapter 3: First Blood

Sol pepper saw the five-ton axe cut through the air and come for her face. Thanks to her sharpened instincts, she rapidly rolled to the left. The ground shook under her as bits of debris rolled off her jacket. She quickly got to her feet to see black tentacles rise from Shadow's silhouette and bind the giant axe-wielding knight.

"I don't think that was a gesture of good faith." Shadow said, "Maybe, we should subdue such a menace."

Shawn quickly grabbed a wooden arrow from his quiver and lined it up with his black bow, "Make him still."

Shadow nodded, cringing his hands, causing the black tendrils to tighten on to the struggling knights body.

Shawn closed his left eye, leaving his right open, pulled back his arrow, and with a breath released it. The projectile immediately became devoured in magic, becoming a golden beam of light. The string of light shot threw the helm of the creature, causing the large knight to just stagger.

"It's still alive." Star said, with a roll of her eyes.

Luna let mist flow from her boots, creating a path of ice to the knight. Next, she crafted blades of ice to emit from her arms and skated upon the cold path as if she was putting on a show. Her movements on the ice were fluid and graceful, her body a quick flash of silver and blue. With a jump and a twirl, Luna made her way to the face of the creature, sticking both her bladed arms into the eyes of the armored being. The darkness absorbed the ice of

Luna and spat it back out, causing the girl to spiral to the ground, where her ice blades shattered.

"Uh," sighed Star grabbing her bladed black Tonfa's, "Guess it's my turn."

With her arms out, Star dashed toward the creature. The creature could do nothing as Star's bladed Tonfa's ate through it's armor. Each slash caused a piercing screech to enter the air, each scratch cut barely into the armor, but with Star's speed only a few attacks needed to be made. In seconds, the chest cavity of the knight burst open, revealing a nauseating smell. Star saw a stomach of rotten skin, black veins ran throughout the body, and the flesh moved as if it was waves on the ocean. Even a vampire like Star saw it as disgusting and she almost vomited as she backed away.

"Just kill it with fire already!" Star screamed to Sol.

Sol ran up to the knight and gave a fiery right jab into the opponents open chest. Sol's orange and red fire sprung to life, eating through the knight's skin, causing the beast of a man to holler as it felt Sol's power. Sol made sure not to use to much of her ability, and retracted her fire after several seconds. Shadow, feeling safe, called back his darkened tentacles back to his silhouette. The monster began to wobble and groan, a greenish liquid came from it's mouth, and with a mighty heft of it's axe the armored beast fell over and knocked itself out on the ground.

Chapter 4: What do we do?

"What in the erased just happen?" Sol said, looking at the defeated knight of metal.

Shadow eagerly raised his hand; "I'd say we just had a dastardly fight."

"I got the critical hit." Shawn added.

Star shrugged, "Like always we're caught in some shit."

"Maybe we should call The Society?" Luna said, "This looks like it might get dangerous."

Sol didn't like any of the answer's, especially Luna's. Call The Society? For what? So Juliet could get her crazy ass over here and take up all the credit? Damn her! Damn this team! Damn her bad luck of getting crappy missions for six months! Damn it all to erased!

"No." said Sol, "Were going to complete this mission and hand the book to The Society."

"But" Luna chimed in.

"But nothing!" Sol screamed, she looked at the creature, then her team, "We've been together for six months," She ground her teeth, "and all we have got is ridicule. We half ass our missions and the small percentage we have completed we've hung by the skin of our asses. We are all just a joke"

"I still have skin on my nether region." Shadow intervened.

"I think she's trying to rile the masses." Shawn whispered to Shadow.

"Oh." Shadow said, followed by an embarrassed smile, "Carry on."

Sol held her forehead with her hand, "I just think we should complete this mission. Show them fools we got what it takes. Show Juliet the Scrub-

Dogs is just as good as The Crows. Hell, we could even be better than The Mads!"

Luna smiled. Shadow and Shawn pumped their fist in the air with elven screams of jubilation, and Star popped her gum, while rolling her eyes, and crossing her arms.

Chapter 5:
Into the Garden

"I can't believe that knight attacked us?" Sol said.

"Maybe it thought we were intruders." Luna answered.

"Yeah," Sol crossed her arms, "but they were briefed we were coming." Sol turned her attention to the tall trees around her that produced blue leaves, "At least this place is pretty."

Luna nodded, "I agree."

The garden that led to the cathedral was a sight beyond earthly conditions. The trees seemed to brim to the sky, producing sea blue leaves, the grass was red and decorated with orange cobblestone paths that led multiple ways, small statues of random gods spread throughout the landscape, representing the many religions the kingdom held.

"A myriad of gods." Shadow said to Shawn, "How does one praise so many?"

Shawn shrugged, "Let's be thankful for Estalia." Shawn scratched his head, "A simple elf as myself wouldn't know what to do with so many gods."

Star popped her gum and rolled her eyes, who cared about gods?

The beginning of the garden was an uphill challengein coming up. However, the more The Scrub-Dogs traveled the more the ground flattened out, creating a cliff plateau for them to see the whole landscape. The Silver Cathedral was in the back, surrounded by the blue and red forestry of the garden, and spread throughout the forest were several

rectangular buildings. Sol was briefed that those buildings were rest stations for the traveling pilgrims. Sol sighed, two to three days with these goofballs. They could make it.

"Uh Sol," said Star, "Someone's stalking us?"

The group turned around to see someone come out from the red and blue forest. It was a shapely woman, with blonde curly hair, wearing a robe made from green leaves; She had strong thick legs, and a smile of cold seduction.

"Well, aren't you a suspicious character?" Shadow said with surprise.

"Shadow." Sol said, walking up to the newcomer, "You know all the right things to say." Sol stopped in front of the new woman, she didn't seem that intimidating and Sol's anxiety wasn't up. "So who are you, another member of the Society?"

"Sol and Luna Pepper." She said.

Sol began to feel uneasy, creating a ball of sparking orange and red fire in her right hand, "Lady, how do you know our names!"

The woman looked eye to eye with Sol, "Because I'm Cassie of The Enlightenment!"

Chapter 6:
Separation?

"The Enlightenment!" Sol said, stepping back.

"Did you think we wouldn't be coming back?" Said Cassie, "Everyone knows about you and your traitor of a sister," Cassie bared her white teeth, "some of the members are burning to get to you two."

"They've latched onto the correct team." Shadow chimed in.

Cassie looked at the child warlock, "Let's hope they think that when the Enlightenment is flaying your skin."

"The Enlightenment has some weird delicacies." Shadow claimed.

"Enough!" said Sol, with her burning right hand, "I'm taking you down and getting this over with!"

Sol charged toward Cassie, her right hand increasing in flame power. Cassie laughed, pointing her right hand towards Sol, and releasing a force of wind. Sol was hit, her feet dragged back, her face smacked to the left, but she didn't fall. Shadow and Shawn leaped into action; Shadow pulled two black tomahawks from his silhouette, while Shawn unsheathed his daggers. The two elves sprinted towards the woman, who spun, letting the wind push her aside as Shadow and Shawn missed with their attacks. Cassie summoned a ground breaking scream and Star hit the ground with bleeding ears. Cassie stepped to the left to see Shawn, who just missed another attack, with a mere touch of her hand Shawn

felt a paralyzing sensation in his right arm and dropped his weapon.

Shadow's eyes became a glowing green at the sight of his elven friend, "Wind witch, can you handle the power of true dark magic!"

The boy threw his tomahawks and they shifted into winged creatures. With a wave of Cassie's left arm, the blackened creatures were cut into pieces.

A blade of ice shot through Cassie's chest. Luna Pepper twisted the frozen weapon deeper into her opponent's body body. Cassie smiled, and her image turned to wind. Rapidly, a gust began to pick up around them, the grass began to violently sway, the leaves of the trees made roars. One by one the adventures were swept off their feet and sucked into the confines of Cassie's tornado.

Chapter 7:
Sol's Fight

Sol Pepper woke up to wet smacks in her ear, the young girl slowly opened her eyes to see a crude campfire. Sol winced at the mad thumping in her head, she could feel blood flow from her ears, her fingers felt sore and stung, but she still made her body move. She got to her hands and feet, panting at the pain ringing through her body. She noticed the smacking sound stopped and she heard a shuffling beside her. Sol turned to the left to see the creature that had accompanied her. It had the body and size of a bear, no eyes, a mouth that let out a sour smell, it's teeth were decorated with red huge pieces of meat, and its dirty claws flickered in the fire. Sol didn't know whether to scream or throw up.

The creature's wet nose turned towards Sol. The young girl froze in panic. The creature sniffed the air, put its bleeding carcass on the floor, and let out a fear-piercing roar. Sol screamed with it, and the creature's claw came diving for her head. She quickly rolled under the attack and then rose forward with a fiery punch to the ribs. The monster stumbled and Sol added a sidekick into the chest of the creature. Due to special engines in Sol boots, fire followed the kick, sending the creature screaming away flames. Sol quickly scanned the dark area, finding afternoon light followed with a breeze. She turned around, activated the fire feature in her boots, and blasted herself through the horrific cave. With three flaming jumps, Sol hit the midday breeze and followed the lime green sun, her red flames danced weakly on the crimson leaves of the forest, and the blue leaves of the trees scratched her face as she put

more and more fire into every jump. She wanted to get away from whatever she was stuck with in there. If she hadn't woken up, she would have been that bloody carcass herself.

Sol's feet slide upon the black dirt, extinguishing the flames on her shoes. She was sure she was far from the cave as needed. She put her back to a tree and began to gather herself. Where were the others? Who was that Cassie chick? Why was she so strong? The girl's stomach began to rumble.

"Could this shit get any worse?" Sol said, checking her busted Z-Phone, "I've got to find everyone, but first I'm going to get to one of those safe houses, there's bound to be some food."

It took some time for Sol to find the cobblestone path again, but when she did she immediately began to follow it. She needed to recuperate and find her Scrub-Dogs once again.

Chapter 8:

Vampire and Tailed Elf Team Up!

Star's bladed tonfa cut through the hard shell of a large insect creature. Shawn nimble daggers cut through several insectoid claws and fangs, each bug being taken down before they even saw the agile elf. Star ducked a singular green claw and threw herself forward, stabbing both of her blades into the creature's head; green sticky blood coveted her body. Shawn back flipped, dodging a claw, landed on his feet like a cat, quickly switched between his daggers to his bow and arrow, and let one of his flying projectiles puncture the head of his enemy.

Star and Shawn quickly got squared up looking at their predicament.

"So…this is the mission that kills us?" Star said panting, "Dying to an army of bugs?"

"Don't lose your battle spirit yet, Seducer of blood," Shawn said, "In my adventures thus far I've been through many sorrowful situations, but a quick thought always seems to yank me from the song of Maiden Death."

"Why do you always take a long time to say shit?" Star responded.

Shawn took several arrows and lined them to his bow, "This is a trick my master taught me."

Shawn aimed the arrows at the sky and let them loose.

"What in the erased was that for?" Star said.

Shawn smiled, "Even though I'm a Tailed Elf, I still have several magic skills."

Shawn's four arrows turned into many, as they reigned down upon the incoming insect creatures. The Tailed Elf watched as the bug

creatures fell one after another, giving a smile for the efficiency of his attack. The young elf eyes grew wide when he saw what he was looking for, an opening! Shawn swooped Star into his arms and sprinted with all his might.

"Hey, long ears?" Star screamed, banging on Shawn's hardened chest, "You could have just told me to run!"

"I'd rather have a rare damsel such as yourself closer to me." Shawn smiled.

"If you tell the others, I'm yanking that tail off and using it for my dinner." Star said, with a cross of her arms.

With one leap, Shawn and Star made it to the high branches of the garden. He turned around to see how many insects were left. Not many. The elf had done major damage to the bugs and the ones that did survive scattered. Shawn and Star looked up at the sky, it was becoming soothing green with black stars. Shawn also noticed something else; he smelled cooking food and saw a faint line of gray smoke. Star smelled the same and licked her lips. The two looked at each other, exchanged glances, and with Star still in his arms, Shawn hopped towards the smell of food.

Chapter 9:
Shadow Black?

Luna Pepper woke up to see the top of trees passing above her, she felt hands on her coat, and looked up to see the young elf Shadow Black. The boy had ethereal bat wings attached to his back, with a fanged smile on his face.

"What happened?" Luna asked groggily.

"Oh, Ms. Pepper, we were attacked by a wind mage of all things," a look of concern came over Shadow's green eyes, "I was only able to secure you in all the mayhem, but I did see something."

Luna grew curious, "What?"

"As I grabbed you and flew away I saw the wind witch talk to several queer looking beasts." Shadow said, "I have no clue how it all connects."

"Hopefully, we'll find the others before nightfall." Luna said, staring at the darkening green sky, and the rising blue moon.

Shadow's black wings of magic spread out and the two smoothly glided into the depths of the forest. Shadow let go of Luna as they closed in on land, his wings dissipating once he touched the soil of the forest.

"I didn't know you could fly?" Luna questioned, "Where was that on our last mission?"

Shadow face took on a look of shock, scratching his Mohawk with admiration, "I think with all the danger about I must of forced a new magic."

Luna smirked, out of everyone Shadow and Shawn were the most mysterious, "I'll take it for what it's worth."

A familiar scent ruptured in Luna and Shadow's nose. Luna immediately knew who was the owner of the scent and smiled at her sister's intellect.

"Those smell like Sol's delicious meat sandwiches." Shadow said.

Luna nodded, "Sol definitely knows her teammates."

"MRS. PEPPER!!!!!!!!!!!!!"

Luna felt a heavy force smack her in the back of her head, she went down before she could even react, the world spun about her, and she saw the true face of Shadow Black.

Shadow saw the beast but the creature was too close for him to do anything. He screamed, as it's massive claw knocked Luna out. Any normal eleven child would have felt fear being along with a massive beast of ten-foot height, claws, gnashing teeth, black fur, and a single eye. The creature rose above the young elf with old rotten pieces of meat in the mouth, it's claws dangling above the boy's head, it's voice a massive fist of force.

Shadow smiled and said, "Oh, how long has it been since I've tried my true face."

The young warlock eyes turned into a misty green, giggles began to emerge from his mouth, as tentacles of black magic bound the creature.

"I haven't eaten in a while." Shadow said with a rumble of his stomach, "Meat sandwiches are fine, but nothing beats the healthy taste of magic."

Chapter 10:
Sol, The Leader

Sol looked at her campfire with delight, watching the meat send its scent into the air. She wasn't sure what type of meat it was exactly, but it looked like the cow meat from back on Terra Firma? She knew there was the chance of a backlash, inviting the denizens of the forest to her camp, she had to take that risk, because her Z-Phone was smashed. She knew once the Scrub-Dogs smelt her famous burgers they would come with hunger on the brain. It was the only way she knew had to regroup her team.

Sol waited in the darkening green atmosphere, looking at the world become hidden around her. Luckily, Sol had her fire and food to keep her company. She wondered what was ahead of them? Why didn't she notice any other pilgrims? Was it wrong not to call The Society? Sol could feel anger as she thought of Juliet Valentine taking this mission away from her team. Those damn Crows! Sol wanted to show Juliet and everyone the Scrub-Dogs was nothing to mess with, they were good just as any of the other teenage groups. The Mads, The Crows, and the Scrub-Dogs all in battle competing against one another, trying to impress the damn adults. Sol laughed, how was any of this different from being in The Enlightenment? Heck, what could she say? She liked competition.

The shaking of the trees interrupted Sol's thoughts. The young girl stood up expecting one of her companions to come out from the brush, but she was mistaken. Instead, what came out were three large frightening beasts. Each of the massive beasts

was the size of a lion; they had bodies of feathers, in the shape of a leopard, their heads took the form of a dog, with the scales of a lizard, and the claws of a wolf.

"More fucking nightmares." Sol whispered, summoning spheres of fire to her hands.

The creatures walked at a fluid pace toward the young girl, showing no fear. Sol wanting to keep the scent alive walked towards the animals, her fire burning bright. The creatures began to pick up pace. Sol smirked and spun aroud, creating a ring of fire around herself. The beasts halted, digging their feet into the ground. Using her specialized boots, Sol launched herself towards the closest of the beast. She met it with a right roundhouse kick that erupted in orange flame. The creature howled with a flaming head, quickly succumbing to its wounds. Sol gave a right roundhouse kick to another of the incoming beast, burning its rib cage bare. She spun with a sidekick, letting the engine in her shoe blow fire at a lunging creature's stomach. The final dog crashed several feet away, with intestines burning like flaming coal.

Sol didn't have time to rest as she felt something bind her body tightly. She summoned her fire to expel from her hands, but the beast was able to absorb the heat. A tongue flickered in Sol's ear, causing her to flinch and face her newest opponent. Sol screamed in the face of a twenty-foot furry brown snake.

Chapter 11:
Sol's Survival

Sol screamed, releasing a stream of fire from her mouth, that washed over the snake. The creature was mostly devoid of its protective layer of fur, releasing its leathery black self. The serpent let out an ear breaking hiss, bashing Sol into the ground. She tried to gain her footing, but the snake still had her bounded, and yanked her into the air. The monster with fangs dripping of clear poison, raised Sol above it's mouth, and slowly began to bring her into it's jaws. However, Sol released explosions of fire from her mouth, burning the inside of the creature. The snake creature bashed her into the ground back first, causing droplets of blood to escape from her mouth. Sol was shaken this time, her head ached from the slam, the world spun around her, and the blood rushed to her head as the snake dangled her above it's mouth once again.

A golden projectile crossed though the night air, piercing the head of the monstrous snake. Sol dropped into the arms of a Shawn Bolt, who looked at his companion with a warm smile.

"Now, we could never let our fiery mistress be caught into the jaws of a slithery villain." Said the Tailed Elf.

"Ewww," said Star, looking at the dead snake with disappointment, "Snake blood is so salty."

Sol pulled away from Shawn and stood on her own feet, "I' could've handled that." Sol said with a roll of her eyes. "I got burgers on the fire, let's wait for my sister and Shadow."

The small Shadow Black was carrying Luna; the young elf had her on his back. Luna was pretending to be sleep, but she had seen everything. She watched as Shadow's magic drained that beast of life, she saw Shadow's green misty eyes and the pleasure he took in killing. The Warlock was definitely pulling a personality ruse, but why? Shadows raw magic power far outweighed the group, and that what's scared Luna.

"Ms. Pepper, Ms. Pepper, Oh do wake up, where amongst the camp." Spoke Shadow's innocent voice.

Luna opened her eyes to see a campfire in the near distance, she saw three bodies, and two seemed to be munching down on burgers.

"Oh! Luna!" Shadow said delighted, "It was meat sandwiches!"

Chapter 12: A New Predicament

The Scrub-Dogs reunited once again, all sat around the fire, munching on Sol's delicious Fire Burgers, the food caused the pains of battles to wear off like a dream.

"Oh, how I do appreciate your meat sandwiches." Praised Shadow.

"It's called a burger." Corrected Sol.

Luna munched her food quietly, staying close to her sister.

Star had her burger made especially raw, "So did anyone else get attacked by giant bugs?"

Sol took a huge bite of her burger, letting the alien spices spark in her tongue, reminding her of the pleasures back home, "I'm pretty sure I got attacked by some dogs and a snake."

Shadow wiped what Sol hoped was barbeque sauce from his mouth, "Luna and I fought a strange beast."

Luna barely nodded, "Shadow did most the work."

"Don't be modest." Said the babyish elf.

Luna watched as the rest of the team praised Shadow, but she alone knew his true capabilities.

"So we have about a day of travel left." Said Sol, getting to other matters, "Let's try and not get separated again."

Star rolled her eyes, "It's not out fault some wind thot came out of nowhere and separated us, and this mission was suppose to be simple."

"Well." Sol said, putting her hands on her lap, "Were the Scrub-Dogs, we don't do simple."

"Sol!" Shadow said happily, "I thought you were quite indifferent to that name?"

Sol Shrugged, "It fits."

"So what strategy of battle should we take if the wind witch appears again?" Asked Shawn.

Sol bit into her lip, "We run."

The group all looked at their leader in surprise.

"I know it's not us usually but the mission was to get the book." Sol stared at the dying embers of her campfire, "We gotta prove we can handle serious work."

"Then we run." Shadow said.

"Escape is clever." Added Shawn.

"I guess if we gotta." said Star.

Luna gave a half smile and nodded, "We run."

<div align="center">***</div>

As the core of the Scrub-Dogs fell into a slumber, The Pepper Twins stayed awake, watching over their comrades.

"I feel like were really coming together." Sol said to Luna, "I don't know why exactly, but look, we were separated in a forest full of monsters, but we all survived, were all here safe and sound. I think we got this one."

"I'm glad you're seeing the light." Said Luna, "But we don't know much about our comrades."

Sol expression became lightly irritated, "We've been with these fools for six months, what don't we know?"

"I'm just saying." Luna said, "Should we trust so easily?"

"Without trust there is no team." said Sol, "You want to go back to the Enlightenment? Get experimented on? Sent out on death missions? The Society of the Unknown might be only different by

name but hey, look how much better they treat us. We get our own rooms, food, for what? Going on a couple of simple ass missions? No more beatings, no more fear, freedom!"

"Is this really freedom?"

"It's my freedom."

Luna didn't have the heart to tell her sister about Shadow, so she didn't.

Chapter 13:
Sol Pepper vs. Chad Rockwall

"Why did you separate them?" said a member of The Enlightenment.

Cassie Shrugged her fair shoulders, "I thought it be fun to see them squirm." She rolled her blue eyes at the floating screen, "Who knew they find each other again so quick?"

"You're a silly woman."

"Are you mad?" Cassie chuckled, "Your little girlfriend is still alive, don't worry."

The wrinkled and gaunt king overhead and smiled, "I quite enjoyed watching my new beasts at work."

Cassie and the other members of The Enlightenment looked down at the alien ruler, with annoyance.

"Yes, I think I will go down there and see how my little girlfriend is doing?"

Sol Pepper woke up to the warm alien sun of the blue sphere. She was the first one to open her eyes out of the Scrub-Dogs; the rest of the group was still plunged in their fantasies. Sol rose with a stretch, the red grass of the outside proving a comfy bed, making her feel revitalized. She looked over her comrades, feeling the same positive vibe of yesterday, adventure was ahead and her team was more than ready. However, as she got to her feet and stretched again, her eye caught someone and her senses went into alert.

A man walked amongst the distance, he wore a loose white robe, showing a pale hardened chest, his cloth white pants were loose, with comfortable

shoe wear made from wool. The man smiled a smile of charm, wit, and prestige. The man's hair was cut short and his auburn goatee full. In the man's hands was a giant rectangular slab of metal connected by a pommel. This man was known as….

"Chad Rockwall." Hissed Sol.

Chad smiled as he closed on Sol, "Dear traitor, I've missed you." Chad held out his arms, "If you and Luna come back I can fix everything."

Sol was sick to her stomach; out of everyone they sent him. With no time to think, Sol used her fire and exploded towards Chad, with his ability she knew her comrades wouldn't wake. She greeted him with a right punch, fueled with fire. Chad simply jumped back, with lightness of a child. Sol performed a fiery right roundhouse kick, and Chad ducked. Sol's third attack was a jumping elbow to the face, and the man of six foot five jumped back and kneed Sol straight in the stomach.

The girl fell onto her knees; smoking vomit erupted from her mouth, her eyes red with rage.

Chad bent down to his knees and whispered in Sol's ear, "If you want to truly escape the Enlightenment defeat me at the Cathedral, show me the ferocity I burned into you." Chad grabbed the sixteen-year-old girl by the face and kissed her cheek, "Remember when we use to train?"

And then Chad Rockwall was gone and time continued.

Chapter 14:
The Enlightenment Attacks

"Sister," Said Luna, realizing since they woke up, "Is something bothering you? Your're not good at hiding information from me."

Sol glanced at her sister, and then glanced back at her three laggards who took their time walking through the forest, enjoying the sights, "I saw Chad."

Luna stopped in her tracks, a blush coming over her face, "Chad…how?"

"Chads a fuckboy Luna." Sol said, the palms of her fist began to smoke, "He used us for his sick needs."

"He taught us how to fight, we survived because of him!" fought Luna, "He's the reason we met the Mad Inventor and the others."

Sol knew Chad had gotten into Luna mentally far deeper than herself, "Whether you like it or not Chad is or never will be good for us. He's a sick fuck that we got away from and you need to purge him."

Luna looked up at her sister and Sol could see the confusion in her sister's eyes. Luna was battling everyday with her urge to return to the Enlightenment. Sol could easily see that.

"Wow!" Shadow screamed, pointing into the sky, "My dear Shawn is that a Zeppelin?"

Shawn scratched his wild hair, looking at the thing in the air give more and more as it grew closer, "Shadow, I think you are quite mistaken."

Star sighed and pouted, "It's probably another monster to come harass us."

The being crash into the ground, and split the earth around the Scrub-Dogs. The shadow of dust

showed a large man of eight feet in height, as the dust cleared the group could see his skin was brown, his hair wild and kinky, white shackles were on his wrist, his upper body bare and his lower covered in cloth baggy pants, and he was barefoot.

The man's pupils held no fear, as he let out a roar that shook the bones of the group.

"That poor man looks in pain." Shadow said.

"He's an experiment of the Enlightenment." Sol growled, "If you don't add up to their standards in a good amount of time you become an enraged slave."

"What a poor fate." Shadow said.

Shawn grabbed his daggers, "I smell the air of bloodshed again, and these foes have been quite grand." Shawn bent his knees, his tail becoming stiff, "I love it."

"I was right." Star said, "More harassment."

The large brown man beat his chest, saliva spilling from his mouth, the sound of his beating bouncing off the air. The Scrub-Dogs looked up at their newest foe. The Enlightenment is here!

Chapter 15:
The Risk of the Enlightenment

Jerome Foster was a lower ranking member
of The Enlightenment. The young man was gifted
with and indomitable strength that helped during
field missions, and as time grew he traveled up the
ranks. One day, Jerome was promised a promotion.
All he had to do was find a certain artifact in a
desolate dimension. However, he failed. He was then
brought before the woman with the cold blue eyes
and pearl necklace. She handled his fate.

Jerome felt the pain of Sol's fire burn into his
right arm, Star's bladed Tonfa's repeatedly cut into
his legs, Shawn's projectiles of magic collided into
his face, Shadow's tendrils rose from Jerome's
silhouette, strapping him into the ground, and finally
Luna came skating onto the scene.

Luna's attacks seemed more like
performances than battle; her graceful lithe figure
seem to smoothly fly on the self made ice, her arms
spread out as she let the wind pass by her face,
causing her silver hair to fly about. There was a
smile on the girls face as she lunged onto the back of
the sorrowful Jerome.

Jerome tried to struggle from Shadow's
magic restraints but it was no use. Every time the
giant man tried to move Shadow would make the
tendrils tighter. The monster man could feel death
upon him; if he didn't get out right away he knew he
would be done for.

Luna spun, and crafted blades of ice from her
wrist and stabbed them into the back of the man
monster Jerome. The ice quickly spread throughout

his body, freezing his intestines, and his heart. Icicles formed onto his ebony skin, and in minutes he was frozen completely solid.

"Good shit, Luna." Sol yelled.

Shadow frowned at the frozen body, Jerome's face looked one of sorrow, "I partly feel bad for harming this man, I feel…. feel he was not in control of his own devices." Shadow shrugged, "Alas, I am a Warlock. I should have more stone on my heart."

Shawn rested a hand on his elven companion, "Having a heart is not something you should neglect."

Star shrugged and waved something cold from her face, "Is it snowing?"

Luna looked down at her companions, who were they? Why should she trust them? This wasn't her home? The Enlightenment? Luna looked up to see silver snow escape from the sky and answered Star's question, "Yes, it is."

Chapter 16:
The True Twins and The Crows

An orange portal appeared within the alien
garden, releasing two young brown-skinned boys
from its clutches. The first boy had long black
cornrows that went down his back, a child like smile
was on his face, his clothes took the form of a gray
hooded jacket made from Kevlar, blue jeans, and
gray hi-top sneakers. The next boy had shoulder
length dreadlocks, a black bandanna tied around his
head, black Kevlar armor, black jeans, and boots.

"Did you really have to finish your
homework before we came?" Johnnie True asked his
cornrowed brother.

Isaac True pulled a piece of candy from his
pocket, took off some lint, and popped it in his
mouth, "Johnnie….Hmmmmmm….that tastes good.
Johnnie….Hmmmmmm…….. If I didn't finish my
essay on Lord of the Moths, Hmmmmmm still good
after a couple of days…… Ms. Hennessey and Mom
would have killed me. Did you finish?"

"Uh…" Johnnie had forgotten completely
about the assignment, "Yeah it's done."

"Awesome Possum, now we can go book
hunting." Isaac said happily.

A blue portal appeared at the fountain of the
cathedral garden. Two young women stepped from
the vortex. The first girl had a complexion of
caramel, with long black and golden hair wrapped
into a braided ponytail. She wore a green tank top,
black jeans strapped with gray kneepads, gray
hunting boots, and a bow made from wires, steel,
wood, and gears. Lastly, she sported a quiver of

arrows on her right leg. The second girl had chocolate skin, and blonde dreadlocks. She wore a black scarf covering her mouth, a silver, red, and black body suit crafted from leather and cloth, and a black cloak, which coveted her double bladed golden spear.

Tiana Forest looked at the rude device strapped to her right arm and pushed a button, revealing a holographic map, "Alright Tasia, it's just me and you for this mission." Tiana scanned the floating map; "I guess we can see what the Scrub-Dogs is capable of before we ruin their party. I knew the Society wouldn't fully trust them with a mission like this."

Tasia nodded, "Do you think the True Twins will intervene?"

Tiana shook her head, "They be stupid to!" the girl scratched her hair with irritation, "I'll have to beat their ass for Juliet I guess."

Tasia smiled slightly under her mask, "How many days until we reach the cathedral?"

"About a day." Tiana said, "Erased, let's start traveling now, we can raid the kitchen of the cathedral when we get there."

"There are safe houses." Tasia advised.

"Yeah, but remember back in the orphanage, the good stuff is always in the fanciest of places."

Chapter 17:
The Simplicity of the True Twins

"Wow," Isaac said, biting into what he hoped was a beef jerky stick. "Whoever thunked there was all this food in the middle of a forest?" Isaac chewed a couple more bits, savoring the salty taste of the unknown meat, "We lucked out."

"Yeah," Johnnie said, stuffing the remainder what were hopefully jerky sticks into a knapsack, "we can use this later for energy."

"Cool beans." Isaac responded, with a thumbs up.

The two boys exited the safehouse, going back into the adventure of the red garden. Johnnie was immediately hit with a scent he knew didn't belong to Isaac or himself.

"Hold on." Johnnie said, sticking out his arm, "Something doesn't smell right."

Johnnie took in another sniff, letting his wolf instincts take over, "Someone's here."

"You mean the naked guy." Isaac said, pointing to a nearly naked man coming into the opening.

The man was covered in sweat, his brunette hair matted on his face, his body gaunt and feeble. The man tripped over his feet, landing near the two boys.

He looked up and spoke, "Are you?" His wide eyes bounced to Isaac to Johnnie then back to Isaac, "Are you part of The Society of the Unknown?"

Isaac shrugged his shoulders, "Kinda?"

Johnnie gave a quick slap to Isaac's chest, "Don't tell this fool that! He could be anyone!"

The man got on his feet and began to head back into the forest screaming, "Where's my suit? I found the Society!"

"You happy anime freak." Johnnie scolded, "Now were going to have The Enlightenment fucking with us."

Isaac smiled, putting his hands behind his head, "The Enlightenment is always on our butts, it'll be okay."

Johnnie shook his head, "If only I could live simple, like you."

Isaac took another bite of his jerky stick, "You just got to play Japanese video games."

Johnnie was going to give a hint of a laugh, but another scent stopped him. This scent was filled with bloodlust. Johnnie's eyes shifted into an eerie yellow and his canines began to become fangs.

"Isaac something serious is coming." Johnnie warned.

Isaac quickly began to look about him, but he couldn't spot anyone, "Where?"

"Right behind you boys."

Isaac and Johnnie both spun around, facing their true foe. He was a man at six foot five height, brown skin, long white dreadlocks tied into a ponytail, a loose white robe with loose white cloth pants, and sandals showing pedicure white painted toed feet. The man held a blue fan in his right hand and used it to hide the smile behind his face.

"The True Twins." The peculiar man spoke, "We've heard lots about you two young men. Quite cute."

Isaac and Johnnie exchanged confused glances.

The man chuckled, "We knew Johnnie's kids would come. You two little brats dabble in everything, but I'm here to stop it." The man waved with his fan arm, hitting the boys with a strong gust of wind, "My name is Darrel Bragg and I'm a member of The Enlightenment.

Chapter 18:
The Crow Feeds

Tasia Snow easily jumped from branch to branch, her cloak billowing, each move a simple jerk of her body, and her instincts on high for any incoming danger. Tiana took the simpler route, using her hover board. She easily rode over the grassy terrain, with her hands in her pockets, and popping her watermelon bubble gum. Tiana wondered what mission did Juliet and Ginger take? Ronald wouldn't give her details.

"Were nearing the cathedral," Tasia said, landing onto the ground, "but we have obstacles."

Tiana frowned, "What obstacles?"

Tasia kept her gaze forward into the depths of the forest, "They're coming."

Tiana began to hear a buzzing that caused her to look up, and she saw the source of the noise. Winged instectoid creatures traveled through the skies, the size of horses and dogs the giant bugs entered the forest, surrounding Tiana and Tasia. Tiana readied her bow. Tasia grabbed her golden double bladed spear the "Snowpiercer." The creatures landed onto the ground, brandished their pincers, showed their transparent wings, and hissed their language.

The girls turned their back to each other, keeping their sights on their bug foes. One of the creatures grew brave enough and lunged for Tasia. With a spin of her blade, Tasia cut vertically through the creature, causing green blood to splash onto her body. The rest of the bugs instantly reacted.

Tasia lost herself in her deadly dance; she spun with her spear flying between her hands, taking

the lives of any creature near her, lime blood splashing onto her body. Her weapon ripped through the shells of her opponent. Tiana's arrows of fire, ice, and lightning scattered through the battlefield, quickly taking down the incoming army of giant bugs. Tiana jumped onto the back of one of the unnatural creatures. The bug released its wings, going into the air with Tiana. The archer held no fear and pulled back her arrow, shifting it into fire. She released the fire arrow and the bug hissed with pain. The Archer quickly sheathed her weapons and took out her Zphone, pushing a button before jumping off the flaming insect's back. The young girl free fell for several seconds, before she landed on her green hover board, where she could continued to cast her projectiles for suppressing fire.

Tasia ducked a claw and replied with an upper slash, separating a limb form the rest of the bug's body. Tasia performed a spin, taking the head of two more opponents. With a backflip, she dodged two claws aimed for her head, and with a throw of her weapon, she cut the two attackers heads from their bodies. She raised her hand, catching her weapon, and spun with it, taking down the last two giant bugs, then she washed in their lime green blood.

"Tasia, my nigga." Tiana congratulated, hovering back down to land to collect her arrows.

Tasia nodded, her breath ragged, the adrenaline of the battle dying within her body, "The Enlightenment knows we're here."

Chapter 19:
The Fight of the Snow

"Are you doing this Luna?" Sol asked, trudging through two feet of snow.

Luna glanced at the sky and shook her head, "I don't think so?"

"Well if you are-," Star said, almost tripping in snow, "Can you like, stop it?"

"Oh, I so do love when the cotton falls." Shadow said, picking up the snow and forming it into a ball to throw at Shawn later, "It reminds me when I was a baby elf and mom use to-"

A ball of snow hit Shadow, causing him to fall back first onto the soft white material.

"I am quite a cottonball maker," Shawn said laughing, "keep your sights open Shadow."

Shadow got to his feet, black tentacles rose around him, each one holding a cottonball."

"You wouldn't dare?" Said Shawn.

Several cottonballs flew into the air, crashing upon Shawn Bolt's face, colliding into Star's mouth, hitting Luna in the head, and finally plowing into Sol on the side of her head.

"What the erased!" Sol screamed, turning around with eyes of flame, "Who did it?"

The group pointed to the lone Shadow, who pointed at Shawn. Sol's mouth curved into a revengeful smile as she stooped down to gather some snow in her hand. In seconds, the Scrub-dogs had gone from secret agents to a group of teenagers, playing in the snow.

However, as the Scrub-Dogs played, a member of The Enlightenment walked through the slowly changing white forest. He was a large man

with many muscles, his hair long and gray upon his shoulders, he wore a white robe around his waist, his feet protected by brown hiking boots. He walked through the snow, taking in the sights, his breath large puffs of white clouds leaving his nostrils; Chimera's and homunculus alike had enough instinct to stay away from him when he walked past. This man was simply known as Zack Tigerstrike of The Enlightenment aka The Snowbeast.

Chapter 20:
Darrel Braggs

Isaac's magenta blade of fire and lightning came down upon Darrel, who dodged the sword strike. Isaac's blade hit the snow, immediately melting it into liquid. Darrel waved his fan and the snow blinded Isaac, but not Johnnie. The wolf lunged over his twin, with his right fist ready for Darrel. Darrel smiled and waved his fan again, the wind acted like daggers into Johnnie skin, sending him falling with bleeding cuts decorating his face.

"C'mon boys." Darrel mocked, "Show me those manly fighting abilities, you guys letting little old me twist you around."

"Oh, shut up." Isaac said, wiping the snow from his eyes.

Johnnie erupted from the snow, "Isaac, were going for a True Punch!"

Isaac eyes grew wide and he screamed, "Yes, I've been practicing for hours!"

Isaac smiled as his right fist became covered in his special fire and lightning, Johnnie focused all his canine energy into his left fist.

Darrel just stood looking at the twins, analyzing in their attack.

The True Twins exchanged glances, linked their right and left arm together, and sprinted towards Darrel. Darrel elegantly waved his fan and summoned a concentrated gust of wind. Isaac smiled and magenta fire and lighting exploded from his specially made footwear, it sent him and Johnnie soaring far above Darrel's wind strike. Darrel looked up with a slight tinge of fear as the boys came falling down, with fists full of energy.

The villain could do nothing as the colossal punch from the boys crammed into his jaw and exploded, sending the man tumbling through trees, flying across snow, his clothes becoming ragged pieces of cloth, his face seared by second degree burns, and his beauty tarnished.

"Ha!" Isaac screamed once again, "The True Punch of Justice totally worked! Didja see it Johnnie! We owned that fool! We're lit! We're more than lit, we're on an uncontrollable fire!"

"Calm down." Johnnie said, scratching his dreads and letting his self healing take place, "We still got hella more bad guys to run through. Juliet and them are probably here too."

"Oh Julie." Isaac smiled, "She's fun."

Johnnie shook his head, "C'mon, let's get going before any more weirdos show up."

"Fine with me." Isaac said, "Hey, you think the guy we just beat up is alright?"

"Don't worry." Johnnie said, with no concern, "He should be fine."

Chapter 21:
A Deadly Fight in the Snow

Sol Pepper ducked a snowball, and felt a powerful force cram into her jaw. The young girl fell into the snow, blood trailing from her mouth, several teeth cracked, and her world blurry and spinning. Sol struggled to look at her attacker, it was a man. A behemoth of a man that stood eight feet tall, his hair long and gray, his face large and monstrous, his chest bare and pulsing with muscle. The huge man looked down at Sol. The young woman tried to move, tried to summon her fire, but, she was still stunned. The man reached for her and….

Shadow's black tentacles broke from the snow, binding the man. Shawn Bolt launched himself into the air, releasing his golden projectiles into the man's back. Star slid between the attacker's legs, cutting his tendons. Luna with a swirl of her hands manipulated the snow and blasted it into the man's chest. To Zack Tigerstrike of the Enlightenment this was all for naught.

Zack released a yell of a hideous beast. The sound caused the Scrub-Dogs to hold their ears in pain. Zack's wounds quickly healed, the snow on his chest melted, and the large man made an impossible sprint for Shawn Bolt. However, Shawn ducked the first blow, he dropped his bow and arrow's onto the ground and unsheathed his daggers, going for a chest strike. Zack countered with a jab to Shawn's chest. Zack took pleasure in seeing the young elf's eyes explode with pain. Then the mixture of spit, vomit, and blood fell from his mouth, and the sound of Shawn hitting the snow and dropping his weapons.

Black misty beasts began to form around Zack; the creatures had green glowing eyes, and walked on all-fours. Zack's senses told him to look up and he saw a young elven warlock. The young man eyes glowed that same lime green as the monsters, black ethereal wings kept him afloat, and the curve of a smile appeared on his cherubim face. The young Warlock snapped his fingers, and his demons attacked. Zack immediately began to fight through fangs eating flesh, claws raking his skin, howls of things he only heard in the darkest of dreams, and he fought through it all. The last beast of blackness met its end with a stomp of Zack's foot. Zack looked up at the warlock, and with a roar of masculine rage, jumped into the air. Shadow Black was shocked. Zack smashed a fist into the warlock's chest, sending him exploding into the snow.

Zack landed with a boom, and shards of ice dug into his skin. The Enlightenment member turned around only to have a blade carve into his face. Another ice shard collided into Zack from Luna, and Star sent a roundhouse kick into the man's ribcage. The two girls were both deadly and agile with their different styles, Zack's vicious punches barely missed them in battle. Star used both Tonfa's to cut into Zack's right leg. Luna ducked a slap and put her hands on the new wounds, freezing the behemoth man from inside out. Zack looked down at the girls and with a swoop of one hand, he caught Luna and with the other backhanded the incoming Star. Zack looked at Luna who tried to freeze his massive hand and threw her into a tree.

The large man looked over the battlefield. All five agents were defeated. He had done his job. The

Enlightenment would pay him handsomely. All could be at ease now.

"He…" Sol caught her breath; her mouth was sore from battle, "Hey Fuckhead."

Zack turned to the battered Sol.

Sol's hands became covered in orange and red flames, "I'm still burning!"

Chapter 22:

Sol Pepper Vs. Zack Tigerstrike

Zack Tigerstrike stared at the beaten Sol Pepper. The girl could hardly stand up, her legs shook with fear, her mouth awash with pain, but she was still able to ignite her fist with a blazing healthy fire.

"I'm still burning!" Sol screamed, "Come fuck with it!"

Zack nodded, she truly was a warrior, how sad she had to trade on The Enlightenment. Zack sprinted and sent a hook punch to the girl's head. Sol ducked and countered with an explosive jab to the stomach. Zack took in the attack, the fires burnt his skin but not by much. When he grabbed Sol's fist on the last attack, Zack could see the courage leave her worn face. Using only his right hand, Zack spun the girl several times in the air, before slamming her down into the cold stinging snow.

"You really think you could win." Zack grumbled, "Even in the Enlightenment you couldn't beat me Sol, never could and never will." The man chuckled as he walked upon the defeated girl, "How hopeless you and Luna must of felt when you saw me? How sad?"

Zack cracked his knuckles and waited for the beaten girl to turn to him. Fire burst from Sol's shoes, moving her out of Zack's way. She quickly shut her fire off, spun around, and blasted toward Zack. The large man felt a flaming fist before he could react. With anger, he replied with a devastating right punch, only to miss again and Sol to blast another punch into his jaw. Angrily, Zack tried to swat her like a fly, but Sol using her fire was too

agile. A kick of fire crashed into Zack's head, causing him to tumble forward, and Sol running out of energy fell to the ground.

Zack turned to the teenage girl; black smoke lifting from his body, his face twisted with annoyance and anger. He crept upon the girl; he could tell she was out of juice. Zack saw Sol struggle to get on her hands and feet, her body shaking, and trying to gain some type of control, she was spent.

Zack stared down at her, "You would have been a grand soldier, but you chose the wrong organization."

Zack pulled his right hand back with a smile, as black veins covered his skin. A portal appeared under the man and black clawed hands emitted from the vortex. Zack's confident smile became one of fear as he noticed his body was frozen, the hands covered his mouth and eyes, they pulled unto his skin, dragging him down into the darkened abyss. Shadow Black laughed, covered in snow, his wings of darkness flapping, as he looked upon his chaos from above. Sol watched at the sinking Zack, his fearful eyes of tears being the only reaction to Shadow's horrifying magic. Shadow raised his hands and the portal began to absorb Zack at a quickened pace. Sol watched as the last of Zack gray's hair became one of the blackness and he was gone. The Warlock elegantly landed onto the portal, the darkness absorbing back into his body.

"I suppose hiding the truth was an entirely false effort." Said the Warlock, taking a bow, "I suppose it's time to reintroduce the true Shadow Black.

Chapter 23:
Shadow tells on Himself

"Wha…Shadow…" Sol looked up at the young Warlock, as he rose from his bow, the snow highlighting his black hair, "Shadow what are you talking about?"

Shadow looked behind him, his comrades were still in a deep sleep from the brutality and harshness of their battle.

Shadow turned to Sol and said, "You have proven to be a leader of some sorts." He took a step closer, and even battered Sol scooted a little back, "For me to keep such secrets behind sealed doors, I suppose I need to tell you a little about myself." The Warlock put his hands behind his back and looked at the sky, "I am not what I portray. I am nothing but many entities crushed into one body filled with magic. Similar to humans, we beings of other species like to adventure, leave the confines of the normal and explore." A quick genuine smile flashed upon Shadow lips, "Hmmmmm, so we did. We escaped in the body of a dying elf boy. Who he was before, I don't know? What he liked, I could only imagine? Did he scream in agony as I devoured his soul and made his body mine? No, he cried tears of joy when I…we assimilated within him."

Sol Pepper couldn't believe what she was hearing. Shadow was some body snatcher? Why was he divulging this information? How was this going to help with the overall mission? It was just more problems she really didn't need to deal with? Was she going to have to fight?

Sol painfully and slowly got to her feet and held up her fist. Shadow gave a look of confusion and lightly giggled.

"We don't want confrontation, my dear Sol." Shadow said, slightly amused, "We want to keep adventuring, we just thought our superior should know the truth."

Sol was hit with a new realization and fell back onto her knees in exhaustion and began to laugh. Who cares what he was, or how many he was, deep down it was still naïve Shadow Black.

Chapter 24:
Taming the Wolf

Johnnie and Isaac True tore through the snow of the red forest. Johnnie used his canine energy to easily sprint through the heavy whiteness. While Isaac rocketed close to the ground, covered in his magenta lightning and fire, left a trail of water in his wake. Suddenly, Johnnie came to a halt, his feet slid across the snow, stopping several feet in front of a small emerald cathedral.

Isaac crashed landed next to his brother, creating a pool of steaming water around him, "Is this where the book is?"

Johnnie walked up to the door, his senses warning him of the danger inside, "I don't know, but its sketch nonetheless." Johnnie put his hand on the center of the ten-foot stone doors and easily pushed them open. A long creak followed with the odor of a light wet must, and Johnnie felt more danger than ever, "Be careful when walking in."

Isaac and Johnnie crept into the small cathedral, the floor was made from cobblestone, and the pews were wooden and covered in cobwebs. The glass showed ancient pictures of the Great Writer and his Book of All. In the center lay an altar and on the altar was a book. Johnnie and Isaac rapidly made their way to the altar, and Johnnie grabbed the book.

"The young wolf rapidly flipped through the pages, his face filling with disappointment, "This isn't it." Johnnie dropped the book on the floor, "Let's go, this was all a trick."

"But we want you to stay." Called out three beautiful women, hidden in silk cloth.

As soon as the twins turned around, Johnnie and Isaac were aware it was a trap, however, they were young men and these were beautiful women. The women had fair skin, soft creamy legs, flirty eyes, moist lips, and curly red hair with lithe bodies. Johnnie found himself caught in their beauty, his young body yearning for their touch. Isaac quickly put his hand over his eyes, he was sure he wasn't suppose to be watching this kind of programming. The lead woman, a redhead walked up to Johnnie, her scent smelled like nature, her cloth dress revealed a pink thigh, and Johnnie whimpered. Her warm hands wrapped around his face and she kissed the wolf. Johnnie felt warmth run through his body, a feeling he couldn't control, something in Johnnie burst forth, a change was happening. The women began to walk back and laugh. Isaac in his confusion took a quick peek to see what was happening and exclaimed at what he saw.

Johnnie eyes's were glowing red, with a howl Johnnie's tail burst forth from his pants, his ears became furry and sharp, canine teeth burst from his mouth, and his sights were on Isaac True.

Isaac, from the amount of videogames and anime he experienced was quickly able to put things together, "Those women have you hypnotized?" Isaac rapidly made his magenta blade come forth from his right hand, "Ah fudge muffins, how am I suppose to free you!"

Chapter 25:
Isaac True Vs. Johnnie True

Feeling fear, Isaac True ducked a right punch from Johnnie True. The young werewolf attacked with a left claw and Isaac jumped back, landing on his butt. Johnnie, trapped in the seductiveness of the three women let out an ominous howl and lunged for Isaac. Isaac in response let out the shriek of a young child and summoned his ability to explode. Johnnie was hit with a combination of magenta fire and lightning, crashing into the pews.

"Johnnie!" Isaac said, getting to his feet, "Are you hurt? I didn't mean to bro....uh"

Johnnie raised from the debris, smoked steamed from his body, and he began to heal immediately.

"Oh yeah!" Isaac realized, "I totally forgot Johnnie could heal." Isaac began to realize how deep in the cow dung he really was, "Johnnie can heal."

Johnnie turned to Isaac with possessed red eyes and began to stalk towards him, with claws ready and fangs bared.

"Johnnie I'm not going to fight you." Isaac said, stomping his foot on the ground, "We're bros, control your hormones!" Isaac heard laughter from the three women, "Free my bro," Isaac said, pointing to the exotic trio, "this shizznite is not funny, we got adventures to go on!"

The women seemed to laugh even more, holding each other with glossed lips, and making the sounds of lusty she-devils.

Isaac looked at his right hand and his magenta blade came into fruition, "Fine, I'll just have to knock Johnnie out of it."

The wolf began to sprint toward Isaac, fangs bared, and saliva dripping down his teeth.

Isaac quickly raised his glowing blade above his head, "I'm sorry bro, but you're going to have to face my Magenta Slash!"

Isaac brought down his blade, creating a horizontal arc of energy that burned throughout the grounds of the cathedral. The Hypnotized Johnnic had no fear as he punched Isaac's projectile with a right jab, exploding it upon impact. Isaac fully realized his attack wouldn't take Johnnie down and began to produce slash after slash, explosion after explosion, rocking the cathedral.

The three she demons did nothing but laugh and taunt the brothers as the battle tore the holy relic apart. Unfortunately, Johnnie was able to take on each explosion, and by the time he reached Isaac, the Magenta Swordsman had wasted all his energy.

Johnnie's right claw wrapped around Isaac's throat, and he snarled showing his white glistening fangs, but Isaac looked in the depths of Johnnie's eyes and saw hesitation.

Chapter 26:
A Phantom!

"John….nie" Isaac choked, "I know…. your deep in there… lifting weights or something?"

The young swordsman put his right hand on Johnnie's choking arm and purple smoke began to emit from Isaac's hand. The Hypnotized wolf paid no mind and his grip around Isaac grew stronger. Isaac began to see the darkness form around his vision, his legs flailed as Johnnie picked him up, his breath grew short and desperate, his eyes rolled into the back of his head and all went silent.

The women laughed as their wolf slave dropped the lifeless swordsman. Johnnie had proved his worth; they would keep him around for a while, until they grew bored.

The three women beckoned the wolf towards them, they would give him a reward of their flesh for his obedience. But instead as Johnnie made his way towards the group, cosmic feathers materialized between the wolf and women. The feathers opened a gate, letting a lean six-foot-three figure pass through. The figure was covered in a white sleek material from head to toe, his face was covered by a white frowning mask, and his head was wrapped in a white turban that moved with the wind.

The women hissed at the newcomer, but the response was a simple "Ahaa."
The newcomer in white disappeared into his feathers and reappeared next to Isaac. The man in white grabbed the boy and they both vanished into purple feathers. The women looked around, causing Johnnie to spin about howling and barking. The man reappeared once again, grabbed Johnnie and

vanished, and then he reappeared in front of the women. The beautiful women began to change; green veins infiltrated their creamy skin, their eyes became yellow, their teeth became fangs, and their breasts became covered in scales.

The Phantom simply said, "Now you see me."

The women could feel their talons about to embrace the white savior.

"Ha, I'm not a White Savior!" He remarked, correcting his description

Correction; the women could feel their talons about to embrace the *Savior in White*.

"Now you don't." The Phantom easily vanished.

<p style="text-align:center">***</p>

The Phantom reappeared at a clearing, where Johnnie and Isaac laid. Johnnie was passed out on a tree, while Isaac layed spread out in the silver snow. The Phantom walked over to Isaac and put his hand on the boy's chest. The Phantom nodded to himself and punched Isaac straight in his core. Isaac eyes opened and fresh air ran into his lungs. Several coughs brought life back into the boy's body and when Isaac recognized where he was, he only saw Johnnie who was still asleep.

Isaac looked at his sleeping twin with a smile and said, "Johnnie must of saved my life!"

Chapter 27:
A Restful Retreat

Tasia Snow looked up at the evening sky, it was becoming an off green, and orange stars began to break into view. Tasia took off her mouth scarf, to breathe in the air, and it felt good. This adventure was turning out to be quite the ordeal. They seemed to be bombarded with Chimeras and hardly had any time to truly rest. This was their longest break yet and Tasia wondered what was being planned behind the scenes.

"We didn't get to the cathedral, but a score is a score." Tiana said, walking out, "You hungry?" She said, passing what she thought was a slab of ham to Tasia.

The young ninja looked at the meat, grabbed it, and began to tear into the juicy substance.

"I still say the food at the cathedral would have been better." Tiana said, sitting down, "Too bad Julie's on a different mission, she would have loved it here." Tiana popped a white grape into her mouth, "Those flying chimera's could have been good target practice for Ginger as well, she's molding good into this batshit crazy team, don't you think?"

Tasia nodded.

Tiana decided to eat the rest of her food in silence, letting her countless cuts and bruises heal, taking in the rare peace of the garden. Tasia decided to rest her eyes, she keep her other senses alert. A breather was a rarity for this mission.

Hidden behind the crimson trees and the silver snow was a reptilian humanoid. The creature watched from the darkness as two girls ate and

talked. Within the creature's mind, he recognized these teenagers. They did something to him, made him like this, but he couldn't remember, too many thoughts, too many senses, hisses scattered his thoughts. The reptilian humanoid crept though the bushes, his tongue smelling everything around him. He kept his eyes on the two females, a feeling of embarrassment and rage filling his heart at the sight of the girls. They were important in his life as a man, he knew that, but he didn't know why? Why did these girls seem so familiar? The reptilian man held his head, and tears streamed down, who was he? Why was he? Why did the name Paul Savaar ring in his head?

Chapter 28:
The True Twins and The Lizard

"So, I almost choked you to death?" Johnnie asked, slightly confused, "Man, I don't remember any of it. I don't even remember what happen to those women." Johnnie glanced at his bushy black wolf tail, "I don't remember going half wolf?"

"Well you did." Isaac answered, striding next to his twin, "Luckily, you broke out of it." Isaac rubbed his neck, "I thought I was wolf chow."

Johnnie took a look at the sky, "It's getting green and oddly darker."

"I'm sure we can pack on a couple more miles." Isaac said.

Johnnie liked that Isaac was so adventurous, but he was letting it get to his head, "Beside the Enlightenment, I've been picking up all kind of strange smells." Johnnie growled, "This forest has all types of shit in it."

"The forest has a lot of poop?"

"No" Johnnie barked, "I mean creatures, some smells I recognize others I don't." Johnnie took in a deep breath through his nose, "Something about the animals here don't seem natural."

"Oooooh," Isaac said, "The mystery thickens."

"Do you have to take every challenge like a game?"

Isaac shrugged, "No, but it does make it twice as fun."

Johnnie shook his head, "I swear –"

Suddenly, Johnnie's face became serious, his fangs bared and he took a quick sharp look to the left, holding out his hand to block Isaac.

"Wha-" Johnnie hand covered Isaac's mouth.

The wolf gave a serious look to his lighter half and pointed to the left. Isaac's light brown eyes followed into the darkness, where he saw the back of a very large beast. Isaac could make out blue scales, and long black spikes, a long tail breached the surface of silver snow every few seconds, and an unnatural hiss filled the air. Johnnie slowly took his hands off of Isaac's mouth and began to move away from the scaly beast, Isaac followed. However, Isaac The Swordsman was not fully paying attention to where he was going, and stepped upon several crunchy leaves, catching the predator's attention straight away

The lizard made a rapid swerve for the boys, and Johnnie attacked with a swift jab to its snout. Isaac in fear and surprise cast a blast of magenta energy into the reptile's body. The combo caused the twelve-foot tall lizard to stagger, and for its right claw to go for Johnnie's head, but Isaac and his magenta blade countered, slicing the beast's claw in two. Johnnie added a hook jab into its jaw, causing it to crash onto its side. Johnnie and Isaac closed in, but the tail of the beast went into a frenzy.

The beast's tail acted like a whip, nearly hitting the twins whenever they came to close. Isaac began to catch on to the tail's habits and he waited for the leather whip to come near him. The tail was so quick; Isaac hardly had anytime to react. With a mighty swing, the swordsman swung his blade, slicing the tail in a vertical fashion. The appendage swung through the air, spraying it's retched lime green blood upon the boys. Johnnie lunged forward, giving a right and left jab to the reptilian's leathery

center, the beast's left hand claw grabbed Johnnie, as they tumbled through the forest.

Chapter 29:
The Lizard King!

Tasia Snow wiped the remnants of food from her mouth, "I'm curious about a certain observation."

Tiana Forest looked at her partner, finishing the last of what she hoped was a sugar donut, "Shoot."

"This is supposed to be a religious place." Tasia said, "But we haven't seen any people of the faith traveling on these paths, just chimeras."

Tiana let out a respectably loud burp, "Probably a trap, but that's normal for us Crows."

Tasia nodded, "Crows we are."

A magenta light caught the two young girl's attention. The howl of a wolf came next, followed by the sight of a giant lizard breaking from the depths of the crimson forest. Accompanying by the large lizard, the girls caught the sight of two familiar boys, one of the boys had his arms around the beast's neck, howling like a lunatic, the other was holding on for dear life onto a bloody tail.

Tasia and Tiana exchanged glances, "The True Twins."

Tasia kicked her doubled bladed spear into her hands, and sprinted into the tall blood grass, covered in silver snow. Tiana grabbed her bow and arrows and quickly made the necessary preparations.

Isaac and Johnnie True crashed into the grass, the beast proving too much for them. Isaac quickly got to his feet, grabbing his right wrist with his left hand.

"No," Johnnie spat, "Were saving that move for a last resort, remember what happened in The Gardens."

Isaac hesitated, and said, "Yeah, I'll just eat some more food."

The boy pointed his right hand toward the towering beast and began to charge his attack, but a projectile of lightning crashed into the reptile's head, piercing between it's eyes, and sizzling it's brain. The stupefied monster gave one final hiss, before crashing into the silver snow, staining it with its bright green blood.

"Wow." Isaac said, disengaging his attack, "That was pretty freaking epic!"

"I could have done better." Johnnie said, getting to his feet.

Tasia Snow jumped onto the dead reptile's body, " So, The True Twins are here."

"Hey, T Snow!" Isaac said, excitedly.

Tasia gave a light wave.

"Ah damn." Johnnie said, "The Crows are here."

"Only half." Tasia added, "We have food, how about we exchange info?"

Chapter 30:
A Party of Four

Tiana Forest, Tasia Snow, and The True
Twins sat in a circle, surrounding the warmth of the
campfire to combat the chill of the snow. The
foursome didn't really have much to talk about; they
knew why each member was there that day. The True
Twins knew Tasia and Tiana worked for the same
government unit that their father worked for, "The
Society of the Unknown." Tiana and Tasia knew The
True Twins were mostly here due to Johnnie True
Jr., who was trying settle a vendetta with the
Enlightenment.

"We might as well work together." Tasia
Snow said, staring at the dance of the orange flame.

"Yeah, more party members!" Isaac said,
"Plus, you guys are pretty strong."

"Will it really be a good idea?" Tiana argued,
"These two aren't exactly agents."

"We're adventurers!" Isaac responded.

"We just want the Enlightenment." Johnnie
said.

Tiana rolled her eyes and shrugged her
shoulders, "Hmmmmmm, I guess. Juliet is always
chilling with you two, if nothing else."

"Cause Julie's the best." Isaac said.

Tasia looked up at the sky and took off her
mouth mask, "We should get to sleep soon. They
will probably send their best fighters in the
morning."

Tiana waved away Tasia's warning, "We'll
sleep when we sleep, ninja girl. I want to talk to the
boys for a few." Tiana looked at the boys with the

eyes of a mischievous teenage youth, "You two single?"

The Carcass of the large blue lizard once known as Paul Savaar began to bubble and melt. The bones churned and wrenched up, the intestine shifted and changed, low pops could be heard as the body began to wake from its slumber of death. Lastly the reptile smiled, a human smile.

Chapter 31:
The Woman of Wind

Sol Pepper smiled as the main cathedral came into view, The Scrub-Dogs were tired, beaten, and running on the last bit of their willpower, but seeing the cathedral renewed them. They were going to complete their mission and be looked at with some respect; no one was going to take this from them.

"Your're quite the leader." Shadow said next to Sol.

Sol smiled.

"So is this it?" Star said, looking at the sacred building covered in red vines, "My feet are tired. I want a shower."

Shawn rolled his eyes, "I assume we could all use a refreshment at this hour."

Luna stayed quiet; she didn't know how to feel.

Sol let out a scream as her right fist became covered in fire and she punched an icicle of spear into hot air.

"An enemy!" Shawn yelled, grabbing his bow and arrows.

The rest of the team followed, scanning the area for the attacker.

"You little nothings got pretty far." said a familiar voice.

"Ah damn!" Sol shouted, "We should have killed you earlier!"

A small tornado of snow formed in front of the group, following it came a haughty laugh. A figure formed within the silver tornado. The figure had curves, the silhouette of her hair was curly, when she stepped from the snow one could see how her

fair feet calmed the land around her, her smiling pink lips seemed pleased by the coldness, her dress was silver and flowing, almost as if the snow had created the dress itself.

"Cassie." Luna whispered.

Cassie smiled as she strode upon the scene, it was great to see fear in the young agents, especially Sol Pepper, "I'm going to freeze you all to death, if that's okay?"

Sol hands became covered in balls of flame, "I'm burning up bitch, and I'm going to that cathedral!"

The snow picked up, whipping the Scrub-Dogs bruised faces, causing them to sting with fear.

Cassie gave a pleasant smile, "The only way you guys are getting into this cathedral is to get through me," the young woman cocked her head to the left, "and that wasn't so easy the first time, was it?"

Chapter 32:
Ice Fight!

"Fuck you!" Sol said, as her hands burned with red fire, "Fuck this whole mission! I'll burn the damn cathedral if I have to!"

Cassie threw a giggle at the feral girl, "It's nice to see you so riled up, but didn't you show just as much energy during our last fight?"

With a flaming right fist, Sol let out a frustrated yell and rocketed towards her opponent. Cassie waved her right hand and Sol was hit with a strong gust of wind and snow, slowing her down. When Sol reached Cassie, the villain was easily able to roll out of the way of Sol's assault. Sol immediately summoned her fire again, melting the ice on her body. Cassie spun her right hand and a tornado of ice covered Sol in its icy embrace. When the tornado dissipated, Sol fell onto her knees holding herself, due to the ice layering her body.

Star and Shawn intervened before Cassie could finish their leader. Shawn's dagger scratched Cassie's creamy face, and Cassie responded with a scream. The scream was manipulated by the wind and blasted Shawn several feet, where he crashed into a pile of snow. However, Star was a tougher challenge for Cassie. Whenever Cassie tried to attack with a gust of icy wind, the Vampire girl was already dodging, just barely missing the icy breeze of Cassie. Cassie waved her arm, making a vertical arc of chilling wind. Star easily rolled to the side, got to her feet, and flanked Cassie on her right. Cassie, in fear of the vampire girl raised her hands, only for black tentacles to rise from the snow and bind her body. Star rushed the woman, sticking her bladed talons

into Cassie's ribs. Blood burst from the woman and traveled down the blades of Star's talons. Star unable to resist, opened her mouth and let the sweet blood drip onto her tongue, where she was overcome with ecstasy.

Cassie looked down at the girl slurping up blood, Star's lips were quickly becoming stained with crimson, and she was becoming lost in the mere act of feeding. Cassie opened her mouth summoning another scream, Star felt small icicles hit her face, and the vampire let go of her precious blades, staggering back as the ice blinded her. However, Cassie was still trapped by Shadow's tentacles.

"Why don't you give up?" Luna said, walking up to the woman, "They'll kill you."

Cassie's blue eyes locked onto Luna's and she could easily tell what the young girl wanted, "You still love him don't you?" Cassie could see the sudden expression in Luna's eyes, the wanting, "I can take you to Chad. You can be with him."

Luna knew Cassie spoke truth. Ever since Luna saw Chad her mind had been adrift, everything seemed so unreal, all her sister did was please The Society but what about Luna's wants? Her own desires?

"C-c-can you really?" Luna, said, almost pleading, "I just need to talk to him, to touch him," Luna fell onto her hands and knees, tugging Cassie's dress, "will he be happy?"

Cassie nodded, "Ecstatic."

"Ice Mistress!"

Luna looked up to see Shadow Black.

"Get away from such a threat." Shadow said from above, his black wings flapping against the ice, "I'll take it upon myself to finish this task."

Luna raised her hand, "Just give me a minute."

The unsuspecting warlock nodded.

Luna looked up at Cassie and a thick tornado of snow covered them, blinding them from everyone's sight. When the ice and wind dissipated, Cassie and Luna were gone. Sol felt failure hit the pit of her stomach, her anger immediately grew, melting the ice around her body, and she screamed the name of her sister.

Chapter 33:
Good Morning

Isaac True woke up to the warmth of an orange sky. The young boy stretched rising to his feet, taking in the sweet air, enjoying that he would take another splendid adventure, with Johnnie and a couple of more friends. Isaac's eyes widened when he noticed something amiss.

The young boy went immediately to his dreadlocked twin, who was sleeping in the grass, with a side of slobber dribbling down his mouth, "Johnnie, Johnnie wake up! Immediately, something totally not Awesome Possum happened."

Johnnie awoke with the yawn of a beast, he sat up rubbing the grime from his eyes. His tail and wolf ears had retreated over night, but his fangs were still there as he smacked his lips, "What is it Isaac?"

"Um, Johnnie, remember the blue lizard monster we fought and defeated with the girls yesterday?"

"What are you blabbing about?" Tiana said, lying in the grass, with her eyes still closed.

"The monster we defeated in mortal combat yesterday is gone!" Isaac hastily said.

Tiana immediately rose to her feet along with Tasia and the two exchanged glances.

"Cut the shit Isaac!" Tiana said.

Isaac pointed towards where the body used to lay and the girls saw nothing there. Tiana and Tasia began to run towards where the body used to be, with the True Twins following close behind. When the foursome reached the destination all they saw was blue liquid that covered the red of the grass.

"Maybe another predator?" Tiana said.

"Another predator?" Tasia questioned, not liking that answer, "It should have come after us too, we would have been easy prey asleep."

"Maybe it had an extra life?" Isaac said.

Johnnie for the dozenth time shook his head, "life isn't a videogame, Isaac."

"Well whose got a better explanation?" Isaac asked.

"We must have not killed it." Tiana said, looking around, "Must have limped off." Tiana was over it, the girl shrugged her shoulders, "Ahhh who in the erased cares, let's head to the cathedral so we can save those no good Scrub-Dogs."

The group fell in with Tiana's thinking and using the girl's holographic map they continued their journey to the destined cathedral.

Chapter 34:
Betrayal

The Scrub-Dogs made their way within the cathedral; The inside of the holy relic was carved with black stone, stairs, alternate paths, and hidden walls giving the place a sense of a maze, lanterns lined the dark walls, highlighting many paths, and the paintings of beast and men finished the decorations of the queer temple.

"LUNA!!!!!" Sol screamed, her breath becoming red flame, "Luna!!!!!! I'm coming!"

Shawn put his hand on Sol's Shoulder, "We will face any danger to save her."

Star shrugged, "From what I saw it looked like Luna wanted to le-"

Shadow's Black's hand quickly covered Star's mouth, "I doubt Sol needs to hear such truths." The elf boy whispered, "Shawn probably saw it too, and Sol doesn't want to admit it." Shadow took a sorrowful breath, "I've seen situations like these, and the truth will show its peculiar face."

Star saw a curve in the young boy's smile that put a chill down her undead spine, so she decided to nod.

Shadow removed his hand, "Good vampire. Now let's not cause Sol anymore unnecessary stress."

Sol Pepper stopped at what it looked like a white grand staircase, "I know what it looked like. Luna, it looked like Luna wanted to go with that woman, but she's just confused. One of the Enlightenment members got into Luna deep, a long time ago, and now he's back to mess with her, but don't worry, Luna will pull back from this."

Shawn, Shadow, and even Star could feel the pity in Sol's voice, the regret, the failure of a sister, and they wanted nothing more but to hear the confidence within their leader once again.

"We'll find her within the depths of this cathedral." Shawn said.

"We won't leave without her in our grasp." Shadow added.

"Even if she wants to leave," Star shrugged, "We'll just force her back."

Once again Sol Pepper was proud of her team.

The young red haired girl's hands became balls of crimson fire, "You hear that, Chad and Cassie, The Scrub-Dogs are coming for you!"

The cathedral let out a piercing moan as if it had breath of it's own. The Scrub-Dogs began to hear booming steps move rapidly above them.

"Maybe that last statement should have been a silent one." Shadow said.

"No need of fearing the enemy now little warlock." Shawn said, homing in on the loud bumps, "It sounds like it has more than four legs."

Star rested her hands on her bladed Tonfa's, "Were always getting into a fight, never a breather."

Sol smiled as the stomping became louder, and she began to hear the hissing of the beast itself, "It would be boring if we just went up there and grabbed Luna, let's burn this cathedral down!"

Chapter 35:
A True Swordsman

"The True Twins and The Crows combine to make-"

"Don't you say it, Isaac!" Johnnie warned.

Isaac looked at his brother wide-eyed and with a smile on his face, and then he turned to Tiana who paid no attention to the boys, and finally Tasia who seemed to be spinning her weapon in her hand, whistling a tune.

"The True Crows!" Isaac screamed.

"Gotdamn you Isaac." Johnnie said.

"So is this it?" Tiana asked Tasia, "Looks like a cathedral to me."

"Oh there are also fake ones," Isaac chimed in, "with scary snake women."

Tiana ignored that bit of information, "Looks like the Scrub-Dogs might have beat us here?"

Tasia quickly brought up the map from her Zphone and nodded, "This should be the location."

Tiana banged her fist together, "In the fashion of our leader Juliet Valentine, let's go kick some fucking ass!"

"Another group of vile young ones." Ran a voice in the wind, "We seem to be getting a lot of spoiled brats here today."

The wind began to circle around the True Crows, the snow blinding, making sight difficult, and small bits of ice whipped at their face. In the midst of the sudden madness, Isaac caught sight of a silhouette. The boy quickly put things together and stretched out his hand, summoning a wave of energy to burst forth. The energy broke through the snow, hitting the silhouette and stopping the snowstorm.

"You almost hit me!" said the voice again, "I'm going to have fun with you."

"Fun?" Isaac said, a little lost.

A miniature snow tornado appeared in front of the group, releasing a man from its clutches. It was a tall man, with long blonde hair; he wore a white robe that covered his body, with loose white pants, and sandals. The coldness of the snow had no effect on the man as he walked towards the group, with a bottle of vodka in his right hand.

"You want to get in that cathedral, cutie with the cornrows." He said, reaching into the snow, pulling out a blade of ice, "I've researched you, you think you're a swordsman soft ass."

Isaac swallowed his own spit, "Can you stop harassing me?" in the boy's right hand a blade of magenta materialized, "I am a swordsman! The best in the State of the Bear!"

"To erased with this!" Tiana said, lining her arrow and bow, "Let's jump his ass."

Johnnie held out his arm, "I think Isaac has this, as crazy as he seems, he spends hours into his sword training."

"I think it's just male pride." Tiana whispered to Tasia.

Tasia nodded.

"You want to get into this cathedral?" The blonde man smiled, "then defeat me, but if I get you, well…I believe you know what I want."

Isaac grabbed his blade with both hands, as the blonde man only had to use one.

"Well I'm Serif Strife, one of the Four Swordsman of the Enlightenment!"

Chapter 36:
Mayhem in the Cathedral

An unknown creature stalked the Scrub-Dogs, from a crevice within the cathedral. The beast had a myriad of eyes, that lusted for the flesh of the teens, it's mouth salivated venom as it thought of their taste. Its many legs shook from the mere anticipation, and finally the grotesque creature couldn't handle it's hunger and dashed for the youth, its sights focused on a redhead, who was climbing the grand stairs.

Sol Pepper was the first one to see the beast. A furry creature with eight limbs, that resembled human arms and hands, it's upper body took the shape of a naked cream skinned woman, with eight blue eyes, and it's mouth full of fangs.

The monster let out a hiss that vibrated the Scrub-Dogs bodies, causing them to be rooted in place. The beast turned its horrific head to Sol and lunged for the young girl. Sol reared back her right fist, which became surrounded in crimson flame and shot it forward into the creature's face. The fire quickly spread, burning the spider woman's milky skin into a charred smoking black. An arrow delivered by Shawn Bolt arced through the air, shooting through the woman's bare chest and through her back. Shadow's raised dark ethereal snakes from the ground of the building and made them sink their shadowy fangs into the opponent. Lastly, Star rushed the creature, bringing out her bladed Tonfa's and digging into the creature's beastly furry underside.

The monster tried to stop Star with it's many hands and feet, but the girl easily slipped between the limbs by spinning and jumping, her blades cutting the fingers and toes off of the beast. The final hit comprised of another vicious attack by Sol, who performed a right roundhouse kick, releasing the fire from her shoe on impact. The spider shot back in a flaming ball, hitting the back wall of the upper floor.

The Scrub-dogs heard the beast scream as it died, it was a mournful scream, as it knew that it was an abomination, this fight was more of a release from its' tortured form, than a way of survival. The Scrub-dogs didn't wait long before moving to the second floor, but they couldn't shake the feeling of a more powerful force waiting for them in the depths of the cathedral.

Chapter 37:
Isaac True vs. Serif Strife

Isaac True sidestepped an icy stab from Serif, then ducked a frosty side swing. The boy performed an explosive upper strike, only for Serif to jump back and let the wind elegantly put him back on land. With a rush of wind, Serif dashed toward Isaac, who was barely able to block with his blade of hot energy, nearly melting through Serif's sword, but the clever ice swordsman easily disassembled his blade and quickly pulled another from the snow.

"You haven't hit me once brown eyes." Serif said, planting his blade in the ground, "Why not just come to my room, after I'm done with you, I'll let you have a turn at the women."

"So weird?!" Isaac screamed, rocketing towards his opponent.

Serif easily spun out the way from Isaac's vicious assault, the boy's blade hit the snow, turning everything into liquid in a five-foot radius. Isaac slipped as he landed and Serif chose that moment to attack. Isaac felt coldness as Serif slashed his shoulder. The boy quickly spun, parrying another hit, and Serif spun around Isaac, getting another clean slash in the back of Isaac's right leg. Isaac's sword dissipated, and he fell into the snow unto his hands and knees.

"Johnnie!" Tiana screamed, "Do something he's your brother!"

"Technically there are the same person." Tasia said.

"Don't get smart with me." Tiana barked back, "You know what I mean. Johnnie go get him!"

Johnnie shook his head, "Isaac's got this."

Serif's Silhouette overshadowed Isaac. The young True Twin looked up to see the blonde man smiling over him, as if he was a puppy.

"I haven't lost yet." Isaac said, getting to his feet, "I've been practicing a new move."

Out from Isaac's right hand came his usual blade of magenta fire and lightning, but out of his left hand came a short blade of magenta fire and lightning, "I'm just getting started."

Serif raised his sword in the air, summoning more snow to compact it, causing the blade to become more thicker and harder to break, "Let's see what a boy like you can really do with a couple of blades?"

Chapter 38:
Trapped!

"Ew," Star said, staring at the picture of the wrinkled skin king, "How is he king?"

"The monarch isn't decided by looks, Star." Said Shadow.

"It's all about the blood." Said Shawn, gazing at the picture, "In my world I worked under the Royal Family. I've been around kings and queens."

"I'm sure that's all well and great." Said Sol, continuing her descent down the moldy hallway, "But we don't have time to be wondering about Star's future husband. We got to find Luna."

Sol half expected some snotty comeback by Star, or maybe some more nonsense from Shadow or Shawn, but she heard nothing. The young girl turned around, facing the back of the hallway. Dying lanterns dimly lit the hallway, spider webs decorated the ceilings, pink glowing mold grew from the floorboards, and lastly there were her teammates, that seemed to be frozen in place. Star still had her arms cross, her eyes glued to the picture. Shadow was on her right side, Shawn her left; the two elves had their mouths wide open, most likely giving an explanation. Sol began to feel nervous.

"So it's just us again."

Sol turned around to find herself in an abandoned cellar, the ground was black and hard, and one green light hung above her, the room itself was only about five hundred feet all around.

"Sol, my Sol."

Sol spun around and faced the charming, yet also disgusting Chad Rockwell. The brunette man sat in a wooden chair, his legs crossed, his right hand

tugging on his goatee, with a smile of pearly white teeth.

"Sol." Chad said, "How I love it when I get to stare at that defined face of yours."

Sol let the rage fill her heart, the girl's fingertips began to breathe an orange fire, and her body began to release a black smoke, "Chad, Chad, Chaaaaad!

Sol burst towards the man, flames spewing from her shoes, and crimson fire covering her right fist. Chad easily spun, and Sol destroyed the chair he once sat upon. With a snap of his fingers, Chad's blade materialized in his hand and with one hand he swung it towards Sol. The girl slid under the horizontal attack and performed a fiery kick for Chad's legs. The man jumped over Sol's fiery effort and slammed his sword upon her; Sol dodged with a roll and got back to her feet with a fiery roundhouse towards Chad's face. The man cocked back his head, his nose smelling Sol's flames. He reared his sword up into the air with a spin, bringing it back down. Sol jumped, rolled, and spun with another fiery kick, hitting Chad straight in the jaw.

The man staggered back, and touched the blood trailing from his mouth, "You did it Sol!" Chad sounded surprised as if he just taught Sol a valuable lesson; "You hit me on your own." The man smiled, "Now I can show you my true skill!"

Chapter 39:
Dual Swordsman

Isaac's right blade sliced into Serif's ice buster sword, causing an explosion of magenta on impact. Serif staggered, to only parry an attack from Isaac's left blade, which gave off a smaller explosion, but one still strong enough to cause cracks in Serif's sword. Serif swung with an icy anger and Isaac parried him with his right blade and went for slash with the left. Serif felt the stinging burn of Isaac's new shorter blade and jumped back.

"Boy," Serif said, "You do have some little tricks up in those pretty brown eyes of yours."

"What does that even mean?" Isaac asked.

"It means I want to become lost in you Isaac True."

Serif jumped forward, using his tippy toes. The surprised attack caused Isaac to flail his blades, missing Serif and he received a slash that broke through his armor and cut his arm. Isaac began to feel coldness enter his right arm, icicles formed on his hands, and his blade vanished, but he still had his short blade. Isaac parried Serif's second attack, and the two young men fell into a series of violent parries, each blow caused Isaac's blade to explode, sending cracks to Serif's blade and melting the snow around them. Isaac ducked a swing, nearly cutting off his ear and slashed Serif's abdomen. Serif laughed at the pain, and went for a stab to Isaac's face, Isaac parried and spun, cutting into the man's ribs. Serif fell onto his right knee and Isaac's blade was at his throat.

"I won." The boy smiled.

But Serif saw the hesitation in Isaac, he noticed how the boy's hand shook, the naivety in his brown eyes, "You won't do it."

Isaac looked confused, "Do what?"

Serif laughed, "Boy, oh pretty boy, you've never taken a human life, have you?"

"I don't do that, only scary monsters."

"Get away from him Isaac." Tiana said, holding an arrow in her bow, "We'll finish this."

"Wha…why." Isaac said, "He's already defeated, does he have to die?"

"Oh, C'mon." Tiana said, "What about when you fought that Paul guy back in the gardens?"

"That was different." Isaac said, "He…. had turned himself into a monster." Isaac realized the weakness of his argument.

"He's an immediate danger." Tasia said, joining the conversation.

"Isaac get away." Johnnie ordered, "I know you can't handle this."

Serif chuckled as blood poured from his mouth, "I'd rather be killed by brown eyes, the wolf is disgusting, and the other two are just horrid women."

"Shut the fuck up." Tiana screamed at Serif.

Serif nodded, "She's feisty, huh Isaac."

Tiana took a deep breath, "Isaac, get away now."

"But-" Isaac lips trembled, "But its murder."

"Isaac," Tasia said, laying her hand on the young boy's shoulders, "Tiana and I are agents, we're hired to kill. The day you accepted taking adventures with Johnnie you accepted responsibilities like this one."

Isaac glanced at Johnnie, who nodded. The boy took a sorrowful look at Serif and evaporated his blade, turning around and walking away a few paces. Tiana focused her bow on Serif and pulled her arrow back. Serif looked at the young girl, holding the deadly projectile and turned his head toward the early orange morning sky. Tiana let go of her arrow and a bolt of lightning shot through Serif's neck.

Chapter 40:
Chad's Comeback

"What do you mean?" Sol said, offended, "I've been kicking your ass here and back, you've been holding back Chad?"

"Chad stood over Sol, a smile on his handsome and wicked face, "Sol, I can show you what I'm capable of."

Sol let a chill run through her body, because Chad looked happy, and when Chad looked happy nothing good could come out of it. Once again, Sol busted forth, her right fist became filled with fire, and Chad smiled. Chad stuck out his right hand and Sol was stuck in the air. Sol tried to struggle, but she couldn't move a muscle. With a wave of Chad's hand, Sol's fire dissipated. The Enlightenment member walked up to the Society of the Unknown agent and let his hand run across her smooth face. Sol could do nothing, but feel his palm rub over her lips.

"My Sol," Chad said, looking into Sol's eyes, that were literally filled with fire, "My Dear Sol, how we've grown apart. I miss you, I miss our play." Chad's right fist smacked into Sol's stomach, "Why wont you comeback home like a good girl." Another fist bored into Sol's body, "Why can't you be good like Luna?" A slap hit the right side of her face, "Why can't you just bend over and listen to me, praise me, let me be your god?"

In the flash of a moment Sol Pepper was on the ground covered in bruises, bile leaving her mouth, her vision blurred by blood in her eye's. She felt Chad's strong grip in her hair and he jerked his head close to her ear and whispered,

"Sol, My precious Sol, did you think you could really escape from me? I'm going to bring you home and break you down, you'll end up like Luna obeying me, lying with me in bed, being my slut."

Sol screamed, she screamed and screamed, but all that rose from her body was a smoldering black smoke, she was wiped out and Chad knew that. Chad slammed her head into the ground and rose, giving Sol a strong kick to the gut. The teenage girl rolled over, staring up at Chad through bruised eyes, hardly able to make out any of his charming expressions, only left with his horrid violence and the fact she was going to be assimilated. Absorbed back into the life she desperately tried to escape from, she had failed.

"I'm sorry Luna." Sol said, closing her eyes, "I'm so sorry."

"Don't be sorry." Said a familiar elvish voice, "Sorry, it took some trickery to work through his abilities, if you could call it that."

Sol smiled through the pain.

Chad looked around, "Who…what." He turned to Sol, "Who is it? One of your new friends." Chad chuckled, "If you cant beat me what make's you think he can?"

Sol began to laugh, even in her defeated state; she could still make out the black veins covering Chad's fair smooth skin.

"The fuck?!" Chad screamed, "What is this?"

The black veins on Chad's skin began to spread, covering him in Shadow's dark magic. The man screamed as creatures with elongated necks, a myriad of red pulsing eyes, and fangs of blackness erupted from his body and began to feast on his flesh. The Enlightenment member rolled on the

ground hollering, screaming, trying to tear the monsters from his skin, but he could do nothing as Shadow's dark magic infiltrated his body, his soul, his being.

Sol looked up at Shadow, she felt ashamed. Here Shadow was a powerful warlock, always coming out on top and saving her ass, and here she was always getting beat and on the bottom.

Sol turned her face away from Shadow, "You saved me again."

Shadow smirked, showing his true personality, and then he bowed, "Just think of me as your familiar, all my magic is yours. Now, what will we tell the others?"

But before Sol could answer, she felt a chill in the air.

Chapter 41:
Luna Pepper Vs. Sol Pepper

"Chaaaaaaadddddddddd!!!!!!!" the words screeched through the cold air, causing Sol bruises and cuts to sting with pain.

A white tornado wavered in front of Sol Pepper and Shadow Black. The tornado opened, revealing Luna Pepper, wearing a wavy dress formed from her own icy power. The girl looked paler than normal, almost blue, her tears were frozen on her face and her eyes were a tranquil gray.

"Sol," Luna's voice danced upon the air, "Sol, my sister, how I followed you to the depths of your own ignorance. The Enlightenment might have their ways, but they instilled discipline, logic, don't you know once they succeed we will become Great Writers. Writers Sol!"

"It's bullshit!" Sol spouted, "Science can't turn you into a Great Writer, the whole Enlightenment is bullshit, don't you see that. Chad is bullshit."

Sol felt the cold air hit her, her body ached, but she found the strength to stand on her own feet, "Luna it's Chad talking, not you. Don't believe in the Enlightenment, their fanatics. They're mad men!"

Luna smiled, "The Society of the Unknown is the same thing. Men who want to go above and become Writers to rewrite the world. Why can't you see where all fighting to become something great, that's all humans can do, fight to become great." Luna, looked down at her sister, "Let's see who has the stronger ideals."

"Luna," Sol said, her hands lightly burning orange, "I won't fight you, but I will stop you from

making stupid decisions." Sol hands became engulfed in a bright orange flame, "I'll stop your nonsense."

Luna hands began to flow with a dark blue mist, "I'd like to see you try sister."

Sol, held out her hand, "Shadow you better not intervene!"

The elf bowed and walked back several steps, "I would never entertain such a betrayal."

"You've seduced the Elf." Luna mocked, "I bet you flow to his dark power like a moth to the flame."

Sol through all her pain smiled, "Don't be mad cause I get the cuter boys."

Shadow blushed, "Oh my."

With the remaining bits of her power, Sol rocketed towards her sister. Luna stretched out her right hand, letting the dark blue mist flow. It hit Sol, dousing her flame. The girl crashed on the floor, her flame extinguished, black smoke emitting from her body, no matter how she hated to admit it, she was done.

Luna looked down at her sister and reached out towards her, but black snakes appeared from the ground and snapped at the girl.

"Shadow." Luna smiled, "didn't my sister say butt out?"

Shadow shrugged, "Your sister isn't even conscious right now."

"You're a strange one elf." Luna said, "Why don't you go back to your world, I know with your power you can."

Shadow gave a charming smile, then put his hands behind his back, "I like this world." he said examining the scene, "The land of Terra Firma and

it's technologies, its people," Shadow glanced at Sol and Luna, "The Children of the Roswell, The Alchemist, Self- Experiments, and Homunculi, I'm interested in it all."

"That interest will kill you." Luna said.

"If I can die?" Shadow said.

Luna looked at her sister again, "I don't want to fight like this, I will get my vengeance for my Chad, but when Sol is at full power and can feel the loss of her defeat." Luna looked up at Shadow as another silver tornado began to surround her, "Tell my sister when I see her again, I won't be so easy on her."

In the next instant, Luna was gone and Shadow found himself with Sol and the others near an ebony staircase, leading to the upper floors.

Chapter 42:
Cathedral's Basement

The Cathedral's underground lair took a most interesting form; it had pews lined up like a service, the chairs traveled down the basement for half of a mile, before stopping at a gloomy black stone altar. The altar formed a picture of a beast, covered in a gray cloak, it had the body structure of a horse, but the legs were human bone and took the shape of human hands, and in it's bony hands, it held a black scythe.

"Looks like the grim reaper." Johnnie True said.

"I've seen the grim reaper." Tiana Forest said, "let's bounce."

"The book might be here?" Tasia Snow said, inspecting the altar.

Isaac True stayed quiet.

Johnnie sighed, "She might be right."

Tiana didn't like the aura of the place, the building smelled musty, she swore she heard bugs scurry everywhere, she felt trapped, and this whole haunted church business was getting to her, "Can we just hurry up, won't you boys help her."

"She's your partner." Johnnie said.

"And you can smell twenty times better than me!" Tiana screamed back, "Now help her Johnnie!"

Johnnie shrugged his shoulders and began to sniff around the altar, hoping he would find something unusual.

Isaac sat down on one of the pews, the death of Serif still haunting him, the words of Tasia still haunting him, he thought adventuring was something to enjoy, but it was more, it was life and death too.

"Hey don't think about that shit to hard," Tiana said, sitting next to Isaac, "stress gives migraine's, just swallow it. You didn't have to do the deed, I did."

"But…I…" Isaac didn't know what to say, "am I?"

"An adventurer." Tiana said, "That's what you and Johnnie are, the adventurers, however sometimes you got to do real shit if you want to see the world. Think about that Isaac."

Johnnie smelled death in the air, the young werewolf turned toward Tiana and Isaac to see the image from the altar brought to life. The creature was covered in a gray cloak, it had the form of a horse, it's red eyes glowed with malice, it's legs took the shape of misshapen hands, and in it's primary hands it held a large black scythe. However, his image isn't what caught the attention of the rest of the group, it was his scream, it sounded like the death of a multitude of women.

Chapter 43:
Star the Mimic

"So, she fought Chad," Star said in disbelief, "and her Crazy ass sister and won?"

"Yes," Shadow answered, "and she fought them quite well. It was a grandiose sight."

"Your magic must have been extremely potent to battle Chad." Shawn said, carrying the snoring and worn out Sol Pepper on his back, "You're not just any warlock, my friend."

Shadow's cheeks became mixed with red, "Aw, it was probably just a hint of elven luck."

"Well," Shawn said, taking a glance back at Star, "You're the main fighter."

Star did her signature shrug, "this will be easy," and rolled her eyes. "The fights been boring lately anyway."

"Before this we just fought queer creatures." Shawn said.

Star walked past Shadow and Shawn, making her way up the stairs, "I got this," the young vampire cracked her knuckles, "I just don't try, once we get back I'm listening to Death Metal Z and laying down depressed in my depression."

"Vampires have a unique way of having fun." Shawn said.

When the foursome reached the third floor they sighted with what looked like a ballroom. The ground was a picture of multiple planet and stars, spiraling around the cathedral. The ceiling took the shapes of a red sky, containing creatures of multiple shapes, flying through the cosmos, each creature had a pair of white powerful bird wings, and they seemed to aim for a sun in the distance.

"It's mesmerizing." Shadow said, staring at the ceiling."

"I'm always surprised by the art we run into, traveling through these different worlds." Shawn said.

"What is this a history lesson?" Star was annoyed, "Who cares about all these funky pictures? Where is the big bad?"

"Not all can appreciate." Shadow said disappointed.

Star shook her head and continued on her way, but a sudden force pinned her to the ground. The girl heard a screech ring through her ear, and blood began to leak out. Shadow and Shawn saw then a creature; the enemy took the form of a eight foot, muscular human, covered in black fur, it's wings were large, leathery, and black, its hands were equipped with sharp black nails, and it's powerful right hand was wrapped around Star's neck.

Star immediately grabbed a bladed tonfa from her belt and cut into the monster's wrist. The creature staggered back and Star spun out the way and leaped toward the creature, stabbing into it's chest. Star and the chimera tumbled into each other, but as the beast landed a jab into the she vampire's chest, Star kept grip of her weapon, spinning through the air, and crashing into the floor.

Shadow stepped forward, raising dark magic from the floors.

"Stop!" Star said, for some reason she had something to prove. Sol wasn't the only one who could fight, "I'll defeat this dickhead on my own!"

Star got to her feet and quickly made her way to Sol. She grabbed the girl's arm and sunk her teeth into it; Sol made a sigh in her sleep as Star

began to suck. The elves had never seen such intimacy, it almost felt wrong to watch, and a blushing came to Star's cheeks, followed by the earth shaking from the large chimera's stomps. Star leaped from the arm, grabbed her bladed Tonfa's and doused them in an orange fire.

A confident smile appeared on the vampire's lips, "Oh Sol, I think I'm burning up!"

Chapter 44:
Underground battle

Isaac True and Tiana Forest leaped to the right, barely dodging the edge of their enemy's large gray scythe. Tiana rolled, got to her feet, spun around, and loaded and arrow into her bow. The monstrous, skeleton creature raised its front legs, turning towards Tiana and Isaac, and galloped forward. Tiana released her arrow, letting it take the form of lightning. The projectile hit, crashing into the creature's empty eyehole and exploding forth. The monster staggered and Johnnie let a right jab land onto it's side, Tasia came from it's left, her spear clashing into the scythe, and the force knocking the monster back.

Isaac watched as the beast regained its balance and charged for him and Tiana. The monster's weapon ate through the pews, turning them into large pieces of debris, it raised it weapon toward Isaac and swung downwards. The gray rusted metal clashed with magenta energy. Isaac's blades were crossed, protecting him from the tip of the scythe. Isaac caused his blades to explode, destroying the monster's weapon. Tiana sent an arrow of flame into its mouth and Tasia Snow leaped forward, her bladed spear tearing through the neck of the bone monstrosity.

The creature fell into a pile of bones, its gray cloak floating down gently on the pile of white.

"Gotdamn!" Johnnie said, "I only got one hit!"

"You only need one hit." Tiana said, rubbing her arms, "This place is the creepiest of landscapes, let's get the fuck out of here."

"You ok, Isaac." Johnnie said, walking up to him.

Isaac nodded, "I think I understand," the boy looked back at the pile of bones, "Next time, I'm going to find a better way than killing people, a prison for them, knock him unconscious, I'll find a way."

Johnnie didn't agree, but he could see Isaac was trying to find a way, "Good, Isaac."

Chapter 45:
A Fiery Star

Star Field stared at the hairy, tall, bat winged beast. The creature screamed a hollowing moan, sending it's threating presence throughout the scene. Star rushed the creature, flames spilling from her Tonfa's. The monster swung it's mighty claw, and Star leaped over the attack, spinning horizontally into the creature's face, and letting her borrowed flames scar its' eyes. Star landed only to slash her weapons rapidly into the creature's stomach, letting the temporary flames spread throughout it's gray fur. However, the flames only burned the outside layer of the creature, letting it shed its soft skin. The flames revealed a creature with shiny coal black skin, its eyes were oval and silver, and it's mouth a perfect circle of ragged teeth.

The creature let out another moan, as it's right claw came for Star's head. The girl raised her weapons, and orange flames showered from the impact. Star leaped forward, performing a fiery vertical slash. The creature felt no pain and let it's left claw clash into Star's face. Star spun into a wall, blood leaked from her eyes and mouth, and her Tonfa's still held tight in her hands. The Coal Creature reverted to all fours and began to charge toward the young vampire. An arrow of untold speed crashed into the head of the horrid coal beast, knocking it off course.

"I said don't help!" Star screamed.

Shawn disapproved, "As a knight, I refuse to let you die."

"I'm a vampire." Star said, feeling Sol's power slowly leaving her, "I'm already dead."

Star pulled herself from the rubble and sprinted forth, bashing her right tonfa into an incoming arm, sparks flew and Star leaped into the air, striking another claw. The Vampire landed on her feet and the creature lunged at her with its mouth wide open. Star raised a single weapon and let the teeth wrap around it. The tonfa exploded in a fiery blaze, sending the creature back. Star threw her left bladed tonfa, letting it bash into the creature's face, and it exploded with another fiery crash. The weapon retreated back into its master hand, smoking black.

"Aw shit." Star felt herself becoming weaker, "Sol's power ran out."

The eight-foot creature emerged from the black smoke, from where Star observed there was no burn marks, no effects she had made no difference. Star began to feel a sense of sorrow, without Sol's abilities she knew she couldn't put a dent on this creature. The monster overshadowed her, and attacked with its right claw, Star jumped up, kicked off of the wall, and launched her self toward the beast. The monster easily swiped her down with its left paw, sending Star crashing into the architecture. The beast reverted to all fours and lunged for the weakened vampire. Twin navy blue daggers parried the black claws, and the creature crashed onto the ground.

"Cantankerous beast," announced Shawn, "it looks like this knight will be the one to slay you!"

Chapter 46:
The Strength of Shawn Bolt!

Shawn Bolt felt the pressure of the monster as he crossed his blades. The tailed elf's boots cratered into the stone from the force of the blow. The creature readied its massive claw back for another attack.

"Star, get back with Shadow." Shawn ordered.

"Who made you my daddy?!" Star yelled back.

The creature threw its massive fist and Shawn once again crossed his blades, taking the blow, orange sparks exploded from his weapons, the force blew the elf's hair back, and his tail billowed in the wind. Star got to her feet, ready to brawl, but black tentacles took her into their embrace as she reeled back.

"Shadow you bitch!" Star fought.

Shadow said, nervously, "I couldn't call myself an warlock if I let you get hurt."

Shawn leaped from a punch and landed on the ground, dodged a massive slap, and spun out of the way from a cratering stomp. The creature move's proved to be deadly but slow, but Shawn was sure the creature was waiting for the right moment to attack. It was tiring Shawn, until the opportune moment. Shawn back flipped to only be caught with a punch in the air, that sent him crashing into the ground. However, the tailed elf still got to his feet, with daggers in hand.

"It's quite difficult to kill one of my kind." Shawn said, putting his right foot in front of his left, "We are known to keep coming back." The elf spit a

glob of blood from his mouth. "We adapt fast too." Shawn bent his legs, and put his left dagger out in front of him and his right dagger close to his side, "If my memory serves correct, tailed elves have been known to fight for many moon cycles."

A black mouth of jagged teeth burst from under the coal creature. It began to bite into its skin, cracking it apart. Black chunks of skin fell from the demonic monster, shattering into smaller pieces. The creature tried to fight it's way out as the giant black mouth ground into its body. Shawn watched in a disgusted awe as the monster pleaded with bloody cries, reaching out for the tailed elf as it was being devoured.

Shadow let out the laugh of a crazed imp as his eyes glowed green and his magic ran rampant. The giant black mouth of sharp teeth began to crunch louder and more ferociously, devouring the coal beast and giving whatever magic it possessed to its master. When the task was complete, Star and Shawn were left in silence and Shadow wiped his mouth as his eyes returned to normal.

"What a delicious palate." Said the warlock elf.

Chapter 47:
The Final Bout

"Shadow, how strong are you really?" Star asked, as the four traveled up the stairs to the final floor, "I need to know before I risk my skinny dead ass again."

"I don't really know I…I just saw you guys in trouble and magic happened?" Shadow lied, "Warlock instinct?"

"Laughing." Star said, suspiciously.

"As long as you can duplicate such madness." Shawn said, "I doubt this book will just be easily received."

"Were pretty wiped and Sol's still knocked out." Star said, "How in the erased are we going to fight?"

Shawn stopped at the ebony door, "We're going to persevere and report back to our superiors."

Shadow happily nodded, "let's keep good spirits up."

"I guess I'll keep on fighting." Star said, with a cross of her arms.

Shadow and Shawn exchanged glances with a laugh.

"What's so funny?" Star said.

Shawn shook his head and with one massive kick, he opened the stone ebony doors. The scene that was revealed was one the group had come to expect. The wrinkly, scaly, no eyebrow king sat on his throne, with the homunculus book in hand. Around the man stood several people in white and red, the colors of The Enlightenment. One of the men stepped down from the upper seat of the throne area and walked down towards the four. He reminded Star

of an army general, but instead of green and camo colors it was all white. The man took a pair of white gloves from his pocket and put them on his hands.

"Without my puppets," Said the General in White, "I'm a little underpowered, but I can handle you four. Just call me The General."

Shawn put Sol on the ground, "I'm going first. I'm going to gauge his strength, Star you attack next, then Shadow."

Shadow nodded, and Shawn sprinted forward with his daggers out. The General simply waved his hand and Shawn was violently tossed through the air crashing back first into a wall, dropping his blades.

"Alright!" Star said, biting into the arm of Shadow.

For an instant, Shadow was in a world of complete warmth and bliss, he let his emotions feel his carnal mind and made his body slightly weak.

"You should recover after I get my ass kicked." Said Star with a sigh, "Shadow, tear these fuckers apart."

Star sprinted for The General, her eyes glowed green, and trails of blackness began to emit from her body. The she vampire leaped into the air, letting out the scream of a banshee and sent herself spiraling toward the general, with blades of darkness surrounding her body. The general smiled as he stopped Star in mid air, a shadow blade a mere inch from his face. The General twirled his hands and Star spun, hitting the ground face first. The General lifted his hands and Star levitated into the air, he put his hand down and the girl smacked the ground again, causing a crunching sound in her nose.

"Furck u." Star mumbled.

"Excuse me girl?" The General said, putting his hand around his ear, "Did you say something?"

Ropes of darkness emitted from The General's silhouette and the man looked at the warlock elf who had eyes filled of a misty green, "You must be the strongest of the crew, am I right? I don't really invest in male dolls but I might make one out of you young warlock.

Shadow smirked at the word "young", "Let's see if you can survive the Epitome of Darkness?"

Chapter 48:
The General vs. The Warlock

The General in White easily moved between Shadow's sporadic tentacle attacks. The member of The Enlightenment had improved his psuedotelekenis and given him the ability to temporarily stop time. Whenever one of Shadow's tentacles neared The General, he snapped his fingers, stopping time to give himself distance from the warlock's magic.

The General decided to end the fight and clapped his hands, stopping time. Shadow was stuck in a maddening position; the warlock's mouth was open wide, his eyes covered in green mist, and his arms spread out. The General easily walked between Shadow's tentacles and made his way to the frozen elf.

"I've researched you." The General said, holding Shadow by the mouth, "Why does an elf from another realm want to hide within Terra Firma? What are you running from Shadow Black?"

The next thing Shadow knew he was on the ground, his nose was filled with blood, and his body badly beaten by The General.

"You see," Said The General, turning to the king, "the Chimera tired out the agents and I beat them with ease. Just think when you have an army of these mighty put together beats at your disposal. Your kingdom will have no enemies, no worries!"

The leathery king nodded, "You members of The Enlightenment have proven far more faithful than The Society of the Unknown." The king reached under the seat of his throne, pulling out an old, worn

black notebook, "Here, you have earned such knowledge."

The General smiled as he walked up the steps holding out his hands. When he felt his fingers touch the notebook a sense of exhalation ran through him, a sense of pride, another notebook had been acquired.

"Is it time to leave?" Asked Cassie, appearing from the wind, "I'm bored of this place."

The General shrugged, "I'd like see if more agents come," The General looked at the defeated Scrub-Dogs, "Using my Psuedotime ability was quite enjoyable."

Cassie rolled her eyes and shook her head, "Boys and their toys."

Chapter 49:
Here come the True-Crows!

Tiana and her team made it to the ebony doors, that lead to the King's chamber. The young archer quickly held out her hand to call a halt. She knew what could be behind those doors and what type of battle could ensue.

"We could be facing The Enlightenment." Tiana said, "Are we prepared?"

"What do you mean?" Johnnie answered, "We go in there and kick ass."

"Yeah!" Isaac chanted, "Kick butt!"

"You boys take this shit like it's some kind of game." Tiana nodded at Tasia, "You ready?"

Tasia nodded.

The four teenagers exchanged glances and walked through the opening the Scrub-Dogs had already created. The battleground was a black tile floor, the walls were lined with torches, and a throne sat on a higher platform. The king was shrouded by several figures and one of the figures seemed to miraculously appear in front of the group. He was a man that looked like an army general but his clothes were in white. He looked at the four with a queer glance. Tiana noticed his gaze stayed the longest on her.

"Finally, another Tiana?" The General rubbed his hands together, "Maybe, I'll make you one of my puppets?"

Tiana pulled an arrow from her quiver and lined it with her bow, "What? You got a thing for teenage girls?" a thought began to circulate in Tiana's mind, "And how do you know my name?

The General chuckled at the comment, "I'll tell you, I'm only fond of women of a certain taste."

Tiana shrugged her shoulders, "Whatever, nigga."

The Archer released her arrow of lightning towards the General, who simply waved his hand. In the next moment, Tiana's arrow was crushed and The General loomed over her. A right jab from Johnnie True came for the General, but once again, time proved to be on his antagonist side who easily sidestepped the werewolf.

The General rocked his hands and Johnnie was sent vaulting into a wall. Tasia sprinted forward, going in an upper slash. The General was almost caught off guard, he saw a flash of metal and snapped his fingers, and Tasia was frozen in place. The dreadlocked ninja suddenly felt several fists cram into her stomach and send her to the floor.

"Time to face an Isaac Slash Attack!"

The General would have been caught off guard if Isaac didn't say anything. With Isaac wasting so much of his energy earlier, his fluid movements were much slower. The General was easily able to dodge the boy and send him rocketing through the ground and back to the first floor.

"Huh," The General said, looking down the hole, "the boy basically defeated himself."

"That's Isaac!" Johnnie roared, with a right hook aimed for The General's ribs.

Johnnie found The General gone and his misguided punch sent him falling down the hole Isaac had just created.

The General appeared where Johnnie had just stood and sighed, "You two are nothing like your late

and still alive father. Unlike you two, he actually thought things out."

"Only we can talk shit about the True Twins!" Tiana said, loading another arrow.

Tasia got to her feet as well, spinning her double bladed golden spear above her head.

Chapter 50:
Tiana and Tasia take a stand

"Fuck this nigga!" Tiana said, lining her arrow and filling it with fire, "We are not letting this fool get pass us Tasia, were getting the book and getting the fuck out this creepy mansion!"

Tasia agreed by slamming her bladed pole into the ground and nodding. Tiana let her arrow of fire fly towards The General. All The General in White had to do was twitch his hand and the arrow went sideways, crashing through a window and out into the wilderness.

"Gotdamn it!" Tiana screamed, lining another arrow and letting it fly in the form of lightning.

Once again the arrow went off course and through the floor.

"AHHHHHHHHH!" Tiana shot an arrow of ice, knowing in the back of her mind it was futile.

The General snapped his fingers and the arrow of ice shattered into bits and pieces. Tiana looked at Tasia and nodded. Tasia yanked her bladed pole from the ground and sprinted at The General. With one leap, Tasia was above her foe and brought her weapon down, ready to slay. The Man in White swirled his hands and Tasia found her self-falling through the hole Isaac had created, crashing back to the first floor.

"It's just me and you." The General smiled at Tiana.

"What did you mean with all that weird stuff you were saying earlier?" Tiana equipped another arrow to her bow, clinging to a false sense of security, "Don't come any closer."

In less than a blink, The General stood in front of Tiana, her arrow pointed at his chest.

"Tiana I know you." The General smiled, "Or better yet, I know a version of you. She use to work for us but in a recent mission was killed."

Tiana shrugged, "Bitch might look like me, but she ain't me."

The General reached his hand out for Tiana, the girl tried to release her arrow but her body was stuck. The General in White's-gloved hand delicately traced Tiana's face.

"How I've missed you, that life in your eyes. I never had to turn you into a doll when we made love. You came willingly. There's something about voluntary sex, intimacy."

Tiana was disgusted by what she was putting together. The General's hand began to take hold on Tiana's neck. The girl could do nothing as she felt the pressure, and her feet being lifted from the ground.

"Oh, how I'll imprint your dying face in my mind."

Tiana began to choke, coughing, as spit escaped her mouth.

"I could turn you into one of my dolls, but your not my Tiana Forest, it won't be the same."

Tiana could feel his hand tighten and her vision begin to blur.

"That night being alone, calling Cookie to comfort me. You know, she's just not the same as my Tiana."

A punch filled with fire crashed into The General's face. The man staggered dropping Tiana and releasing her from his psychic hold. A beaten

black-eyed redhead stood before The General, with fire brimming from her hands.

Chapter 51:
Sols and Tianas Powerful Combo

Tiana Forest grabbed the last of her arrows, "Sol, that's who you are right?

Sol nodded.

"I'm going to fire one of my arrows straight into this fucker's face," Tiana lined the arrow to the bow and pulled back, "When I do, surprise him."

Sol nodded. The young redhead was aware of who was talking to her, Tiana Forest of Juliet's gang. However, there were more important things to worry about at the moment.

"Get ready." Tiana said, letting her arrow fly.

The General in White watched as the wooden projectile shifted into a blazing comet of fire. He simply waved his hand to stop the time surrounding Tiana's attack, but he wasn't aware of Sol rocketing herself into the air, and then bursting back down to the ground to land a flaming hit into his jaw. The General in White twisted into the air before the girl's and crashed face first into the ground.

"We got that bastard!" Sol celebrated.

"Don't count him out." Tiana warned, running up to the scene and pressing her boot onto the General's head, "You see!" her fierce eyes turned to the leathery king, "Why you traded on the Society of the Unknown I don't know, but obviously you can't trust The Enlightenment either."

The leathery king looked at the young human girl and decided to talk, "I don't know much about you humans or care, but I'm honored by the way you fight and show resolve, but you are young. How can you understand the worries of Kings and Queens of other worlds?"

Tiana clinched her fist, she didn't know how to answer, "I know this guy under my foot and everyone he works for is a piece of shit!"

"The Enlightenment has supplied me with my own army." The King said and The General began to laugh.

"My father use to obey The Society of The Unknown and it got him half truths and losses in war." The King snapped his fingers and a hissing began to fill the innards of the room. Tiana and Sol's skin began to crawl with an overwhelming worry, "Unlike my father, I will seek new ways to protect this world of religion and self sacrifice."

The General began to laugh under Tiana's hold, "You thought I was trouble, wait until you've seen what I've made!"

Slithering rapidly from out the darkness entered a woman, a woman with blue scales for armor, her hair was white and tied in knots, her face simple and beautiful, and her lower half took the form of a dark blue serpent .

Chapter 52:
Blue Medusa

"Is it going to turn us into stone if we stare at it?" asked Sol.

Tiana rolled her eyes, "Na, that's only in those stupid myths." The archer reached for her arrows, but quickly found out there were none, "Damn, I'm out."

"It doesn't matter" Said Sol, "The girl's hands began to breathe a weak orange fire, "I got enough power for this blue bitch."

Sol Shoes propelled her forward; with a roundhouse kick she connected into the ribs of the she monster. Sol landed onto the ground and landed four punches of fire into the chest of the creature and ended the combo with an uppercut to the jaw. The blue she creature caught Sol's wrist as she connected with the last punch, Sol tried to escape with an explosion of fire but all she got was black smoke. The creature realized the young redhead's mistake and served a head-butt into Sol's skull. The world became a collage of blurs to Sol as her feet began to wobble and she fell onto the ground. Sol Pepper tried to snap off a left punch but she was too weak to connect. The Blue Medusa lifted up the girl and threw her to the side, where she crashed into several pillars.

Tiana Forest was left alone, again. The Blue Medusa smiled as it picked out the singular girl. It slithered showing a smile of fangs, and its white claws scraped upon the ground as it pulled itself closer to Tiana. Having no arrows, the girl quickly took out a dagger from her back holster.

"I ain't just got one trick." Tiana said, holding her dagger tightly in her hand.

The Blue Medusa neared the girl, Tiana held the knife out horizontally, ready to stab, and two blades of magenta and lightning pierced through the belly of the beast.

"Isaac True's Inside out Explosion!"

Tiana was vaulted back as magenta fire and lightning flew out from The Blue Medusa's chest, spreading smoking gore across the floor.

"Woah," Isaac said, his blades barely visible, sweat running down his face, and his body covered in bruises from the past battles.

"Leave it to a True Twin to save my ass." Tiana said, dropping her knife in relief.

"That snake monster didn't even see me fly back up here." Isaac complained, "It was wayyyyyyyyyy too focused on you." The boy's blades fully disappeared as he put his hands behind his head, "What a boring match up."

"You know this isn't a videogame right?" Tiana said.

"Yeah I'm aware." Isaac said, with a smile.

The General flexed his hands and he was instantly free from the ground and stared at the two with a predatory gaze, "Oh, we have much more than her."

The General snapped his fingers and blue portals began to materialize around Isaac, Tiana, and Sol. The Portals released blue skinned women, with leather armor, and tails for legs.

Chapter 53:
Out of Time!

The General in White looked down at the three remaining fighters, the she creatures had them surrounded. He couldn't help but smile at their scared teenage faces, how would they react? Would they react? The Society of the Unknown was nothing but a bunch of fools to send children to handle business as serious as securing the Homunculus book. How could they?

"Let's go." Said Cassie, "Those kids are done."

The General held out his hand, "I want to see the moment of their death." The general rubbed his cheek where Sol Pepper had gained a hit, "Especially that redhead, I might even make her a doll."

"Look at all the baddies." Isaac observed.

"Shit," Tiana said, "I'm out of arrows."

"Doesn't matter." Said Sol, "I'm burning everything down!"

A claw of white nails shot for Isaac, who quickly stepped to the right and released the last of the energy from his right hand. A blast of magenta fire and lightning ate through several of the creatures, turning them into a black crisp. Another lunged for Sol, who met the monster with a roundhouse kick of black smoke. Tiana kept her dagger in hand, swiping away to keep the beasts back. However, one of the creatures got behind Tiana and began to bind her with its tail. Sol and Isaac were to busy with their own problems to provide any help, leaving Tiana to her own devices. The Archer tried to get her arm out from the bind it was in, but it was

caught. The Blue Medusa opened its mouth revealing venomous fangs and retched breath. Tiana faced the beast, and a golden blade shot through the creature's mouth.

The blade was immediately retracted from Tiana's opponent, and as the monster fell Tiana was relieved to see Tasia Snow. Tasia quickly turned around, performing a horizontal slash, and taking down three more of the reptilian women. Isaac found himself cut off from the group and surrounded by several of the serpent women. The young swordsman was low on energy, and he knew he couldn't last much longer. He quickly dodged a tail strike from one creature to only feel the nails of another one rake the back of his armor. Isaac in a flash created his sword and spun, taking off a creature's head, his blade dematerializing instantly after.

"Oh, stuffmuffins." Isaac panted, "I've gotten myself in a bit of a sour doughnut."

Isaac quickly parried a strike, creating his blade at the last moment. The hand of a snake woman fell onto the ground as its owner screamed. Isaac felt the nails of one dig into his face, and cause blood to spill. A tail tripped the boy onto the ground, Isaac looked up to see demonic female faces stare down at him, their teeth wet with anticipation, their dilated eyes lustful for flesh, they moaned as they reached for the boy and Isaac had used up all his energy.

A howl broke the moans of the monster women. Johnnie True had yellow glowing eyes of rage, black claws, wolf ears, and a bushy black tail. The half wolf tore through the serpent women, like a rabid beast. Wolf claws tore through reptilian skin, teeth tore through necks, punches broke ribs and

bones. None of the serpent women could stop
Johnnie in his bloody onslaught.

The General looked at his pants and smiled,
"I think I'm getting excited."

Chapter 54:
The Conclusion of Battle

Shawn Bolt rose from the wreckage; The Tailed Elf vision's was a blur, his head pulsed, and he could taste blood in his mouth. Shawn noticed the battle in front of him and grabbed his bow, picked up an arrow near his boot, and lined it up. The archer aim shook, his hands ached, but he let the arrow fly. It crashed into the throng of snake women, flying over one's head and sinking into the eye of another. The Creature screamed, only to be silenced by the dying embers of Sol Pepper's uppercut.

"Look's like the tall ears are waking up." Sol Said.

"About fucking time!" Tiana said, stabbing a snake woman in the chest with a dagger, "They're the hard hitters right now!"

Tasia continued to slice into her opponents.

Shadow woke up next, his green eyes groggy, his attitude irritable. The young warlock saw his comrades in trouble, surrounded by the blue snake women and their gnashing teeth. The elf began to swirl his beaten hands, black fanged mouths began to emit from the snake women's silhouette and bite into their tough flesh. Shadow eyes locked on The General and produced a cunning smile.

"Look at the fools." The General said to Cassie, "Fighting amongst the chaos, for what?" The General shook his head, "The Society trusting babies, what do they expect to happen? This scavenger hunt for the Homunculus books will be quicker than expected. By the time these children are done with my toys we will be gone."

Cassie smiled, "I will be forever young."

"I'll be able to make any woman my puppet." Said The General.

A large creature of blackness rose from the darkness of the ground and opened its mouth upon The General.

The General simply opened his hand, and created a force that blew the monster back, "Did you really think such tricks could hurt me Warlock."

Shadow fell onto his knees; he was wasting too much magic. The Warlock needed time to rest; the string of battles had been too much of a strain on his body. Shadow could feel himself weakening, the sweat dripping down his face, his lungs gasping for air. He looked up to see a snake woman glaring at him, claws ready. Shadow raised his hand, only a trickle of magic swirled around his body. The monster woman attacked when blue claws shot through her neck, ending her life. The serpent woman dropped upon the ground and Shadow was face to face with a reptilian man creature, covered in blue scales with a long leathery blue tail.

"Get back." Paul Savaar hissed, turning to The General, "I got some Enlightenment niggers to deal with."

Chapter 55:
The Return of Paul Savaar

"Paul?" questioned The General, "I'm surprised you were able to find yourself."

Paul smirked, while cracking his newly evolved hands, "I was tough before I joined your little group and I'll still be a reckless bastard after."

Paul Savaar began to walk towards The General, nimbly moving his body as he by passed the serpent women, and countered with a vicious strike of his own. The lizard man made his way up to the throne room, shadowy figures including Cassie moved behind The General, entering a rapidly materializing blue portal.

"Paul, do you really think I have time to play with you?" asked The General.

Paul Savaar sprinted, his blue steel like claws aiming for the General's face. The General swirled his right hand and Paul went tumbling down the stairs. However, the Lizard man refused to be stopped by that setback and halted his descent with his tough nails. With a leap, Paul soared back towards his opponent, letting out a battle hiss, and striking with his right fist. The General put out both his hands, stopping Paul in mid-attack.

"Silly reptile." The General let out a yawn, stretching his arms, "All this fighting, I wish there was some women to watch instead of teenage girls, masturbation clears my mind." The General entered the portal "Well, that makes two, we're tied."

Time passed and flowed.

Paul landed onto the ground, his anger rising, "Writerdamn it!"

A blue thunderbolt crashed through the roof of the battle-ridden cathedral, creating a sphere of gray smoke and the silhouette of a man.

Sol and Tiana exchanged glances, "Ah shit!"

When the dust cleared an ebony man was revealed, his hair was cut into a fashionable flat top, his lab coat a clear white. The man wore stylish silver glasses, and a face of silent intellect. He raised his glasses, letting out two blue beams of lightning. The bars of energy tore through the remainder of the serpent women, spraying the floor with a rotten black blood, and leathery skin. The man looked over the scene of defeated teenagers, dead snake women, and then Paul.

The Lizard man let out a hiss and lunged for the nearest window, breaking through and out into the open. The man shrugged. He looked at the king, who maintained a stubborn leathery face.

"Tiana and Tasia, I thought you two would be of help." The man known as Jeremy Whizz shook his head, "I see I was wrong."

"Were out of our league," said Tasia Snow walking up, "The Society knew that."

Jeremy shrugged, "With the loss of our men due to the transfer, we had to risk it. The majority of you have been trained since the age of five. You needed to be ready. Now were tied." Jeremy turned his disappointed face to the True Twins, "And your father will be hearing about your illegal escapades."

"Ahhhh," Isaac whined, "That's not fair, we tried really hard this time!"

"Isaac," Johnnie said, exhausted from battle, "Shut up, the old man's going to kill us."

Tears and fear began to form in Isaac eyes, "Maybe mom too?"

Jeremy snapped his fingers, summoning an orange portal to appear under each teenager. The adult scientist looked at the teenage trainees, each one holding a face of shame, disappointment, or both.

They would need this pain for the upcoming battle. They needed to evolve further, if they wished to battle The Enlightenment. Once, The Society of the Unknown was a name that ran chills into the world of the supernatural. Now, they were just a relic of their former selves. These teenagers are the Black Shonen Generation and they need to survive and thrive.

Epilogue:

"Ronald, I'm going to be real with you." Tiana Forest took a glance back at Sol Pepper and rolled her eyes, "I thought the best action would be to help the Scrub-Dogs."

Ronald Donald nervously nodded, "Tiana, what did I tell you?"

"If I got in too much shit call Jeremy." Tiana shrugged her shoulders, "Fuck Jeremy."

Ronald took out his blue handkerchief, wiping his bald head, "You need to listen to Black Science."

"Black Science isn't out there in the field risking their asses." Tiana said, getting frustrated, "Who in the hell are the bigger heads anyway? I've been part of the Society as long as I remember and all I see is the agents, never the guy who runs the shit."

Ronald leaned back in his chair, "They are busy, but they are disappointed in The Crows performance."

"The Crows?!" Tiana screamed, "What about the damn Scrub-Dogs they still haven't completed a mission?"

"Hey," Said Sol, rising from her seat, "I won't have you talking about my team, when there not here!"

"I'm surprised they even call you a leader." Tiana said, still facing Ronald, "You even lost your damn sister to the enemy."

Flames erupted from Sol's fist, "You take that back, or I'm sending these flames into that fucking pretty face of yours!"

Tiana turned around to Sol, "Do it Sister, and I'll send an arrow down your throat bigger than any cock."

"Girls!" Ronald screamed, wanting to break the tension, "Well it happened, we might have lost a book but you guys along with The True Twins took down several of their agents. You might have lost the battle but you have gained us an advantage for the war."

"Then why does it seem like were being punished?" Sol said.

"Cause the higher ups are a bunch of bullshit." Tiana said, heading out the room, "I'm going to my bed, wake me up when Juliet gets back from her mission."

"I'm sure she will wake you up herself." Said Ronald.

Sol watched Tiana leave, "Are the Scrub-Dogs that bad?"

Ronald let out a sigh, "I admit out of the Black Shonen Generation the Scrub-Dogs are bottom tier, but there is progress. You showed that during this mission, you got your team back in a time of crisis."

"But Luna?"

Donald held his hands together, "Luna was bound to trade on us."

Sol eyes widened at Donald, "What?"

"Luna," Ronald said, "you never noticed but all she talked about was The Enlightenment, how she was confused, how she didn't see the difference between The Enlightenment and The Society of the Unknown. She was a lost young woman, but maybe there is time to bring her back, to save her Sol."

"In The Society's hunt for the fifth book, the Scrub-Dogs want in, I know my sister will be waiting for me."

Donald nodded and smiled, "I'll put in a recommendation."

Sol let out a sigh and returned the smile, "I'm going to bed."

Ronald took out his laptop from his desk, "That would be good. You were a leader today Sol Pepper."

Sol was quiet, reflecting on the adventure and Donald's words, she looked up at the bald man, smiled, and left the room.

Ronald Donald opened up his sleek black laptop and woke it. He clicked an icon on his home screen that read "Oni." The screen showed a live feed of a chocolate milk skinned girl wrapped in chains, her hair was blue, and silver horns grew from her head. The woman sat there struggling, trying to tear the enchanted bindings loose, but she couldn't, and in frustration she let out a scream that belonged to a beast.

"She'll be a nice addition to Black Shonen."

The Extinct God
Prologue:

The General in White sat on the stone seats of an ancient coliseum. In the middle of the crumbling arena stood two of his most precious dolls. The General in White couldn't help but be fond of both of them; he had stolen them from a world where artificial soldiers were made in the form of sixteen-year-old girls. What criminal would expect a teenage girl to be ten times stronger than the average man? The General couldn't have two of his dolls looking so alike, so today they would battle and whoever won would be his companion as the new "Cookie."

"You really get a hard-on for females fighting over you, don't ya." Said Cassie as she crossed her creamy legs, turning to The General.

"To see a woman in the depths of battle, blood covering her skin, sweat in her hair, her mind preoccupied on what to do next." The General in White smiled, "I love to see women in the heat of battle."

Cassie shook her head, "Just promise not to get your general juice all over me."

The General put his hands in his pockets and looked at the sand covered sky, "Ah, you don't even understand." The man rolled his shoulders and stood up looking at the two girls. His original doll, the original Cookie, had half of her hair twisted into a wild orange ponytail, while the other side stayed neat and green. the original Cookie's dress was green, flowing, and simple. In the young woman's right hand were three knives, in her left a dagger. Barefoot

and barely sane, Cookie bowed to her master with a giggle and a bit of saliva ran down her mouth.

"Show me you want to stay by my side Cookie." Said the General

The young woman who was fighting for the title of Cookie held a completely different aura. The young woman seemed to have a confident smile on her face, her ponytails were both long and a mixture of black, blonde and red she sported a black and red skirt with matching biker shorts, socks, and hi-top shoes. She flicked her wrist, summoning three silver needles to each fist.

"Ah, poor sister," Said the nameless girl, "Looks like they guy up there did ya in good."

Cookie responded with a scream filled of saliva.

The nameless girl pouted, "Look at you, a masterpiece brought down to a barely able girl, don't worry sis, I'll end it for you."

Cookie seemed to be able to understand the red and black haired nameless girl and a frown appeared on her face.

"Oh, did I get you mad sis?" The nameless girl asked, "Come and give your younger sis a big hug."

Cookie dashed toward the girl with a scream, saliva spilling from her mouth as her knives were held out to strike. The nameless girl was easily able to dodge the slashes of rage coming from her lesser half. The nameless girl could see the envy in every swing her sister produced. Who said the crazy couldn't be jealous. The nameless girl watched the rage patterns of her sister and parried, orange sparks showered the two girls and Cookie arms flailed. The

nameless girl thrust six needles forward, shooting into her sister's chest.

"Go to sleep sis." The nameless girl spoke, "I'm the new Cookie now."

The General in White smiled, "See a battle is all that was needed."

Cassie saw the smile and the rise of The General's crotch area, she shook her head, "Men."

Chapter 1:
The Gunslinger and The Enlightenment

In a barren realm with clouds of red and lightning of blue stood a temple. The temple use to be a shining emerald, the years had worn it down to sickening brown, vines covered the cracks and moss covered the holes. The building itself once housed a powerful deity, but years of abandonment caused the god to wither away, leaving the last of its power within the building's confines.

A blue portal appeared on the steps of the temple, releasing several warriors. The first one to exit the portal resembled a classic gunslinger. The young man had a brown worn cowboy hat, with a equally worn matching trench coat, his boots were equipped with spurs, and his long flowing green hair a spectacle against his brown skin. The next to follow the gunslinger was a fairy, no bigger than a finger, her hair was short and green, her dress made from the leaves of marijuana, her wings were bright, giving a green glow.

"Is this the place Cowboy Harris?" Asked the fairy.

Cowboy looked up and a flash of blue cracks stained the crimson sky, "Yep, I hate when da Dimensional Estate gives us these no good Enlightenment missions, pay ain't worth da skin off my feet."

Indicia rolled her eyes, "Do you have to be so disgusting?"

The next to come out the portal was a girl with ponytails of red, blonde, and black flowing down her side, her skirt, biker pants, socks and hi-top shoes all matched her hair in a chaotic but flowing

pattern. Unlike Cowboy Harris and Indicia who dread even coming to this realm, Cookie Dough Cream was more than ecstatic.

"Who knew other worlds could feel so tranquil." Cookie said, spinning out the portal, "It's Great!"

Cowboy Harris and Indicia glance back at the twirling girl.

"I told you she's crazy." Indicia said.

"Crazier than u I reckon." Cowboy answered.

"Oh shut up," Indicia answered, "Were in the middle of what could be the Erased World, and she's spinning like we're at an amusement park."

The next girl to come out had a body suit of black and silver armor from a foreign world, her hair was brown and curly forced into a ponytail, on her back was a jagged black sword decorated with alien writing, and covering her back flowed a tattered cloak, Lastly, a black cloth covered her eyes.

"Cookie settle down." The Swordswoman voice was soft yet held a strong tone; "We need to keep our senses on full alert."

Cookie immediately obeyed and turned to the Swordswoman, "Sorry Warlord."

"All that dilly dalling can get us kilt." Cowboy Harris added.

"I just." Cookie smiled while sticking out her tongue, "It's all just so exciting, you know?"

A redhead with a cape, ripped jeans and a black shirt with a "U" on the chest burst from the portal, with the smile of a child-enjoying wonderland, "Cookie was right this place is amazing." The redhead began to giggle while holding her face, "What are we going to do next?!"

Cowboy Harris pointed to the building, "We are venturing into dat temple up ahead, I was hired to guide you guys to da artifact, I've done extinct templez before." Cowboy Harris and Indicia took a look at each other and sighed, "their filled wit monstas, traps, an more monstas. Let's keep our eyes open and heads up ladies."

Chapter 2:
First Trial

Cowboy Harris pressed his hands on the cold stone doors. The young Gunslinger closed his eyes and the door gave a lime green glow, before opening with a loud drawn out screech.

"Were in luck," Cowboy Harris said, "Thiz temple iz basically a forest withun a building, "Me and Indicia should be stronger than normal here."

"Power up!" Cookie and the redhead known as The Heroine said.

The Warlord crossed her arms and shook her head in disappointment at her comrades.

"It's going to be a long mission, huh?" Indicia asked Cowboy Harris.

The Gunslinger answered with a nod and hesitantly walked in the temple. The team was greeted with a room that had grass as a floor, the walls were covered in moss and in the middle of the room lay a white statue of a woman. The woman's face looked frozen in delight as her eyes were rolled near to the back of her head. The Statue held everyone beside The Warlord in a trance; one by one the team hit the soft grass ground and closed their eyes to sleep. However, The Warlord resisted the spell due to the enchanted cloth covering her eyes. The Swordswoman's hand immediately went to the pommel of her blade as she looked up to see an extremely large silver spider.

The arachnid had eight pink eyes that stared at the Swordswoman. The Warlord began to slowly bend her knees, they had just started this mission and she refused to lose, it just wasn't in her. With one powerful jump, The Warlord reached the spider,

unleashing her blade upon the large arachnid. The jagged blade ate through spider flesh, spilling pink blood among the green grass and companions. The swordswoman landed, sheathed her faithful blade, and watched as her companions began to rise.

"Ahhh, why did I take a nap?" Cookie said with a yawn.

"And why am I covered in sticky pink goo." The Heroine answered.

"Wake up!" Indicia screamed, shooting out a yellow beam from her hand at Cowboy Harris's face.

The Gunslinger woke himself up with a slap to the face, "Dagnabit, I can't believe I fell for dat one before I could even use a bullet."

Indicia put her hands behind her head and frowned, "I can."

Before the Gunslinger could enter another of Indicia's arguments the ground began to shake and the statue moved to the left revealing showing a downwards staircase.

Chapter 3:
The mission at hand

The four walked down the mossy staircase, as Indicia floated along. Cookie had found her way right next to The Gunslinger and wanted to ask the young man some questions.

"So what's an Extinct God?" Cookie asked, "I heard The General talk about it but I still don't understand the concept."

Cowboy Harris glanced at the young woman, would she even understand, "Deitiez, spiritz, ghost whateva you wanaa call'em are brought forth into da world due to people. People decided somethin alive, decided it needz to get praized and dey give it power. The deitez is realized into our world and serves da people, then most da time da people change, they leave the deity and it dies in it's temple leaving an artifact of it's powa behind. Your leader hired me and Indicia to extract dat artifact for him, obviously you three are here to assist me and make sure I don't run away wit da item." Cowboy Harris smirked, "Me and Indicia are so trusted. "

Cookie understood, but she was still a little lost on one thing, "I think I understand it better, but The Enlightenment is so strong, I've been told we've acquired numerous artifacts from numerous worlds. Is this temple that dangerous?"

"This artifact is important to whoever run The Enlightenment," Cowboy Harris said, "My peoplez told me it can powa him up, make'em stronga."

Cookie nodded, "That's why were here. It's the leader's fail switch if The Society of the Unknown get too powerful."

Cowboy Harris nodded, maybe she wasn't totally off her rocker, "The Society has been makin headway with deir Black Shonen Generation, I herd they were giving you guyz trouble."

Cookie shrugged, "I haven't got a chance to fight anyone from there yet, so I don't know, but were currently tied in Homunculus books, I guess that's something?"

Cowboy Harris suddenly stopped, his hands flew to his double barrel shotguns and he pointed them up ahead, "Neva underestimate ur enemy."

The girls followed the Gunslinger's actions and got their weapons ready for the monstrosity that blocked their passage.

Chapter 4:
Queer Creature

The monster at the bottom of the staircase had a lanky seven foot body; it held the form of man but was covered in a green fury coating, it's head was that of a bird, it's beak jagged and sharp as a blade. It rapidly paced up the stairs, it's arms swinging, its head bobbing, it's body arched in a humpback. Cowboy Harris held both his shotguns at the creature and released the triggers. The guns siphoned the gunslingers energy, releasing it from the barrels in the form of green glowing bullets. The projectiles hit the creature in its center and large branches began to erupt from its body. Cookie rushed down the stairs, jumped up and stomped her shoes into the creature's head, causing it to backflip and tumble down. However, it grabbed one of Cookie's shoes and the two tumbled down the stairs together!

The Warlord immediately rushed past her comrades, gaining access to the beast. The monster threw Cookie into a moss wall and ran for The Warlord, as the branches from Cowboy Harris choked its throat. The Warlord raised her sword and brought it down vertically upon the beast. It separated the bladed monster into two pieces as lime green blood decorated her outfit. The Heroine decided to overkill the creature, using her ice vision and she sealed the body.

"Heroine," The Warlord said, "There was no need to waste such energy."

The Heroine eyes grew big and teary, "I…just…I don't…. I," The girl searched for words, "I just felt like I needed to help."

"We all need to keep our energy up." The Warlord scolded, "Only help when you need to."

The Heroine nodded, her hair flopping everywhere, "Sorry."

Cowboy Harris and Indicia made their way to the creature," Ugly ain't it?" The Gunslinger said to his fairy companion.

Indicia nodded, "looks like that girl you took home the other day."

Cowboy Harris smiled, "Come on, Old Suzie Lou looked a lil betta dan dat."

"When you're drunk everything looks better." Indicia responded.

The Gunslinger waved the fairy away, "you see dis ladiez." Cowboy Harris put his barrels on the head of the creature, "Beasts like this r going to be spread all over dis temple, most believe it might be peoplez who stayed dedicated to the extinct god, living for ever in its glory, in its image." Cowboy Harris quickly closed his eyes and wrote an image of The Pen in the air, "Bless da fools."

Chapter 5:
The Wall Flower

The farther the group traveled the more plants, flowers, and moss covered the rocky path of the temple. The Heroine was the most intrigued with the transformation, her eyes scanned the beautiful blue and red flowers that grew from the ground, she could feel a breeze pass by her face, and she even noticed queer bugs that resembled dragonflies. However, The Heroine's mind was still filled with regret for her overkill. She hated when the Warlord scolded her, all The Heroine wanted to do was impress The Warlord. The young redhead constantly went over the scene of freezing the beast, expecting applause, but receiving criticism.

"Da more da temple becomes a forest da stronger da beast." Cowboy Harris explained, "Keep your eyes open."

"And don't fall asleep," added Indicia, "You forgot that one!"

"Ah, Shut up." Cowboy Harris said.

"How long have you two been together?" Cookie asked with a cherubim smile, "You guys seem so close."

Cowboy Harris smirked, "I've been cursed with Indicia the day I accepted the Sativa Project."

"Cursed?" Indicia Exclaimed, "I've saved your ass more than you can count." Indicia rolled her eyes, "If you can count?"

Cowboy Harris ignored Indicia's comment and pointed one of his shotguns to the ceiling of the temple, "Look at dat beauty, ladiez."

The girls looked up to see a large orange flower with black dots attached to the ceiling, the

flower swayed ever so often, and The Heroine with her improved hearing swore she could hear noises within.

"Would it be best to not disturb it?" The Warlord asked.

The Gunslinger nodded, "Letz just walk unda the large sucka and be on our way."

The team of five cautiously made their way under the flower, but The Heroine senses were already alerted that it was too late.

"Guys." The Heroine screeched, "It's attacking!"

The large flower opened, revealing horrific creatures of human design but no features, the arms and legs were blades of bone and loose flesh, soon a large multitude surrounded the adventurers.

Chapter 6:
The Heroine the Ultra Girl

Cowboy Harris's spurs bashed against the head of one the queer creatures and the pop of his shotgun sent a branch straight through its heart. The Gunslinger spun with a roundhouse kick, bashing into the stomach of another of the beasts, Cowboy Harris swerved to his left, shooting one at point blank range, where a blue flower blossomed from the monsters stomach, stealing the moisture from its body.

With one mighty swing of her jagged blade, The Warlord easily cut through a multitude of the nasty creatures, crimson blood spattered before her, as she spun the large sword above her heard and swung it down vertically on a bladed beast, cutting it in two.

Cookie smiled with glee, as she back flipped, dodging a flesh blade, she pulled her silver needles from her socks, three in each fist and sprinted for the nearest monster, it tried to swing, but Cookie rolled to the left, dodging the attack and came up with a spin of her needles, cutting into the monster's body, ending the fight with a right thrust into its neck. She quickly performed another backflip, landing one on of the monster's back, with a high shriek of laughter, she began to madly stab the creature, until it fell lifeless on the ground.

The Heroine noticed the creatures kept pouring from the open flower, and if they didn't do something soon they would be overrun. With a leap, The Heroine flew into the air, hovering just below the flower and with a lungful of air released a powerful gust of fire. The fire traveled throughout

the monstrous flower from the inside out,
automatically killing the remaining of the minions.

Harmless bits of flame fell upon the group
like rain as The Heroine floated down towards The
Warlord.

"Did I do good?" The Heroine asked.

The Warlord patted the young girl on the
head and smiled, "You did splendid."

The Heroine could do nothing but blush and
smile back.

Chapter 7:
The Sativa Project

Now that thing's were cooled down again, Cookie wanted to ask Cowboy Harris and Indicia more about their lives. The two seemed so interesting, why did they always make fun of each other, but seem to have a mutual friendship?

"So what's the Sativa Project?" Cookie asked, "Is it the reason you and Indicia are together?"

"It's the only reason were together." Indicia stated.

Cowboy Harris walked a little head of the group, listening to the conversation, "Me and Indicia have a thorny past, I guess in a way we depend on each otha."

"Yeah," Indicia said with a roll of her eyes, "It seems so long ago."

A three hundred pound Estaban Cannabis had snuck into the abandoned lab of Johnnie Sr. (Johnnie Jr's father) A childish smile appeared on his triple chinned face. Estaban was delighted as he saw the computer modules, the unknown plants scattered about and the smell of cannabis that fused with the lab.

"The Lab of Johnnie Sr," said the three hundred pound hacker, "A place of True Science."

The Hacker made his way to the computer module and immediately connected it to his laptop. As the download began, Estaban began to grow with excitement. Estaban was a great fan of Johnnie Sr. and just having this data could improve his survival in this barely alive world.

"The Canna Pistols." Estaban read, "Need Indicia A.I. to be supportive? Indicia A.I.? I wonder what in the Erased is that?"

Unknown to the overweight Hacker, several large Venus Flytraps had spawned from the roof of the lab and swiveled their way downwards towards the young man. Before Estaban even noticed, he was grabbed by the plants and dragged to the center of the lab, where a vault of a sticky green liquid could be seen. Estaban had tried his best to escape, screaming, squirming, yelling, batting the plants away with his pudgy fist, but it was all for naught.

When he awoke he was covered in green liquid, naked on the floor, and a hundred and forty pounds lighter, in his face a green fairy asked for his name.

<div align="center">***</div>

"Seemz like agez ago." Cowboy Harris said."

"Ohhhh," Cookie squealed, "What a cute story."

Chapter 8:
Rivals

The crew had found a high tree branch that followed along the inside of the temple, similar to a terrace. The tree branch served as a shortcut, letting the team bypass several rooms with ease. Cowboy Harris called himself a lucky dog to find it, but as the tree branch ended, leading them back to the grounds of the temple, The Gunslinger quickly slammed Cookie and The Warlord to the side of the wall relying on mere instinct."

"I don't know if I like you like that." Cookie boldly stated.

"What is the meaning of this?" The Warlord said, grabbing the pommel of her blade with her right hand, "I only serve The General in times of sensual matters."

The Heroine eyes began to let out a cold mist, "What are you doing to my sisters!"

"Shut up dagnabbit!" Cowboy Harris whispered.

Indicia pointed downwards, "We have company."

<center>***</center>

"Where in the fucking erased is this damn artifact!" Juliet Valentine yelled,
"We've been here for fucking hours, defeating all types of shit!"

"Calm down cuz," Trina laughed, "We'll find it soon enough."

"Maybe if you weren't caught up in battle like some Neanderthal we would have found it." The Mad Inventor touched a contraption on his wrist that

brought up a map of the Temple, "We've barely even touched the center."

"estoy muy cansada chico." Ginger said, "I mean, I feel like we've been here for at least a day."

"Yeah, Ginger!" Juliet agreed, "It feels like fucking days."

"It's been four hours." The Mad Inventor replied.

"Your watch is broken." Juliet declared.

"This mission is broken." The Mad Inventor responded.

<div align="center">***</div>

"It be a real wild party if they spotz us." Cowboy Harris said.

"There should be an alternate route?" The Warlord suggested.

Cookie looked down at the four, "Are they really that strong?" her fingers began to twitch for her needles, "They look around our age."

Cowboy Harris shook his head, "I herd the rookiez of the Black Shonen Generation are tougher than monster dung."

"But we just got a homunculus book." Cookie argued.

"Yeah," Cowboy Harris nodded, keeping his eyes on the four below, "I heard they also took down a good number of your agents, during the last couple of bouts."

"I wasn't there." Cookie shrugged.

"Lets' do it." The Heroine screamed, letting her excitement take over her brain, "Let's end the Society of the Unknown!

Chapter 9:
Juliet's Gang

Juliet Valentine looked at herself within the large moss well. She was a beautiful girl of sixteen, sporting her black and red Kevlar tank top, her favorite black hat, with baggy khaki pants and black and red combat boots.

"We should get going," Stated the Mad Inventor as he surveyed the land, "rather then sitting here enjoying the artificial weather of this cursed temple, tch."

The Mad Inventor was a young man whose brain was always turning, trying to find a result that would be the best outcome for himself. The young Inventor sported his favorite black and purple Kevlar lab coat, with fitted gray pants and his black boots.

"I don't know." Trina said, " I kinda like the setting, makes me feel like I'm in a fairy tale."

Trina took the appearance of a witch, with a droopy black wizard hat, black tight shorts, black stockings, and a loose black coat that showed her toned chocolate stomach.

"I wouldn't mind going on a date here." Trina said, admiring the landscape.

"Ohhhh una cita seria encantadora." Ginger responded.

Ginger was the newest recruit to the Black Shonen Generation; however, she was fitting in very well with The Crows. She sported a body suit of Kevlar armor decorated in black and red, with a red ribbon in her hair that resembled cat ears.

"Maybe we should take a break and eat before we continue." Ginger suggested.

"Good thinking." Juliet agreed.

"I ate like ten minutes ago but I can eat again." Trina added.

"Is that all you women think about is food?" The Mad Inventor questioned.

Ginger, Trina, and Juliet turned to him and said in unison, "Yes!"

The Mad Inventor rubbed his eyes, "I'm stressed."

"We can kill them right now!" The Heroine eagerly said, "Julie let me go!"

"I don't know who Julie is?" said The Warlord, "Heroine you know your mind gets mixed up when you're excited."

"But they're right in front of us!" The Heroine said.

Look here Gal," Cowboy Harris said; grabbing the girl by the arm, "You gon get us kilt."

The Heroine quickly swung Cowboy Harris off, causing The Gunslinger to stagger back.

The Heroine eyes began to grow wide, her mouth got wet from the anticipation of battle, and her mind began to get scattered."

Cookie raised her right foot, getting ready to kick The Heroine in the temple, but the red head burst free before Cookie could perform the kick and The Heroine with an eager smile zoomed towards Juliet's group.

Chapter 10:
The Heroine's Chaos!

Juliet saw the blur of red before she could react. The fair fist of The Heroine sent the Swordswoman cratering into a nearby wall. The Mad Inventor was the first one to spot the redheaded villain, he saw the wide blue eyes, the mouth agape filled with saliva, the way her fingers twitched, and finally the bend of her legs as she leaped for Ginger Snap. The Mad Inventor quickly countered, releasing his own plasma pistols, but the ex-superhero swerved through the bullets letting out shrills of laughter as she neared the Inventor, nearly wrapping her eager hands around the young boy's neck. Fortunately, The Inventor had his inventions and four metallic legs burst from the spider device on his back. The legs struck down towards the girl in a rapid series of attacks, but The Heroine had easily grabbed two of the upper legs and swung The Inventor in the air, where he spiraled, before his metallic legs softened his landing.

A pillar rose before The Heroine and began to shift and turn into a large fist, striking down towards the girl. The Heroine reared her own fist back and with one punch turned the fist into boulders of granite. Two bullets shot into The Heroine's back and exploded, the girl turned to see Ginger with both her pistols aiming forward. The Heroine went for another giant leap, but the bullets stopped her, entering her neck and exploding. The Heroine hit the ground, her neck covered in blood and raw flesh as she gurgled to breathe, but her face remained smiling.

"Dagnabbit redhead." Cowboy Harris said from below, "Guess we got to reckon and bust her out."

"You sure she's alive?" Indicia asked.

The Warlord nodded, "The Heroine has amazing healing ability, we should help here nonetheless."

Cookie was someone who also got excited from battle, but unlike The Heroine she could control her urges, "fun!"

Juliet walked out of the crater, nearing her friends, the surprise attack pissing her off, "Yall got that hoe yet?"

"Yeah Cuz." Trina said, "We totally thrashed her!"

"She was quite the annoyance, The Inventor said, rubbing his swollen nose, "From the Enlightenment no doubt."

"She was a tough chica." Ginger said, "Luckily my bullets did the trick."

The group didn't get to ponder for long as they heard something drop in front of them and looked forward to see three more warriors to oppose them.

Juliet grabbed her blade and smiled, "Looks like I still get to fuck shit up."

Chapter 11:
Black Shonen Vs. The Enlightenment

"Alright guys, we bust dem down, git The Heroine, and git out of dere." Cowboy Harris said, jingling his shotguns.

"I got the one with the guns and blades." Cookie observed.

The Warlord looked at Juliet and felt a pull towards the young swordswoman, "I'll handle the sword wielder."

Cowboy Harris took on the responsibility, "And that leaves two for me."

The Warlord decided to start the battle by leaping forward and sprinting straight to Juliet Valentine; Juliet swung her blade, performing a parry of orange sparks. The Warlord came with a forward strike, but Juliet immediately countered and flowed into a spinning slash, that was knocked back by the Warlord's upper swing. The stumbling Juliet quickly bent her body back, letting a large silver, jagged ebony blade by pass the tip of her nose.

"Almost got me ho!" Juliet said, raising her sword in the air and slamming it down.

The Warlord easily rolled away from the attack and went for a horizontal slash for Juliet's ribs. Juliet swung her blade, and deadlocked the two. The young swordswoman locked eyes with The Warlord and her young teenage mind began to realize whom she was fighting.

"Your bitches!" Juliet began to get excited, "I'm bitches too!" The girl let out a laugh at the grinding of their blades, "The Enlightenment finally got their shit together and got another me!" Juliet let out a snicker of a smile, "This shit is just too great!"

Cookie easily danced between the Mad Inventor's bladed attacks. It didn't matter when the Inventor chose to strike, Cookie would spin and jump like a trained ballerina, and when she got in close she would use her needles and slash at the Inventor's face, causing blood to leak into his eye. Luckily for The Mad Inventor , he didn't need his sight.

Cowboy Harris had his fill with two opponents, with one of his majestic shotguns he aimed at Trina, noticing she had to concentrate to trigger her ability. The other gun he had focused on Ginger, shooting randomly as trees and flowers of a large size sprouted from the ground, distracting the girl from aiming.

In the midst of the battle's madness, The Heroine healed and rose from the ground, watching everyone trapped in their world of fighting. The Heroine got ready to enter the fight, but a large pool of water doused her. The girl looked behind herself to see a myriad of green, slimy, large tentacles flutter about from the open well. The Tentacles instantly acted, grabbing each fighter with its slimy embrace and flailing them in the air like children's toys.

"What in the Erased!" Juliet screamed, "I was fighting my double's Black ass, get me out of here!"

"EWWWWWWWWWW," Trina screamed, "It's so slimy!"

Cookie let out a smile, "It kinda feels good."

"Indicia! Stay by me." Cowboy Harris warned.

"Unhand me! You aquatic imbecile!" The Mad Inventor screeched.

"Stupid Chico." Ginger screamed to The Inventor, "You think the monster is really going to listen?"

The group of eight heard a large moan emit from the well and then the tentacles dragged the youths into deep water.

Chapter 12:
The Women who Practice with Swords

Juliet Valentine woke up completely wet, She opened her eyes, looked around the grassy area, and coughed up water. She saw vines that climbed up the wall, and the fluorescent flowers that spread amongst the ceiling. She found her loyal blade a couple of feet away. As she looked, she found another person; This woman was covered in water, passed out, and clad in black skintight armor, donning a tattered cloak. Juliet's mind instantly reacted, and she remembered. The young girl raised her sword above her head, took a deep breath and spun, swinging her jagged blade into the ribs of an eight-foot muscular creature, with a bird's head, and a long jagged beak. Juliet smiled at the creature's scream of pain and yanked her sword from the ribcage, just to swing it again into the same spot.

"You thought you had me motherfucker!" Juliet warned.

With massive right fist, the creature aimed for the girl, Juliet tried to yank her blade out, but this time she was too slow and took on the attack at full force. Blood spilled from Juliet's mouth as she fell back, her sword still lodged into the beast's ribs. The monster of the temple overshadowed her, and raised his fist for a final blow, but as it fell a black blade came into view, cutting its fist horizontally in half. Green blood washed the ground as The Warlord walked up to the temple beast. The Warlord with only one hand swung her massive blade again, cutting the beast through the stomach, the upper body violently spun, with blood gushing out like a

loose cut-up soda bottle, the bottom half fell with a loud squish.

Juliet, confused, stood on her feet, "Hey, Future me, or whatever," Juliet's right hand went for her blade, but then she realized it was still trapped in the monster, "Okay bitch, you going to get me unarmed, you really are a no good lousy ho-"

The Warlord ignored Juliet's threats, snatching the girl's blade from the monster and throwing it to the teenager in return. Juliet caught the blade by the pommel and sheathed it by habit, "w-why?"

"We have some type of connection, do we not?" The Warlord asked.

Juliet nodded, "Yeah, I'm pretty sure we're the same bitch."

"We're lost." The Warlord shrugged, "I don't have a map."

"Me either." Juliet said, wringing out her hat.

"For now it be best if we tried to work together."

Juliet didn't know if she truly like the idea, but The Mad Inventor had the map, what could she do? "You walk in front, and I got my eye on you."

The Warlord nodded.

Chapter 13:
The Inventor and the Crazy Girl

The contraption in the shape of a spider sent a shock into The Mad Inventor's heart, waking him up from his slumber. The young man found himself in a forest full of ruins. He saw stone pillars covered in moss, reaching the ceiling. Flowers of all colors decorated the land, the smell of dew hit his nose, and all around him was a slight fog.

"What a romantic scene for a fight." Said a happy voice.

The Mad Inventor turned around to see Cookie break from the mist, three needles in each fist, water dripping from her long hair, her mascara running down her face like black tears.

"Do you really think this is the best time to fight, girl?" The Inventor questioned.

The question stopped Cookie in her steps, for the mere fact no one had questioned her in a battle.

"What do you mean?" Cookie asked, her right eye becoming larger than her left, and her head cocking to the side.

"Were lost, and I have the map to what you want." The Inventor said, "How about we travel to the center of this forsaken temple for the jewel and decide each other's fate when we get to the ideal destination?"

Cookie thought about her situation, she was lost, she didn't know how to get out, and The Gunslinger had the map.

Cookie Shrugged, "Fine, I'll kill you afterwards."

The Mad Inventor smiled a full smile, "You can try, darling."

Chapter 14:
The Two Gunslingers

Cowboy Harris awoke wet and cold, everywhere around him fireflies let off a blue light, the ground was solid granite, there was a light flow of water around the pathway, and as he looked around he could see a staircase leading upwards, with a shining light to accompany it.

"Where's indicia?" The Gunslinger questioned.

Cowboy Harris immediately began to furiously look for his fairy companion, knowing without her he would lose all sanity!

"Dagnabbit, I told that lil devil to stay close."

Cowboy Harris felt something within his inside pocket and took out the cold body belonging to his fairy companion. Cowboy closed his fist that held his partner and began to concentrate, causing a green glow to emit from the enclosed hand. When he heard several coughs he opened it, to see Indicia hovering, and vomiting up the water left in her body.

"Indicia you're luckier than a horse with one leg you know dat!"

Once Indicia got under control, she looked at her partner and waved him away, "I knew what I was doing."

Cowboy Harris spun around, aiming both his pistols at the darkness ahead, "Come out sweetie, I herd dem stepz."

"Who?" Indicia asked.

Ginger Snap stepped from out the darkness, her guns in hand, her bow ears dripping with the weight of water, "Chico, just give up before I take you down and your fairy."

Cowboy Harris gave off an amused smile, "I tink you know's hose the better Gunman around these parks, little kitty." Cowboy Harris crept forward, keeping his eyes on Ginger, "How bout you turn round and git to goin."

Ginger shook her head, "How about I shoot you and your little novia."

Cowboy Harris and Indicia looked at each other and spat out their tongue.

"Were like siblings." Indicia answered.

Ginger's eyes grew wide and she almost dropped her weapons as she stumbled back, "Lo que borro?"

Cowboy Harris and Indicia identified the creature by the sharp screech it gave. The Gunslinger and fairy turned around to see a silky, enormous, white serpent, binding its body to the path ahead, with mal intent glowing crimson from its fierce eyes.

"Well sweetie, looks like were goin to have to work togetha." The Gunslinger stated his voice quavering with fear.

Chapter 15
Alchemist Vs. Superhero

Trina scooted her feet forward, The Heroine twitched her fingers, Trina's eyes shivered, The Heroine let out a smile filled with saliva, Trina scooted back, The Heroine scooted forward. The Heroine lunged forward, rocketing into the sky; Trina hands flew up, producing a moss covered wall that The Heroine easily broke through. With a swirl of Trina's hands, the wall shifted and turned around The Heroine trapping her in a moss and rock cage.

"Can we talk?" Trina asked.

The Heroine stood up, giggles echoing from her throat, "For what?" she loudly laughed, "You're the enemy and I'm going to kill you and turn your bones in to the Enlightenment, doesn't it sound like oh so much fun?" The Heroine squealed with giddiness at the end of her sentence.

Trina let out a nervous, twitching smile, "Hey, if you've noticed were surrounded by grass and flowers and stuff, we're kinda lost."

The Heroine looked around the environment, "Maybe if we go left, or....er...right maybe????"

"Yeah!" Trina said, feeling like she was gaining some ground, "If you kill me or whatever how are we going to get out of here?" then came Trina's "finisher", "If you kill me you'll be stuck in this grassy temple forever, with no way to get out, or at the worst travel alone."

The Heroine tilted her head, trying to think about the situation, "So you'll be my bestest girlfriend until I find my real friends?"

Trina shook her head rapidly with a smile, "Best girlfriends in the whole world!"

With one effortless punch, The Heroine destroyed the cage and gave Trina a super hug, "Were going to have so much fuuuuuunnnnnnnnn!"

Trina wondered what she had got herself into.

Chapter 16:
The Gunslingers VS. The Snake

With Ginger in his arms, Cowboy Harris dodged another vicious bite from the pasty serpent.

"Put me down Puta!" Ginger screamed, "I can handle la serpiente myself."

Cowboy Harris looked down at the fiery gunner and gave a smirk, "I believe you could if you wanted, but rite now lil lady, I thank it be best if I show dis beast a thang or two."

The snake looked down at the two again, bearing white teeth covered in poisonous liquid. The serpent let out a loud hiss and struck out at the two again. Cowboy Harris threw Ginger into the air and yelled, "shoot!"

To Ginger an experienced Gunner, the five seconds in the air was all she needed to aim at the head of the snake and implant her bullets into the serpents head. Cowboy Harris caught the girl and the snake screamed, as its leathery skin burst apart. Cowboy Harris with one pistol shot his energy into the throat of the beast. A large branch tore out from the midsection of the snake and it let out a pained gargle as blood filled its throat.

Ginger in the arms of the Green Gunslinger pointed her gun towards the snake and launched two bullets into its left eyehole. The creature bashed its head on the wall as it's eye exploded with pink pus and it's body went limp with a last breath.

"Did we kill it?" Indicia asked.

"What did you do?" Cowboy Harris asked.

"I was around." Indicia answered.

"You can let me down." Ginger said.

With another sly smile, Cowboy Harris let the girl onto the ground, she gave a quick look at the Gunslinger and with the flash of blush turned the other way, "I think we should stick together until I find my friends, or the crystal, whatever comes first."

Cowboy Harris happily nodded and Indicia rolled her eyes.

"Alright lil lady, I'll keep you safe until u can find ur friendz once again."

"I don't need your protection!" Ginger said, making sure to put some extra attitude into her response, "I just need someone to have my back, okay."

Cowboy Harris noticed the slight sound of compassion in her voice, "Alright." He said, sheathing his pistols, "Lead da way lady gunslinga."

As the gunners quickly found a staircase leading to the upper floors, the snakes working right eye made sure to follow them.

Chapter 17:
The Ritual

"What is this?" The Mad Inventor questioned, "It's barbaric!"

"Awwwww, they look like cute elves, I just want to pink their weebly cheeks."

The Inventor made a face of disgust, "She's nuts."

The Mad Inventor and Cookie Dough Cream hid behind a hill as they watched green, short, big nose, humanoid creatures dance around a white fire and gnash their teeth.

"Should we go and steal the food?" Cookie asked, "I mean I just ate but-"

"No!" The Inventor scolded, "We don't even know if it's edible, what is it with women and food?"

Cookie sighed, this guy was dense, "Then what should we do?"

"Obviously were going to destroy them and continue upon our path."

"They haven't done anything to us."

"They are disgusting creatures and they exist." The Mad Inventor spoke, "And right now they are between us and our separate, yet same goal."

Cookie nodded, he wasn't wrong.

The Inventor's face became a smiling troll's, "We defeat them, torture them, and make them tell us where this so called crystal is." The Inventor began to fantasize about his idea, "it all sounds so pleasant."

The Inventor heard his blade like legs react on their own, a sudden shrill cry came from Cookies mouth, the next thing he knew Cookie and he were

vaulting through the air, and they landed in the middle of the goblins.

"What th-" The Inventor immediately got up to spot what he could only call an ogre at the foot of a hill, Cookie and himself were hiding seconds before. The being was nine feet in height at best, with an oily green skin, and a large belly, it had only two teeth and its yellow stained eyes were filled with a bestial malice. The goblins bowed in front of their ogre lord and began to make small chatters as he came down the hill.

"What are they doing?" Cookie asked.

The Inventor cackled, "Their praying, because their scared."

Chapter 18
The Two Juliet's

The two swordswomen walked side by side.
The younger Juliet Valentine took constant glances
at The Warlord. Now that Juliet wasn't in the midst
of battle all types of questioned crammed into her
head. Was this a version of her from the future?
Another dimension? An alternate dimension? What if
it was an ancestor? Juliet Valentine wanted to know,
so she was going to ask.

"Why do you work for The Enlightenment?"
Juliet asked.

The Warlord kept her pace, her hips moving,
her walk stylized and evenly paced, "I only
remember working for the Enlightenment, when I try
to think farther back all I come up with is a blank.
I've realized my mind has been tampered with, but I
don't even know who I am?"

Juliet was beginning to understand, "So the
bastards brainwashed you?" Another questioned
popped up in the young swordswoman mind, "Do
you have a Romeo?"

"What is that?" The Warlord said, "Romeo?"

"Hmmmmm?" Juliet pondered, "I bet you
have one as well, those bastards probably erased
where it's hidden. If I were you, who I am, I would
definitely keep mines hidden from The
Enlightenment. What's the scarf for?" Juliet couldn't
help herself, she wanted to learn more about her
other self, "bet your sword has some tricks up its
sleeve as well."

The Warlord grabbed Juliet by the shoulder
and Juliet grabbed her pommel upon reaction. The
Warlord pointed forward and Juliet saw another

queer beast come into view. It was large and muscular, skin blue, beak jagged, it walked on all fours like a gorilla. When it saw the two girls it began to beat its chest and hoot it's howl.

Juliet Valentine and The Warlord both unsheathed their blades, using their right hands and took the same swords stance; the swordswomen had their right and left hand on the pommel, right foot in front, left slightly horizontal and to the back.

"You ready to take this bitch down!" Juliet screamed.

The Warlord gave a hint of a smile and said, "Yes!"

The two swordswomen leaped forward meeting the mad beast with two large slices into the ribs, blood squirted upon the women as the beast screamed in agony. Juliet released her sword from the flesh and spun, implanting her weapon in the stomach of the beast. The Warlord yanked her sword from the swollen skin and violently slashed downwards, taking away a leg. The beast began to fall, The Warlord rapidly moved her blade again, embedding it horizontally into the face of the creature, tearing through its eye and stopping halfway into the middle of its head. The Warlord roared, bathing in the monsters rotten blood, and with one swift tug she released her blade. The monster fell onto the ground with a wet splash.

Juliet Valentine looked at her other self in amazement, "I think I'm in fucking love."

Chapter 19:
Best Friends Forever!

"So Trina?" The Heroine said, filled of excitement and giggles, "What's your favorite color?"

Gray and Black." Trina said, getting caught up in The Heroine's bubbly mood, "I've always felt comfortable in those colors for some reason. You?"

"Well," The Heroine said, thinking critically about the question, "I've always liked blue, black, and red, similar to my outfit. It says, hey girl I'm fly and I can kick butt."

"Those are good colors." Trina agreed.

Wait, The Alchemist thought to herself *I'm getting caught up in girl nonsense again.*

"So, Trina." The Heroine asked with a curious grin, "Do you have a boyfriend?"

Trina gulped and blushed, "I mean, I've tried, but I'm always so busy, it be nice to have one around, were kinda at that age where we got to do that type of stuff."

Damn I'm getting caught up again. Trina thought, *It's not my fault, she has interesting questions, it's hard to think of her as the enemy.*

"Do you have a boyfriend?" Trina asked.

The Heroine sighed, "It's hard to come across boys my age, but when I do find one I'm going to hug him, and pet him, and cuddle him, and do this and that." The Heroine began to blush, "Were going to do this and that all the time."

Trina gulped and blushed, "Have you done this and that before?"

The Heroine looked back at Trina with a wide grin, "No, but I do look at videos so when it's time I'll be ready."

Trina blushed and took a bigger gulp, "Maybe, I should look at some videos?"

The Heroine nodded, "I recommend it. It clears up a lot of confusion and they are everywhere on the Interweb."

Trina nodded, "This girl knew her stuff, whenever she asked Juliet about her life the swordswoman would always change the topic, but here was a woman. The Heroine knew her stuff and had lots of info. Trina began to wonder, maybe she could get this chick to change sides?

"Hey, redhead." Trina said, "I know were enemies but I don't want to hurt you, let's promise to stay best girlfriends even if we have to fight each other." Trina took out her hand.

The Heroine didn't know how to react, Trina was the opposition, but Trina was so nice. She listened, gave thoughtful answers, and made The Heroine feel really important. Trina could be considered one of those rare friends every girl dreams about.

"Yes." The Heroine said, eyes wet with tears, "Let's be the best friends ever." The Heroine wrapped Trina around in her arms giving her the hug of a lifetime.

"Hey, Hey, whatever your name is? I can't breathe." Trina squealed.

Chapter 20:
A Hydra Dozen

Cowboy Harris and Ginger Snap had found themselves in a spot within the temple, untouched by forest and vegetation. The ground was an onyx concrete, the walls glittered gold, and Cowboy Harris focused on the black writing scattered on a white mural.

"It'z probably da story of da temple." Cowboy Harris said out loud.

"All temples have them." Indicia answered.

"Can you read the language?" Ginger asked curiously.

"Na," Cowboy Harris said, reluctantly, with a tip of his worn hat, "But Indicia and I have explored enough ta know what went down." Cowboy Harris sighed, "At some point dis temple held a deity, da deity was da centa of da people, da people eventually forgot about da deity, da deity lost powa and put it's remaining abilities within dis temple, within an artifact. It's last remaining gift."

"How sad." Ginger said.

Cowboy Harris shrugged, "Just shows dat everythang dies eventually."

"Even Dios." Ginger said to herself.

Cowboy Harris understood Spanish, but before he could respond a loud hiss disturbed their somber thoughts. The three turned around to face the white snake they thought they had once defeated. The snake instead of one head had three, each one equipped with fangs and poisonous saliva, their blue eyes locked on the three fighters and with a snap of their necks they all struck at once. Cowboy Harris

with swift grace swooped Ginger into his arms and jumped back as the heads crashed before him.

"Always saving the damsel." Indicia said, "Even if she is the enemy."

"I'm not a damsel!" Ginger screamed back.

"I think we shuld wurry about da snake, ladiez."

The three-headed snake attacked again and once again the Gunslinger quickly moved, but this time Ginger fired her pistols at the middle head of the snake, which detonated into fireworks of flesh. The explosion caused the snakes to tumble and bumble towards one another, trying to combat the pain. Cowboy Harris took a shot aiming for the head on the right. It plopped into the hissing mouth of the serpent and a tree immediately burst forth. The snake however chomped on the tree, biting through the bark and swallowing it rapidly down a whole. The middle snake's flesh began to heal as smoke began to spill from its mouth.

"You think we should run?" Indicia asked.

Cowboy Harris scratched his head with his pistol, "Don't matta, it'z just going to chase us like rabbits all through dis temple."

"It's better than fighting a losing battle," Ginger said, still in Cowboy Harris arms, "Maybe we'll find the others?"

The fully healed Hydra snake produced a wicked hiss from all three mouths, that sent the three warriors running, hoping to find their companions within the ancient maze.

Chapter 21
Girl's Party Interrupted

"So, the last episode of Real Spacewives was really intense." The Heroine recalled.

"You guys have that show too!" Trina excitedly expressed, "I've followed all 720 episodes."

The Heroine scratched her head, "We only have 605?"

"Weird?" Trina said, "So I have a question?"

"Shoot sister." The Heroine said.

"You seem really pleasant," Trina observed, "Why would someone like you join the Enlightenment?"

Trina could see The Heroine try to think about the question; The Heroine rolled her eyes, her mouth went to the right in an attempt to find some type of hidden answer, but in the end she shrugged her shoulders and said, "I've always been with The Enlightenment as far as I can remember. "

"I wonder about that?" Trina questioned, "You remember nothing before?"

The Heroine eyes became wide like a child as she shook her head, "Not a thing, guess it wasn't important."

The sounds of screams interrupted Trina's interrogation. The two girls looked up to see a large white snake burst through the moss covered walls.

"Correr!" Ginger said, still in Cowboy Harris arms, "Es una serpiente grande!"

"Wow." The Heroine screamed, "Its so big and long."

Trina reacted in fear, twirled her hands, and caused two large pillars to shoot up out the ground.

With a wave of Trina's hands, the pillars bashed into the snake, and the serpent fell limp onto the ground.

The mayhem came to a halt as the five stared up at the serpent.

"See," Trina smiled, putting her hands on her hips, "I did it."

The snake's blue eyes twitched and it rose once more, letting its hiss reach fearful ears. With a scream coming out from everyone the scared youth ran deeper into the temple, with the snake slithering at their heels!

Chapter 22:
Swordswoman!

Juliet's Valentine's jagged blade impaled several blue goblins into the moss-covered wall.

"You see that!" Juliet gloated, "Three in one swipe!"

The Warlord nodded and pointed to the five goblins coming her way. With both hands, The Warlord swept her blade back and with a grunt brought it forward, cutting straight through the goblin creatures like a hot knife through butter.

Juliet Valentine stomped her foot on the ground, "Yeah! So what bitch, my kills looked cooler."

The Warlord gave a slight smile to her acknowledge her victory, this competition was soothing to her.

"What do you enjoy doing?" The Warlord asked, "When you're not fighting"

Juliet looked up at her other self, "Huh, I mean." The girl scratched her curly hair under her sweaty hat, "Lots of shit; hanging with the girls, talking about stupid boys, eating, ragging on the True Twins, making fun of Old Man True and his bald head. Oh, some nights we eat tons of candy and have pillow fights until we throw up, like I said lots of shit."

The Warlord smiled and a tear ran on the side of her face, but before Juliet could question her change of mood, she heard a large explosion, followed by a hiss and screams.

"Cuzin! Get out the way!" Trina screamed, as The Heroine flew holding her, "There's like a six headed snake chasing everyone!"

"Es una serpiente grande!" Ginger screamed, still in Cowboy Harris arms.

"Blast daggit, that's right into my ear." Cowboy Harris complained while running, "Want me to throw you down?"

"And let me get eaten by the serpiente." Ginger screamed back, pounding The Gunslinger's chest with her petite fist.

Juliet grabbed her blade with both hands, "We can probably tear this fucker apart."

Juliet felt the Warlord's hand grasp her shoulder, "Look at it, really."

The monster of a serpent had produced four more heads, giving it ten in total, each one sported horns and had fangs lubricated with poison, their eyes shined blue, and Juliet's body went into a state of panic.

"Let's retreat." The Warlord said, grabbing Juliet by the wrist and joining with the others in a run full of screams.

Chapter 23:
The Inventor tries to duel the Madness

Cookie Dough Cream performed a backflip, nimbly dodging the cratering punch of the ogre. Crimson plasma littered the body of the raging beast, a swipe from Cookie's needles buried into the ogre's ribcage and all four of the Inventors' metallic blades plunged into its chest.

The Inventor smiled a gleeful smile as he pointed his plasma pistols towards the beast's stomach, "Despicable creature from an evolution source I partly don't care about, you thought you could face the mighty Inventor in combat and win, you thought I would let you tear me from limb from limb in some sick ritual, fool! I am The Mad Inve-"

"Oh my Writer, can you shut up!" Cookie whined, her legs wrapped around the neck of the creature as the needles in her hand skated on its rotten skin, "Just kill it already, what with this epic monologue?"

The Mad Inventor sighed, "Someone doesn't understand the importance of the setting."

The Mad Inventor shot the creature, using both pistols at from point blank range. At the same time, Cookie struck at the monster's neck, causing it's life blood to spill upon the ground. Cookie landed on her feet like a perfect gymnast. The Mad Inventor sheathed his pistols as his blood soaked blades retreated into the metallic spider on his back.

The Goblins who watched the fight scattered now that the ogre was dead. The Mad Inventor expected as much, now that their leader was gone their bravery was lost, but for some reason they seemed much more stressed than he expected.

A wall shattered, causing the two to turn around and see the myriad of pale heads break forth. The Mad Inventor eyes grew wide when he saw the monstrosity, Cookie eyes grew wide in curious excitement.

"Run you no good bitches!" Juliet screamed, sprinting with all her might, "We can't take this fucker!"

"Keep steady Chico." Ginger said, turning towards the snake and pointing her pistols forward, while Cowboy Harris still held her, "Pistol de Phantasma!"

Ginger released the remainder of her bullets within her pistols; they crashed into the large mass of snakeheads but did no damage.

"Una mierda." Ginger said in disappointment.

"You think I should use my ice vision?" The Heroine happily asked Trina.

Trina who was holding onto the flying heroine for dear life shook her head, "I'd say we keep flying away best friend."

The Mad Inventor, a man of logic knew he couldn't take down this beast on his own, but like every man he had his pride.

"I'll take this serpent down in the name of me!" The Mad Inventor proclaimed.

As the titanic serpent grew closer, the other youthful agents ran by the crazed Inventor, giving no heed to his futile statements.

"Hurry yo ass up!" were Juliet's last remaining words as she passed by.

The Mad Inventor gave a vile smile as the serpent slithered closer, heads beyond ten now gnashing their teeth, their blue eyes shining with

hunger, their heads hypnotically moving back and forth.

The Inventor felt something tug at the collar of his coat and the next thing he knew he was being pulled back by a stronger force.

"Let's get out of here!" Cookie said, sprinting forth, "You can't give your essay speeches if your're dead!"

Chapter 24:
Fight or Flight

"Ah, Erased." Juliet Valentine said, looking at the onyx wall, "It's a dead end."

"Well," The Warlord, grabbed her blades with both hands and turned toward the many-headed serpent, "We just have to fight."

"Yeah!" Juliet grabbed her own blade and faced the beast, "Now you speaking my language."

"Wait!" Trina said, as The Heroine landed her on the ground, "Maybe I can use my alchemy to open the wall?"

"Na," Cowboy Harris stuck out his arm in protest, "Extinct Temples r filled wit all kindz of trapz, for all we know we could be openin a hole anotha set of problemz."

"Where's that mechanical monstrosity." The Mad Inventor questioned.

"It's getting upgraded." Juliet responded. "We just got to fight this shit, nigga and niggets."

The rest of the group prepared, while the white serpent sporting over twenty heads now slithered forth, its hisses scratched ears, its tongues made wet smacks against it's mouth. Juliet, The Warlord, Cookie Dough Cream, Cowboy Harris, and The Mad Inventor were all prepared for the fight ahead. While Trina, The Heroine, Indicia, and Ginger Snap had fear travel through their spines.

The seconds past, the snake inched farther, adrenaline and fear mixed the combatants hearts and then they clashed. Jagged blades cut through leathery flesh, bullets of silver exploded heads into to steaming meat, flowers burst from hissing mouths, needles scratched eyes and caused scars, the ceiling

rained stone arrows, metallic legs stabbed into flesh, and super human punches shook the temple itself.

Unknown to the combatants, the ground beneath them began to crack. Veins began to spread throughout the area, the field began to move under their feet and finally everything gave way. One by one the youths began to tumble into a blackened abyss. Even The Heroine fell, who was too scared to fly with the snake furiously hissing and tumbling after them.

Chapter 25:
Juliet's Last Stand

Juliet Valentine woke up on the spongy surface of fresh vegetation, she could smell the dew on her nose, she could feel her sore body wrapped around the vines. With a grunt, she pushed herself out, tearing the plant from her body and standing on her own feet. She looked around to see everyone spread out and passed out from the fall. The body of the snake circled around the youths, with a large piece of stone protruding from its body. The Swordswoman eyes kept scanning the area until they stopped on an altar and on top of the altar was a green jewel, the size of a pearl. Juliet knew this was the object of the mission. The young girl's aching muscles pushed her forward, as a smile began to play on the teenager's face.

But to Juliet's dismay, she heard a click belonging to a pistol, "I don't thank it be to smart to be takin any extra steps sword gurl."

"Fuck." Juliet whispered, with a roll of her eyes. "Our teams did well together, right?" Juliet argued, "How about you let this defenseless bitch get the jewel and you can make something up to those dear old Enlightenment fucks."

Cowboy Harris smirked with a shake of his head, "I've ben n' dis buziness for a while know, it'z filled wit all typez of treacvhery and such, I knew to keep my eye on u since da beginnin." Cowboy Harris unleashed a full on smile of perfect white teeth, "Oh dear mizz Juliet, come on down and give ol' Cowboy Harris dat jewel."

Juliet knew she had dropped her sword somewhere. Her mind began to think of ways she

could escape this gun shooting bastard but she knew without her weapon it would be all for naught.

"Fuck it all to erased!" Juliet yelled and sprinted for the jewel.

A shot echoed in her ear, branches began to bind her limbs and she was shot up thirty feet in the air. The branches moved and swerved about her until they had her in the pose of a cross.

Cowboy Harris looked up at his masterpiece and smiled, "I told ya gurly, I had my eye on u."

"Shut uuuuup." Juliet mocked, "I had my eye on you! You didn't have your eye on shit!"

The girl hacked a loogie that Cowboy Harris caught with his mouth, "The taste of victory."

"Your so fucking gross." Juliet commented back.

"I'm a gunslinga mam, aint no pride in it, but I do it."

"Are we alive?" Indicia the fairy said, emerging from Cowboy Harris's hat.

"Yes'um." Cowboy Harris casually said, looking up at the immobile Juliet, and we bout to get our reward my fair fairy."

"This time don't spend it on booze and succubus demons, okay." Indicia warned.

Cowboy Harris shrugged, "I don't kep promisez."

A metallic leg shot forward, Cowboy Harris spun, the blade nimbly cut some of his luscious green hair, the cowboy shot on instinctively, and The Mad Inventor leaped to the side, took out his plasma pistols and shot back. Cowboy Harris leaped to the tree he had just created to capture Juliet, blocking The Inventor's shots.

"I heard it." The Inventor spoke, "I heard it all while I was stuck in the land of unconsciousness."

"Whup his ass." Juliet interrupted.

"Your dialect!" The Mad Inventor said, "Is death to ears of the sane and I will not stand for it!"

"Here I am trying to do the mission," Juliet complained thirty feet in the air, "And this nigga over here tripping about vocabulary."

The Mad Inventor pointed his guns toward the tree Cowboy Harris was using as a shield and gave a ghastly cackle, "Now let's see who's really the Gunslinger."

Chapter 26:
A Battle of Bullets

Cowboy Harris had to find a way out as The Mad Inventor went trigger-happy on the base of the tree. The Inventor seemed like he knew what he was doing, but the green haired gunslinger had killed countless guys like this one, the biggest weak point was their ego. Cowboy Harris pointed both his guns towards the ground and shot them. The energy traveled under the ground and sprouted under the Inventor in the forms of thick green vines that spouted energy stealing flowers, but the Inventor didn't mind. The Inventor's cackle grew louder as his metallic blades shot out from his back and displayed their ingenuity, as they began to chop, slice, and cut through the vegetation with ease.

"You thought such parlor tricks could stop me!" The Inventor challenged.

Cowboy Harris emerged from his cover and shot two bullets, they went over the Inventor's head, hitting the back wall, and exploding in the form of two large Venus flytraps. The Inventor's legs shot forward, ready to stab The Green Cowboy, but the Venus flytraps countered, releasing a sticky fluid from their mouths, it doused The Inventor, his metallic appendages became stuck, and suddenly erratic. The inventor tried to shoot but the liquid had covered his hands, causing his guns to fall. The Inventor gave one of his goblins like smiles as the liquid began to cover his face and then he splatted onto the ground, asleep.

Ginger had awoken a minute before; she saw the battle between Cowboy Harris and The Mad Inventor. She decided to stay quiet, Tasia Snow had

given her multiple tips on how to surprise people, and she knew this was one of those times. When she saw The Mad Inventor fall, she had already made her way to the left of The Gunslinger. When she arose and clicked the barrels of her gun, The Gunslinger smiled.

"Git hur Red hair."

Ginger felt a massive blow in the back of her head and fell to the ground into the land of the unconscious.

"Sorry for ya." The Heroine said with a giggle and a smile, "I'm just happy it wasn't Trina."

Cowboy Harris sheathed his pistols, and turned around facing the jewel, he quickly snatched it, "all dat for this purty green lil ball."

"Another transaction completed," Indicia said, floating next to Cowboy Harris.

Cowboy Harris quickly rolled up his left sleeve, showing a device with wires and lights, in a watch formation. The Gunslinger hit the center dial and said, "I've recovered da artafact, send a portal."

Chapter 27:
Silva Feather

"I'm sorry Trina." The Heroine said, looking up at her newest friend being entangled in the tree, "I know we just became best friends but it's my job."

Trina looked down at the Heroine and sighed, "No, Problem. We can't fight our work."

"What the erased are you talking about?" argued Juliet, who was just above Trina, "They got us up here crossed out like the next coming and you're over here sad you and red hair didn't trade Z numbers."

"But she has really good fashion sense." Trina said.

"Fuck her fashion sense!" Juliet screamed, "Is the dumbass inventor and Ginger still knocked out."

Trina looked below, she could see the bodics bound by the branches but she didn't see any movement, "They still seem sleep."

"If any one of them are dead cowboy, I'm going to tear off that dick of yours, you hear me!" Juliet stated.

Cowboy Harris and the others looked up from the altar, The Gunslinger for some reason didn't feel right about the whole thing, but work was work.

The Warlord stared up at Juliet, watching the girl struggle and cuss felt so familiar.

"All we gotta do now iz wait." Cowboy Harris said to Indicia, "git r money and git out of her," Cowboy Harris smiled, "Maybe, I can persuade that Ginger too."

Indicia pulled at The Gunslinger's ear, "Don't get any Idea's, its you and me only, leave your women in the bedroom."

"So cold fairy gurl." Cowboy Harris answered.

Cookie laid spread out on the grass, her eyes not really focusing on anything, the end of another adventure she thought, back to that worn out General in White, who would do nothing but try his brainwashing methods on her, they didn't really work. Cookie's brain was far to advanced to be influenced by something as simplistic as his brainwashing. Cookie did feel bad for The Warlord and The Heroine, they seemed like they could have been nice people before, but now they served only the General in White, with no room for their own dreams and goals. Cookie didn't appreciate that life.

A white portal materialized in front of Cowboy Harris's group, disturbing them from their thoughts. A man walked through the portal in loose white cloth pants, a white, black, and golden kimono, and white boots. The man skin was tan, his hair bright white, ears were pointed, and most curious of all he sported a white furry tail.

"Looks like The General in White did good with the team pickings." Said The Tailed –Elf known as Silva.

"The Mission iz dun, I want my money." Said Cowboy Harris standing up.

Silva smiled as he hopped toward Cowboy Harris, when Silva got close to the green haired wonder he quickly bowed. Cowboy Harris pulled out his wrist contraption and Silva tapped it. The Gunslinger smiled when he saw 40,000 dimensional credits added.

"Now," Silva said, holding up a dagger he removed from the inside of his kimono, "since I'm a tailed elf, I'm not that good at magic, but I still have some destructive spells."

"What in the tarnation?" Cowboy Harris said, as he saw the dagger produce a milky white substance, "What are you doin wit dat attack?"

"Get in the portal." Silva said, "I'm going to wash out these Society of the Unknown children."

"What's da point?" Cowboy Harris argued.

"Yeah," The Heroine intervene, "They really didn't get in our way."

"What's the point of killing children?" The Warlord said, "Let's go home and report we have the artifact."

Cowboy Harris threw the green pearl towards Silva, the elf caught it with his opposite hand and inspected it, as the dagger kept charging. The elf sighed, the white substance evaporated, and the elf put his dagger in his kimono, "I guess this would do, I don't think I had enough magic anyway. I bet The Society are coming to pick up their youth any second now."

Silva put the green jewel in his kimono and spun around to face the portal, "One at a time, we don't want anyone getting lost on the trip."

"Hold it." Cookie said, getting to her feet, "I'm a little bored, a little shaken up, want to spar."

Silva looked at the girl, and put a hand through his hair, "Cookie are you serious? The Society of the Unknown are going to come for their children any second."

"Cookie stand down." The Warlord warned.

Cookie shrugged, "I just want to see Silva's true strength."

Silva, entertained by Cookie, released his silver daggers from his kimono, "I've been trained in combat since an infant child," The Tailed-elf let out a light laugh, "do you truly think you can fight brilliance?"

The Heroine hid her excitement with her hands, she didn't want Silva to see her smile.

With a flick of Cookie's hands, three needles appeared in each of her fists, "How can brilliance fight insanity?"

Cookie sprinted, Silva stayed in his place. The girl neared the elf with a spin, her needles flinging out from her right hand, aiming for Silva's face. The elf easily parried with his left dagger then parried the girl's next strike. Silva lashed out his leg, kicking Cookie in the ribs, the elf heard the sweet sounds of ribs breaking, then stepped in with a downward swipe of his right dagger, it cut the side of Cookie's face but the girl summoned three more needles from her right hand and went into a flurry of slashes. Silva ducked, rolled, and parried, Cookie's attacks were all for naught as far as far as the battle hardened elf went. A right sidekick bashed into Cookie's stomach and a spinning left roundhouse kick clashed against her temple. Cookie eyes immediately rolled into the back of her head, her needles fell from her hands, and Silva caught the girl in his right arm, before she fell into the soft grass.

The White haired elf sighed, "Let's go," his eyes fell on Cookie, "I heard no matter how much she gets brainwashed she still has her main core persona, The General might have picked up too much chaos with this one." With his left dagger Silva moved some of the hair from Cookie's face. "I've heard she has tried to spar against many

Enlightenment Generals. What's your aim young girl?" Silva looked up and smiled at the rest, "Don't follow her example." The Elf hefted the young girl on his back, "Now let's return home safely."

Chapter 28:
Final Chapter

When Juliet and her team were found they were fast asleep cradled by a large tree within the Extinct Temple. The Society of The Unknown freed the kids from their high perch and when Juliet awoke she was in her dorm, which she shared with her Crow team members. However, when she awoke she only saw Ginger laid out and snoring up a storm. Juliet's head felt clouded like she had just witnessed a dream, but she knew everything was real; Juliet's body was still extremely sore, bruises covered parts of her chest, and her armor was still covered in monster blood. The young swordswoman stretched, everything hurting, then she produced a yawn and smacked her lips.

She walked over to Ginger and began to shake the girl up, "Get yo ass up, we got briefing."

When Juliet and Ginger got to Ronald's room, The Mad Inventor and Trina were already present, yawning and smacking their lips.

Ronald wiped his head of sweat when all four were present, "We seem to have taken another loss."

"No shit Ronald." Juliet said with a yawn.

"Sorry." Trina said, rubbing sleep from her eyes.

"Is there really a need to be sorry." The Mad Inventor said, "We were up against monsters and The Enlightenment, all we need to do is make better plans."

"Yes, but know they have the Nature Amulet." Ronald said, "From their data and what we've acquired through the recent battles, we have

noticed a number of them are gifted with wind abilities." Ronald wiped his head of sweat, "Nonetheless the Nature Amulet will improve their powers.

"And the Oni Stone will improve Romeo." Juliet argued.

"Yes," Ronald said, "but that doesn't change the fact The Enlightenment is stronger now. More worries." Ronald shuffled through several papers, "More worries."

"So what's the outcome?" Ginger asked.

"24 hours of rest," Said Ronald, "Then the next mission, we find the last Homunculus Book."

The Hailing Palace
Prologue:

"Put the money in the bag!" ordered the man in the green trench coat, "You don't want me to cut you." The man pointed his scimitar at the bank teller and looked around to see a dozen of his men repeating the same actions to several employees, "You do this quick and I'm gone."

The woman hurried, pushing large gobs of cash into a bag, her hands quickly becoming sweaty, as the blade point stared her in the eyes.

The man sighed; the bank clerk's anxiety was causing a hindrance, "Stop spilling the cash!"

The woman screamed.

The doors to Los Perfecto Bank burst open, revealing a team of people decorated in black Kevlar armor and equipped with blades, knives, and guns.

"This is LPMP!" one of the Kevlar men yelled, brandishing his gun.

The Los Perfectos Military Police poured into the bank and began to shoot the robbers. The guns of the police were able to manipulate the elements and soon the bank was filled with balls of fire, walls of ice, strings of electricity, and blasts of snow. The robbers shouted as they tried to combat the police, using only blades and arrows, but they were soon vanquished.

The main robber, the man in the green trench coat wasn't finished. The robber was a special man that had been through the wringer of bad luck. Today all that was going to change.

The man opened his hand, materializing a blue light, "You see I have a gift!"

A blur of blonde hair whizzed through the police and attacked the robber with a right jab enhanced equipped with brass knuckles. The robber crashed into a wall, his head cracked open beyond repair. The savior was a lone military police man, with messy short blonde hair, and a scar on his left eye. He went by the name Joseph Blood.

"Joseph!" said one of the military police as they walked back into LPMP headquarters, "You were great!"

"Yeah!" said another, "We didn't even see you move past us."

"What kind of training regimen are you on!"

Joseph had been with the Los Perfectos Military Police for five years and had enjoyed every bit of it. Here he was commended for his brilliance and for his skill, people looked up to him and knew deep down the force would be nothing without him. He fared far better here than he ever would within the Society of the Unknown under the Black Seinen Generation. Good thing that generation was dead and he had moved on to the military police. No one on the force knew about his special skill, which meant he got to lick up all the glory, take down the biggest criminals, and get the sexiest women. Joseph's Blood life was perfect, until the chief opened his door.

Joseph was the first to notice a sad look on his balding, chubby chief. Joseph had never seen the man look so dismayed. He walked up to Joseph, and the shorter man put a hand on the blonde's shoulder.

"You've done good work these last five years." The chief said with a sigh, "When you first came you were a firecracker and I particularly didn't

like you." The chief sighed again, "but you always did good work."

"What's wrong chief?" Joseph asked curiously.

"It's the Government, Black Science is rewriting you to a new area."

"No." Joseph said lowly, "Why?"

The chief sighed, "They Z-mailed me, they said they need you to return to your original post, a car will be here within the hour."

Joseph couldn't believe it; the damned Society was calling him home.

Chapter 1:
Joseph Blood
Vs.
Black Shonen

Joseph Blood couldn't believe it, why was this happening to him? Not only was he called back into the confines of The Society of the Unknown but know he had to deal with a group of unruly looking kids, who glared at him through the coldness of the hailstorm. The one who caught Joseph's attention the most was the sixteen-year-old girl, who went by the name Juliet Valentine. The young woman stared up at Joseph with a ghastly sneer on her lips. The Kevlar hood that settled around her face gave her the visage of an angry demon.

"What you looking at nigga?" Juliet said with a cross of her arms, "We don't even need yo ass, I could lead this team without you."

Tiana Forest, Juliet's right hand woman touched the angry girl by the shoulder, "Remember Juliet, you promised Ronald you be good if he let us come on this mission."

Juliet growled, not only was this fool in front of her pissing her off, but also she was shivering, cold hail surrounded her, and Tiana was over here trying to be a mediator.

Joseph couldn't believe it, was this girl really the daughter of Romeo?

Juliet scoffed, "Hurry up and tell us the details."

Joseph looked at the two girls, dressed in the rain resistant uniform of a gray Kevlar jacket; blue baggy cloth pants, and gray rain resistant boots, The Society sure didn't change.

"What details are there to tell?" Spoke the Mad Inventor, who wore his specialized silver rain resistant trench coat with silver pants and boots, "This is the Hailing Palace, a pocket dimension trapped in a never ending storm of ice, and the destination of the last Homunculus book."

The Mad Inventor's partner for the mission, Natalia Espada nodded, "The Inventor made me memorize the mission details, I don't need a briefing."

Similar to the Inventor, Natalia had modified her racer outfit for the duty of the hail. Natalia's one-piece suit was now gray with navy blue boots.

"I didn't read the briefing." Said Sol Pepper, "But eh, I'll just wing it."

Shawn Bolt gave a hearty laugh, "The Scrub Dogs best trait is thinking in times of peril."

"How can you laugh in all this fucking rain?" Asked Juliet.

Shawn smiled, "When you're a Scrub Dog the worst is the best."

Juliet shook her head, "See Sol, even your teammates are used to losing."

Sol's right hand became engulfed in flame, ignoring the rules of the rain, "You shut up Sword bitch or I'll burn you right here."

"You want some fire ho, who copied my outfit today." Juliet barked back.

"It's a uniform!" Sol screamed.

"Why doesn't your partner have it?"

"Oh," Shawn happily intervened, "this is a special outfit for elves, the all white outfit-"

"SHUT THE FUCK UP!" Juliet and Sol ordered.

Joseph didn't want to be here, the thirty-year-old man looked at the teenager's quarrelling, this wasn't the military police. This was a march into death with children. How was he going to survive this?

Chapter 2:
Joseph's Determination

Joseph looked at the Hailing Palace as it sat on it's depressing wet cliff. The square building had a tower on each side, followed by a bridge in the middle of the construct that seem to connect one side to the other, by all other means it looked like a normal place, but Joseph knew better. He was once apart of Black Seinen, traveling through the dimensions, and fighting creatures only heard about in dreams or saw in nightmares. When you dealt with the supernatural and The Society of the Unknown nothing could be expected. Joseph glanced back at the arguing teenagers, now the world was left to brats who couldn't even work with each other. Terra Firma was going to shit.

"Do you feel that?"

Joseph turned to Tiana, the girl seemed to be looking in the foggy distance, her eyes squinting.

Joseph followed her gaze and caught a silhouette growing, "Alright, an enemy is nearing!"

The Statement caught everyone's attention.

"Who's the weakest out of the teams?" asked Joseph

All eyes glared to Sol and Shawn.

"Hey!" Sol screamed, "We took out a big general on our last mission!"

Juliet shrugged, "Still got your ass whooped."

Sol ruffled her red hair, "Only by circumstance, we were out classed!"

Juliet smirked, "And your asses were whopped."

"So!" Sol said, "I heard your last mission you didn't come out on top either, sword girl."

Juliet looked toward the palace, "My ass didn't get whooped though, and I just fell asleep."

"Grab my hand." Joseph said to Juliet.

"Ewww, why." Juliet said.

"Cause we are getting out of here."

Joseph quickly grabbed Juliet's wrist, "Tiana grab your partners hand."

Tiana suspicious, obeyed.

Natalia understood and grabbed Joseph free hand, and The Inventor caught to the idea grabbing Natalia's wrist.

Joseph looked upon Shawn and Sol, "You two are going to fight whatever burst from the fog."

"What!" Sol squealed, "You're leaving us!"

"I thought you had this, fire bitch!" Juliet mocked.

Sol grinded her teeth together as smoke began to emit from her fist, "I got this shit, go on ahead!"

Shawn nodded, taking out his bow and arrow, "Me and the Mistress of Fire can handle such a task, go on, we'll meet you all soon."

At least the elf has some pride, Joseph thought.

In a splash of water Joseph and the others were gone and up the hill toward the palace, leaving Sol and Shawn to battle the monstrous creature within the depths of the fog.

Chapter 3:
Coded Palace

Joseph's Blood fingers rapidly typed upon the symbols of the small altar, whenever he got a wrong combination a loud beep would ring through the air.

"Wow" Juliet said after the fiftieth beep, and roll of her eyes.

Tiana turned her sight back toward the bottom of the hill. Sol and Shawn had just engaged in combat with the monstrosity, "You'll think those two will be alright?"

Juliet kept her eyes on Joseph and his failures, "I give that redhead ho a bunch of shit, but I believe in her somewhat."

"Let me try." Said the Inventor, walking up to the altar, "Obviously speed can't do everything."

The Inventor's back was attached to a metallic spider he wore like a backpack. The spider released four blades like legs that spanned seven feet in height. The legs pierced the altar and The Inventor smiled as the spider downloaded the code into his brain. The Inventor put in the correct symbols, and the door began to screech as a cold brush of air welcomed the team inside.

Chapter 4:
Berserk Yeti

"W-w-w—w-w-w-What!" Sol's red eyes stared at the monstrosity that stood above her and Shawn.

The creature was covered in white fur, washed in faded red blood, it's icy blue skin was seeable on it's stomach, it's hands and feet were decorated with claws, and had shards of meat hanging on their edges.

"Don't lose confidence!" Sol felt Shawn grab her as he leaped, dodging a massive right fist, "Sol focus, this beast is not here to entertain us."

Sol quickly understood and got to her feet, letting a red fireball capture her right fist, "Sorry Shawn, we can't let those Crows outdo us!"

The Yeti balled up it's fist and let it fly towards the two, but Sol Pepper met it's challenge with her own fist filled with flame. The punches connected, water steamed around the two, and Sol's fire burned through the fur and skin of the creature. The monster recoiled, holding it's burnt right fist, to only to be assaulted by a golden streak of light, that punctured its right eye. The wounded creature held its eye with its burning hand and stumbled back from the rookie agents. Sol grew in confidence and let a right jab settle into the creature's stomach; once again fire breathed, and caused the creature to roar in agony. Shawn quickly equipped another arrow and let it fly. The arrow flew above the poor creature and burst into a hundred small bolts of light, the myriad of shards pierced into the large gorilla like monster's body, and caused it to die, with a thundering fall!

"We busted that shit!" Sol screamed, "Who's' the bitch now Juliet, Who's the bitch now!"

Shawn was always happy for his Mistress of Fire, realizing that she was in a constant state of low confidence, due to the history of the Scrub Dogs. The elf loved to see the redhead jump up and down, smiling in her victory. However, the smile for his comrade quickly became one of fear, when he saw a feminine figure materialize next to Sol. The figure was a girl with light blue hair filled with shards of ice, her skin was pale almost blue, and her dress was crafted from snow, crystal, and rock. Shawn was aware of the identity of the young woman, it was Luna Pepper.

Sol saw her sister before it happened; the fiery spirit summoned her flame, aiming for a punch to her floating sister's gut. Sol became quickly entrapped in a tornado of snow and ice, in the next instant the two were gone.

Shawn Bolt was left alone, in the cold, the hail falling into his sacred locks, the coldness burrowing into his being. The elf looked at the sky and then turned to the palace. Luna had to take Sol there; Shawn began to sprint madly towards the lone building.

Chapter 5:
Infighting

The walls of The Hailing Palace resembled
an icy blue, the cobblestone floor was laced with a
light stream of water, and the ceiling produced a light
drizzle. Joseph found himself annoyed by all these
things, or maybe it was the four teenagers who he
still had to watch, their youthful eyes burning with
disapproval of him. Joseph took a quick glance back
to see Juliet Valentine with her arms crossed and her
mouth twisted into a snarl.

"You know if the redhead or elf dies I'm
kicking your ass, right?" Juliet said.

Joseph smirked, "If you can catch me."

Tiana put a reassuring hand on Juliet's
shoulder, "Ignore him."

"Is the enemy quarreling with one another?"

The five looked upwards to see the presence
of The General in White, floating in mid air.

"It's so funny how you children are always
lagging behind us," The General looked off into the
distance, "We've been here for a long while,
searching in this wizened structure. Searching for the
damn book, we knew you youthful sprites would
come and try to stop us in our efforts." The General
snapped his fingers and the small crew began to hear
claws rake upon the wet surface, "I'll be going to the
higher floors." The General gave off a crafty smile,
"Goodbye dear rivals."

Joseph leaped into the air, The General in
white eyes grew in excitement, followed by a smile,
as the blond prepared his fist for a strike. The
General snapped his fingers; Joseph hit the wet

ground with a splash, and The General evaporated into balls of light.

"We all knew Joseph was an ass." Juliet said, grabbing the pommel of her blade as the sound of claws grew closer, "looks like we got to kill another weird ass creature."

Tiana stepped up next to Juliet, shaking her head, "I guess in the end it's always up to The Crows."

"Eh!" said Natalia, "The Mads are here too."

"Better yet." The Mad Inventor said, unleashing his plasma pistols, "I'm here!"

"We only need two." Joseph said, quickly grabbing Natalia and The Inventor, "And were out." Joseph turned to Juliet, "See ya little bitch."

Joseph, The Inventor, and Natalia were gone before Juliet could even get out a swear word, leaving she and Tiana to deal with the incoming beast.

Chapter 6:
The Beast of the Palace

The monster to greet Juliet and Tiana had the head of a bull, with the blue body of a man, and the lower feet of a crocodile. The beast stood twelve feet in height, smoke poured form its nostrils, it's eyes burned black as it looked upon the girls, and it's hands were covered in cold grime. The creature aimed for Juliet first throwing a wild right fist. Juliet met it with the serrated edge of her blade, digging into the beast's knuckles. Tiana was eager to try her new crossbow, the weapon was attached to her right arm, and her quiver was attached to her left leg. She quickly equipped arrow to bow and aimed it for the creature's head.

The young woman hit the trigger of the bow, "Be careful, it's a little hot."

The arrow flew from its bow, shifting into a winged creature of flame, and clinging onto the overmatched beast. The monster roared as fire scorched its throat, it raised its hands in the air and slammed them upon the ground. Both girls jumped out of the way, water splashing around them, and the palace floor shaking under their bodies. The stunned beast threw a left haymaker for the girls and Juliet intercepted with her blade, the force of the punch caused her to slide back, freezing water splashed upon her body, but her blade bit deeper into that fist, causing the beast to finally pull back. Tiana released another arrow, this one becoming lightning and shooting straight into the center of the creature. The water around the beast increased the effectiveness of Tiana's attack. The monster roared as its insides

burned, as it's tongue bubbled from the heat of the pain and it finally fell.

"Did we kill the fucker?" Juliet asked.

Tiana slowly crept up to the beast, its mouth was filled with foam, it's fingers twitched from pain, "We at least immobilized it." Tiana let out a sigh, "Looks like my crossbow packs a good amount of power."

"Yeah!" Juliet said, standing on the stomach of the beast, "Let old elf boy have the boring ass normal bow, the crossbow totally fits you more."

"Juliet!"

But it was too late, the chimera's mighty hand wrapped around Juliet, and the creature rose back to its feet. It roared with foam dripping down its mouth, blood squirmed from parts of it's body, but it was still alive. Juliet let out a scream, the creature put pressure on the swordswoman's body; she could feel bones getting ready to crack, as she tried to struggle for freedom. Tiana immediately aimed her bow and let two arrows shoot off one after another; both arrows took the form of fire, burning into the creature's face. The monster in its pain threw Juliet and the girl went spiraling through the air, while letting out a storm of swear words. Tiana tried to rush back to catch her, but the young girl was traveling in the air to fast. Juliet saw the world spiral around her, she saw the water rushing up close, her body tensed, and then she was caught. The water splashed around her and Juliet looked up to see Shawn Bolt looking down at her.

A blush came to Juliet's face, "Nigga, if you don't let me down, I'm going to cut you in half!"

Shawn let off a light chuckle amidst the madness, and lay Juliet back on her feet, "Sorry

Mistress of the Blade, should I let you do the finishing touches to the beast ahead."

Juliet rolled her shoulders, "I got this pretty boy."

The monster was tired, it breathed hard as it looked down at the three, and puffs of white left its nostrils. Juliet rushed the beast, her sword dragged in the water, causing it to spray as she sprinted. The monster saw the girl's efforts and let out a roar that shook the walls. Juliet let out her classic amazon scream and swung her blade. The sword bit straight through a leg of the beast. The monster threw a right punch and Juliet met it with the spin of her swing, the sword bit through the knuckle and the force of the swing caused the monster's arm to burst, revealing shards of bone covered in blue blood, soon rotted black meat exploded and stained the water. Tiana and Shawn both released their arrows towards the head of the creature. Tiana's projectile became lightning, striking straight between the eyes, and causing the beast to stagger. Shawn's projectile became a quick flash of golden light, shooting into the same space as Tiana's, puncturing the beast's brain and ending it's life with a mighty splash.

Juliet Valentine walked up to the face of the beast and planted a kick straight into its jaw, "It's dead this time."

"Sorry." Tiana said, "I should have made sure it was dead the first time."

Juliet waved the comment away, "We killed it, no probs." The Swordswoman turned to the elf, "Where's Sol."

Shawn Bolt let failure appear on his face, "I'm sorry dear ladies, but I have failed to protect my

own mistress, but I will save her, while you all go for the book."

Juliet put her fist on her waist and sighed, "Shawn, I'm going with you, Tiana once we find the way meet up with the others."

Tiana nodded, she liked when Juliet acted her leader role.

"I might not like the redhead bitch but I ain't leaving her behind."

Shawn bowed, "Thank you Mistress of the Blade."

Chapter 7:
The Inventor Takes a Stand

The Mad Inventor and The Mad Racer both hit the cold wet floor.

"You two take the right elevator, I'll take the left." Said Joseph.

The Mad Inventor got up from the ground, and pulled his pistols out from his dripping trench coat, " I Say Joseph, I've grown quite irritated of you."

"Por Favor." Natalia said, standing up, her eyes boring into The Inventor's, "Let's just ignore him, remember this whole mission is for the books."

The Mad Inventor didn't like the way Joseph was doing things; it was too chaotic, too unplanned, too unexpected. Joseph plans were far worse than anything Juliet could dish out, at least she did try to come up with plans, it seemed like this guy was trying to rush everything.

The Inventor played with his triggers as he pointed his pistols at Joseph, "Was a man like you really part of Black Seinen. You seem so anxious. Don't like returning to the world of the supernatural, I heard after work got slow all you Seinen members decided to spread out to different government factions. Why comeback?"

Joseph looked at the little Inventor; he wondered if the muchkin was a kid of any of the Seinen members, "You don't know shit kid."

"Enlighten me."

Joseph looked at the two elevators, square platforms that could take them to the next floor; it bothered Joseph that there were two of them. It also bothered Joseph he didn't understand the language

next to the platforms, but he learned doing this work he had to take risks.

Joseph looked at the two again, shook his head, and walked to the left platform, "We all survive this kid, I'll tell you something."

Joseph walked unto the left platform pushed a button on the wall and the platform began to levitate, taking Joseph to the next destination.

"Tch." The Inventor didn't like being ignored; he would show Joseph his true intelligence one of these days.

The Inventor sheathed his pistols, shoved his hands in his pocket, and began to walk to the platform.

He showed off in front of your little girlfriend.

"Tch." *Your back, The Inventor thought.*
Yep.
You were quiet for some time, why pester me?
Cause I'm you and you're me.
Your girlfriend's cute.

"She's not my girlfriend!" Screamed the Inventor.

"What are you talking about?" said, Natalia.

The Inventor was brought back to reality, "Errrrr…nothing." The Inventor growled over his own foolery, "You wouldn't understand, my mind is complicated, a mess, a lock in the midst of wild intellect."

The two stepped on the platform and Natalia pushed the button, "I know were not close but we are partners, you can share your feeling s onto me, hermano."

The Inventor rolled his eyes, "I'd rather not."

Chapter 8:
Cassies's Temptation

Cassie of The Enlightenment was stationed on the third floor of the Hailing Palace. The Enlightenment was fully aware that the Society of the Unknown would eventually find the Hailing Palace before they could find the Homunculus book. So their leader made sure to station his generals and chimeras in certain spots to keep the Black Shonen group busy. The third floor fitted Cassie's taste of relaxation; the floor had a warm pool to the far right, it was mostly a flat spot, chairs and tables were stationed around the pool, and Cassie sat on the floor.

The woman let the rain float around her as she paid attention to her high arched feet, admiring how even in battle she kept her soles soft and filled with wrinkles. Cassie liked her feet, men liked her feet, each toe developed, each toe worshipped. Cassie believed she was what every man wanted, what every man needed, and soon once this whole Enlightenment business was done she would acquire the world, men would kill to be with her, she would plant her feet on their faces, and rule the land with a haughty laugh and a swish of her bright blonde curly hair.

As Cassie lost her self in her delusion a peach colored portal appeared, swirling in liquid form. A young boy stepped out from the portal, he had dreadlocks, a gray thermal hooded shirt that covered his arms, a Kevlar tank top, with black baggy jeans and combat boots.

"Where in the hell did Isaac go?" said Johnnie True Jr., "Don't tell me the old man's busted Warp Sphere separated us?"

Cassie immediately got up, due to this development, *he was young she thought but still quite cute,* "Do you belong to the Society of the Unknown, boy?"

Johnnie looked at the woman with irritation, while scratching his dreads, "Eh, old lady you seen my brother?"

Cassie face became red with anger, "Old woman, I'm 22!"

"And I'm sixteen." Johnnie looked around the palace, "It's pretty warm in this room, with a name like Hailing Palace I thought it be cold."

Cassie took out her trusted fan and with a single motion waved it toward the wolf. Johnnie was hit with a combination of wind and water; the wind feeling like a steel gauntlet punching into his face, however, the boy did not fall.

Johnnie felt the sore side of his cheek and turned to Cassie, "You're an Enlightenment member, huh?"

Cassie laughed, letting a pale toned leg slip free from her white robe, "What if I am, I really don't feel like fighting today, how about we just chill in the spa and I can rub those nice brown muscles of yours."

Johnnie smirked, showing his fangs, "Women don't easily seduce me, I come from a world where trusting a woman is a reliable way to get you killed." The Wolf put his left foot behind his right, and put his fist up in front of his face, "Come on Cassie, I know your're more than just a pair of legs and

swollen booty, show me what The Enlightenment has to offer."

Cassie smiled, "I hope you can handle it, boy."

Chapter 9:
The Inventor's feelings

The Inventor sighed, shifting his hands in his pockets, glancing at his boots, he looked at Natalia. The young woman had a stern look, her pink hair wet and plastered to her body, her bright skin glittering amongst the rain droplets.

Just ask her out.

"Shut up." The Inventor whispered.

"What!" Natalia said.

The Inventor was almost caught off guard, "I wonder what these higher floors hold?"

"Thanks for choosing me."

"What?" The Inventor was caught off guard.

"Choosing to be your second for this mission, I thought you would have picked Trina, she would have been a big help in this situation."

The Inventor didn't know how to talk to women, "Trina is a little bit to naïve for my taste, you seem much more grounded, plus our abilities compliment each other. I need someone I can rely on."

Natalia didn't know much about The Inventor, he seemed to keep to himself, and even on missions he mostly would scream at Trina. Today though he seemed decent and that was nice.

The Inventor saw a tinge of a smile appear on Natalia's face as she looked away.

Maybe the comment did its work.

"I originally thought, you thought, I was just some crazy hard edge bitch, with tattoos who wanted to prove herself. Most of the others do, I guess, I'm trying to say it's nice, you trust me."

"No need." The Inventor was getting nervous, his hands kept moving in his pockets, causing them to get sweaty, "It is only facts."

Natalia smiled again, "Well I li-"

The platform stopped moving and it settled on a square room. The two walked out to see a woman standing in the middle of the room, she wore black skin tight armor, had her curly brown hair wrapped in a ponytail, and in her right hand was a giant black jagged blade covered in alien writing.

When she heard the two come in, her red eyes focused on her opponents, "I'm The Warlord, a tool of The Enlightenment!"

Chapter 10:
The Wolf on Ice

With a flap of Cassie's fan, Johnnie Jr. was hit with a cold wind. Ice began to form in the werewolf's locks, and his skin began to develop a frosty layer.

"Silly beast," Cassie teased, "Is that all you can do?"

Johnnie sneered, his fangs appeared in his mouth, his eyes faded into a rage of yellow, and a bushy black wolf tail erupted from his pants. The Werewolf pushed through Cassie's gale of freezing wind and he almost reached the woman's neck with his clawed hand. Cassie's eyes grew in excitement as she witnessed the wolf overthrow her ability, but with a laugh and a stronger gust of wind, she flung the wolf back.

"Almost got me!" Cassie flirtatiously spoke, "I bet when you do reach me you'll be too worn out to have any fun." Cassie put her left fair leg out, it was decorated in an icy high-heel, she put her right high-heeled foot in the back of her left and raised her fan high above her head, "Are you ready wolf? This one will chill you so much I might not even be able to warm you up afterwards."

All Johnnie did was snarl and sprint towards the woman. Cassie let the fan fall and a punch to the gut from Joseph Blood made Cassie fall onto her knees.

The blonde man looked down at The Enlightenment member and a smile recognizing his superiority swept over him.

"It took me a damn long time to find this place," Joseph Blood glanced back at The Wolf,

"You teenage boys let anything with a pretty pussy stop you huh?"

Johnnie gave the man a vicious bark, "She caught me off guard, and who in the erased are you?"

"Fuck, that old man never told you about me?"

"My father?"

"Don't play dumb brat." Joseph was tired of all these teenagers, "You look just like old man Johnnie."

Joseph turned toward Cassie, the girl was still on her hands and knees, and she looked up at Joseph through blue spheres, she stuck out her tongue and closed her eyes, she reached out her hands for Joseph's crotch, and the man slugged her in her cheek.

"Take care of her." he turned to Johnnie, "Stop thinking with that hairy dick of yours too."

In the next instant Joseph was gone, heading to the fifth floor.

Cassie rose to her wobbly legs, a trail of blood dribbled from her lips, her blue glowing eyes turned to Johnnie, the water around her began to levitate in droplets, it churned and waned around her tempting body, a smile crossed Cassie's bruised lips, and Johnnie senses began to prick up and recognize a monster he couldn't handle.

Chapter 11:
The Warlord in all her Glory

"I am the Warlord." The Warlord rose from her one-kneed position, grabbing the pommel of her blade, which was planted into the icy floor, "A tool of The Enlightenment." The Warlord yanked her giant blade and balanced it on her shoulder, "The Black Shonen Generation is my enemy." Finally, The Warlord opened her glowing crimson eyes.

The Mad Inventor and Mad Racer both walked into the room to meet their foe. The Warlord bent her knees preparing to sprint.

"We need to be wary." The Inventor spoke to The Racer, "Juliet said she was quite the foe."

Natalia shook her arms, activating the metal bracelets on her wrist. The bracelets made from nanotechnology spread throughout Natalia's hands, forming pink miniature cannons.

"I've got your back, hermano." The Racer stated.

The Inventor readied his hands on the handles of his pistols, but the Warlord made her move, aiming for Natalia. The Warlord with both her hands wheeled her blade back as if she was making her incoming for The Mad Racer. With one mighty swing, she aimed her blade for the girl's neck, but a metallic slender blade intercepted her.

Natalia realized what she needed to do and aimed her left cannon at point blank range; within her cannon her hand held down a trigger and a thick beam of pink energy crashed into The Warlord. The Swordswoman hit the wall with cracked armor, blood trailed from her curly hair, and her ragged breaths came out in cold clouds. However, she got

back on her feet, and hefted her jagged blade on her shoulder.

The Inventor was entertained, "Still alive?"

The spider legs from his pack erupted and The Inventor made a dash for the wounded Warlord, but she did not falter. She grabbed her blade with bloody hands and horizontally attacked the incoming mad man. Two of The Inventor's bladed legs were destroyed leaving chunks of metal, while the other two retracted back into the spider emblem on the Inventor's back.

Natalia released blast after blast from her dual mini cannons, and The Warlord spun between beams, rolled under their massive energy, used her blade to block, and lastly bashed a pink projectile with her blade, causing energy to spread around the room. The Swordswoman leaped upon Natalia, The Inventor had just reached his guns, but Natalia saw as a face of anguish hit The Warlord. The Swordswoman dropped her blade and hit the floor as she held her head in pain.

"F…..Fu……fuc….." The Warlord stammered, falling onto her knees, "Fuck you General!"

Natalia took this opportunity and with both cannons released a blast. The Warlord was hit, the majority of her armor peeled off, she was flung through several rooms of the palace, creating bruises and cuts throughout her body. When she found herself tumbling outside the palace, several hundred feet in the air she felt no fear, no regrets, nothing. She let herself fall with her cloak slapping against the wind. She hit the ground and the force broke her neck. Oddly, her blade had followed her throughout

the blast and clanged on the ground next to its master.

Chapter 12:
Getting to know Shawn Bolt

"Fuck." Juliet said, looking at the two elevators, "Arrrrrghhhh, which one should we take elf boy?"

Shawn looked at the two platform elevators; they were both identical with the same cryptic language he didn't understand, "How about the right, lady of the sword?"

"Damn right I am!" Juliet agreed.

"Then looks like I'll take the left." Tiana began to head toward the designated elevator.

"See you at the top bitch!" Juliet said, "Don't die on me!"

Tiana entered the elevator and turned toward her leader, "If I died who would keep your crazy ass alive?"

Juliet ghoulishly smiled, "Nobody, I'd be the craziest bitch alive!"

Juliet Valentine and Shawn Bolt entered the platform elevator and let the doors close, no matter what they would save Sol.

"So I've never worked with you elf boy." Juliet said to Shawn, "How is the life of an elf, you got crazy hocus pocus attacks or something?"

Shawn shook his head, "I'm a Tailed-Elf, we are low in magic but high in physical abilities, I've had a blade and a bow as far back as I can remember, even if it is a bit muggy."

"What do you mean?" Juliet asked.

Shawn Shrugged his shoulders, "Ever since me and Shadow came to this world I don't exactly know who I was before, I remember bits and pieces, like my fighting style, my likes and dislikes, but my

memories of my homeland is muggy. Shadow said he messed up the spell and it messed up my mind."

"Shadow said?" Juliet questioned, "The other elf?"

Shawn nodded, "He said in our world we were in danger and had to escape."

"What danger?"

Shawn shook his head, "I don't know."

Juliet nodded, "Shadow, huh?"

"He said the elf world is full of prejudice."

"Shadow, huh?"

Shawn stared at the floor, was Shadow hiding something?

The platform suddenly took a sudden left throwing the Swordswoman and Elf to the floor. Then it took a right, and then went up, then to the right, then a left.

"What the erased?" Juliet said, as Shawn helped her from the floor.

"This elevator has many tricks." Shawn said.

The blue doors opened, revealing a room layered with a silver ice. Sol Pepper was in the middle of the room bound by silver chains, her veins were glowing orange, trying to keep herself warm. Luna Pepper floated down next to her sister and an icy blue-lipped smile crossed her stoic face.

"My sister's playmates have arrived."

Chapter 13:
The Archer and The Wolf
VS.
Cassie of the Enlightenment

Tiana Forest was met with a queer scene once the elevator reached its destination. She saw a fair skinned, attractive, blonde woman screaming her head off as she held Johnnie True of the True Twins, with a tentacle that was a mixture of ice and water. The lady's eyes glowed eerily blue in her madness, her face looked bruised, and Tiana was pretty sure the woman had lost her mind. Tiana saw Johnnie True in his half wolf form desperately trying to claw himself lose, but it was all for naught. The Archer was aware of what she had to do.

She quickly loaded an arrow and shot it at Cassie. The arrow shifted into a white lightning, shooting straight through Cassie. Cassie screamed as the lightning tore through her body, and she hit the ground with her knees.

Johnnie Jr. rose to his feet, wet and rubbing his neck, "Is Juliet and all the rest of them here?"

"How about a thank you?" Tiana exclaimed.

"I could've handled it," Johnnie said, walking past Cassie, "Let's just go and get this book, I gotta put this shit to rest."

Tiana shook her head, "That's why nobody want yo ass, no appreciation."

Johnnie shrugged his shoulders, "Women can go to the Erased World in that aspect."

Tiana crossed her arms, "You like dick nigga?"

Johnnie growled, "I like women! I just don't trust them when it comes to relationships. Where I

come from women only go for the man with all the resources. Love, emotions, all that stuff is dead."

"Well you ain't in yo world your in mines."

Johnnie shrugged, "To each his own."

Tiana looked around the area; "You telling me this ho was just sitting around at a pool, waiting for you."

Johnnie glanced at Cassie; she was on her knees, foaming at the mouth and violently gyrating, "Should we put her out of her misery?"

Tiana turned to Cassie and sent a normal arrow to the back of the woman's head. Cassie's face hit the ground with a splash, "She's out."

"Hey," Johnnie said, not giving a second thought about his former foe, "I kinda forgot but I need to find Isaac."

Tiana put her hands on her hips, "After all that shit you was talking you want me to come help you."

Johnnie shrugged again, "We are headed to the same place, right?"

Chapter 14:
The Bridge of Ice

Wow, the bridge is pretty.

The Mad Inventor rolled his eyes as he looked at the bridge crafted from ice, it sparkled amongst the hail, giving it a mythic feeling.

"Wow this bridge is muy Hermosa!" exclaimed Natalia, "That's one of the things I enjoy since The Society of the Unknown have found me, all the exotic places our missions take us, its breathtaking."

See, she think it's beautiful as well.

"I guess nature can make some spectacles." The Inventor said, heading onto the ice.

"Si, si." Natalia said, "I wonder if this bridge was made naturally or did something make it."

Or did the palace make it.

"Or did the palace make such nonsense."

Hey! You stole my statement.

The Mad Inventor accessed the nanobots in his eyes, showing him where most likely the book would be, "I'm 86 percent sure, it's on the fifth floor."

"More travel." Natalia said, "I wonder if the others have already made it this far."

The Inventor shrugged, "Maybe the imbeciles did." The Inventor put his hands into his coat pockets, "I hope that Joseph has found his cold grave, I quite don't like him."

"He doesn't respect your brilliance." Natalia joked.

"He doesn't respect either of our brilliance."

Good save. You must really like her.

Natalia lightly smiled.

A screech had interrupted the two's conversation, The Mad Inventor and Mad Racer looked up to see a winged creature on the other side of the palace. Its skin was a sickly white, its eyes were black balls of flesh, it had the shriveled naked body of a human and its wings were massive and strong, with a fanged screech and a leap from the building the albino gargoyle glided down towards the two.

Chapter 15:
Battle in a room of Ice

Juliet Valentine and Shawn Bolt stepped onto the icy platform of Luna's chamber. Sol Pepper was on her knees, her limbs covered in links of ice, her veins glowing orange, her body shaking, battling the icy spell Luna put her under. Luna floated next to her sister, impressed that fighters had actually made it to her lair.

"Alright Luna," Juliet said, grabbing the pummel of her blade, "cut the shit."

"This can all be fixed." Shawn hands hovered above his daggers, "Luna, come back with us."

Luna glanced at her sister, "Oh, Sol, how do you always manage to seduce the elves?"

With a flick of Luna's wrist, a spear of ice shot up from the ground, aimed at Juliet and Shawn. Juliet quickly unsheathed her blade, bashing the spear into a sprinkle of icicles.

Luna gave a placid smile, "Looks like your not all talk Valentine."

"How about you free your sister before I kick that icy ass of yours." Juliet said.

Luna held out her left arm and covered it in ice, forming it into a curved blade, "My mentor taught me so much." Luna eyed her newly crafted weapon, "Sol never stuck to any of it. She never listened, always making her own decisions." Tears of ice began to fall on Luna's unfeeling skin, "He took away my mentor, that Shadow Black." Her eyes fell to Shawn, "You'll do."

In a rush of cold wind, Luna flew over Juliet, making her way to Shawn Bolt. The elf met her sword of ice with his daggers of steel. The weapons

deadlocked, Shawn could feel coldness pour into his body, his hands began to ache, his legs began to wobble, Luna began to push, forcing the elf back as he began to lose feeling in his hands, but then in came Juliet.

Juliet started out with a swing to Luna's neck; the icy girl freed her sword from, Shawn, and ducked. Juliet raised her sword above her head and brought it down upon Luna Pepper. Luna performed an upper slash, which caused her blade of silver ice to crack. Juliet stumbled back from the force and she also began to feel a coldness seep through her armor.

"What the Erased?" Juliet said, "This shit is suppose to keep us warm."

"Luna's abilities have been improved." "Shawn said, "She's gone far beyond normal skill."

"Fuck this ho."

Juliet rushed the powerful Luna and the two met with another clash of their blades. The ice around them cracked, bringing up shards of debris, when their blades unlocked a cold gale spiraled around them. Luna opted for a downward strike but Juliet parried, and aimed for a slash to the shoulder. Luna twisted her free hand and Juliet was swept off her feet by icy wind and sent spiraling into a wall.

"Luna! Stop this!" Shawn yelled, "Your part of our family! We've been through many campaigns together, why are you like this?!"

Luna looked down at the elf, "I want Sol to suffer."

Chapter 16:
Shawn Bolt
Vs.
Luna Pepper

Juliet tried to tear herself from out the wall, but she was implanted into its being. The more The Swordswoman struggled, the colder she got, and the more she got stuck, even worse she was implanted upside down. She saw Shawn bolt dodging ice spears on the ceiling, which was actually the floor. The ice spears coming from under Luna were sharpened to a point and flew with a vicious quickness, that Juliet was surprised that Shawn could dodge them, but Juliet wanted to fight too, so she kept struggling.

Shawn back flipped, dodging several spears, a spin caused him to dodge several more, a parry caused one to turn into silver shards and a duck let him miss three more. Shawn was beginning to sweat, Luna's cold air was slowing his body down, and Juliet was trapped into a wall. What were his options?

Shawn smiled as a crazy idea ran in his mind. The elf spun again, dodging several more spears, but in his dodge he switched to his bow and arrows. When he came to a halt the elf madly began to release arrow after arrow, each projectile turning into several streams of light, combating the icy weapons of Luna Pepper. The Tailed Elf held his position, projectiles of ice passed by him as he shot his arrows, cuts of coldness began to appear on his body, slicing through his armor, but he persisted.

Juliet watched the battle from upside down, she saw as the elf worked through his pain, his face grimacing, his body beginning to shut down, but he

kept shooting his arrows and continued to keep up with Luna's pace!

Shawn reached back to grab an arrow, and a realization flooded through his body, he was out of arrows! Shawn looked at Luna with a sudden tinge of fear. He could destroy some of the spears with his daggers but he knew eventually he would be overcome. Luna was no fool and understood what was happening, she had won. Luna focused all the remaining ice spears around her with a spread of her arms. They all aimed solely on The Tailed Elf. With her right hand, Luna pointed at Shawn Bolt.

The Elf rapidly switched to his daggers, and began to slay ice spear after spear, but he was quickly overwhelmed as cuts began to cover his body, a spear pierced his leg, freezing it, a spear hit his shoulder, numbing it, several spears hit his chest and in seconds Shawn was a frozen version of himself.

Juliet was pissed, here she was stuck in this wall of ice unable to do anything, and she had just lost a comrade. Luna turned her eyes to The Swordswoman and began to float over. Juliet wasn't going to lose, she didn't know how but she was going to escape her ice prison. She was going to save Sol and get the Homunculus Book! She was going to win!

Luna was startled as Juliet's icy prison exploded into silver dust. Within the dust, they ice woman could make out a figure covered in a bright pink energy. When the particles of ice settled Luna could make out Juliet Valentine holding her blade with her right hand, bending her knees, The Swordswoman's right side was covered in pink

glowing tribal symbols, her glowing eyes a matching pink, and a menacing smile crossed her face.

Chapter 17:
Cookie's Surprise!

Cookie Dough Cream was bored, the young girl wandered the halls of the fourth floor of The Hailing Palace. Originally, she was supposed to wait in a trap room to battle one of the Black Shonen members, but that idea grew tiring. She'd find the members herself and fight them, which could be fun. The young lady had her hands behind her head as she stalked the palace, there was nothing really exciting about the place. All the walls and floors were an icy blue, the ceiling let off a light sheet of drizzle, the windows let you see out onto the cliff and the cold water below, and then there was the sound of the hail. The only redeeming quality about this place, the sound of the hail hitting the palace, tink, tink, tink, tink, it calmed Cookie.

Cookie in her abysmal boredom made a left turn to witness a beast in her way. The monster reached twelve feet in height, it had silver horns, with the head of a lion, the body was leathery but took the shape of man, the claws were red, and its tail was that of a lizard.

"Oh yeah!" Cookie said out loud to herself, "They told me monsters would be all throughout this floor." Cookie smiled at the beast, "How cute."

The Enlightenment had a wide range of chimeras; they were their most useful source of muscle. Some of the chimeras proved to be more useful than others, being able to tell friend from foe. However, the one that Cookie found was not one of those types.

The beast roared at the girl, letting out white sticky foam.

"Does someone need a nap?" Cookie guessed she could kill off some of her dullness with this crazed beast.

The monster answered with another roar and lunged at Cookie. Cookie, who was wearing a black hooded Kevlar outfit, pulled out her needles from the pocket of her pants and crossed slashed into the creature's stomach. The monster fell back on its feet and Cookie gave it a right roundhouse kick to the face, the beast staggered only to get a swipe of needles into its visage. Cookie gave another left roundhouse kick with a giggle and went for a left thrust into its chest, but the monster grabbed her wrist. The lion head smiled, it had the young girl and gave her a head-butt. A crack echoed upon the walls and Cookie's legs almost gave out, but the girl was not a softie and gave a head-butt right back. The monster's grip didn't weaken as it stepped back. With its opposing fist, it slammed a hard punch into Cookie's stomach. The girl tried to attack with her free hand but the monster easily dodged. The creature cracked its elbow into Cookie's head and let her go, the young woman stumbled about. The creature with no fear walked up to the girl, balling its right fist for a killing blow.

A portal of peach opened behind the creature, "Magenta Cross!"

In a flash of magenta lightning and fire a boy appeared in front of the wobbly Cookie. The boy had cornrows that traveled down his neck; he wore a white hooded thermal with a silver and black Kevlar vest, gray jeans, and black combat boots. The boy caught Cookie as his bright explosion swallowed up the beast behind them.

"The Name is Isaac True and you are?"

Chapter 18:
The Fight at the Ice Bridge

The white, sickly-looking, winged creature spiraled through the plasma bullets of The Mad Inventor. It swooped down to the bridge and spun between the Inventor's two remaining spider blades. It swooped back up and spun in a loop, nimbly missing the large pink beam of Natalia Espada a.k.a The Mad Racer. The creature let out a screech to mock its opponents.

"Should we just ditch it?" Natalia asked.

"So the menace can just stalk us the remainder of the mission." The Inventor said, watching the beast, memorizing its flight patterns, "The little devil is probably trying to distract us."

The monster flew in a circle again and decided to loop down towards the two.

"I got this," Natalia said, as her dual mini cannons began to load up, "let it come to me."

The Inventor was about to argue…

Let her do it.

The monster glided rapidly down toward the bridge and pulled up several feet above it. Natalia watched as the creature spread its almost transparent wings and glided in on the icy wind. She noticed when it wanted to go up in the air it usually did it in a straight line. She just had to wait for the creature to pull up. The creature flew over them producing another screech and went upwards using a cold draft. Natalia pointed both her cannons upwards and released the charges within. A thick pink beam of energy enveloped the monster, turning its form to dust.

The two inventors looked at each other and nodded.

"Well done." Said the Inventor, sheathing his guns, putting his hands in his pockets, and continuing forward.

Oh yeah, you look real cool Inventor.

"Tch." Was all The Inventor could produce.

Natalia rolled her eyes, shook her head, and continued forward, "Boys."

Chapter 19:
The Fairy Buster
Part 1

Two Years Ago…….

A wooden carriage pulled by two massive black unicorns came into a city that sat by the sea. The grounds of the city were produced by seashells, the adorable cottages were crafted from wood, pearls, and rocks. The trees produced bright sea green watermelons and reached heights of thirty feet, the breeze was filled with salt, and the day had bright warmth.

The residents of the city took the shape of men but some of the people had gills, other had fins, others had big wide eyes that bobbed in their head, while still others looked perfectly normal by human standards. The civilians looked as the carriage stopped at the entrance. The doors opened revealing three fourteen-year-old girls. The first one had chocolate skin with a red and black Kevlar body armor, brown khaki pants, a gray hat covering her kinky brown ponytail, and red and black combat boots.

"Is this where that bitch made wizard ran off to!" she also had a serrated broadsword on her back, she went by the name Juliet Valentine.

The next girl to come out had dark chocolate skin with long golden cornrows wrapped into a ponytail, she wore a simple tank top, with pants, and boots all doused with the color dark green. She had a winged bow made from wood on her back, with quivers of arrows attached to her right leg.

"The tracker did say he flew into the forest of Seashell City" ;answered Tiana Forest.

The third girl to pop out had golden locks and caramel skin, she wore ripped and worn body armor crafted from black and gray cloth, silver wraps surrounded her legs, a gray cloth covered her mouth and simple gray slip on cloth shoes covered her feet. On the young girl's back was a double bladed silver pole weapon named, Iron-cutter.

Tasia Snow took out her Z-Phone, which made a holographic map of the beach forest, "The tracker says he's right in the middle of the forest, most likely starting his spell using the Fairy Buster."

Juliet Valentine fourteen years old smiled her classic sly smile, "Then let's get that nigga."

Chapter 20:
The Fairy Buster
Part 2

In the midst of an enchanted forest, a rogue wizard chanted into a crystal ball. The mage's young hands spiraled the glass sphere, his mumbles were incoherent, and his mind focused on the magic within. Next to the wizard was a large jagged blade, the weapon glowed symbols in a pink light and gave the magician an extra boost in power.

A chuckle came to the mage's lips, "Ah, such young and fertile maidens."

Juliet Valentine, Tiana Forest, and Tasia Snow traveled within the captivating forest. The limbs of the trees twisted into awkward positions, balls of light floated around the girls, mushrooms grew to the size of humans, flowers produced sweet smelling glitter, and the grounds were soft and easy to traverse.

"I'm tired of all these damn fetch quests!" Juliet complained, "You know, this mage business might be the highlight of our careers so far!"

"Weren't you happy to get this mission a couple of hours ago?" Tiana reminded.

"Yeah, but now that the mage escaped and we've been in this forest for three days, I'm getting irritated."

"It's been two hours." Tasia stated.

Juliet crossed her arms, "Well it feels like fucking forever."

Tasia summoned the hologram map, "It looks like were closing in on him."

Those words excited Juliet and her hands went to the pommel of her serrated broadsword, "I want first blood."

Tiana readied her bow and arrow, "Usually with these guys some creature is going to burst from the woods before we can get to him."

Tasia pointed forward.

Several yards ahead, the queer trees and mushrooms began to move.

"Wizards," Juliet said, unsheathing her blade, "Never any new material."

Chapter 21:
The Fairy Buster
Part 3

The creature revealed itself to the trio of teenage girls; the monster had brown fur that covered its body, it stood on two strong legs, it's two arms looked like massive logs, the creature reached seven feet in height, its face was like a primate's, and when it beat its chest and let out a fanged roar the girls bodies shook due to it's imposing presence.

Juliet was the first one to rush towards the wizard's familiar. The monster threw a massive right punch and Juliet rolled under the punch, and stabbed her sword into the creature's chest. A left punch came for the girl's head, but Tiana's arrow of fire countered, burning the primate's fist. Tasia joined in next; the monster was busy with its wounded fist, giving Tasia enough time to produce a slice up and into the creature's ribs. Juliet yanked her sword from the primate's stomach to counter a left fist with her blade, cutting into the monsters knuckles. Tiana released an arrow of concentrated water that pummeled the monsters chest. Tasia leaped into the air, and with a swift cut of her spear, separated the monsters head from the rest of its body.

There was no blood, no gore; the creature's head spouted a green glitter at it's defeat. The body did not fall but evaporated into green dust along with the head, and left the girls in silence.

"Curse those little sluts," The Mage seethed, "that was one of my strongest familiars." The mage began to swirl his hands around the crystal ball

quicker, chanting and sweating. What was he going to do if they came?

"Is that the nigga we suppose to kill?" Juliet whispered from behind a tree, watching the wizard chant eagerly.

Tasia nodded.

Tiana pulled out an arrow and loaded into the bow, "I can take him out right now with a lightning arrow."

"But you always fuck up." Juliet reminded.

Tiana rolled her eyes, "I got this."

Juliet shrugged, "If you say so."

Tiana closed one eye, as she pulled back the arrow. The young girl gave several quick breaths and began to concentrate. The arrow began to shine a white light; tendrils of lightning began to come forth, burning the grass around her.

"I got this shit." Tiana repeated, letting the arrow fly from her bow.

The arrow shifted into a violent projectile of white lightning. The wizard sensed the projectile and with a wave of his hand caused the arrow to veer off and crash into a crooked tree behind him. The young mage got to his feet and quickly found the girls peeking out from behind a tree.

The wizard's hands became covered in a purple fire, "Oh little harlots, I've been waiting for you!"

Chapter 22:
Fairy Buster
Part 4

"Shit." Tiana said.

Juliet stuck out her tongue, "Toldja."

Tasia stayed quiet.

Juliet rushed out before her companions could stop her, the young swordswoman summoned her blade and went for a right swipe to the wizard's midsection. The magician flipped his hand and Juliet went spiraling up into the air. The girl hit the ground face first, her nose planted into the soft grass. The Wizard swirled his hands, summoning up another spell, but Tasia Snow didn't let it happen. The swift girl was on the wizard before he could even chant. He ducked a swipe from the bladed pole and jumped back from another attack. He shifted his head to the right, dodging Tiana's flame arrow and opened his right palm, freezing Juliet in place, who was already on her feet. Tasia twirled her spear above her head, leaped, and came down with the sharp edge of the blade aimed for the wizard's head. The mage looked up and opened his hand, releasing a purple smoke, the smoke surrounded Tasia, and when she hit the ground she was a wide-eyed baby.

Tiana looked back from the trees she used for cover, Juliet and Tasia were down. She was all that was left. She cursed her luck and hid back behind the tree to see the Wizard staring into her eyes. On instinct, she shot an arrow from point blank range. The arrow turned to sand before it even left the bow. The wizard curved his fingers and the branches of the tree bound to Tiana.

"Ahhhhhhh magic is so cheap!!!!!!!!" Tiana screamed.

The Wizard smiled, The Crows were captured.

Chapter 23:
Fairy Buster
Part 5

"So how was that lightning arrow?" Juliet said, bound to a tree next to Tiana and Tasia.

"You're a bitch." Tiana responded.

"I try to be." Juliet smiled.

Tasia was back to her normal age by then and stayed quiet.

The wizard was several feet away in the heat of his spell, purple smoke surrounded the magician and the blade next to him glowed so bright sometimes the girls had to squint their eyes. The mage began to laugh due to the influx of magic, now was his time. He would go back to the Magic University and show them why he shouldn't be expelled, that his magic was supreme, that he deserved to be captain of the Magic Squad! Those slutty witches who teased him wouldn't look down on him anymore. The Fairy Buster would be overwhelming!

"Ay nigga!" Juliet screamed to the mage, "Could you let us out so we can continue kicking your ass."

"We were whooping his ass?" Tiana said sarcastically.

"Yeah," Juliet said, "we had that nigga."

Tiana rolled her eyes, "Sure."

The mage stood up and turned around towards the trio of girls, "I'd like to test my new magic on you, if that's okay?" The Mage's voice was deep.

"Yeah sure." Juliet responded, "Let us go magic boy."

The mage raised his hands, and snapped his fingers, causing the branches to free the girls.

"Oh nigga, you fucked up!" Juliet said, rushing the wizard and unleashing her trusted blade.

Tiana couldn't believe it, "The ho never learns."

The Wizard shot a tendril of purple smoke at the girl but Juliet quickly leaped to the right and continued her mad dash, "Tricks don't work twice nigga!"

The mage began to bend his fingers in awkward ways but an arrow of fire collided with his face. The mage laughed as his face burned and Tasia was upon him and sliced the wizard in half. The mage's body turned into a myriad of bats and began to circle the girls, biting into their flesh, and screeching into their ears. Tiana through the pain of bites and scratches pointed her bow towards the sky with arrow equippcd, she let out a scream and let the arrow fly. The arrow became fire and burnt the bats around it, causing the magician to revert back to human form.

The magician looked at his burnt hands, which healed rapidly, the power flowing in him was transcendent, "I AM GOD!"

Chapter 24:
Fairy Buster
Part 6

Juliet hit the ground, dodging another purple cloud. Tasia performed a backflip letting one of the clouds fly under her; Tiana countered a cloud with a fire arrow.

"You can't stop greatness!" The mage said, as the blade near him glowed its pink radiance.

Juliet sprinted towards the mad wizard, and went for a strike to his head. The wizard's skin became steel and the blade deflected right back, throwing Juliet off balance. The mage turned towards her, his eyes wide and dilated from magic, and he thrust out his hand, causing Juliet to float in mid air. He pointed with his other hand and Tasia Snow hit the ground. An arrow surrounded by blades of wind came for the eye of the wizard but with a blink the arrow became ash.

The mage released Juliet and Tasia and began to walk towards Tiana, "The Swordswoman is the brawn, the rogue is the stealthy intellect, the archer is the reliable one, archers are always reliable."

Tiana rapidly released an arrow of concentrated water only for it only to be evaporated by the overpowering mage. The mages hands bent in queer ways and Tina could feel pressure on her throat. She fell onto her hands and knees, dropping her weapons and began to gasp for air.

"This is how every female should be near me," said the wizard, "on their knees and gasping for my essence."

"Hey," Juliet screamed, "bitch ass nigga look over here."

The Wizard quickly turned around to see Juliet Valentine near the Fairy Buster, the source of the wizard's power. Juliet grabbed the handle of the blade and the weapon instantly reacted in a bright flash and a scream from its former owner. When the girls could see again all that was left of the wizard was a smoking black skeleton, clothed by a charred robe.

"Nigga was all talk." Juliet said, yanking the Fairy Buster from the ground.

"The blade's huge." Tiana said in disbelief, "It's as big as your body, how are you able to hold it?"

Juliet who never thought about such trivial matters shrugged her shoulders, "I don't know, all I know is that it feels light to me, way better than my old sword."

Tasia pushed several buttons on her watch and a peach vortex appeared behind her, "Let's get his remains and take it back to The Society, our mission is done."

Chapter 25:
The Fairy Swordswoman

Present time.......

Juliet Valentine let out a scream as the Fairy Buster filled her with power. The blade's pink hieroglyphs shone brightly, and spread to the right side of its new owner's body. Luna looked upon the girl, gaining in increasing fear as the seconds passed. The right side of Juliet's body jerked, releasing a ten-foot wing from her body; it took the form of a dragon's wing with the aesthetic of a blue and yellow butterfly. Juliet fueled with power flapped her wing, rocketing towards Luna. Luna tried to put up a defense but Juliet was already upon her, with blade cutting downwards upon Luna's shoulder.

Luna hit the cold wall, blood gushing from her arm. She had barely dodged the attack, but Juliet was above her, casting that wicked smile. Luna quickly formed her right arm into a spear of ice and batted away the second attack from Juliet. However, Juliet was quick to recover, performing a horizontal slash for Luna's chest. The Ice Witch ducked, and pointed her left hand towards The Swordswoman's face, producing a spear of ice. Juliet tweaked her head; the cold sensation scratched her cheek. Juliet twirled her large bright blade in a circle and brought it down, Luna rolled to the left, transformed both her hands into ice blades and leaped towards Juliet. Juliet shot up, her one wing granting her twelve feet of air, she performed a twirl into a backflip and thrashed upon the ground, running her blade down Luna's back.

Blood decorated Juliet's armor, Luna stumbled several feet, her knees became weak, her vision blurred. Luna used her ability to seal the fatal wound on her back and the one on her arm, and she began to melt. Juliet realized her icy opponent was melding in to the ground and began to chase her. Juliet was suddenly thrust from her new form back into her original form. Juliet's knees buckled as she hit the ground, her body felt as if several boxers had pounded on it, and every movement flared with pain. Luna turned towards Juliet, her head the last thing melting into the ground, and she turned to look at her sister Sol. Sol was barely conscious, using the remains of her ability to fight the cold and stay alive. And then Luna Pepper vanished.

The daggers belonging to the frozen statue of Shawn Bolt began to shine brightly. In a flash of gold, Shawn Bolt was released from his imprisonment and able to move once more. The Elf quickly wrapped his arms around himself, trying to gain some sense of warmth. He looked around to see the passed out Juliet Valentine and the chained Sol Pepper.

"Drat," Shawn commented, "I missed the confrontation."

Chapter 26:
The Black Dragoon

"This whole mission is coldness and misery."
Johnnie True Jr. said, as Tiana and himself crossed
the ice bridge.

"Then why did you come?" Tiana asked
beside him.

"To get revenge for my father," The Wolf
looked off into the stormy sky, "The Enlightenment
won't do anything good with those books anyway.
They might seem like imbeciles but I've encountered
their leader before, he's competent."

"He's that bad huh."

"He has a mastery of wind, probably the one
supplying to all the other members. Calls himself
The Adversary."

"They always like to give themselves a
name."

"Helps distinguish themselves among the
rabble."

Tiana had stopped walking and even in the
density of the hailing storm Johnnie's nose had
picked up something different. Tiana pointed to the
sky and Johnnie had seen it. A slender creature
moved upon the gray sky with powerful black wings
of leather. Tiana immediately equipped an arrow to
her crossbow and launched a projectile of lightning,
but the flying creature spiraled away from it and
dove for the bridge, landing with a shattering crash.
The creature wanted to fight its opponents face to
face.

Johnnie bashed his knuckles together and let
out a deep moaning howl, "A fight would be the
perfect thing to warm me up!"

The wolf sprinted towards the creature. The black winged beast used its wings like a blade aiming for the wolf's neck. Johnnie ducked the attack and got an uppercut into the monster's chest. The creature staggered and Johnnie launched a jab into the stomach, a left hook into the ribs, elbow to the ribs, and lastly a left jab to the jaw to end his combo. The creature fell into the left side of the bridge and Tiana shot another arrow of lightning, sending the creature spiraling into the cold blue waters.

"For someone who doesn't trust women we make a good team." Tiana said.

"Well it's dead now." Johnnie growled, "I hope Isaac didn't get into any mess. He might be fifteen but he's a fucking child in the head."

"Seems like you and your brother don't get along too well."

"He's not my br-"

"Yeah, The Society already told us the deal with you two." Tiana turned towards the entrance to the fourth floor, "Same person, different dimensions. You two couldn't be anymore different. Shows what an environment can do."

"Hmmm," Johnnie put his arms behind his head and continued to walk forward, "Let's just find the fool before he blows up something."

Chapter 27:
The Fourth Floor is a Monster Boss!!!!!

"So what team do you belong to?" Isaac rapidly asked, "The Crows, The Mads, or The Scrubdogs?!"

Cookie didn't know what to say, but she had to keep this lie going, "I'm part of-"

"Or maybe you are part of a whole new team!"

Cookie rapidly shook her head, "Yeah a new Team" the girl began to scratch her multicolored hair, "It's called the…Candies!"

Isaac eyes grew wide in excitement, "So cool! So what do you guys do weapons, abilities, trademark catchphrases?!"

The questions were too much for Cookie; this guy was obviously deep within The Society of the Unknown. Cookie didn't know how long she could keep the lie up, but if he found out, would she be able to take him? Additionally, a part of her didn't even want to harm the boy, "Look there's a mysterious door!"

The fourth floor was almost like a maze with doors, multiple pathways, monsters, trap rooms, and trick rooms. Cookie was surprised they had walked for a good hour and a half with nothing to delay them, but now she was happy if anything happened.

Isaac looked at the door, it was a contrasting crimson amongst the cold ice walls, and it had a black ring on its center and two black knobs to pull. Isaac eagerly walked up to the door, his mind totally distracted by its wonders.

"You think a boss monster is behind it?" Isaac asked. "Usually in Japanese videogames there

would be a boss monster behind a suspicious door like that.

Cookie shrugged. She didn't know either.

"Well maybe it is?" Isaac said grabbing the knobs, "Maybe this time I'll get the Homunculus Book and Johnnie has to buy me the next volume of my favorite manga "Two Piece.""

Isaac opened the door to see a singular entity. It's skin was blue; its muscles large, even in the darkness of the room Isaac and Cookie could sense the great bloodlust it held. When it stepped into the light the two teenage fighters could make out its details. It looked like a human, but it's muscles seemed too bulky, hair covered it's face, and its teeth were crooked and sharp, in its hand it held a large stone blade.

The creature opened it's mouth, "I.a...m...sword.... of...Enligten...." it's voice was deep yet gurgled, it voice was loud yet unclear. Isaac generated his blades of energy; Cookie flicked her needles into existence between her fingers.

The large misshapen ten-foot human looked at Cookie and shook it's head, it pointed to Isaac and said, "Swordsman...fight...swordsman."

Isaac genuinely smiled, "Why would I have it any other way?"

Chapter 28:
An Ascent of Emotion

The Mad Inventor's guns caused the light blue spiders to become green blood upon the staircase of The Hailing Palace. The Mad Racers bright beams vaporized the small creatures into black smoking dust. The two had quickly found out the staircase leading to the fourth floor was filled with spiders the size of kittens. The creatures released webs of ice and if they pierced the skin they could turn the insides of their victims into cold blue water. Luckily, the Inventor and Racer were equipped with Kevlar armor and their superior weapons.

The Mad Inventor spotted the last of the creatures above Natalia. The small creature leaped from the ceiling and one of the Inventor's remaining legs shot out from its pack, robbing the creature of its sweet victory.

Natalia rewarded the Inventor's deed with a smile. She didn't know how she truly felt about the inspiring inventor but she knew there was a place developing for him, he had saved her countless times today, and on other missions he always kept an eye out for her.

Natalia moved some of her pink hair out of the way, "Who knew there would be so many obstacles?"

She's blushing.

The Mad Inventor kept up his countenance and continued to walk up the steps, "An obstacle is all it is, and such things don't matter when it comes to genius."

You totally ruined it.

Natalia crossed her arms as she followed The Inventor; in the end he was still a prideful man.

"The Enlightenment really crafted the handiwork in this palace." The Inventor noticed, "Tch, Traps, monsters, bridges, and staircases, the book really landed in a labyrinth."

"I guess that would be the best place to hide it."

"Tch, I wouldn't be surprised if we found the book first. We are the smartest."

Natalia slightly smiled.

Chapter 29:
Shawn the Protector!

"I got this shit, elf boy." Juliet said, leaning on Shawn's left side, with her arm around his neck, "I don't need no damn help."

"I refuse to leave a damsel in distress." Shawn responded.

"I ain't a damn damsel." Juliet answered.

"Can't you just except help?" Said Sol, leaning on Shawn's right side, with her arm around his neck, "He's my teammate, he could of just left your ass sleeping."

"And I could have just left you with your sister!" Juliet screamed into Shawn's ear.

"No one asked for your help anyway!" Sol screamed into Shawn's ear.

"You needed my help you useless bitch!"

"Useless! The cathedral that was me!"

"My bitches had to help your sunburn ass."

"Can we have some form of peace?!" Shawn intervened, "I don't truly see the point of being hostile to one another in such delicate times. We have the Homunculus book to worry about assigned by our superiors and the safety of one another."

Juliet and Sol rolled their eyes, glancing opposite ways.

Shawn sighed.

The three crept upon the challenging of the creaky ice bridge. The hail seemed to be heavier than seconds before, causing the sound of the tink noise, and the trio could see a figure floating in the center. It was Luna Pepper.

"The bitch is still tryna fight?" Questioned Juliet.

"Looks like I got to put my sister out." Said Sol.

Juliet snickered, "You haven't even recovered your powers yet, what you going to do give her a pumpkin spice latte?"

Shawn ignored the girl's arguments and carefully put the two girls on the side of the wall.

"Ay, elf boy, yo ass lost too." Juliet reminded.

"Shawn, she's my sister, I got this."

Shawn shook his head, "Both of you are unable to partake in this battle." Shawn laid his hands on his daggers and let out a breath of cold white air, "I will win this battle. I've learned from my last bout."

Shawn walked out onto the coldness of the bridge, Juliet tried to get up but only fell, her chin bashing against the cold icy ground. Sol got to her feet to only to lose feeling and fall on top of Juliet Valentine.

"Bitch!" The two girls yelled.

Chapter 30:
The Woman with Pearls

Joseph Blood made it to the top of the fourth floor, the Black Seinen member found himself in a spherical room, with blue tiles, and ice angels attached to the two hundred foot ceiling. The room was filled with glass windows, letting the agent witness the never-ending hail that surrounded the palace. In the midst of the room stood a mature woman. The woman wore a blue dress with white pearls surrounding her neck, her face looked youthful, but her hair was snow white. The lady was equipped with white high-heels and her lips glimmered pink.

"It took us five hours to find this book." Said the woman, fingering an old worn black notebook, "Originally, The Adversary, the leader of our organization wanted to leave, giving you fools another way to attack. The man, I think he likes the adventure. We The Enlightenment have gone through many worlds, and stolen many dreams." The woman reached behind and unzipped her dress, revealing pale unblemished skin, her breasts small and round, her nipples pointy, and her petite body distracting, "It's time."

The pale lady got onto her hands and knees, her blue eyes stayed on Joseph, and she began to growl. The Lady with Pearls skin began to produce blue veins, her body began to convulse, and foam began to exit from her mouth. Joseph began to back up, feeling an increased need to get away from the situation, but he refused to budge. He was going to end it.

The Lady with Pearls let blue horns pierce from out her forehead, her teeth became dark blue fangs, in height she reached fifteen feet, her skin became covered in blue fur, and her head shifted into the form of a cat. The naked feline woman let out a mighty scream that caused the icy angels to shake in the air. Joseph looked up in pure irritation, why did The Society bring him back to this bullshit?

The Woman looked down at Joseph and the agent could see she held intelligence in those black orbs. The creature raised a mighty claw and curled it up into a fist. The punch came down toward Joseph Blood, he performed a quick dash, and slid among the slick floor. However, in this feline form she was very quick and swirled around to smack Joseph in the back. The man screamed, feeling the dagger like claws tear into his flesh. Joseph spiraled into a wall and the cold air immediately began to sting his wounds. The Speedster forced himself back to his feet, ducking a tail swipe for his head. A massive left fist collided into his body, causing him to slam against the wall and almost lose consciousness. Joseph was down, no matter how fast he was he always lacked defense. The man chuckled, he had got caught in The Society's lies, he had become their bastard once again, and now he was going to die for it. Feline hands reached for Joseph's throat and he closed his eyes.

Chapter 31:
Another duel!

Magenta blades of energy and a sword of stone bashed, causing their owners to stagger back. Isaac swooped under a slash for his head and returned with an upper slash, using both blades. The deformed foe stumbled back, let out a gargle roar and thrust for the boy. Isaac parried with his right blade, strings of magenta energy hit the air, and with his left Isaac stabbed the pathetic creature and caused his imbedded sword to explode. The monster swordsman was shot back, crashing down the hall.

"That's not going to hold him for long," Isaac said, breathing hard, "he's one tough mini boss. Gotta be in the high 30's."

"What are you talking about?" Cookie giggled.

"Fights like these are easier if I relate to videogames!" Isaac shrugged and smiled, "Sorry."

Cookie shook her head, "I find fighting fun as well, it IS all a game!"

Cookie rushed the recovering beast man; it spotted the girl, and raised its blade and let it soar down upon her head. Cookie swirled, the blade nimbly passed her hair and her needles tore into the chimera's ribs. Cookie halted her spin, positioning herself behind the creature and jumped into the air, bashing her feet into the opponent's back. The monster stumbled forward; Cookie landed onto its the shoulders, tightened her legs around the neck, and stabbed all six needles into the creature's throat. Drowning roars spilled from the monster's mouth, as it tried to shake the girl off. Isaac rocketed forward, stabbing his blades into the monster's stomach and

once again an explosion ruptured through the creature's body, tossing it through the air. Cookie unlocked her legs and flipped back, landing next to Isaac True.

"We make a good team Isaac True!" Cookie congratulated him.

"Did he say he was a swordsman?" Isaac questioned.

Cookie shrugged, "Maybe?"

"Hope I didn't explode him to much?" Isaac began to walk down the hall, "Since we defeated him we're probably on the right path."

"You mean like he was a checkpoint?"

"Yeah, in all the great Japanese adventures that's what it suppose to mean." Isaac put his hands in his pocket, let out a big sigh, and began to walk down the hall, "If we run into more we just got to slash harder and quicker!"

"Yeah!" Cookie cheered, "Scary monster creatures can't face The Society of the Unknown!"

Isaac pumped his fist in the air, "Black Shonen!"

Chapter 32:
Battle within the Icy Study!

"How do we know which way to go?"
Johnnie looked around at the various pathways,
"We've been walking for a while now and I feel like
were going nowhere."

"You sound like Juliet." Tiana teased.

"That girl is a massacre of emotions,"
Johnnie rolled his eyes, "She's worse than Isaac, how
do you all deal with her?"

Tiana shrugged, "Once she opens up, you
learn how to handle her."

The two companions took a left.

"This labyrinth is annoying," The Wolf began
to growl.

"We just got to keep our eyes open." Tiana
said, "Look for something different."

Johnnie looked around, the ice walls all
looked the same, the doors all looked they belonged
to a castle, and the floor looked the same. Everything
to Johnnie looked the same; once again he blamed
everything on Isaac.

"Here it is." Tiana stopped on a door to the
left of Johnnie, "You see something different?"

Johnnie glanced at the frozen door, it had a
symbol of an angel on it, and with icy wings spread
wide. Tiana turned the knob, the door refused to
budge. Tiana equipped an arrow and aimed at the
door, she shot and the arrow became strings of fire, it
covered the door and melted away the ice. Johnnie
grabbed the steaming knob, not caring if it burned his
skin, due to his healing ability and opened it.

Johnnie and Tiana walked into a room filled with bookshelves, and the door shut behind them. Tiana went to the knob and found out it was locked.

Johnnie began to examine the books, the literature took to the form of novels with peculiar titles.

"The Wet Wet Monster. The Drowning of Youth, The Frozen Mistress, The Essence of the Beast." Johnnie sighed, "Sounds like something Isaac would read."

The wall to the right of the two opened up and Johnnie could smell the scent of something feral. The young man's bushy wolf tail became stiff, his ears became pointed so he began to growl. Tiana noticed the creature as well, when it crept out, she noticed its large dark blue paws, when its body exited from it's keep, she noticed the lean wolf like body, and its fangs which hung from outside its mouth.

Chapter 33:
The Inventor's Cheat Code

"What is this old cold contraption?" The Mad Inventor complained, "Did they really think they could stop us with something as simple as a labyrinth." The Mad Inventor chuckled, "Do they think I'm some kind of commoner in intellect?"

"Labyrinths are confusing." Natalia said, "It might be old, but it is a good way to stall."

The Mad Inventor shook his head and chuckled, "Nothing is confusing to a man such as me! Just watch."

The Mad Inventor opened his mouth and in disgust Natalia saw a metallic spider the size of a baseball leave the Inventor's orifice. Covered in fluids, It crawled down his body and hurriedly made it's way down the hall and made a left.

"Now we just follow." The Inventor proclaimed, wiping his mouth, "It'll take us the least dangerous route."

Chapter 34:
Shawn Bolt vs. Luna Pepper!

Shawn faced the cold sensation of the hail, the icicles sprinkled throughout his tied locks, his boots splashed against the cold water of the bridge, and The Tailed Elf looked up to feel the stinging winds beat on his face as he looked at the floating Luna Pepper.

Shawn pointed his right dagger at Luna, "Luna, we don't have to fight, I still would rather you come with us, but if you stand in our way of acquiring the artifact, I will have to partake in battle with you."

Luna looked down at the warrior elf and frowned, "You elves believe anything. You all fall for Sol filled with her words, she is a traitor among The Enlightenment, you don't think she will trade on The Society." Luna cocked back her head and laughed as she floated down upon the bridge, "My sister is a master manipulator." Luna's cold pale arms became covered in swords of ice, "Let's end this Shawn, I've always despised you elves."

Luna lunged at Shawn, and came down towards the elf with both blades. Shawn braced himself and crossed his daggers, the weapons hit, cold winds surrounded the two and they broke apart. Luna recovered first, dousing Shawn with swing after swing, Shawn parried and dodged, the ice weapons numbing his bones with each clash, he was still far from fully recovered.

"Got damn that elf!" Juliet swore, grasping to the wall, "Dude is always trying to be a fucking hero."

"Shawn can do it." Sol said, sitting on the ground, "He's physically the toughest on my team. He's brought us through many hardships."

Juliet used her sword as a cane to inch closer to the entrance of the bridge, "He better be cause it looks like your sister is seriously trying to end his ass."

<center>***</center>

Shawn dodged a slice with a backflip, landed on the ground, and jumped off his tippy toes, clashing with Luna. Steel and ice smashed against another, the rings of their weapons beat out amongst the wind. Shawn received a shallow cut to the face and responded with a deep cut into Luna's left shoulder. Luna screamed and Shawn was hit with a cold current of wind, his chest was impacted by a left kick and he stumbled back. Luna went for a finishing blow, a clean swipe to the head; Shawn ducked, parried the incoming next blade and was hit with kick straight into his chin. The elf was attacked with several more cuts that froze into his body. The Tailed Elf dropped his weapons and fell onto the ground with a bang. He had received too much damage; the coldness was numbing him once again. Shawn Bolt had lost.

Chapter 35:
Johnnie True and Tiana Forest!

The creature in its full form resembled a wolf mixed with a lion, it snarled showing shining white fangs, its mane was bushy and long, its tail was thick and filled with muscles, veins bulged throughout its body, and its eyes locked on Johnnie True. The creature let out a roar that signaled the beginning of the battle and lunged for the wolf boy. Johnnie reared back his fist and let it shoot forward, clashing against the creature's lower jaw. The monster still fell upon the werewolf, pinning him to the ground with sharpened claws. Tiana's arrow pierced into its face, taking the form of lightning. The monster fell back with yelps of pain, Johnnie rose to his feet and scored an elbow into the monster's snout, an uppercut into its stomach, and a left jab into the side of its jaw. White fangs spiraled through the air, hitting the shallow water of the library floor.

"This ain't too hard." Johnnie said, bouncing on his feet, his fist in front of his face, "I'm way too quick."

The creature rushed the two, before Tiana and Johnnie's eyes the chimera shifted from a quadrupedd to a biped, and wrapped its massive arms around the werewolf. Johnnie tried to escape the bind, pitting all his strength against the beast, but it was to no avail. The creature proved to be much stronger as it hugged Johnnie close to it's chest, the wolf could hear his own bones breaking, a howl of pain escaped the young wolf's mouth, then an arrow of fire then caused the beast's mane to go aflame. The monster held it's bestial face as it let out wails of pain. Johnnie dropped onto the floor, and Tiana let

out another arrow filled with lightning that pierced the monster's chest.

Johnnie and Tiana watched as the lightning traversed through the creature's body, steam exited from its mouth, it's eyes boiled, and its tongue melted within its mouth shutting it shut. Johnnie rose to his feet, his bones fully melded back together, he let out a howl and sprinted towards the creature, jabbing the beast with his left hook punch. The monster crashed into one of the many bookshelves, and the books created a tomb upon his body.

"I could've handled it." Johnnie said, rolling his arms, "It was somewhat fun."

"Your unbelievable," Tiana walked to the tomb of books, "You're definitely worse than Juliet. Does it kill you that much that a woman helped you?"

"Like I said," Johnnie, said, heading through the entry way of the beast, "In my world you died from too much trust in a woman."

Chapter 36:
Cookie's Situation!

Cookie didn't know how she was going to get out of this situation? One minute she was by herself testing the strength of the beasts within the palace, but now she was traveling with a member of the Society of the Unknown, her enemy! At least he was cute, but still what could happen when he met up with his friends, they would definitely know she wasn't a member. Could she take on all those members at once?! It could be an interesting fight, but how would Isaac think of her and why did she care?! Sure he was a good fighter, but something about him saving her gained her attraction and she didn't know why?

"Hey!" Isaac said, as the two trekked through the ice labyrinth, "Your really strong, how come I don't see you with Juliet and her gang. You should be a Crow!"

"I like solo work." Cookie lied, "Being by myself I don't have to worry about other people and everything is on me. It's easier that way."

"Hm." Isaac pondered, "I think I like being on a team more, all the different abilities and personalities, it's really fun to be with people."

Isaac had a good attitude, something The Enlightenment was missing with it's male counterparts, "You like being with people?"

"Yeah, I'm usually teamed up with my twin, but we got separated." Isaac put his hands behind his head, "I'm sure I'll find him somewhere around this place."

Cookie knew she was getting to deep in her lies, if they ran into Isaac's brother it would be over.

He would probably be able to tell she wasn't part of the team and then she would have to fight. She would fight the twin, not Isaac. Isaac was a cool guy in Cookie's eyes.

The two passed a corner and came into a fork in the labyrinth, Cookie found her way of escape, "How about we separate?"

Isaac turned to face the young woman, his eyes resembling a puppy that had just been abandoned, "Should we really?"

For the first time feelings tugged at Cookie's heart, she felt hot, nervous, and for some reason she wanted to hug this young man, but why?"

Cookie couldn't look directly at Isaac, it was to much, "Um…. because…I…I…I…I-"

The floor fell from out of Cookie's feet, Isaac saw her face full of surprise as she tried to reach out. The young swordsman tried to grab The Enlightenment member but his hands barely touched her fingers before she fell into a void on the floor. Isaac didn't hesitate to jump after her, and the floor froze above him.

Chapter 37:
Joseph's Defeat!

Joseph hit the floor covered in blood; the woman was far too strong for him. The Black Seinen member watched as the monster before him changed back into an attractive older woman. She was naked, her breasts perfect baseballs upon her chest, her body pale, untouched, even at the head of death his lower parts still yearned for the woman's touch and Joseph hated himself for it. The man harnessed his anger and pulled himself up to his feet. He could feel a burning sensation within his body, his chest heaved with pain, his hands were going numb, and blotches of black covered his vision. The naked older woman laid a hand on Joseph's face.

"Poor man." She said, "You could have been a large help to The Enlightenment, so strong, so fast."

The older lady kissed Joseph, she forced her tongue into his abused mouth and swished around in there, smoothing his gums, tangling with the tongue, her hands opened his Kevlar armor and searched his bruised chest. Joseph fell into lust, grabbing the woman's soft and fluffy bottom. The woman broke from the intimate moment and Joseph was a statue of ice.

Chapter 38:
The Inventors!

The Mad Inventor and The Mad Racer looked upon the large steel door covered in ice. The Mad Inventor pulled out one of his plasma guns and shot several times into the icy boulder. The ice easily melted giving the two a path to their next destination.

"As people of academia we need to be prepared," The Inventor deviously chuckled, "Let's retrieve this book."

The Mad Inventor pushed the doors open, revealing a room in the shape of a perfect circle, the floor was decorated with dark blue and light blue tiles, the ceiling was decorated with angels. The walls had large windows, revealing the never ending hail that poured form the gray skies, and in the midst of the room was a naked gray haired woman. She was staring at a statue that resembled Joseph Blood.

The Mad Inventor, a man of logic and technology easily put two together and grabbed his plasma pistols, "Aim for the woman."

The Mad Inventor started the assault, releasing plasma bullet after bullet at the woman, the older woman leaped to the left, and took to her bestial form.

"Que ha borrado." Natalia said, at the sudden transformation.

In her cat like form the woman took to all fours and made a beeline for Natalia Espada. The Mad Racer shook her arms and her metallic bracelets immediately shifted into her pink mini dual cannons. The Young woman bent her knees and aimed her weapons at the incoming beast. Natalia let out a scream and her cannons fired. The cat beast leaped

over the attack, twisting her body in the air and landed on her feet, to only be barraged by the Inventor's plasma fire. The woman beast took the damage and leaped again, she landed, a paw pinned the Inventor onto the ground, but the madman released his spider blades. Due to The Inventor's nanotechnology, the two broken blades had been restored and he was back to full form. The four lean swords pierced the paw of the she-beast and the animal let out a female scream. A large blast of pink energy crammed into the opponents left side, sending her cratering into a nearby wall.

"I got you Chico." Natalia said to The Inventor.

The Mad Inventor rose with a nod, "I did right to choose you, our weapons compliment each other."

Natalia couldn't help but let out a genuine smile.

The cat she-beast tore herself from out the corner, stretching her body and letting out another eerie roar that held the presence of a woman's scream.

The Mad Inventor pointed his pistols toward the woman, "We don't need the others, I'm sure we can handle such a simple challenge of a creature."

Natalia stood by the Inventor, she felt safe next to the Mad Man, and with him she knew they were unstoppable.

Chapter 39:
Rematch:
Sol Pepper vs. Luna Pepper

"Ah, shit." Juliet said, "Elf boy just went down."

"Shawn, never." Sol said, "He would never lose."

"I ain't got to lie bitch," Juliet said, trying to steady herself with her blade penetrated into the frozen ground, "Don't worry, I'll finish Ice Ho."

Sol's veins began to glow orange as she raised her self from the ground, "She's my sister, I'll defeat Ice Ho."

"You can barely walk." Juliet snapped back.

Sol smirked, "My fire will warm me up." Sol painfully began to walk outside to the bridge, her legs began to sting with life, her fingers were starting to gain movement back and her hair was starting to get wet. When she reached outside steam began to flow from her body.

Luna Pepper watched as her sister weakly came upon the bridge. Sol could hardly stand up. When Sol passed Shawn, Luna could see a vague form of irritation possess her sister's eyes."

"I'm far stronger than you, sister." Luna said.

Sol's hands doused themselves in fire, Sol's boots began to spark with flame, and the girl leaped. Luna made one of her icy blades and the two clashed. Fire and Ice met in mid air, the two elements swirled around the sisters and exploded, causing them to crash into the base of the bridge. The two immediately rose and rushed each other. Sol ducked an icy swipe for her head, and performed a right sidekick into her sister's stomach, followed by an

explosion of fire. Luna staggered back to only let out her famous ice scream. Sol screamed and released a small explosion of fire, canceling out Luna's attack.

Sol summoned another boost from her boots and got a clean fiery roundhouse kick into her sister's jaw. Luna didn't move, her anger kept her steady and a left swipe dove for Sol's head. Sol ducked the attack and swung a fiery uppercut into Luna's jaw. This time the woman did fall back and Sol got an extra fiery hook into her sister ribs. Luna reacted and swiped her right blade against her sister's skin. A cut of ice began to form on Sol, but she ignored it. Sol jumped back from a slice for her stomach and sent a fiery jab into her sister's gut.

"I was always stronger Luna." Sol boasted, "Chad might have liked you more but we both know I was always the stronger one!"

"Stronger!" Luna said, holding her stomach, misty drool seeping from her mouth, "Stronger! I was stronger! Caused I love Chad! That makes me stronger!"

Chapter 40:
The Wolf Strikes!

"Hey, Wolf." Tiana said, feeling around in the darkness of the open passage, "Can I use your shoulder, you know, since you can see and all?"

Johnnie rolled his eyes, "Sure."

"So you trust me?" Tiana said with a tease.

Johnnie could feel the girl's hand tighten on his shoulder, "Why do you care?" "Your interesting Johnnie."

"And you're a nuisance."

"It's not my fault you can't get over your weird hatred of women."

"Its more than that."

"Is it re-"

Johnnie True and Tiana Forest were hit with the unusual high screeching roars of a mighty beast. The passageway began to give off a white light, and an extreme cold wind. The two continued to walk into the brightness, and came upon a room in the shape of a circle, blue tiles covered the ground, angel sculptures hung in the sky, and a mighty cat beast battled The Mad Inventor and The Mad Racer.

Johnnie was confused by the scene, but could slowly piece everything together. Maybe, The Inventor and Racer had already found the book and this monster was the obstacle in their way, but where was Isaac if the book was here? Did he get trapped by some other member of The Enlightenment, or is he?

"I'm going back." Johnnie said to Tiana.

"What?" Tiana strike back, "I understand the Inventor is an asshole, but we shouldn't let him die, plus Natalia is here too."

Johnnie growled, "None of it matters! I thought Isaac was here but he's still lost! That dumbass is prolly somewhere dead, and now I got to go save him."

Tiana smirked, "You pretend to hate Isaac but you always worry about him." Tiana shook her head in disappointment, "I've never met someone so opposed to his feelings, and it's not healthy."

"You know nothing about me!" Johnnie yelled, bearing his fangs.

"Maybe you should open up more!" Tiana screamed back.

Before the two could continue screaming out their emotions, the ground began to shake under their feet. Jonnie and Tiana turned to face the mighty cat beast, sprinting at them on all four feet.

Chapter 41:
Cookie and Isaac Slide into The Fight

"Weeeeeeeeeeehawwwwww!" Cookie screamed, sliding down a tube of misty ice, "This is the greatest!"

"Cookieeeeeeeeeeeee!" Isaac screamed, sliding down the tube on his stomach, "Is this the way to the boss?"

Cookie in the midst of the craziness shrugged her shoulders, "I'll guess we'll see!"

The cold wind passed by the two's faces, tears streamed from their eyes, their mouths rippled with the pressure, the walls became icy blue and they were hit with a bright light. They slid into a room in the shape of a sphere, with blue tiles under their feet, and angels hanging on the wall. Before realizing where they had landed, a scream of a roar bounced off the walls.

"Isaac!" Johnnie True said, sidestepping a claw, "Get your ass over here and help!"

Chapter 42:
Who will win?

"Chad?" Sol spat a steaming lugie, "I doubt an insidious love like his can make anyone stronger."

Luna shook her head with a trembling smile, "Chad is who I am." Along with her arms she began to cover her legs and feet in ice, forming them into sharpened icy points.

Sol growled, hot smoke left her mouth, "Chad even in his death still got you still fucked up."

"He's not dead," Luna cried, "He's not dead!"

Luna came for her sister, spinning with her icicle blades out, soon becoming a tornado of cold blades. Sol let fire boom from her shoes and connected with a knee to the face, interrupting Luna's attack. Sol continued her assault with a fiery punch to the stomach, a right jab into the ribs, and a fiery roundhouse to the cheek. Luna twirled, hitting the hard surface of the bridge.

"We don't have to do this." Sol gave out a hand to her sister, "Come on, and let's end this. I'm pretty sure The Society will still accept you. The Scrub-Dogs miss you."

Luna's face scrunched up at the word Scrub-Dogs, "You really put your trust in those idiots."

Sol rolled her eyes, "What do you have against them?"

"You changed once you met them." Luna said, "You're pulling away."

Sol sighed, "They made me better."

"They made you weak."

Sol put her hands on her hips, "What do you want me to do Luna, what can I do?"

Luna smiled with tears in her eyes.

Sol was hit with a whirlwind of icy snow, once again she could feel ice seep into her veins, she could feel her body become rigid, she could feel her lungs slow down, but she summoned her fire. Orange flames released from Sol's body, melting the vengeful ice and restoring her to full power. With a scream, Sol exploded out of the icy trap, and landed an explosion of flame into her sister's jaw. Luna twirled through the air, hitting the frozen ground face first, and falling into the land of darkness.

Sol turned around, Luna was not her sister anymore. It was time to warm up Shawn and get Juliet. Sol was prepared to get to the Homunculus book immediately.

Chapter 43:
An All out Attack

Johnnie's right fist clashed with the mighty left claw of the cat beast, the ice splintered under them, the cold angels attached to the walls swayed, and bones broke. Johnnie and the beast staggered back to only punch again with the opposite fist. Ice cracked under feet, the thirteen-foot cat beast smiled as she saw Johnnie howl in pain, step back, and both his arms go limp. A bolt of lightning crashed into the animal's eye, plasma bullets rained on her chest. Isaac and Cookie ran between the beast's legs, slashing with thier weapons at her tendons. The monster roared as it almost fell over, blood leaking from her eyes and feet as she turned around to face the retreating Cookie Dough Cream.

"Cookie!" The beast growled, "Traitor!"

"Cookie?" Tiana said in confusion.

"Isaac!" Johnnie said, pointing with his semi healed right arm, "Who's that girl next to you?"

Isaac flashed his classic smile, "This is my new friend! She helped me."

Johnnie slapped his hand on his face, "That's the traitor! Where did you find her?"

Isaac scratched his head, "But how?"

"Of course the boy accidentally teams up with the villain." The Mad Inventor said to The Racer.

"Can't blame him, the chica is pretty." Natalia stated.

"Tch, Hormones." The Mad Inventor responded.

The Cat Beast raised her left claw above Cookie Dough Cream, "Do you think you'll survive young lady?"

Cookie looked up to see the claw overshadow her, "Awwwwww, are you going to miss me?"

The Claw began to fall, Cookie's hands twitched, ready to slice the furry beast apart, but Isaac True jumped in front of her, "Don't worry buddy, I got this!"

Isaac grabbed his left wrist with his right hand and pointed it at the incoming claw, "Magenta Burst!"

A wild blast of bright lightning and fire exploded from Isaac's open palm, obliterating the deadly claw into burning ashes.

The entire limb of the creature was gone. The monster wailed, as it's left stump steamed magenta. It looked at the crowd of fighters in pain and agony and stomped it's healthy limbs. Icicles formed from out of the ground, creating two towers and entrapping the Black Shonen agents within.

Chapter 44:
The Rocking Labyrinth

Juliet Valentine and Shawn Bolt had an arm each wrapped around Sol Pepper's shoulders, trudging through the labyrinth. Sol using all her strength pushed forward, knowing Juliet and Shawn were counting on her, this was her time to prove herself.

"Looks like your sister was a real bitch." Juliet said, wincing from her overused muscles.

"My sister is a follower." Sol said, "Always has been."

"One day," Shawn said, looking forward, "One day, we will rescue her."

Sol shook her head, "Doubt it, Luna is fully aware of what she is doing."

"She is your sister." Shawn said.

"And she is an enemy." Sol said, "My enemy."

Juliet nodded, "Looks like you're not just a useless Ginger."

Sol smiled, "And you're not just an angry bitch."

Juliet let out hearty laugh, "I am an angry bitch."

The ceilings of the labyrinth began to spill with hail; the grounds under them began to shake and rattle, and the labyrinth made a tilt.

Sol began to lose her footing, causing the other two to fall with her.

"Sol, you better catch my black ass." Juliet said, slipping from the redhead's grip.

Shawn tripped, falling upon his face and sliding away from the girls.

"Got dammit." Sol screamed.

The redhead tried to reach for her companion, only for her to slip, and the back of her head to hit the icy bottom. The Labyrinth shook and tilted again, causing the three to slide, crashing against walls, spinning against the slippery floor and finally sliding into a gate filled with light and the sound of roars and screams.

Chapter 45:
The Ice Trap

Johnnie True punched the ice wall and it barely cracked against his fist, a second punch provided the same result and a third effort just frustrated the wolf.

"Maybe you should scream louder." Cookie joked.

"You think I should blast it." Isaac said.

"Probably be better than a punch." Tiana pointed out.

"How about all three of you shut up!" Johnnie roared, "I'm the only one actually trying to break out this trap, you three just sit here and ridicule me!" Johnnie pointed to Cookie, "And she's a traitor!"

"Johnnie, that is your name?" Cookie said, "Is this really about me or your insecurity about not breaking us out?"

Isaac and Tiana looked at Cookie, then Johnnie, and nodded their heads.

"What?" Johnnie said, "It's obvious you're a traitor!"

"But Johnnie," Isaac chimed in, "Sol was a traitor too and The Society trusts her."

"Cookie just traded!" Johnnie argued.

Cookie looked at Tiana and Isaac shrug, and turned to smile at Johnnie, "I'm with you guys, no trade backs."

"See Johnnie, she said no trade backs." Isaac said.

Tiana nodded, "She did say no trade backs."

Johnnie highly annoyed turned around from his companions and proceeded to continue punching the wall.

<center>***</center>

The Mad Inventor shot plasma bullet after plasma bullet into their icy cage, while his spider legs carved into the wall.

"Maybe I should use a cannon blast?" Natalia suggested.

The Mad Inventor shook his head, "We need your power for when we run into that blue beast again, my plan should suffice."

"Gracias." Natalia said.

The Mad Inventor made a frown, "For what? You have put equal contribution into this mission, the others distracted us and that is the only reason we were caught. If it was just me and you I'm sure we would have found a way to get the book and defeat this idiotic beast."

"Why do you have so much faith in me?" Natalia questioned.

The Inventor shook his head, "You're an Inventor like myself. I don't find too many people to be compatible with, out of all the members you're the least annoying."

<center>***</center>

Juliet Valentine was the first one out of her group to slide into the sphere room. The young swordswoman looked up to see the two cages of ice and the thirteen-foot cat beast that stalked the room. Juliet weak and exhausted got to her feet, easily able to read the situation.

"Hey, cat ho!" Juliet unleashed her blade, almost falling over from her numb arms, "Come face a real bitch!"

Chapter 46:
Juliet and the Beast

The Former "Lady in Pearls" in her cat form turned toward Juliet Valentine. The young swordswoman was sweating, her arms sore and numb, her body yearning for a rest. The monster stomped toward her, her giant feet sending cracks throughout the floor, her breath deep and producing large puffs of white, and her mouth opened showing fanged teeth. Juliet noticed the slash marks at the cat woman's tendons, obviously whoever did it before wasn't paying attention, but Juliet knew she could make it work.

The cat beast made a sprint to Juliet, running on all four legs. Juliet took a deep breath, sheathed her sword and ran towards the monster. The beast opened its mouth. Juliet smiled and fell into a slide. The beast made a dive for the girl, with fangs wide open. Juliet unsheathed her blade and bashed it into the monster's mouth, the creature's head flung to the side and blood spilled from the wound. The Swordswoman moved her blade in wild circles as she continued to slide, fully cutting the tendons of each leg.

Once Juliet was out from under the beast, she struggled to get to her feet, "Ha, take that you ho! Juliet always wins!"

The cat beast fell onto the ground, and blood seeped from its legs. Juliet made her way over to the face of her opponent, the monster's eyes looked as if they were about to close, this was followed by soft whines.

Juliet chuckled, "My ass might have been late, but I always make a goddamn good entrance."

The young woman looked around to see two towers of ice; one of them exploded with a beam of magenta energy and Juliet was fully aware who was the source.

"The True Twins." She muttered to herself.

"Hey it's Julie!" Isaac said, escaping from the icy prison, "Hey Julie!"

Johnnie came out next, "Looks like your fearless leader is here."

"Shut up," Tiana said, "don't act like you don't like her."

Johnnie chuckled at the thought, "You're far off with that one."

"I'm Cookie." Said the pigtailed girl, introducing herself to The Swordswoman, "I just felt like joining today!"

"Your not part of our group!" Johnnie yelled.

"But why?" Isaac protested, "She helped me and she dresses cool."

Cookie smiled.

"That has nothing to do with the situation Isaac, she's the enemy!" Johnnie argued.

"You got to learn to forgive." Isaac said.

Cookie and Tiana nodded.

Johnnie grumbled, "Juliet will you help me?"

Juliet looked the girl up and down, "She's cool."

Johnnie crossed his arms, "I'm surrounded by nonsense."

The second Ice cage received a melted hole, soon The Mad Inventor and Mad Racer came through.

"Well, the beast was defeated and looks who stands proud." The Mad Inventor said, with his arms

behind his back, "Given enough time me and Natalia could produce the same results."

Laying it on thick.

The Mad Inventor sneered, "Now we just have to check the body for the book."

"Found it!" Cookie said, pulling it out of the embedded fur of the creature.

Screams entered the room as Shawn and Sol slid in, stopping right next to the group.

"More party members!" Isaac screamed.

Sol with the help of Shawn Bolt got to her feet, her legs felt numb, the world felt like it was spinning, but she pushed herself away from the elf to stand on her own.

Sol's hands became infused with fire, "Where's the bad guys! So I can burn them to a crisp!"

"They're already defeated!" Isaac screamed back.

"You mean it's defeated." Johnnie said, "It was only one monster."

"We miss the big battle." Sol said with disappointment, her fireballs becoming black smoke.

"Yeah, yeah you did." Juliet gloated, "And I killed the monster, easily too."

"After we wore it down." The Inventor said.

"Yeah, Chica." Natalia added.

Juliet shrugged, "I got the winning hit, I won."

"That is how they count it in videogames." Isaac recalled.

"This isn't a game." Johnnie said.

"It is now." Juliet said. "It's a game and I won, I'm the best."

"Does this mean I get to join?" Cookie said, handing Juliet the book.

"Of course." Juliet said.

"But she's the enemy!" Johnnie added.

"Was." Juliet said, "Now she's with us."

Sol pepper recognized the girl, "Aren't you that Cookie girl The General always had at his side?"

Cookie shook her head, "That was my sister, and I don't too much like The General."

Sol nodded, "Yeah, sisters seem to like the creepy dudes."

However, the contributions of Cookie didn't last long, The Cat beast had a healing factor and as the teenagers argued over the spoils, the beast got to her feet. The young agents saw the shadow cover them, they turned around to see the huge creature let out a scream, the sound reverberated through the agents bodies, causing them to vomit, their eyes to bleed, and finally they all passed out.

Chapter: 47
The Adversary

A wind rattled through the fourth floor of the Hailing Palace, it flew between the bodies of laid out youth, caught in their own darkness, it circled through the gray hair of The Lady with Pearls, and caused her eyes to flicker. The wind circled within itself, churning and mixing, becoming visible, taking the form of a man. The person wore an outfit of fitted white cloth pants, white combat boots, and a hooded white trench coat, which hid his face.

He smiled as he looked at the defeated Black Shonen and carefully tread between the teenagers to pick up his comrade, The Lady with Pearls. The man held her close, her head leaning on his chest.

"Looks like you did quite a job." The man said, as the woman began to become transparent as the air, "You did more than enough today, go back to the base and heal."

The woman's body vanished.

The man gave a genuine smirk, "Almost forgot the book."

Once again, the man made his way into the mass of youth and found the book on the ground next to a young girl, who was equipped with a large jagged blade. He quickly acquired the artifact and made his way out of the pile to look at the mischievous teenagers. They had caused this man so much trouble, and he wanted to burn their images in his head. The man's eyes looked away to the Homunculus book, the leather bound worn out notebook was the center of all this trouble. His organization traveled through many worlds, hoarding inventions, trying to gain some sort of power to fill

their own insecurities and it brought them here, to battle with a group of teenagers who proved to be more opposition than any other group before them.

The man thought about killing the young fighters right here, but then who would chase him? Who would keep his blood boiling, keeping him sharp on his toes. Killing these kids was such a waste, and they drove the man to do better. They were a necessity!

"Give…m…me…"

The man turned around to see a youth with dreadlocks and burning yellow eyes, the man smiled, "Your always following me, aren't you Isaac?"

The Dreadlock boy got to his feet but almost fell over, he caught himself and rose up, with blood streaking from his eyes and flowing over his face, "My name is Johnnie True and you're the man who killed my father!"

Chapter 48:
The Battle of Truth

Johnnie True's knees felt wobbly, his arms pulsated with pain, his head felt heavy, he could feel vomit forming in his stomach, and his mouth tasted like metal.

"You're the man who killed my father," Johnnie eyes shifted into their burning yellow, "and...now I'm going to sink my teeth in," Johnnie flexed his claws, "to tear through you!"

The man smirked, "No matter where I go," The man shook his head with a growing smile, "I always run into you, Isaac, Isaiah, Jonathon, Sam, a different name but always the same face. Who are you?"

Johnnie smiled a mouthful of fangs, "I'm the Blackwolf!"

Johnnie used the last of his energy and sprinted toward the murderer, the man let the wind guide him, he easily moved to the side, and twirled his right hand. Johnnie felt a force bang into his chest and crashed onto his hands and knees, near the man's feet.

"And you always fall for the same tricks." The man said.

"Owchies." A young swordsman rose from the pile of teenagers, "Johnnie, why are my eyes leaking Kool-Aid?"

"Two of them!" The Man said in fascination.

Isaac saw Johnnie on the floor and immediately went into action, ignoring the rising pain in his body, "You touch my bro, and now the Magenta Swordsman has come to play!"

Isaac conjured his magenta blades and pointed one of them toward the mysterious man, "Your're about to face an Isaac True Assault!"

"Isaac!" The Man said. "I've heard that name the most."

Isaac smiled, "My name is pretty cool, there's probably thousands of people that want it."

The man motioned Isaac with his hands to attack and Isaac fell for the taunt. The young swordsman rocketed himself toward The leader of the Enlightenment, but he side stepped from Isaac's downward strike, and the boy's blade ate through the hard ice.

"You are very powerful." The man noticed, "More powerful than others I've ran into, well there was that prince."

"Isaac." Johnnie grumbled, "It's my fight."

"You can't even get up." The man stated, "Leave this to the real warriors."

Isaac pointed one of his swords towards the man and released a wild magenta beam, the man vanished, the beam crashed into a wall, and created a storm of ice."

"You twins are quite interesting." Said the man, reappearing in mid-air.

"It's the True Twins." Isaac said, his firing blade vanishing in his hand, "Aw stuffmuffins, I'm all out of superpowers."

"See Isaac." Johnnie said, standing erect with pain, "You can't just go using your powers all crazy, now look your completely wiped."

Isaac grimaced, "Guess I got to go in this battle with no MP!"

The man opened his right hand and The True Twins were hit with an explosion of wind, bringing them back to the floor.

"If you two want to learn the truth of your situation meet me on the fifth floor." And The Adversary vanished.

Chapter 49:
The True Twins journey to the Fifth Floor

Using superior willpower, the True Twins limped their way up to the fifth floor. The words of the menacing man echoing in their heads. If they wanted the answer to everything he would have it. Johnnie True was the more frustrated, he recognized the scent, this was The Adversary, the man who killed his father and changed his world forever. Johnnie growled as he thought about his recent loss, what was he going to do when he reached the floor? The Wolf knew he was in a bind but he kept climbing up the stairs.

"Isaac don't interfere when we get to the top."

Isaac was offended, "I'm totally going to help you, and you can hardly walk."

Johnnie shook his head, "This is my fight, and he killed my father."

"He was my father too, just from another dimension!" Isaac argued.

"You got to stop." Johnnie said, "Everything is not a game."

"I know." Isaac responded, "That's why we got to kick butt together."

Johnnie let out a sigh of cold breath, "You're such a child."

"The Imagination of a child is pure, Johnnie-san."

Johnnie shook his head, "I hate you."

"You love me Johnnie-san."

The Adversary looked out of a window of the Hailing Palace, he watched the ice bang upon the

architecture, bouncing off into the water. The Adversary witnessed a travel; it was an adventure for the ice. The Adversary wondered where would he be when his adventure ended. He began to reminiscence on the beginning, The Enlightenment, when he first discovered the ability to travel through worlds, when his love for adventure began to blossom. The Enlightenment was originally an organization that simply wanted to travel through the worlds and experience it. To understand there was more than just the eye could see, alternate realties, other dimensions, other planets, other galaxies, other universes, there was so much to explore. For some reason The Enlightenment had mutated and twisted itself into something horrid and unrecognizable. However, The Adversary didn't mind too much as for what The Enlightenment became, it still allowed him to travel and experience the wonder of other worlds, and that's simply all he wanted.

The Adversary turned around thanks to the warning in the wind; he saw the True Twins and smiled.

Chapter 50:
The Truth of Everything

"You boys made it." The Adversary said, "I did not doubt you."

Johnnie True could feel his body trying to heal, bones mending back in place, soreness dissipating, and with every second passing he could feel more strength pouring into his body. Would it to be smart to attack this man again? The Wolf didn't care. Johnnie sprinted again, The Adversary opened his hand, and a concentrated ball of wind crashed straight into Johnnie's stomach, the boy staggered back, blood seeping from his fangs.

"You are just like an animal." The Adversary teased, "No matter how much I beat you, you just keep using the same tactics."

"That's why we have new tactics!" said the voice of Isaac True.

Isaac was above The Adversary, his magenta blades shining in his hands. The boy swiped his swords downwards and an explosion came next.

"Are you okay?" Isaac said, helping his brother to his feet.

"Did you get him?" Johnnie asked.

The Twins looked as the magenta and ice dust cleared. In the center stood the Adversary, parts of his clothes were completely vaporized and the remaining tatters smoked magenta, his crumbling hood revealed a tan face, with emerald eyes, and a taunting smile.

"I've never felt such rage." The Adversary said, "but you're an Isaac, I shouldn't be surprised."

"How do you know us?" Isaac asked.

"Circumstances." The Adversary said, "You, The dreadlock boy, I've encountered many other versions of you all of which have tried to stop my plans." The Adversary shrugged, "Most have just been a nail in the cog, but the locks and you have been a constant thorn, stopping my adventure, and halting my progress. It's amazing to have rivals." A thought came to the Adversary and his eyes fell on Johnnie, "Your father was also a hard one to kill."

Johnnie rushed at the Adversary with an uppercut, but the man let the wind tilt him back and the punch barely grazed his chin. The Adversary swirled with a roundhouse kick into Johnnie's ribs, and another sidekick in the face sent Johnnie crashing onto his back.

"Stay down wolf boy." The Adversary taunted, "The sidekicks should stay back while the heroes and villains come to play."

"Johnnie-san is a hero!" Isaac screamed.

The Swordsman reformed his blades, the boy knew his energy was low, bruises and cuts ran rampant throughout his body, he could feel warm blood traveling down his left arm within his armor, and he could feel his heart beat with fear and excitement. Isaac bent his legs and magenta electricity and fire spiraled around his body. The Swordsman flashed his good luck smile and blasted towards his opponent.

Chapter 51:
Isaac's Fight

Isaac's magenta blade went for a horizontal slash to The Adversary's midsection, but the opponent shifted into wind. Isaac performed a slash to the shoulder but the attack passed through the enemy. The boy's growing frustration resulted in a frenzy of slashes, his magenta blades sizzling away with every stroke, fire and lightning blazing away with every attack, with The Adversary using the wind to roll, spin, and phase out of the way. A front kick wrapped in wind hit Isaac in the chest, the boy stumbled back, feeling vomit rise to his mouth, a roundhouse kick hit his jaw and Isaac spun, hitting the ice face first.

Johnnie replied with a right jab to the jaw, The Adversary spun with a low kick tripping the wolf, and before Johnnie could hit the ground a second kick straight into his stomach finished a 1-2 combo.

"Are you done boys?" The Adversary watched as the two struggled to their feet, "This has been one of the most entertaining days of my thirty years of existence. The final battle will be the climax of this long running war between our two factions."

Wind began to surround the man as his eyes stayed on the True Twins, with another hearty laugh the air absorbed The Adversary and he was gone.

"Where in the double fuck is he?!" Juliet Valentine screamed, entering the fifth floor "I heard that nigga talk his shit! Where is he?!!!!!!!!!!!!!"

The True twins were sitting down, their energy spent, their pride tarnished, and their dreams eradicated.

"He's gone." Johnnie eyes stared at his reflection into the icy floor, "He beat us both."

"Of course he whooped you niggas." Juliet said, "I wasn't here."

Isaac lay on his back, wincing from the pain, "Cold part we tried everything, that guy was really good."

"It was like he was aware of our attacks at all times." Johnnie added with a snarl, "It frustrates me how useless we were."

Juliet could see the Twins were down, their eyes were cast towards to the ground and they didn't seem their usual selves, but Juliet didn't know how to comfort people, especially boys, "Well, we can't all be The Crows, let's just head home, we just got to whoop The Enlightenment, that's all."

A peach colored portal appeared in front of the three and two beings appeared from out the vortex. One was a man in a trench coat, with a flat top and thick silver-rimed glasses, his name was Jeremy Whizz. The second was a much larger man, he sported a perfectly round afro, with brimming muscles and a white lab coat with the sleeves torn off. This man was known as Tyrone Steel.

The Two men looked around.

"Where are the others?" said Jeremy.

Juliet crossed her arms, "Downstairs, everyone got pretty thrashed, where were you two niggas?"

"I have no need to answer a child." Said Jeremy, "Tyrone please receive the others."

Tyrone grunted and followed orders.

Juliet watched as he passed and completely ignored her, this is why she hated Black Seinen they treated everyone else like invalids.

Jeremy Whizz took one more look around and sighed, "Come Juliet, gather the boys, we have a debriefing on your performance and what we must do to conquer The Enlightenment."

Epilogue

Juliet Valentine hit the white floor, covered in a clear liquid. People in black lab coats quickly covered her in white towels, drying her off, and then they proceeded to clothe her in a white shirt and shorts. They got the young woman to her feet and walked her down a black hallway, the floor was cold, but the clothes seemed to emit a heat that soothed Juliet. Juliet tried to look at the people but their lab coats had hoods, covering their faces. The young girl also felt light headed, almost happy. They turned a corner, opened a door, and Juliet was in an all white room.

The young woman instantly recognized the people sitting on the floor; it was the True Twins, Tiana Forest, Shawn Bolt, Sol Pepper, The Mad Inventor, and Natalia Espada. Suddenly, Juliet's head began to clear up, and she remembered they had lost. Juliet's regular personality began to set in and her happiness began to fade. People guided her into the room and sat her down next to Tiana. There were several adults dressed in lab white coats in front of the youthful agents, and one man in a black tuxedo.

The names began to flow back into Juliet's mind. The bald old intimidating man was Johnnie Senior. He specialized in botany, especially marijuana. The old man looked at the youth in disappointment, rubbing his head and scratching his beard, his dark eyes focusing on his twin sons. The younger man next to Johnnie was Jeremy Whizz, a member of Black Seinen that had returned to the Society of the Unknown a few years back to train Black Shonen. The man fiddled with his glasses while smirking. The Next man was Tyrone Steel, a

tall, large muscle bound man whose lab coat was ripped at the seams. He had his arms crossed and stared at Isaac who was trying to make him blink. Last was Ronald Donald, the man in the tuxedo, The Coordinator of the Black Shonen Generation of Society's Agents.

Ronald, The young bald man wiped his shining head of sweat as he stepped up, "Today has been rough hasn't it?"

"Stop being soft on these fuckin kids," interrupted Johnnie Senior, "were in deep shit."

"They were trained, yet they failed." Jeremy said simply, "Even with Joseph on their side."

"Is he still in the healing pod?" Tyrone asked. Jeremy nodded.

"I thought we won?" Sol said.

"You motherfuckers let ya guard down." Johnnie Senior said angrily, "Jezzers, get me out of this shit." The old man took out a joint and lit it with his lighter, "I'm too old for this shit, I keep telling you people!"

"But dad we tried." Isaac whined.

"Ya ain't supposed to be trying shit, Eyes." The old man roared, taking a deep inhale of his joint and letting it smoothly leave his nostrils "Ya suppose to be normal boys and be at school flirting with girls and trying to get pussy, not this shit."

"But dad! Adventure!" Isaac complained.

"Shut up!" Both the Johnnies yelled.

Isaac sighed and looked down to the ground.

"So what is the next strategy?" Asked The Mad Inventor, "Obviously, we can't stay here wallowing in past failures and regressions."

Ronald nodded, "That just what I…. I…. I. Was… about to get too." Ronald told himself to keep

it together, "We will infiltrate The Enlightenment Headquarters. Sol use to be a member, she's knows the coordinates and the layout." Ronald smiled, "We recently acquired another member of The Enlightenment, she's getting used to her room."

"Each Black Shonen Team will infiltrate a floor of the Enlightenment, there's five in all." Added Jeremy, "Each floor has a blocker, preventing us to create portals within the building."

"The top Floor will hold The Adversary, and most likely the books." Tyrone Steel said, "That's when us members of Black Seinen should have access using the portals, we'll charge in and defeat The Adversary."

"Hold the fuck on." Juliet said, raising her hand, "Us Shonen members are doing all the dirty work while Seinen gets to take all the glory."

"It's not about that." Ronald said, "It's about both teams working together to complete a goal."

Juliet crossed her arms, and locked her eyes with the adults, "Sounds like bullshit."

"Why would we trust you, Shonen?" Said Jeremy, "This group of agents has failed at every chance to gain respect, you're the laughingstock generation of The Society of the Unknown."

Juliet rose to her feet and threw a right punch at Jeremy, who simply stepped to the left, and laid a hand on her forehead. Juliet eyes rolled in the back of her head, as she hit the ground foaming.

"She won't need a healing pod." Jeremy said, "Just give her two hours."

Tiana shook her head.

The other members watched in astonishment at the twitching Valentine, she had been taken out in less than a second.

"Dad?" Isaac said, gaining excitement, "Are you really letting us do this?"

"You niggas too deep in this shit now." Johnnie Senior answered, "Bridge is going to kill me."

Johnnie Jr. nodded, "I can finally get revenge for my father."

"Don't die nigga." Johnnie Sr. said to his other dimensional son.

"Don't worry dad." Isaac said, putting his arm around Johnnie Jr., "I got his back."

Johnnie Jr. rolled his eyes, "I take everything back, I want to die."

Johnnie Sr., Shook his head, "This ain't no game."

"It's better to be in high in spirits and with confidence." Said Ronald, "This will be Black Shonen's most serious and dangerous mission. You wanted to receive a true mission, Juliet," Ronald said, looking at the girl's body convulse, "You got it."

To Be Continued??????????????????????????????

Operation
Enlightenment
Prologue:

The Adversary stood on a diamond platform, the man looked to his right to see The Lady with Pearls give a slight smile. He looked towards his small yet effective army. The bulk of the army belonged to the Chimeras. The Chimeras were creatures cut and spliced together to make a whole new being, some used to be animals, others humans. Once he mixed up and made the new creature they became a pawn for the cause. The next faction of his paramilitary troops were the humans, humans who were seen as defective in their respective worlds gravitated to The Enlightenment to find some type of cure for their loneliness. Last were the subhumans, humans who had died during their most recent adventures for the organization brought back to life due to technology or other means. The Sub-humans were the newest faction of The Enlightenment.

The Adversary smiled at his people, his comrades, his army. This last battle would be an end for The Enlightenment or Black Shonen or maybe both. All in all, The Adversary didn't care, he just wanted a conclusion, and either way he had backup plans so he could survive and continue the "adventurc" alone. Maybe he could make a new faction that wasn't filled with so many broken people?

The Adversary raised his fist to his mouth and let out a cough, "Today my army…"

Cowboy Harris and Indicia watched from a crevice of The Enlightenment Headquarters. They

were hired help, no better than mercenaries. The two didn't need to hear what the leader of the organization had to say.

"Da Estate really has my brain runnin in circles." Cowboy Harris said, watching the leader speak, "Y are we with des fools?"

Indicia shrugged, "You know, The Estate they keep their values to their selves and send us out to put things in place."

Cowboy Harris sighed, "I mite escape from dem too."

Indicia rolled her eyes and shrugged, "Like we could ever escape them, don't forget they have eyes everywhere watching us."

Cowboy Harris sighed and looked at his newly modified revolvers, "I guess we just like dem."

"We will," Said The Adversary, "continue our adventure."

The army of The Enlightenment cheered to their leader's words and promises.

<p style="text-align:center">***</p>

Ronald Donald straightened his tie, which was stuck in a knot due to his sweaty hands. The man took out a light blue handkerchief and quickly wiped the sweat from his shining bald head. His eyes glanced at his audience, the wonderful Black Shonen group who looked at him with tired expressions and eyes filled with disappointment.

"Ahem." The Man coughed.

"Hurry yo ass up." Said Johnnie Sr., walking into the room with several members of Black Seinen behind him.

"Is Ronald giving one of his hollow speeches?" Jeremy said, fixing his glasses.

"Are they really hollow?" Asked Tyrone, "I've always quite liked them before a big mission."

"If these kids can handle such a task?" Said Jeremy, "This team of agents are low tier to say the least."

"Give the little niggas a chance." Said the raspy voice of Johnnie Sr., " I remember when yall was small, you two were just like my boys over there, every mission was a game, and every mission was a time to prove yourself and your skills." Johnnie Senior took a long puff of his joint and exhaled, "You two only straightened up when she died." The old man shook his head, "Give the niggas a chance."

"We have faced numerous losses," said Ronald Donald to his audience, wearing his black tuxedo, "but I say it has made you youth stronger, we've gained new companions and…."

"I really don't give a fuck what Ronald has to say." said Juliet Valentine to Tiana Forest, "All we gotta do is kick ass, niggas act like it's the hardest thing in the fucking world."

Tiana shook her head, "I think it's a little bit more complicated than that."

"One." Tasia said, next to the two, "We have to rely on the other teams and hope they can even make it to the designated floor."

"Did you hear the damn mission briefing?" Juliet asked, "Those damn True Twins get the lab and we get the dormitory!"

"Facil." Ginger clapped happily.

"No," Juliet argued, "I want the hard stuff!"

"Can you shut up?" Sol overheard, "I'm trying to listen."

"And we didn't ask for the lab." Johnnie said, stepping up to Juliet, "Even without my wolf hearing you're still louder than ever."

Juliet snarled at the two, "Once the girls are done with the dorm and Romeo and I are done with the bodyguard, we'll make sure to get that Adversary fucker."

Johnnie ignored her statement, "I'll be the one to get revenge for my father."

Sol squealed a laugh, "I'll get that fucker for the both of you don't worry."

"Can you two shut your orifices?" ordered the Mad Inventor.

Ronald nervously wiped sweat from his head, "And we, The Society of the Unknown will prevail!"

A small part of the room fell into several claps and then everything fell silent and Isaac raised his hand, "Sorry, Ronny can you say all that stuff again?" Isaac gave his classic smile, "I was laughing at Juliet and my brother arguing."

Chapter 1:
Here comes Romeo!

A large, swirling, orange portal appeared on a perfectly cut lawn. In the midst of the lawn stood a five floor white mansion. Golden gates protected the building front, spires protected its sides, and a golden outline protected its borders. The building came equipped with its own guardian. The guardian came in the form of a lion, with the body of a man, equipped with a jagged cutlass of bone, and at a height of seventy feet. The Chimera Guardian let out a mighty roar when it noticed the swirling vortex. The vortex released a knight composed of metal, cables, cogs, a tattered cloak covering its body, and a large jagged blade strapped onto its back. The Mechanical Knight that appeared to be a symbol of peace to some and a nightmare to others went by the name Romeo.

Juliet looked at the chimera beast from Romeo's cockpit, "So that's the ugly fuck I gotta take down." Juliet began to feel a wild excitement takeover as her feet played with the pedal that controlled Romeo's legs, her hands tightened against the joysticks that activated its arms, and her vile smile appeared on her face, "It's time to tear shit apart."

The sixty foot robot tore itself from the swirling portal and dashed toward its feline opponent. The Feline Swordsman parried a slash from The Black Mechanical Knight, and stumbled back. The Death Knight came back across with a downward stroke but the feline quickly deadlocked with its opponent, bone and steel produced orange sparks as the weapons scraped against one another.

A smaller portal several feet away from the battle of giants materialized onto the scene. The portal contained four people and one by one they matriculated from the vortex. The first one to come out was Sol Pepper. The Redhead donned in her classic outfit of a red Kevlar vest, her customized Kevlar pants that had one leg black, the other doused with the colors of yellow, orange, and red, and her specialized black and red boots.

The second to materialize was her loyal companion Shawn Bolt. The elf sported his skintight green Kevlar shirt, he was also equipped with baggy cloth pants, steel pointed gray boots, and his trusty black bow and arrows.

The third to come into the world of The Enlightenment was Shadow Black, the second elf of the crew. The happy impish boy wore a simple black and green hooded jacket made from cloth, baggy black cloth pants, and black leather boots.

The fourth to come out was The Mimic Vampire, Star Field. Star wore her black and red bodysuit, which was composed of spider webs that had the same properties as metal, but felt thinner than cloth.

This foursome of teenage agents were known collectively as the Scrub-Dogs.

Chapter 2:
The Gardens

"Just push it open." Star blandly said, "Damn if we do, damn if we don't right."

Sol didn't take to the idea, "And get trapped before we can even start the fight." The girl took a quick glance to her left, where she could see Romeo battle the lion creature from afar, the ground shook whenever the two monsters clashed their blades, "I'm not getting played like last time, we're going to be the ones who take down The Adversary."

"Didn't Ronald have a plan?" Star reminded.

"Fuck Ronald and his plan." Sol proclaimed, "The Scrub-Dogs are going to take this win."

"I love when she says our name." Shadow said to Shawn.

"I think it has grown on our young Mistress of Fire." Shawn replied.

"Will you two fantasy characters shut up?" Sol said, turning back to the gates, "I think I'm just going to blast this sucker open."

"Hurray." Star sarcastically cheered.

Sol let her right fist become doused in fire and went for a jab to the center of the gate. The punch exploded with red flame on impact, causing the gates to burst open and letting the team enter the gardens of the mansion. To Sol's team the garden looked like paradise, silver cobblestone laid upon the path, large flowers in the form of blue, yellow, and pink covered bushes that crawled upon the sides of the gardens. Birds of orange and turquoise chirped among the scene and a fountain with a cherubim spilling water from it's mouth lay in the center of the garden, piecing everything together as a solid

beautiful picture. However, Sol who had once lived here knew it was all an illusion.

"Don't touch the birds." Sol said as they ventured forth.

Shadow's eyes followed one of the birds as they walked to the entrance of the mansion, as a warlock he was curious about the warning. The impish boy watched as everyone walked ahead of him, their minds so focused on the task ahead, to Shadow all this was a distraction. The Warlock was pretty sure if the whole Black Shonen team fell and if needed, he could bail everyone out, but in reality all he really needed to do was to save was Shawn.

Shadow's lime green eyes watched as a bird flew above his head, The Warlock turned his palm upwards at the bird and let swivels of darkness escape his hand, the darkness took the form of hissing black snakes and snatched the bird from the air as Shadow's palm became a salivating fanged mouth. The Warlock excitedly watched as he devoured the creature, learning it's secrets, it's abilities, and anything else he needed.

"Ohhhh," Shadow realized, "that's why she was so scared."

"Kaw, Kaw, Kaw, Kaw"

The sound caused the Scrub-Dogs to look up and Sol already knew what was happening.

"Shadow!" The redhead screamed, "Did you touch one of the birds?"

"I just slightly touched its wing," The elf claimed, shrugging his shoulder, "ooops."

Chapter 3:
The Guardians of the Garden

Sol could see the three dots in the perfect blue sky, "Shit, shit, shit, guys get ready."

Shawn looked out to where she was looking and saw how the dots in the sky began to get bigger and their caws began to grow louder, "Shadow my closest friend, I think you may have triggered a form of alarm."

"Did you really think we get in the garden without a fight?" Star said.

"That was the plan." Sol said.

Star shook her head, while taking out her bladed tonfas, "When do your plans ever work?"

The three dots grew at a rapid pace, crashing into the ground, and separating Shadow from his comrades. The monstrosities had the form of ravens with drooping human bodies, their wingspan reached eight feet, and their beaks were as sharp as blades. The creatures wore ragged pants and had metal collars on their neck. They stared down at the three teenagers before them and spread their wings, cawing and beating their chests, to start the attack.

Sol was the first one to strike; the redhead caught a punch from one of the queer looking creatures and stepped in with an explosive jab. The monster let out a screech as it took to the sky, trying to pat the fire out from itself. The next bird creature received blades into its ribs. Star kicked the misshapen creature from off of her weapons and it fell to the ground. The third had tried to gain air to fight Shawn Bolt but the elf easily shot it down with one of his rapid arrows. Shadow did a happy dance, while moving his fingers all type of ways and the

remainder of the Scrub-Dogs watched as the bird creatures were devoured by their own Silhouettes.

"I fixed my mistake." Shadow apologized, "Sorry, I'll be way more careful next time."

Sol realized something as The Warlock feigned his kid-like smile, she remembered during the fight with Chad, this personality Shadow was portraying was fake. Shadow must have had some other purpose for signaling the alarm. Sol let her negative thoughts flow away, Shadow was a part of their team. Whatever The Warlock was doing, Sol guessed it was for the benefit of the Scrub-Dogs.

Shadow twirled his right index finger and darkness seeped in between the crevices of the large oak door to the mansion. The door came open with a silent swish, letting the Scrub-Dogs continue their mission.

Chapter 4:
Between the Mission

"Go Julie!" Isaac screamed at the monitor, "I have faith in you, clobber that lion man, Julie Julie Julie ohhhhhhhhhh!"

"Shut up," said Johnnie Jr. "You screaming ain't going to help her win or lose."

"You sure?" Isaac asked.

Tiana smiled, "Don't worry, I've been on many missions with Juliet, she'll be fine."

"She better," Isaac said, "or at least hold out until me and Johnnie get there."

"And me too." Cookie jumped in.

"Oh yeah!" Isaac exclaimed, "The True Twins got a new party member."

"She's not part of our team." Johnnie sighed, "She's definitely not a True Twin."

"Awww, Johnnie." Cookie said, batting her eyes at the wolf, "Accept me, Isaac has, he's the best."

Johnnie shook his head, "I barely accept Isaac and I only need one psychopath in my life."

"But two is better than one." Isaac said.

"Kill me." Johnnie said.

"None of your missions really matter." Said the Mad Inventor, judging through the monitor, "Seinen is stationed at the trophy room where the books are, everyone else is just fodder for The Enlightenment."

"Portate bien" Natalia said to The Inventor.

The Inventor rolled his eyes.

"Escucha a tu novia." Said Ginger.

Natalia couldn't help but let out a light smile, The Inventor looked at the girls and rolled his eyes in disgust.

Don't act like you don't like it.

Ronald sat back, proud none of the Scrub-Dogs caught the cameras he had put on their clothes, or the drone that followed Romeo and Juliet. The Supervisor thought it would be good for youthful agents to see their peers during the big mission, it would give them high hopes for when it was their turn to infiltrate The Enlightenment.

"Shadow!" Sol screamed from the monitor, "Did you touch one of the birds?"

"I swear." Johnnie said, looking at Isaac, "That Shadow kid is just as bad as you."

Chapter 5:
Silva's Adventure

The alarm for invasion blazed in Silva's ear, lights of red blared on the walls, and several dozen human members of The Enlightenment rushed by Silva's side, with weapons in hand. Silva was excited, The General had warned him of The Society of the Unknown's invasion. The elf took one effortless jump and landed in front of the doors to the first floor, the cafeteria. On a normal basis, this was Silva's favorite place, he adored eating food from different worlds, worms that tasted like chicken, purple noodles with green sauce, creepy crawly things oozing with green secretions! Silva loved the cafeteria, but today he would be fighting on behalf of his own safety, for where would he go if The Enlightenment fell?

Silva kicked the doors open, entering the crimson-lit room of the cafeteria. Several members stood in front of the doors; their legs shaking as Silva noticed tentacles made from dark magic weave through the entrance.

"Oh," Silva smiled, his hands reaching into his kimono, "They have a warlock, hmm, I wonder from which world?"

"Silva?" Said a blonde doe eyed Enlightenment member, "What should we do?"

Silva nodded, "Good man, good man, I say we wait."

The man didn't talk back and Silva began to back up from the door.

The doors to the garden burst open with flame.

Silva first noticed the redhead, she came in mouthing several cusswords, punching and kicking surrounded by a bright orange fire. Another paler girl leaped from the smoke of chaos, equipped with two weird bladed sticks, but what really caught the elf's attention and made him join the battle were the two elves he saw next.

Silva noticed one of the elves was able to control darkness at his whim and even though the small elf still resembled a child, his magic was far above his age. The second elf really caught Silva's attention because it was a Tailed Elf! Could these two elves be from his world?

Chapter 6:
The Fight of Elves

"Remember guys," Sol said, as Shadow's ability began to open the door to the first floor, "The Inside of the mansion is like a separate pocket dimension, unless someone was watching we most likely could get a surprise attack," Sol smashed her tight fist into her left palm, "We just got to go in with a blaze!"

Shadow 's ability fully opened the doors, letting in a rush of wind. Sol saw as several dozen Enlightenment members stood with weapons in hand. Sol and Star exchanged glances.

"I thought no one would know we were here." Star sarcastically stated.

"Shut up." Sol reacted.

Sol started the battle with a fiery punch to a member's face, causing the young man to twirl and hit the ground. The young redhead swirled in with a roundhouse kick, burning and breaking someone's ribs, then an uppercut sent someone smoking onto the floor. Star came in right after Sol, her bladed tonfas cutting her opponents and staining crimson upon the ground. The Mimic Vampire felt a wounded member grab her leg, and Star brutally kicked the man, sending him crashing into the cafeteria wall.

Shadow came out next, the young imp smiled as he raised his hands, and the silhouettes of his opponents rose into the world of 3D. When Shadow snapped his fingers, the silhouettes began to attack their owners, clawing flesh, biting eyes, picking up utensils and stabbing their originals. Shadow laughed at the chaos, it was hilarious. Shawn was a clean

killer; his blades slit swiped the necks of his opponents, sending bodies limp upon the floor. The majority of the members were too slow for the elf. When they thought to attack, the elf's blade was already fatally slicing their flesh, when they brought out their weapons, Shawn already had daggers in their chest, when they tried to surprise him from behind, the elf would spin, exterminating his opponents like pests.

Sol gave a fiery glare to the remainder of her opponents. The Enlightenment members looked at each other scared, some had exotic weapons like electric whips, floating daggers, and blades crafted of ice, but even the queer weapons didn't give the members enough bravery as they scrambled upstairs to the higher floors. Only one Enlightenment member stayed.

"Such a dashing performance." Silva said, clapping his olive hands, "For a human you're quite a monster."

"Glad you took notice." Sol stared.

The black, gold, and white kimono wearing elf put his hands in his outfit taking out two blades, "I would like to do battle with the Tailed-Elf," Silva said, showing his own furry white tail, "I think were from the same world, I would like to know how everything is over there."

Shawn walked towards Silva, "You're from the same world as Shadow and I?"

Silva smiled, twirling his daggers, "Looks like it."

"Two daggers." Shawn said, "You also train in the Host of Blades!"

Silva smiled, "Oh! Yes we definitely live in the same realm."

"Ooooh, someone from our world! Can I fight him?" Shadow said stepping up, *who would have thought The Enlightenment had an elf from the same world, Shadow thought.* The Warlock sneered, *this could be bad*, "I think it would be fun."

Silva shook his head, "I have no fun with you non-tailed elves and all your cheap magic. I'd rather test my skill against blades."

Silva threw his daggers in the air and caught them in his hands, "Come my tailed brother."

With a flick of his wrist, Shawn wiped his daggers of their crimson stain and dashed towards Silva.

Chapter 7:
Shawn Vs. Silva

Shawn ducked a cut for his face, jumped low,
and stuck out his feet, bashing them into Silva's
chest. Shawn spun and gained two more slashes into
Silva's body. The opposing elf smiled, watching his
own blood flow and came forward with two slashes
for Shawn's neck. Shawn quickly parried both
attacks with his right dagger and tried to perform a
killing thrust with his left to Silva's neck but was
quickly parried by the white haired elf. Shawn went
for a head-butt, causing his enemy to stumble back
from the surprise attack, a front kick caused the
white haired elf to fall on his back and Shawn
jumped onto his opponent's chest and put both his
daggers onto the surface of Silva's neck.

"I thought it was just a thought." Silva said,
his eyes wide, his heart beating hard, "locked hair,
brown skin, daggers, bow and arrows. It sounds like
you but is it?" the white haired elf began to let out a
laugh, "Are you from my past? Hehehehhehe. Am I
your future?"

Shawn looked at his fellow elf in confusion.

"The Dark Knight and his Warlock minion,"
Even though Silva was staring at Shawn, the white
haired elf seemed to be lost in his own thoughts,
"they told us stories about you two to keep us quiet
when I was a child."

"What?" Shawn was bewildered, but the
words felt familiar, "Dark Knight?"

Silva's knees perked up, hitting Shawn in the
stomach. A quick slash of Silva's dagger raked
across Shawn's face, causing the young elf to scream
and for Silva to get free from Shawn and retreat up

the stairs. Shadow smiled as he saw the elf leave and twirled his finger, causing dark magic to materialize and aim for the escaping elf. Silva twirled, his daggers glowing white and obliterating Shadow's magic.

"The bastard." Shadow whispered, biting his lip until blood ran, "I'll end his life soon."

Shawn gained control of his pain and stood up, holding his right eye. Shadow looked at his companion and twirled his hand, causing a bandage of dark magic to cover Shawn's eye.

"Are you ok my dear friend?" Shadow asked.

Shawn looked down at his friend and the words from Juliet ran through his head, "I'm good my dear companion."

Shawn felt Sol hit his shoulder, "If it wasn't for that cheap trick you would have won." Sol began to look around for the Portal Block, "However, after we set up the portal we got to make plans on how to get that wack ass Adversary guy."

Chapter 8:
Who Were They?

Once upon a time, in a world far from Terra Firma, in a world where elves ruled, where elves with tails were physical, and elves with no tails were filled with magic, there was a trial.

Several elves stood amongst black ruins, they chanted swaying their bodies, and their faces covered by dark hoods.

One tailed elf was chained to a wall, decorated in destroyed black medieval armor, blood spilling from his face, his body bruised, torn, and broken. The Tailed-Elf howled in pain each time he tried to escape his chains, bound to the half destroyed wall, too weak to escape. Next to the Tailed-Elf was a chained non tailed-elf, who did nothing but laugh, dressed in black and green robes.

"Why are you laughing?" Said the Elf in black armor.

"Cause look at them!" the elf in green and black screamed, "These pointy eared buffoons are so scared of the unknown, so scared of what we have become, an enigma in their world. They don't understand why a Tailed-Elf and non Tailed-Elf would ever work as one; we threw them off and almost took over their kingdom. We, two people, we almost took down a whole kingdom and what do they do?! They throw us into the darkest of pits scared of our Union!!!!!!! THE FOOLS!!!!!!!!"

The Tailed-Elf in the broken dark armor looked upon his captors and saw the king and princess of the kingdom they nearly demolished. The princess was a beautiful woman with dark skin and kinky blonde hair. She looked at the warrior and

warlock elf filled with pity even as she began to chant along with her father.

"Shera?" The Dark armored elf screamed through his tears, "Why would you do this? I did everything?"

She ignored him and chanted, her eyes staring to the ground.

"You see!" The green and black robed elf screamed, "She doesn't care about you, she might bed you when others are sound in their dreams, but in the world of reality she will never tell the ones her true desire. She's a coward my boy!"

"You're wrong!" The dark armored elf said in tears.

The robed elf let out a wild scream, "You see! We were nothing but above average pawns! These people are so sick it's great!"

The armored elf looked at the princess who stole his heart and understood his world was ending.

Chapter 9:
Behemoth Swordsmen
Part 1

Romeo's large jagged blade clashed upon the bone sword of the lion soldier. The chimera's feet sunk into the grass, the monster could feel his bones bending, the creature snarled with saliva as it tried to react, but Romeo kept forcing the creature back. The chimera's eyes began to flicker red, it let out another roar, and began to overpower The Knight Mech. A slice of the bone blade came for the robot's head and the Knight violently turned, parrying the blade with a large explosion of orange sparks.

Chapter 10:
Here comes True Twin Force

"They are taking a long time to find the blocker." Johnnie Jr. said, staring at the monitor.

"Oh, don't worry bro," Isaac said, "I'm sure Shadow and his gang will find it."

"Then it's our turn!" Cookie said, appearing behind Isaac.

"We really don't need you to come along." Johnnie stated, "Me and Isaac got this."

"Noooo," Cookie disagreed, pouting and shaking her finger, "Young Baldy said I can come and Isaac said I could too."

"Yeah, Johnnie." Isaac agreed, "Ron said she could join the True Twin Force!"

Johnnie shook his head, "That is not our name."

"Just go along with it," Tiana said, "be happy your team is growing."

"Yeah Johnnie." Isaac agreed.

"Be happy wolfie." Cookie smiled.

Johnnie looked at Tiana and sighed, "Why do you want to cause me suffering?"

"Found it!" Star said, yanking the blocker from the wall and crushing it, "It was behind the refrigerator the whole time."

"Typical," Sol said, taking a small metal ball from her pocket.

Sol put the ball on the ground and the device immediately produced a swirling orange vortex, "Looks like those crazy twins are next." The girl looked at her team and sneered, "But we'll get the last hit."

Chapter 11:
The New True Twins

The Scrub-Dogs watched as the orange vortex spiraled and twisted, projecting silhouettes in its reflection.

"Here they come." Said Sol.

"I feel like they're more disorganized than us." Said Star.

Sol nodded, "Probably."

"Awww." Shadow smiled, "I quite like the twins, the one with the cornrows always makes me laugh."

Shawn nodded, "I heard they are quite a force."

"Get off me you two!" Was the first thing the Scrub-Dogs heard from the vortex?

"Johnnie I can hardly see!" Said a second voice.

"Whoa, your guys vortexes are way thicker than ours!" Came a third feminine voice.

In True Twin fashion, the three teens came bursting from their portal, crashing upon the floor.

"Owchies!" Isaac said, rising first from the ground, "That was pretty fun!"

The young cornrowed boy sported his fitted baggy blue jeans, black and gray hooded Kevlar jacket, and high top silver lace shoes.

"I wanna do it again!" Screamed Cookie, leaping to her feet.

The young woman had refused to wear any armor, seeing no point. Instead, Cookie wore a red and black button up jacket, with a pink hoodie, a black skirt, and red and black biker shorts with matching socks and shoes.

"Why couldn't I be with the old man?" said Johnnie True Jr.

The werewolf sported baggy fitted jeans, long sleeved Kevlar armor, and boots, all dressed in black.

"Are you guys gonna be alright?" Sol said.

Johnnie could see she had a look of concern, and rubbed his hands through his dreads with a sigh, "We'll be fine."

"True Twins!" Isaac screamed, running up the stairs.

"Twins of Truth!" Cookie screamed, dashing after Isaac.

Johnnie sighed again, "Anyone wanna switch?"

Chapter 12:
Journey to the Second Floor

"Spiral staircases are cool!" Isaac True said, running up the stairs.

"Spiral staircases always lead to a boss, right Isaac!" Cookie exclaimed, chasing the boy.

Johnnie True Jr. looked up as the two traveled the stairs and blew a dread away from his face, "Those two are going to get me killed."

The Wolf began to jog up the stairs, thoughts blinding him to the mission in front of him. When he ran into the Adversary what was he going to do? Hand to hand combat for Johnnie against a man that could turn and use wind was useless. Maybe Isaac? Maybe Cookie? What should he do? How was he going to defeat The Adversary?

"Johnnie!!!!!!" Isaac screamed.

"Wolfie!!!!!!" Cookie yelled.

Johnnie was immediately broken from his thoughts as his jog became a dash that evolved into a sprint. When Johnnie hit halfway up the staircase, he witnessed a stunning sight. Isaac and Cookie stood in front of a revolting beast, the creature's eyes were many and spread throughout its face, a myriad of blue tongues hung from outside its mouth. Its body was like a bear and a human furry and burly. The monster's claws shined silver and its fangs were a rotten black.

The monster beat its chest and a right claw went straight for Isaac, who countered with a swing of his shining magenta blade. The sword vertically severed the claw down the middle and Cookie immediately thrust her needle filled fist into the gut of the beast. Purple blood spilled upon Cookie, and

the beast hardly felt the wound as it swiped the young girl with its claw, tossing her into the wall. Johnnie came in with a right hook into the creature's ribs, causing the monster to hunch over. Isaac stuck both his blades into the exposed neck of the beast. Cookie had recovered and leaped into the air, scoring a flying kick to the monster's face.

The creature stumbled, rotten blood leaking from its wounds. Unfortunately, the monster still had power as it let out a roar and began to let fly a berserk flurry of punches. Isaac fought back with his energy blades, cutting through the creature's arm. Cookie dove and spun, using her needles to cut through the massive claws that came after her. Johnnie weaved between the punches, just barely missing the claws tearing for his face. The Werewolf smoothly got close to the beast and began to lay haymakers into its stomach, each punch shaking the beast's core.

The three fought, their arms becoming restless, sweat pouring down their faces, thoughts of failure ringing through their heads, and then the beast fell. It gave one last roar as it crashed, hitting the ground with a loud smack.

Chapter 13:
The Chimera Lab

"So this must be where the monsters get made." Johnnie said, with his hands in his pockets.

"Ooooohhhhh." Isaac and Cookie chimed in unison.

"Spooky monsters." Isaac said.

"I never have seen this part." Cookie said, "Want to push buttons Isaac?"

"No!" Johnnie roared, "We are not pushing buttons, were going to find the blocker and that's it!"

"Awww but buttons." Isaac whined.

"Buttons." Cookie pouted.

"Why?" Johnnie said, running his hands through his locks, "Why am I teamed up with crazy people?" The Wolf sighed, "Can we just get through this?"

"Sure." Isaac and Cookie shrugged.

Johnnie ran his hands through his dreads, "Maybe they're the twins?"

The Three had found themselves in the depth of the Chimera lab, the floor was black, the lights dim, and the area was decorated with a myriad of humans sized tubes, holding creatures covered in a yellow slime.

"It's a monster factory." Isaac said, staring at one of the tubes, "Looks like a dragon."

"I wonder if this is how I was made?" Cookie asked.

"You're artificial?" Isaac wondered.

Cookie shrugged, "Yeah, but I came out a lot cuter than those guys."

"Is it weird being artificial?" Isaac asked.

Cookie shrugged, "No, not really."

Isaac tapped on the tube, "I wonder how different you two are?"

"Come on guys," Johnnie coaxed, "we got to find the blocker."

Chapter 14:
The Battle of Behemoths
Part 2

Romeo and Juliet were stuck on the
defensive. The chimera lion continually bashed away
at the Mech Knight's blade. When the weapons made
impact, Juliet violently shook within the cockpit.

"I'm so tired of this nigga." Said The
Swordswoman.

Juliet quickly pulled the joysticks back, and
stepped on the pedals. Romeo parried the latest
swing of the chimera and leaped back. The chimera
stepped forward with a swing and Romeo parried,
adding a shoulder tackle into the creatures chest.
Romeo quickly raised its sword above the monster
and brought it down with a mad fury. The robot's
attack was too quick to parry and its blade ate
through chimera meat. Blood poured from the
massive creature falling onto rusted metal. Romeo
yanked his blade from its flesh and wheeled his
sword about, performing a swing from the side,
aiming for the ribs. The Chimera monster flipped
over the attack and landed with a slice into Romeo's
left arm. The metal appendage hit the ground,
leaving The Knight with only its right arm, which
held tightly to its blade.

Chapter 15:
The Return of an Old Face

"They actually work good as a team." Tiana said, smirking at the monitor.

"Si," Ginger nodded, "I think Cookie was the missing piece to the True Twins."

Tasia Snow nodded.

The Mad Inventor glanced at the monitor, " Monkey see, monkey do."

"I've never seen anyone use needles as a weapon." Trina said, leaning extremely close to the screen, "Maybe I should try that?"

"I think your powers are strong enough." Natalia said, "What are needles to a girl who can manipulate anything she wants?"

Trina thought seriously about the question, "You're right, the way I fight is way more spectacular. Needles are cool though."

The Inventor shook his head, "I'm teamed up with fo-"

Natalia turned toward the Inventor with a frown, "What were you about to say Chico?"

The Inventor crossed his arms and looked away from Natalia, "Nothing."

Tiana caught something on the monitor and moved Trina's face from out the way, "What is that in the background?"

"Stop!" Johnnie growled, "I can smell something up ahead."

"What does it smell like?" Cookie said, highly curious.

Johnnie began to stalk forward, "Stay in back of me you two."

Isaac appeared on the wolf's right, Cookie appeared on his left, and The Wolf shook his head. The three crept within the dim light of the lab, moving between the large tubes that held half developed monsters, and Johnnie's sensitivity was on high alert for what lay ahead. Johnnie True was the first one to notice the source of the scent; the boy saw an older man appear under the low light, his clothes were completely white and took the form of an army general. The man held a sense of superiority in his smile, his eyes looked at the three like they were prey and when he opened his voice it made Johnnie eyes shift to a blood thirsty yellow.

"Hey General!" Cookie said, happily waving her hand, "I'm with these guys now, sorry!"

The General acknowledged, "Oh, Cookie, I realized that you were far too advanced for a man like me, your brain far too developed."

"I remember you!" Johnnie barked, "You were at the church!"

Isaac's eyes grew wide in excitement, "Oh yeah, I think I was there too."

"Of course you were there!" Johnnie said, "I swear, sometimes I think those cornrows are too tight on your head."

The General broke off a smile, "You three are all so cute, and I'd like to thank you for taking in my Cookie." The General snapped his fingers, "I've recently acquired an easier pet to control, Terra Firma's prehistoric period was very interesting."

Chapter 16:
Battle in the Lab

Isaac True, Johnnie True Jr., and Cookie Dough Cream all looked up to see The General's newest partner. The blonde was a stunning seven feet, her body was composed of vein pumping muscles, in her left hand she held a stone club, and her frame was dressed with the furry skin of some kind of beast. The large woman looked down at the three, but her eyes focused on Cookie. The cave woman reared back her club and with the roar of an ancient beast, she slammed it toward the small teenage girl.

Cookie easily leaped out of the way, following the The True Twins.

"She's huge!" Isaac reacted.

Cookie rose to her feet with excitement, "You guys get The General, I'll take care of my replacement."

Johnnie decided not to argue for once, cracking his knuckles, "You ready Isaac?"

Isaac nodded with a grin and materialized his blades in a magenta explosion, "Letsssss goooooo!"

The boys rocketed toward The General who only thought of his attackers as a way to past the time. The General had made sure to wear his Pseudo-Telekinetic gloves and with a wave of both his hands the boys were flung into the air and crashed into one of the development tubes.

"C'mon boys, I know you have more spunk than that." The General teased.

Isaac got to his feet and pointed his right blade towards The General, "I have all the spunk!"

Isaac fired a blast from the tip of his weapon, to anyone else it would have been far too fast to dodge or stop, but for the General it was as easy as waving his right hand. Isaac watched in disbelief as his fire and lightning curved, exploded a test tube nearby and spilling its contents onto the floor.

"Oh my." Said The General, putting a hand on his mouth, feigning worry, "You just ended that creature's life."

While The General in White was doing his acting job, Johnnie decided to dash for the man, as the wolf lunged for his opponent he found himself caught in mid-air. All The General could do was smile at such nonsense.

"See wolf boy, I'm far above your primal tactics." The General swirled his finger.

Johnnie found himself spiraling into the floor, crushing his nose with a loud crunch.

Several bright beams of magenta came next for The General and The General simply raised his hands, creating an invisible shied to protect himself from the destructive explosions.

"All you did was kill more unborn creatures." The General began to walk towards Isaac, "Show me real power."

Chapter 17:
The Depth of Cookie

Cookie leapt, dashed, and spun like a crazed
ballerina as she dodged the massive crashes of her
opponent's club. The Cavewoman was more of a
challenge than expected, not only was the large
woman strong, but she was extremely fast with her
weapon. Cookie had to act from instinct. The teenage
girl watched as the woman screamed, reared back her
massive club, and slammed it down with such speed
and power Cookie almost fell when she dodged the
attack, but she held herself up and leaped forward,
landing on the club. Without a thought, she leaped
toward the woman's face, wrapped her legs around
her neck, and began to slash her silver needles across
the cavewoman's visage.

The prehistoric woman screamed, and
dropped her club as Cookie scratched her eyes out.
The woman in her death moans raised up her hands,
Cookie thrust her right hand into the woman's face,
and tore out her moist tongue. The Cavewoman
clapped her hands, but Cookie was already in the air.
The young girl landed on the ground, slipped on
some blood, and fell on her butt as she watched the
larger woman scream in pain. The woman's giant fist
crashed against several of the tubes, shattering them
and letting half developed beasts spill onto the floor.
Cookie quickly stood up and clicked her shoes
together, summoning wheels and rocket boosters.
The girl clicked her shoes again and they activated,
shooting her forward towards the half blind
cavewoman. Cookie leaped over a wild swing of the
club and pierced her needles into the prehistoric
lady's throat.

Cookie eyes flashed a glowing red as she delivered the killing blow. The large woman gurgled a scream as she fell on her back. The young girl yanked her needles out of flesh to only put them back in, tearing through the woman's esophagus. Cookie giggled when she saw bright red blood contrast with her own pale skin. Cookie had no feelings when the lust of battle took over, all she could do was laugh at such gore, and laugh that such a small girl could do such violent things.

Chapter 18:
Let's fight The General

"You twins?" Said The General, "I've heard our leader has run into you in many worlds, I wonder what's so special?"

Isaac shrugged his shoulders, "Um…you know? I'm kinda cool, so I'm probably spread everywhere."

The General stared blankly at Isaac, "To me you're nothing but a child, what our leader sees in you I don't understand, heh, I'd say he even might fear you and the wolf, but I don't."

Johnnie's right jab crunched into the spine of The General, "Looks like you were too focused on Isaac." Johnnie sent in a second punch, The General crashed into one of the tubes, "Got his ass."

All the General could do is laugh as he regained his balance and used his man-made special abilities to heal his spine, "Naivety, do you really think I could be defeated due to a surprise?"

Johnnie walked toward The General, "I got you didn't I?"

The General turned toward Johnnie and aimed his gloved hands at the boy, "Goodbye wolf."

Johnnie smiled and moved to the side, "Not before we get you."

At first the General was confused by Johnnie's confidence but as he saw what lay ahead The General began to realize more. Isaac held his left wrist with his right hand, building a ball of magenta flame and lightning aimed at The General.

The General stared at the ball and stood erect, holding out his hands, "I'm sure I can stop this."

"Isaac shoot!" Johnnie screamed.

Isaac was slightly hesitant, he wanted to stop The General, not kill him, he really hoped this didn't end the man, "Magenta Burst!"

The General rapidly held out his hands as the magenta beam tore through the ground, causing tubes to burst open, and obliterating anything in its way. The General could instantly feel the heat burning through his gloves, he could feel the magenta light gorging into his eyes, he watched as the magenta fire covered his skin, turning it black and The General let out a defeated scream as the magenta light enveloped him.

Chapter 19:
The Battle of Behemoths
Part 3

"You think Romeo ain't shit with only one arm?" Juliet screamed from within the cockpit of her mech.

Romeo rapidly ducked a slice from the chimera's bone blade to deal a slice into the beast's chest. The beast landed an elbow into the head of the mech, and with both its hands the creature tightened the handle of its blade and swung down. Juliet moved the joysticks and Romeo blocked it then pushed forward upon the beast. The monster pushed back, deadlocking their blades.

"Fucking cat!" Juliet screamed within the mech.

Romeo pushed forward, it's gears grinded, sparks exploded from it's metal, and the robot broke the creature's blade, gaining another hit across the shoulder and exposing more crimson onto the scene.

"Got ya bitch!"

Chapter 20:
The True Force Wrapping Things Up!

"Cookie, muy loca." Ginger said, leering away from the screen, "So bloody."

"She's far more aggressive than Juliet." Tiana said, a little worried.

Tasia nodded.

The Inventor looked at the massacred body of the cavewoman, "Tch, I could have done a better job, cleaner too."

"Are we really arguing about this?" Ginger asked.

"The Inventor argues over everything." Trina chimed in.

Natalia giggled.

With a flip of the Remote from Ronald, the screen on the monitor switched to The True Twins.

"Oh no," Isaac said, poking at the semi burnt body of The General, "Did I kill him?"

The General let out a moan.

"Nope." Johnnie said, "You see, he's breathing."

"Yes!" Isaac yelled, rising his hands in triumph, "Killing is very bad!"

"Hey boys."

The True Twins turned around to see Cookie in full gory display. The young woman's outfit was covered in crimson, her long hair carried globs of flesh, and her needles still held shreds of skin.

"Oh," Cookie reached in her jacket pocket, her tongue swirling as she searched, her eyes went wide when she found the object "Is this the Blocker?"

Chapter 21:
A Gunslinger vs. Three

Cowboy Harris and Indicia were positioned to protect the staircase leading to the third floor, the dormitories. The Gunslinger and Fairy were bored until they heard the blaring alarms, they could even hear the faint sound of fighting on the second floor. When the doors to the lower floor burst open, Cowboy Harris and Indicia looked down to see three young women traveling up toward them.

The Gunslinger smiled, "If it ain't my old girlie Ginga."

When the three young women neared The Gunslinger, he already had his revolvers out, twirling them on his index fingers, "What do yer lil girlies doin out yonder, this aint no place for beauts?"

Ginger rolled her eyes, "No worries chica, he's a joke."

"Ah, don't play r luv." Cowboy Harris said with a smirk.

Tiana and Tasia shot a glance at Ginger.

The Gunslinger dressed in his black thermal, brown suspenders, brown fitted jeans, and brown leather boots. He analyzed the young women in front of him; the first girl had ebony skin with bright blonde hair tied in cornrows. The blonde cornrowed woman wore a tank top and pants in green, and gray boots. The second girl had milk caramel skin with flowing golden locks, she wore a ragged gray and black loose outfit of cloth for mobility, wraps around her legs and black slips on shoes. Lastly, was The Gunslinger's recent crush Ginger, with bright brown skin and raven black hair. Ginger wore a Kevlar

body outfit of red and gray, with her cat ear red ribbon on her head.

"Ay, Chica's," Ginger responded, "he helped on a mission only!"

"So you like the bad boys." Tiana Teased.

"It's nothing like that!" Ginger screamed.

"Don't deny r luv." The Gunslinger said.

"Arghhhhhhh" Ginger pointed her gun towards The Green Wonder and shot.

Indicia intercepted the bullet with a weak energy beam, "Can you be careful?"

"I doubt she would've hit me." Cowboy Harris said, scratching his hair with his revolver.

Indicia shook her head, "I can't with you."

Cowboy Harris felt a vibration in his pocket and quickly sheathed his right gun and looked at his Z-Phone, "Dis iz da reason, eh?" The Gunslinger quickly put the Z-Phone in his pocket and sheathed his other gun, "So boss man jus told me da reason why I'm hure, can I join u guys to da fift floor."

The three girls a little confused exchanged glances.

Chapter 22:
Back from the dead

"Most of da human fighta's is spread through da mansion." Cowboy Harris said, "dis floor iz prolly da less guarded."

"Why you helping us Chico?" Ginger asked.

Cowboy Harris smiled at the young woman, "I told ya, da boss changed my mission, plus I kinda like ya."

Ginger frowned and looked the other way, "Tonto."

Tiana pointed her loaded crossbow at The Gunslinger, "Your telling the truth aren't you?"

Cowboy Harris pointed his revolver down the path, "We jus go head."

The Gunslinger made sure to lead the way to put the girls at ease. Tiana decided to follow first, Ginger second, and Tasia kept up the rear.

"So you know this guy?" Tiana whispered to Ginger with a smile, "You didn't say anything about being teamed up with tall, handsome, and bright haired man."

"Nada." Ginger said, she wanted to be a little loud so The Gunslinger could hear, "He's a loser."

"Wit a fairy." Cowboy Harris added, "A losa with a fairy and two revolvars."

Indicia rolled her eyes, "You do anything to impress a girl, huh?"

Tiana overhearing lightly laughed, accidentally bumping into the Gunslinger's back.

"Hey, you tryna pull something?" Tiana said, raising her crossbow.

"I thunk you kicked the bucket?" Cowboy Harris sighed, ignoring Tiana and looking straight ahead, "Damn ur gunna be a hard one."

The Girls looked around The Gunslinger to see a woman covered in skin tight black steel armor, her eyes looked lifeless, there was deep gash on her neck, and her black jagged blade lay sheathed on her back.

"La Jefe Military." Ginger said with fear.

Chapter 23:
Johnnie's Request

"Isaac," Johnnie True Jr. said, staring at the stairs, "I'm going to the higher floors."

"What!" Isaac exclaimed, "Dad said after the lab we have to wait for the rest of the rules."

Johnnie shrugged, "I'm going to defeat The Adversary. He killed my father," Johnnie turned toward Isaac and Cookie, "You two need to stay right here."

"But Johnnie!" Isaac said, "I'm your right hand, we got to do this together!"

Isaac was far to good natured, Johnnie thought, "That's why Isaac, I need you to stay, you're my bro, if anything happens you got to get Cookie out of here and tell dad what I did."

Johnnie looked in his other's bright brown eyes to see if the boy understood, after a while Isaac sighed and nodded, "I'll wait."

"Don't worry." Cookie squealed, admiring the love between the two boys, "You'll be with me, you can tell me about your cool Japanese comics."

Isaac's eyes grew wide, the smile of a young boy came to his face and he immediately forgot about Johnnie and started to spill random facts about the wonders of Japanese manga to the young woman.

Johnnie turned towards the stairs, partly feeling guilty about lying to Isaac. It wasn't that he wanted to keep Isaac safe, he just knew Isaac would probably get the last hit on The Adversary before him.

"I'll see you guys later." Johnnie said, and with a sprint he headed to the third floor.

Chapter 24:
The Battle of Behemoths
Part 4

The one armed Mech ducked a horizontal slash then rose with a vertical slash into the chimera's chest. The robot continued it's combo and swung around its mighty blade and clashed it upon the beast's sword, breaking the weapon into two and gaining another vertical strike into the chimera's stomach. The wounded beast staggered back and Juliet pushed her pedals forward and swung around her right joystick. Romeo stepped to the side, letting his blade taste blood with a horizontal slice. The Chimera's head came flying off, spouting red liquid in a circular form.

Juliet, sweaty and tired screamed in victory, holding up her arms in triumph, "Got you nigga!"

Chapter 25:
The Gunslinger's Employers

Some time ago…

Cowboy Harris stared into the blue eyes of his three blonde employers, "Whaddya hav me do mastas?"

The three blondes laughed in unison, the majority of their body language hidden behind white robes, and their blue eyes glancing at one another for some form of comfort. Once the awkward laughing was over, the young female blonde sat up and her desk opened, she reached into a drawer and handed Cowboy Harris a piece of paper.

As The Gunslinger read on, Indicia and he glanced at each other on several occasions and the blondes noticed.

"Is there any problem?" said the blonde on the left that was an old man, "We can talk it over, and you are one of our best agents."

Cowboy Harris held up his hand, "I can't read and talk at da same time."

"You can hardly talk." Indicia said.

Cowboy Harris shooed the fairy away and continued to read.

"I think he'll like it." Said the female blonde to the young blonde man on her right.

The young man had his head in his hand, his eyes drooping about, and his face in a frown, "Cowboy Harris and his fairy have done every mission with no negative feedback, he'll be fine."

"The name's Indicia." The Fairy said.

They young male blonde waved his hand, "Are you sure you don't want to hang with me Fairy?

I'd love to add you to my collection of strange beings."

Indicia shivered at the thought, "Don't you know if me and Cowboy are separated we both die?"

Cowboy Harris nodded, "Sorry bud, she's stuck wit me."

The young blonde man smiled, "I like you two together.

"As do I." Said the female blonde.

"As we all agree." Said the old man.

Cowboy Harris and Indicia both nodded once they finished the mission brief, "So you want him to join up as an interdimensional terrorist? Asked Indicia.

"The Enlightenment is a very interesting group." Said the older blonde.

"They travel through the dimensions killing people and stealing their inventions." Said the young blonde.

"They have quite the collection!" said the female blonde, "Warpers, engines that run on water, items that grant extra abilities, books with the forbidden knowledge on how to make humans, oh, Cowboy they have so much!"

The old blonde man smiled, "Yes, yes, they have so many interesting items but for this endeavor we only need one dear Gunslinger."

"And wat iz it?" Cowboy Harris asked.

"We need you to spend several months with The Enlightenment and snag the Ogra Crystal, it powers our craft."

"Without it there will be no Dimensional E state." Said the female blonde.

"And by the rules of The Dimension we would have to put all the agents back to their original worlds, including you!" said the older blonde.

The Gunslinger's world was as 'good as dead', "Sen us were to go."

Chapter 26:
The Meeting of the Enlightenment

Several months later in time…

Cowboy Harris and Indicia had searched for The Enlightenment for several months, stealing items that might have had some sort of interest to the group, but the duo came up with no results. Cowboy Harris leaned back in his chair at his favorite table crafted from rock and dirt within his favorite outer dimensional bar and stared at the beer-ridden ceiling.

"How ya thank the beer gets to da roof?" Cowboy Harris asked Indicia.

Indicia, the small fairy dangled her chocolate feet over the edge of the table and shrugged her shoulders, "How are we going to find these guys?"

Cowboy Harris grabbed his goblet and swirled down the purple alcohol, "We juz gotta find da next item on da list."

Indicia rolled her eyes, "We almost exhausted the list!"

Cowboy Harris was ignoring Indicia because his eyes settled on a curvy blonde beauty. To The Gunslinger her fair skin held a glow, her face held a red blush, her lips full, and the white dress she wore flowed like a flower in the wind, showing strong thick legs as her bare plump feet teased the dirty wooden ground. Cowboy Harris locked eyes and she breezily came his way, sitting across the table, her smile causing the green haired man to react.

"I uzualy don't get such a clean lookin woman as urself comin my way." The Gunslinger said.

Indicia had a feeling she was going need to need cotton balls in her ears tonight.

"I've heard you been looking for my people." The Woman said, "I'm Cassie."

Cowboy Harris sat up, adjusted his hat, and exchanged glances with his partner, "You mean Da Enlightment."

Cassie smiled, her teeth were perfectly white, "The Enlightenment."

Cowboy Harris followed the way of her lips and tongue, it cause him to shuffle in his seat, "Yea, dat's wat I said beautiful."

"My boss has been watching you." Cassie said, "He notices the strange items you're collecting, he wants to know why?"

Cowboy Harris smiled, "Cuz I'm tired of bein stuck on dis planet, I want adventa. A man such az meself needs sometine to grasp him."

Cassie smiled, "We need someone like you, someone we can send to the field and collect items that are too dangerous." Cassie leaned in close, so The Gunslinger could smell her breath of peach scent, "Someone like you, strong, quick, and handsome to scour the land for our organization." Cassie's manicured hand rubbed Cowboy Harris's shoulder, "It be nice if little old me had a nice strapping young man to come to her side every night."

Cowboy Harris looked into Cassie's full vanilla cleavage, knowing it was all a trick, but if he could get a taste of what was under that dress, this mission was all worth the risk, "U got yaself a gunslinga!"

Chapter 27:
Terror of the Warlord

Present time…

By the time The Gunslinger reached for his
revolvers, The Warlord's blade was already flying
towards his neck, but Tasia Snow and her white
double bladed pole The Fear Factor halted the
sword's progress. Tasia couldn't believe how much
The Warlord looked like Juliet, it almost felt wrong
to attack. Using The Fear Factor, Tasia pushed the
woman back and an arrow of lighting pierced into an
opening in The Warlord's armor. The Warlord
screamed in pain, as she felt her body sizzle, but with
the ferocity of a beast she tore the arrow out.
Cowboy Harris shot both his revolvers at The
Swordswoman but the Warlord was quick enough to
leap into the air.
 However, Cowboy Harris wasn't aiming for
The Warlord. The bullets smashed into the ground
and vines immediately burst from the floor. The
Warlord landed with a swish of her blade, cutting
through the growing flora. One vine had appeared
from behind The Warlord and began to bind her.
Ginger shot two bullets towards the trapped woman,
where Tiana had shot just before and they watched as
The Swordswoman convulsed from the pain.
 With another terrific scream, The Warlord
broke from the bondage of the vines. She sprinted
forward and brought her blade downwards, making
contact with Tasia's weapon. The collision of blades
locked the two in a dance of slashes, ducks, rolls, and
parries. The two had fallen into a combat so quickly
and organically it had almost looked like a stage

rehearsal; the way they bounced from wall to wall, bashing each other's weapons, only to roll on the floor and swing their weapons again.

Cowboy Harris shot one of his bullets into the wall and a large branch burst out in the form of a hand, binding The Warlord once again. Tiana shot an arrow, she aimed for the neck. The young girl knew this wasn't her Juliet, there would be no blame for a quick death. However, when the arrow hit, Tiana was surprised, she had goofed, no lightning ran through The Warlord's veins instead ice formed, and it froze The Warlord.

Tiana shrugged, "Either way got the job done."

The Four walked up to the frozen swordswoman and awed at her.

"She really looks like Juliet." Tiana said.

"Gemelos." Ginger said.

"She wuz one of da gud ones." Cowboy Harris reminisced.

"The General finally took over her mind," Indicia explained, "I heard it took several months for him to fully hypnotize her."

As Tiana continued to stare at the warlord of ice, she felt something press into her hand and looked down to see Tasia handing her the blocker.

Chapter 28:
Johnnie's Fight

Johnnie sprinted up the stairs, heading to the third floor. The Wolf was sure The Crows had already taken care of any trouble, which led to the fourth floor where The Mads would be located and then the last floor. The Last floor would probably have The Adversary and the rest of The Homunculus Notebooks. Johnnie just had to get there. Johnnie felt a sense of danger and The Wolf tweaked his head in time to dodge a right kick.

The Wolf was introduced to a masculine figure surrounded by feathers in a glowing cosmic aura. The man was wrapped in white cloth and leather; a turban surrounded his head, with a white mask that held a frown. For some reason, Johnnie felt like he had run into this person before.

The Wolf fell into his boxing stance, fist out in front, and right leg behind the left. The Phantom began to bounce side to side on his toes, his hands dangling, and his form confidently relaxed. Johnnie's senses told him this person was dangerous, so The Wolf attacked first. With the first punch, The Wolf could tell he was on the losing end as The Phantom easily rolled under his attack and scored a swift front kick to the wolf's chest. Johnnie refused to show pain as blood leaked from his mouth and violently turned back towards The Phantom, with a haymaker punch. The Phantom an expert in his reflexes jumped back, dodging the attack then stepped in with a sidekick, and Johnnie heard his bones break.

The Wolf let out a deep howl, as his eyes became yellow, his tail burst, and wolf ears shot out of his locks.

"Good boy." The Phantom teased, "Got any other tricks?"

Johnnie performed a half punch half claw attack, for it to only be surrounded by cosmic feathers and for The Wolf to receive a palm thrust in his back. The Wolf stumbled forward, caught himself, and punched the air with a spin, hoping to get The Phantom in mid-warp. But The Wolf failed, The Phantom appeared to the side and caught Johnnie's arm. In the blink of an instance, The Phantom served over a dozen kicks into Johnnie's body, causing The Wolf to vomit and revert to his human form. Johnnie tried to fight the blackness covering his vision, he tried to stay awake as his body tried to go under from the pain, in the end Johnnie fell to the Phantom. The Phantom picked The Wolf up buy the collar of his armor and the two burst into bright purple and black feathers.

Chapter 29:
Juliet X Sol

"I'm going up to the higher floors." Sol said to the Scrub-Dogs.

"And we will come with." Said Shawn, being a protector as always, "You are our Mistress of Flame and we are your underlings."

"I wouldn't say all that," Star said in protest.

"I got to take care of this one by myself guys," Sol sighed, "If I run into Luna again I jut want it to be me and her," Sol clenched her fist, "No one else this time!"

Sol felt a hand grab her shoulder, "Alright bitch, you can save your ice queen sister but I got some shit I want to tear up."

Sol turned around to see the determined face of Juliet Valentine, "Wha…how?"

Juliet gave a ghastly smile dressed in her typical outfit of khaki baggy fitted pants, a red and black Kevlar tank top, her red and black boots, and her red and black backwards baseball cap, "That Chimera was no problem for a crazy bitch like me." Juliet began to walk up the stairs, "Listen ho, I want to get my blade into that Adversary bitch, it's like a bad itch on my asshole." Juliet wasn't use to saying stuff like this but she was going to say it, "I get it, you want to talk some sense into your sister one last time, besides The Adversary's there, and someone else I want to see too."

Sol knew Juliet was talking about The Warlord, Ron had updated everyone about her from Juliet's battle.

Juliet grabbed the pommel of the Fairy Buster, "How about me and you tear some shit up until we get what we want?"

Sol could do nothing but agree, "You three stay here." Sol told her team, "I'll hit you guys on the Z-Phone."

The Scrub-Dogs agreed and watched the two rivals run into the depths of The Enlightenment.

Chapter 30:
Flame and Blade

During the fight of The True Twins vs. The General many chimera incubators were destroyed. The majority of the incubators held half developed chimera that died as soon as they touched fresh air, but one survived. That chimera was mostly formed, so when its tube was destroyed it took its first breath. The beast during the battle found a set of spiraling stairs and made its way to the first floor.

With each leap, Sol soared through the air, passing over a dozen stairs. During the week between The Hailing Palace and the current mission Juliet had trained with the Fairy Buster. The Young Swordswoman could access a small percentage of its power, causing her to run far above her ability, but since Sol was faster she was the first one to see the escaped monstrosity. Sol gasped as she saw the grotesque beast; it had the head of a bull, a third eye lay between the two main eyes, it had a hairy human body, it's height reached twelve feet, and its stomach formed a second mouth filled with fangs. Sol reacted by Instinct; the redhead leaped and reared back her right fist and covered it in flame, burying her fiery punch into the jaw of the wild beast. Juliet came in with a second attack; The Swordswoman buried the teeth of her blade into the right leg of the creature.

The monster stumbled back, blood dripped from its leg, and it looked down at the small yet brave Swordswoman. The beast threw a quick and massive punch but Juliet jumped back several steps, just barely missing the attack. Sol leaped and gained another punch into its jaw, almost tipping it over the stairs. Juliet sprinted, pink bolts of energy emitted

from her body, and faint pink tribal signs appeared on her right arm. The Swordswoman flashed a mischievous smile as she saw the beast beginning to lose balance and with one mighty scream she swung at the wounded leg, letting her blade cut through it completely. The beast's dark eyes gave a look of concern as it felt itself lose footing and the two girls watched as it spiraled several dozen feet and hit the floor with a loud crack.

"Wait!" Juliet said, "Is that a whole nother dead monster body to the left?"

Sol instantly saw the second chimera body and shrugged, "Guess it is."

Chapter 31:
The Mads Enter the Fray

"Why do you trust those two destructive women, Juliet and Sol?" The Mad Inventor asked Ronald, "They never listen to the mission statements."

Ronald gave a sly smile, "I doubt any of the Black Generations have ever truly listened to me." Ronald said, wiping his bald head of sweat with his handkerchief, "Have you noticed Juliet and Sol are getting along?" Ron's smile grew wider, "Have you noticed Juliet is finally learning to harness that blade?" Ronald turned his attention to the ceiling and leaned back in his chair, "When young people don't listen and rebel is when they truly discover themselves."

"Oh," Trina said, paying attention to the monitor, "The Crows have set the Mini Warp Sphere."

The Crows and Cowboy Harris watched as an orange vortex appeared before them and The Mads began to enter the scene. The first Mad to appear was the Mad Inventor; he wore his usual black and purple Kevlar lab coat, with fitted gray pants, simple black slip on shoes, and a long sleeve black shirt.

"The Crows," The Mad Inventor said with distaste, "I was actually surprised you guys were able to fight a version of your nonsensical leader." The Inventor turned to the Green Gunslinger, "I remember you, the man who has no vocabulary, you disgust me more than them."

Cowboy Harris gave a slight chuckle, "I neva to much kared about how men luked at me."

The Inventor rolled his eyes, "Stick to guns and fairies."

"How about you talk that shit when Juliet is here?" Tiana warned.

The Mad Inventor displayed a haughty smile, "Tch, do you think I fear the woman or any of you?"

"Inventor!" Natalia yelped, exiting the portal with Ginger.

The Inventor looked at Tiana, Cowboy Harris, and Natalia then sighed, "Stay out of my way."

"Sorry about that guys." Natalia apologized.

"No Problem." Tiana said, "Boys can be hard to deal with."

"Si." Natalia and Ginger said in unison, glancing at their respective hard heads.

The Mad Inventor glanced at the frozen Warlord, and began to walk up the stairs to the fourth floor, "Come ladies."

Trina and Natalia waved bye to the Crows and Cowboy Harris and with an exchange of glances between the two partners of The Inventor they rolled their eyes and followed up the stairs.

Chapter 32:
Johnnie Jr.'s Past

Some Time Ago……

"Nigga put this in your pocket!" The Johnnie Senior of Johnnie Jr.'s world put an old leather worn notebook in his son's back pocket, "Now go in the Warp Pad and get the fuck outta here! I programmed it to a world similar to ours, the same with the books!" Johnnie Senior scratched the bald spot in his puffy afro, "Jezzers, these Enlighten fucker's don't play." The Old Man's bloody right hand became engulfed in vines and branches, becoming a cannon of flora, "Go nigga!"

Johnnie Jr. shook his locked head, "I'm not leaving you father." The Wolf locked eyes with his dad, "I'm going to fight alongside you!"

"Don't be a dumb nigga!" Said Johnnie Senior, "If they get you, if they get these books a lot more fucked up shit is going to happen, this is bigger than me and you little nigga."

The door to the lab exploded, revealing three silhouettes. The first one belonged to The Adversary, next was the seductive Cassie, and third was the loyal General in White.

"Old Man Johnnie." Said The Adversary, walking down steps covered in marijuana, "How about we end such things and you give me the books, so I can continue my adventure?"

Johnnie Senior pointed his cannon arm towards the three and shot a blast of bright green energy at his opponents, but due to the strength of The Adversary's wind abilities, he shielded his team from any real harm.

"Just give up old man." The Adversary stated.

Johnnie Jr. rushed The Adversary, his fangs out, his tail and ears stiff, and his claws ready as they landed a jab into The Man of Wind. The Man felt no pain, he had phased into air, completely dodging the punch. The General snapped his fingers and a wild looking girl with orange and green hair, barefoot, and a fierce look in her multicolored eyes seemed to come out of nowhere, stabbing Johnnie Jr. in the chest with several daggers. The Adversary twirled his hand and The Wolf was knocked back, falling into an open blue portal.

The Adversary shrugged, "Looks like I just threw your son halfway across the dimensions."

Johnnie Senior released his rugged laugh, "Just what a nigga wanted." Johnnie Jr. felt like he was stuck in a heavy liquid, it was hard to move, every second he felt like he was being tugged farther and farther away from his world. He could still see his father's lab; he could see The Adversary hold the old man in the air. Johnnie Jr. saw The Adversary close his hand, his father's body twitched and went limp, and then everything went black.

Chapter 33:
The Adversary remembers

Present Time….

Johnnie Jr. woke up with his body sore from healing. He painfully stood erect to find himself standing on white marble. Bookcases, artifacts holding peculiar items, and even some weird statues resembling demons lay around Johnnie. The Wolf realized he was in the treasure room, the fifth floor!

"How are you doing, wolf boy?" Johnnie spun around to see The Adversary holding a crystal skull.

Johnnie snarled, his eyes became yellow, his tail and ears became stiff, and he lunged at the man. The Adversary simply held out his palm and Johnnie was hit with a burst of wind that sent him spiraling back to the floor.

"Do you ever listen or do you just attack like a deranged animal?" asked The Adversary.

"You killed my father!" Johnnie snarled, "Why would I ever listen to you!"

The Wolf tried to get back to his feet but The Adversary waved his hand and wind shot the boy back down.

"Your father was far more rational than you." The Adversary said, feeling the teeth of the transparent skull, "He was a fun man to chase down, he stopped me many of times, besides these Black Shonen kids, he was a constant thorn in my side. Oh, what a day, when The Enlightenment showed up on that nearly drained planet. Do you know if your world is still alive?"

Johnnie growled.

"It's probably gone." The Adversary answered, "Or near gone, that planet was surviving on a thin thread." The Adversary set the crystal skull on its platform, "I think the old man knew that as well. That's why he sent you here."

"My father sent me here to protect the books!" Johnnie roared.

"Are you aware of a parent's love?" The Adversary questioned, "Most will do anything to protect their child. Trust me, that concern, oh, protect the books. Maybe that was a small sliver of why he sent you, but he sent you because he wanted you to have a life."

"Why are you telling me this?" Johnnie growled, getting to his feet once again.

"Johnnie." The Adversary walked up to the boy and put a hand on his shoulder, "You're durable, loyal, strong, Join The Enlightenment."

Johnnie pushed the man's hand away, "Fuck The Enlightenment."

The Wolf let out an angry roar and began to continue the attack on his captor.

Chapter 34:
Return of the Beast

"Julie!" Isaac and Cookie screamed in unison.

"My nigga and bitch!" Juliet responded, "Where's wolf boy?"

"Johnnie went into his emo wolf phase. He's going to the top floor to fight The Adversary." Isaac answered.

Juliet crossed her arms, "That nigga would." The Swordswoman shrugged, "Guess I'll be mee-"

A roar covered up the rest of Juliet's statement, causing the four to turn toward the entrance of the second floor. A beast with the hairy body of a man, the head of a bull, a third eye, a missing leg, and a mouth for a stomach came rushing through the entrance. The monster's horns bashed through incubators, and more undeveloped demons sloppily hit the floor. The rampaging creature was angry, its eyes were red, and smoke steamed from out its nostrils.

"I thought we killed the son of a bitch?" Sol said.

Juliet unsheathed her sword and began to summon her pink bolts and signs, "Looks like we just got to fuck it up one more time."

Isaac gave off his goofy smile as his blades materialized in his hands, followed by bits of magenta lightning and fire emitting from his body, "Ooooh, another monster, this time I won't have to hold back!"

Cookie flicked her wrist and her needles appeared, "The monster looks so cute with its big face belly."

Juliet got the first hit, she was so quick she even surprised her self once her blade bit into the creature's ribs. The monster tried to swat the young girl but Isaac protected her, crossing his blades to block the attack and his swords burned into the creature's skin. Sol's shoes released fire and the girl connected with a flying kick into the jaw. Cookie ran around its remaining leg, causing gashes with her needles into its calf. The beasts opened its stomach mouth and a green snake shot out, it bound Isaac and took him into its depths. The mouth closed with a snap.

"Isaac!" Cookie Screamed, "I'll sa-"

The monster's second mouth exploded with bright bolts of lightning and fire and Isaac came crashing out covered in magenta steam, "Ahhhh I stink now, that monster's insides were gnarly."

Sol had gained altitude again and the heel of her shoe crashed into the beast's head and exploded with crimson flame, making the monster crash into the ground. The monster immediately tried to rise and Juliet swiftly cut off it's other leg, as the monster began to fall forward Juliet leaped again, letting her blade separate the monster's head from it's body.

Chapter 35:
A Meeting of Juliet's

"Isaac, come with us." Juliet said, "I know you want to be by Johnnie's side when he's fighting The Adversary."

The True Twin thought about it for a while, putting his hands behind his head, "I'm going to let Johnnie do this one alone. When he talked to me he seemed really determined and I wouldn't want to hurt my bro's pride." Isaac sighed, "I feel like I didn't help the first time we fought The Adversary, Johnnie might do better on his own."

"Don't worry girls." Cookie said, patting Isaac on the shoulder, "I'll make sure to go with him when he decides to chase his brother."

"You're a strange one True Boy." Juliet turned to Sol, "You ready?"

Sol nodded and the two headed to the third floor.

"You Know?" Tiana said, staring at the frozen body of The Warlord, "The Enlightenment had a version of me as well."

Cowboy Harris nodded, "She wuz a diffikult one." Cowboy turned to look at Tiana, "You madam are much eazier to deal wit."

"I wonder how many other me's there are?" Tiana said, "Shows that were not as individual as much as we thought."

Cowboy Harris didn't agree, "No, lady, even tho there mite be multiple people wit ur face, a true person indivivuality iz da soul, no one kan replicate dat."

Tiana thought about it, "Could be?"

"My bitches!" came the dominant voice of Juliet Valentine.

The Crows and Cowboy Harris turned their faces to see Juliet and Sol enter the scene.

Juliet threw up a frown once she noticed The Gunslinger, "Alright, Ginger are you sleeping with green hair?"

"NO!" Ginger screamed.

"I decided ta trade spotz." Cowboy Harris said, "I ben a spy dis hole time. Now it's time for me to collect an leave."

Indicia nodded in agreement.

Juliet's eyes settled on the frozen statue, "So she had to be put down, eh?"

"I know last time you said she was alright." Tiana explained, "But when we saw her she was on a permanent rampage. I had to take her down."

Juliet walked over to the statue, "Tiana stick in several flame arrows and melt it."

Tasia expected just that reply.

Tiana hesitated, "She was really strong, she took us all down easily!"

"Give me the arrows!" Juliet screamed, "If anyone is truly taking down the bitch I am! I knew The Enlightenment wouldn't let her keep her mind forever. If we gotta kill her, I'll do it!"

Chapter 36:
The Battle of Valentine

Tiana Forest planted several flame arrows into the icy body of The Warlord. The Crows, Cowboy Harris, Sol, and Indicia watched as Tiana's flame rapidly ate through the ice, turning it into warm liquid and watched The Warlord's armor become a glowing red, bringing the woman back to life.

"Get back everyone." Juliet said, once she saw The Warlord begin to blink, "I want me to be the first ho she sees." Juliet Valentine grabbed the pommel of the Fairy Buster, "I still don't know how to use this shit."

The Warlord's blonde eyes sprung to life, blinking rapidly, in seconds they became a glowing crimson. The Warlord screamed as she grabbed her blade, tearing herself from the ice with one mighty swing. The Mad Swordswoman immediately turned her eyes to her younger self and made an animalistic dash for her counterpart. Juliet knew she didn't have time to dodge, so she quickly unsheathed her sword and blocked the first several wild swings. The Younger Swordswoman quickly found out The Warlord was exceptionally strong, each hit of her blade caused Juliet's whole body to shake, each clash caused the girl to step back, each bash caused her confidence to falter. Juliet screamed and her blade began to glow with pink symbols. The Warlord raised her blade and let it fall and Juliet met her powerful parry. The Crazed Warlord stumbled back and Juliet made a quick and clean cut to the ribs.

However, The Warlord caught Juliet's sword with her left hand. The gauntlet of the menacing

woman had stopped the blade from going through but it was deep in her palm. Juliet settled her feet into the ground and spun, yanking the blade from the Warlord's hand. Juliet quickly flipped her own sword and went for the other side of the ribs. The Warlord quickly blocked the second attempt with her blade and kicked Juliet in the stomach, sending her to the ground. The Lord of War rapidly followed up with a downward slash, but Juliet rolled. The young woman got back to her feet and leaped forward, experiencing a quick bash of her blade from The Warlord. The two then fell into a sing-song of slashes.

The Warlord swooped for her opponent's legs but Juliet easily jumped over the attack and tried a swing for the neck in mid jump. The Warlord bent her head back, and Juliet's blade passed by her full lips. The Woman came with a downward vertical slash but Juliet parried the attack to the right and then feeling the power of the Fairy Buster leave she decided she had to end the fight. The Young Swordswoman summoned as much of the remaining power as she could from the enchanted blade and went for a deadly thrust. Juliet heard the blade burst through the armor, rip through the skin, and burst from the back of The Warlord's blackened breastplate.

Juliet reverted to her normal form, her body felt heavy, and she dropped her blade, falling to the floor. The Crows immediately surrounded their leader and Juliet looked at The Warlord, as her eyes reverted to their natural gold. The Warlord fell onto her knees, following a vomit of blood. Tears began to stream from The Warlord's eyes as she tried to reach out to Juliet Valentine. Juliet, also feeling some

type of connection with this woman began to cry too as she crawled for her touch.

The dying Warlord grabbed Juliet by the back of her neck and whispered, "3.332, 5.444, 7.9999, 8.33333, in the Vile Placid Sector."

The Mighty Warlord took another lungful breath of air and fell limp with Juliet's blade imbedded in her stomach. Juliet wiped the tears from her face, stood up, grabbed the pommel of her blade, put her right foot on The Warlord's chest, and yanked the blade out with one powerful movement.

Juliet stared at the body for several seconds and Sol and Tiana put a hand on each shoulder, "Crows stay here." Juliet held back a sob, "Me and Sol won't be answering our Z-phones in case The Society try to stop us. You guys need to answer and cause a distraction."

"But they have cameras?" Ginger said.

"Fuck their cameras." Juliet sniffled, "You ready Sol?"

Sol nodded; Juliet did have feelings, "Let's go."

"Watch out." Tiana said, giving warning, "The Mads are on the higher floor and you know they play by the rules of the Society, even your cousin."

Juliet shrugged, sucked up the last of her snot and smiled, "Fuck The Mads!"

.

Chapter 37:
The Interrogation of the Mads

"Ohhhh, why did we have to come here?" Trina said, holding on to her droopy witch hat, "Why couldn't we get a nice looking place to invade?"

"It's not that scary chica," Natalia said, "plus, you're an alchemist, you can manipulate anything."

"Not my fear!" Trina said.

The Mad Inventor turned around; his multi colored eyes stared down the two girls. Today Natalia had chosen to wear her black Kevlar tank top, the top half of her blue Kevlar jumpsuit wrapped around her waist and her favorite black and gold boots. Trina had on her black short shorts, gray stockings, black shoes and her black button up shirt.

"You women annoy me." The Mad Inventor stated, "I understand we are in a dark room with only a few areas of light, this place stinks, and there are placid pools of water all around us, but as The Mads we have to persevere."

"But it's scary." Trina whined.

"Don't worry." Natalia said, "There's nothing here."

"Indeed." The Inventor added, "It's all in your mind, gain control of such substance."

"But what is that?!" Trina pointed ahead, with tears in her eyes.

The Mads looked ahead to witness a robot in one of the blotches of light the half working lanterns provided. The Metallic being was six foot five, with every fluid movement screeches could be heard, the robot had lanky limbs, and its eye was a solo camera.

"I was wondering when someone would come to test my presence." The Inventor said, pulling out his Plasma Pistols.

Natalia summoned her pink mini dual cannons, "I'll back you up."

Trina with shaking hands, began to make signals, activating her alchemic powers, "Me.m-m-m-m-e too."

The Inventor with no fear of the robot began to walk towards it, unleashing the power of his guns. The robot moved in complicated ways, it's limbs spun, and its body disconnected certain parts and reconnected dodging each bullet. The Robot attached itself to the ceiling, turned its right hand into a blade and leapt for the Inventor. A pink beam arced through the air, but the robot twisted its body like a cat, the last particles of the beam just lightly burning some of its metal.

The robot clashed on the ground with a thud, only for the ground to form into a large mouth, thanks to Trina. The Robot leaped again, falling towards The Inventor who summoned his spider blades from his back. The sentient swords went on the attack, but the robot with it's speed and queer movement turned all his limbs into blades and began to spin as it fell, battling madly with The Inventor's spider blades. While the robot was distracted Natalia got on its left side while Trina got on it's right. The Inventor recognize the combo forming and leaped back.

Natalia bashed her cannons together and let out a pink beam, Trina shot her right hand out in a punch and the wall behind her immediately shifted into a giant fist, flying towards the robot. The

metallic being quickly already calculated that it was too late and let the attacks demolish it.

The Inventor sheathed his pistols, "Well that was quite simple."

Chapter 38:
A True Brother

As much as Isaac True wanted to keep his promise about letting Johnnie handle his own problem, Isaac couldn't shake the feeling his brother was in need of help. It wasn't a fear but more of a sense, but would it be right to hurt The Wolf's pride on account of it?

"You look worried brown eyes." Cookie said, staring up at the boy.

"Well, I totally looked cool and mature telling Juliet I wouldn't help Johnnie," Isaac said, "but know I got this feeling that won't come off, like my bro needs me. Look, I'm nothing but his sidekick in the end but I got to help him."

"Sidekick? Cookie raised a brow, "I see you two more as partners but if you help Johnnie I'm coming with you."

The boy smiled, "You don't have to. It's a True Twin matter."

Cookie pouted, "I thought I was a True Twin, and," The girl looked at her fingers and began to twiddle them, "I like hanging with you, Isaac True."

The boy felt a warmness rise in face and smiled like a child on Christmas, "I like hanging with you too."

Cookie began to understand Isaac a little bit more, "Well, let's go get Johnnie!"

Chapter 39:
A Knight's Pride

"Was it right to let the two ladies go onto their own venture?" Asked Shawn Bolt.

"She's with Juliet Valentine." Star said, with a cross of her arms, "She's safe, chill."

Shawn wasn't to sure, the battles at the Hailing Palace showed The Elf that he wasn't as strong as he naturally thought, was Juliet? Was Sol?

The Young Elf took out his daggers and began to lightly bash them together, "She's our mistress and we should protect her." Shawn also wondered if the losses at Hailing Palace hurt his fighter's pride, he was all but useless in the last mission, being defeated twice by the same person. The Elf began to twirl his daggers, was this all for him? "I'm going." Said Shawn heading up the stairs.

Shadow clapped his hands with a smile, "I'm going too, I was bored."

"Hey!" Star said, crossing her arms and stomping her foot, "We are suppose to wait guys! Why do you two follow trouble like a forty dollar thot!"

The two elves looked back at her and not fully comprehending her complaints continued up the stairs.

Star stomped her little foot again, "Hey, I'm second in command now, listen to me!"

The little vampire watched as her companions went farther up the spiral staircase, she cussed under her breath, and followed them.

Chapter 40:
A Reptilian's Chance

A man with dirty white pants, a red trucker hat, an even a dirtier white shirt with stained white shoes walked upon the first floor of The Enlightenment's headquarters, "Good to be home."

The Man looked at the many bodies laid on the floor, some were burnt, some had cuts, and some look drained of life, "Woooooooo, those little niggers know how to have a good time, I wonder which of' em did this?"

The Man walked over to the kitchen; usually it would be a buffet with all kinds of food but not today, not during wartime. The Man could only wonder what was going on in the higher floors? The mayhem and carnage, it's what The Enlightenment deserved. The Man went into the kitchen, opened the refrigerator, and saw several large pieces of cooked meat, from which animal he didn't know, but he bit it anyway. It was chewy and sweet, each bite felt like he hadn't eaten for years, and when he was done he even chewed and swallowed the bone, making his teeth go from blunt molars and incisors to sharp little knives.

The Dirty Man also known as Paul Savaar let out a huge burp, smacked his lips, and headed to the higher floors, "I'm coming for you O'l Adversary." Paul smiled a mouthful of fangs, "I wonder if Wolf Boy is here?"

Chapter 41:
The Placid Queen

"It's dark and it stank." Sol said, covering her mouth with her left hand and containing a ball of fire in her right.

"I thank dis iz da interrogation room." Said Cowboy Harris.

"So why you following us again?" Juliet asked The Gunslinger, with her hands in her pocket.

"I toldja, I don't work for Da Enlightment." Cowboy Harris said, "My boss just told me to go to da top floor and steal something of importance to dem."

Juliet stared at The Gunslinger cockeyed, "Who do you work for nigga?"

Cowboy looked down at Juliet with a smirk, Indicia's green glow highlighted the young woman's face, it was beautiful yet savage, "Me an dis fairy work fo Da Dimensional Estate, a world that's outtas worlds, my world was dyin, they thought I was useful so they took me as n employee."

Juliet scrunched her mouth up, "If you do anything funny I'm slicing up dick."

Cowboy Harris smiled and tipped his hat, "I promise lil lady."

"Don't little lady me." Juliet mocked, "I see how thirsty Ginger is for you!"

"Uhhh guys?" Sol pointed, "What's that?"

The three looked towards a dying lantern, under the failing light water swirled and twirled into a 3D field. The liquid churned and connected, forming the silhouette of a woman. The water shifted into skin, the three watched as a white dress ragged and smudged in dirt formed on a curvy blonde. The

woman's flesh was covered in grime, some parts of her body were rotted, and her eyes were dim and dead.

"Cassandra?" Cowboy Harris said, walking up to the woman, "Iz dat really u?"

The woman lifted her hands and cascades of placid water formed around her, creating whips around the decaying woman. She raised a tentacle toward The Gunslinger, her face held no emotion. The Woman just stared at the Green Haired Wonder as she brought down her mighty appendage. Cowboy Harris reached for his revolvers but the young man knew he wouldn't make it in time, as he could smell the rancid water coming for him. Suddenly a blazing kick from Sol Pepper countered the attack. Sol blasted toward Cassie with a flaming right punch in the mouth, then a sidekick in the jaw, she finished her combo with a flurry of fiery punches to the stomach.

The Undead Cassie hobbled back, sewage spilling from her mouth. Juliet grabbed the pommel of her blade, ready to attack, but Cowboy Harris acted first. The Gunslinger pointed the revolver towards his old lover, held down the barrel, and pulled the trigger. Cassie's head reared back and the woman hit the water, melting into a moldy liquid.

"She waz a ruckus in bed." Cowboy Harris regretfully stated.

Indicia and Juliet shook their head at The Cowboy.

"Even in the depths," Indicia said with disappointment.

Cowboy Harris made a cross in the air, "Let'z go."

Chapter 42:
Silva of the Dagger

Silva Blanca walked the spiral staircase to the fourth floor. The elf had spent time moving in between the battles of Black Shonen and The Enlightenment. Silva wasn't a fool, he enjoyed a battle but he also enjoyed living. However, the elf was intrigued that the myths of The Knight and his Warlock were true. Heh, they were in this building causing mayhem, like he was told all those years ago. Silva sighed, he was aware this project was over, The Enlightenment was going to fall, these kids were far too determined. It was time to go the fifth floor, steal a Warp Pad and make a life in another realm, but as the elf saw the entrance to the fourth floor an explosion caused him to stumble. The elf looked back seeing magenta smoke everywhere and a cornrowed boy ran up to him with huge brown eyes.

"Hey Shawn!" Isaac True said, once the boy got closer he began to realize his mistake, "Your not Shawn, huh?"

"No he's not." Cookie said, walking past Isaac, "Using the shortcut to skip the third floor, I thought we might miss him," Cookie began to feel an excitement enter her frame, "His name is Silva and he owes me a fight to the death."

"Do you really want to do this now young girl?" Silva said with a smile, "I have things to attend to."

Cookie flicked her wrist, summoning her needles to her fist, "Oh, Silva, before I leave here and go with my Isaac it will be such a pleasure knowing I defeated you."

Silva reached into his kimono pulling out his daggers, "Killing you will be a form of 'art'."

"Isaac." Cookie smiled, her eyes glowing crimson, saliva gushing over her tongue, and her body tensing, "Stay back."

Isaac obeyed, stepping several steps back, not really knowing what was going on, "Cool beans."

Silva bent down, "I hope you enjoyed this life."

The two fighters locked eyes with each other and sprinted toward one another. Isaac wasn't able to tell who made contact first, all he heard was the sound of metal upon metal. The fighters were silent as they spun and jumped between each other deadly dances. Silva thrust and Cookie spun. Cookie went for a slice to the face and Silva elegantly moved his head back. Silva went for a horizontal slash to the chest and Cookie parried. Cookie went for a slash to the face and Silva parried. With a spare second of freedom, Silva scored a cut into Cookie's face, and crimson spilled on the stairs.

"This is really fun!" Cookie squealed, the adrenaline in her body taking over, the crimson in her eyes burning brightly, "I want it to last forever!"

Chapter 43:
An End of a Friendship

"The Adversary is a man of wind." The Mad Inventor preached, "We need to think of anti-wind tactics." The Mad Inventor crossed his arms behind his back, "We cannot let him use his abilities!"

Trina and Natalia could tell The Mad Inventor was a little nervous; The Inventor's hands shook, there were light traces of perspiration on his forehead, and he seemed more on edge than normal.

Natalia put her hand on The Inventor's shoulders, "Everything is going to be ok."

The Mad Inventor angrily looked back at Natalia and moved his shoulder away, "We can't live on hopes and wishes, we have to plan for everything."

"Red!!!!!" Trina squealed with delight "Is that you?"

Trina pushed through the two inventors to see her friend float down upon the stairs but something was different. The Heroine sported a frown upon her face, her pupils were nonexistent, clothes of blue ripped jeans, a black shirt with a red U, and sneakers seem ragged and dirty.

"Red?"

The Heroine's hand shot out, wrapping around Trina's throat. The Witch was surprised as the hand tightened, cutting her off from oxygen. Trina was too much of a friend to hit the redhead, so she tried to pry The Heroine's hands off, but the girl's fingers felt like stone. The Witch could feel her head get light and her knees grow weak, traces of darkness began to fill her vision, but four bladed legs erupted from behind Trina and pierced The Heroine

in her chest and shoulders. Two bullets of plasma also collided into the redhead's face, causing her to stagger back and lose her grip on Trina's throat. Coughing, Trina swirled her hands and quickly raised them up, causing the granite of the stairs to rise around The Heroine and trap her in a cage.

"Natalia," The Mad Inventor ordered, "Blast her, full power!"

"No!" Trina said, jumping in front of the cage, "She's my friend!"

"Yes, Yes, I'm aware you two made some sort of comradeship back in the temple." The Mad Inventor turned to the angry redhead, "But obviously, The Enlightenment has ruined any sense of self she once had."

"It's sad." Said Natalia.

Trina looked as her friend punched the cage fist after fist, each time cracks spread through out it and Trina quickly reinforced it, "What's wrong? What did they do to you?" Tears began to fill up in Trina's eyes, "We were suppose to paint our nails and talk about cute boys."

The Heroine head-butted the cage and let out a roar only to head-butt it again.

"Oh," said a voice, "You caught our experiment."

The Mads looked to see a woman with pale skin, and white hair. The woman wore a blue dress that hugged her petite frame and a set of white pearls circled her neck. She seemed like she should had been an older woman but there was an aura of youth about her, and when she walked up to the three she licked her lips in considering how tense the teenagers appeared.

"I have grown exceptionally tired of you children." Said The Lady With Pearls.

"And I'm tired of all these fucking people in my way!" screamed Juliet Valentine, sprinting up the stairs, her right hand on the handle of her blade, and ready to unsheathe it.

The Lady with Pearls smiled at the newcomer and her two companions and raised her right hand that had a peculiar silver bracelet with a blue jewel and snapped her fingers.

Chapter 44:
The Defect of Cookie Dough Cream

Cookie twirled and slashed tearing into the skin of Silva. The elf could feel the fight getting away from him. This girl was too fast, too deadly, and too wild. Silva wasn't even sure she was aware of what she was actually doing? The girl let out high pitched scream of delight as she knocked a knife out from Silva's hand, with a thrust she entered his chest and watch as the elf eyes grew wide in surprise.

"You like that." Cookie whispered, "You like when I push it inside." Cookie shot her other hand into the chest as Silva moaned with pain, "Yeah, let me hear it, let me hear your death moan, that's all I want."

Cookie raised her foot and kicked Silva in the chest, causing him to splash in the sand. Cookie stalked over to him, her needles dripping with his lifeblood, her eyes becoming crimson orbs, her face flushed with adrenaline, and her body needy for a kill. The young woman sat onto Silva's bloody chest, raised her right hand in the air equipped with needles and went for the strike, but a hand grabbed it.

"Cookie!" Isaac yelled, "That's enough!"

Cookie looked up at the boy and growled, then with a flip of her arm Isaac crashed into the night-covered sand. Cookie turned towards The cornrowed boy and sat on his stomach before he could get up, she raised her needle hands, and Silva's daggers pierced her chest, with an agitated grunt the elf threw the girl's body like a ragdoll, where it hit the wet sand, and the salty ocean passed by her lips.

"Why did you do that?" Isaac screamed, getting to his feet, "I stopped her from killing you!"

Silva smiled, gaining his breath and wiping his hands through his hair, "Boy this is war, not some game where you can yell stop."

Isaac began to find himself growing angry and summoned his blades to his hands, "I'm not going to kill you." Isaac said, as magenta lightning and fire circled around his body, "But I am going to destroy you!"

Chapter 45:
Castle of the Moon

"What in the fuck?" Juliet said, looking at the night sky and three pink moons.

"Where are we at?" Sol said, turning around to see tree after tree, "How in the erased did we get in a forest?"

"Prolly one of da Enlightenment's Inventions." Said Cowboy Harris.

"Wouldn't doubt it." said Indicia.

"It's an Interdimesional Transporter, "Said the lady with Pearls, coming from behind a tree, "One of the many Inventions that we stole."

Juliet unsheathed her blade, Sol summoned fire to her hands, Cowboy Harris grabbed his revolvers, and Indicia got ready to use her sting blast. The Lady with Pearls smiled and zipped off her dress, exposing her naked lithe body to the group.

Cowboy Harris's mouth dropped.

Indicia pulled The Gunslinger's ear.

Blue fur began to cover the woman's body, her nails became black as coal and grew extremely long, her teeth turned sharp, her body made popping noises as she convulsed and lastly her ears shifted into that of a feline. The Woman smoothly switched to all fours and sprinted towards the three.

Sol made the first move; fire flashed from her right jab as the Cat Lady performed a front flip. The Feline Woman landed behind Sol and performed a spinning kick into the girl's head. Juliet's blade came in with a downward swing, but the sword's jagged teeth hit dirt as The Cat leaped. Cowboy Harris chose to shoot bullet after bullet, vines and branches swirled and twirled trying to impale the woman, but

she easily ran, jumped, and flipped, barely missing the flying projectiles of The Gunslinger. Sol decided to chase after her, using her Flame Boots to their fullest of potential, each blast lit up the forest, as she tried to catch up with the quicker woman.

The Cat Lady looked back to see Sol leaping after her, so she decided to run up a tree. It didn't matter to Sol who easily followed the woman, cutting the power from her shoes at the exact moment to blast again and follow with precise accuracy. The top of the tree covered in leaves was large and expansive, branches made multiple paths and connected to other trees, giving the place a labyrinth type style. Sol sighed, and continued her searching, leaping from tree to tree, trying not to use too much power to not catch the leaves on fire.

In mid-leap, Sol felt a kick to her face, the girl spiraled downwards, her face bashing against branches, her body bruising with each smack, until she slammed on onto the ground. The Cat Lady landed on the redhead's stomach, only to jump back again as Juliet's blade swung at her waist. The Cat Lady landed on Sol's stomach for a second time and leaped away before Juliet's sword could even touch her, sprinting into the forest.

"Could you watch what the fuck your doing?" Sol angrily screamed, rising to her feet, "I don't know if you saw but she was jumping on my stomach like a trampoline."

"Oh well, bitch." Juliet said with a wave of her hand, "You're alive aren't you?"

"I swear Juliet." Sol cursed.

"Ladiez." The Gunslinger intervened, "We shuld wurry about da cat rite?"

Sol and Juliet angrily exchanged glances and the team chased after The Cat Lady.

Chapter 46:
The Inventor Experience

"What, What in the-" The Mad Inventor knew a few seconds ago he was fighting on a staircase.

Now he seemed to be in a desecrated castle; the floors were black, webs covered the ground, the air smell of must, the walls rotten, and bugs moved around everywhere.

Trina rubbed her neck, "Where are we?"

"Esa mujer." Natalia said.

The Inventor began to grow irritated as he played with the triggers of his guns, "I'm going to dissect the woman and the girl."

"She's my friend!" Trina screamed.

"She's nothing but an obstacle in my way!" The Inventor claimed.

"Your so," Trina furious and with tears grinded her teeth, "you're a…a…a…fuckboy!"

The Inventor didn't care, "Do you think your poor dialect is going to affect me?"

"Hey!" Natalia said, used to being the mediator between the two, "How about we complete our job and look for the redhead, ok?"

The Inventor didn't answer, he simply walked away, "I'll go to the bottom floor, you women can check the top."

Once again, Natalia was pretty sure she had saved her team from dissolving, rubbing Trina's back so she could calm down, the girls walked up the stairs.

"He's so stupid." Trina whined, "You know I don't even like cussing, it's more Juliet's thing."

"The Inventor can be rough, but I think he's just scared." Natalia answered, "I think this has been our most important mission and all the stress is really getting to him."

Trina looked at Natalia, "You sound like his girlfriend."

"No I don't!" Natalia blushed, "Me and The Inventor? Does he even like people?"

"No." Trina said, wiping away her tears, "Just his stupid machines."

The two girls laughed.

"I bet he's talking to them right now." Trina said.

Chapter 47:
No one plays with The Magenta Swordsman

Silva parried an energy blade, his hands felt the intensity of the sword. The elf spun, parrying another blade, but he could feel his skin roast with every connection of Isaac's weapons. The elf didn't know who was worse, Cookie with her speed and agility, or this boy with his ferocity and endless stamina. Silva parried a right swing; Isaac's energy ate through his skin. Isaac performed a downward swing, Silva spun; the elf could feel the heat just pass by him. Isaac let out a scream as his left blade came near the elf's neck. Silva ducked and tried for a low kick, but had to turn his body to miss a stab coming at him from Isaac. Silva didn't really like what he was about to do but he wanted to survive and with his foot he quickly kicked up sand into Isaac's eyes.

The boy was temporarily blind, on instinctively Isaac's swords evaporated so he could get sand from his face and Silva stood up with a smile and performed a running thrust. The sound of metal against metal rang in Isaac's ears.

Silva was intrigued, "Your still alive young lady?"

Cookie pushed back against the daggers with her silver needles and gave a giggle with her multi-colored eyes, "I haven't ran out of lives yet?"

Cookie performed a straight kick into the elf's stomach, and added a combo, a right kick to the temple. The elf staggered and shot out a swing with his right dagger but he easily missed entirely and received a stab straight in the shoulder.

"Now that I have you close and right where I want you Mr. Elf, I think you should leave now."

Cookie giggled again, "This fight is done though and sadly I can't kill you or Isaac would be highly upset." Cookie stepped up on her tippy toes and whispered, "Just drown yourself after I stab you then I won't be to blame." Cookie pushed her needles deeper into the elf's shoulder and Silva seethed with hatred for the girl, "You might have been trained to kill little Silva, but I was made to kill."

Cookie jumped into the air and bashed her shoes into the Elf's face. Silva hit a protruding rock on the back of his head while falling and tumbled into the darkness.

"Isaac?" Cookie turned around to see Isaac desperately trying to get sand from his eyes, "Here."

Cookie took the boy's hands leading him to the beach water and filling her hand with the cold liquid she poured it into Isaac's eyes.

"Thanks Cooke." Isaac said, as his vision began to come back, "Are you ok?"

Cookie smiled at The Young Swordsman, "Yeah, sorry, sometimes when I fight I get a little too tuned in."

"It's fine." Isaac said, "So does Johnnie."

Cookie nodded, "I'm lucky to have you as my friend Isaac, not once have you judged me."

"Why would I?" Isaac said, sounding confused, "Your cool, you can fight, have style, and you seem to be really open about videogames!"

Cookie blushed and stared down at the clear water, she liked seeing her and Isaac's reflection next to each other.

"Um, Cooke's I got one question though," The boy looked around noticing the black sky with many stars and three pink moons, he also noticed they were sitting on a beach, there was a forest

behind them and farther back an old black Victorian
Castle could be seen, "Where are we?"

Chapter 48:
A Person Destroyed

The Mad Inventor walked down the abandoned stairs of the castle, thinking to himself about the task at hand. If he disobeyed his orders and fought The Adversary with his team would he win? How many risks was he taking? The Mad Inventor grimaced while moving his hands in his pockets. Did he act too rashly? Did he let Juliet and her brash attitude get the best of him? No, he couldn't, he was The Mad Inventor; no one could top him in gadgetry and intellect. He always made the right decisions.

The Mad Inventor looked round the castle, at the stained walls, the rotten pictures, the bugs scurrying among the floors, it was all empty.

The Inventor sighed, "Why aren't you pestering me now?"

"I don't think The Mads would have stayed together without you Natalia?" Trina said.

Natalia smirked, "Really?"

"Yeah, you kind of keep everything together." Trina admitted, "More than I ever could, you're really good at dealing with the madness The Inventor brings."

"I've come from a kind of rough background." Natalia had forgotten about those days, "I've dealt with men like The Inventor, he just needs for someone to show that they care."

"Do you care about The Inventor?"

"I think this is the top floor?" Natalia said, opening the black door.

The wood creaked as the two walked in, a single large window let the pink light of the moons

spill in to the rectangular room. Trina looked up to see silver spider webs decorate the ceiling, she saw things crawl and white glowing eyes peek at her. Natalia saw a person huddled in the farthest corner. Trina noticed the person seconds later by sighting her red hair. The young woman held her bright head and moaned as tears ran down her face, then she banged her head on the rotted wood.

"It's alright." Trina said, inching her way toward The Heroine with an outreached hand.

"Don't." The girl moaned, "Please…I'll…. I'll…. hurt…you."

"No you won't." Trina's hand began to shake.

"He'll make me." The Heroine whispered, "They've made me kill so many innocent people…I…I…I…" tears began to pour more rapidly as the ex-super heroine stared at the black wall, "I can still hear them crying when I tore their flesh apart, I can still smell the cooked meat of human bodies."

Natalia summoned her pink dual cannons.

The Heroine turned her tired eyes toward Trina, "After I met you, I…I…I began to remember things of my world." the girl sucked in her snot, "I remember people use to look towards me for protection, not anymore." The redhead began to shake her head, "Not anymore. Not anymore. Not anymore. Not anymore. Not anymore. NOT ANYMORE!!!!!!!"

Chapter 49:
The Great Cat Chase

Juliet Valentine didn't know how long she was going to be able to keep using the Fairy Buster. She knew using the weapons abilities put a heavy strain on her body but the girl was one to be reckless. She was going to be seen as a serious agent within The Society, and no one was going to tell her different. Using the small percentage of the sword she had unlocked, the girl was able to keep up with the sprinting Cat Lady.

The Feline Woman looked at Juliet surrounded by the pink strands of energy coming out of her symbol-covered arm. What power was this girl using? Whatever the power was it gave her abilities a tremendous upgrade. The Feline Lady watched as the young girl weighing no more than a hundred pounds grabbed her large jagged blade and with both hands swung in aiming a horizontal swipe. The Feline Lady leaped over the attack and in mid-air looked to her left to see Sol Pepper with a blazing kick, the feline twisted, dodging the fiery attack.

"Did you not just see her jump over my attack?" Juliet screamed, "Why would you try the same shit?"

"Because it be the quickest way to stop her!" Sol screamed back.

The Feline Lady laughed and continued running from the girls, *in the end they were stupid kids she thought.* The ground erupted, lurching the cat lady forward. The Hybrid woman twirled, but she was caught by vines that raised her into the sky and tightened around her limbs. Cowboy Harris smiled as

a separate spire of vines brought him level with the trapped Cat Lady.

"Ah, wat did I katch hur?" The Gunslinger smiled, "I thunk I got me a keepur?"

The Feline Woman held a blank expression, "Do you really think I'm trapped by something so elementary?"

"Theres nuthin elemteray bout dis darlin." Cowboy Harris said.

"You sure?" Indicia asked.

Cowboy Harris ignored her, "Now take us bac to yer mansion." The Gunslinger put a revolver to her face, "Or we gon see wat a kat luk like as a plant."

The Lady with Pearls was a woman with many schemes, many alternate routes, she would never be caught by simple fools such as children. When her body began to enlarge a hefty chuckle left her mouth, her blue fur fully took over her body, her hands became paws, horns burst from her forehead, her teeth became blue fangs, and she easily ripped through her prison made of plants.

Cowboy Harris glanced at Indicia and shrugged, "I fogot she could do dat."

Chapter 50:
The Heroine's Fight

"NOT ANYMORE!!!!!!!" The Heroine rushed by Trina and grabbed Natalia by the throat.

Natalia put her mini cannons on the side of The Heroine's head and fired. The pink energy covered the redhead and Natalia smelled burnt flesh but when the attack was over The Heroine's head was still untouched, besides the pink smoke emitting from her skin. The angry redhead threw Natalia into a wall and began to summon her fire vision but the floorboards around the ex-heroine wrapped around her body and eyes like a snake.

"Stop!" Trina said, as her fingers twisted, trying to keep The Heroine still, "We can help you!"

The Heroine screamed, Trina twisted her fingers, the floorboards bent back, and let The Heroine release her fire through the ceiling. Natalia wasted no time and even through her pain pushed the triggers of her cannons, hitting the redhead once again. The floorboards peeled from The Heroine's body as she crashed through a wall.

"Perra." Natalia said, taking herself from out the wall.

The two girls looked through the hole to see The Heroine rise from the wreckage, the girl floated in mid-air, her eyes two balls of flame. Regretfully, Trina clapped her hands together and two blocks of wood from opposite walls crashed upon the redhead, but in the end they had no effect. The Heroine flew from the debris, tackled Natalia and began to choke the girl on the ground.

"Stop!" Trina yelled, "Can you just stop I don't want to hurt you?!"

Natalia released blast after blast from her cannons but it was useless, each time the blast would show no results and Natalia would feel more pressure on her neck. Natalia didn't know what to do and tears began to pour from out from her eyes in frustration.

Unexpectedly, Natalia was hit with a wall of blood. The Mad Racer through her stinging eyes saw four silver blades pierce through the heart of The Heroine.

Chapter 51:
Who is this Man?

Isaac and Cookie's battles were done. The two sat on the edge of the beach letting the water run up to their fingers and like all teenagers do, they released their emotions through conversation.

"The Stars." Cookie said, "I like them, light always hides them, but they are light, weird right?"

Isaac nodded, "Even before I hung out with Juliet and them I was always aware the world was way more than what I was shown. I always knew there was an adventure in the background behind normal life, waiting for me." Isaac smiled, his eyes staring at the triple bright moons, "I'm happy I met you Cookie, Juliet and everyone else, before Johnnie I don't think I had anyone I could call a friend, and now I have many." Isaac sat up, and dusted the sand from his pants, "Cookie we got to get out of here and help my bro, I can't play around."

Cookie was enjoying the alone time with Isaac, it was nice, he was nice, but in the end she guessed he was right, they couldn't play in paradise forever, "Well direct me out cause I'm just as lost as you."

"How about we ask the guy walking up to us on the beach?" Isaac asked.

Cookie immediately went on the offensive, grabbing Isaac's hand with her right and summoning her needles with her left.

She glanced at the man, "We need to run."

"Why, is he an Enlightenment member?"

"Yes," Cookie said, "One I could never beat in a fight, even though he's dead."

"Dead?" Isaac asked, "He's a zombie!"

Cookie nodded, "Yeah, name use to be Chad Rockwell, heard he was a pretty high ranking guy in The Enlightenment. When Sol and Luna escaped and came to you guys on a mission he tried to get them back. He came back a shadow of what he was, so they made him an undead soldier. Chad is pure battle instinct in style." Isaac felt Cookie's hand shiver, "They had me train against him a couple of times, never won, even when I lost it." Cookie looked at Isaac and for the first time the boy saw fear in her face, "I'm too tired to fight, he'll kill us both."

Isaac True understood, released Cookie's hand, and walked up to Chad. The man at one point had a handsome face, but now it had black and green moldy splotches, his sandy wavy hair was still intact, his body decaying yet still had muscle, his clothes were bright white pants, and white boots, his right hand held a slab of metal connected to a pommel.

Isaac materialized his blades, "The name's Isaac True and I'm The Magenta Swordsman!"

"Isaac!" Cookie pleaded

Isaac looked up to see the zombie flash a smile, "Now, let's see who the real Swordsman is?"

Chapter 52:
The One Armed Death Knight

Juliet Valentine and Sol Pepper watched as
The Lady with Pearls shifted into a slender, and
seductive feline, with horns protruding from her head
and tail, her blue fangs dripping with saliva, and her
height on all fours reaching an intimidating forty
feet.

Juliet knew what she had to do, "O Romeo,
Romeo," Juliet chanted, "Wherefore art thou
Romeo? Deny thy father and refuse thy name. Or if
thou wilt not, be but sworn my love And I'll no
longer be a Capulet. 'Tis but thy name that is my
enemy: Thou art thyself, though not a Montague."

Sol hid a giggle, Juliet sounded so scholarly.

A swirling orange vortex appeared in the sky,
the sound of a boom could be heard, white
thunderbolts shot out from the orange portal and a
mechanical knight fell through. Juliet smiled as she
watched her mecha fall upon the land in front of The
Giant Cat Lady. It hit the earth with a quake, as its
cloak flowed over its body. It was in a kneeling
position, facing Juliet. The young woman ran to her
robot, The Giant Feline saw this and raised a massive
paw to stop the girl, but just then a green bullet shot
into the claw, trapping it in vines. The Feline looked
to see The Gunslinger standing on the branch of one
of the many trees, tipping his hat as his fairy stuck
out her tiny pink tongue.

Juliet climbed the rope ladder, jumped into
the seat, and activated the robot. The rope ladder
retracted, the doors slammed, three holographic
screens appeared in front of her, and Romeo The
Mech Death Knight rose to its feet. As Juliet checked

the joysticks she slapped her forehead, how could she forget?

Sol slapped her forehead as well, "Why in the erased does it only have one arm?!"

Chapter 53:
Shawn Bolt vs. Tiana Forest

"What mayhem struck here?" Shawn Bolt asked, analyzing the fourth floor.

"There's blood everywhere." Star said, a little excited.

Shadow walked up to the walls, "ooohhh, look at the deep cuts."

Shawn's eyes grew wide when he saw the body on the floor, "Sword Mistress!"

"It's not her." Shawn looked up to see a confident Tiana Forest with her two comrades Ginger Snap and Tasia Snow behind her, "It's an alternate version of her from another world, Juliet already took care of her."

Shawn looked down at the body again, understanding what was taking place, the elf nodded, "Oh, well me and my party will be going."

Tiana shook her head, "Going where?"

"To help our mistress." Shawn said.

"She's got Juliet." Tiana said, "She's fine."

Shawn could sense the defiance in her voice, "Doesn't matter, we will be taking part anyway."

As second command of the Crows, Tiana had to make a stand; "You will be infringing on our leader's duty. She only wants a few up there to handle The Adversary, the rest of us are going to serve as a distraction to The Society."

Shawn smirked, "And I have a duty to my mistress. The Scrub-Dogs and I will be going."

Tiana rapidly loaded an arrow to her crossbow and pointed it at Shawn, "You're staying here under Juliet's orders."

Shawn rapidly grabbed his black bow, "Do you truly think I will be such easy prey?"

Tiana smiled, "Yes."

The girl released an arrow of pure fire, Shawn quickly easily back flipped over the attack, landed on his feet and released his own arrow. Tiana rolled, but still felt blood leak down her arm, Shawn had another arrow in the air before she could follow it. The projectile scratched the side of her arm and it felt like embers imbedded into her skin.

However, Tiana was Juliet's right hand woman, the one that kept everyone together and followed Juliet's rule when it made sense. What would it look like if she lost? Tasia, Ginger, and even Juliet would see her as weak. She would defeat this elf.

Tiana screamed, releasing an arrow that took the form of a creature of fire, spreading its wings and releasing a screech at The Elf. Shawn rushed the creature, sliding on his knees under the beast and releasing an arrow that barely missed Tiana, scratching her cheek. Tiana aimed for the elf's chest, Shawn leaped, and came down on Tiana with his daggers to her neck. The girl didn't even see the switch of weapons take place.

"Let us pass." Shawn stated.

Tiana grimaced, "My team is coming too."

Chapter 54:
Luna

Sol watched the battle of Romeo attacking The Feline Lady within the depths of the forest. The trees were uprooted, Romeo's giant blade caused wind to whip, the screeches of the robot played on the ear, and against the three pink moons and night sky the whole scene looked like a wild fairytale to Sol Pepper. As the redhead continued to watch, she began to feel a cold shiver travel up her spine, bits of snow began to fall on Sol's face and the girl turned around to see her sister, Luna Pepper.

Luna floated within the snow, wearing her dress of ice, rocks, and dirt. Luna's hair was silver and filled with icicles, the girl's skin was pale almost blue and as her eyes settled on her sister an angry smile came to her, she said, "My dear sister, alone, in a foreign world were she will die. They resurrected Chad, we are happy, but whenever I mention your names he hides in fear. I will correct that."

"I've been waiting for some action." Sol's hands became fireballs, "I only came here to kick your ass and kick The Adversary's ass for abducting us." Sol's boots exploded with flame, vaulting her towards her sister, "It's time for you to get melted, bitch!"

Sol started off with a fiery jab, but Luna sidestepped and sent a kick surrounded by ice into her sister's stomach. Sol stumbled and then spun with a roundhouse kick of flame. Luna ducked and then screamed, trying to freeze her sister. Sol's fire kept her safe and an uppercut landed in Luna's jaw, followed by a front kick sending her crashing into a tree.

"Luna we don't have to do this!" Sol spouted, "I don't enjoy beating the fuck out of my sister!"

Luna got to her feet, and wiped icy blood from her mouth, "It's always you Sol, you believe you're so strong, so powerful." Luna's hands shifted into swords of ice, "I will defeat you! I will be the stronger one!"

Luna madly flew towards her sister and went in for a forward thrust. Sol punched the blade, exploding it into liquid. She quickly grabbed her sister's wet arm and hugged Luna Pepper.

"Please." Sol said, with steaming tears, "Please, Luna be my sister again."

Luna could feel the warmth of Sol, and her knees grew weak, her eyes released freezing tears, her weaponless arm embraced her sister, it was nice to feel her warmth. It was nice to feel a natural love. Luna raised back her bladed arm as the two cried and stuck her icy blade straight into Sol's chest.

Chapter 55:
Victory!

"Feline Bitch!" Juliet Screamed.

Romeo slammed his jagged sword upon the ground, just barely missing the large cat. The cat quickly turned around and bashed it's back feet into the robot's head, but Romeo spun his blade, nearly taking off the creature's head. The cat let out its queer womanly roar and jumped on Romeo, sinking its teeth into the robot's neck of cords and gears. Sparks emitted from The Mechanical Knight as The Cat Lady put on more pressure with its mouth. With a missing arm, Juliet knew she was in trouble. She quickly jerked her working joystick to the side and Romeo mimicked the movement, causing its blade to sink its teeth into the cat's back.

The Large feline leaped off and Romeo immediately raised his sword and scored another hit into the creature's back. Even Juliet could feel the pressure of bones breaking. The cat's head lurched forward, puncturing Romeo's remaining arm. The Feline Lady jerked her head causing cables to disconnect and sparks to fly into the night, but Juliet didn't care. She jerked her joystick back with both hands and Romeo raised his one arm will all its mechanical strength. Juliet let the joystick go and the sword slammed into The Feline's back.

The Cat Lady released her hold with a scream; Juliet pulled the joystick back again and let it go. Romeo's arm flew downwards, butchering the cat creature in two. Crimson blood flowed like an ocean throughout the forest, a wailing went through the air, and in her human form The Lady with Pearls looked up at Romeo. The giant knight loomed over

her, with its cloak swaying with the night wind, she swore the robot took pity on her in her final moments and as she closed her eyes Juliet Valentine stayed on her mind.

Chapter 56:
Isaac True Struts his Stuff

Isaac ducked Chad's massive blade and pointed his sword to the Zombie Swordsman's chest, releasing a blast that threw the fighter back, but it didn't matter. Undead Chad rose with sword in hand and rushed Isaac True. The boy blocked his charge with a crossing of blades and another explosion sent Chad crashing into the sand, but the zombie didn't stop, no matter how many times they clashed and Isaac exploded, the creature would come back with a ferocious roar and go back to wielding his blade like a madman, as Isaac ducked and dodged.

The lively, young swordsman found a gap in Chad's undead swordsmanship and gained a cut into the man's stomach, maggots and bugs poured out, followed by a disgusting stench. To Undead Chad none of this mattered, he thrust his blade towards the boy. Isaac leaped to the side and using both blades sent two beams of energy into Chad. The explosion took large bits of skin off and Isaac could see the black rooted bones of his opponent. The Zombie slammed his sword down as Isaac rolled and stuck his swords in the ground. Magenta veins traveled through the sand and erupted under the undead. Magenta fire and lightning tore through Chad's body, charred his bones into ash, and the last thing Isaac and Cookie heard were the dying moans of a once handsome man.

"That…. that…?" Isaac blinked several times, "He was dead right, it doesn't count as a person right?"

Cookie jumped on The Swordsman, wrapping her arms around his neck, "Wow! You actually beat

Chad!" Cookie began to look over Isaac's body, "Is everything good?"

Isaac nodded.

Cookie blushed, realizing how she was acting, "Sorry, it's just you're my only friend and I didn't-"

Isaac looked at Cookie and gave a tired smile. Cookie could feel his hot breath, his hands felt warm, and she could feel the callouses on his hands from his sword training.

"I am your friend." Isaac said, grabbing Cookie's soft and sweaty hands, "and we will always have each other's back, ok buddy."

Cookie nodded, her ponytails bouncing with her head as she smiled, "Isaac, I will always protect you."

Isaac looked at the three moons, he knew Johnnie was in deep trouble but, "You want to chill for a little longer?"

Cookie nodded, and stayed lying on top of Isaac, she liked being so close to someone who had protected her on numerous occasions. Isaac was wild, brash, naïve, a little crazy, but she was gaining an admiration for the boy.

"Ok, Cookie, only like five minutes?" The boy reminded, "Cause you know, Johnnie's probably getting tortured."

Chapter 57:
The Heroine The Unbeatable

Natalia looked up at The Heroine. The redhead showed no pain as slender blades hefted her into the air and slammed her upon the ground.

"Be careful!" Screamed Trina.

The Mad Inventor frowned, "Tch, You women hold no bounds of friendship," The Mad Inventor pointed both his pistols at The Heroine, "She tried to kill you and here you are pleading for her life." The Mad Inventor snarled at The Alchemist, "Trina, this is why I've never liked you."

The Frustrated Inventor put his fingers on the triggers, but The Heroine rose with the blades still inside her and rocketed to the sky, crashing through the window, and dragging The Inventor with her.

Trina sighed as she watched The Inventor laughing in hysteria and shooting at The Heroine, "After what he said to me, I wonder should we even save him?"

"He didn't have to say that." Natalia said, watching the Inventor fall into a battle frenzy, "I'll make sure to talk to him after this, he's gone too far."

"If he survives?" Trina teased.

"Is this magic Shadow?" Shawn Bolt asked, looking at the night sky with its many stars and three pink moons.

"I don't think I even noticed when everything changed." Tiana said, touching the cool salty water. "Weird?"

Shadow enjoyed the technology, how did they acquire such feats, "This is far different from elf magic."

Tasia Snow pointed to the left of the sky, "Look!"

The six turned their heads upwards to see what looked like a red comet arc through the night with something else following behind, shooting bright lights at the comet. The small squad watched as the red fireball flew several times in a circle and came spiraling towards them.

"Uhhhh, maybe we should move?" said Star, feeling nervous.

"Good idea." Said Ginger, already beginning to sprint.

The rest of the group began to move, but the comet crashed into the sandy grounds of the beach, causing everyone to fall into the loose sand. What rose from the crash was The Heroine holding The Mad Inventor by the throat, as he shot plasma bullets that barely burned her body. With a wicked smile, she slammed the smaller inventor into the ground, tore out the blades from her chest and instantly healed.

Tiana was the first one to get a good look at the redhead, as she maniacally laughed, holding her head as her wounds closed. The revitalized heroine turned her eyes to Tiana and began to stalk right towards the girl. Tiana immediately equipped an arrow, concentrated and shot cold ice. The Heroine caught the freezing arrow and snapped it in two.

"Shit." Tiana cursed, shooting an arrow of fire.

The Heroine swatted it, barely feeling the heat.

Star came from the left with her bladed tonfa and made a quick slice into The Heroine's face. The redhead hardly noticed. caught Star in her second

attack, and head-butted the young vampire. Star's knees buckled and with an easy toss the girl was thrown several feet, crashing into large rocks. Shawn and Tasia jumped in front of the redhead, releasing slashes upon her body. The redhead took the pain, letting the cuts ruin her shape, and due to with a quick elbow, the back of Shawn's head hit the sand. An unstoppable punch to the chest then stopped Tasia in mid-swing.

Strings of darkness rose from the sands, wrapping around The Heroine's limbs and body. The Heroine tried to pull away roaring and speaking incoherently but the darkness tightened, keeping her in place. Ginger took out her pistols and sent two bullets straight into the chest. The Heroine roared with pain as the shock went through her insides. Seconds later the redhead moaned, smoke steaming from her mouth.

"Perdon." Ginger said, "I know you and Trina made good friends."

The Heroine roared.

Tiana walked up to the redhead and put a loaded arrow to her face, "Well, I'm pretty sure this isn't the same girl Trina made friends with."

Tiana sighed, she felt this girl really had no choice in her own death; Tiana's arrow began to shift into brilliant lightning, and for some reasons tears began to stream from her eyes. Tiana Shot the arrow. The Heroine screamed as her brain was fried from the inside out, her body shook, her tongue boiled, her eyes sizzled, but her skin stayed untouched. Tiana wiped her face as The Heroine slumped, the fight was over.

Chapter 58:
Reunion

"Wha.. Er…bi…Fu…Rom…" Juliet was confused; she was back on the staircase.

The majority of the Black Shonen group was littered about the scene, each one bruised up and exhausted from battle.

"Sol!" Shawn bolt yelled, running up the steps.

The Elf and the rest of the Scrub-Dogs ran past Juliet and circled around their leader.

"Looks like someone healed the wound." Star said.

"With Ice." Shawn added, he was pretty sure the rest of the team knew the culprit.

"Don't worry guys." Shadow said, "I can think I can heal the rest." The Warlock moved his fingers and dark tentacles wrapped around the icy bandage and sunk beneath, "I just need some time." Shadow smiled. "Healing with dark magic is a little difficult, I've only done it a few times."

"Sorry." Tiana said, walking up the stairs to Juliet, "We didn't feel like listening."

"You bitches never do." Juliet smiled, "Yall ready to kick some ass?"

Tiana, Ginger, and Tasia all nodded, following Juliet up the stairs.

When Juliet passed by the Scrub-Dogs she looked down at Sol and asked, "Is she going to be alright?"

Shadow who continued to heal her nodded.

Juliet balled her fist; even though she won the battle she felt defeated at letting Sol get hurt, "I'll kill this nigga for the both of us."

<center>***</center>

"We're back!" Isaac said, getting to his feet.

"Awwwww, I wanted to rest a little bit more." Cookie said, stretching awake.

Cookie's saw Isaac's face hadn't remained that of a happy go lucky boy, but had become that of a determined man, "Let's go save my bro."

<center>***</center>

The Mad Inventor walked up the stairs of chaos and worry. The Young Inventor stopped at the white doors of the fifth floor. The design of the door was that of a golden leaf in the wind. The Mad Inventor reached for the knob and grabbed it. The young man hesitated, casually feeling his neck, what if he couldn't handle it? What if he got everyone killed? What if?

The Mad Inventor felt a hand on his shoulder, "We're behind you Chico." Natalia said.

"I set the timer." Trina crossed her arms and avoided eye contact with The Mad Inventor, "It's set to unlock the blocker thirty minutes from now."

The Mad Inventor nodded, took a deep breath, and opened the door.

Chapter 59:
Final Move

The Adversary sat on a comfortable white throne as his hands ran through the bloody locks of The Werewolf Johnnie True, "The wind is telling me we're receiving some visitors young man, some to save you, and others to kill me." The Adversary sat back in his throne and closed his eyes, "I wonder who will win?"

The doors to The Adversary lair open, revealing The Mads. The Adversary kept his eyes closed but let a mocking smile cross his lips, "Hello young minds, how are we doing today?"

The Mad Inventor pulled out his pistols, "Don't talk to me like some school teacher!"

The Adversary opened his eyes, "Shoot."

"He's baiting you." Natalia said.

The Adversary turned his eyes to Trina, "You looked pissed off young lady, want to attack me?"

Trina stared at the man with her arms crossed, "It's kinda my job."

"Trina ignore him." Natalia warned.

"Are you their mother?" The Adversary asked.

But before Natalia could answer The Crows walked in full force.

"What in the fuck did you do to him?" Juliet roared, as she saw Johnnie bloody and hardly conscious on the ground.

"I've heard much about you young lady." The Adversary said to Juliet.

Juliet had no words, she unsheathed her sword, her rage causing fairy magic to pulse through her veins. The Young Swordswoman let out a scream

and sprinted, the pink symbols on her right arm appeared sparking with energy, and Juliet with one swing cut the throne in half, but her sword had tasted no blood.

Juliet whirled around, standing in front of Johnnie, "Where is that bitch?"

Immediately The Swordswoman grabbed her throat as oxygen began to leave her lungs.

The Adversary materialized in front of the girl, "How do you like having the very essence of your life being snatched from you."

Tasia was in the air in seconds, her double bladed spear in hand, her eyes aimed for The Adversary. The Adversary opened his left palm as The Ninja came down and she was instantly blown away, striking a wall. The Mad Inventor and Ginger went trigger-happy. The Man of Wind vanished into air, leaving Juliet choking on the ground. He appeared behind The Crows, Tiana turned around releasing an arrow of fire for his face, the man made his head vanish, as his body preformed a double palm thrust, bashing The Crows deeper into the room.

A pink beam of energy swished through The Adversary's body, bits and pieces of the wood broke apart from the house, taking the form of birds, and shot through The Adversary like missiles. The Mad Inventor neared The Leader of The Enlightenment constantly shooting his plasma pistols; each concentrated beam of energy went through The Adversary's transparent body.

"I can do so many things." The Man of Wind teased.

With a swish of movement, The Adversary put a hand on The Inventor's chest, "Boom."

The Inventor dropped his guns as a condensed form of wind plunged into his stomach, vomit and blood shot out from his mouth, his eyes grew wide in pain as he staggered back. Natalia ran to catch him but The Adversary swiftly sent a punch surrounded by wind into her gut and fell. Trina put her hands on the floor and fingers grew from the wall, trying to catch her opponent. The Adversary ran, reinforced by the wind, he zigzagged through the many limbs, grabbing, scratching, and clenching. When he made it to The Witch he performed a front kick filled with wind straight into her face, Trina wheeled onto the floor, unconscious.

The Adversary was feeling the heat of battle, the adventure of fighting, and it was all very great to him.

Chapter 60:
The Crows Last Stand

Juliet Valentine slammed her blade into the ground, using it as a crutch. The girl was exhausted and bruised. Whenever she took a breath, she could feel her ribs and lungs ache.

The Adversary turned around, facing Juliet, "Oh, mighty Juliet, Mighty Warlord!"

Juliet through the pain stood up straight and hefted her blade on her shoulder, "I'm taking your ass out."

Juliet's right arm glowed pink with hieroglyphs, and bright energy emitted from her body. The young woman could see her comrades behind The Adversary, shuffling to their feet. Juliet knew Tiana knew what to do. The Young Swordswoman sprinted, leaped, and front flipped, crashing her blade into the image of The Adversary. The blade ate the through the floorboards causing wood to splinter, but no Adversary. Tiana, Ginger, and Tasia watched as the opponent materialized behind Juliet. Tiana reacted, equipping her arrow and shooting forth a blaze of lightning. The Adversary let out a painful moan as he staggered back, fading into the wind. Tiana immediately went to Juliet's side, standing back to back, Tasia and Ginger did the same.

"Where are you bitch?" Juliet screamed.

"You know he's trying to get us off guard." Tiana warned.

"Esto es estresante." Ginger said.

Tasia kept her eyes open to scan.

Juliet hated to admit her sword was wavering because her fist was shaking. Juliet tried to put the

feeling in the back of her mind, nothing would stop her, and The Crows would get this victory! A scream from Ginger and Tasia sent the girls flying into the wall and slamming into the ground. Juliet tried to grab Tiana's hand as Tiana was lifted into the air and her back slammed against the ceiling. In a blink, Tiana crashed onto the ground with a groan then back into the wall and the floor again with a solid thud.

"Your all alone now little girl."

Juliet felt an invisible force bury into her stomach, the girl dropped her blade, another force slammed into her back, she staggered forward, another crashed into her ribs, and tears of frustration began to form in Juliet's eyes.

"You fucker!" She yelled, "Fight me fa-"

Dozens upon dozen of wind missiles began to pummel the girl's body, Juliet screamed in anger as the pain began to be too much. How was she going to win? Then she received a hard hit in forehead, and her eyes rolled in the back of her head. Juliet Valentine crashed upon the floor defeated.

The Adversary appeared in front of the half dead body of Johnnie True Jr. The boy was still in a barely conscious state, only able to speak incoherent moans.

The Adversary smiled, "Look at you, your body still so wrecked, you don't even know where you are? All that healing takes such a long time when you're close to death."

"Don't you touch him!"

The Adversary stood up and turned around, "Isaac, I'm so glad to see you."

Chapter 61:
The Magenta Swordsman vs. The Adversary

"Cookie stay back." Isaac said, materializing his blades.

Cookie could see Isaac was different now, and she didn't dare stand in his way. The Young Swordsman began to concentrate, his veins began to glow magenta, bright fire and lightning emitted from his body, his swords sizzled, and the young man bent his knees.

The Adversary spread out his arms, "Come to me, dear rival."

Isaac blasted towards the man, with a devastating slash, but the attack phased right through The Adversary.

"Will you ever learn boy?" The Adversary mocked

The man thrust out his palm at Isaac, and The Swordsman was shot back from the wind force. Isaac decided to ignore the pain and opted for a rocketed thrust, but The Man of Wind easily sidestepped and countered with a wind-enforced punch into Isaac's jaw. The boy twirled but caught himself and performed a downward sword strike, creating a horizontal arc of energy that crashed into The Adversary. It made no difference as the man flew from out the destruction, kneeing Isaac in the nose. The Wind Man went in for a kick and in a flash of magenta Isaac appeared behind him scoring a slash into the man's back. The Adversary laughed from the pain as he turned around sending out a tunnel of wind, but Isaac had already zipped past him, with a crucial cut into his ribs.

"Oh, we fast fast now." The man mocked.

Isaac appeared in front of him gaining another slash on the shoulder. The Adversary smiled, the boy was getting slower. Isaac went for another slash and The Adversary countered with a wind punch. Isaac crashed into a wall, his swords burst into useless energy, catching himself on all fours before he hit the ground.

"Stuffmuffins! I almost had it!" The Magenta Swordsman said to himself, "If only I had a little more extra time to train my Zap-Strike."

Isaac felt the hand of The Adversary touch his cheek, the hand was warm, "How many Isaac's have I killed? I think you will be the one I remember the most?"

The Adversary spun his hand and Cookie hit the wall with a brutal force, dropping her needles, "I'm pretty sure I broke your little girlfriend."

Vines wrapped around The Adversary's body.

"And I'm purty sur I jus broke u." Said Cowboy Harris with revolvers in hand and a fairy at his side.

Chapter 62:
The Crazy Gunslinger

"It's quite interesting." The Adversary said, keeping his eyes on the exhausted Isaac True, "All the youth in my organization seem to always trade on me, I should have kept the ages higher for joining." The wind around The Adversary became violent and sharp as blades, cutting the vines from his body; The Adversary said, "You were quite stimulating to keep around, you and the fairy."

The Adversary turned around and shot out a concentrated ball at the Gunslinger. Indicia tried to warn him but it was too late, Cowboy Harris was hit. The Green Haired Gunslinger felt something pound into his chest and vomit squirted from his clenched mouth. Cowboy Harris on instinctively shot a bullet and The Adversary easily phased through it.

The Adversary disappeared and reappeared in front of The Gunslinger, "I know currently right now I can't kill you, but I can stop you."

The Adversary smiled as wind concentrated around his arm, forming a transparent blade. With a swift movement, The Gunslinger felt a stinging cut into his chest. The Gunslinger reacted with a right roundhouse kick aimed for the head, The Adversary rolled under the kick and attacked with a palm strike to the Green Haired Boy's chest. Cowboy Harris spiraled through the air, but landed on his feet and shot two more bullets. The Adversary phased through the bullets and sprinted toward Cowboy Harris. The boy began to release bullet after bullet, but with the help of the wind The Adversary was able to easily zigzag each projectile and made it to The Gunslinger. The Adversary raised his sword and

Indicia released a blast that crashed into The Adversary eyes. Cowboy Harris performed a right kick into The Adversary's ribs and shot a bullet straight into his legs, and vines began to immediately grow.

"Gotcha." Cowboy Harris said, "Every Gunslinga needz a fairy." The Gunslinger with both guns aimed for the man's head, "Gudbye."

Cowboy Harris could feel something was wrong, something was going to happen, but he had to ignore it, he had to focus on defeating The Adversary right now, whatever his anxiety was he had to ignore it. He had to win! Cowboy Harris shot both bullets; The Adversary spun, becoming a small intense tornado and tearing through his trap. The tornado spun with a deadly howl; it entrapped The Gunslinger, cutting through his body like a twister of blades. When the attack was finished, Cowboy Harris was a mess of flesh and green blood, cuts decorated his body, his hat was torn to shreds, revealing his long, bright green hair, the boy fell to the ground with a slump, and for the first time in a long time there was no smile, just a look of defeat as he bled out.

Chapter 63:
The Legend of the Knight and his Warlock

"Please!" Indicia came flying down from the fifth floor and retreating to the stairs of the fourth, where the Scrub-Dogs laid.

"Please, oh, please." Indicia pleaded with lime green tears in her eyes, pulling on one of Shawn's locks, "He's going to die if we leave him any longer, "Please!"

"Looks like we're the only ones left." Star said.

Shawn looked at the portable Warp Sphere, "Where are our superiors?"

Shadow and Star exchanged glances and shrugged.

Shawn looked at Indicia; the fairy was in high distress, *how angry must she feel the elf thought, knowing she can't save her friend.*

Shawn sighed and stood up, "You two watch Sol."

The Elf Knight held on to his daggers as he mounted the stairs, and entered the chambers of The Adversary. The Man of Wind stood waiting for Shawn. The Elf noticed this man already had some battle damage, nothing major but it was there. The Tailed-Elf saw his comrades defeated around the room and Shawn knew he was worse for wear. The elf readied his legs and sprinted madly toward his opponent. The Adversary watched the elf, he was fast, and ran straight at him. The elf leaped, and twirled in mid air, with daggers out. The man evaporated with a swish of Shawn's blades and appeared in back of him, blasting The Tailed-Elf

with a cannon of wind. Shawn heard his ribs break as his face slammed against the wall.

The Adversary raised his hands, concentrating the wind in his right palm, "I wonder what a disabled elf looks like."

Tentacles with the magic of darkness wrapped around The Adversary's body, the man activated his ability but for some reason he couldn't phase.

"I couldn't let my dear friend into the thicket of death." Said the always-cheery Shadow, "I won't, I say I won't, and I swear it."

The Adversary laughed as Shawn noticed the draft slowly picking up. Shadow looked around as his cloak swirled wheeled about from the force of wind. Shawn looked at the smiling Adversary, there was no hesitation in this man's ability, no worry. Shawn wondered if this whole fight was just some stage act for this man, but his thoughts were interrupted as his feet began to leave the floor. Shadow and Shawn wheeled about in The Adversary's tornado. The wind current was so strong Shadow lost concentration in his magic, and The Man of Wind was freed as his tornado grew stronger and the elves rotated faster and faster.

"And I have won. The wind told me so."

Shadow and Shawn dropped onto the floor with an impact that caused cracks to spread throughout the floorboards.

The Adversary looked around him, "Nothing but a bunch of teenage brats, each one of you caused trouble in your own way." a laugh came to the adventurer, "Now you're all half dead or knocked out, leaving me to start my travels once again." The Adversary turned to the window and looked at a

sunny eternal sky, it was always sunny from that window, nothing ever changed, "How I would like to just be a simple adventurer once again."

The Adversary heard a loud beep and turned around to see an orange swirling portal and within the portal he saw silhouettes coming through, shapes of what looked like grown men, "Is this where the real fun starts?"

Chapter 64:
The Grown Men

Johnnie Senior walked into the fifth floor of The Enlightenment's Mansion. The Old Man looked around to see the defeated Black Shonen members laid out on the floor. The Old Man took a puff of his lit joint and let out a breath. Johnnie Sr. looked to see Johnnie Jr. covered in blood, the boy was barely able to tell where he was at, as he tried to get up to only fall on the floor. The old man rushed to the dreadlock werewolf, giving him a hand.

"Isaac…" Johnnie Jr. barely breathed, "Where's Isaac?"

The Old man looked for his other son to find him snoring on the floor. Johnnie Sr. Laid Jr. on the side of the throne and moved to Isaac, "Nigga must be starting his healing sequence." The old man grumbled, "We got to get all these little motherfuckers, home." Johnnie Sr. looked around, "Where the fool that fucked these kids up?"

"Oh!" Came a taunting voice, "I'm right here."

Johnnie Sr. swirled around to see The Adversary several feet away, "So you the fucker that hurt my boys."

"Johnnie Sr." The Adversary said delighted, "Pleased to meet this world's version of you. It's been too long Old Man."

"What you talking about nigga?"

I've met you before." The Adversary said, "In different worlds, different versions, I've fought you many times, for some reason no matter where I go I always run into your lineage."

"What you want nigga, a cookie?"

"It was for The Homunculus Books." The Adversary said, "But it's become so much more than those silly books, its become an event." The Adversary looked around at the defeated teenagers, "These children have given me a run for my money, heh, some even got a good jab in me during the trials of battles. But, yet, they couldn't pull it off and once again it's come down to you and me. It always comes down to you and me."

Johnnie Sr. puffed his joint and vines began to spiral around his arm, making a spear of foliage.

The Adversary smirked, "I appreciate the gesture but can you really handle me Old Man?"

Johnnie Sr. smoked the last of his joint, tossing it to the ground, "Let's see what an old nigga can do."

Chapter 65:
Johnnie Sr. vs. The Adversary

Johnnie Sr.'s spear of fauna stretched, going straight through the transparent chest of The Adversary. The man turned into wind destroying the spear, but seeds remained from it. The seeds rapidly grew into large blue flowers, releasing green pollen. The Adversary tried to sweep the dust from the room, but he was forced back into his solid state and began to cough. Johnnie Sr. released a rare smile. Two concentrated beams of blue energy burst from the portal, hitting the Adversary on the back, burning through his simple cloth and scarring his flesh. Jeremy Whizz was the next one to leave the portal, fixing his gas mask.

"Your plan worked." Jeremy said, walking up to the old man, "Well, you are Tezuka."

"My plan worked cause I'm a nigga who been through way more shit than you youngsters." Said The Old Man.

"Noted." Jeremy said, fixing his gas mask, the young man looked back at the portal, "Tyrone!"

A large muscle bound, gas mask wearing man, came dashing from out the portal, slugging The Adversary right into his jaw. The Adversary hit the floor with a thud.

"Welp, that shit's over." Said Johnnie Sr.

"Once again these children have failed us." Jeremy said.

Johnnie Sr. shrugged his shoulders, "They're doing better, Odds weren't in their favor this time."

Tyrone began to inspect the kids for fatal wounds, while Jeremy searched for the books. The old man looked at The Adversary again, he was

knocked out cold, "This fight should put some skin on those bones."

Jeremy found the remainder of the notebooks and quickly threw them within the open portal. Tyrone began to throw several of the unconscious kids on his back, so he could take them through the portal and then immediately come back, grabbing several more and taking them in. Johnnie Senior bent down to look at the face of The Adversary. The Old Man was weird like that, he liked to know the faces of the people he defeated. The boy was so young, prolly just made thirty. The Old Man had seen lives be extinguished in seconds during his lifetime, did he really have the energy to take another?

Johnnie Sr. stood up, most of the kids had been taken through the portal and Jeremy was giving his last look around. Johnnie Sr. began to head to the vortex.

"You're not completing the mission?" Jeremy asked.

"The Mission was to get the books." Growled Johnnie Sr., "This nigga is done, the kids killed all his fuckin generals, and we're taking the books, he can't make any more monstrosities." The Old Man sighed, the marijuana was leaving his system, he was feeling old again, "He's wiped, and if he ever decided to come back I doubt he will be strong as he was now. You saw how easily we defeated him, he prolly defeated the kids quicker, let's go."

Jeremy didn't quite understand, but he respected Johnnie Sr. so he obeyed.

Epilogue of Homunculus Saga

Two days later…..

The Crows

Juliet Valentine and The Crows rested in the lounge living room of their dormitory. Juliet was wearing gray baggy sweats, a white tank top, and white socks, soaking up the latest reality show, "How I fell in love with a Lawnmower," while scooping cereal into her mouth. Tiana in gray sweats and a gray tank top was making a smoothie, half paying attention to the show. Tasia in a gray pajama onesie was sitting cross-legged and meditating and Ginger in her red onesie had been sitting next to Juliet, texting away and giggling to a certain Gunslinger on her Z-Phone. The Girls were well rested and the events of two days ago almost felt like a far off mission they could laugh about, even though Juliet still held a good amount of anger for being taken out so early.

"Ronald's coming." Tasia said, with her eyes closed.

The door opened, revealing a baldheaded nervous young man, "Girls how are you?"

Juliet gave a quick glance, "Were doing fine Ronald."

Ronald nodded, "I just wanted to say great, you all did great with The Enlightenment. I'm proud."

Juliet paused the show, "What! We got our asses kicked and those old bastards hogged all the glory!"

Ronald wiped his head of sweat, "I know it l..l..l..looks that way, but you young adults did far more than any generation h..h...h...had did at that age. You should be proud."

"Tell that to Seinen." Juliet said.

"Jeremy just wants to know you kids will be okay." Ronald said, "Anyway I just came to tell you the higher ups are pleased with your performance and we also have had a spike in paranormal activity. Maybe The Adversary set off some type of reaction? You girls will be buried in missions soon enough."

"Ron." Juliet said tiredly, "Thank you for not being an asshole."

Ron smiled, "Your welcome Miss Valentine."

The Scrub-Dogs

Sol laid on her bed, dressed in a black tank top and gray leggings; she had been in this position for the most of two days, besides eating and using the bathroom. She didn't even get to see The Adversary; she didn't even get to punch him. Juliet was going to give her shit like no other, and she could hear it now. It wasn't fair; she wanted to take down the big bad. He even beat Shawn and Shadow! Those elves were the two strongest people on her team! It wasn't fair! Sol's door creaked open, and it was Shadow. Shadow The Elf who played a boy with many secrets. One day Sol would figure out Shadow.

"It's Ronald." The Elf wore a black shirt and baggy black sweats with matching socks.

Sol huffed and got to her feet, she felt where she got stabbed by her sister, it was healed but raw, "Let's go."

Everyone else was in the living room, Shawn was shirtless with gray sweats performing pushups, while Star wore a gray tank top with red basketball shorts lounging on the couch.

"Hello Scrub-Dogs." Ronald said, "I'm very impressed by your work two days ago."

Sol crossed her arms, "The work of getting our asses handled?"

Ronald shook his head with a laugh, "Haven't you guys seen the vast improvement in ability? Not even a month ago would I have trusted your team with such a mission, but you all persevered. The Scrub-Dogs will have much respect now."

Sol huffed again, "I'll believe when I see it." The girl was going to head back to her room but a thought clicked suddenly in her head, "What about Luna?"

"We didn't find a body, I have drones searching through the dimensions but nothing has showed."

Sol nodded and went back to her room to sulk.

Ronald looked at the remaining members, "The Scrub-Dogs are going to be looked at a higher level, other people are going to start looking at you all for guidance. You guys went into the heart of the enemy and lived, that speaks volumes about your team efforts." Ronald gave one last huge smile, "Great things are coming for The Scrub-Dogs."

The Mads

The Mad Inventor was by himself working within his lab. He needed to improve his Plasma Guns. The weapons were useless against that

redhead. He felt even more useless against The Adversary; the whole fight was a disaster. He needed to get stronger. The Inventor noticed a call on his Z-Phone, it was probably Ronald with more dribble. The Inventor didn't care.

"You guys did great." Ronald said to Trina and Natalia.

"Don't you need the Inventor here too?" Trina said in her cat pajamas.

"He told me he wasn't coming." Natalia said, in a gray tank top and pink pajama bottoms, "I think he's a little depressed."

"He's never been the one for failure." Ronald said, "Well just let him know there's a spike in paranormal activities, this team and The Crows will be at the forefront while The Scrub-Dogs will pick up the slack."

"Sounds like were all working together." Trina said, happily.

Ronald nodded, "I am the Coordinator and Supervisor of you guys."

The True Twins

"So were going to be invited to more missions." Isaac said, happily.

"Will you shut up boy?" Johnnie Sr. said, "I don't need yo momma hearing."

"Yeah, Johnnie Jr. said, "Shut up."

"Don't tell him to shut up, little Johnnie." Cookie squealed, "Only big Johnnie can do that."

"Why is she here?" Johnnie Jr. said.

"Because she's my new best friend!" Isaac explained

The team had crammed into the home lab of Johnnie Sr.

"You know I can send you back to your world if you want?" The Old man said to his other dimensional son, "I didn't know, ain't your mission done here?"

Johnnie Jr. looked at Isaac, who looked like he was on the verge of tears if Johnnie left. Johnnie Jr. had become use to Isaac's mother and father and even got used to Cookie. The Wolf's original world was basically dead, there was no family or anything back there. What would have his father wanted?

"I'd like to stay." Said The Werewolf, "Isaac be dead if I didn't exist."

"Stuffmuffins on a Tuesday morning!" Isaac screamed, "My bro is staying for more high flying adventure!"

"Shut up Isaac!" Both the Johnnie's and Cookie screamed in unison.

The Enlightenment

Luna walked along a sandy sun beaten desert, her dress was melting from her skin, her hair was sticky and smelled, her feet ached on the burning sand, her mouth was dry, and every swallow came with an abysmal pain. In her right hand was the zombified head of Chad Rockwell. She had used The Enlightenment's technology to get far away from them and her sister. She just wanted to be alone with Chad. She stopped as she saw a green portal stir into view. Did the Enlightenment win? Was the Adversary coming to pick her up? She realized she was right when she saw Cowboy Harris step through.

"We won didn't we, is my sister dead?"

"I herd from da grapvin she be alrite." Cowboy Harris said, putting his hands on his revolvers, "I got som tings to tihten up."

Indicia flew next to the Cowboy, giving him a mischievous smirk.

In a flash, The Gunslinger grabbed both revolvers and shot. Luna's head reared back as vines began to escape from the wound, the foliage swirled around her body, absorbed her moisture, and went down her screaming dried mouth. She tried to use her ice powers and freeze the vines in place but more plants kept erupting, kept strangling her, until she gave up.

The Adversary sat on his throne, his mouth filled with dried blood, his back aching, his thoughts running rampant, he would have to build a new organization, or maybe go solo, people sucked anyway. The man sat laughing at his deeds, what should he do? The Adversary was caught off guard by a gray portal and was surprised by what he saw emerge. It was a younger version of himself, tan skin, emerald eyes, low cut haircut, and a face of determination.

"Another me, how amusing?" The Adversary spoke, "Who-"

This younger version of The Adversary was much quicker and more proficient than his older half. A rapier lay in The Adversary's heart.

"You got me." The Adversary chuckled, and then he became limp.

The younger version yanked out his sword, "You killed my best friend Isaac. I will never forgive you."

The Younger Adversary turned around entering his portal and vanished. As the dead body lay there one last person came through. He wore a trucker hat, with ratty jeans, and a stained white t-shirt.

"Look like them niggers got ahold of you." Said Paul Savaar, playing with The Adversary's head, "Look at dat. The smart handsome Adversary on his throne dead, while good old Paul Savaar lasted through the war to fuck the spoils!" Paul grimaced at the dead man, "You were never any fun you know that?" Paul sighed, "Well, since this gig is dead guess I'm going to the warp room and get the fuck outta here." Paul looked down at the dead Adversary and smiled, "See ya later boss man!"

In an unknown dimension, an unknown man sat in an unknown room. This man sat quietly in a comfortable black leather chair, his hands patiently clasped on his desk. When his client appeared in feathers of the cosmic, the man smiled. The Phantom walked up to the man and put a device on the table.

The man's hands coveted the machine, "An Interdimensional Transporter, you did great."

Hang with The Black Shonen Generation again in The Second Saga: Hollow Firma!

Made in the USA
Las Vegas, NV
03 February 2021

16971003R00348